Catlin and His Contemporaries

University of Nebraska Press: Lincoln and London

BRIAN W. DIPPIE

Catlin

and His Contemporaries:

The Politics of Patronage

Publication of this book was
assisted by a grant
from the National Endowment
for the Humanities.

The paper in this book meets
the minimum require-
ments of American National
Standard for Infor-
mation Sciences – Permanence
of Paper for Printed
Library Materials,
ANSI Z39.48-1984. ∞

Library of Congress Cataloging
in Publication Data
Dippie, Brian W.
Catlin and his contemporaries :
the politics of patronage /
Brian W. Dippie.
p. cm. Bibliography: p.
Includes index.
ISBN 0-8032-1683-1 (alk. paper)
1. Art patronage –
United States – History – 19th
century. 2. Art and state –
United States.
3. Catlin, George, 1796-1872 –
Finance, Personal. I. Title.
N8835.D57 1990
759.13–dc20 89-4963 CIP

For my brother *Bruce T. Dippie* because he said it was about time

CONTENTS

ILLUSTRATIONS

One early spring day in 1872 George Catlin dashed off a letter to the president of the New-York Historical Society. His circumstances were peculiar, to say the least. After an absence of nearly thirty-two years, he had returned to the United States the previous fall to exhibit a collection of paintings in New York—Catlin's Indian Cartoons. He had sailed to England in December 1839 with great expectations and an entirely different collection, Catlin's Indian Gallery, and through the 1840s had created a minor sensation in Britain and France. But declining novelty and unwise speculation had brought him to ruin. In 1852 creditors seized his gallery, leaving him destitute and adrift. His gallery found its way back to Philadelphia and storage in a boiler factory, and he had gone on to recreate it, augmenting the original portraits and views among the western Indians painted in the 1830s with new scenes from South America and the West Coast north to Russian Alaska painted in the 1850s. Now Catlin was back home, still trying to capitalize on his collections, still hoping to redeem the first and sell both to the United States government as permanent memorials to America's vanishing Indian tribes. In the past he had often approached Congress, coming within a whisker of success in 1849. He was close again in 1852 when the Senate tabled a resolution for purchase, dashing his hopes and capping the financial crisis that cost him his Indian Gallery.

Catlin never shook off a feeling of betrayal. The government had failed a deserving native son even as it had handsomely rewarded some

of his harshest maligners—men like the ethnologist Henry Rowe Schoolcraft who, in a fully subsidized multivolume work on the Indian tribes published in the 1850s and illustrated by a rival artist, had dismissed Catlin as a mere tourist and cast doubt upon his most important Indian scenes. Catlin was seventy-five years old when he returned to America, lame in the knee and stone deaf. But he was still vigorous in his pride, still seized by the purpose that first sent him West to paint Indians, when he addressed the president of the New-York Historical Society.

Catlin's circumstances were peculiar in 1872 because the same government that had repeatedly turned him away had, through the Smithsonian Institution, made him an offer: free use of a large hall to exhibit his cartoons while he tried once again to catch the eye of Congress. At summer's end the Smithsonian would go even further, literally taking him in, providing him a painting room and living quarters. But before accepting the Smithsonian's offer and moving to Washington, Catlin wanted to make a last stab at selling his life's work to the New-York Historical Society instead. "I am now in my old age," he wrote, "very anxious to complete some arrangement by which I can see my ancient collections, and get in the midst of them, finishing them up, and arranging them for perpetuity. . . . I should feel more proud of leaving them under the protection of your noble institution, than in the unfastening hands of the government, or in the hands of individuals who are enquiring about them."

"Unfastening hands"—the story of George Catlin's fruitless years as a patronage seeker. Even the "noble institution" he was addressing had twice turned him down and was about to do so again.[1]

But unfastening hands greeted most artists and writers who sought public patronage in nineteenth-century America. They found themselves in the midst of a burgeoning mercantile power, ruled by the laws of commerce and accumulation, indifferent to aesthetic frills. The government mirrored the values of the marketplace. "This country is essentially sustained by its great commercial interests which form, it may be said, the most prominent feature of our national character," a New York paper boasted in 1836. Government, by extension, should limit its patronage to practical endeavors that would advance the country's economic growth. It had no constitutional role as a patron of the arts. Art patronage reeked of incense and candles, established churches and Old World decadence. It was the pastime of pampered aristocrats and bored monarchs. It had no place in a bustling republic dedicated to equality of opportunity, where each prospered according to his merits and where artists, like their fellow countrymen, had to make their own way in the world. Provide a useful service, sell a useful product, and success would follow. If artists could not meet such utilitarian criteria, they should find a different line of work. They should not expect the state to support them.[2]

There were, of course, those who disagreed—institutions and individuals convinced that attainment in

the arts was the crowning glory of a republic and the surest measure of national greatness. They asserted "the intimate Connection of Freedom with the Arts" and urged the government to set an example. "The artists in this country can never expect to be supported by individual patronage, it is to the public that they look for encouragement," Thomas Sully insisted in 1812. The artist could approach state or municipal government in hopes of a portrait commission, an order for a statue or a mural, or at the least encouragement, since cities like Boston, Philadelphia, Baltimore, and New York were vying for cultural preeminence in the years before the Civil War. But if there was to be great national art, the federal government would have to take the lead. Lillian B. Miller has chronicled Congress's fumbling attempts to formulate a policy toward the arts before 1860; none emerged.[3]

Consequently, artists were left to make their cases individually, mustering whatever influence they could. With party loyalty dominating antebellum political life, all patronage seekers had to put their affiliations to the test. Artists were no exception. A rough correlation existed between a party's stance on constitutional issues and its position on artistic patronage. This lent a sectional cast to the patronage question, since strict constructionists, given to a literal (and limited) reading of federal powers, were generally unsympathetic. But the key point is that there was no *systematic* federal policy toward the arts. Government patronage worked itself out in practice as a succession of private mem-

bers' bills, breeding rivalries and bitterness while providing precious little in the way of sustenance.

Periodically statesmen and editorial writers joined artists in deploring the situation. "A Plea for the Fine Arts" in Washington's *Daily National Intelligencer* in 1852 assailed the "niggardly patronage" offered in America: "There can be no doubt that the arts are not duly appreciated among us; and that the zeal for the useful (so called) has smothered the humanizing impulses in favor of the elegant. . . . What is wanted is national encouragement; an encouragement that will diffuse its potency over the whole country, through all classes of the people." The ancient democracies had cultivated the arts; Thomas Jefferson thought art compatible with republicanism and recognized that "individual enterprise would avail but little, if the hand of Government be so paralyzed as to refuse to lend its aid." In the 1830s Congress had voted substantial sums for the ornamentation of the Capitol building, but there "public liberality" stopped. "What we want is a national gallery, in imitation of that of the Louvre." The rotunda of the Capitol with its eight historical paintings was only a beginning, while the Smithsonian had done nothing at all for the arts. "To the National Legislature, therefore, we must look, and to it indeed we ought to look, for the establishment and support of a national gallery. We have the subjects and the artists; we wait only for the munificence of Congress."[4]

What makes this editorial important is that there was not a new idea

in it. Four months after it appeared, Congress rejected Catlin's latest plea for patronage. Some of those who voted against him had probably read the piece in the *Intelligencer* and nodded in agreement. But they agreed even more with their colleague Senator Solon Borland of Arkansas, who during the debate on Catlin's bill remarked that governmental responsibility to the "ornamental branches" of the arts and letters was strictly secondary to the support owed "the practical business interests of this country." A tug at national pride and an appeal to patriotic virtue could not win the vote for Catlin or unfasten Congress's hands.[5]

* * *

This book began several years ago as an article. I intended to detail George Catlin's quest as a case study in the history of art patronage in America. I was attracted to Catlin because of his surpassing importance to students of Indian culture. Quirky, evocative, and vivid, his paintings and the vision behind them have become part of our understanding of a lost America. We see the Indian past through Catlin's eyes, imagine a younger, fresher land in his bright hues. His paintings seem to have always been there, like the sun and the seasons. We forget the conscious calculation, the decisions taken and the sacrifices made to produce works that are today national treasures.

Catlin's excursions among the western tribes in the 1830s have been often chronicled. He spent only a few years in what he considered real Indian country. The rest of his long life—with the exception of his enticingly obscure wanderings in South America in the 1850s—was devoted to promoting, repainting, and selling his collection. Thirty-five years, in short, went to marketing what had been created in a few years all told. Students of Catlin's career are aware of his bootless efforts to dispose of his Indian Gallery to the federal government, learned bodies at home and abroad, or any private collector of means who might express an interest. My intended contribution was a thorough exposition of how one significant nineteenth-century American artist went about the business of trying to make a living from his work.

But George Catlin did not live in a world of one. His patronage quest intersected those of others like him who had made the Indians their subject—fellow artists, certainly, seeking what support was to be had for the painter who went outside conventional portraiture, and antiquarians devoted to the study of native cultures. They shared the assumption that the Indians were doomed to disappear before the advance of civilization in America. Consequently they believed their subject was the most intrinsically American of themes: nothing could be more native than the natives, and those who wrote about them or painted them thus had a special claim upon the nation. Antiquarians and artists alike scrambled for the meager institutional and governmental support available. With so little to be had, allies became rivals, and sometimes bitter adversaries, as the range of human qualities mani-

fested itself in a frustrating competition that I have called "the politics of patronage."

As those who intersected with Catlin emerged as individuals, the limited case study I had once contemplated became a series of case studies, all linked by the common themes of patronage and Indians, and my article became a book. Since Catlin put so much blame for his defeats in Congress on Henry Rowe Schoolcraft, it was necessary to introduce Schoolcraft and his own search for support for his antiquarian studies. Schoolcraft led to an army officer–artist, Seth Eastman, who served as illustrator for Schoolcraft's congressionally subsidized magnum opus on the Indians. Eastman in turn pointed to a fur trader–politician who loathed Catlin, Henry H. Sibley. If Sibley was the catalyst in forging the Schoolcraft-Eastman collaboration, antiquarian Ephraim George Squier served as a solvent. Subsequent to his falling-out with Eastman, Schoolcraft briefly latched onto another artist to illustrate his Indian history, John Mix Stanley. With an Indian gallery of his own to rival Catlin's, and with Eastman's backing, no less, Stanley would press his case for patronage on Congress until 1865, when disaster destroyed his hopes and revived Catlin's. Bookseller, antiquarian, and patronage seeker John Russell Bartlett was acquainted with Catlin and knew Schoolcraft, Eastman, Squier, and Stanley. He was a contact point for all of them. Others too figure in this history of the politics of patronage: queens and kings and wandering no-

blemen (Victoria, Louis-Philippe, the marquis de Lafayette, Sir William Drummond Stewart, Prince Maximilian), scientific luminaries (Alexander von Humboldt, Benjamin Silliman, Joseph Henry, John James Audubon), philanthropists and collectors (Ralph Randolph Gurley, Ezra Cornell, Sir Thomas Phillipps, Sir William Blackmore), antiquarians and literati (Albert Gallatin, William W. Turner, Buckingham Smith, Edwin H. Davis, Brantz Mayer, George Gibbs, George Gliddon, Francis Parkman, Charles F. Hoffman, Charles Lanman, John Howard Payne, James Hall, George Sand), statesmen and officers (Lewis Cass, Daniel Webster, Solon Borland, William H. Seward, Jefferson Davis, James H. Hook, Charles Wilkes), Indian Office officials and fur traders (Thomas L. McKenney, Lawrence Taliaferro, James Kipp, Henry Boller), Indians and Indian painters (Keokuk, Osceola, Pigeon's Egg Head, George Copway, Maungwudaus, Peter Rindisbacher, Charles Bird King, James O. Lewis, Alfred Jacob Miller, Karl Bodmer, Paul Kane, Frank B. Mayer, George Winter—even Eugène Delacroix), that American original P. T. Barnum, and such formidable presences as Clara Catlin, Miriam Squier, Mary Henderson Eastman, and Mary Howard Schoolcraft. Most have only bit parts in this chronicle, but all, I hope, emerge as something more than names. For the issues involved here were human issues, and they defined themselves in intensely human terms.

Patronage in nineteenth-century

America was the story of artists hungry for preferment and forced to subsist on crumbs. That they produced so much of enduring importance in such trying circumstances was the sought-for miracle that had seemed to elude them in their lives.

ACKNOWLEDGMENTS

During the course of researching and writing this book I have contracted a debt load George Catlin would have appreciated, though mine is a pleasure to acknowledge. I want to mention first the unfailing courtesy my inquiries, in person and by correspondence, have met from the professional staffs of every institution, library, and repository I approached while working on this study; they are listed individually in the Bibliographical Note. Additionally, I want to acknowledge the help I received from the staffs of the Marion Koogler McNay Art Institute, San Antonio; the St. Louis Mercantile Library; the Litchfield Historical Society, Litchfield, Connecticut; and the Butler Library, Columbia University, New York.

Friends and colleagues have assisted me in varied and numerous ways. I want to thank Alfred N. Hunt, SUNY-Purchase; William C. Hine, South Carolina State College, Orangeburg; William H. Goetzmann, University of Texas, Austin; Paul A. Hutton, University of New Mexico, Albuquerque; Carol Clark, Amherst College, Amherst, Massachusetts; James D. McLaird, Dakota Wesleyan University, Mitchell, South Dakota; Angus McLaren and Wesley T. Wooley, University of Victoria, British Columbia; Terry Eastwood, University of British Columbia, Vancouver; Arlene McLaren, Simon Fraser University, Burnaby, British Columbia; Ron Tyler, Texas State Historical Association, Austin; David L. Nicandri, Washington State Historical Society, Tacoma; Lynn Brittner, School of American Research, Santa Fe, New Mexico; Joseph C. Porter, Center for Western Studies, Joslyn Art Museum, Omaha, Nebraska; Fred Myers, Thomas Gilcrease Institute, Tulsa, Oklahoma; Sarah E. Boehme, Whitney Gallery of Western Art, Buffalo Bill Historical Center, Cody, Wyoming; Lonn Taylor, Smithsonian Institution, William H. Truettner, National Museum of American Art, Smithsonian Institution, and Nancy Anderson, National Gallery of Art, Washington, D.C.; A. H. Saxon, Fairfield, Connecticut; Joseph G. Rosa, Middlesex, England; Robin May, London; R. L. Wilson, Hadlyme, Connecticut; Mary Ann Di Napoli, Brooklyn, New York; Sandra Lucas, Calgary Alberta; Mme Wernert, Aix-en-Provence, France; and Donna Evleth, Paris. Inspirations in their separate ways were F. Joy McBride and Charles W. Cowan, Victoria, British Columbia, and my brother Bruce T. Dippie, Seattle. At the University of Victoria I especially want to acknowledge my debt to Betty Gibb and the friendly and efficient staff of the Interlibrary Loan Service and to June Bull, typist extraordinaire. A study of patronage (and the lack thereof) such as mine makes one all the more grateful for the support offered scholars in our day. My work has been generously aided by grants from the University Presi-

dent's Committee on Faculty Research and Travel and a Leave Fellowship from the Social Sciences and Humanities Research Council of Canada.

As always, I owe most to my family—Donna, Blake, and Scott— who accepted my absence when I was away researching and when I was at home writing, too absorbed to be much fun. For their patience, their encouragement, and simply for being themselves, my thanks and love.

Catlin and His Contemporaries

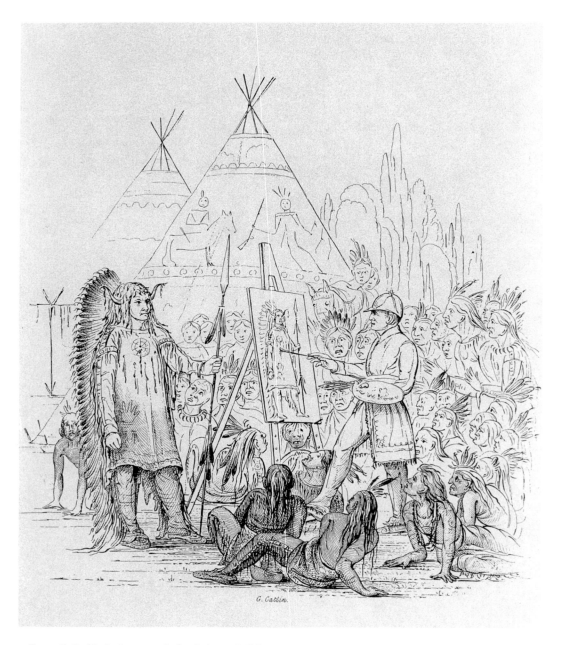

1. George Catlin, *The Author, Painting a Chief at the Base of the Rocky Mountains,* a portrait in self-satisfaction that served as the frontispiece to Catlin's *Letters and Notes on the Manners, Customs and Condition of the North American Indians* (1841).

Mr. Catlin has contrived to bring before our eyes the fullness of the life of the Western Indians. . . . The galleries illustrative of national character and antiquities which are to be found in London, Paris, Florence, and other cities, have been collected by the power of great kings; and the outlay of immense treasure. . . . This is the work of a single individual, a man without fortune and without patronage, who created it with his own mind and hand, without aid and even against countenance; and who sustained the lonely toils of eight years in a region fearful and forbidding beyond the conceptions of civilized life, in order to present his countrymen with a work which he knew they would one day value as the most remarkable thing they owned. . . . He may point to his magnificent collection, which now receives the admiration of every eye, and may say with honest pride, "Alone I did it!"

Philadelphia *Saturday Courier,* in *A Descriptive Catalogue of Catlin's Indian Collection* . . . (1848)

A New Path to Fame and Fortune

George Catlin and the Western Indians, 1830–1836

It was June 16, 1832, and Fort Union at the confluence of the Missouri and Yellowstone rivers was in sight. Cannons roared a welcome; Indians lined the shore, their surprised cries adding to the din. George Catlin had been heading upriver for nearly three months now, and with his fellow passengers aboard the American Fur Company steamer *Yellow Stone* was seven hundred miles farther up the Missouri than anyone had been carried by steam before. A compact man, five foot eight, under 140 pounds, just short of thirty-six years old, wiry and tough for his size— hard as hickory, as the saying went—he had observed with unflagging enthusiasm the prairie panorama that rolled by. Some passengers had found the scenery monotonous, the trip interminable. But he had stood by

3

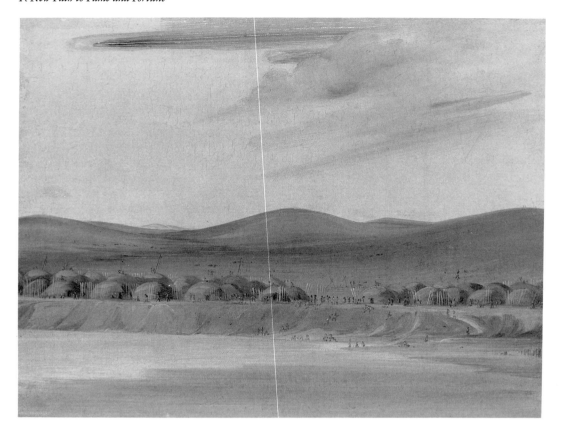

2. George Catlin, *Arikara village of earth-covered lodges, 1600 miles above St. Louis* (1832), a view from the steamboat *Yellow Stone*. National Museum of American Art, Smithsonian Institution; gift of Mrs. Joseph Harrison, Jr.

the rail for hours on end enraptured by the variety his artist's eye discerned—a landscape that seemed enchanted and a human pageant of unfailing interest. For beneath the hard exterior he was pure romantic, "here in the full enthusiasm and practice of my art." He had come West to paint unspoiled Indians, still dressed in native finery and practicing rites that may have been old when Columbus touched shore in the New World. Alcohol and disease and misery and dependence on the white man's goods had corrupted the Indians most Americans saw, reducing them to hapless beggary. But by venturing far beyond the frontier, the ragged line of white settlement straining westward, one could still see Indians in "the honest and elegant simplicity of nature," Greek statuary come to life. No artist, he was sure, had gone "farther to get *sitters*," and none was more enamoured of "nature's trackless wilds." When he looked down from the deck of the steamboat he might have reflected on reality's darker hues: the Missouri's turbid waters were as brown as a cup of chocolate, totally opaque below a sixteenth of an inch, he reported. The *Yellow Stone* was floating on a current of mud, the channel clogged with snags and ever-shifting sandbars. But the river was his highway to adventure, the steamboat that carried him to Fort Union a magic carpet transporting him to "fairy land."[1]

4

Three months out of St. Louis, more than half a year absent from family and friends, George Catlin was still dizzy with the excitement of a dream being realized. "I set out on my arduous and perilous undertaking," he remembered, "with the determination of reaching, ultimately, every tribe of Indians on the Continent of North America, and of bringing home faithful portraits of their principal personages, both men and women . . . ; views of their villages, games &c. and full notes on their character and history. I designed, also, to procure their costumes, and a complete collection of their manufactures and weapons, and to perpetuate them in a *Gallery unique,* for the use and instruction of future ages." Not just an adventurous artist, Catlin was a man with a mission.[2]

* * *

There was little in George Catlin's background to signal this departure except iron resolve and an ambition bred in the bone. He was born four years before the new century, on July 26, 1796, the fifth of fourteen children, the third of nine sons. His mother, Polly, made her family her life. Of limited education, she was rather timid and unworldly, but she served as a counterweight to her husband, Putnam, a proud man with social pretensions. Putnam Catlin's father was an officer in the Revolutionary War, and he himself saw service as a fifer. When the fighting ended Putnam trained in the law and was admitted to the bar in Wilkes-Barre, Pennsylvania, in May 1787, while the Founding Fathers were meeting in Philadelphia to draft the new Constitution. He married the next year and was soon a father himself. Polly bore their first child in 1790, their last in 1815—a quarter-century span that saw the nation through another war with Britain. Putnam took his role as patriarch seriously. He was a loving parent but stern and demanding, determined to *will* his sons to success. He continued to practice law after 1800 while farming in western New York and Susquehanna County, Pennsylvania, and he also filled local offices—assemblyman, treasurer, school trustee, judge. Indeed, he was something of a patronage seeker, wise to the ways of politics. In 1818, through the intercession of his old friend Timothy Pickering with Secretary of War John C. Calhoun, Putnam had one son appointed to the Military Academy and tried unsuccessfully three years later to have another admitted as well. He accepted political setbacks philosophically. After the "dull" government refused him a county post, he concluded it was for the better: "It will fix me more quietly on my farm." But his hopes were resilient, as his son's would be. In 1827, with his family scattered and moving again on his mind, he approached another old friend, Abra Bradley, the assistant postmaster general, about a position with the New York customs house. His staunch Federalist sympathies may have worked against him, as well as his age (he was sixty-two), though he used his age to advantage, playing on the fact he was a Revolutionary War veteran who had for forty years "resided in the

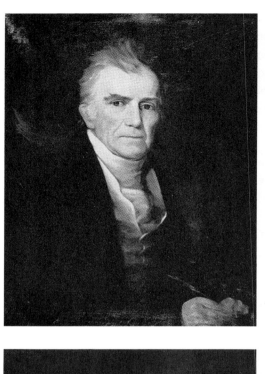

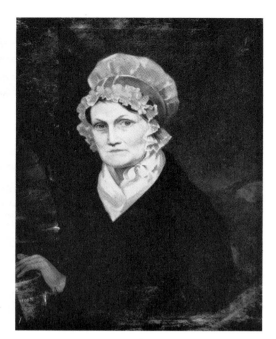

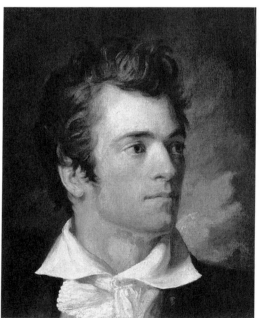

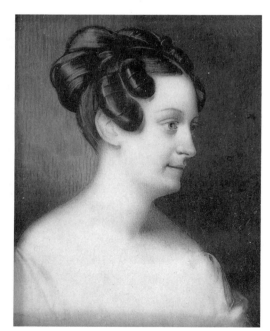

interior of Penna without patrimony patronage or pension." He did not get the customs post, but he did get a pension—and he provided a model for George Catlin's own long career as a patronage seeker.[3]

Putnam Catlin's passion was to see his sons well launched in life. George and his brother Julius, eight years George's junior, had both shown artistic promise, but art was not a proper profession, and Putnam steered the one into law, the other to West Point. George entered the highly regarded law school of Tapping Reeve and James Gould at Litchfield, Connecticut, in July 1817, just before he turned twenty-one. By the standards of the time this was a late start, and it may have indicated a propensity to drift that George's worried father hoped a strict regimen of study would correct. Catlin remembered his rural childhood fondly, recalling that he grew up "with books reluctantly held in one hand, and a rifle or fishing-pole firmly and affectionately grasped in the other." Nature would always be his school of choice. But in 1817 he bent to his father's will and the task at hand at Litchfield. Sit down, Putnam wrote, "and imagine that I am present lecturing and admonishing you." George should read and ruminate, polish his writing skills, and accustom himself to public speaking, accomplishments that would in fact serve him well in later life, though not to the ends his father contemplated. Be "thoughtful and industrious," Putnam counseled, and "make the best efforts to succeed handsomely."[4]

Financial constraints limited Catlin to a single year at law school, but he was adequately prepared for admission to the bar in Connecticut in September 1818 and in Wilkes-Barre a few months later. His training went against his nature, however, and the law could not hold him. A *"Nimrodical* lawyer" at best, he abandoned his practice within a few years, sold his law library, bought brushes and paint pots, and moved to Philadelphia. He kept his rifle and fishing tackle, however, as an affirmation of his continuing love for the outdoors. It was a passion that never deserted him and that had more than a little to do with his later choosing Indians as his life's work. Even in 1839, with his Indian Gallery a reality and the pressures of a New York exhibition weighing him down, he found relief in a short visit home "taken up with friends, gunning, fishing, &c."[5]

Doubtless disappointed by the turn of events, Putnam reserved judgment on his son's mercurial behavior. Settled in Philadelphia with quarters on Walnut Street, where he would reside until 1825, George early in 1821 had resolved to become a portrait painter—which at least offered the prospect of a decent living. Resigning himself, Putnam sent a letter exhorting his son to greatness by chanting the names of "the Artists in your line": Michelangelo, Rubens, Raphael, Rembrandt, Titian. They stood before him, a Legion of Honor. Would he earn admittance to their immortal company? "Most painters of eminence have worked at portraits & history," Putnam noted; "few have confined themselves to miniatures." Behind

3. *Top left.* George Catlin, *Putnam Catlin* (1840s), showing a stern but loving father (1764–1842) who was determined to will his sons to success. Courtesy Marjorie Catlin Stevenson, Eugene, Oregon.

4. *Top right.* George Catlin, *Polly Sutton Catlin* (1840s), honoring a pious mother (1770–1844) who clutches the Bible that was her lifelong guide. Courtesy Marjorie Catlin Stevenson, Eugene, Oregon.

5. *Bottom left.* George Catlin, *Self-Portrait* (1824), a Byronic image. There is something of the dreamer here, though the Indian is not yet a gleam in his eye. The Thomas Gilcrease Institute of American History and Art, Tulsa, Oklahoma.

6. *Bottom right.* George Catlin, *Clara Gregory Catlin* (1828), a miniature of the woman who would sustain him, painted in the year they married, when she was just twenty. National Museum of American Art, Smithsonian Institution; Catherine Walden Myer Fund.

some names, he jotted a capsule assessment: died rich was his favorite. So Putnam gave his blessing and awaited proof that George had made the right decision. If he would not be a lawyer, perhaps he would be the Blackstone of art, the best (and richest) portrait painter in America.[6]

This was a great age for American portraiture, and Philadelphia, though fading, was still one of the places to be. There was the luminous example of Thomas Sully as inspiration; the Peales were there, as were sympathetic contemporaries like John Neagle. Nearby cities afforded additional opportunities. Indeed, the portraitist's life was often an itinerant one: every small town was a potential market for his talents, and when hard times or too much competition dried up a market, moving on was the solution. "Looking neither to the right nor left, you should *manufacture* heads," Benjamin Latrobe, Philadelphia's premier architect, advised a painter in 1810. "That most essential support of all Art," he said, was "Money," and portraiture was the way to make it.[7]

Where Catlin fit in is uncertain. He had honed his skills as a miniaturist, exhibiting at the Pennsylvania Academy of Fine Arts each May from 1821 to 1823. In February 1824 he was elected to membership. A satisfied client that year praised his miniatures for their handsome execution and fidelity—"the *original* is readily recognized in all of them." But miniaturists were at the lowest level of the profession, their ambitions as circumscribed as their format. With the initials P.A. (Pennsylvania Academician) behind his name, Catlin aspired to more. Though the academy's catalogs still listed him as a miniature painter, he was represented in the exhibitions of 1824–26 by a watercolor copy of Rubens's *A Bacchanal* and a striking self-portrait in oil.[8]

Proficient on a small scale, on a larger scale Catlin was inconsistent. Canvas gave scope to his ambitions, but also left room for his weaknesses to out. He had trouble keeping head, trunk, and limbs in proportion. "I like to work upon my own plan with a picture," he explained, "and when I have done all I intend—exercised my own taste & judgment, then I like to be corrected & if possible make the improvements suggested." Standing figures more than once defeated him even after he was well launched as an Indian painter; in the 1820s they were simply beyond his skills. Nevertheless, in 1827 he set himself up in New York City as a portraitist, and in 1828 he was commissioned to paint Governor DeWitt Clinton for the New York Common Council. It was "the worst full-length which the city of New York possesses," according to a contemporary, but the Franklin Institute in Rochester had a copy made, and the fact of the commission bolstered Catlin's reputation. An officer at West Point that same year ordered a portrait at $40 and a group at $60, putting Catlin however modestly in the company of his friend Thomas Sully, who between 1815

and 1839 executed a series of portraits for the West Point Library at fees ranging from $300 to $600.[9]

This flurry of activity may have convinced Catlin that financial success was within his grasp and a family of his own now possible. On May 10, 1828, he married Clara Gregory, from a prominent family in Albany. Her brother Dudley, a prosperous businessman, would later be mayor of Jersey City and a Whig congressman (1847–49) from New Jersey. The Catlins liked Clara at once—"George is the most happy man to appearance I have ever seen," a sister wrote—but Putnam's letter of congratulations was a case study in misreading his son: "I will anticipate seeing you very happy as a husband, with a wife looking over your shoulder, encouraging and admiring the arts, rather than leading you by the heart-strings into the fashionable mazes of luxury and dissipation. You will now be more happy and composed, what is the world now to you? In your room, and in your little parlour by your own fireside you will find contentment and solace, no where else." His relief was understandable: he was passing responsibility for keeping his son in line on to another.[10]

But in marrying, George Catlin was not settling down. More than ever ambition was gnawing at him—the desire to do something great was a hunger that domestic "contentment and solace" could not appease. Far from being reconciled to respectable attainment and comfortable success, he was dreaming of adventure and scheming to get away. Portraiture was hack work, after all, a living death; it could never satisfy a real artist. His brother Julius, who had graduated from West Point in 1824 and served two years as a lieutenant in the First United States Infantry at Cantonment Gibson in Arkansas Territory, had further confounded Putnam Catlin by resigning his commission in September 1826 and taking up miniature painting. Julius may have planted the desire to see Indian Country in his older brother's head; at any rate, the two contemplated a tour of the West together. But in September 1828, after delivering the copy of George's Clinton portrait in Rochester, Julius drowned in mysterious circumstances, with a hint of foul play. He was a martyr to art, the papers said, having swum into the Genesee for a better view of "the Principal cascade and the romantic scenery adjacent," which he was sketching. The tragedy only made George more restless. Now escape was a need that could not be resisted.[11]

A second factor may have contributed to Catlin's restlessness in 1828. Despite his apparent acceptance as an artist, there were also setbacks. In 1826 he was elected a member of the newly formed National Academy of Design in New York, though his inclusion was enveloped in controversy. Proposed earlier, he had been put off until elected by a unanimous vote not of all members, the minutes specified, but of all members present at the

9

meeting. Subsequently his work was denigrated by fellow academicians, notably William Dunlap, who described him as "utterly incompetent." The issue came to a head in a stormy exchange at the meeting on May 7, 1828, when Catlin protested the arrangement of his works in the annual exhibition. "Serious and unpleasant words passed," the official record noted, and Catlin, in high dudgeon, demanded the return of his pictures and tendered his resignation, which was immediately accepted. Certainly Catlin's work was substandard in an organization whose membership boasted Samuel F. B. Morse, Henry Inman, Rembrandt Peale, Thomas Cole, and Asher B. Durand; and though he exhibited with the rival American Academy of Fine Arts instead, his paintings (including his portrait of Governor Clinton, one of the academy's founders) were classed among the "leaden caricatures." Dunlap noted that Catlin went on to paint western Indians, "and I doubt not that he has improved both as a colorist and a draughtsman. He has no competitor among the Black Hawks and the White Eagles, and nothing to ruffle his mind in the shape of criticism." Such waspishness supports William Truettner's contention that Catlin's mixed reception in New York played a part in his decision to paint Indians, placing him beyond academic criticism, literally a nonpareil.[12]

Catlin ignored such motives in favor of a single creation myth for his Indian Gallery. One day in Philadelphia—he never gave the year—while he was casting about for a higher purpose in life than portraiture, Inspiration visited him. It came in the form of a touring delegation of western Indians, "noble and dignified-looking," who "suddenly arrived in the city, arrayed and equipped in all their classic beauty,—with shield and helmet,—with tunic and manteau,—tinted and tasselled off, exactly for the painter's palette!" After a brief stay they continued on their way to Washington, but Catlin had been transformed. He had found a "branch or enterprise of the art, on which to devote a whole life-time of enthusiasm." He would paint Indians, unspoiled natives in their western wilds, "thus snatching from a hasty oblivion what could be saved for the benefit of posterity, and perpetuating it, as a fair and just monument, to the memory of a truly lofty and noble race."[13]

This account, burnished by repeated tellings, is faithful to the tradition of the artist captive to his art. There is a kernel of truth in it. Catlin's family had gone along with his decision to abandon law for art, but they balked at his latest brainstorm and raised the same objections Samuel F. B. Morse's mother did when, twenty-three and full of himself, he renounced "mere" portraiture in 1814 to pursue "the intellectual branch of the art," history painting. "You must not expect to paint anything in this country for which you will receive any money to support you, but portraits," she chided. How could Catlin make a living indulging his personal preferences in art? Who would pay his way? How would he support a wife? Catlin's answer:

he was making an investment in the future. To the charge that his plan was impractical, he replied that in painting the Indians he was creating a monument to them *and* to himself. Art, with its putative refining qualities, was often advocated as a "foil to materialism and economic selfishness," but some artists were themselves "expectant capitalists," as eager as any businessman to turn a profit on their outlay of time and labor. Art and the "spirit of gain" were not incompatible. In America, art would not be the exclusive domain of moon-eyed dreamers, pale, precious, and unworldly; it would attract men of good sense dedicated to achieving success, artist-entrepreneurs, and Catlin was of the type. There was calculation in his decision to paint Indians, then, an altruism tempered by his conviction that they would be for him "a new path to fame and fortune."[14]

Why Indians? Catlin's personal experience offers few clues. His associate John Neagle painted a delegation of Pawnees and Otos who passed through Philadelphia in 1821, but Catlin did not. Nor did he anticipate Neagle's 1823 oil sketch of Red Jacket; his own bust portrait of the Seneca notable was painted in Buffalo three years later, while his full-length study of Red Jacket may have been inspired by Robert W. Weir's 1828 portrait, with Niagara Falls in the background of both. Until 1828 Catlin had shown no special interest in Indian subjects. That fall, however, he took a decisive step when he painted full-length portraits of nine members of a Winnebago delegation touring the East Coast. William Truettner has called the results "gruesome," but despite their failings as art the paintings accurately foretold Catlin's future direction. In painting Indians, he was answering the call that had echoed since the end of the War of 1812 for a distinctive American culture drawing its inspiration from the land itself.[15]

* * *

The War of 1812 had been a disaster in most respects—the nation's new capital occupied, public buildings razed, the coast blockaded, and what began as an offensive war becoming by 1814 a desperate defensive struggle to save the young republic from internal dissolution and external conquest. The Treaty of Ghent, signed on Christmas Eve 1814, had been a signal success simply in calling for a return to the status quo ante bellum, and Andrew Jackson's victory at New Orleans on January 8, 1815, though militarily meaningless, had done much to salve wounded national pride. A period of almost giddy nationalistic fervor followed as Americans heaved a collective sigh of relief and resolved to build upon their near disaster a stronger, more unified country. Nationalistic ardor briefly touched every phase of American life, and though the Era of Good Feelings proved illusory, the campaign for a national culture carried on. Why not a policy of government subsidization of the arts equivalent to that for canals and manufactories? Cultural independence was as much a requisite of nationhood as political or economic independence and was peculiarly the respon-

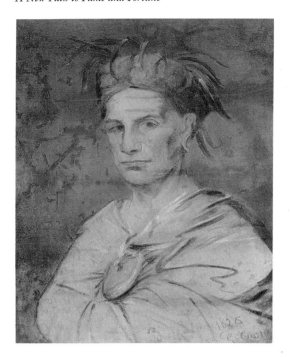

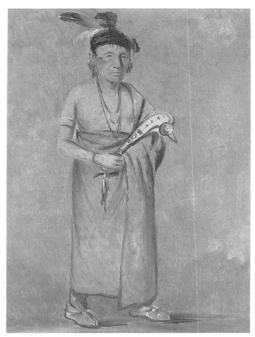

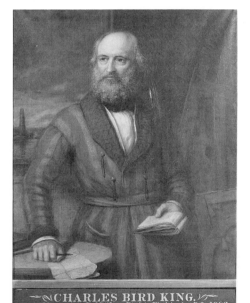

CHARLES BIRD KING.
Born in Newport A.D. 1785. Died in Washington D.C. 1862.
This Portrait painted by himself when 70 years of age.
Attributing much of his success in life to an early taste for Literature and
Art, cultivated within the walls of this Library; he repaid the obligation
by successive Donations to this Institution. At his death he made to it the mun-
ificent Bequest of Real Estate yielding Nine Thousand Dollars, his Library; his valua-
ble Engravings, and more than Two Hundred Paintings which adorn these walls.
A life-long Friend, —— May his Name and Benedictions be held in perpetual remembrance.

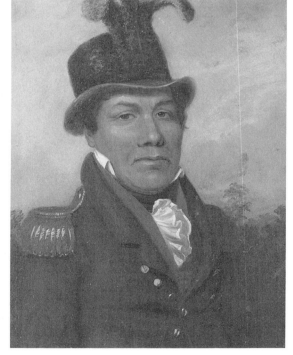

7. Top left. George Catlin, *Red Jacket* (1826). The Thomas Gilcrease Institute of American History and Art, Tulsa, Oklahoma.

8. Top right. George Catlin, *The Spaniard,* a Winnebago painted in Washington in 1828. National Museum of American Art, Smithsonian Institution; gift of Mrs. Joseph Harrison, Jr.

9. Bottom left. Charles Bird King, a self-portrait painted in the 1850s when King (1785–1862) was a Washington fixture. Redwood Library and Athenaeum, Newport, Rhode Island.

10. Bottom right. Charles Bird King, *Pushmataha* (1824), a Choctaw war chief in the kind of parlor portrait Catlin hoped to eclipse by visiting the Indians in their native country. The Warner Collection of Gulf States Paper Corporation, Tuscaloosa, Alabama.

sibility of government in a republic. Cultural nationalists suggested appropriate themes: the Revolutionary War, the War of 1812 (presumably its better moments), patriotic heroes, raw nature, and the people themselves, "the word Democratic, the word En-Masse." American historical painting, landscape, and genre would meet the challenge. But no theme seemed more appropriately American than the native tribes, and none more likely to garner government support.[16]

Under the Constitution, Indian affairs were a federal responsibility, and after the War of 1812 the government redefined its relations with the border tribes. The war had brought Americans few military victories, but it had achieved one clear result: the tribes east of the Mississippi River from the Great Lakes down to the Gulf coast had been rendered impotent as a serious threat to white settlement. Twin blows struck in close succession in 1814 shattered Tecumseh's visionary alliance in the Northwest and Creek resistance in the Southwest. After the war the fate of the tribes was, as never before when the possibility of a foreign alliance still existed, at the pleasure of the American government. Treaties would still be signed and the concept of tribal sovereignty upheld in law. But with the passage of the Indian Civilization Act of 1819 the government had taken the first step in defining Indians as wards of the nation. A leap of logic suggested that research about them was also a legitimate federal responsibility. If the government was to deal with the tribes from knowledge, ethnological information was essential. A collection of Indian curios would be desirable, and perhaps pictorial representations as well. Studying and painting Indians might not be strictly within the scope of the government's constitutional jurisdiction, but both served functions that were: informed policymaking and effective administration.

By 1819 Indians were already a familiar prop in the historical painter's bag of tricks—Benjamin West stuck them in as so much staffage—and Indians often symbolized America in allegorical works. The Indian as Indian had been done only rarely, however, and almost never in his native wilds. With the sanction of the government, this was about to change. In 1819, the year the Indian Civilization Act became law, Samuel Seymour was appointed draughtsman to Major Stephen H. Long's Yellowstone expedition, and Titian Ramsay Peale, from the distinguished Philadelphia family of artists, was made assistant naturalist with responsibilities that included natural history illustration. After wintering on the Missouri just above the mouth of the Platte River, Long's expedition to the Yellowstone fell victim to the financial panic of 1819 and, with its objectives curtailed by Congress, headed due west instead the following spring. Within sight of the Rockies it turned south, Seymour accompanying one party down the Arkansas, Peale a second down the Canadian (it was supposed to be on the Red), the two reuniting at Fort Smith on the Arkansas. The expedition

13

was in many respects a failure; it repaid its frustrations by saddling the region traversed with a label that stuck: the Great American Desert. The contribution of its two artists was also disappointing, since only a handful of their 272 sketches were published with the official reports. But Seymour and Peale had accomplished many firsts—views of tipis, plains warriors, dances, buffalo hunts, buffalo grazing on the plains, new wildlife species, the Rocky Mountains. No first was more important, however, than the precedent they set for later artists who accompanied the army exploring expeditions that fanned across the Far West in the middle of the nineteenth century and left a graphic record of scenery and Indian life.[17]

In this period the government also got into the business of commissioning Indian portraits. Even before Lewis and Clark set off up the Missouri to begin their epic exploration in 1804, a delegation of twelve Osage men and two boys from the newly purchased Louisiana Territory was on the way to Washington to visit the Great White Father and take in the sights. They conferred with Thomas Jefferson and toured Baltimore, Philadelphia, and New York. Several also sat for their portraits, establishing another precedent that became policy of sorts in 1822 when the superintendent of Indian trade and head of the Office of Indian Affairs, Thomas L. McKenney, with the War Department's sanction, commissioned the first in a series of oil portraits of visiting Indian dignitaries. By 1842, when the practice was abandoned, the collection numbered nearly 150 paintings, at least 124 of them the work of Charles Bird King.[18]

King (1785–1862), a native of Rhode Island, trained as an artist in New York and under Benjamin West in London, returning to the United States in 1812. Like so many aspiring painters, he made his living as an itinerant portraitist before settling in Washington in 1818 to become the "Nestor of metropolitan art," as he was described at midcentury. His sitters included the Adamses, Monroe, Calhoun, Clay, Jackson, and Webster, but no portraits he painted made the stir that his gallery of Indian heads did. He got from $20 to $30 for busts, $27 to $60 for full-length figures. The most he was paid for a single painting was $150. All told, he received $3,500 from the government between 1822 and 1842. That he died prosperous was obviously more a credit to his artistic versatility, longevity, hard work, and shrewd real estate investments than it was to government munificence. But his twenty-year collaboration with the War Department did further establish the Indian as a paying proposition for the American artist.[19]

* * *

In his first letter to the newspapers from Indian Country, Catlin indicated that he was well aware of the War Department's "interesting collection" of portraits. Its cessation under the Jackson administration had contributed to his resolve to go West and make a collection of his own. Even earlier, on

February 22, 1829, he had taken the liberty of addressing the outgoing secretary of war, New York Democrat Peter B. Porter, to announce his artistic ambitions and suggest ways the government might advance them.[20]

Tired of portraiture, that "limited and slavish branch of the arts," Catlin was aspiring with "a sleepless and painful enthusiasm" to something higher. "Life is short," he told Porter,

> and I find that I have already traveled over half of it without stepping out of the beaten path in the unshackled pursuit of that Fame for which alone, the Art, to me, is valuable, and for the attainment of which I wish to devote the whole energies of my life.
>
> I have thought of two ways in which you may possibly have it in your power . . . to place me in possession of *time* and the *best models* which our country can afford, for the progress of my studies. . . . The ultimate object of my ambition is Historical painting, and either of the plans which I am about to suggest would afford me decided advantages for that purpose. . . .
>
> The first of these is the Professorship of Drawing in the W. Point Institution, which, for my services in the class two hours of the day would just pay the expense of my family, and allow me the rest of my time to devote to the prosecution of my exalted views in the Art.
>
> The other would be an appointment to some little Agency among the Savage Indians, up the Missouri River, which would pay my expenses for a year or two, where I could have the benefit of the finest School for an Historical painter now to be found in the world, where, among the naked Savage I could select and study from the finest models in Nature, unmasked, and moving in all their grace and beauty.

The professorship of drawing occurred to him because he was aware of general dissatisfaction at West Point with the incumbent, a foreigner of limited ability. "With regards to the other proposition," he continued, "(supposing that you have the power of appointing the Indian agents &c. on the frontiers) I have thought it possible that you might yet have some agent of that kind to appoint up the Missouri, . . . and to the duties of which you would feel proud of appointing one who would forever feel thankful for the patronage you had thereby shewn him in his favourite Art."

Catlin saw himself soliciting a favor the government should gladly grant a deserving artist. He wanted no money but did have a money-making proposition in mind. Two years in Indian Country, he explained to Porter, would "enrich" him with subjects for a lifetime of painting and would enable him "to open such a Gallery, first in this Country & then in London,

as would in all probability handsomely repay me for all my labours." It was the voice of the artist-entrepreneur speaking, though Catlin conceded that he required help to get him started. He had no knowledge "of the rules & regulations" governing patronage—indeed, had never received patronage apart from portrait commissions—but should he receive Porter's assistance he would be eternally grateful for any "elevation" thereafter achieved in his "Sublime Art."[21]

It was a remarkable letter, outling the generous scope of Catlin's ambitions. Contrary to the impression he later fostered of a decision impulsively taken and rigidly fixed to make Indians his life's work, Catlin in 1829 was in fact still undecided about his future. All he knew for certain was that he wanted to get out of portraiture. He was fooling himself if he thought he could seriously challenge the incumbent, French-born Thomas Gimbrede, for the professorship of drawing at West Point. Thus although he put two propositions to Porter, it was the second he was banking on. Catlin was convinced that he must paint Indians in their own country, not in a studio like King and the other Washington artists. His entire enterprise rested on the conviction that the Indians were a vanishing race.[22]

The theme, an old one, had resounded with particular urgency since the War of 1812 and the government's gravitation toward a policy of general Indian removal. An 1818 article, "The American Aborigines," began: "This people is rapidly passing away. Treaty after treaty and cession after cession, curtails the extent of their domain. The wild animals of the forest, on which they mainly depended for food, retire from the sound of the axe." Could the Indians be civilized and saved? "Surrounded by the whites . . . their character suffers a daily depreciation . . . their numbers are rapidly reduced. . . . By mixing with us, they imbibe all our vices, without emulating our virtues—and our intercourse with them is decisively disadvantageous to them." For the artist, the fate of the Indian offered an epic theme—an *American* tragedy. William Tudor, Jr., first editor of the *North American Review,* elaborated in an 1815 Phi Beta Kappa address at Harvard.[23]

The Indian was neither all good nor all bad, Tudor explained; he was the product of his condition. In his native state, he epitomized the savage virtues: "hospitality, reverence to age, unalterable constancy in friendship, and undaunted fortitude in every species of enterprise and suffering." He was, Tudor thought, "the counterpart of what the Greeks were in the heroick ages." But civilization debased him, stripping away his redeeming qualities and hurrying him, "like snow before the vernal influence," to extinction. For the artist, the important thing was to remember there were two types of Indians, not to be confused: the corrupted and the uncorrupted. "The degenerate, miserable remains of the Indian nations, which have dwindled into insignificance and lingered among us, as the tide of civ-

ilization has flowed, mere floating deformities on its surface, poor, squalid and enervated with intoxicating liquors," Tudor continued, "should no more be taken for the representatives of their ancestors, who first met the Europeans on the edge of their boundless forests, severe and untamed as the regions they tenanted, than the Greek slaves, who now tremble at the frown of a petty Turkish tyrant, can be considered the likeness of their immortal progenitors. . . . To form an idea of what they once were, to see them in the energy and originality of their primitive condition, we must now journey a thousand miles." The trip would be worth it. In the West lay the materials for a national art, needing only shaping. "The same block of marble, which in the hands of an artisan, might only have formed a step for the meanest feet to trample on, under the touch of genius, unfolded the Belvidere Apollo, glowing with divine beauty and immortal youth."[24]

Some doubted there were any distinctions to be drawn among Indians and doubted even more that such refractory material could be shaped into art. John Bristed, writing in 1818, conceded there was, "to be sure, some traditionary romance about the Indians; but a novel describing these miserable barbarians, their squaws, and papooses, would not be very interesting to the present race of American readers." How wrong he was became apparent eight years later with the publication of James Fenimore Cooper's *Last of the Mohicans,* which provided models of Tudor's two types of Indians: Uncas, clean-cut and pure as the marble statuary to which, in his physical perfection, he was likened; and Magua, "born a chief and a warrior" and happy in his forest solitude until at twenty he was debauched by the white man's firewater and transformed into the "Prince of Darkness" leading a pack of "bloody-minded hellhounds." Not everyone was persuaded by Cooper's poignant theme—Lewis Cass, as spokesman for hardheaded western realism, said of *The Last of the Mohicans,* "as Byron said of 'The Last of the Minstrels,' 'May they be the last.'" But Cooper's image of a distraught Chingachgook standing alone at story's end, "a blazed pine, in a clearing of the palefaces," lamenting his lost people, made an indelible impression on readers and helped launch a literary vogue that thrived in America until midcentury, when changing tastes and boredom rendered it obsolete. "The fall of the Indian is interesting and affecting," a critic observed in 1834, "but it is only the repetition of a sigh—melancholy and monotonous."[25]

For Catlin, the simplicity of the theme—its predictability and familiarity—was its great appeal. The idea of a vanishing race would unify his work, lend poignancy to portraits and hunting scenes alike, allow him to transcend the literal and be an artist rather than a mere reporter. And it gave urgency to his mission to visit the remote tribes before civilization first debauched and then destroyed them. He wanted to see "how they *live,* how they *dress,* how they *worship* . . . in the uncivilized regions of their

uninvaded country." "Uncivilized" and "uninvaded" conveyed a crucial meaning to Catlin, since he, like Cooper, accepted Tudor's categories. "Of the two millions remaining alive at this time," he wrote of the Indians in 1840, "about 1,400,000 are already the miserable living victims and dupes of white man's cupidity, degraded, discouraged and lost in the bewildering maze that is produced by the use of whiskey and its concomitant vices; and the remaining number are yet unroused and unenticed from their wild haunts or their primitive modes, by the dread or love of white man and his allurements." It was to prevent the latter from being judged by the former that Catlin had to journey West. Thus his appeal to Peter Porter.[26]

* * *

Catlin waited in Washington, hoping for an interview with Porter that probably never took place. Porter's days as secretary of war were numbered, with the new administration under Andrew Jackson about to take office. Stymied, Catlin passed most of a disconsolate year around the capital seeking portrait commissions and running into the stiff competition provided by established artists like Charles Bird King. The Jackson administration proved as hard line on Indian rights as Catlin had suspected in approaching Porter when he did; the new secretary of war was unlikely to help an artist whose work might arouse sympathy for the natives. Americans in this period preferred their art unburdened with social messages; implicit in Catlin's project was his conviction that it was civilization that was destroying the Indian. He was out of tune with his times. Being around the capital whetted Catlin's appetite for patronage without offering tangible prospects, but he did complete an ambitious work early in 1830, *Virginia Constitutional Convention*. It showed all 101 delegates assembled in Richmond to draft a new state constitution and was evidently a bid to join the august company of John Trumbull and Samuel Morse.

Trumbull had become the envy of all ("a most and only fortunate artist," John Vanderlyn complained to Thomas Sully) when Congress in 1817 commissioned him to paint four scenes illustrating events of the Revolutionary War for the princely fee of $32,000. Trumbull's *Declaration of Independence*, a portrait gallery of the signers in solemn convocation, set the standard for such pieces. Though much criticized after its installation in the Capitol Rotunda, that it was there at all spoke volumes to other patronage seekers. Morse, who aspired in vain to a similar commission, completed *The Old House of Representatives* in 1822. At seven feet by eleven, Morse's painting was much smaller than Trumbull's (twelve feet by eighteen), but easily topped its forty-seven figures by squeezing in eighty-six, including a likeness of the Pawnee visitor Petalesharro (probably modeled on King's Indian Office portrait), who peered down from the balcony, the displaced native presiding ghostlike over the proceedings of his usurpers. Hoping for a popular success, Morse toured his magnum opus; Trum-

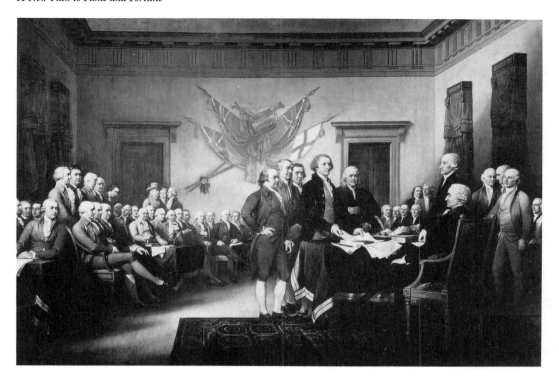

bull also augmented his fee by touring *Declaration* before its installation but grew "heartily tired of a showman's life." With both examples before him, in *Virginia Constitutional Convention* Catlin borrowed Trumbull's composition to create a stiff three-tiered arrangement of legislators "perched around the chamber," William Truettner observed, "like so many magpies."27

Catlin's evident frustration with the picture was echoed in a letter from his father, who still misunderstood why his son was disgruntled. "I am as anxious as ever to hear of your fame and success as an artist," Putnam wrote on February 15. "On your own account, on Clara's, on mine, & your country's, continue to make every possible exertion—persevere and do not get discouraged." The Virginia Convention was not what Catlin wanted to be painting. However, with the audacity that marked his career, he had decided to make the best of a bad situation by having his painting engraved, and he turned for help to none other than the marquis de Lafayette in Paris.28

Portrait prints were popular decorations in American homes before the Civil War, the bread and butter of the print stores. There was a market for the likenesses of politicians, businessmen, writers, and entertainers. Catlin's miniatures of Timothy Pickering and DeWitt Clinton had been engraved in Philadelphia in 1822 and 1825, his bust portrait of Tapping Reeve in New York in 1829. The customary procedure was to sign up

12. George Catlin, *The Virginia Constitutional Convention of 1829–30* (1830), Catlin's bid to duplicate Trumbull's patronage coup. Courtesy of The New-York Historical Society, New York.

subscribers beforehand to justify the expense of publication. The Reeve portrait, for example, was priced at one dollar payable upon delivery; Catlin's subscription book listed only nine subscribers, however, all but three from Litchfield. If this indifference was not sufficient warning about the risk of such undertakings, Catlin might again have profited from Trumbull's experiences. Anticipating widespread public interest in an engraving of *Declaration of Independence,* Trumbull had aggressively sought subscriptions in 1818. With the names of the four living American presidents topping his list—Adams, Jefferson, Madison, and Monroe—he was confident of success and had his agent place a prospectus on the desk of every congressman. In two days, not a single name was added to his subscription book; cajoling eventually persuaded seven senators and twenty-seven representatives to sign up at twenty dollars apiece—a decent start, but hardly the groundswell of enthusiasm Trumbull had counted on. Nevertheless, in August 1830 Catlin pressed ahead with his plans to have his picture of the Virginia Convention aquatinted abroad; thus his overture to Lafayette, venerated in America as a companion to George Washington and a true friend of liberty. Catlin implied a prior meeting, but he must have been among the blur of faces that welcomed the sexagenarian marquis on his triumphal tour of the United States in 1824–25. This much Catlin knew: Lafayette's name associated with the publication of the Virginia lithograph "would render me an essential service in its success in this country."29

But Catlin wanted more than Lafayette's name; he wanted his active assistance as well. Timeliness was everything. The aquatint would have to

be ready before Congress adjourned the following spring if there was to be any hope for profit. He sent Lafayette what he described as a drawing of his painting with instructions that it be "placed in the hands of one, *only,* who will proceed with the work *immediately,* and upon the condition that the *whole* amount shall be paid, the moment that the plate is finished, and no part of it before that time." Catlin admitted that his drawing was deficient, but he could not be bothered to correct the defects himself. Lafayette should tell the engraver to make the necessary adjustments, leaving the heads unchanged. Besides contracting a suitable artist at a reasonable price, Lafayette should observe the work's "*actual* progress" and report back to Catlin. What the marquis thought of this extraordinary imposition can be gleaned from his silence. In follow-up letters requesting the drawing's return and apologizing for his presumptuousness, Catlin continued to insist he might have published the print to "great advantage," with $1,000 already subscribed in 1830–31.[30]

The entire episode was pure Catlin and is instructive as to his lifelong modus operandi. He never hesitated in approaching the influential for endorsements and sales. At home, rich men and congressmen, senators and cabinet officers were alike handmaidens to his ambition; abroad, lords and ladies, kings and queens were never beyond his Yankee calculation. He would try anything to make a dollar from his art. He had one Indian portrait engraved before the subject was cold in the ground, and for almost two decades he lived the showman's life that tired Trumbull in two months. While he exhibited and lectured and schemed, he dreamed of a patronage coup equal to Trumbull's. His initiative would one day be rewarded, of that he was certain. He was less certain about painting Indians, judging from his hesitant embarkation upon his chosen path to fame and fortune. Had something equally promising from an artistic and financial standpoint turned up as late as 1830, Catlin might never have gone West. Even in 1837, with his western tours behind him and his Indian Gallery a reality, during the second round of government appropriations for the Rotunda decoration he hoped against all probability to receive one of the four coveted commissions. Although he would be named in the press as deserving, along with Thomas Sully, Thomas Cole, and William Sidney Mount, no offer came his way. And while the 101 likenesses in *Virginia Constitutional Convention* about exhausted his capacity for conventional portraiture, he fell back on "manufacturing heads" whenever in need. If he is to be believed, Catlin portraits painted to support his South American wanderings in the 1850s may still be sprinkled around Brazil, Uruguay, and Argentina.[31]

 * * *

Catlin's indecision ended with the Virginia picture. It was a disappointment he did not care to repeat. Nothing else turned up, and so in the spring

of 1830 he finally took the plunge and headed to St. Louis. Perhaps Peter Porter had found the time to write a letter of introduction after all. Catlin had one with him when he arrived in St. Louis and touched base with the government official there who could do him the most good, William Clark, hero of the epic exploration with Meriwether Lewis, former governor of Missouri Territory and from 1813 until his death in 1838 superintendent of Indian affairs with jurisdiction over all the western tribes. The governor operated a little museum out of his home—Clark's Indian Museum, as it was known—where visitors could examine artifacts at their leisure and possibly the Indians who attended councils there. Lafayette visited the museum, as did a host of others who would figure in the Catlin story— Henry Rowe Schoolcraft, Sir William Drummond Stewart, Prince Maximilian of Neuwied with his hired artist Karl Bodmer, the Sac and Fox chief Keokuk, and Major Lawrence Taliaferro, Indian agent for the Upper Mississippi who donated the largest item in Clark's collection, a decorated Sioux tipi cover. Clark's cabinet of curios may have planted in Catlin's mind the idea of forming a similar collection. The most numerous class of manufactures represented, forty-five Indian pipes, included a calumet with its head "cut out of a sort of argillaceous earth," a German visitor wrote in 1826. "In time of war the spot where this earth is dug out, is regarded as neutral, and hostile parties, who meet each other at that place, cannot engage in anything inimical against each other." Likely Catlin saw the same pipe and heard the same story in 1830, sparking his intense desire to see the quarry for himself. He would do so six years later, on his last excursion West, and his name would be permanently linked with the sacred red pipestone.[32]

Besides acquainting himself with Indian manufactures and customs in 1830, Catlin did a full-length formal portrait of Clark, similar in composition to his *DeWitt Clinton*. Perhaps it was intended as a thank-you for the man whose kindness was so critical to his enterprise in its formative stages. That summer Catlin accompanied Clark to Prairie du Chien on the Mississippi to witness an Indian council; later the same year he painted portraits of representatives of eight different tribes in and around Fort Leavenworth. His subsequent itinerary is unclear, but William Truettner places him back East by late fall and in Washington in the early months of 1831 to paint two Indian delegations, Menominee and Seneca. He apparently spent the rest of the year completing portrait commissions to finance the major excursion he planned for the following spring. Catlin was in St. Louis again by mid-December 1831, where he painted a Plains Cree and an Assiniboine, Pigeon's Egg Head or The Light, passing through on their way to Washington. Pigeon's Egg Head's transformation after his exposure to white civilization in the East and his subsequent tragedy would constitute the major cautionary tale in Catlin's repertoire of Indian stories.

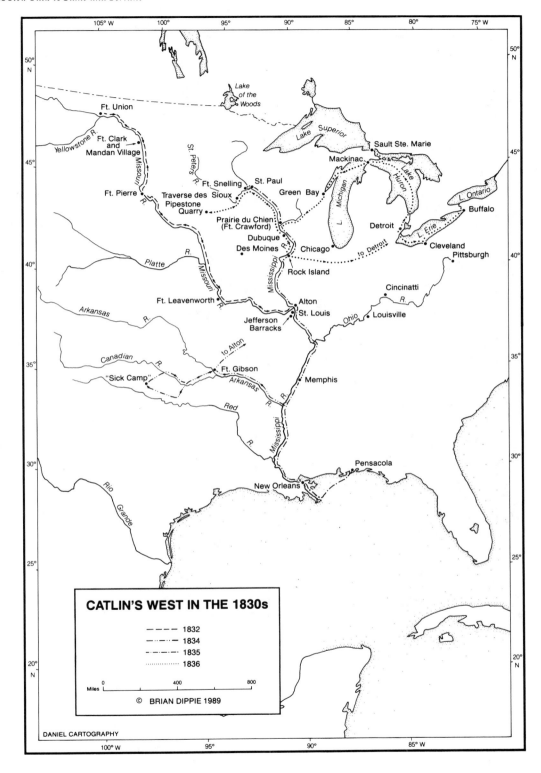

Map 1. Catlin's West in the 1830s.

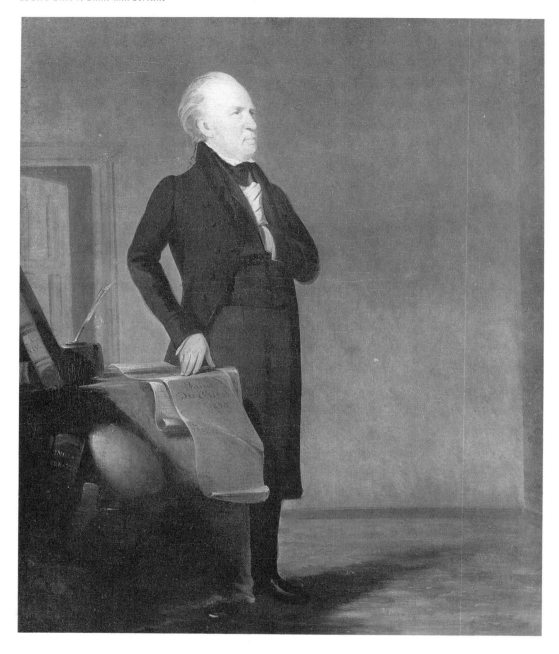

13. George Catlin, *General William Clark* (1830), a tribute to the great explorer (1770–1838) who befriended Catlin, and a testimonial to the artist's struggle with the standing figure. National Portrait Gallery, Smithsonian Institution.

But such portraiture was just marking time, hardly an advance over what Charles Bird King had produced for years in his Washington studio. As winter shaded into March Catlin impatiently awaited the opening of the Missouri to navigation. He was at last on the eve of realizing his ambition, the long-contemplated tour of western Indian country.[33]

Catlin would bring to his task a skill at heads, a mixed success at full-length figures, and a background in landscape. He had made creditable

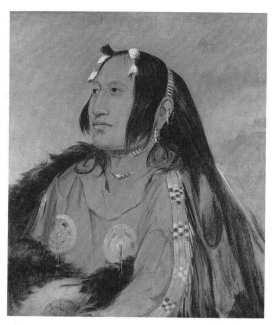

14. George Catlin, *Pigeon's Egg Head (The Light), a distinguished young warrior* (1831). This handsome Assiniboine would serve Catlin as a symbol of Indian decline and of his own struggle for acceptance. National Museum of American Art, Smithsonian Institution; gift of Mrs. Joseph Harrison, Jr.

views along the Erie Canal, at West Point, and in 1827 a series on North America's most famous natural landmark, Niagara Falls. He got under it (*View of Table Rock and Horseshoe Falls from Below*), over it (*Imagined Aerial View of Niagara Falls*), back from it in a seven-foot panoramic mural (*Niagara Falls*) and created his own three-dimensional model. It is worthy of note that model and mural were exhibited with his Indian Gallery when it toured abroad, American nature providing the context for the American native, both untamed and in their different ways majestic. With a decade of experience and his artist's supplies, Catlin boarded the steamboat *Yellow Stone* on March 26. It was back in St. Louis by July 7. The local paper recorded its voyage as a milestone in Missouri River history, since there had been disagreement within American Fur Company circles over its feasibility, unresolved by the *Yellow Stone*'s maiden voyage the previous year, when the 1,800-mile run to Fort Union had to be cut 700 miles short. In 1832, however, having reached Fort Union without serious incident and with its master reporting no impediments to a higher ascent, the *Yellow Stone* had demonstrated "the entire practicability of steam navigation in that upper region." Important men—among them Pierre Chouteau, Jr., president of the Western Department of the American Fur Company—had made the run, and a St. Louis paper celebrated the advantage it would give Americans over their British rivals as Indians flocked to do business with the traders whose "*Fire Boat* walked on the waters." But no man aboard the *Yellow Stone* in 1832 would impress himself so indelibly on history by this single excursion as George Catlin.[34]

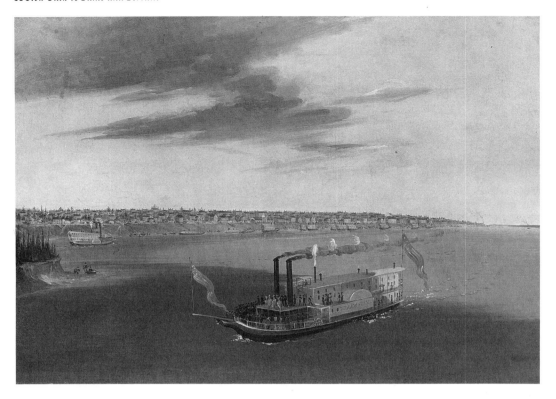

15. George Catlin, *St. Louis from the river below* (1832–33), showing the American Fur Company steamer *Yellow Stone,* Catlin's magic carpet to "fairy land." National Museum of American Art, Smithsonian Institution; gift of Mrs. Joseph Harrison, Jr.

He painted in a frenzy on the ascent, lingered for a month at Fort Union, his own rendezvous point with a variety of tribes—the "splendid costume" and ornamentation of the Crows and Blackfeet particularly impressed him—then pushed off mid-July with two voyageurs for a canoe descent. They spent almost a month at Fort Clark, the American Fur Company post serving the Mandans. Catlin was at Fort Leavenworth, the army's outpost on the Missouri twenty-three miles above the mouth of the Kansas River, by mid-September and stayed about a month painting the neighboring tribes. Showing the commercial instinct that was a trademark, upon reaching St. Louis he made a beeline for Jefferson Barracks, just below the city, to take portraits of Black Hawk and nine of his Sac and Fox warriors imprisoned there. An item in a St. Louis paper for October 16 reported his return, portraits in tow: "We are requested to say, that persons wishing to obtain copies—would do well to apply soon, as he intends removing them to New York in a short time." Catlin did indicate later that he was in Ithaca that fall, ordering cases for the miniatures he was still painting to finance his western trips. But as he was so often to do, he had obviously telescoped two years into one, since a letter written on December 20 placed him in St. Louis yet, planning another tour the following spring and still excited by the prospect.[35]

The year 1832 had been phenomenally productive for Catlin. One

estimate is that in the space of eighty-six days on the Upper Missouri (Fort Pierre northward) he painted more than 135 pictures; when the entire trip is taken into account, the number swells to about 170 paintings in five months. Catlin's portrait technique of outlining the figure, elaborating only the facial features, allowed him to work at such a rapid rate while participating in the life around him and even guiding his own canoe. Certainly Catlin was flushed with success at year's end, holed up in St. Louis, as he put it, "like a hermit in his cave, retouching and finishing my numerous sketches." When he wrote to a friend in Washington that December, Major James H. Hook in the Commissary General's Office, his excitement fairly leaped off the page: "My course will be, as soon as the navigation opens, to the sources of Missisipi or the Arkansaw, I have now about 300. portraits & sketches of manners & customs—dancing, Buffalo hunts &c &c I had a fair chance of joining in all the sport of the Country— of Buffalo hunting &c & of sketching & studying those inimitable scenes to my heart's content. I am now pursuing my Enthusiasm and practicing my art in that manner in which it is capable of affording me the greatest pleasure." He neither knew nor cared what the "final result" of his "singular undertaking" would be. "If my life be spared, nothing shall stop me short of visiting every nation of Indians on the Continent of N. America. I go entirely at my own expense, and though as poor as Lazarus I would still go."[36]

* * *

But responsibilities were calling Catlin home. After the absence of a year, his course from St. Louis would be east, not west. In Cincinnati he visited an official of the American Fur Company, who expressed concern that his letters from Indian Country (three had already appeared in the New York *Commercial Advertiser,* to considerable acclaim) might focus unwanted attention on the company's operations—the first inkling of a later falling-out. Catlin reached Pittsburgh in early January only to be laid up nearly a month with an inflammation of the lungs, or pleurisy. Impatient to be home, he found his confinement "like imprisonment in a dungeon." But at last he was reunited with his family in Great Bend, Pennsylvania, where his father had relocated in 1831. One can almost hear Putnam Catlin's sermons on his wandering son's duty to stay put awhile and attend to his wife. George was unrepentant. "I have . . . just stopped to rest for a while amongst my family friends," he wrote from Great Bend on February 18, "& then at it again." He and Clara spent mid-March in Washington but were Cincinnati bound by April. Catlin exhibited his paintings for a week in Pittsburgh, and the local paper noted that the hundred or so on display were "yet in an unfinished state, he only having had sufficient leisure to secure correct likenesses of the various living subjects of his pencil and the general features of the scenery which he had selected, the back grounds and

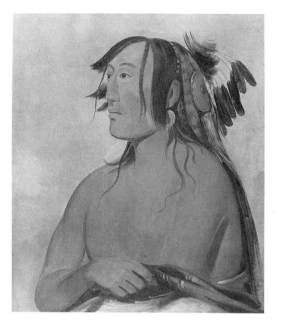

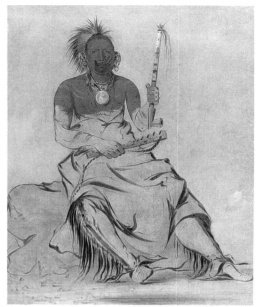

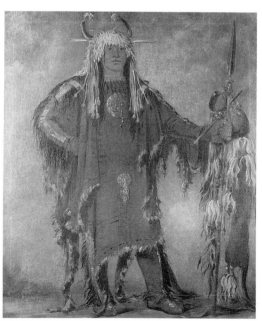

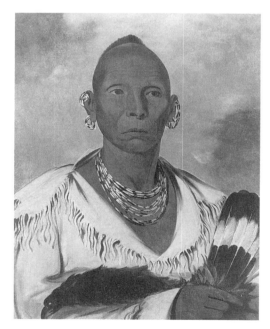

16, 17, 18, 19. A Catlin Indian Gallery, 1832. National Museum of American Art, Smithsonian Institution; gift of Mrs. Joseph Harrison, Jr.

16. *Top left. Two Crows (The Younger),* Crow orator.

17. *Top right. The Cheyenne, a Republican Pawnee,* showing Catlin's portrait technique.

18. *Bottom left. Eagle's Ribs, a Piegan chief,* assuming a classical pose favored by Catlin, who doted on the chief's costume.

19. *Bottom right. Black Hawk, prominent Sauk chief,* an eloquent study in dignity and misery.

details being reserved for the labours of a future time." Those labors kept him in Cincinnati, where the couple took room and board from May 7 through mid-November. Clara had family there, and George had work to do.[37]

There has been confusion about this long residence in Cincinnati, most of it created by Catlin. In an utterly unreliable synopsis of his "roamings" compiled late in life, he claimed to have ascended the Platte to Fort Laramie, visited Pawnees, Omahas, Otos, Arapahos, and Cheyennes, and reached the shore of the Great Salt Lake during the summer of 1833. The impossibility of this journey has been conclusively demonstrated. In a letter written at the beginning of the year, he expressed his intention to publish more stories about his experiences on the Upper Missouri, "leaving my notes on the Sioux—Puncahs—Ottos—Mahas—Pawnees—Konzas, &c. &c. for future consideration." This confirms William Truettner's assumption that he painted those tribes at Fort Leavenworth the previous fall, though there is a remote possibility he supplemented this series in 1833. A letter from Memphis that September began: "I am on my way back again from Indian Country & shall proceed in a few days as far as Cincinnati." At the least it establishes that Catlin was not in continuous residence with his wife. In the 1850s he portrayed himself hunting buffalo with a Colt's revolver on the north fork of the Platte River, and his last series of Indian scenes, painted in the 1860s, showed him greeting the Scottish nobleman Sir William Drummond Stewart "on the great prairie of the Platte, returning from a visit to the Crows. 1834." In the catalog of the same collection, published in 1871, many scenes were set on the Platte in 1833 or 1834, and in his own copy Catlin amended the description of two Cheyenne group portraits to read: "painted at Fort Laramie 1833." There was no Fort Laramie in 1833, and his other claims are equally suspect. But it would be wrong to flatly assert, as one Catlin biographer did, that "beyond reasonable doubt" the artist was in Cincinnati from May to December 1833 "working on his pictures." Perhaps, with his wife holding down the fort, he did make a mini-excursion westward.[38]

The April 1833 exhibition in Pittsburgh inaugurated the series of exhibitions Catlin would hold over the next six years. That fall he showed his works, touched up and properly framed, in Cincinnati, then in Louisville till year's end. He advertised widely, with a flair for showmanship, and charged a modest fee at the door. His notices in 1833 were good, if marked by puzzlement and tinged with controversy. When his paintings were compared unfavorably with John James Audubon's, Catlin replied diplomatically. He too admired Audubon's talents and hoped one day to have the pleasure of meeting a man "whose works would seem to hold a rank between living nature and art." The sentiment was not shared; Audubon would prove himself a vicious detractor.[39]

More reassuring was a glowing review by James Hall in the Cincinnati-based *Western Monthly Magazine*. Like Audubon, Hall would reappear in Catlin's future, but he was all enthusiasm for the artist's "arduous and novel enterprise": "We are glad that we have a native artist, who instead of carrying his talents to a foreign land, and blunting his sensibilities by the study of artificial models, has had the good sense to train his taste in the school of nature, and the patriotism to employ his genius on subjects connected with his own country. We are proud of such men as Audubon and Catlin—of native artists who are diffusing accurate knowledge of natural objects, in the land of their birth, by means of the elegant creations of the pencil." Catlin displayed 140 finished pictures in Cincinnati and claimed to have an equal number unfinished. "There is a vividness of portraiture, and a degree of life, and truth, and nature, about them," Hall wrote, "which attests their genuineness; and we have no hesitation in assigning to the ingenious artist who has collected them with a great expenditure of money, and hazard of life, the merit of originality in the conception of his enterprise, and of talent and fidelity in its execution." This pretty much summed up Catlin's case in 1833 as an artist-entrepreneur seeking public patronage.[40]

Writing in November, Hall noted that Catlin intended to return to the western frontier the next spring to expand his gallery. Indeed, the plans he had mentioned to Major Hook the previous December were beginning to jell. All he needed was government—specifically, War Department—cooperation. He asked no financial aid. But the military was potentially a pipeline to federal patronage, and mindful of the precedents—the War Department's Indian portrait gallery, the services of Seymour and Peale on the Yellowstone expedition—Catlin in his letter to Hook managed to mention both:

Many of my friends have advised me to solicit Government for aid, but I doubt very much, in the first place whether they would give it, and in the next place I value the privilege of saying that I alone & unaided took the Bull by the horns. If however there should be anything like an exploring or military movement beyond the mountains, for the purpose of fixing the mouth of Columbia &c &[c] you must not fail to announce it to me in due season and make application for me. . . .

I have made a visit to Jefferson Barracks & painted the portraits of Black Hawk & eight others. . . . I had thought of sending them on to Washington & offer[ing] them to Government to add to their Collection, but as that Collection has been stopped under the present administration I suppose there is no prospect of their encouraging artists and further in making additions to it. . . . Please to write to me

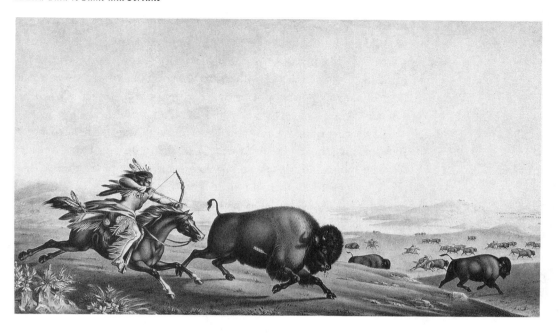

20. Peter Rindisbacher, *Assiniboin Hunting on Horseback* (1833), typical of the watercolors by Rindisbacher (1806–34) that Catlin likely saw in Washington before going west. Amon Carter Museum, Fort Worth, Texas.

soon after the receipt of this and give me any information that can be of Service.[41]

Catlin could expect Hook to be sympathetic. A veteran of the War of 1812 and a friend to art, Major Hook was the missing link in another pioneer painter's story. Peter Rindisbacher, a Swiss, had been lured with his family to Lord Selkirk's colony on the Red River below Lake Winnipeg in 1821. Fifteen years old and already an able draftsman, Rindisbacher sketched incidents along the way, and at York Factory on Hudson Bay he made his first Indian drawing, of a Cree family. Other watercolors followed during the Rindisbachers' years at Red River. In 1826 the family relocated at Gratiot's Grove in the southwestern corner of modern Wisconsin; Peter's reputation accompanied them down the Mississippi and on to St. Louis, carried by officers from Forts Snelling and Crawford who had seen his portfolio when he passed through. Living in the heart of Winnebago and Sac and Fox country, Rindisbacher continued to paint Indians. When he moved to St. Louis in 1829 in search of better opportunities, a local paper credited him with having "marked out a new track, and almost invented a new style of painting. . . . His sketches of groups or single Indians, are deserving of the highest admiration." Rindisbacher was just beginning to attract national attention through appearances in the *American Turf Register* when he died suddenly in 1834. He was only twenty-eight.[42]

Somewhere along the way Rindisbacher had acquired an admirer in Washington, identified thirty-six years after his death as "Major Hughes"

31

and, according to Rindisbacher's biographer, the probable donor of the West Point Rindisbacher collection. Almost certainly the individual meant was actually Major Hook. An article in the Georgetown, D.C., *Gazette* in April 1833 told of Black Hawk's trip to Washington to visit the president. One stop on the Indians' itinerary was a reception at Major Hook's, where a hundred guests waited in anticipation of meeting "the great War Chiefs." At last they arrived. "Paintings by Rindisbacker of various Indian dances, Buffalo hunts, and the Drunken scene, were shewn them [they had already seen the Indian Office portraits]; among some of the pieces they recognized two or three of their old friends."[43]

Catlin was likely acquainted with Rindisbacher's work through Hook, whom he knew well. He had visited the major in Washington before making his tour up the Missouri, in quarters that would have been much as Washington Irving described them a few years later, "fancifully decorated with Indian arms, and trophies, and war dresses, and the skins of various wild animals, and hung round with pictures of Indian games and ceremonies, and scenes of war and hunting." On his return Catlin intended to "amuse" Hook's "bachelor hours with tales & sketches of scenes in the North and West." He was confident enough of their friendship to beg Hook's intercession with the secretary of war to procure permission for him to accompany a military expedition to the West: "Such facilities as Government might think proper to afford me in this way would be of great service to me in my difficult, laborious & expensive undertaking." The secretary of war Catlin meant, Lewis Cass, was himself a student of Indian culture. Although the Democratic administration might be hostile to Catlin's enterprise, Cass, the second in his position under Jackson, assuredly was not. He had been the mentor of others who took an interest in the Indian, notably Henry Schoolcraft, and since he was in office from August 1, 1831, through October 5, 1836, his term spanned all of Catlin's major western excursions. It was Cass's letters of introduction that gave Catlin entrée to government posts and agencies, just as it was the American Fur Company's desire to cultivate good relations with scientific men, writers, and artists that permitted him access to company posts and traders. Indeed, since the fur companies were themselves licensed through the Indian Office under the Trade and Intercourse Acts, the secretary of war was the final arbiter, his permission the essential key to unlocking Indian Country.[44]

For his planned excursion in 1834, Catlin especially required Cass's support, since he wanted to accompany a military expedition into the field. In September 1833 he asked another officer well disposed toward his Indian Gallery, Thomas L. Smith, to serve as his intermediary with Cass and Major General Alexander Macomb, commander of the army. They would both, he was sure, "feel willing to aid me in the way I ask. I wish to

go at my own expense and on my own account, asking for nothing but their countenance and protection." He wanted some kind of permit or order drawn up specifying his duties on the distinct understanding that he would be free to come and go as he pleased. If all went as planned, he would "astonish the *Civil* ones in a little time." Smith conveyed Catlin's request to Cass as soon as he received it, on October 15, with an earnest recommendation for speedy compliance. Technically, Catlin would be accompanying the expedition "for *scientific purposes*," an acceptable reason. Cass responded on the twenty-third, the commanding general on the twenty-fourth, and the next spring Catlin was at Fort Gibson, Arkansas Territory, headquarters of the newly established regiment of dragoons, bound for Indian Country and the second great adventure of his life.[45]

<center>* * *</center>

A note of tentativeness about Catlin's health—or his continuing good health—had entered family discussions in this period. Americans lived by maxims like "Man appoints—God disappoints," and Catlin's life was less certain than most. He made long journeys into remote country, exposing himself to danger. And he traveled in epidemic times.

Cholera first visited America in 1832. It scourged New York over the summer and accompanied every form of conveyance into the interior. No route was safe, no region isolated enough. President Jackson's handpicked solution to the Black Hawk War that year, General Winfield Scott, moved quickly toward the combat zone on the Upper Mississippi only to have cholera track his army from Detroit to Chicago and immobilize it, ending his campaign. While Lewis Cass visited the stricken city of Detroit, his oldest daughter died of cholera in Washington. The Black Hawk War proved an ephemeral embarrassment—Indian resistance in Illinois and Wisconsin was permanently ended with the battle of Bad Axe in early August—but cholera tarried awhile in the West. Catlin believed he had escaped into a paradise of clean water and pure air on the Upper Missouri. From the mouth of the Yellowstone in mid-July he wrote: "The health and amusements of this delightful country render it almost painful for me to leave it. The atmosphere is so light and pure that nothing like fevers or epidemics has ever been known to prevail here. . . . If the Cholera, should ever cross the Atlantic what a secure, and at the same time, delightful refuge this country would be for those who would be able to reach it." But the very steamboat that carried Catlin to Fort Union in 1832 on its ascent of the Missouri the next year lost a pilot and three crew members to cholera. Catlin's trips West would be bracketed by cholera in 1832 and a devastating smallpox epidemic in 1837, suggesting how brief would be that magic moment he had witnessed of Indian cultures in full vigor. In between, in 1834, the fatigue and toils of a summer campaign on the southern plains caught up with him as well.[46]

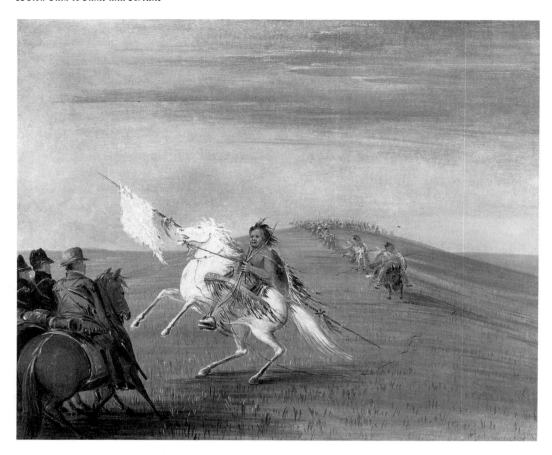

21. George Catlin, *Comanche meeting the dragoons* (1834–35). Colonel Dodge's party (with Catlin in the peaked cap) are greeted by a Comanche envoy on a "milk white horse." National Museum of American Art, Smithsonian Institution; gift of Mrs. Joseph Harrison, Jr.

Catlin approached the dragoon expedition with a premonition of disaster. Its departure was delayed two months by organizational difficulties, and this meant the march would be over the hottest season of the year, with water scarce and brackish, game perhaps in short supply, and the Indians likely to be skittish, irritated if not intimidated by the column of soldiers crossing their lands. The chief purpose of the expedition was to meet the Pawnee-Picts (Wichitas), Comanches, and Kiowas. Peace and friendship were intended, but also a show of force to cow the Indians and prevent further raids on American traders. "I start this morning with the dragoons for the Pawnee country, but God only knows where that is," Catlin wrote his brother-in-law from Fort Gibson on June 19. Eight hundred men—the dragoons and the Seventh Infantry—made for a formidable force on paper, but their march would be exhausting and full of privation, and Catlin was unusually pessimistic about the success that would attend their efforts. Still, with the hills "echoing back the notes of the spirit-stirring trumpets" and terra incognita ahead, he was eager for the chase.[47]

The expedition left Fort Gibson on June 15. Catlin still found beauty all

around, a "Panorama too beautiful to be painted with a pen," verdure "of the deepest green." From a promontory the column marching over undulating hills had "the appearance of a huge snake gracefully gliding over a rich carpet of green." As one of only three civilians with the expedition, Catlin was favored with the company of General Henry Leavenworth, the division commander, and Colonel Henry Dodge, the dragoon commander. But by the time the expedition reached the mouth of the Washita on the Red River, ten days' march and two hundred miles from Fort Gibson, fatigue had set in and his enthusiasm was on the wane. "The public are expecting that I will see these Indians or I should almost be ready to abandon the expedition & come home," he confessed to his brother-in-law. The heat was intense, a debilitating fever rampant. The expedition had left Fort Gibson well under strength, with 450 instead of the 800 soldiers planned on, and illness had since reduced the command to 250 able-bodied men; but on August 5, from a camp on the Canadian, Catlin could report unconditional success. They had met the Comanches, and through them the Kiowas and Wichitas, and all on friendly terms.[48]

What Catlin did not report in his newspaper letters was his absence at the grand council in the Wichita village on July 22. He had been on hand for the meeting with the Comanches but was too sick to sit a horse and had become the one thing he did not want to be, an encumbrance. Provoked by the delays caused by the litters carrying Catlin and five others, Dodge established a sick camp on July 18 and left seventy-five men behind under cover of a "breastwork of felled timber" while the remnant of his command, now reduced to 183 men, pressed southwest for the meeting with the Wichitas.[49]

Even Catlin's irrepressible romanticism could not make fairyland of this. The Indians were colorful and as untamed as he liked them, but the return journey was a misery. He left sick camp in a litter on July 28 for a twelve-mile march. Rations were short, the heat "overpowering." So it went, day after day. On August 5 news reached the command that General Leavenworth, who had remained at the camp on the Washita, had died; one-quarter of the force that left Fort Gibson in June had perished by the time the column straggled back in mid-August. "Our retreat," Catlin wrote, "was almost as disastrous as Bonaparte's retreat from Moscow." In his last letter from the Southwest he summed up his impressions of a sickly land: "The disease seems to be entirely of a bilious nature and contracted by exposure to the sun, and the impurity of the water. . . . The beautiful and pictured scenes which we passed over had an alluring charm on their surface, but (as it would seem,) a lurking poison within. . . . The sickness and distress continually about us, spread a gloom over the camp and marred every pleasure which we might otherwise have enjoyed." One need

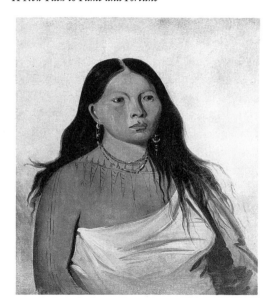 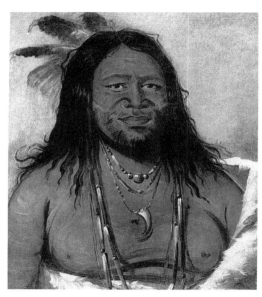

22, 23. A Catlin Indian Gallery, 1834. National Museum of American Art, Smithsonian Institution; gift of Mrs. Joseph Harrison, Jr.

22. *Left. Thighs, a Wichita woman,* one of several Catlin portraits of Indian women, none more entrancing.

23. *Right. Mountain of Rocks, second chief of the tribe,* a man of Falstaffian proportions with the facial hair sometimes affected by Comanches.

only consider Catlin's production in 1834, meager compared with that on the Missouri two years before, to realize the toll that summer's expedition had taken.[50]

In later recall, Catlin's illness dominated the 1834 excursion. His compulsion to escape Fort Gibson was reminiscent of Ichabod Crane's panic flight at midnight with the Headless Horseman hot on his heels, though it was the Pale Rider Catlin meant to elude. "No argument could contend with the fixed resolve in my own mind, that if I could get out upon the prairies, and moving continually to the Northward, I should daily gain strength, and save myself, possibly, from the jaws of that voracious burial-ground that laid in front of my room." So he set out from Gibson with a compass to guide him and his horse his only companion, bound for Alton, Illinois, and a reunion with his wife. He covered the 550 miles in twenty-five days despite his weakened condition, suggesting his desperation to leave behind what had become a graveyard for many friends and perhaps for his larger ambition to visit all the Indian tribes. He had returned to civilization "a wreck," he admitted, in need of convalescence.[51]

* * *

The details of Catlin's recuperation are unclear, but Clara was by his side and determined to remain there in the future. She always fretted in his absence, and now her fears had been justified. In January 1835 they accepted quarters with a brother of his in Pensacola, Florida, where Catlin strolled about the town, taking its measure with an eye to investment potential. The family was always engaged in more or less of the real estate speculation that was virtually an American hobby in the 1830s. Pensacola seemed a fair extension of a predominantly western activity, its climate

unexampled in all of the South, Catlin wrote, balmy in winter, pleasant in summer. He rang Pensacola's praises so loudly it is a certainty his wife's family if not his own had holdings there. Catlin's entrepreneurial spark was rekindled, and with it the desire to augment his Indian Gallery by making an excursion in 1835, not to the Southwest, that sweltering hell, but by steamer far up the Mississippi to the land of the Sioux and the Chippewas. And this time Clara would accompany him.[52]

Her presence was a professional as well as a personal concession on Catlin's part. After all, his letters from the Far West had made much of the obstacles overcome in forming his collection of Indian portraits. He had gone where few white men and no artists had gone before, one with the Boones and the buckskin brigade of pioneer heroes. Asked in 1836 about the feasibility of missionary women crossing the Rockies to Oregon—a trip he himself had never made—he dismissed the idea outright. White women would be an enticement too tempting for Indian men to resist, and the fatigues of the journey would certainly destroy them. This about-face on Catlin's estimate of Indian character was a tactical maneuver; the Far West must remain a *man*'s country if his enterprise was to be credited. However, Catlin's advice was ignored on the sensible ground that his objections were all "supposed," and when Narcissa Whitman and Eliza Spalding reached Oregon later that year Catlin did another about-face, fondly recalling the part he had played in getting them there and describing their safe arrival as a vindication of Indian character against unwarranted suspicions. The trip up the Mississippi with Clara that Catlin planned for 1835 presented no such challenge to his enterprise. Indeed, he proposed it as an alternative to the "fashionable tour" of Europe, encompassing the only part of the Far West "to which *Ladies* can have access."[53]

He and Clara made the ascent of the Mississippi by steamboat. The scenery out of St. Louis was nondescript, but above Rock Island it increasingly assumed the charm he had found on the Missouri, and above Lake Pepin "every reach and turn in the river" was touched with magic. On June 24 the Catlins arrived at Fort Snelling in a "dashing rain," and the weather never let up during their stay. July was unseasonably cold, with frequent showers and gusting winds. Fires were necessary for warmth, and while vegetable gardens flourished the hay lay wet and uncut in the fields. Clara collected mementoes of the trip—pebbles, wild flowers that bloomed in profusion around the fort—but she must have been relieved to board a steamer for Prairie du Chien downriver on the morning of July 18 and watch Fort Snelling disappear behind her (a violent storm the night before, in parting salvo, had torn the boat loose from its moorings and set it adrift). And she must have been more mystified than ever by her husband's continuing passion for such wild and forlorn country. Rain could not dampen his ardor or shorten his stay. He remained until the twenty-seventh, attend-

24. Catlin and his horse alone on the vast prairie, fleeing death and homeward bound, 1834. *Letters and Notes on the Manners, Customs and Condition of the North American Indians* (1841).

ing councils, listening to speeches, interviewing prominent Indians, witnessing a marriage, discussing policy matters with the agent Lawrence Taliaferro, and painting, always painting. He had found what he wanted on the Upper Mississippi—Sioux and Chippewas unacculturated enough to interest him yet peaceful enough to pose and, for a price, stage dances and ball games approximating in fury the periodic clashes between the two tribes that still reaped a small harvest of scalps each year. Catlin painted as many as three portraits a day besides the scenery, impressing Taliaferro with his industry: "The great world know nothing as yet of these things and it seems that it has been left to Mr. Catlin to open the Sluices of information & by the magic of his pencil to hold the Mirror up to public view."[54]

Catlin made a leisurely descent by canoe, mostly unaccompanied, poking into bays and lakes, periodically reconnecting with his wife. They spent a few weeks together at Prairie du Chien and later at Dubuque; she made the separate legs of her journey by steamer, while he paddled himself to their next rendezvous point. He rode with her from Dubuque to Camp Des Moines, but after seeing her aboard a steamer for St. Louis, he ascended to Rock Island and retraced the ninety miles back to Des Moines by canoe. His interest was in the land itself, the minerals and the scenery, rather than in any Indians who might be found so close to civilized centers.

He finally wrapped up his unhurried voyage by boarding a steamer at Des Moines and rejoining Clara in St. Louis on November 5.[55]

During the short run a fellow passenger, an English geologist of his acquaintance, pressed Catlin as to his future plans. Recognizing that a comprehensive Indian gallery was "an arduous task for an unassisted individual," the Englishman pointed out that should his enthusiasm wane, his collection would prove an encumbrance. Catlin agreed, but observed "that its rarity could not fail to attract much attention in the large cities of America and Europe, which might indemnify him for his labours." He still casually referred to arrangements he had made to cross overland to the Pacific and the Gulf of California in the near future, but practicalities were weighing on him. He had to get his existing collection into shape and on display. He would turn forty in 1836. Clara was pregnant with their first child. There could be no more idyllic summers drifting with the current and lolling on pebbly shores. Duty was calling. Exhibitions, culminating in a major New York show, were in the offing. His enterprise was about to enter its second stage.[56]

 * * *

But Catlin was an addict who could not quite kick his habit. On the spur of the moment in early July 1836, he grabbed an available steamboat and the chance to see new country, canceling a long-planned exhibition in Buffalo to visit the Great Lakes and the area between the St. Peters (Minnesota) and Missouri rivers, the Côteau des Prairies. So abrupt was his departure

25, 26. A Catlin Indian Gallery, 1835. National Museum of American Art, Smithsonian Institution; gift of Mrs. Joseph Harrison, Jr.

25. *Left. Red Man, a distinguished ball player,* a well-porportioned study of an Eastern Sioux.

26. *Right. The Ottaway, a warrior,* a strikingly painted Chippewa.

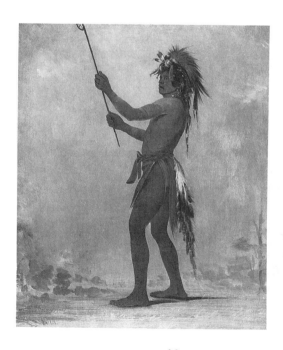

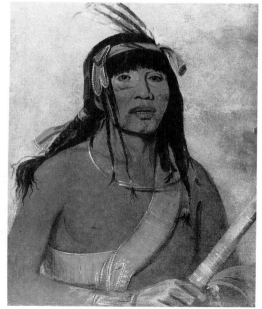

39

that he left his paintings hanging, their descriptive labels neatly in place, on the walls of a small church he had rented in Buffalo, along with stacks of broadsides and circulars advertising the exhibition and unpaid printing bills. His long-suffering family was left to clean up after him—his father and two brothers to dismantle the exhibition, settle the rent, pack up the paintings, and store them in his absence. A sister in Delta, New York, was left to comfort Clara, grieving over the loss of their baby but weeks before. His mother, shocked by his sudden departure, thought he was "crazy." It mattered not. Days short of turning forty, Catlin was off again, seized by the restless urge that drew him back to Indian Country, far from his domestic and financial cares.[57]

This time Catlin had a dual purpose. He would divide his wanderings between the relatively mundane and the romantically alluring—between the Indians of Michigan and the newly created territory of Wisconsin, who were too tame for his tastes, and the red pipestone quarry on the southern end of the divide known as the Côteau, an area he had longed to visit since examining the calumets in Clark's museum. The quarry was sacred to the Indians, he believed, *"classic ground,"* "their greatest medicine (mystery) place." He had intended to visit the site earlier but his plans, fully formulated in 1835, were frustrated each time. To one of his romantic temperament, however, the quarry's lure remained irresistible. It was the heartland of Indian legend and myth, the dwelling place of "the Indian *Muse*":

> The Great Spirit at an ancient period, here called the Indian nations together, and standing on the precipice of the red pipe stone rock, broke from its wall a piece, and made a huge pipe by turning it in his hand, which he smoked over them, and to the North, the South, the East, and the West, and told them that this stone was red—that it was their flesh—that they must use it for their pipes of peace—that it belonged to them all, and that the war-club and scalping-knife must not be raised on its ground. At the last whiff of his pipe his head went into a great cloud, and the whole surface of the rock for several miles was melted and glazed; two great ovens were opened beneath, and two women (guardian spirits of the place), entered them in a blaze of fire; and they are heard there yet . . . by medicine-men, who consult them when they are visitors to this sacred place.

Catlin simply had to see the quarry for himself, to round out his western travels, his Indian Gallery, his notes and his collection of curiosities. That done, he promised (and this time meant it), his wanderlust would be satisfied and he would concentrate on readying his paintings for a New York exhibition.[58]

So Catlin left Buffalo, strategically situated on the eastern end of Lake Erie, making it with Chicago, according to a contemporary, "the two

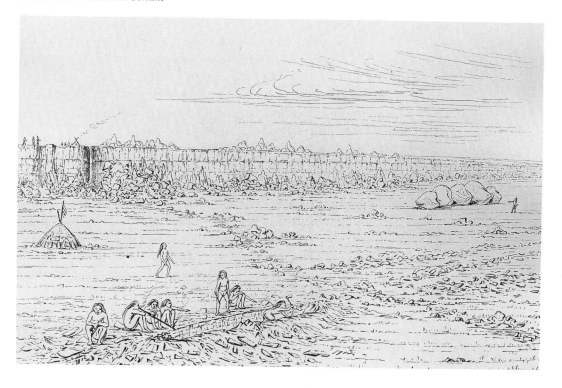

27. George Catlin, *Pipe Stone Quarry*. Catlin considered the quarry the Indians' "greatest medicine (mystery) place" and the natural culmination of his western tours. *Letters and Notes on the Manners, Customs and Condition of the North American Indians* (1841).

correspondent valves that open and shut all the time, as the life-blood rushes from east to west, and back again from west to east." It took two days to navigate Erie's green waters, with brief stopovers in Cleveland and Detroit, before entering Lake Huron and what struck other, less experienced western travelers as *real* Indian country. For his part Catlin was impatient with the familiar, the often described. Sault Ste. Marie and Mackinac Island, commanding respectively the entrances to Lake Superior and Lake Michigan, seemed commonplace to him. He paused on Superior, and at the Sault he observed Chippewas netting whitefish and racing canoes, scenes that he painted along with portraits of some of the local Indians. He found them too acculturated, however, and thus devoid of pictorial interest, and he quickly pressed on to Green Bay, then Prairie du Chien, down the Mississippi on the southwestern border of present-day Wisconsin, where he took the opportunity to write to his family on August 1.[59]

The next morning he would be off in search of the unknown, the pipestone quarry. It would be "a pretty hard traipse" on horseback, he conceded, but trusting all went well he would shortly accomplish what he had been "impatient to do" and be headed home. In fact, his anxious family would receive no further news of his whereabouts until mid-November. Catlin and his traveling companion, an Englishman named Robert S. Wood, did not actually leave Prairie du Chien until the ninth, by boat, with

a contingent of soldiers bound upriver for Fort Snelling. They covered the last leg of the trip overland, reaching Snelling on the seventeenth. The weather was poor—cold, with heavy rains—and the Indian situation tense, but Catlin set off with Wood on the twenty-first determined to see the quarry. They were back at Fort Snelling by September 5, though none of Catlin's later accounts indicated their visit was so brief. Instead, he emphasized the risks they had taken.[60]

The Santee Sioux who claimed the quarry site had strenuously opposed Catlin and Wood's going. Trouble appeared imminent. The scene was a trading hut at Traverse des Sioux on the St. Peters, about 150 miles from the quarry. Angry Indians surrounded the two travelers, virtually holding them prisoner while alternately cajoling and threatening them. The Sioux resistance to his visit exposed a glaring inconsistency in Catlin's position: sympathetic to the Indians and appreciative of their cultures, he was trapped in the same dilemma as an anthropologist entrusted with secret lore who feels compelled on scientific grounds to publish it. Catlin might admire, but he *must* expose: that was his mission. "No white man has been to the red pipe and none shall go," a grim-faced warrior warned him. But the threat carried no more weight with Catlin than the man's reasons, cogent though they were. Brandishing a red stone pipe, the Sioux explained: "You see that this pipe is a part of our flesh. The red men are a part of the red stone. If the white men take away a piece of the red pipe stone, it is a hole made in our flesh, and the blood will always run. We cannot stop the blood from running." The Indian's splendid imagery was lost on the white travelers. Unwittingly, unavoidably, they were part of that process of debasement and dispossession that Catlin vociferously deplored. Nothing would prevent him from visiting a site he himself described as sacred to the Indians and freely violating it by collecting mineral specimens. "We have started to go and see it; and we cannot think of being stopped," he replied, and the next morning the travelers saddled their horses and rode through the Sioux.[61]

The quarry, Catlin wrote, justified his every expectation; it was "truly an anomaly in nature." There the Indian spirit was palpable. He described the quarry often and at length, paying particular attention to the geological features that, he believed, would make it "hereafter an important theme" for scientists, while "the red pipe stone, I consider, will take its place amongst minerals, as an interesting subject of itself." The specimens he broke off with his hammer "certainly bear as high a polish and lustre on the surface, as a piece of melted glass," and he was convinced that the red stone, "which differs from all known specimens of lava, is a new variety of *steatite*." Subsequent analysis in the respected *American Journal of Science and Arts* confirmed Catlin's suspicion, and the stone still bears the name conferred in his honor, catlinite.[62]

Mineralogy aside, the quarry was all Catlin wanted it to be. "Bivouacked on its very ridge, (where nought on earth is seen in distance save the thousand *tree*less, *bush*less, *weed*less hills of grass and vivid green which all around me vanish into an infinity of blue and azure)," he and Wood contemplated the "splendid orrery of the heavens," and man's mortality foretold in "the swollen sun *shoving down* (too fast for time) upon the mystic horizon." It was grand stuff, and when the travelers moved on, leaving "this shorn land, whose quiet and silence are only broken by the winds and the thunders of Heaven," Catlin was closing his notebook on more than the red pipestone quarry. Though they still had an arduous journey ahead, as he and Wood wended their way past the Thunders' Nest and the Stone-man Medicine and down the valley of the St. Peters Catlin must have realized that a chapter of his life had ended. It was time now to make good on his promises to his wife and family, time to profit from the vast outlay of energy and money represented by his Indian Gallery. Stick with me, he would advise his youngest brother at year's end. While still "too *poor* to do *anything*," he was polishing his sketches and preparing his newspaper letters for publication. "The time will come ere long when I can begin to make some money." The next year he would print up a catalog of his collection and embark upon a full-time career as lecturer and showman, more entrepreneur than artist.[63]

The return journey from the quarry was made all the more poignant by Catlin's awareness of the curtain's ringing down. His enterprise rested on the distinction between corrupted and uncorrupted Indians, but everywhere he went in 1836 the distinction was blurring. In the year 1800 about two-thirds of the United States' 5.3 million people lived within fifty miles of the Atlantic coast, and the West was that region stretching to the Mississippi. Perhaps half a million Americans had penetrated beyond the Appalachians, most settling below the Ohio River. In 1803 the Louisiana Purchase added nearly a million square miles to the national domain; suddenly America's West stretched to the headwaters of the rivers tributary to the Mississippi. Government-sponsored explorations beginning with Lewis and Clark's in 1804–6 fixed some boundaries on the map, but the American West seemed as limitless as the imagination. Between 1810 and 1830 2 million people pushed into the interior. The Northwest mushroomed in the 1830s: Indiana's population doubled, that of Illinois tripled. By 1840, when Catlin left America to exhibit his Indian Gallery abroad, more than one-third of the nation's population, nearly 6.4 million people, lived west of the Appalachians, and the Far West, now well beyond the Mississippi, was, as he said, "a phantom, travelling on its tireless wing."[64]

One consequence was land speculation, a fever that in 1836 showed no sign of abating. The powers behind the creation of Wisconsin Territory,

carved from Michigan Territory that July 3, were typical of the times—mining interests, of whom Henry Dodge, the dragoon commandant in 1834 and now the territory's first governor, was acknowledged leader, and land developers pressing Congress for faster surveys, more land offices, and every form of internal improvement that would speed the movement of people and goods. New western metropolises sprouted overnight in the minds of town-site speculators. One-quarter of the business before Wisconsin's first legislative assembly involved charters to incorporate banks, railroads, mining companies, and the like, and settlers continued to stream into the Great Lakes area in sufficient numbers for Michigan to achieve statehood by 1837. All this activity, as a traveler through Wisconsin Territory noted that year, was taking place in a region but "recently rescued by the enterprise and valor of our hardy pioneers, from the wandering Indian, whose only occupation was to hunt deer and spear fish, although dwelling in a Western Eden." The tribes, in short, were the losers, as the dozens of treaties of cession negotiated in the 1830s attest. The vanishing Indian had never seemed more a certainty.[65]

In late September 1836, on the right bank of the Mississippi River opposite Rock Island in Wisconsin, Catlin and Wood, who had left Fort Snelling on the seventh, witnessed the spectacle of a treaty council between Dodge, in his capacity as territorial superintendent of Indian affairs, and representatives of the Sacs and Foxes. On the twenty-seventh the Indians, as a token of their friendship to the United States, ceded their lands lying between the state of Missouri and the Missouri River (theirs by the treaty of Prairie du Chien six years before); on the twenty-eighth, they threw in another 256,000 acres on the Iowa River, theirs by a treaty signed only four years earlier. The compensation offered them was reasonable by existing standards—about seventy-five cents an acre, one-fourth of which would go to the traders, who as always at such treaty councils were on hand to press their claims. The Sacs and Foxes, led by Keokuk resplendent in white buckskin leggings, blanket, and a bear-claw necklace, appeared to be willing partners to the agreement, and while Catlin might deplore how casually they squandered their patrimony for the temporary pleasures money would bring, he was impressed. "The whole of the Sacs and Foxes are gathered here," he wrote. "These people have sold so much of their land lately, that they have the luxuries of life to a considerable degree, and may be considered rich; consequently they look elated and happy, carrying themselves much above the humbled manner of most of the semi-civilized tribes, whose heads are hanging and drooping in poverty and despair."[66]

Catlin could not blame the Sacs and Foxes for selling out. Some Indians had tried the opposite tactic in 1832 under Black Hawk, taking up arms to oppose white trespassers, but they had been quickly routed and the price

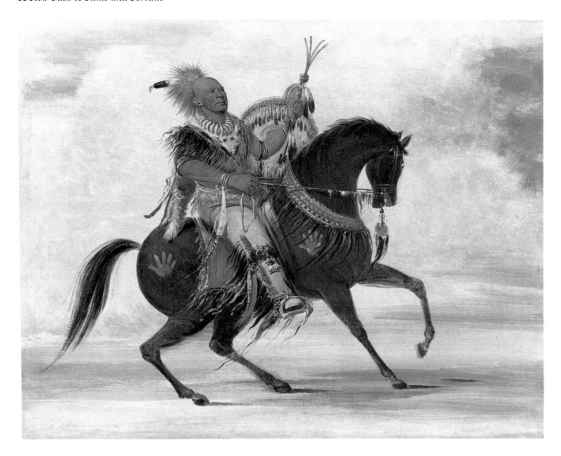

28. George Catlin, *Keokuk on horseback* (1835), one of two Catlin portraits of the Sac and Fox chief. National Museum of American Art, Smithsonian Institution; gift of Mrs. Joseph Harrison, Jr.

was high: a treaty in 1832, made under the duress of defeat, that extracted 6 million acres from the Sacs and Foxes, leaving them the 256,000-acre reservation on the Iowa River. Now the government desired it as well, and Keokuk, who had negotiated the so-called Black Hawk Purchase in 1832, would give the Americans what they wanted, making sure he was looked after in the bargain, while Black Hawk—still a name to conjure with—lingered on the fringe of the crowd at Rock Island, a broken, pathetic figure in "an old frock coat and brown hat," cane in hand, denied the right even to address the council or sign the treaty that surrendered more tribal land to the whites. Dodge, as a colonel of militia, had helped defeat him in 1832; now, as governor of a territory embracing Sac and Fox lands, he simply ignored him.[67]

Resistance or negotiation, the result was the same. Black Hawk was yesterday, Keokuk the future; and though Catlin had made a special trip to Jefferson Barracks to paint Black Hawk's portrait in 1832, it was Keokuk who caught his eye in 1835 and now again in 1836. "This vain man," as Catlin called him, had the opportunity to express his approval of Catlin's flattering likenesses (one an equestrian portrait) in New York the following

45

autumn while touring with a Sac and Fox delegation three days after signing another treaty with the government ceding an additional 1.25 million acres directly west of the 1832 cession. White land hunger would not be satisfied until the Indians had nothing left to sell. Sac and Fox prosperity was illusory, then, and that was Catlin's underlying message in reporting the relatively minor cessions of 1836. What he and Wood were witnessing when the Indians signed the treaties of September 27 and 28 was, in effect, the whole process of Indian dispossession.[68]

From Rock Island, Catlin pushed on home. He was singularly uninformative about the journey, noting only that the summer's travels had been conducted "at a DIFFICULT, [(]and almost cruel) rate; and if, in my over-exertions to grasp at material . . . the cold hand of winter should be prematurely laid upon me and my works, in this northern region, the world, I am sure, will be disposed to pity, rather than censure me, for my delay." In fact, his family was inclined to do a bit of both. When at last they received word from him in mid-November, his mother, who was the family's severest critic of its most famous member, put the matter succinctly: "All Georges friends has been opposed to his course this summer, but perhaps it is all for the best." She could afford to be equitable, since he had paid a price for his obstinancy, a painful shoulder injury sustained in a stagecoach accident. Forced to recuperate in Tecumseh, some forty miles southwest of Detroit, he was still a long steamboat and stagecoach ride from home.[69]

Catlin did do one thing of significance after his convalescence: he looked up Henry Rowe Schoolcraft in Detroit. At the time, neither knew how fateful their meeting would prove.

Mr. Schoolcraft and Mr. Catlin have done more to preserve the fleeting traits of aboriginal character and history than all their predecessors in this field of inquiry, and none can follow them with the same success, as none can have the same range of subjects before them. The scene is changing with each year, and the past, with respect to the Savages, does not recur. . . . Those who have seen them most during the last few years, have seen them best.

Detroit *Daily Advertiser,* June 17, 1839

None Can Follow Them

Catlin and Schoolcraft, 1836–1842

Henry Rowe Schoolcraft was born in upstate New York on March 28, 1793, the seventh of thirteen children, and at a young age he succeeded his father in a glassworks at Hamilton, New York. His vocation took him to Vermont and New Hampshire, where in 1817 he and a partner were forced into bankruptcy by the general business slump following the War of 1812. "The smash of my affairs in New England" he recalled as "a turning point in my life," leading to two fateful decisions: he would make money by writing a book, *Vitreology; or, The Art of Making Glass,* and he would go west to seek opportunity, to Pittsburgh, Cincinnati, Louisville, up the Mississippi to St. Louis, and on to the town of Potosi, Missouri. From there in 1818 and early 1819 he

47

5

" Having examined Mr. Catlin's collection of Portraits of Indians of the Missouri to the Rocky Mountains, I have no hesitation in pronouncing them, so far as I am acquainted with the individuals, to be the best I have ever seen, both as regards the expression of countenance and the exact and complete manner in which the costume has been painted by him.

" J. L. BEAN, *S. Agent for Indian Affairs*."

" I have been for many years past in familiar acquaintance with the Indian tribes of the Upper Missouri to the Rocky Mountains, and also with the landscape and other scenes represented in Mr. Catlin's collection, and it gives me great pleasure to assure the world that on looking them over, I found the likenesses of my old friends easily to be recognized ; and his sketches of Manners and Customs to be portrayed with singular truth and correctness.

" J. PILCHER, *Agent for Upper Missouri Indians*."

" It gives me great pleasure in being enabled to add my name to the list of those who have spontaneously expressed their approbation of Mr. Catlin's collection of Indian Paintings. His collection of materials place it in his power to throw much light on the Indian character, and his portraits, so far as I have seen them, are drawn with great fidelity as to character and likeness.

" H. SCHOOLCRAFT, *Indian Agent for Wisconsin Territory*."

"Having lived and dealt with the Black Feet Indians for five years past, I was enabled to recognize *every one* of the Portraits of those people, and of the Crows, also, which Mr. Catlin has in his collection, from the faithful likenesses they bore to the originals.

" *St. Louis*, 1835. J. E. BRAZEAU."

" Having spent sixteen years in the continual acquaintance with the Indians of the several tribes of the Missouri, represented in Mr. Catlin's Gallery of Indian Paintings, I was enabled to judge of the correctness of the likenesses, and I *instantly recognized every one of them*, when I looked them over, from the striking resemblance they bore to the originals—so also, of the Landscapes on the Missouri.

"HONORE PICOTTE."

"The Portraits, in the possession of Mr. Catlin, of Pawnee Picts, Kioways, Camanches, Wecos, and Osages, were painted by him *from life*, when on a tour to their country, with the United States Dragoons. The *likenesses* are good, very easily to be recognized, and the *costumes* faithfully represented.

"HENRY DODGE, Col. of Drag.	D. PERKINS, Capt. of Drag.
R. H. MASON, Major of ditto.	M. DUNCAN, ditto.
D. HUNTER, Capt. ditto.	T. B. WHEELOCK, Lieut. Drag."

29. Schoolcraft's endorsement as it appeared among the certificates prefacing every edition of Catlin's Indian Gallery catalog from 1837 to 1848. *A Descriptive Catalogue of Catlin's Indian Gallery . . . Exhibiting at the Egyptian Hall, Piccadilly, London* (1840).

conducted a mineralogical survey of the mining district that resulted in a second book, well received by America's scientific community, *A View of the Lead Mines of Missouri*. Convinced he could turn his expertise in "mineralogical science" to good account, Schoolcraft campaigned for appointment to a post of his own devising, superintendent of mines for the Western District. He got a respectful hearing from the president and from Secretary of War John C. Calhoun, and though the superintendency did not materialize, Calhoun was sufficiently impressed to offer Schoolcraft a position as geologist on an exploring expedition, mounted by the War Department in 1820, to Lake Superior, the headwaters of the Mississippi, Lake Michigan, and back to Detroit. Over four months in duration, it covered four thousand miles, exposed Schoolcraft to the Indian cultures of the region, took him to Sault Ste. Marie (where he met his future wife) and Mackinac, homes to him for almost twenty years, gave him his first taste of federal preferment, and introduced him to Lewis Cass, then governor of Michigan Territory (1813–31) and leader of the expedition.[1]

A man on the rise, Cass became a father figure to Schoolcraft, though only eleven years his senior. Impressed by Schoolcraft's zeal and efficiency as expedition geologist, Cass made him secretary to a commission to treat with the Indians at Chicago in August 1821. En route to the treaty site, the two men explored along the Mississippi and formed an even closer relationship that paid off for Schoolcraft the next year when Cass had him appointed head of the newly established Indian agency at the Sault. "I had now attained a fixed position," Schoolcraft later wrote; it was not the one he had in mind, but it could serve as a stepping-stone to something better.[2]

Adjusting to circumstances, Schoolcraft shifted his interest from mineralogy to the Indian cultures around him. He was startled, he confided to his journal in July 1822, a few weeks after arriving at the Sault, not only to learn that the Chippewas related "oral tales of a mythological or allegorical character," but by the tales themselves, which, as both entertainment and instruction, revealed as nothing else the hidden contours of the Indian mind. This "fund of fictitious legendary matter" was, he concluded, "quite a discovery," and along with the Indian languages formed the core of his ethnological investigations over the next thirty years.[3]

Schoolcraft's marriage in October 1823 to Jane Johnston, the daughter of a Chippewa woman and an educated, prosperous Irish-born fur trader, put him in an excellent position to pursue his studies, since his wife had been schooled abroad and was fluent in both English and Algonquian. But what inspired and then sustained his enthusiasm for Indian researches was the example set by Cass. Through the 1820s—a decade in which Cass negotiated a series of treaties with the northwestern tribes—the two men worked as a team. They went together on treaty tours and cooperated in the literary endeavors that helped pass the long winters when time dragged

almost as slowly for Cass in Detroit as for Schoolcraft at the Sault. School-craft was a constant scribbler—he filled a journal, wrote poems, contributed to the newspapers, circulated his own manuscript magazines, and added to his first books three additional titles in the 1820s: *Journal of a Tour into the Interior of Missouri and Arkansaw* (1821), *Narrative Journal of Travels through the Northwestern Regions of the United States . . . to the Sources of the Mississippi River in the Year 1820* (1821), and *Travels in the Central Portions of the Mississippi Valley* (1825), dedicated to Lewis Cass in recognition of his services as explorer, governor, and student of the "traduced native population." For all his literary credits, when Schoolcraft collaborated with Cass on various Indian studies for the *North American Review* there was no question who was the senior partner, who the junior. Cass was responsible for organizing the data and advancing conclusions, with Schoolcraft serving as research assistant. He prepared vocabularies, read Cass's drafts, and eventually, through Cass's influence, was himself asked to contribute on his specialties.[4] With Jared Sparks—later a regular visitor at Catlin's house in London—serving as editor, the *North American Review* in the 1820s was fulfilling its mandate as a voice for American themes and was warmly receptive to papers on the native tribes. There was room in its pages for both men, but when Schoolcraft in 1829 thought an essay he had proposed on fur trader–Indian relations might overlap one Cass was preparing on Indian removal, he stepped aside in favor of his mentor, heard Cass's paper read in draft, and wrote a letter to Sparks endorsing its conclusions and urging its publication uncut.[5]

In a review, Cass praised Schoolcraft as a rising authority on the Indians: "He has surveyed them with the eyes of a cautious and judicious observer. He has avoided the extremes of reproach and panegyric, and has seen and described them as they are." In turn, Schoolcraft heaped praise on his mentor. Cass had staked out the field of Indian research in a pamphlet published in 1823, *Inquiries, Respecting the History, Traditions, Languages, Manners, Customs, Religion, &c. of the Indians, Living within the United States*. It was to how Indians thought, how their minds worked, that Cass addressed his queries, and Schoolcraft was so dazzled by the originality of his approach that he "determined to be a laborer in this new field." By the end of 1824 Cass had drafted a "Plan of a Philosophical Work on the Indians," drawing on his researches, and Schoolcraft was again impressed. "Few men have seen more of the Indians in peace and war," he wrote. "Nobody has made the original collections which he has, and I know of no man possessing the capacity of throwing around them so much literary attraction." He only hoped that Cass would persevere in his plan. In fact, Cass's 1830 essay on Indian removal brought an end to his aboriginal researches, attracting such favorable attention in administrative circles that President Jackson broke with precedent (Cass was the citizen of a territory,

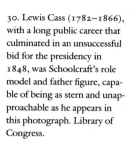

30. Lewis Cass (1782–1866), with a long public career that culminated in an unsuccessful bid for the presidency in 1848, was Schoolcraft's role model and father figure, capable of being as stern and unapproachable as he appears in this photograph. Library of Congress.

not a state) and appointed him secretary of war in 1831. Thus began a high-level career in Washington that would culminate in 1848 in Cass's nomination as the Democratic candidate for the presidency. His elevation effectively placed him beyond Schoolcraft's social orbit, a realization that dawned only slowly. Meanwhile Schoolcraft continued their joint investigations on his own. Eventually he would eclipse Cass as the best-known Indian expert of the western school, steeped in the realities of Indian administration on the frontier and a stranger indeed to panegyric.[6]

Relocated in 1833 as agent at Mackinac with supervision over the subagency at the Sault, Schoolcraft found his reputation growing. "I have often been written to, by persons at a distance wishing for information on the Indian tribes, or their languages, or antiquities, and uniformly responded favorably to such applications, sending a little where it was not practicable to do more," he noted in his journal in July 1834. By the fall of 1836 he had appeared twice in the *North American Review,* and its editor was pressing him (at Cass's suggestion) for an essay on Albert Gallatin's memoir on the Indian languages. Other journals also solicited contributions, and he had signed a contract with Harper's in New York to publish a collection of Indian tales. His correspondents included Peter S. Du Ponceau, a leading philologist, Dr. Samuel George Morton, the foremost craniologist of the day, George Bancroft, America's premier historian, and Washington Irving, one of the country's most popular authors. Schoolcraft had reason for self-congratulation. Lacking formal education he had, through perseverance, or "natural assiduity" he preferred to call it, made

himself a considerable name in his chosen field. When it came to Indians, people came to Henry Schoolcraft—people like George Catlin.[7]

* * *

Catlin probably met Schoolcraft during his brief stopover on Mackinac in July 1836. He had just come down from the Sault, where Schoolcraft's brother James, who had the mail contract between the two outposts, had attested to the accuracy of four Chippewa portraits painted in his presence there. Schoolcraft recalled giving Catlin his hand, and his endeavors his blessing, at Mackinac, but he thought the encounter took place in 1833, on Catlin's return from a visit to the St. Peters River. If they did meet in July 1836, neither man recorded the fact. Catlin saw no need to "detain" the reader of *Letters and Notes* with descriptions of the Sault or "the inimitable summer's paradise" of Mackinac, both "an hundred times described," and Schoolcraft was mum about Catlin in his compendious *Personal Memoirs*.[8]

But that November the two men definitely met face to face in Detroit, where Schoolcraft, taking advantage of his new title as superintendent of Indian affairs in Michigan, had moved his headquarters for the winter. Catlin was pleased to show off the gleanings of his summer's wanderings, specimens of red pipestone that intrigued Schoolcraft both as mineralogist and as ethnologist. On November 12 he wrote a friendly letter emphasizing the scientific importance of Catlin's discoveries:

> I have been highly gratified with the portraits, costumes and sketches of Indians made by you during your recent visit to the Coteau des Prairies, and with a cursory inspection of the specimens brought by you, illustrating the geology of the formation of the Grand Pipestone quarry, which exists on the summit of that hitherto unexplored elevation. You have rendered a service to science by this enterprize, as well as the Indian race, whose personal features, & dress you have perpetuated in your paintings & designs. Some of the portraits are of chiefs personally known to me, and exhibit faithful likenesses of their features.
>
> The ample collections of specimens & articles of dress, curiosity & ornament, which you have made so far as I have seen & examined them, together with the labours of your pencil, and notes of scenic features, and the aboriginal traditions & customs, give you the command of a body of original material, of a highly interesting character, which it is hoped, nothing will prevent you from immediately preparing for the public.

Schoolcraft's endorsement sounds as if it was written at Catlin's request. A similar testimonial served as one of the certificates of authenticity that appeared in every edition of Catlin's catalog beginning in 1837: "It gives

me great pleasure in being enabled to add my name to the list of those who have spontaneously expressed their approbation of Mr. CATLIN's Collection of Indian Paintings. His Collection of materials place it in his power to throw much light on the Indian character, and his portraits, so far as I have seen them, are drawn with great fidelity as to character and likeness. H. SCHOOLCRAFT, Indian Agent for Wisconsin Territory."[9]

But however cordial their relations might have been in 1836, Catlin and Schoolcraft were working at cross-purposes. Before Catlin's visit, Schoolcraft had spent nearly six months in Washington ushering through to ratification treaties he had negotiated with the Ottawas and Chippewas involving an enormous cession of land in Michigan Territory—estimated at 15 to 16 million acres. The *"all important treaty"* was signed on his birthday, March 28, and he considered it a personal triumph to crown his forty-third year, after fifteen years spent in the government's Indian Service. "A treaty was signed to day, by the Indians, which secures to this unfortunate race, great advantages," he proudly wrote his wife. "All that could be wished in the way of schools, missions, agriculture, mechanics &c, &c, is granted. Much money will be annually distributed, their debts paid, their half breed relatives provided for, every man, women & child of them, & large presents given out. Rejoice with me. The day of their prosperity has been long delayed, but has finally reached them."[10]

Catlin saw no cause for rejoicing in such cessions. Had he stuck to his original itinerary in 1836 he would have been back at Mackinac in September for the first disbursement under the new treaty; instead he was at Rock Island witnessing the Sac and Fox cession, "luckily in time," as he put it, "to see the parades, the forms and solemn rites of a savage community, transfering the rights and immunities of their natural soil, to the insatiable grasp of a pale-faced voracity." But Schoolcraft was delighted with the September gathering of more than four thousand Indians, united in "joy and satisfaction" on Mackinac. "Fourteen years before, I had taken the management of these tribes in hand, to conduct their intercourse and to mould and guide their feelings," he wrote. "They were then poor. . . . They were now at the acme of Indian hunter progress. . . . I had allied myself to the race. I was earnest and sincere in desiring and advancing their welfare. I was gratified with a result so auspicious to every humane and exalted wish." There was a dark side to Schoolcraft's self-congratulation. He benefited all too directly from the generous claims payments made to his in-laws the Johnstons, stirring up a scandal he never quite shook, try though he did to sanitize the transaction.[11]

When Catlin met Schoolcraft in 1836, then, their common concerns—fair treatment for the Indian, the almost missionary zeal with which they approached the task of recording the native cultures in paint and words—

53

overshadowed their differences. By 1839 both were considered Indian experts. Catlin had exhibited and lectured in the major eastern cities by then, and Schoolcraft had just brought out his long-promised collection of tales and legends, *Algic Researches, Comprising Inquiries Respecting the Mental Characteristics of the North American Indians*. The Detroit *Daily Advertiser* linked them in a review published on June 17, 1839, and the Detroit *Free Press* embroidered the comparison a few days later: "Catlin may be called the red man's painter; Schoolcraft his poetical historian. . . . They have done much which, without them, would, perhaps, have remained undone, and become extinct with the Indian race." A New York reviewer made the same point in 1844: "There are few men who could undertake such a work [as Schoolcraft's], fewer still;—we know of no one else save Col. [Thomas L.] McKenney [head of the Office of Indian Affairs, 1824–30], and Catlin, and perhaps Gen. Cass—who could relate the greater part of it out of their own personal experience."[12]

It was an interesting juxtaposition of names—Schoolcraft, McKenney, Catlin, and Cass—since only Catlin had never been connected with the government's Indian Service. Schoolcraft was an agent long resident in the Indian country, Catlin a traveler passing through; the one was a practical administrator, the other an artist. Indeed, their backgrounds were as incompatible as their approaches to the Indian and his destiny.

 * * *

Where Catlin saw verdant prairies, enchanted streams and lakes, riverbanks that dissolved into castles in the mind—an infinity of scenes to delight the eye and stir the heart—Schoolcraft saw lead mines in the Michigan wilderness, board feet of lumber in a forest grove, town sites on the shore of Green Bay, and highways of commerce in the Great Lakes system. He thrilled to evidences of the prospering interior in the boats that daily steamed by within view of his plaza on Mackinac. He wrote poetry of a stiff and—a distinguished contemporary diplomatically informed him—old-fashioned sort, channeling emotions into rigid classical forms where thought ever dominated feeling.[13] Catlin wrote prose but *was* a poet, raggedly eloquent as he told what he saw and what he felt, the two experiences one for him—a criticism frequently voiced by his detractors. A romantic, he reached toward a concept of the oversoul in a vocabulary sprinkled with terms dear to transcendentalism:

> I often landed my skiff and mounted the green carpeted bluffs, whose soft grassy tops, invited me to recline, where I was at once lost in contemplation. *Soul melting scenery* that was about me! A place, where the mind could *think* volumes, but the tongue must be silent that would speak . . . even the soft tones of *sweet music* would hardly

preserve a spark to light the soul again, that had passed this sweet delirium. I mean the *Prarie*, whose enamelled plains that lie beneath me, in distance soften into sweetness like an essence . . . I mean *this* Prarie, where Heaven sheds its purest light and sheds its richest tints.

For Catlin had encountered a grave in the wilderness and felt an instant bond: "Stranger! Oh, how the mystic web of sympathy links my soul to thee and thy afflictions!" Though the sentiment was conventional, there is a stirring here anticipating Margaret Fuller's response to "a sunset of the melting kind": "Only by emotion do we know thee, Nature."[14]

Schoolcraft, a level-headed man of affairs and a self-taught scholar, responded cerebrally to the world around him, classifying phenomena, condescending toward what was better studied than understood, accommodating experience to theory. His head ever ruled his heart—Hawthorne's "unpardonable sin" and one the emotional Catlin rarely committed. Both men spoke of civilization and savagery, but Catlin fretted over their relative merits while Schoolcraft never doubted for a moment which was superior. He had long deprecated the ignorant who adhered to "the poetic view" of Indian character, failing to recognize that the Indian was a "weak, vacillating, and desponding and suffering being . . . wasting his time in sensual quiescence," incapable of self-governance or governance by others. Savagery and civilization were "the alpha and omega of the ethnological chain," Schoolcraft wrote, unable to coexist. Savagery—"the nomadic and hunter states of society"—would one day perish in America as it had elsewhere on the globe, in accordance with God's ordinance.[15]

Catlin agreed that progress was inevitable without accepting the cruelty that too often accompanied it. He was in league with the romantics who deplored the destruction of the wilderness as the desecration of God's temple. Wild nature had always been seen as civilization's enemy. In the 1780s the French émigré J. Hector St. John de Crèvecoeur had described the wilderness as "a door" through which the Indians "can enter our country whenever they please." This was the common fear. The wilderness loomed like a black wall around tiny clearings in the forest; log cabins huddled in the openings, built from the trees whose absence permitted light to flood a land so recently in shadow; the homes of pioneers, they represented progress and domesticity. But they were naked, vulnerable to the terrors that lurked unseen in the dense woods around. Catlin always recalled the toll pioneering in Pennsylvania's Wyoming valley had taken on his forebears. His mother, as a girl of eight, was held captive by the Indians. The eighteenth century had bequeathed the nineteenth an image of the wilderness consistent with Crèvecoeur's. But Catlin, as a child of the new century steeped in romanticism, had pushed against the door and

found it swung both ways. At midcentury, Herman Melville asked in *Moby-Dick,* "Are the green fields gone?" Had America turned into just another Europe, where the machine ruled the garden? Catlin had already framed his answer: out there, beyond the reaches of civilization and the smoke of the factory, was "a vast country of green fields, where the *men* are all *red.*" Out there was Indian Country.[16]

For Catlin the Indian was both an idea, a noble savage with all the virtues and flaws the phrase implied, and a human being; for Schoolcraft, the "representative of a *condition.*" He considered the struggle between Indian and white a "war of conditions of society." So viewed, its outcome could be contemplated without flinching. If the Indian declined and the white man increased, "it was because civilisation had more of the principles of endurance and progress than barbarism; because Christianity was superior to paganism; industry to idleness; agriculture to hunting; letters to hieroglyphics; truth to error." Severely judgmental in his narrow Presbyterianism, Schoolcraft accepted the Indian's fate with the clear conscience that came from knowing what was right and wrong.[17]

Catlin, groping toward a rudimentary cultural relativism, in his original letters viewed the Mandan creation myth as "stupid" save where it corresponded to biblical teachings about Eve and the flood, and he referred to Indians as "yelling savages." But in his book he questioned the use of savage as a synonym for Indian, defended the Indians' right to their own beliefs, and deplored the white man's complicity in hastening the inevitable:

> Of this sad termination of . . . [the Indians'] existence, there need not be a doubt in the minds of any man who will read the history of their former destruction; contemplating them swept already from two-thirds of the Continent; and who will then travel as I have done, over the vast extent of Frontier, and witness the modes by which the poor fellows are falling, whilst contending for their rights, with acquisitive white men. Such a reader, and such a traveller, I venture to say, if he has not the heart of a brute, will shed tears for them; and be ready to admit that their character and customs, are at *this time,* a subject of interest and importance, and rendered peculiarly so from the facts that they are dying *at the hands* of their Christian neighbours; and, from all past experience, that there will probably be no effectual plan instituted, that will save the remainder of them from a similar fate.

Schoolcraft once wrote that "a wolf and a lamb are not more antagonistical in the system of organic beings, than are civilization and barbarism, in the great ethnological impulse of man's diffusion over the globe." To Catlin

56

the parallel was sadly apt; it was his duty to remind the world that in America the white man was the wolf, the Indian the lamb.[18]

* * *

Their opposite approaches to Indian rights and character placed Catlin and Schoolcraft on a collision course. Federal policy would provide the issue. Catlin tended to be positive about the officials he met on his western wanderings but critical of what they stood for. He warmly thanked the secretary of war (Lewis Cass, though Catlin did not mention him by name) for letters of introduction instructing post commanders and Indian agents to show him every consideration, and he praised the officers and men who escorted him in 1834 for their soldierly integrity, their "noble bearing," their chivalrous conduct, their taste. But he fussed over the purpose of the expedition he accompanied into Comanche country, hoping its object was humane and not that of "an invading army carrying with it the spirit of chastisement." Similarly, he complimented some of the government agents he met on their commitment, humanitarian zeal, and "unequalled familiarity with the Indian character"; but in their official capacity they implemented policies that were debasing the Indians and stripping them of their lands. Removal west of the Mississippi Catlin judged simply "cruel." It had arrested the progress of the eastern tribes and delivered them into the hands of the avaricious whites—"whiskey-sellers and traders"—who swarmed along the frontier. Schoolcraft, as an agent of the government, treated for land cessions, facilitated trade and intercourse with the Indians, and favored removal as "sound policy." He took pride in having molded and guided the Indians under his charge to the government's ends. Yet in doing his duty, Catlin considered he was guilty of a monstrous crime. "Where injustice and injury are visited upon the weak and defenceless, from ten thousand hands—from Governments—monopolies and individuals—the offence is lost in the inseverable iniquity in which all join, and for which nobody is answerable," Catlin warned, "unless it be for their respective amounts, at a final day of retribution."[19]

Catlin was essentially at odds with the spirit of a burgeoning West. He spoke of preserving Indianness at a time when white traders, settlers, land speculators, and a slew of enterprising businessmen wanted freer access to Indian Country in order to improve it. Moreover, Catlin published his views in the newspapers. Cautious following his initial probe up the Missouri, he became increasingly outspoken as he traipsed around the Southwest in 1834, went up the Mississippi in 1835, and visited the red pipestone quarry the next year. By 1837, as the last of his letters were appearing in the New York *Commercial Advertiser,* he was promising to issue the lot in book form. Would he prove that most ungrateful of guests, turning the hospitality of his hosts against them?

Catlin's relationship with Pierre Chouteau and the American Fur Company had been strained by his published accounts of Indian life on the Upper Missouri. His newspaper letters were unobjectionable, even flattering to the company, but it feared they might jeopardize its position by attracting competition or inadvertently throwing an unfavorable light on its dealings with the Indians. As early as January 1833, Catlin had assured Chouteau that he would never knowingly harm the company's interests. Indeed, in a letter intended for early publication he would assert the "vast importance" of the company's efforts in "opposing British influence" and "securing to the U.S. a share of the Fur Trade of our own Country." In the same letter he would discuss the trade's "immense liability to heavy losses"—thereby discouraging potential rivals—and advocate the federal government's lifting its ban on alcohol in Indian Country, since prohibition "must inevitably result in a complete annihilation of the Company's business." These views, so out of harmony with his later position, suggest how dependent he was on Chouteau's continuing goodwill in 1833.[20]

The letter appeared that June, as Catlin said it would. In it he tortured logic to justify the American Fur Company's every practice. The company furnished the western Indians arms, ammunition, and "other necessaries of life," meaning liquor, at fair prices and scant profit owing to its high overhead (forts had to be built and manned, goods shipped over vast distances). As if these obstacles to trade were not enough, the government had prohibited liquor in Indian Country. This policy would "undoubtedly destroy all prospects of trade" and was unnecessary anyway, since the western tribes used liquor "entirely without the pernicious effects which it produces amongst the bordering tribes," which had easy access to whiskey, he explained, and were thus destroyed by it. The remote tribes, "obliged to pay so high a price for this article," tippled only at cocktail hour, if Catlin were to be believed, sipping the whiskey "in small and precious draughts." A "rare and scanty" commodity—and correspondingly harmless—liquor was nevertheless essential in enticing the Indians to trade. If the Americans could not supply it, their British rivals, having neither scruples nor laws to contend with, would, thereby establishing a complete fur monopoly in the West. The United States government would have to repeal the ban.[21]

Well satisfied, Chouteau granted Catlin use of the American Fur Company's St. Louis facilities for storage of his collection in 1834. But his expedition with the army that year altered his views. In his last letter from Fort Gibson, dated September 8, Catlin argued against permitting traders to set up shop among the Kiowas and Comanches. "I have travelled too much among Indian tribes, and seen too much, not to know the evil consequences of such a system," he wrote. The Indians were rendered dependent on trappers who were "generally the lowest and most debased class of society." Shut off from good example, exposed only to bad, they

learned contempt for all white people. Have the Indians trade at the army posts, where competition would ensure fair prices and soldiers would set a proper example of civilization while implanting in the Indian mind a realization of the white man's strength, the futility of resistance, and the need to adopt civilized modes of living. In meeting the southwestern tribes—innocent of white corruption—the government had an unrivaled opportunity to "adopt and *enforce* some different system from that which has been generally practised on and beyond our frontiers heretofore." From the moment these sentiments appeared in print in October 1834, Catlin had a powerful new enemy: the American Fur Company.[22]

"That man has a hard name through out this Country," John James Audubon wrote on June 13, 1843, from Fort Union on the Upper Missouri. America's most distinguished artist-naturalist, rather cranky at fifty-eight, could find nothing good to say about Catlin or his work. He filled his journal of the steamboat trip up the Missouri—the very trip Catlin had made in 1832—with splenetic asides. Catlin's book was "altogether a humbug. Poor devil! I pity him from the bottom of my soul; had he studied, and kept up to the old French proverb that says, 'Bon renomme vaut mieux que centure dore,' he might have become an 'honest man.'"[23]

Audubon was suffering more than a minor bout of professional jealousy. Catlin's enterprise had often been equated with his own and Catlin dubbed "the Audubon of the Indians"—yet Catlin had preceded Audubon up the Missouri by eleven years and seen things that no longer existed with younger eyes. The immediate source of Audubon's animosity, however, was effective American Fur Company propaganda. Almost everyone who went up the Missouri after Catlin branded him a humbug. Some, for variation, settled on charlatan. Complaints that he had embellished the stories of veteran fur traders, repaid company generosity with ingratitude, and misunderstood what he saw darkened into an attack on his honesty. He did not simply misunderstand, he misrepresented. He could not be relied upon for particulars and actually made up whole chunks of what he reported. Catlin the ingrate, the imaginative tourist, became Catlin the cunning deceiver, the liar. He was defamed from post to post; every visitor after his book appeared in 1841 (with the letter currying Chouteau's favor deleted) heard stories about his fabrications. Traders he considered friends hewed to the company line and blackened his reputation. George Catlin simply could not be trusted, and the American Fur Company made sure that fact was known to all.[24]

Audubon was a case in point. As Chouteau's guest in St. Louis, he had been handsomely entertained before boarding a company steamer for the run up the Missouri. Passed along from attentive agent to attentive agent, he so absorbed the fur trade viewpoint that by the time he reached Fort Union he was the company's unthinking apologist. Fur traders had not de-

59

based the western Indians, as Catlin charged. There were no noble red men out there, only squalid savages living in unspeakable filth, beneath debasement. When a party of Crees from the British dominions approached Fort Union and were told they could not have whiskey, Audubon wrote, they replied that in the future they would trade with the Hudson's Bay Company exclusively. It supplied them all they wanted. "Now ought not this subject be brought before the press in our country and forwarded to England?" he demanded. "If our Congress will not allow our traders to sell whiskey or rum to the Indians, why should not the British follow the same rule? Surely the British, who are so anxious about the emancipation of the blacks, might as well take care of the souls and bodies of the redskins." Audubon could not know that in parroting the American Fur Company line he was following Catlin as surely as in making his ascent of the Missouri. But Catlin had recanted. Audubon would have none of it. Instead, drawing freely on company man Alexander Culbertson's 1834 journal at Fort McKenzie in Blackfoot country, he rested his case: "From these extracts the nature of the Indians of these regions may be exemplified a thousand times better, *because true,* than by all the trashy stuff written and published by Mr. Catlin."[25]

At the time Audubon was writing, Margaret Fuller Ossoli was reading Catlin's *Letters and Notes* in Chicago preparatory to her own summer excursion to the West. Of the available books on Indians—"a paltry collection truly"—she considered Catlin's "far the best." Nevertheless, she was told on her tour of the Great Lakes that he was "not to be depended on for the accuracy of his facts," and she conceded that it was "obvious . . . he sometimes yields to the temptation of making out a story." But as a leading transcendentalist thinker attuned to the impulses astir in Catlin, Fuller knew intuitively what his critics would not admit, that he was "true to the spirit of the scene, and that a far better view can be got from him than from any source at present existing, of the Indian tribes of the Far West."[26]

Perspective was everything in evaluating Catlin's achievement. A traveler like Fuller, responsive to the appeal of natural man in his natural setting and skeptical about what passed for progress in mid-nineteenth-century America ("mushroom growth," fur trade avarice and a flinty Christianity that would civilize the Indian out of existence), could find in Catlin a truth lacking, for example, in Schoolcraft, type of the "stern Presbyterian with his dogmas and his taskwork," whose Indian books emtombed vital material in stodgy prose. Understandably, Catlin's kind of truth offended many resident westerners, though what they deemed his ingratitude was something else entirely.[27]

The American Fur Company had provided Catlin passage and accommodation on the Missouri, but he kept accounts at Forts Pierre, Union, and Clark and covered all his personal expenses. When he was in the field

with the United States dragoons two years later, he carried a letter from the secretary of war ordering that he be supplied and protected, but he accepted protection only, not wanting the government to incur any expense while he pursued his "own private objects." By his reckoning, then, Catlin was indebted to fur traders, Indian agents, and army officers for the common courtesies shown frontier travelers and nothing more. After all, without prior acquaintance or prospect of future recompense, the Indians had hosted him too:

> I have seen a vast many of these wild people in my travels. . . . And I have had toils and difficulties, and dangers to encounter in paying them my visits; yet I have had my pleasures as I went along, in shaking their friendly hands, that never had felt the contaminating touch of *money,* or the withering embrace of pockets; I have shared the comforts of their hospitable wigwams, and always have been preserved unharmed in their country. And if I have spoken . . . of them, with a seeming bias, the reader will know what allowance to make for me, who am standing as the champion of a people, who have treated me kindly.

No one had sponsored him, and no one, certainly, had bought his silence.[28]

Aware that he was being smeared for his independent views, Catlin fought back. In October 1837 he stood before a New York audience holding up a scalp. It had been, he said, torn from the head of a once-honored warrior by his own people and, as a gesture of contempt, sold to a white trader who three years later sold it to Catlin. This "barbarous trophy" capped a story charged with personal meaning for the artist.[29]

Wi-jun-jon or the Pigeon's Egg Head was a handsome young Assiniboine much admired by his tribesmen. Late in 1831 he accompanied a small delegation of western Indians to Washington to visit the president. Impressionable, curious, and determined to remember what he saw—an Indian Catlin—Wi-jun-jon and another Assiniboine kept count of the settlers' cabins scattered along the Missouri by notching a pipestem, then a war club handle, and finally several long sticks, before abandoning the tally upon reaching St. Louis with its thousands of residents. Catlin met Wi-jun-jon there and painted his portrait "in his native costume, which was classic and exceedingly beautiful." In Washington over winter Wi-jun-jon drank in the sights and studied the white people. "He travelled the giddy maze," Catlin wrote, "and beheld, amid the buzzing din of civil life, their tricks of art, their handiworks, and their finery; he visited their principal cities, he saw their forts, their ships, their great guns, steamboats, balloons, &c. &c. and in the spring returned to St. Louis, where I joined him and his companions, on their way back to their own country." Wi-jun-jon, a model

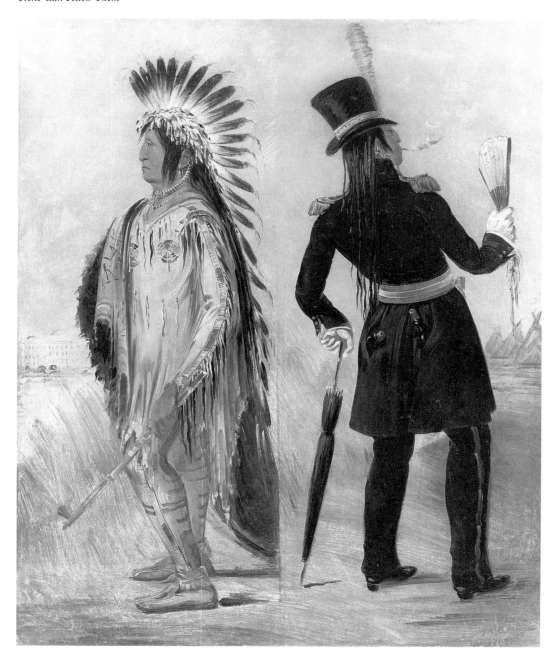

31. George Catlin, *Pigeon's Egg Head (the Light) going to and returning from Washington* (1837–39). The ridicule and suspicion that greeted Pigeon's Egg Head on his return West served Catlin as a parable for his own reception in the East. National Museum of American Art, Smithsonian Institution; gift of Mrs. Joseph Harrison, Jr.

of the unspoiled Indians who lured Catlin west, was now dressed in an army uniform, with boots, sword, and epaulets, white kid gloves, and a high-crowned beaver hat. He carried a blue umbrella, a large fan, and having drunk in more than the sights, a small keg of whiskey. "In this fashion was poor Wi-jun-jon metamorphosed, on his return from Washington, and in this plight was he strutting and whistling Yankee Doodle about the deck of the steamer that was wending its way up the mighty Missouri, and taking him to his native land again; where he was soon to light his pipe, and cheer the wig-wam fireside, with tales of novelty and wonder."

Catlin might have found the spectacle instructive, even sobering, as he himself set out for parts unknown much as Wi-jun-jon had six months before. But each time he glanced at "this new fangled gentleman" he had to laugh; the denouement, however, was not funny: "After Wi-jun-jon had got home, and passed the usual salutations among his friends, he commenced the simple narration of scenes he had passed through, and of things he had beheld among the whites, which appeared to them so much like fiction that it was impossible to believe them, and they set him down as an impostor. . . . He sank rapidly into disgrace in his tribe; his high claims to political eminence all vanished; he was reputed worthless—the greatest liar of his nation." After three years of listening to his fabulous stories, the tolerant disbelief of his tribesmen turned into suspicion and fear. Wi-jun-jon was allied with evil spirits; his harmless fabrications were actually cunning deceits endangering the tribe. He had to be stopped. So Wi-jun-jon was assassinated as a social menace. Catlin drew the moral carefully: "Thus have ended the days and the greatness, and all the pride and hopes of Wi-jun-jon, the Pigeon's Egg Head, . . . who travelled eight thousand miles to see the President, and all the great cities of the civilized world, and who, for telling the truth, and nothing but the truth, was, after he got home, disgraced and killed for a wizzard." What people could not understand, they dismissed; thus ignorance consoled itself. Speaking of Wi-jun-jon, Catlin told a friend that they could profit from his misfortune. "We may call it a caution; . . . the fate of this poor fellow, who was relating no more than what he actually saw, will caution you against the imprudence of telling all that you actually know, and narrating all that you have seen, lest like him you sink into disgrace for telling the truth."

Catlin made this cautionary tale his personal parable. He raised it in his lectures where credibility was an issue and introduced it at controversial points in his book on the Indians. It was his all-purpose reply to his critics: what they could not understand, in their ignorance they denied. Need had qualified his independence in the past. But need ended with his western excursions. Now he would speak out in defense of the defenseless. Some might consider it ingratitude; he deemed it a higher obligation.

Summing up the lessons of her summer's tour of the Great Lakes in 1843, Margaret Fuller urged Congress to found "a national institute, containing all the remains of the Indians, all that has been preserved by official intercourse at Washington, Catlin's collection, and a picture-gallery as complete as can be made." That much, at least, the United States owed "the first-born of the soil." But Catlin's passage to Washington would prove more tortuous by far than his ascent of the Missouri, more desperate than his fevered trek across the southwestern plains.[30]

* * *

Making a living from his Indian paintings had always been a Catlin priority. Indeed, he turned from portraiture to the Indian in the expectation that he would improve his standing as an artist *and* profit in the bargain. It was in this spirit that he wrote to the secretary of war in 1829 outlining his master plan for an Indian Gallery. Through the 1830s, as he added to his gallery and, after 1836, exhibited in the major eastern centers, he consistently stressed the national importance of his collection. He periodically approached government for specific commissions. But his constant hope was that the government would acquire his Indian Gallery in its entirety as a monument to America's vanishing native tribes.

From a staunch Federalist family, Catlin surmised that Whig principles were best aligned with his own interests. An enlarged view of the federal government's proper role in fostering national objectives—cultural as well as economic and diplomatic—made the Whig party, prospectively, the artist's best friend. In the years spanning his concerted campaign for government patronage, 1838–52, Catlin confronted two Democratic (1837–41, 1845–49) and two Whig (1841–45, 1849–53) administrations. Both Whig presidencies were disrupted by death, and the second was checkmated by Democratic majorities in the House and Senate. Indeed, in the period 1837–53, the Twenty-fifth through the Thirty-second Congresses, the Democrats controlled both houses on five occasions, the Whigs only once, in 1841–43, at a time when Catlin was preoccupied abroad. In 1843–45 the Whigs held a majority in the Senate, the Democrats in the House, and in 1847–49 their positions were reversed. Apart from this last period, each time Catlin appealed to Congress to purchase his collection, the Democrats controlled both houses. Presidential parity was misleading, then, but Catlin anticipated the elections eagerly, awaiting a patronage bonanza. A few days before Americans went to the polls in 1840, Clara Catlin was hoping that when the new president was elected the government would "think proper to buy" her husband's Indian collections; four years later Catlin wrote to his brother, "If Clay is next President, I shall sell my Collection for money, or for (perhaps 100,000 acres of) wild land (ha?), and then we may make a swell in Wisconsin." Things were less

propitious in the spring of 1838, with the country suffering the disastrous effects of, as Catlin saw it, nine years of Democratic mismanagement. Nevertheless, that April he opened his Indian Gallery in Washington's Old Theatre with the avowed purpose of forcing congressional action on its purchase.[31]

Influential Whig politicians like Daniel Webster, a family hero, had accepted his invitation to view the collection when it was in New York City; and it was another Bay Stater, Whig representative George Nixon Briggs, who on May 28, 1838, introduced a resolution in the House ordering the Committee on the Library to look into acquiring the Indian portraits then on display in Washington and to "ascertain from Mr. Catlin upon what terms they may be possessed by the Government." Sensitive to the criticism that his paintings, however valuable as historical documents, were deficient as works of art, Catlin had prepared a defense in the first (1837) catalog of his collection. Allowance had to be made for the peculiar circumstances under which he labored. His pictures were facsimiles of what he had seen, not "finished works of art." Given time and encouragement, he would "place them, in turn, upon his easel, and render them eventually more pleasing to the eye," justifying Congress's patronage.[32] But no action was taken. At the next session, on February 11, 1839, Briggs introduced a similar resolution, upping the ante. The commissioner of Indian affairs was to investigate the matter personally and set a price for the whole collection, Indian curios as well as portraits. The commissioner did not bestir himself to report a bill, however, and though Catlin went over his head to the secretary of war, the resolution again expired without action.[33]

Catlin anticipated this result. Because he expected Congress to shirk its patriotic duty, he had an alternative plan. Europe had always been in the back of his mind. Three years before he ventured up the Missouri he told Secretary of War Peter B. Porter that, were his ambitions realized, he would exhibit his Indian Gallery at home and then in London, where he was confident it would provide him "a successful introduction beyond the Atlantic." At that time he hoped to make his reputation as a pure artist; painting Indians would be the means to that end, providing an unmatched opportunity for study in unselfconscious nude models, preparatory to tackling large-scale historical themes. His taste presumably ran to the works of contemporaries like John Vanderlyn and Washington Allston. Captivated by classicism, even late in life he was still drawing parallels between the Indians and antiquity: "The native grace—simplicity, and dignity of these natural people so much resemble the ancient marbles, that one is irresistibly led to believe that the Grecian Sculptors had similar models to study from; and their costumes and weapons . . . the Toga—the

Tunique & Manteau—the Bow—the shield & the Lance, so precisely similar to those of ancient times, convince us that a second (and *last*), strictly classic era is passing from the world." Had Catlin succeeded in his artistic ambition, had he done what he hoped to do—or been as good as his father hoped he was—toga-clad men and women, kin to Claude's and Poussin's, would have gamboled in woods and fields, few viewers realizing their prototypes had just stepped out of animal-hide tipis in the Far West, not Arcadia.[34]

But the Indians of course became an end in themselves, the contemplated gallery an obsession, freeing Catlin from the burden of tradition by a departure so novel it could have no precedents. A reviewer praised his gallery as "unique, '*instantia singularis*,'" its creator as representative of those "men of ONE IDEA, the enthusiasts of art or science," who compass "for the world's advantage what the world without them would not compass." Such singularity came at a price. Catlin might, as a contemporary suggested, shout "Alone I did it!" and his gallery might stand as an "abiding monument" to such republican values as free enterprise and self-sufficiency. But long before he made final plans for his move to England, he would have gladly exchanged some abundant republican individualism for some scarce republican patronage. He had become Thoreau's prototypical American, the property of his possessions, an artist too busy to paint. During the all-important exhibition in Washington in 1838, he complained that he was tired of touring and lecturing; it was a slavish existence that deprived him of the use of "pen and brush" without yielding a sufficient income to justify the sacrifice. "It will be for his credit & fame if the Government should take . . . [his paintings] off his hands, & let him return to his eazel and his . . . domestic comfort," his father wrote. "It would certainly take off his shoulders an immense load, and make him at once independent enough." Failing that, Catlin insisted, he would ship his paintings overseas.[35]

He had threatened to leave so often by then in an attempt to force Congress to act that he had run out of maneuvering room. Some papers misunderstood his motives and took him at his word. "His collection is destined to adorn the scientific halls of either London or Paris," the New York *Morning Herald* editorialized. "Go, Mr. Catlin, to Europe, and your labors will endure as long as the world shall last, for the friends of science and antiquities will enable you to preserve your treasures for posterity." Other papers wrung their hands at the prospect. Woe! shame! that a country as wealthy as the United States should so cavalierly squander its own heritage.[36] Through the first half of 1838 Catlin still clung to the hope that Congress would make an offer for his collection. But in July he obtained a letter of introduction to the earl of Selkirk from Henry Clay and

in November an exemption from the usual import duties on paintings from the Lords of the Treasury, clearing the way for a London exhibition. He thought he might leave as early as the following July, and the American correspondent of a leading London journal alerted its readers to his impending arrival; in fact it was a year later—November 25, 1839—before he embarked for England. "In the bustle and in describable confusion" of packing up his collection, he had little time to reflect that, far from escaping his burden, he was bringing it with him.[37]

Catlin did have misgivings. The decision to go abroad almost certainly meant a final parting with parents and some brothers and sisters as well. He was breaking up the family band. Consequently, on the eve of sailing he wrote that were the government to come up with an offer for his gallery he would be "ready and glad" to return to America "at a weeks notice." Meanwhile, he would be off on a new adventure.[38]

Unlike many of his contemporaries, he was not going abroad for belated art lessons. He intended to astonish Europe with a fait accompli, paintings as raw and vital as the West itself. He was going not to learn, but to "struggle amongst this world of strangers for some of its *goods*." In England and on the Continent one could find that enthusiasm for New World antiquities absent in America, as well as a class system that, for all of its inegalitarian drawbacks, encouraged the fine arts. The government had failed him, and private patronage in America was, with few exceptions, almost nonexistent. The promise of a republican art bolstered by a prosperous merchant class had never materialized.[39]

In the 1830s to 1850s some influential collectors and the New York–based American Art-Union took their patriotic duty to heart. The Art-Union in particular forged links between American painters and sculptors and the American public. Its membership, at five dollars a year, was open to the multitudes. Their dues bought works that were exhibited, then distributed in an annual lottery, serving the artist through exposure and purchase and the public by acquainting people with the best in home-grown talent. At its peak in 1849 the Art-Union's membership stood at 18,960; during its thirteen-year existence, 1839–52, it exhibited more than five thousand works to millions of people. "We seek to establish a national school of art," the union's fourth president declared, but despite its success the union was well short of that goal when it ran afoul of New York's lottery laws and ceased operations in 1852.[40]

The Art-Union had always been intended to supplement, not replace, private patronage. But serious collectors in the United States were few, their artistic nationalism fickle. The people may have been educated to enjoy art through illustrated books and periodicals, newspaper reviews, art unions, exhibitions, and colored prints, but they lacked the means to

acquire originals. Usually artists had to rely for support on small business-men who embraced the value of the marketplace. To them, art was some-thing foreign—you bought it abroad or had copies made. You dealt with artists when you needed a sign made to hang in front of your establish-ment, a carriage decorated, or a portrait painted. "In truth Art finds America an ungenial soil," an editor conceded at midcentury.[41]

Abroad, all would be different. Catlin was confident the British Mu-seum or some other well-endowed institution would want his collection; certainly the English public would pay to see it. So he sailed, not realizing as he gazed back at New York harbor that more than thirty years would elapse before he laid eyes on it again.

Catlin was already settled in London, and his Indian Gallery had been open a month at the Egyptian Hall, Piccadilly, when a third resolution came up before the House of Representatives, this one instructing the Committee on the Library to inquire into purchasing his collection. Intro-duced by Alexander Duncan, an Ohio Whig, on March 9, 1840, it too was ignored. On that inauspicious note Catlin's first concerted campaign for federal patronage fizzled out.[42]

 * * *

At the time, Catlin had too much else on his plate to worry excessively. "Like the whole of my life, everything ahead rests on uncertainty, and, as I *have been,* I am ready to meet the chances, such as will come," he wrote from London. "I have no fears if my health is spared, but that my labours will eventually be turned to good account." For three years he had been promising the momentary appearance of a two-volume work to be entitled *Catlin's Letters and Notes on the Manners and Customs of the North American Indians*. This became a time-consuming project: getting the manuscript in shape, finding a publisher, executing the engravings, covering expenses. Time was something he always lacked, but in London, he had discovered, there was a season for everything. Summer and early fall were the "dull season." The fashionable were out of town—and exhibitions simply died. In August 1840, then, Catlin decided to make use of the quiet period by getting his book out. Originally he thought a few months would be sufficient. He would employ six or eight "expert engravers" to come to his gallery. Working together, "we will etch and put forth all the plates in a very short time." Money as always was the hitch. Not only would the book make idle time profitable, it would in the end pay Catlin well; but bringing out such an elaborately illustrated work was an expensive proposition. Catlin approached John Murray, publisher of the prestigious *Quarterly Review,* which had given friendly notice of his gallery in the past, confident he would do the book—and was turned down. Murray wanted Catlin to realize the utmost from his labors, and self-publication, promotion, and sales were the best means to that end. All that would then be required for

success, Murray counseled, was favorable notice in the influential papers and quarterlies.[43]

"Good and generous old man!" Catlin later recalled of Murray's disinterested kindness, but at the time he must have wondered. Money was his problem, and Murray's advice did nothing to solve it. Thus the autumn of 1840 was spent trying to raise the necessary funds and hoping, Catlin hinted to one potential patron, that "some lucky star falls." It would take £600 to £800 to set things into motion; £1,000 would do the job. But the end of December found him still £500 short, casting about for a loan. Prudence would later desert Catlin in his financial affairs, but only a year after his arrival in London it still dictated his course. He did not want to begin publishing and contracting debts until he could see his way clear to covering them. To make a success of the publication he would have to sell it by subscription. His prospects received a royal boost when another friend, Charles A. Murray, master of the queen's household, who had met Catlin on the boat from Des Moines to St. Louis in 1835, obtained the names of Queen Victoria, Prince Albert, and the Queen Dowager to head the subscription list.[44] This was enough to shake loose the money Catlin needed. "He has found several kind friends who are willing to aid him by advancing a sum necessary for the commencement," Clara wrote home on February 28. The bad news was that Catlin would have to work with minimal assistance in preparing the hundreds of illustrations, which meant more delays. But he chose to approach publishing as another adventure whose success "is yet to be decided, like everything else of my life, by the experiment." Because the outlay in time and money was so heavy, the book's appearance would have to be followed by a tour of the provinces with his gallery to promote sales. Catlin labored on through the summer, troubled by the mounting expenses but still hopeful of a "handsome" profit.[45]

Review copies of the first volume of *Letters and Notes* were sent out in September, and the second volume followed a few weeks later.[46] Subscribers had signed up at £2.2 for the set, but the cost of the second volume exceeded estimates by nearly £200, and Catlin was forced to sell to nonsubscribers at £2.10—nearly $12 a set—enough to discourage prospective buyers. Two thousand copies were printed, and the total outlay for both the English and American editions reached £1,965, or $9,825. It was up to Catlin now to sell, and sell hard; time alone would tell whether his latest venture would prove profitable. There were the usual requests from the prominent for free copies and the risk of offending if they were not filled. Catlin had sent out forty presentation sets and still had twenty requests on hand in mid-January 1842, he informed an irate correspondent who had been overlooked. Dutifully, Catlin forwarded the book and chalked up another £2.10 to goodwill.[47] Whatever the annoyance, he

could take perverse pride in the thought that once again he had completed a major project without any financial assistance. With publication impending, he wrote:

> For the four months past I have been more nearly crazy than any thing else—with all the actual labour of preparing my notes & drawings for my Book, reading proof &c . . .—together with the toils of my Exhibition, and the almost unpardonable delay of my Engravers, who have put me two months back of the time specified in putting forth my Book, leaving my heavy acceptances to become due, and peremptorily calling for liquidation, which, altogether have made me a perfect slave to circumstances. . . . In getting out my notes I have had the aid of no one, publishing myself, with all the hazards on my own shoulders, & probably all the publishers against me, and my outlays have already been heavy & almost ruinous.

By spring, however, the results were in, and his latest experiment was a success. The reviews were exceptional—"many (and in fact unanimous) encomiums," he crowed—while the cost of the whole was nearly all paid off by March 1842. Substantial profits seemed likely.[48]

These were to come mainly from the American edition, and that was the one cloud on the horizon. Catlin had hoped that his book, which had been well plugged in the newspapers at home, could be marketed at $8 and had assumed that the plates or the actual letterpress would be admitted into the United States "sans duty."[49] But Congress foiled him again. On April 12, 1842, the Committee on Ways and Means reported adversely on Catlin's petition for an exemption from the heavy import duties on letterpress, which he had argued would deprive him "of all his contemplated profits" on the American edition. After minutely examining his case, the committee concluded that it was without merit; but then, infuriatingly, as the United States government was wont to do, it offered him a verbal bouquet:

> The work of the petitioner is peculiar in its character. It may be regarded, in some respects, as a national one. The author has explored new fields of interesting and curious knowledge. He may have rescued from oblivion incidents of aboriginal life, customs, manners, names, and nations, which the people of the United States are interested in preserving in their recollection, and handing down to posterity. These would be strong inducements for recommending an exemption of the work from any charge, if the committee were permitted to indulge the feelings with which, as individuals, they are impressed. But, as the mere representatives of the public interests, and, in some degree, the guardians of the public revenue, they can only express their regrets that the clear provision and policy of the

law forbid them from making a favorable report on the case of the petitioner.

Catlin had expected more from a Whig administration and a Whig Congress than "regrets." He would have to await an improvement in the economic situation in the United States sufficient to encourage healthy sales at the going price. Meanwhile, he could bask in the laudatory reviews.[50]

* * *

The British response was almost as good as Catlin claimed. He subsequently reprinted complimentary excerpts from several notices, omitting the usual criticism that his book was somewhat disorganized and his prose as unpolished as his paintings. Mostly the reviewers enjoyed his conversational style, sprinkled with Americanisms, and found in *Letters and Notes* that winning curiosity that characterized the best travelers' accounts. None failed to mention the importance of Catlin's record of the fast-vanishing Indians, and few resisted the opportunity to take a swipe at the United States government for its culpability. After listing the causes "hastening their inevitable extinction"—epidemic disease, liquor, incessant wars—the *Dublin University Magazine*'s reviewer concluded: "Unfortunately, the only power which might alleviate these evils is itself the greatest curse of all—we mean the government of the United States. To enter upon the discussion of the Indian policy of the United States, . . . in the end, would only prove the well-known fact, that the highest intellectual civilization is compatible with the morality of the most barbarous times."[51]

Americans might be impressed by the British attention accorded a countryman, but such blanket indictments of their government's policy, flowing directly from Catlin's emotional portrayal of unoffending natives debased and destroyed by cynical whites, aroused resentment. Some American critics ended up reviewing the reviews more than the book. They charged Catlin with overenthusiasm in his presentation of Indian virtue and a willful blindness in his neglect of Indian vice. The Indians were hardly innocent victims—"they are at least as ready to receive as the whites to give." Their decline was the product of a flawed racial character, and they were doomed by the same law that ordained civilization's victory over savagery wherever the two conditions met. This view achieved its fullest expression in an essay in the *Southern Literary Messenger*, "A brief Vindication of the Government and People of the United States from the Accusations Brought against Them, by the Author of '*Letters and Notes*. . . .'" Catlin, the reviewer ("an inhabitant of the middle states") complained, "prefers savage to civilized life," and this preference had "seduced" him into the "habitual indulgence of a severe and bitter prejudice against the latter." Worse, he had taken to condemning his own country in a foreign

land, garnering the ready applause of America's "maligners." After blaming the British for originating the general system of Indian affairs in North America and praising the United States for humanizing what it had inherited, the reviewer remarked that Americans "have been, and still are, perpetually assailed, by a spirit of mistaken philanthropy aggravated into fanaticism, as the stern inflexible oppressors of the red man and the black man. . . . Philanthropy has enlisted under the banner of political interests and antipathies; and the jealous rivalry of a hostile nation vented its spleen under the disguise of universal benevolence. A course of policy hitherto sanctioned by the example of all ages and nations, is now denounced as devoid of every attribute of justice and humanity." This was not to deny Catlin's sincerity, or the many pleasures his book gave. But, the reviewer concluded, "we frankly declare we have no respect for a philanthropy confined to only one color, and which embraces every country but its own. . . . 'It is a base bird that befouls its own nest.'"[52]

* * *

Henry Schoolcraft was in complete agreement. It rankled to see Catlin praised and the United States condemned in the same British quarterlies that had spent the thirty years since the War of 1812 impugning American motives. The British ministers at the peace conference in 1814 had set the tone by calling Americans a race of exterminators, and the attacks had continued unabated. Lewis Cass, son of a Revolutionary War soldier, had fought the British in 1812, and as governor of Michigan Territory in 1813 he had the task of countering British influence among the Indians in the Old Northwest by establishing an American presence throughout the Great Lakes region—at Green Bay, Prairie du Chien, Chicago, and Mackinac Island. The instructions he issued Schoolcraft in 1822 as first Indian agent at Sault Ste. Marie, 390 miles northwest of Cass's headquarters in Detroit, warned against "an undue share of foreign influence" in the area.[53] During a decade in office, Cass negotiated eighteen major Indian land cessions; to him British attacks on United States Indian policy were thus personal affronts, and he took particular exception to an article in the London *Quarterly Review* in 1824. With a disdain sure to enrage any patriot, the writer had indicted American frontiersmen ("there is not to be found on the face of the globe a race of men so utterly abandoned to vice and crime") and American treatment of the Indians ("nothing short of their extermination will complete the views of the American government"). These pronouncements, along with the opinion that little worthwhile had been written about the Indians previously because "educated Englishmen could very rarely be thrown into contact with them," could not be ignored. They appeared in a review praising the memoirs of a white man allegedly held captive by the Osage Indians for sixteen years, John Dunn Hunter.[54]

72

This gave Cass his opening. When he discussed the same book in 1826 in America's answer to the *Quarterly Review,* the *North American Review,* he dismissed Hunter as an imposter and his memoirs as a transparent fabrication whose acceptance as genuine by the British critics would be laughable were it not motivated by malice. Cass's ire, a countryman explained, had been aroused by the *Quarterly*'s "illiberal, unsupported, and *unsupportable* attacks upon the national character of the United States, and particularly upon the Western country." In another long essay in the *North American,* Cass compared the British and American records in Indian affairs. The British, he concluded, had always engaged in a policy of expedience—Indians *"were useful, and were used, in war to fight, and in peace to trade"*—while the Americans had assumed the great burden of civilizing and preserving them. That failure had met every effort was a judgment on Indian capacity, *not* American morality.[55]

Though never as outspoken on the subject as Cass, Schoolcraft also bore a grudge toward the British. His father too was a Revolutionary veteran who, during the fighting in 1813, wrote, "We are determined to assert our liberty with the muzzles of our guns, & the points of our bayonets." Thus in the 1820s Schoolcraft cheered Cass on in his paper war with the *Quarterly Review,* fumed over European arrogance in general and the condescending ignorance of foreign travelers in particular, and consistently defended American Indian policy. He had a personal reason for discrediting Hunter. He had never resolved his own anxieties about marrying a part-Indian woman. When he mentioned his wife, he always emphasized her distinguished lineage on her Irish father's side, her educational attainments, her refinement—her *whiteness.* Men like John Hunter were troubling. They had "gone Indian," a prospect Schoolcraft found abhorrent. To exorcise his demons, he excoriated them. He coupled this motive with Cass's anglophobia, calling Hunter an "imposter," his book "an utter fabrication." But in 1848 Catlin would defend Hunter. He had met him and believed him. Though he could not verify Hunter's long residence among the Osages, he had encountered Indians who knew of Hunter, and Hunter's observations on life in the wigwam rang true. Catlin concluded with fellow feeling that Hunter had been "cruelly and unjustly libelled" because he dared to criticize American Indian policy. For him defending Hunter was as important as discrediting Hunter was to Cass and Schoolcraft. Eventually Schoolcraft's assessment of Hunter's book—that it "abounded in misstatements and vituperation of this government"—would be his assessment of Catlin's as well, and the day would come when he would lump Catlin with "travellers of the John Dunn Hunter or Psalmanazer school," notorious for their "vapid descriptions and ill-digested theories." It is not the United States, but the aborigines, who have been their own worst enemies," Schoolcraft explained. "Their general idleness and dissipation are sufficient

to account for their declension, without imputing the decline to political systems."[56]

Sentimental views like Hunter's, Cass had argued, created the false impression that Indians offered something malleable to work with rather than the granite obstinancy that met all efforts at their improvement. "We are among those who think that their customs and manners, laws and observances, have not materially changed, at least since the days of Cabot and Hudson," Schoolcraft stated in 1828. "Too much stress is laid upon the transforming effects of their intercourse with Europeans." By extension, those who broadcast sentimental views of Indian character, however well-intentioned, were responsible for the unfair attacks on American policy.[57]

Catlin was a good example. His opinions were being trumpeted by the British critics as confirmation of what they already knew. The *Quarterly Review*—Cass's old adversary—ended a flattering essay on *Letters and Notes* with the smug reflection that the English government, unlike the American, had made "every possible exertion to do its duty towards the Indians" and had "invariably maintained their rights," with the result that "their respect for our flag is unsullied by a reproach." Insist though he did that he was an American patriot, Catlin had pandered to British prejudices to promote sales. Gone were the passages in his newspaper letters defending the American trade in whiskey as a response to British abuses. This one-sided presentation would remain an issue between Catlin and Schoolcraft, but in 1842 it was not serious enough to cause a rupture in their relationship.[58]

Indeed, at the request of the *North American Review*'s editor, Schoolcraft wrote a good-tempered critique of *Letters and Notes* for the April number. Catlin brought to his task "his warm feelings of admiration for the nobler traits of the red race, his accurate observation of their personal features, their costume, and wild sports, and his pictorial skill in transferring those features to the canvass." There were errors in his book—"descriptive, geographical, or theoretical"—but it had never been designed on a "systematic plan." Its strengths and weaknesses were those of the genre. Catlin had an eye for the colorful that worked especially well when his subjects were relatively unknown. "But when our author has touched on nations and tribes nearer home and better known, or taken up topics which require care and study, we have felt the wish, either that he had yielded more time to the subject, or been directed by sounder logic in some of his deductions." In sum, Schoolcraft offered a positive assessment: the reader should plunge into Catlin's narrative and enjoy his descriptions of the Indian cultures met along the way without taking his opinions too seriously.[59]

Given Schoolcraft's later public disagreements with Catlin, this was a

remarkably mild critique. Their differences had not yet driven a wedge between them. That would be the slower work of their rival quests for government patronage.

* * *

Henry Schoolcraft had never lacked for ambition. He persuaded himself that Lewis Cass's elevation to high national office would ensure his own. Mackinac was indeed the "inimitable summer's paradise" Catlin had called it, but its winter isolation was monotonous, and even its summer charms cloyed. A traveler stranded there a few extra days found that the scenery that had delighted him twenty-four hours earlier had grown wearisome, and he concluded "they have very long days in Mackinaw." Schoolcraft was stuck there year round, cut off from literary society, the just rewards of his reputation, and the chance to get ahead that any good Jacksonian coveted. He had traveled East in November 1835 on a hunting expedition— officially, to negotiate the Indian treaties that kept him in Washington through the following May, but also to make contacts with publishers and men of influence who could advance his career. President Jackson himself was privileged with Schoolcraft's analysis of the situation in Oregon where, Schoolcraft warned, British traders under the joint occupation agreement were conniving to turn the Indians against Americans; only a "special agent" sent to the region as the president's personal envoy could effectively counteract foreign influence. He, Henry Schoolcraft, was available.[60]

Lewis Cass remained his main hope for advancement. As secretary of war, Cass headed the department in which Schoolcraft labored, and his favor meant certain promotion. But Schoolcraft found the going unexpectedly rough. Cass seemed cool, distant. Schoolcraft's letters explaining his personal objectives in making the visit East went unanswered. But after his arrival in Washington on December 20 he made some headway. He gave Mrs. Cass a pair of moccasins and some maple sugar cakes for Christmas, stayed with the family, and reported at the end of January that the general was "quite friendly." He pressed his advantage. Perhaps he could be made the new governor of the territory of Wisconsin? At the least he wanted a grander title—superintendent of Indian affairs for the northern zone, for example—and more authority where he was. When his wife grew resentful in his protracted absence—"I must confess it is worse than Widowhood"—Schoolcraft reminded her of his reasons for going East in the first place: "That my *long seclusion* had placed me in a disadvantageous position, & that without this *active step on my part,* I was likely to be left *unnoticed* & *forgotten.* Success has, therefor, crowned my exertions." The success referred to was partly a heightened visibility, partly a clarification of his "future official duties": "The supervision of all the Indians within the lake region will be committed to me, under an arrangement which will permit me to pass the summer, or any part of it, at Mackinac or the Sault, if I

75

choose." This would prove a hollow victory for his family, however: that October 31, interpreting his instructions to include the privilege of relocating in Detroit over winter, he left them behind on Mackinac. The new commissioner of Indian affairs was unimpressed. Where, precisely, had Schoolcraft obtained authority to move to Detroit? From the former secretary of war, he replied—Cass having resigned—and in a long letter to the commissioner, Carey A. Harris, he denied that "personal convenience" was his main motive for moving. He did not forget Harris's insinuation, however—he was never one to forget—and in his journal he described the commissioner as inexperienced and unfit for office.[61]

For all his reputation in some scholarly circles, Schoolcraft was not a likable man. Evidence abounds of a quarrelsome, petty streak and of vindictiveness when crossed. With no formal education, he was determined to publish his way to renown. His desire for self-advancement made him heedless of others; he had to run his own show. Underlings found him officious, and immediate superiors resented his habit of going over their heads. It was this tendency, perhaps, that explains Cass's distancing himself from Schoolcraft in 1836. Bureaucratic protocol, after all, was a handy safeguard against importuners. Certainly Schoolcraft's bristly insubordination made him vulnerable when the Democratic party was defeated at the polls in 1840. The Whig victory that raised Catlin's prospects that November dimmed Schoolcraft's.[62]

Schoolcraft had been in the government service so long by then that he had almost forgotten his security rested on political fortune. An active Democrat, he deluded himself into believing that his relatively minor post would escape the postelection shuffle. He did not last a month after the Whigs took office. As a further blow to his pride, he was replaced by a fur trader resident on Mackinac, Robert Stuart. They were not friends—Schoolcraft subsequently denounced Stuart as an abolitionist—and even before Schoolcraft was officially notified of his dismissal, his son was taunted after school, "My Father has got your *Father's place!*" But the mortification was nothing compared with Schoolcraft's practical predicament. For the first time in nearly two decades, he would have to scramble for a living. His wife, upon receiving confirmation of his dismissal, dissolved into tears and found solace in prayer. What was to become of them all? A continuing scandal over Indian fund misappropriations under his administration only added to his woes, and though he complained to all who would listen, six years passed before Schoolcraft again enjoyed federal government preferment. Meanwhile he was left to seek another position that would provide a reasonable income, respectable status, and the opportunity to pursue his literary studies.[63]

Painters were not the only Americans to discover that their busy, commercial nation had little regard for learning and the arts. Writers lived off

patronage appointments, sales to the periodical press, and meager royalties; scholars sought university or college posts and sinecures within the federal civil service or learned to abide poverty. Schoolcraft would continue to press his case for reinstatement with the commissioner of Indian affairs, the secretary of war, and the president while angling for a new appointment—as the librarian of Congress (no, the incumbent was perfectly satisfactory) or "Consul at Bristol or some other English post." And while riding out the Whig "hurricane," he took the initiative, circulating the prospectus for a new periodical to be published in New York and London and titled *The Algic Magazine, and Annals of Indian Affairs*.[64] Schoolcraft spent June and early July gathering testimonials in Michigan (the acting governor, the mayor of Detroit, judges, churchmen), in learned circles (Albert Gallatin, the president of the American Philosophical Society, the editor of the *North American Review*), and in Washington (two Whig congressmen, three senators including John C. Calhoun, the General of the Army, the commissioner of Indian affairs—but not the president, who declined to sign).[65]

Given the limited time at his disposal, Schoolcraft had done well. The magazine he contemplated would have been a sober affair designed to counter the "hasty and diffuse spirit of generalization" in Indian studies. "To acquire, accumulate and preserve facts" was his first and last object, *"peu et peu"* his guiding principle. "The data brought forward," he wrote, "are to be regarded chiefly as contributions, and must be left to speak for themselves. . . . To simplify theories and disenchant the public mind, on an abused subject, has been a leading object, and in this the greatest stress is laid on the plainest facts." Schoolcraft's prospectus reaffirmed his attachment to Cass and the inductive tradition; the careless observers with their uninformed theories and misrepresentations had to be put in their place. One day he would level these charges at Catlin in particular. To commence publication, the *Algic Magazine* required fifteen hundred subscribers; when this public patronage failed to develop, Schoolcraft was left to recast his plan. What was needed was an Indian encyclopedia in book form rather than a periodical. Now his problem was to find a publisher. When the American houses proved cool Schoolcraft, like Catlin before him, decided to go overseas.[66]

Dismissal from government service had the advantage of freeing Schoolcraft from an agent's confining routine. For years he had wanted to go abroad, but his superiors had never granted him a leave of absence. "Try again later," Cass—who first recommended such a trip in 1823—advised him a decade later, and subsequent requests always met the same response. Now Schoolcraft needed no one's permission. So he booked passage for England and on May 8, 1842, left behind "the green shores of America in all the bloom & beauty of spring," arriving off the southernmost point of

Ireland fourteen days later. He strained his eyes all morning but could not penetrate the clouds enshrouding the coast. It was noon before he caught his first glimpse of land. "It was the Sabbath," he recalled, "the 22nd day of the month, and instead of feeling exhilarated by what we had all so ardently wished for, my spirits were entirely overcast, and sank lower & lower at every attempt to rally them." His depression, he concluded later, was a premonition of sad tidings at home; it could also have been seen as a portent of the disappointments ahead. But his gloom lifted with the mist on the final day of the voyage, revealing the "green & highly cultivated fields of England spread out before us, . . . like a magnificent garden." The boat glided past farmhouses and mansions all "neatly separated by hedges, and intersected by fine roads," and at last Henry Schoolcraft stood on the stone steps of Liverpool, the very spot where his great grandfather had set sail for America a century before.[67]

Schoolcraft was the first in his family to make the return voyage, as brimful of expectation on his arrival in England as his westering ancestor must have been upon reaching the shores of the New World. He carried with him letters of introduction from Albert Gallatin and Washington Irving, attesting to his prominence at home. Now, if all went as planned, not only would he see London and the principal capitals of Europe, he would be *seen* by the literary and scientific men whose works he had admired and whose acquaintance he longed to make. At the age of forty-nine, Schoolcraft was excited. Change had been forced on him, and he would try to make the most of it. "I feel deeply my situation & responsibilities," he had written to his wife on the day of his departure, "and am resolved, with the aid of providence, to employ my best exactions to sustain you & the children. . . . Farewell."[68]

Besides the letters of introduction, Schoolcraft carried with him the prospectus for a new work with a self-explanatory title: "Cyclopedia Indianensis; or, A General View of the American Indians, Comprising their manners & customs, history, antiquities, biography, religion, superstitions, mythology, oral tales & traditions, songs, hieroglyphics & picture writing, eloquence, civil polity, arts, trade, employments, games, & amusements, medical & mechanical skill, domestic economy, mode of subsistence, costume, numbers & condition, ethnographical affinities, origin, territory & present position, & geographical & proper names, with their knowledge of cosmogony, astronomy & architecture, and other traits of their character & condition, past & present, including a comprehensive lexicon of the Indian languages; the whole Alphabetically Arranged." What he had in mind was an ambitious undertaking directly anticipating the six massive volumes he would compile for the United States government in the 1850s. In 1842 he thought that two volumes of fourteen hundred pages would do the job. He expected to call on American and

European savants for contributions, though most of the text would be drawn from his own writings and he would edit the lot. The "Cyclopedia" would be issued in parts (eight numbers in all, suggesting how close it was to the *Algic Magazine*) and when completed would stand in lieu of an entire library on the American Indian. Schoolcraft's immediate task was to sign up interested buyers, then parlay the subscription list into a lucrative publishing contract. "It is, in truth, in connection with this . . . work, that I have planned my visit," he told Irving. The success of his European tour would be measured by how far it advanced his publishing plans.[69]

So Schoolcraft arrived in England, another American seeking opportunity abroad and resting his hopes on Europe's perpetual fascination with the Red Indian. He came with his reservations about Catlin in mind but had no wish to make them public. Within a week of settling in London he attended an informal gathering at the American minister's residence, where he chatted with one of the power brokers in the Jackson administration, erstwhile publisher of the *United States Telegraph,* Duff Green. Green bemoaned the "improper views entertained in England" about America's treatment of her Indians, and Schoolcraft seized the opportunity to send him the prospectus for his "Cyclopedia." When published, Schoolcraft wrote, it would become a "standard of reference" that would "most effectually put at rest . . . many erroneous impressions which are entertained both here, and on the continent." He added a telling postscript: "PS. It is surely time, that something of a more substantive character than the vapid [illegible] of our good countryman Catlin, should be brought forward—I say this sub rosa, as I should not be willing to do any thing to injure the sale of his book, or to expose its erroneous views & statements. By knowing nothing of *our Indian system* he has put our govt. in a shameful position." This, the opening volley in Schoolcraft's war on Catlin's reputation, established the position he always took thereafter. He had held office among the Indians from 1822 to 1841. What right did Catlin, a tourist between 1830 and 1836, have to pose as an Indian expert? More to the point, what right did he have to judge the actions of those who had lived in Indian Country and dealt with Indians daily over many years? What could he, with his romantic notions, seriously contribute to policy debate? Yet because of his paintings, his passionate lectures, his entertaining *Letters and Notes*—his showmanship, in short—he had won the public over.[70]

Schoolcraft felt the need to stress his superior experience and rebut Catlin and his kind. After his return to America, while still trying to place his retitled "Cyclopedia Indica; or, An Ethnological Dictionary of the Indian Nations," he thought of writing another book: "Twenty-four Years in the Indian Territories; or, Contributions, to a Knowledge of the History, Manners, Customs, Language & Institutions of the North American Indians." And when he published a compilation of extracts from his jour-

nals and correspondence in 1851, it bore the telltale title *Personal Memoirs of a Residence of Thirty Years with the Indian Tribes on the American Frontiers.* Experience and mature reflection were what he had over Catlin. That same year, 1851, Schoolcraft complained that for "too long our Indian tribes have been in the hands of casual & hasty remarkers, who struck with the interest of the subject, have done little but excite a popular taste, without, however, gratifying it." It would be Schoolcraft's task, *his* personal mission, to provide a more nourishing diet—even if, as events transpired, it consisted mainly of scraps.[71]

* * *

In 1842 Schoolcraft entertained his opinions about Catlin privately. Indeed, he sought Catlin out shortly after arriving in England and took tea with Clara at the family's cottage outside London in mid-June. George was exhibiting in Liverpool at the time, so no meeting took place. In Detroit in 1836 Catlin had called on Schoolcraft to solicit his endorsement. Now their situations were reversed. Catlin was the established figure, Schoolcraft the supplicant seeking an interview—and possibly a favor. Catlin's biographers have all maintained that Schoolcraft's primary purpose in coming to England was to persuade Catlin to illustrate his government-subsidized Indian history. Catlin, the story goes, politely but firmly refused, thereby incurring Schoolcraft's undying animosity. The single source for this incident is George Catlin's recollection a quarter-century after the fact. His fullest version appeared in a memorial to Congress he prepared in December 1868:

> H. R. Schoolcraft made a visit to London, and as he represented to me, to effect an arrangement with me for the privilege of using my paintings to illustrate a large work which he contemplated editing for the Government of the United States. General Cass, he said, had promised him an appointment, as *Indian Historiographer to the Congress:* And that if he could effect the arrangement for the use of my paintings it would help to insure his success: And he brought to me a letter from General Cass, (then a member of the Senate) intimating the same thing, and advising me to agree to the arrangement.
>
> . . . Mr. Schoolcraft stated to me that I had all the material for illustrating his great work . . . that no Indian Book need be published afterwards: And that if I agreed to his proposition, he could make it a fortune for me, etc.; and that, as a Bill was pending in the Congress for the purchase of my Collection, he could, with the influence he would then have, easily secure its passage.
>
> . . . I replied to Mr. Schoolcraft, that I had already incurred great labour and considerable expense towards a publication of my own, and that I therefore must decline his proposition.

The denouement: Schoolcraft, on his return to Washington, "used his utmost efforts with the members of both Houses" to defeat Catlin's bill.[72]

There are several problems with this account, beginning with the chronology. The sequence of events had blurred for Catlin, and as he sometimes did for the sake of a good story, he had telescoped a decade into a single year. Schoolcraft's machinations against him were real enough, but the bill he helped defeat was before Congress in *1852*. In fact, although Catlin had put out feelers in the House for the purchase of his gallery in 1838, 1839, and 1840, he had no bill before Congress in 1842 save the one, reported unfavorably, providing for the entry of his *Letters and Notes* duty free into the United States. The Schoolcraft-Catlin meeting is always dated 1846, four years after Schoolcraft's only trip abroad. In 1842 when he actually was in England he had no government-subsidized history to dangle before Catlin; indeed, he was in no position to offer Catlin anything. He was abroad precisely because the government patronage he had sought since his dismissal from office the previous year had eluded him; thus his encyclopedia scheme.

It makes sense that when the two men met they would discuss Schoolcraft's publishing plans. And it follows that Schoolcraft would propose using some of Catlin's paintings as illustrations. According to his prospectus, the "Cyclopedia" was to be embellished "with Plates of ancient ruins, hieroglyphics, portraits &c." The "portraits &c." could well refer to Catlin's collection. Schoolcraft may also have brought along a letter from Lewis Cass, though it has not been located. Catlin *did* receive a flattering letter from Cass the previous December thanking him for a copy of *Letters and Notes*. Indian Gallery and book "are equally spirited and accurate," Cass wrote. "They are true to nature. Things that *are* are not sacrificed, as they too often are by the painter, to things as in his judgment they should be." In light of later developments these comments are of interest. But nowhere in his letter did Cass suggest a Catlin-Schoolcraft collaboration. He was "struck" with Catlin's "vivid representations" of the Indians and concluded, "your collection will preserve them, as far as human art can do, and will form the most perfect monument of an extinguished race that the world has ever seen." Years later Catlin may have confused Cass's endorsement of his work with one for Schoolcraft's "Cyclopedia." Finally, in 1842 Cass was the American minister to France, three years away from a Senate seat. Obviously he could not have promised Schoolcraft appointment as "Indian Historiographer to Congress."[73]

* * *

Granted that parts of Catlin's recollections were impossible, why doubt the rest? That is, why doubt that Schoolcraft formally proposed a collaboration? Surely Catlin could not be wrong on such a basic point. But there is a strong possibility he was, having confused Schoolcraft, his later nemesis

32. *Left.* James Hall (1793–1868), jurist, man of letters, and one of Catlin's early admirers. James Hall, *The Romance of Western History; or, Sketches of History, Life and Manners in the West* (1871), engraving after a painting by J. O. Eaton.

33. *Right.* Thomas L. McKenney (1785–1859), active in Indian affairs from 1816 to 1830 and originator of the War Department's Indian Office portrait gallery, the basis for his ambitious *History of the Indian Tribes of North America*. Thomas L. McKenney, *Memoirs, Official and Personal* . . . (1846), engraving by Albert Newsam.

and ever on his mind, with another promoter who had an Indian book to hawk, Judge James Hall of Cincinnati. In 1836 Hall made a proposition almost identical to the one Catlin attributed to Schoolcraft. A leading light in western literary circles, Hall was trained in the law in Philadelphia, fought in the War of 1812, was admitted to the bar in Pittsburgh, and in 1820 moved his practice to Illinois, where he served as circuit attorney and, from 1825 to 1828, circuit judge before his election to state treasurer. Throughout his legal and political career in Illinois, Hall edited newspapers and magazines that he stocked with his own prose. Articles and books seemed to flow from his tireless pen, most concerned with life on the frontier. Committed to encouraging the arts and education in the West, Hall wrote the first significant review of Catlin's gallery, in the November 1833 issue of the *Western Monthly Magazine* (established after his move to Cincinnati earlier that year).[74]

At the time Hall viewed it, Catlin's collection was incomplete, but still "the most extraordinary and interesting" thing he had ever seen, constituting a "valuable addition to the history of our continent, as well as to the arts of our country." Hall mentioned Catlin's paintings of the Mandans and tribes six hundred miles farther up the Missouri, twenty-seven in all, and stressed three points. Catlin was the first in his line and deserved praise for originality. His work was eminently American. Best of all, he had only begun. "His enthusiasm is equal to his genius," Hall remarked, and he would not stop until he had completed a comprehensive gallery of Indian life.[75]

Catlin's plans were considerably advanced by February 1836, when Hall next approached him. The paintings from his southwestern tour and his first trip up the Mississippi augmented the collection that had hung in Cincinnati a few years earlier. But Hall's plans were also far advanced. In partnership with Thomas L. McKenney he was then preparing a monumental work on the American Indian.

This project, the most ambitious publishing scheme involving Indians yet advanced, was really McKenney's brainchild and anticipated Schoolcraft's later "official" compilation. Without Schoolcraft's pretensions to scholarship, McKenney was an equally dedicated patronage seeker with an even longer career in the Indian Service. Appointed superintendent of Indian trade in 1816, he headed the government's factory system till it was abolished in 1822 and the rather amorphous Office of Indian Affairs within the War Department from its establishment in 1824 till 1830. He was Schoolcraft's superior through the 1820s, and their relationship was professional rather than close—Schoolcraft found fault with McKenney as he did with all but one of the commissioners he served under. In the summer of 1826, Lewis Cass and McKenney attended a treaty council with the Chippewas at Fond du Lac near the western end of Lake Superior. Schoolcraft organized the council and provided most of the Chippewa vocabulary appended to McKenney's published account of his experiences, *Sketches of a Tour to the Lakes, of the Character and Customs of the Chippeway Indians, and of Incidents Connected with the Treaty of Fond du Lac* (1827). The book (useful but thoroughly dull, Margaret Fuller thought) was illustrated with drawings made in the field by a Detroit artist, James Otto Lewis, who accompanied the expedition at McKenney's request. Like Schoolcraft, McKenney would eventually pay the price of patronage politics. Though well known as a friend of John Quincy Adams and an opponent of the Jacksonians, he survived the initial purge of the Indian Service after Andrew Jackson took office in 1829 but was dismissed in August 1830. One of the members of Jackson's "Kitchen Cabinet" who helped bring him down was Duff Green—the man to whom Schoolcraft confided his reservations about Catlin at the London gathering in 1842. In 1830 Green still lived in Washington and used the columns of his paper, the *Telegraph*, to flail Jackson's enemies, among them the "Kickapoo Ambassador," Thomas McKenney.[76]

In preparation for his likely dismissal, McKenney hatched a money-making scheme: an elaborate portfolio, to be issued in twenty parts consisting of six lithographs each taken from the Indian portraits he had been commissioning since 1821. By 1829, when he began formulating his publishing plans, they covered the walls of his office in the War Department. Each number would cost $6—$120 for the set—making it an expensive proposition. McKenney concluded his initial publishing ar-

rangements one year before he was removed from office. From the outset he described the contemplated work as "truly a national one," his constant theme during its many vicissitudes over the next fifteen years. For despite McKenney's initial burst of enthusiasm, the costly work failed to get off the ground. By 1834, after a substantial outlay and myriad problems with lithographers, publishers, and funding, only a specimen number had been issued, and the future of the project was in doubt. It was resurrected late in 1835, however, when James Hall agreed to step in. He would be responsible for the text, drawing freely on McKenney's knowledge and the "vast hoard of official correspondence, and other documents" McKenney promised to provide; the Philadelphia publisher Edward C. Biddle would cover all expenses. It was this restructuring of McKenney's original concept that brought George Catlin into the picture.[77]

Hall remembered Catlin's Indian Gallery from three years before, and during a conversation in Cincinnati in 1836 made an offer: Would Catlin become a partner in Hall's joint venture with McKenney? Catlin was noncommittal; at least he did not give a definite no, since Hall tried to see him again shortly afterward in Pittsburgh, where the expanded gallery was exhibiting. Failing that, Hall wrote him from Philadelphia on February 12 "for the purpose of renewing the proposition" made in Cincinnati:

> The work which I am engaged in, in connection with Messrs. Key & Biddle of this city, is a general History of the Indian Tribes of North America, to be illustrated with portraits. The portraits are those in the Indian Department at Washington painted by [Charles Bird] King. . . .
>
> Your collection contains many portraits which it would be very desirable to unite with ours, as they are those of Indians of the more remote tribes—and it has occurred to me, that if you should feel disposed to unite with us, we could reject from our collection the portraits of the least important persons, say half of them, retaining those only of distinguished men, and add the same number from your collection, or even a larger number, if it should be thought expedient, and the work would then be the most complete & splendid of the kind that has ever been attempted. . . .
>
> Should you think proper to join us, we shall have in our hands a complete monopoly—no other work can compete with that which we could make. We shall begin to print in a few days. As soon as two numbers are complete, an agent may be sent to Europe where the sale will probably be very extensive.
>
> Your object I presume, will be to make money by the exhibition of your gallery—and it will doubtless be a fortune to you. But you could in no way enhance the value of your gallery more, than by

publishing a part of it in such a work as ours, which would naturally excite the public attention towards it.

If you feel disposed to join with us, we are willing that you shall become interested in our work, and take such part of the proceeds as shall be considered fair. In this case you would only be asked to contribute the use of such of your portraits as we might agree upon, for engraving, say from 30 to 50—and a few of your landscapes—with such rough notes respecting them as would enable me to write short biographical sketches—My part of the work is to do the writing—Mssr Key & Biddle furnish all the funds, and attend to the labor of publishing, selling &c.

In this way we can get up a work from which an immense profit may be realised. Your part of the enterprise will cost you little labor—while the success of the future exhibition of your gallery would be greatly promoted.[78]

Catlin was well aware of the background to Hall's offer, specifically the federal patronage awarded Charles Bird King in the 1820s, and had tried cutting in on King's arrangement a few months after returning from the Upper Missouri in 1832. He had portrayed Black Hawk and his principal men, and "every Delegation of Indians which have been in Washington since that appropriation was stopped & could therefore make up the collection complete to the present time, on the plan that it was started, provided the Government should want them," he told a friend that December.[79]

As his reputation spread through the 1830s, Catlin became openly scornful of King's parlor portraits. A few months after rejecting Hall's proposition, he sent the New York *Evening Star* a letter intended to put the pretenders in their place—the Lewises and the Kings and, for that matter, the McKenneys and Halls with their portfolios of Indian pictures. He was, he said, "astounded" to learn in Pittsburgh, where he was then exhibiting, "that there was a great National Gallery of Indian portraits opened to public view in Philadelphia—that it was to visit all the cities in America, and be handed down to posterity, &c.; that it was a Gallery unique and magnificent, &c. &c." The reference was to McKenney's personal collection of portraits copied by Henry Inman from the Indian Office originals. McKenney had commissioned the duplicates for use by the lithographers in Philadelphia, and in April the publisher, Biddle, had issued a pamphlet titled *Catalogue of One Hundred and Fifteen Indian Portraits, Representing Eighteen Different Tribes, Accompanied by a Few Brief Remarks on the Character &c. of Most of Them*. To promote the work then being published, potential subscribers were encouraged to visit Biddle's shop and compare the lithographic copies with the Inman oils. This was the "great National

Gallery of Indian portraits" that Catlin had heard about and that the *Evening Star,* impatient with his failure to exhibit in New York, had praised effusively when it opened there in June. McKenney's gallery might not equal Catlin's, but who was to say? Certainly it was "the most remarkable that has ever been presented to the inspection of the public." Though Catlin's rejoinder was facetious, his displeasure was real:

> I had been travelling at great expense and risque of my life, for six years past, and undergoing privations of an extraordinary kind, living and eating with almost every tribe east of the Rocky Mountains, painting my portraits by their own firesides [an obvious dig at King], and studying (for the world) their true manners and customs, and having my arrangements made for crossing the Rocky Mountains to the Pacific and Gulf of California, supposing that *I* was going to possess the *Gallery Unique,* and that *I* would write a book also; but I find the world becoming so full of books and paintings on my return, histories, traits, port-folios, portraits, &c. &c. of American Indians, that I thought best to . . . enquire of you how such splendid schemes could have been started and accomplished while I have been immersed in the wilderness and whether it is actually so or not.

Besides McKenney and Hall's ambitious project, a rival work had begun publishing in Philadelphia the previous year, and Catlin had reference to it as well.[80]

In May 1835 James O. Lewis issued the first number of his proposed *Aboriginal Port-Folio.* Likened to Catlin's "opus magnum" by the *Evening Star,* when completed in ten monthly installments it would comprise seventy lithographs, bound together under the title *The Aboriginal Port-Folio; or, A Collection of Portraits of the Most Celebrated Chiefs of the North American Indians.* Though published by Lewis himself and on the whole crudely executed, the *Port-Folio* stole some of McKenney and Hall's thunder, since forty-five oil portraits in the War Department gallery derived from Lewis watercolors. Moreover, Lewis's *Port-Folio* was to be issued in half the numbers proposed by McKenney and Hall, each at one-third the price ($2 each), making it substantially cheaper. There was one important difference that favored McKenney and Hall: Lewis's *Port-Folio* lacked text, and though in the third number he promised to rectify this by publishing an eleventh part, free to all subscribers, containing historical and biographical data, it never appeared. Despite its shortcomings the *Port-Folio* ran competition to McKenney and Hall's more elaborate project—and Lewis had published it with a touch of malice. It had annoyed him that King was to gain the fame and McKenney and Hall the fortune while his primary contribution was ignored. After all, the prints as they appeared were often likenesses at fourth hand—from Lewis through King, Inman, and the

34. *The Little Crow: A Cele-brated Sioux Chief,* painted by James Otto Lewis (1799–1858) at the Treaty of Prairie du Chien in 1825 and published in the second number of his *Aboriginal Port Folio* (1835), Lehman and Duval, lithographers. The Thomas Gilcrease Institute of American History and Art, Tulsa, Oklahoma.

engravers. Lewis's *Port-Folio* was, an early advertisement stressed, "the *first* attempt of the kind in this country." Though unpolished, his paintings were the product of direct observation and, since they were done expressly for the Indian Department, had official sanction.[81]

Whereas Catlin could disdainfully dismiss McKenney's "gallery," Lewis presented a more serious challenge. Artistry was not the issue. Catlin has been called a primitive; Lewis was something less than that. McKenney praised one of his Indian portraits as a "perfect likeness"; he also thought Lewis, who entertained around the evening campfire during their tour of the lakes, a fine singer. If he sang as well as he drew, the loons passed a restless summer. Forgetting anatomy, which bedeviled many of his untrained contemporaries, including Catlin, Lewis lacked a basic grasp of physiognomy. Eyes and giant noses wandered about his Indian faces, anticipating Picasso without the intention. Crude though it was, however, the *Port-Folio* evinced initiative of the sort Catlin admired. Most lithographs were identified by treaty—Prairie du Chien, 1825; Fond du Lac (Lake Superior), 1826; Fort Wayne, Massinnewa (Indiana), and Green Bay, 1827—establishing their documentary claims. One of the portraits had been made for Cass in Detroit, and three plates were based on the work of other artists, Lewis having exhausted suitable material as his project neared completion. But the work as a whole was the product of firsthand observation, and Lewis's explanation for its defects had to strike a sympathetic chord in Catlin, who would offer a similar defense of his

Indian Gallery a few years later: "The great and constantly recurring disadvantages to which an artist is necessarily subject, while travelling through a wilderness, far removed from the abodes of civilization, and in 'pencilling by the way,' with the rude materials he may be enabled to pick up in the course of his progress will," Lewis hoped, "secure for him the approbation, not only of the critic, but of the connoisseur." His circumstances had to be borne in mind. The constant need for haste and the "deep-felt anxiety . . . to possess a large collection" meant that he could not lavish time on any one picture.[82]

Catlin understood the problem; that Lewis had also surmounted it undercut his boast that he was the first artist to go *to* the Indians. (Catlin could not even claim to be the first to go entirely unaided and show Indians on their own turf pursuing everyday activities rather than in the special circumstances of a treaty council, since Peter Rindisbacher had done exactly that in the 1820s. Rindisbacher actually lived in the West and had established a reputation in St. Louis as a painter of Indians before Catlin even arrived in town. He was another rival Catlin could not have ignored, but his premature death in 1834 removed him from competition. Rindisbacher did leave an impression on McKenney and Hall's work, however; his *War Dance of the Sauks and Foxes* and *Hunting the Buffalo* served as frontispieces to two of the volumes.) Lewis was an ongoing concern, and when he described his *Port-Folio* as "the *first* attempt of the kind" he was scooping Catlin as well as McKenney and Hall. This was Schoolcraft's point exactly when, a few months before meeting Catlin, he jotted in his journal: "Mr. J. O. Lewis, of Philadelphia, furnishes me seven numbers of his Indian Portfolio. . . . He has painted the Indian lineaments on the spot, and is entitled to patronage . . . as a first and original effort."[83]

If Catlin resented the public patronage accorded artists like King and Lewis, he could take satisfaction in a story that circulated in the press in late September 1837. Officials in Washington had encountered resistance trying to persuade a visiting delegation of Sioux to sit for King. Even if they never posed, Catlin informed the commissioner of Indian affairs, Carey A. Harris, "they will not be unchronicled to the world." He had already painted the most prominent and would be in town with his gallery at the beginning of the next session of Congress. Should the Indian Office still require the Sioux likenesses, he would be happy to oblige.[84]

The following January Catlin finally received the long-sought government commission, to paint not Sioux, but Osceola and other Seminoles held captive at Fort Moultrie, South Carolina. He obtained permission to visit the prisoners from the secretary of war on January 10 and left New York for Charleston by steamer three days later. He was back in New York on the thirty-first with a full report for Commissioner Harris. He had taken portraits of the five chiefs designated by Harris and would have delivered

35. George Catlin, *Osceola, the Black Drink, a warrior of great distinction* (1838), one of the Seminole portraits done for the government but never submitted. National Museum of American Art, Smithsonian Institution; gift of Mrs. Joseph Harrison, Jr.

them himself had the captain of the steamer been willing to drop him off at Norfolk. "As soon as the copies can be made for the Indian Department" he would bring them to Harris's office. Osceola and the other prisoners had not been cooperative at first, Catlin observed, thinking it "very strange" that the Great Father would want their portraits. But having "construed it into a compliment, or rather an indication that . . . [they] were to be called on to Washington soon (an event which they are anxiously looking for)," they had consented to sit.[85]

Harris received Catlin's report on February 3, acknowledged it on the thirteenth, then waited patiently for him to deliver on his promise. However, Catlin had since had second thoughts about turning such a valuable property over to the government. Osceola had died on January 30, only hours after posing. In death, he was widely regarded as an Indian martyr. Well managed, his portrait might be worth its weight in gold. With such considerations in mind Catlin, having finally secured a commission from the federal government, proceeded to ignore it, as well as a rebuke from Harris's successor, T. Hartley Crawford, who wrote in mid-November: "In your letter to this office of January 31st, you remarked, that as soon as copies of the portraits of the five Seminole Chiefs which you were authorized to take for it, could be made, you would deliver them here. [A]s I presume you have since had ample time to complete them, I have to request their early transmission and that at the same time, you will forward your account." Catlin did neither. Maintaining a monopoly on Osceola's portrait made better business sense than allowing it to become public property for a pittance. (Lewis had received $609 from the government for his Indian portraits; they were subsequently repainted, added to the War Department gallery, and reproduced in McKenney and Hall's work without additional compensation. Feeling cheated, Lewis would petition Congress for extra payment in 1841 and be turned down.)[86]

It was for related reasons that Catlin declined James Hall's proposition in 1836, determined to go his independent way. Hall bore no grudge. In his biographical sketch of a Fox chief he noted that the Sacs and Foxes who visited Catlin's "extensive gallery" in New York in 1837 praised "the fidelity and likenesses of their acquaintances." McKenney and Hall's project, grandly titled *History of the Indian Tribes of North America; with Biographical Sketches and Anecdotes of the Principal Chiefs,* simply moved forward without Catlin. An advertising pamphlet dated March 1, 1837, indicated that the first part was out and nineteen more would follow in alternate months. Were this schedule adhered to, the final number would appear in April 1840. Testimonials from distinguished Americans, procured by the persistent McKenney, and a smattering of press notices proclaimed the work's merit. The portraits, wrote Peter Du Ponceau, president of the American Philosophical Society, offered the only "consola-

tion" one could find in contemplating the whole sad history of the tribes. "By means of this great work, the effigies of those former lords of the American soil, will at least, after their destruction, serve the purposes of philosophy and science, as the bodies of murdered men, in the hands of the surgeon, serve those of humanity."[87]

The advertising for McKenney and Hall's *History* continued to hammer on the message that it was a "GREAT NATIONAL WORK." Because of McKenney's former position, it assumed a quasi-official status. The subscription list in 1837 included Andrew Jackson, Martin Van Buren, and Daniel Webster, as well as the king of England, the marquis de Lafayette, and Audubon (whose work alone, according to one reviewer, surpassed McKenney and Hall's as an American achievement of enduring beauty). Indeed, the *History* owed much to several forms of government patronage. The original collection of portraits used as illustrations had been assembled at War Department expense, along with the library of reference volumes that McKenney hoped to mine for biographical and historical information. While in office, he had pulled strings to preserve a monopoly on the portraits, and out of office he continued to act as though they were his own. He still enjoyed franking privileges courtesy of his congressional friends, a substantial savings on postage. Lacking reliable information for some of the biographical sketches, he cast about for assistance—urging Cass, for example, to get Schoolcraft to scare up some facts out West, as though they were still his subordinates. The financial viability of the *History* from the outset rested on the War Department's agreeing to purchase fifty sets—a $6,000 commitment that would cover the actual cost of publication and that was honored in October 1837 when Congress advanced half of the total, though only one-quarter of the work was out. In addition, McKenney persuaded the commissioner of Indian affairs to order twenty-eight new portraits of visiting delegates, including Black Hawk and Keokuk, whose likenesses he wanted for his portfolio. This was the commission that brought the letter from Catlin volunteering his services should the Indians refuse to sit for King. Had Catlin turned his Seminole portraits over to the War Department in 1838, doubtless they would have graced McKenney and Hall's *History;* instead, he issued his own lithograph of his full-length Osceola portrait.[88]

The various courtesies extended McKenney amounted to a subsidy of his publication. No wonder that, upon returning the most recent King portraits to the War Department in July 1838, McKenney's publisher felt obliged to thank the Indian commissioner "for the loan of *them* & for the assistance rendered me in the prosecution of the Book itself." In 1842, as the work dragged on well behind schedule and parts showed up irregularly at the War Department office accompanied by urgent appeals for prompt payment of the $300 owing for the fifty copies, the secretary of war

entertained second thoughts. One copy was all the department needed or, for that matter, had ever agreed to buy. The secretary's demurrer caused a minor panic. The publishers—the fifth connected with the project since its inception, Biddle having dropped out in 1842—admitted that the original subscription list, which at its plumpest carried 1,250 names, had been so reduced by hard times attendant on the panic of 1837 that the work could continue only with the War Department's full support. The secretary backed off, the unofficial government subsidy continued, and the project at last reached completion in January 1844—almost fifteen years after McKenney conceived it and seven after the first part was issued. The "great national work," undertaken with such optimism, had proved, like Catlin's Indian Gallery, a costly venture. Even government patronage, which Catlin could not boast save for the Seminole portraits, had been inadequate to ensure its success.[89]

But McKenney, again like Catlin, was enticed by fairer prospects overseas. He had been convinced all along that European subscriptions would earn the *History* a substantial profit, and his head swirled with golden fantasies about the duplicate portraits in his possession. The Inman copies, McKenney wrote in June 1839, would easily fetch $100,000 if exhibited abroad for a few years, and another $100,000 if sold abroad—calculations similar to those that lured Catlin to England that December and Schoolcraft three years later. In the very period when Horace Greeley was advising his countrymen to go West to find their fortunes, such westward-gazers as McKenney, Catlin, and Schoolcraft were turning their eyes eastward to the same end.[90]

* * *

When Schoolcraft circulated his plans for a "Cyclopedia Indianensis" in England in 1842, then, he was blazing no new trail, though he found the going far tougher than he had anticipated. Too many others had been there before him trying to sell the American Indian. The pertinent question is, Did Catlin, twenty-six years later, confuse the McKenney-Hall and Schoolcraft projects?

Certainly Hall's proposition *sounds* like the one Catlin attributed to Schoolcraft. Even his remembered response—that he must decline Schoolcraft's offer, having already "incurred great labour and considerable expense" toward a publication of his own—makes more sense if the proposition preceded the appearance of his *Letters and Notes,* which Hall's did and Schoolcraft's did not. The evidence is inconclusive, since Catlin's publishing plans did not end with *Letters and Notes.* In 1844 he issued *Catlin's North American Indian Portfolio: Hunting Scenes and Amusements of the Rocky Mountains and Prairies of America.* Published privately out of the Egyptian Hall, Piccadilly, it was intended as the first in a series of volumes. Later ones—an echo of James Hall—would concentrate on portraits ac-

companied by biographical sketches. The note accompanying the first plate in the *Portfolio,* "Group of North American Indians, from Life," established Catlin's unvarying theme, the "lamentable fact" that in the West the Indians and the wild game were both "rapidly travelling to extinction before the destructive waves of civilization." Civilized man, Catlin charged, had spread his "poisons and diseases" with the usual results, dissipation and death for millions of natives. It was exactly this kind of rhetoric that so infuriated Schoolcraft, as though civilization could be held accountable for the fate Providence visited upon savagery around the world.[91]

One fact remains: *if* Schoolcraft did indeed propose a collaboration that Catlin rejected in 1842, there is no contemporary evidence for it. Nor is there evidence for an immediate rupture between the two; in fact, there is evidence to the contrary. Schoolcraft's irritation with Catlin's work must have festered after his return to America. Besides their basic disagreement over the morality of Indian policy, envy was likely a factor. Catlin was still something of a "lion" in England in 1842. His gallery and his lectures were apparently well patronized. *Letters and Notes* had brought him critical acclaim, and he appeared to be prospering. Schoolcraft, in contrast, passed disconsolate days in London, especially as his stay neared its end. His "Cyclopedia" had been spurned by the publishers. He had hit England, he wrote, "in the lowest state of commercial distress," with the book trade "at a low ebb." The only title arousing interest was Charles Dickens's forthcoming work on his American tour—more English lies, no doubt, but Schoolcraft still coveted an interview, which Dickens denied without an answer. (Dickens had no empathy for Indians anyway; he was one Englishman who visited Catlin's exhibition without succumbing to the lure of the noble savage.)[92]

So it went. Schoolcraft's American reputation had not traveled well across the Atlantic; though he visited Thomas Carlyle, the great were mostly unavailable to him. Plagued with a touch of rheumatism, he was chilled by the early autumn weather and out of sorts. An entry in his pocket diary a week before he sailed for home reflected his mood: "Ill—was chilly, after the bathing, & took cold, at least feel ill, loss of apetite—morbid feeling. . . . Ordered fire in the evening, took Doven powder & tea went to bed sick & low spirited—. . . Weather gloomy." Worst of all, Schoolcraft would be returning to an empty house. For within two weeks of his arrival in England, the meaning of the clouds that had shrouded the southern coast of Ireland and so unaccountably depressed him became clear. Word reached him that his wife, Jane Johnston Schoolcraft, long frail and sickly, had died on May 22.[93]

Among the letters of condolence Schoolcraft received was one from Clara Catlin. Dated June 22, it indicated only that Schoolcraft had tried to make contact with her husband. They may have met earlier, but with

Catlin touring the provinces with his gallery they had little opportunity to meet again. Two days before he left England, on October 5, Schoolcraft dropped Catlin a farewell note at Liverpool. Was there any service he could render his countryman back in America? Catlin replied to Schoolcraft's "kind & very friendly letter" on October 9.

> It has been [a] subject of deep regret to me that I could not have seen more of you whilst in this country, and have been constantly disposed to write you (& hearing you had gone to the Continent) I have been obliged to defer it.
>
> My wife long since communicated to me the most afflictive intelligence of your bereavement, in which you had our deepest sympathy. . . .
>
> I will still hope to see you and spend some time with you before you leave for U. States. . . .
>
> I am sorry to learn that no encouragement has been offered you by Murray or others in London, and I fear now that *piracy,* by which the Book Trades are mostly living in these days, will await your work in this Country & America—I shall wish you all the success that your very curious and valuable researches deserve, but in the present prostrated (& prostituted) condition of the Literary world, I shall constantly fear the pecuniary result; and whatever may be your disappointment in that respect, and whatever the poor Indians from his commerce with the mercenary [world?], I shall hope and trust that the pen of one so familiarly acquainted with his character & his just claims, will not cease to speak for him & his rights, who has no means of speaking for himself.
>
> My Exhibition in Liverpool closed two months since, after a very successful six weeks. . . . I shall give two Lectures with Costumes in Balton, 10 miles from this, and after that go to Sheffield where they have just completed the building of a very fine Room (120 feet in length) for my whole Collection to be arranged on the walls, & I confidently hope you will delay your voyage awhile & come and spend a few days or weeks, with us. We shall occupy a very fine & spacious cottage within 50 yards of my Rooms, with spare room in abundance for you, and there you shall be at rest and most welcome, and *there,* perhaps we may originate some *plan* for the ultimate protection of the dying & strangled races of the Red Men.

Catlin's reference to a plan to help preserve the Indian stakes out the safe high ground of philanthropic concern where he and Schoolcraft could meet as allies. In his denials years later that his criticisms of hasty travelers meant Catlin in particular, Schoolcraft too would fall back on platitudes about the need for all those committed to the Indian cause to pull together.

Nevertheless, Catlin's letter establishes an absence of malice in 1842, though between its lines one can read relief that Schoolcraft would soon be on his way, leaving the Indian field uncluttered. Catlin did not reply till two days *after* Schoolcraft was to sail, and his tone was patronizing, suggesting that encouragement was being offered in lieu of practical assistance, something he had often enough experienced himself. But if Schoolcraft had entertained hopes for a collaboration, there is no evidence of that here and no basis for the assumption that the two men parted company in England with Schoolcraft stung by Catlin's rejection and plotting revenge.[94]

* * *

As Schoolcraft sailed home, empty-handed and discouraged, a London publisher was negotiating with Catlin for the rights to sell the five hundred copies of the third edition of *Letters and Notes* intended for the English market. Catlin was still worrying about the book's cost. His experiences lecturing and exhibiting in the provinces and the "constant objections" raised to the £2.10 price had convinced him it should be nearly halved, to £1.10 per set, to give the work "a fairer chance." Three editions—4,000 copies—and a still-enthusiastic reception in England, while Schoolcraft's "Cyclopedia" prospectus was packed away with his other papers for a return voyage made all the drearier by the uncertain future awaiting him. His hopes for the "Cyclopedia" were of a kind with the futility that had characterized his entire venture abroad. The contrast between the two men's fortunes in 1842 could not have been more sharply drawn.[95]

Back in the States, Schoolcraft was left to pick up the pieces of his domestic life and press on in search of a position that would suit his talents and support his children. Musing over his English experiences, he also began to refine his plan of attack. He needed to vindicate himself and his country by compiling an encyclopedic work on the Indians. It would expose their inherent limitations, justify the government in its course toward them, rout the critics, and establish Schoolcraft as America's supreme Indian authority. Best of all, it would be paid for out of the public purse.

36. Catlin as a London show-
man. Under Catlin's benign
gaze, an Iowa addresses a rapt
audience in the Egyptian Hall,
its walls festooned with Indian
portraits. George Catlin,
*Catlin's Notes of Eight Years'
Travels and Residence in Eu-
rope* . . . (1848).

CHAPTER THREE

So much I am doing for
the history of our
Country, and I do think
the government, from
which I never yet had a
shilling, should call my
Collection home and pay
me for my labours.

George Catlin to Daniel
Webster, April 4, 1852

My *Grateful* Country

Catlin Abroad, 1842–1852

Writing from Paris early in 1853, George Catlin brooded on the events of the past fifteen years. They had been, for him, years of personal triumph and of absolute despair. He had met the queen of England and the king of France; and he had lost his wife and children, his Indian Gallery, and his reputation. He had won international fame as the painter-historian of the native American, and he had been driven from the United States by indifference, from France by revolution, and from England by the threat of debtor's prison. Through it all he had struggled to make a living from his Indian paintings, while dreaming of the fortune awaiting him could he but persuade the United States government to buy his works entire. In the end he had come up literally empty-

97

handed—bereft not only of money, but of everything he treasured. "Since I saw you, I have had troubles and anxieties enough to make me almost forget my nearest and best friends," he wrote to an English patron; ". . . I know you will have pitied me, after a life spent as mine has been in the endeavour to do something for the history of my *grateful* Country." The story of these fifteen years constitutes one of the great sagas of enterprise and thwarted ambition in the annals of nineteenth-century American art.[1]

* * *

Only a month before Schoolcraft sailed for England in 1842, the Committee on Ways and Means had ruled against Catlin's plea for an exemption from the import duties on the letterpress of his *Letters and Notes*. Despite this latest setback, however, Catlin appeared to be prospering. After years of delay, *Letters and Notes* was out, and it was still creating a stir in the British quarterlies. Schoolcraft harbored doubts about it, but he had contributed to its generally warm reception, making the proprietor of the Indian Gallery a literary lion as well as an artist and lecturer with an exotic subject and a noble cause.

Catlin *had* been lionized by some. That January he had gone to Windsor Castle to exhibit his large model of Niagara Falls for the queen and Prince Albert, and while he would have preferred a coveted royal visit to his Indian Gallery (since a "rich harvest" would inevitably have followed), he could bask in the knowledge that he was "still honoured" in England. But show business was even more draining abroad than at home. London audiences were spoiled with a profusion of amusements and fickle in their patronage. Catlin's rooms at the Egyptian Hall alone cost £550 annually. When his lease expired in May 1842 he did not renew, instead removing his gallery to Liverpool and, by year's end, launching a lecture tour of the provinces.[2]

It was one of Catlin's strategies to put the best public face on any situation. Thus what Schoolcraft *saw* in 1842 was more apparent than real. The decision to go abroad had been correct, Catlin would insist. But as early as August 31, 1840, he had confided the truth to his father:

> Many people think, no doubt, that I am making a great deal of money, but they are much mistaken. Perhaps it is as well that the world should think so, as otherwise, if they will: but for me and my friends, suffice it that we know better. My expenses have necessarily been enormous, and my receipts, at a shilling per head (which is the price of all Exns. in London) are not calculated to make a man rich short of a very long and a very fair trial. London is to be sure, a wonderful place, almost a world of itself, and one would suppose the place of all in the world to fill an Exn. but the City is filled with Exns. & places of amusement in proportion to the numbers of its inhabit-

ants, and all such strive & struggle for their proportion of visitors, who seem divided and drawn so many ways as to be unable to give to each more than an ordinary share of support. . . . There seems to be . . . some considerable talk yet about the purchase of the collection, but I have not much faith in it—I never *sold* anything in my life time, that I recollect, and it will be more than I expect of good luck, if I turn anything to good cash account until it is too late to enjoy its products.

Catlin's balance sheet after one year told the story. As of January 31, 1841, 32,500 visitors had paid to see the Indian Gallery, bringing in $9,433. His nephew scrawled on the back of a letter, "Spent *all*."[3]

As the attendance figures attest, while Catlin had not advanced his fortunes a whit, he had enjoyed a fairly good first year. Visits from such notables as the duke of Wellington and a slew of dinner invitations kept spirits up even when receipts were down. As he had done on the frontiers in the 1830s, Catlin would again prove himself an indiscreet if not ungrateful guest, publishing an account in 1848 of a typical English dinner party. After a long day with his collection, lecturing till his chest hurt and answering the same mind-numbing questions over and over, he would be whisked away for an evening's relaxation by some well-intentioned rescuer—only to be bombarded before, during, and after dinner with demands for a good Indian story and more of the same questions. Catlin was jaded enough to provide a list of the most-asked questions, along with his answers. Like the description of a typical dinner out, or his anecdote about the fashionable English lady who claimed to have closely followed his wanderings in India, the list was meant to be amusing. But it was also a rebuke to his hosts and patrons—the English public who paid his bills—and it suggested the weariness of a man who had aspired to be a great American artist and had ended up a harried showman.[4]

That was George Catlin's dilemma. He was trapped by financial necessity in an uncongenial role that paid the bills but nothing more. What would happen when his popularity waned? For in London he had been forced to recognize a hard show-business truth: you can be the latest sensation only for a while. The competition for the public's attention—and purse—was fierce. As England's major population center, London drew every conceivable exhibition into its boundaries, and Catlin was right there with the carnival hawkers, freak shows, scientific charlatans, magicians, ethnological curiosities from Africa and the South Sea Islands, strange animal acts, fire-eaters, panorama painters, and the rest—all clamoring for the same shillings he sought. Like them, he stood or fell on his novelty.

His American experience had prepared him in some respects. In New

99

37. *Left.* Catlin in the 1840s, a celebrity but not yet a financial success. *Catlin's Notes of Eight Years' Travels and Residence in Europe . . .* (1848).

38. *Right.* George Catlin, *Theodore Burr Catlin in Indian Costume* (1840–41), part of the entertainment offered at the Indian Gallery. National Museum of American Art, Smithsonian Institution; gift of Mrs. Joseph Harrison, Jr.

York City's Stuyvesant Institute in the fall of 1837, he had displayed his Indian paintings and delivered lectures in October, erected a beautifully decorated Crow tipi in the middle of the exhibition area in November, and introduced his "perfect model, colored," of Niagara Falls in December. In January 1838 he traveled to South Carolina to take the likeness of the most recent Indian to capture the public's fancy, the Seminole Osceola, and add it to his gallery. "In every era," Richard Altick has written, London's showmen "staked their livelihood on a shrewd perception, if not anticipation, of what the public wanted at a given moment." Catlin arrived well schooled to compete. His daytime lectures were eventually supplemented three evenings a week with "tableaux vivants," tribal dances and ceremonies staged by English men and boys in makeup and Indian costume. His nephew Theodore Burr Catlin, a strapping six-footer with an eye for the girls and a fondness for fun, joined them as a Pawnee chief. He liked to appear at fashionable parties in full costume, a red crest with feathers topping his shaved head, a stripe of paint across his face, ornaments dangling from his ears and nose, a bear-claw necklace and blanket completing the masquerade. He would sweep into the room, scornfully eye the assembled guests, and, with a translator at his side, "talk gibberish with great effect":

> "Oh, goodness, gracious! bless my soul!
> Do only look, my dear;
> Here is a live one—let him pass—
> I wouldn't go too near;

The savage Ingin! what a size—
 His skull all shaved and red;
And that 'ere tuft of feathers as
 Is growin' in his head!"

Well, first the savage Ingin goes
 A stridin' round about;
And turns his toes way *in* as In-
 Gins do, instead of *out;*
And now and then he gives a start,
 And now and then a yell;
And no one ever saw an In-
 Gin do it half as well.

Burr partook liberally of refreshments, however, and London, which had seen its share of Hottentots, Laplanders, Eskimos, and real Indians would not be indefinitely impressed by the ersatz.[5]

In 1843 Catlin began offering his audiences the real thing. He hooked up with Arthur Rankin, an American showman who had accompanied nine Ojibwas to England, and in December he escorted the troupe to Windsor Castle where they performed authentic dances "to the apparent surprise as well as amazement" of the queen. These real Indians held the public's attention through the following spring; the press reported their outings, and Catlin was always on hand, ostensibly to interpret their remarks, in fact to promote his gallery. When the Ojibwas' novelty wore off and receipts again fell, Catlin broke with Rankin; the bitterness had barely subsided before he was involved with another party of Indians, this one more to his liking, since it consisted of fourteen Iowas "from their hunting grounds, 500 miles west of the Mississippi," the land of unspoiled noble savages described in *Letters and Notes.* They brought with them striking costumes, a whole arsenal of weapons, and a determination to encamp "in some open space" where they could lead their lives as they would at home—or as close as one could come in the wilds of London. Their dances impressed the *Illustrated London News,* which pronounced them "by far the most pleasing and just representation of the North American Indians ever seen in England," superior not only to Catlin's English "Indians" but to the Ojibwas as well.[6]

Beginning on August 24, the curious could visit the Iowa camp at Lord's cricket ground, St. John's Wood Road, and watch them shoot arrows, pray to their spirits, erect tipis, play ball, dance, sing, and orate— all "under the Superintendence of Mr. George Catlin." Though the Indians proved disappointing archers and their dances and ceremonies were performed on a stage, the outdoor setting was inspired show business, anticipating by forty years a key element in the magic of Buffalo Bill's Wild

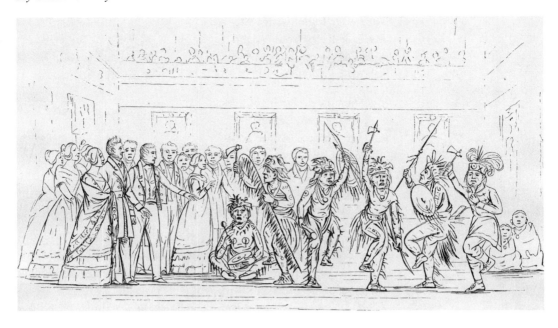

39. Catlin explains the Ojibwa war dance to Queen Victoria and Prince Albert at Windsor Castle, 1843. *Catlin's Notes of Eight Years' Travels and Residence in Europe* . . . (1848).

West that captivated England in 1887—the golden jubilee year—and brought Queen Victoria out of her long seclusion at Windsor Castle for a command performance at Earl's Court arena. As the queen greeted a few of the Sioux afterward she might have cast her mind back on an evening long ago when, in the company of her beloved consort, Prince Albert, she had watched the Ojibwas perform the medicine, pipe, and war dances while the drumbeat reverberated off Windsor's walls.[7]

The link with Buffalo Bill is made the more compelling by the fact that the mastermind behind the Iowas' visit in 1844 was the greatest American showman of them all, Phineas T. Barnum. Barnum had arrived in England that March intent on conquering Europe with his diminutive treasure, the show-business sensation of the day, General Tom Thumb. They were soon ensconced in one of the smaller exhibition rooms in the Egyptian Hall. When Francis Parkman, at the tail end of a European tour, approached the hall to see Catlin's Indian Gallery in May 1844, it appeared a hive of activity—cabbies and servants in livery waiting at the door, men passing out handbills, boys crowding around to peer in—and he rejoiced in the apparent success of his fellow American. But Parkman's elation was short-lived. Catlin's day was over, his novelty gone; he had sublet the hall's "great room" to the object of the crowd's curiosity, Tom Thumb. Parkman glumly watched "the little wretch" entertain the audience with his dancing, singing, and impressions. The Catlin Indian portraits still covered the walls, shadowed, dusty, and darkened by the London damp and smog since Parkman first saw them in Boston in 1838, vibrant as the green wilderness of America.[8]

But if Parkman found London a depressing study in drizzle and gray, for Barnum and Tom Thumb it brought a "golden shower." Catlin's gallery may have "ceased to be a lion" by 1844, but the two-foot midget "with a voice like a smothered mouse" was soon squeaking out his rendition of "Yankee Doodle" for the queen and her court at Buckingham Palace. Little wonder Catlin, on his return from the provinces, struck a deal with Barnum. The Ojibwas had become a nuisance, especially since his rupture with Rankin, who had promptly rented another room of the Egyptian Hall to run Catlin competition. Barnum had had previous experience exhibiting "Rocky Mountain wild I[ndians]" in New York City in 1843, and it was his idea to arrange for the Iowas, probably the selfsame Indians, to sail over from America in July. They were not exactly fresh from the prairies, then, having played to thousands while encamped at Hoboken. The most recent river they had lived west of was the Hudson, and it is likely that the decline in their archery skills observed in London had commenced in the shadows of Manhattan. On August 1, Barnum wrote to an associate back home: "The Indians will be here tomorrow, and Catlin and self will make money on them I *think* to a large amount—but alas for the fallability of all human expectations. We may *lose* a heap instead of make, but my *hopes* are *high* on the subject." His hopes were still high a few weeks later. The Indians, he said, were "under full blast," and he was contemplating buying out the Adelaide Gallery in London and running it in company with Catlin's nephew, "a regular roarer" in costume or out.

40. The party of Iowas, including Little Wolf (5) and his ill-fated wife (11). *Catlin's Notes of Eight Years' Travels and Residence in Europe . . .* (1848).

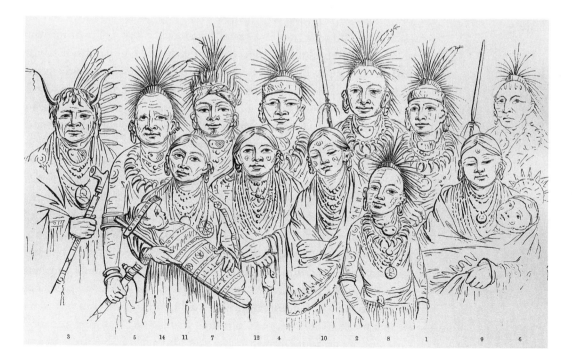

3 5 14 11 7 12 4 10 2 8 1 9 6

41. Phineas T. Barnum (1810–91)—low, contemptible, and unprincipled, according to Catlin—with his diminutive treasure General Tom Thumb. A. H. Saxon, ed., *Selected Letters of P. T. Barnum* (1983).

But the relationship between Catlin and Barnum soured, and before the year ended they were estranged.[9]

In his memoirs Barnum wrote that the Iowas "were exhibited by Mr. Catlin on our joint account, and were finally left in his sole charge"; Catlin never mentioned Barnum's name in his book about his experiences with the Indians in England and on the Continent, a silence Altick has attributed to "his reluctance to be publicly associated with a showman" who shared few of his ideals. In fact, money was the solvent that dissolved the partnership, anger the wax that sealed Catlin's silence. Touring the provinces with the Iowas in January 1845, Catlin wrote to his wife from Newcastle: "Tommy Thumb you will have seen ere this, and no doubt he has made a grand *swoop* in Brighton. You must tell me all about it and Barnum, who I suppose was in the house with you. . . . I think him a low and contemptible fellow, fit for any mean and underhanded act to take advantage, so I shall try to keep entirely free from him." Perhaps he would take the Indians to Paris, perhaps New York. He was undecided, but not about Barnum. George H. C. Melody, as Barnum's agent, had chaperoned the Indians on the way from America and had remained with them on their travels with Catlin. Both had kept up the pretense that the tour was somehow an educational experience rather than just a money-making proposition. But Barnum, relentless where money was concerned, had been hounding Melody for payment of a debt, forcing him to the brink of a mental breakdown. Furious, Catlin told him he was "not only the most consummate blackguard" he had ever met, "but an unprincipled puppy in

the bargain. So we stand."[10] By April 1845 Catlin, Melody, and the Iowas were in France, and Catlin had occasion to reflect on the high cost of showmanship as he escorted his citified and all-too-worldly charges about Paris. In London the Iowas, who enjoyed a nightly glass of *chickabobboo,* or wine, had developed a remarkable aptitude for spotting—and enumerating—all the gin shops along the city's streets. In Paris their tastes ran to daily bottles of "medicine"—each neatly itemized in Catlin's expense accounts—"Wine etc.," and cab rides. One entry reads: "Cab for little Wolf to the Woods of Boulogne."[11]

In the end, Barnum's expectations of making a profit off the Indians were foiled. He, of course, had other irons in the fire ("what with them [the Iowas] and Tom Thumb, my automaton writer exhibiting at the Adelaid Gallery, the Bell Ringers, American Museum and Peale's, giants, dwarf, etc., I guess I have about enough on hand to keep *one* busy"); it was Catlin who again found the path to fortune blocked. In May 1844 he had written to his brother Francis that England "is one of the hardest countries on earth to *make* money in, and one of the most easy and necessary to *spend* it in." Nothing had happened since to change his mind, and his next stay in England would prove even more financially disastrous. Meanwhile there was France.[12]

* * *

Catlin had been thinking of Paris since the fall of 1843, when he had made a rapid reconnaissance to determine the prospects for a profitable exhibition there. The poor taxes were a particular worry—one-tenth of receipts, he understood. But Clara Catlin, pregnant again, liked the idea of passing the winter in France, and if rooms could be booked for December 1, Catlin intended to cross the Channel. The departure date got pushed back, but on December 3 he wrote to a member of the American legation in Paris for aid in obtaining the necessary permissions for his exhibition and to a friend for help in pressuring the official to act promptly. He also had good news: his family of three girls had been augmented by "a stout Boy," and both mother and child were "doing well." This was cause for hope: a new year in the offing, a new beginning. Paris seemed not only possible, but certain.[13]

By January 1844 Catlin was writing the prefect of Paris for authorization to open his exhibition on the Champs Elysées on May 1. The French taxes still worried him, however, and his plans were temporarily derailed. They were back on track by October, Catlin having replaced a liability with an asset, as he saw it, in cutting free from the Ojibwas and taking over the Iowas, a "noble, wild and beautifully costumed set of fellows" and all "anxious to go to Paris." "How far do you think their personal appearance—their Dances, games, &c will amuse and attract Parisians, in connection with my collection," he asked a French contact, "and how would they do for an Exhibition without the collection?"[14] If the paintings would not

sell, Catlin was willing to go with the Indians alone. His concerns were practical—theatrical exhibition fees, availability of suitable rooms, likely profits—not artistic. The mission that had fired his imagination fifteen years earlier had cooled in the struggle to make a living. Both of his books had been financial disappointments. Costs "cut off all profits" on *Letters and Notes,* while sales of the *North American Indian Portfolio* did not justify a projected second volume, and in early March 1845 Catlin offered a bookseller up to twenty bound copies at a substantial reduction, preferring cash in hand to the larger sum consignment sales might eventually bring. He needed to raise funds quickly for France. When he finally crossed over to LeHavre in April 1845, he brought Indians *and* paintings with him, as well as a new lease on hope.[15]

Catlin confessed himself Dame Fortune's ardent suitor. Often indifferent and fickle in the past, in France she proved a cruel mistress. Never would Catlin enjoy such prestige, such heady praise. And never would he experience such desolation, such loss. Three months after arriving in Paris, on July 28, 1845, Clara Catlin died. Hers had been a life of sacrifice to her husband's "Enthusiasm," as a friend put it. She had suffered his protracted absences in the 1830s, uncertain he would return from his latest excursion into Indian Country, forced to live a marginal existence relying on relatives, her own needs constantly shoved back by his. She had reluctantly left America and her aging parents in 1840, depressed at the thought that she would never see them again but buoyed by her husband's contagious enthusiasm and the promise that one day they would return wealthy and famous. Living abroad was itself an education. Clara Catlin appreciated the spectacle that was England but fretted over the evident "extremes of wealth and beggary." And she never overcame her sense of isolation as she raised four children and trailed after her still peripatetic husband, by letter normally, in person occasionally. She was George Catlin's anchor, his sustenance. He poured out to her all the troubles he concealed from the world—and his exhilaration when things were going right or he had hatched yet another surefire scheme to make them rich. His yearning to succeed—succeed spectacularly—was evident in every line he wrote her. Not for his own sake, he always insisted, but for the family's, "I am day & night working hard—hard—*hard*." He fussed over the children, inquired about them in words choked with emotion, drove himself half crazy with fears for their health. A letter from Clara sealed with what in the dark of a nighttime coach ride appeared to be black wax threw him into despair until the morning's light revealed a red seal instead and the tidings that all was well at home. Catlin was in a race against himself, torn between the need to grasp the brass ring and the desire to settle down and play the doting papa in fact as well as form. Through it all Clara offered him comfort and

counsel, much of it scriptural, tended the children, reassured him of their love and hers, and gave him free swing to be himself.[16]

April 1842 was a month of sadness for the Catlins. On the second, Clara learned of her father's death, only days before George received word that his own father had died. It was a double blow, harder for her to bear because her sphere was more constricted, peopled mostly by loved ones too far away to see. "I feel my separation from home and my dear friends so painfully," she wrote, "that I am often reminded of the eternal separation of earthly ties." She did not sink into depression or allow repeated disappointments to harden her emotions. For all that she had never had or asked, this much she wanted: to return home to live out her days. But things came up—especially the touring troupes of Indians—and she died among strangers in Paris, her remains shipped back to New York to "rest for ever in her native land."[17]

Catlin was distraught. Everything he had ever done had been for his wife and children; now his wife was gone, and only the children remained to justify his existence. The children and his other responsibilities. After many bureaucratic delays his exhibition had opened in Paris on June 3, and though the reviews were enthusiastic and attendance good, expenses ran high. Bureaucracy remained a headache; the red tape included daily certificates from the Hospices Civils de Paris for the "droit des indigents sur les spectacles," the dreaded poor tax. And then the Indians. Catlin had kept the Iowas, as his main draw, out of sight through most of May awaiting approval to open his exhibition. The lack of activity pleased neither the Indians, who became restless and homesick, nor Catlin, who was left to bear their expenses without compensation. Then the death of Little Wolf's wife in mid-June firmed up the Iowas' resolve to leave within the week. Their timing was "unfortunate," Catlin noted, since "the heavy outlays had all been made for their exhibitions, and their audiences were daily increasing." Could they have held out a month or two longer, all would have benefitted financially. But the Iowas were off—Catlin could not blame them—and shortly after his own wife had died. At this juncture, when he might well have cut his losses, closed his exhibition, and himself returned to America, another touring group of Indians—eleven Ojibwas from Canada—crossed the Channel with their English manager and volunteered to fill in for the departed Iowas. Catlin accepted on his usual terms: he would make the Ojibwas part of his exhibition, sharing expenses and receipts with their manager, who in turn would pay them a monthly stipend and guarantee their passage back to London. They might not be wild prairie Iowas, but the Ojibwas offered Catlin a second chance to make a profitable run in France and depart a success.[18]

When he waved them off in Antwerp five months later, however, it was

42. The party of Canadian Ojibwas, led by Maung-wudaus (1); his wife Woman of the Upper World (11) and three of his children would die abroad. *Catlin's Notes of Eight Years' Travel and Residence in Europe . . .* (1848).

with unmitigated relief. The Ojibwas had been for him both a financial and a personal disaster, forcing him to confront openly what circumstances had made him. For almost three years, out of the need to support his family, Catlin had played the role of showman to the detriment of his reputation as sincere friend and student of the Indian. In the future, when "humbug" was bandied about at mention of his name, he was paying for the company in which he had traveled too long. This third troupe of Indians summed up all that had befallen him of late. They were not a band of uncorrupted natives from the wilds of Canada, but a touring group organized by a well-educated former Methodist missionary, George Henry, traveling under his Ojibwa name Maungwudaus or, as he translated it, Great Hero. After barnstorming through the northern states from Buffalo to New York City, the troupe had crossed the Atlantic in March 1845 and set themselves up in the Egyptian Hall to make a killing exploiting the wild side of native nature. Eight years before, in a Methodist newspaper, George Henry had likened his uncivilized tribesmen to orangutans, "for they appeared more like them than human beings"; now Maungwudaus, decked out in tradi-tional finery, offered English audiences twice-daily demonstrations of the "Operation of Scalping!" By all accounts a slick operator, Maungwudaus was initially attracted to Catlin's old stamping grounds, the Egyptian Hall, and then to Catlin himself because of his reputation in Europe as a

showman specializing in Indians. In turn, despondent over the loss of his wife and more financially desperate than ever, Catlin was a willing partner. Through the autumn, the arrangement appeared to be working. The Indians amused their French audiences and provided Catlin an entrée into fashionable society. There, if anywhere, patronage might be found.[19]

But the arrangement was flawed. The Englishman who accompanied the Ojibwas from London proved an irresponsible sharper, and it fell on Catlin's shoulders to get them back across the Channel. He did not have the money to pay their passage and hoped a few weeks exhibition in Brussels, Ghent, and Antwerp would raise the necessary funds. But disaster struck in Brussels in the form of smallpox. The Indians were too sick to exhibit, and expenses mounted. Catlin related his woes in a pleading letter from Brussels dated January 12, 1846. The Indians he wrote, were owed 1,000 francs in back pay, and he himself 800 francs, by their former manager. During the six-week lull in Paris after his exhibition closed and before he took the Ojibwas to Belgium, expenses were 1,500 francs; an additional 1,700 francs had been paid out since leaving Paris, and another 1,000 francs would be required to get the Indians back to London and himself back to Paris. No one, he warned, should consider bringing Indians over to Europe in the expectation of turning a profit, "at least for many years to come."[20]

The toll in human terms had been appalling, underscoring the dubious nature of such enterprises. While Catlin accompanied the Ojibwas, the original party of eleven was increased by one birth and reduced by two deaths from smallpox in Brussels and a third in London. After they were out of contact with Catlin, another four died—Maungwudaus's wife and three of his children. Of the eleven Ojibwas who crossed the Atlantic, only five made the return voyage. "The melancholy results of this awful catastrophe," consistent with Catlin's own fatalistic reading of the Indians' destiny, provided "a shocking argument" against the propriety of bringing Indians overseas for exhibition. For himself, he vowed to wash his hands of such spectacles. They did nothing to advance the Indians' cause, and the amusement they afforded audiences did not justify their cost. So Catlin, bereft of wife and sobered in purpose, rededicated himself to his original mission and, in "a comfortable *atelier*" in his Paris apartment, his motherless daughters and son playing near him, "painted on, dividing my time between my easel, my little children, and the few friends I had in Paris, resolving and re-resolving to devote the remainder of my life to my art."[21]

* * *

The brush with Rankin, Barnum, and Maungwudaus must have alarmed Catlin and reassured him as well. Compelled by falling attendance at his gallery he *had* veered markedly in the direction of showman-entertainer since his arrival in England. Once he had been the Indians' champion,

describing their unfamiliar cultures and pleading for justice in lectures brimming with conviction. In Boston in 1838 he had stood in the wash of sentiment that swept New England during the removal debate, and only months after Ralph Waldo Emerson publicly reprimanded the president for the scandalous treatment of the Cherokees had captivated his Amory Hall audiences with his "warm and animated manner." Then he had had a claim on the public conscience, acknowledged when city officials granted him free use of Faneuil Hall for a month; he could say with Daniel Webster, "Hear me for my cause" and expect the respect due a serious advocate. That was the company he had wanted to keep. But in England he had reordered his priorities, advertising his gallery as an elaborate amusement even as he insisted it was a scientific treasure of enduring value. When Maungwudaus's cousin, the Reverend Peter Jones, met Catlin in Paris in March 1846, Jones judged him a "thorough blue Yankee" and dismissed his "great professions of attachment for the Indians" as a showman's cant.[22]

Catlin's dilemma was real but not insoluble. As governments in the nineteenth century assumed responsibility for public instruction, they stripped the popular exhibition of its more sensational trappings and harnessed a sobered form of entertainment (museums, art galleries) to the work of general enlightenment. Catlin's gallery too might pass from the exhibition room of the Egyptian Hall through the portals of some national museum. The "tableaux vivants" and visiting Indians would have to go; but the paintings and artifacts would remain, newly legitimated.

The year 1846 provided an appropriate time for stocktaking. To date, the European venture had brought Catlin international recognition but only disappointment in his quest for fortune. "I am tired and worn out with a showman's life and passing the most valuable part of my life away to no purpose," he wrote an American friend. His thoughts drifted homeward, to the depleted ranks of his family and the cemetery where his wife lay buried. The United States could yet honor the bright promise it held out to those with initiative and talent enough to merit success. And it could yet reclaim the full affection of one of its exiled sons who had labored on in the hope that one day his Indian collection would be "perpetuated on the soil where these ill-fated people have lived and perished." Reports of an overflowing treasury—a surplus of more than $12,000,000—convinced Catlin in April 1846 to press his case for patronage upon Congress.[23]

Previous failures were explained away. The panic of 1837 had annihilated the spirit of speculation, shaken the American economy, chastened the government, and foredoomed the House resolutions of 1838, 1839, and 1840 providing for purchase of his collection. No such obstacle would block a favorable decision now. With the "auspicious time" at hand, Catlin drafted a memorial on April 21. His collection, familiar to some congress-

men from its exhibition in Washington eight years before, now occupied "a large gallery" in the Louvre, at the pleasure of the king of France. Its creation, he estimated, had cost him eight years and $20,000 out of pocket, since he received "no government or individual aid." Confident that it would eventually be "appropriated and protected by the government of his own country," he had crossed the Atlantic simply to make a living from his work pending a favorable decision by Congress. As proof of his patriotism and the intrinsic value of his collection, Catlin claimed to have spurned "several very respectable offers" in Europe, encouraged in his refusal by the friendly interest Congress had shown (as he recalled it) in 1837 and 1838. Indeed, he understood that the chairman of the House Committee on Indian Affairs had been prepared to endorse the purchase when time ran out and Congress adjourned.[24]

Catlin had a conveniently selective memory. In 1839, the year he meant, he had left Washington only days before the session ended, disappointed at the foot dragging of the Indian Affairs Committee and "pretty full convinced" that nothing would be done about his gallery despite the chairman's assurance "from day to day that they had resolved to make a Report in favour. . . . So the thing rests, and I shall have the mortification of having made, at their request, an offer of them at a very low price, and still unable to see them perpetuated in my own country."[25]

Congress in 1846 would have another opportunity to buy on the same terms as before, $65,000, a genuine bargain, since the gallery had been expanded in the interim. The nearly six hundred paintings were now in a finished state, properly framed; the collection of Indian artifacts had been augmented by purchases in England; forty life-sized figures, "the heads of which are facsimile casts . . . of distinguished Indians on the frontier, and colored from nature," permitted proper display of the costumes and weapons. For its $65,000 Congress would also get nearly two tons of mineral specimens and fossils from the West—and, Catlin insisted, scientific cachet, since his collection would be "the nucleus of a *museum of mankind,* to contain eventually the records, resemblances, and manufactures of all the diminishing races of native tribes in various parts of the globe." With that bold promise Catlin brushed away the last traces of Barnum and reclaimed his respectable status as artist-historian of the American Indian.[26]

Catlin's memorial was presented in the Senate on June 5, the House three days later, and was referred to the Committee on the Library. Three supporting documents, one actually received by the Library Committee before the memorial was introduced, showed that Catlin had orchestrated this campaign with care. Fifteen American citizens residing in London had signed a petition, referred to the Library Committee on June 3, expressing their "deep interest in the collection, preservation, and protection of works of art, of literature, records, and whatever may illustrate the early history of

our country." Catlin's Indian Gallery was a case in point. Congress should act promptly to restore it to the United States, and Catlin should be retained to enlarge and perfect it. Two weeks later Lewis Cass, then a Democratic senator from Michigan, presented a memorial signed by eleven American artists living in Paris urging acquisition of the gallery. Eager to make the case for government patronage of the arts, Catlin's peers had rallied to his cause. They stressed two points: his collection, which was attracting buyer interest in England and France (as a possible addition to the Historical Gallery of Versailles), was of *"peculiar* interest" to the United States and might soon be lost; second, "interesting to our country-men generally, it is absolutely necessary to American artists." As the Vati-can was to the Italian, artifacts of the ancient Gauls in the Louvre to the French, and the armor and weapons in the Tower of London to the British, so Catlin's Indian Gallery was to the American historical painter, an invalu-able repository of material.[27]

This argument was not trumped up for the occasion. In 1839 Thomas Sully had turned to Catlin for advice on a cradleboard to be included in his *Indian Mother,* and in 1843 Henry Kirke Brown, a Massachusetts sculptor resident in Florence, wrote to Catlin for help with the model of an Indian boy. Like other American artists living abroad, Brown had discovered the appeal of a native theme, romantic in its own right and fresher than another Apollo or Bacchus. His compatriot and neighbor in Florence, Shobal V. Clevenger, was also working on an Indian subject, a war chief resting on his bow. They needed expert guidance. Brown had access to some Charles Bird King Indian heads and a bust of Osceola sent to Horatio Greenough to aid him in his federal government commission, the *Rescue Group,* but he knew nothing of Indian costume, hairstyles, weapons, moccasins—the specifics that would stamp his work as authentic. Conse-quently he wrote to Catlin as "the fountain head of such information"—exactly the point the artists in Paris made in their petition to Congress three years later when they prayed that Catlin's collection be acquired to form the "nucleus for a national museum, where American artists may freely study that bold race who once held possession of our country, and who are so fast disappearing before the tide of civilization."[28]

Another petition favoring purchase was introduced in the House on July 7 and in the Senate two days later by a future secretary of state, Delaware Whig John M. Clayton. It was brief but impressively supported: fifty-two artists from New York City joined their "brother artists" in Paris in recommending acquisition of Catlin's gallery. The signers included such luminaries as Asher B. Durand (who knew Catlin from a six-week stay in England in 1840), Daniel Huntington, the western genre painter William Ranney, and John G. Chapman (who had used Charles Bird King's Indian portraits in painting *The Baptism of Pocahontas* for the Capitol, 1837–40,

and could appreciate Catlin's collection as source material for the historical painter).[29] This petition was but one indication of a growing sense of artistic community in the United States. Durand, as president of the National Academy of Design, felt a particular need for collective action to serve notice that artists were a profession to be reckoned with, and certainly consulted, whenever decisions concerning art were to be made by Congress. John Vanderlyn, Thomas P. Rossiter, Benjamin Champney, William Morris Hunt, Thomas Hicks, and John F. Kensett had all signed the memorial from Paris; Samuel F. B. Morse and George P. A. Healy submitted separate supporting letters. Thus Catlin's latest appeal was backed by some of America's most renowned artists and "Messrs. Morse, Inman & Co.," as one disgruntled outsider dubbed the National Academy. His cause was theirs, underscoring the federal government's neglected responsibility to the fine arts.[30]

Introducing the New Yorkers' petition, Clayton argued that the acquisition of Catlin's collection was "a matter of high national importance." Just as European nations had "manifested a laudable anxiety to preserve . . . memorials of their aborigines," Clayton said, it was "eminently proper" Congress do the same and, indeed, it would be "discreditable" were it not to do so. On July 24 the Library Committee reported back in favor of purchase. Its members had been duly impressed by Catlin's energy, initiative, and self-reliance, and their report emphasized the Americanness of the artist and his work. "In transferring his collection to Europe, Mr. Catlin had no intention of alienating it, or changing its nationality and destination," the committee stated, "but, by its exhibition, sought to secure support for his family, and obtain means of bringing out his great and expensive work on the Indians." Catlin had won renown abroad. The king of France had taken a personal interest in the collection and ordered its private exhibition in the Louvre; the king of Belgium had presented Catlin a gold medal in recognition of his achievement. American artists studying abroad, and in a position to appreciate both the artistic and the national value of Catlin's gallery, had urged its purchase by Congress. Catlin would come with his collection and "in a few years" of concentrated work, "double it in value and extent." The price was fair, the opportunity at hand. The House of Representatives had just passed a bill establishing the Smithsonian Institution, which was to include a gallery of art. "No productions, your committee believe, at present exist, more appropriate to this gallery than those of Mr. Catlin, or of equal importance." Therefore, the committee recommended that the Smithsonian bill be amended to provide for the purchase of Catlin's Indian Gallery for $65,000, payable in annual installments of $10,000. At long last Catlin was on the threshold of fortune. Nothing could go wrong—but it did. Congress failed to act before the session ended.[31]

Until reports of an overflowing Treasury revived his hopes in 1846, Catlin had been in an unusually pessimistic mood. In mid-February, with American-British relations testy over the Oregon question and the situation along the Mexican border deteriorating daily, he had despaired that "the blast of wars" would shatter his chances in Congress. Anyway, he was disgusted with the government's shilly-shallying. A bill for the purchase of his gallery had been before Congress for five years, he claimed with his usual exaggeration, but "there is so much apathy with them and so little soul for works of art or history" that he would be willing to let a British buyer have it at a fraction of its worth just to "vex" them. This analysis of the general reluctance to purchase his collection was acute. But in 1846 Catlin chose to emphasize the particular and ignore the general that, if accepted, would have precluded further appeals to Congress. He was not yet ready to resign himself to defeat, so, still feigning optimism in public, he came up with a ready explanation for his latest disappointment. "The sudden commencement of the Mexican war" in mid-May, he wrote, blocked action on his memorial. "It now remains to be seen whether the Government will take it up again. . . . My unavoidable belief still is, that some measure will be adopted for its preservation in my native country."[32]

For the next session, Clayton devised a different strategy. Frustrated in his attempt to amend the Smithsonian bill, on February 27, 1847, he proposed instead to amend the bill making appropriations for the government's civil and diplomatic expenses. It was an omnibus bill anyway, so Clayton's suggestion that the government set aside $5,000 annually for some ten years to purchase Catlin's Indian Gallery was appropriate. Since most senators were acquainted with the gallery's merits, as well as the memorials urging its purchase, Clayton made a straightforward appeal. Catlin's six hundred paintings had met "unqualified approbation" in Paris; now, providing that the Smithsonian Institution could "find a place for them" in its art gallery, they must be brought back home.[33]

The Smithsonian proviso was significant. The creation of the Smithsonian in 1846, following a decade's dispute over the proper disposition of Englishman James Smithson's $500,000 bequest to the United States government for the establishment of an institution for the "increase and diffusion of knowledge among men," had turned Washington's intellectual community topsy-turvy. Since 1841, the second floor of the Patent Office Building, a hall 290 feet long and 60 feet wide, had served as the museum of the National Institution for the Promotion of Science, a private society that, in the absence of any public alternative, was custodian of the government's collections, notably—and only temporarily—the tons of specimens gathered by the United States Exploring Expedition. Under the direction of Lieutenant Charles Wilkes, the Exploring Expedition had spent four years, 1838–42, collecting specimens in South America, Antarctica, and

the South Seas. Corals, plants, crustaceans, reptiles, fish, insects, over two thousand birds, some stuffed, even more awaiting mounting, "40 to 50 bushels" of shells, minerals, skulls, and South Sea Islands weaponry and artifacts were already housed in the Institute's museum by 1842. So were Peruvian mummies, Persian carpets, and an assortment of treasures turned over by the State Department, including beautifully crafted muskets and swords, jewels, ancient coins, medals, and snuffboxes presented to American officials by foreign potentates, along with manuscript treaties and the original Declaration of Independence. The National Institute had also acquired the War Department's Indian collection in 1841, and the 150-odd portraits by Charles Bird King were already hung when a visitor inspected the Institute's holdings that December. "It is to be hoped that this number will be increased," he observed, "that we may have in our possession the portraits of the chiefs of the aborigines of this country, who are fast fading away." That was the enlarged view, King's paintings serving as the nucleus for a constantly expanding collection (like Catlin's, for his proposed "museum of mankind"). But King's collection could also be seen as adequate in itself. How many Indian pictures, after all, were necessary? How much space could be devoted to a single subject?[34]

In 1847, then, with the Smithsonian a fledgling institution lacking permanent quarters, Senator Clayton's proviso was more than a formality. Catlin's collection would be purchased *if* the Smithsonian could find the room to house it, which meant *if* the Smithsonian would be willing to take on another commitment. It was not at all certain that it would. Under its first secretary, Joseph Henry, the Smithsonian shrank from the twin legacies of the Exploring Expedition and the National Institute, fearful of being swamped by their sheer bulk and rendered dependent on congressional largess—an unenticing prospect given the government's track record. Indeed, the Smithsonian was created as both a public and a private body because of the government's reluctance to assume sole responsibility. Henry, aware that dependence on Congress would be chancy, throughout his thirty-two-year tenure maintained that the Smithsonian was primarily neither museum nor art gallery, but an institution devoted to pure research. His position had direct implications for Catlin's case. Meanwhile, King's portraits hung on the walls of the Patent Office Building a short walk from the Capitol, providing congressmen a convenient excuse for inaction on Catlin's appeals.[35]

Opposition to Clayton's proposed amendment came from two Democratic senators. Sidney Breese of Illinois argued that the six hundred paintings in Catlin's collection were not, "of themselves, of such excellence as would probably be selected" for the Smithsonian's gallery, yet they would entirely fill it; and James D. Westcott, Jr., of Florida could find no redeeming value in the portraits of savages. "What great moral lessons are

43. George Catlin, *OSCEOLA. of Florida* (lithograph, 1838), an unblushing bid for commercial success in which Catlin's expressive likeness (fig. 37) has yielded to a positively jaunty interpretation. Amon Carter Museum, Fort Worth, Texas.

they intended to inculcate?" he asked. He would rather see the likenesses of the white citizens murdered by Catlin's models and would never "vote a cent" for an Indian's picture.[36]

Catlin was again paying the price for his outspokenness. As noted, in January 1838 he had secured War Department permission to visit Fort Moultrie and paint Osceola and a few of the other 250 Seminoles and Yuchis held prisoner there. Osceola, a leading figure in the second Seminole War, had been captured by ruse under a white flag and thus had become a cause célèbre. Poets sang his praises; Catlin, in turn, showing the opportunism that coursed through his career, rushed to the scene of Osceola's incarceration and captured him again, on canvas, carrying his prize back to New York in triumph. In his private dispatches he expressed reservations about Osceola, but in a letter intended for publication he described him as "a fine and gentlemanly looking man, with a pleasant smile that would become the face of the most refined or delicate female—yet I can well imagine, that when roused and kindled into action, it would glow with a hero's fire, and a lion's rage. His portrait has never yet been painted." At the time of Catlin's visit, Osceola was dying of quinsy, or putrid sore throat, and the proverbial broken heart caused by white treachery. Here was an Indian chieftain of "liquid name," handsome, young, and doomed, who breathed life into romance and gave the noble savage convention intensely human form. Here was a prime opportunity to turn a profit.[37]

Catlin's heart might bleed, but his eye was coolly fixed on the main chance. The public expected him to document the latest Indian sensation, and he would not disappoint. "I am catering to the world at great expense to myself," Catlin wrote, ". . . but things to be done, MUST be done." His father put the matter succinctly: the Seminole portraits were essential since they would lure "thousands of visitors," to the Indian Gallery. Despite his claims, Catlin was not the first to paint Osceola's likeness; he was the last, however. Osceola died only hours after Catlin packed up his oils and brushes and sailed for home, a "fortunate" development from a business standpoint. By April, when he opened in Washington, Catlin had added the Seminoles and Yuchis to his gallery and inserted slips listing them in 2,000 copies of the catalog of his collection printed the previous fall. Three officers and the surgeon who attended Osceola at Fort Moultrie certified that Catlin's likenesses were "remarkably good" and that the Indians posed "in the Costumes precisely in which they are painted." Catlin had lavished care on two portraits of Osceola, bust length and full length, and capitalizing on the popular interest he drew the standing figure, rifle in hand, on stone and struck off a lithograph (20″ x 26″) for sale at $1.50. He advertised by handbill and in the newspapers, and with agents flogging the print on commission, anticipated that OSCEOLA. *of Florida,* as he called it, would be a money-maker.[38]

This contradictory blend of altruism and self-interest, perhaps inherent in his role as artist-entrepreneur, created a dilemma Catlin never entirely resolved. It made him an exploiter of the Indian as surely as the avaricious frontiersmen he deplored. It also made him a typical American, according to the French visitor Alexis de Tocqueville, who traveled in the United States in the early 1830s and saw firsthand the consequences of an Indian removal policy officially defended as humane and just. In a journal entry for July 20, 1831, Tocqueville analyzed a "feeling" he had everywhere encountered:

> "What is the life of an Indian?" . . . In the heart of this American society, so well policed, so sententious, so charitable, a cold selfishness and complete insensibility prevails when it is a question of the natives of the country. . . . This world here belongs to us, . . . [Americans] tell themselves every day: the Indian race is destined for final destruction which one cannot prevent and which it is not desirable to delay. Heaven has not made them to become civilised; it is necessary that they die. . . . In time I will have their lands and will be innocent of their death.

Catlin might be emotionally involved with the Indians, but like their most unfeeling usurpers he could be coldly selfish and insensible. Once he had caught their likenesses, they were worth more to him dead than alive.[39]

His years abroad made Catlin more aware of his personal inconsistency. His own analysis of American culpability in Indian decline grew progressively more severe, though once again this could be discounted as self-serving, since he was playing to a whole audience of Tocquevilles. But he also struggled to define a more flattering role for himself in resisting national abuses. Thus in his later years he told a story, certainly apocryphal, about his extraordinary efforts in 1838 on behalf of Osceola and the other imprisoned Seminoles. Upon leaving them at Fort Moultrie, he recalled, he went straight to the White House to plead for their release but was peremptorily dismissed by the president. The nature of this tale suggests that Catlin's personal exploitation of Osceola weighed on his conscience, guilt spawning self-justifying fabrication.[40]

But in 1847 it *was* Catlin's advocacy of the Seminoles that had goaded Senator Westcott into opposing purchase of his Indian Gallery. A native of Virginia, Westcott had been active in Florida politics through the 1830s, and by 1838 was part of the Democratic coalition pushing for statehood, achieved seven years later. His political career spanned the second Seminole War (1835–42), which shaped his views on Indians. While Catlin might express sympathy for the unoffending white settlers who died in Florida, Westcott was not about to honor their murderers by buying their portraits. Catlin's advocate, Senator Clayton, ignored Westcott's diatribe, reiterated the point that the gallery was a uniquely American work, and reassured Senator Breese that if the Smithsonian "could not provide a place for them the paintings would not be purchased." The amendment was then put to vote and defeated.[41]

Catlin had almost no time to register this latest defeat (he had all along thought Senator Clayton's initiative too "*slim a chance*" to bother coming to Washington to lobby personally) before he was absorbed by cares closer to home. After disentangling himself from the last troupe of Ojibwas in January 1846, he had returned to his art full time and seemed to have regained his bearings. John Howard Payne, another "exile from home" whose struggle to make a living as an American artist paralleled Catlin's, wrote on New Year's Day 1847 with a heartfelt wish: "May neither of us ever again experience such annoyances as both have suffered during the year which has departed."[42]

Catlin did find unaccustomed contentment early in 1847 as he worked away at his easel surrounded by his four "chicks." "The days and nights and weeks and months of my life were passing on whilst my house rang with the constant notes of my little girls and my dear little 'Tambour Major,' producing a glow of happiness in my life . . . which I never before had attained to." But late in April the idyll ended. His eldest daughter was sent home from school with fever and an inflammation of the lungs "so violent," Catlin wrote Payne, that he was "in great distress for her safety." The

44. Louis-Philippe's party inspects Catlin's gallery in the Salle de Séance at the Louvre, where paintings and Indian accoutrements cover the walls. Catlin holds open the flap of the Crow tipi first displayed in New York in 1837; behind him, a nurse tends his four "chicks." *Catlin's Notes of Eight Years' Travels and Residence in Europe . . .* (1848).

other children took sick as well and were bedridden through May. On June 1 Catlin's cherished "Tambour Major," his youngest child, only son, and namesake, died of "dropsey of the brain." Catlin was devastated. Two weeks passed; the boy's body was at sea, bound for burial in an America he had never seen; and Catlin still had not broken the news to his convalescing daughters. His grief was absolute—"my whole soul," he wrote, "was set upon this dear and pretty boy"—and came near to unhinging his reason. With this "lovely flower" planted beside his wife in Brooklyn, Catlin retreated into himself, overwhelmed with grief and a sense of failure nothing could alleviate except a success so spectacular it would justify the mounting toll of sacrifices to his personal ambition. Now the stakes were higher than ever; there would be no turning back until his course had been vindicated and his collection sold.[43]

* * *

Meanwhile Catlin went about his business in Paris and tried to secure patronage nearer at hand. The king of France, Louis-Philippe, was his particular hope. When Catlin first arrived in Paris in 1845, he sought a royal audience through the American minister; it was granted him and the troupe of Iowas on April 21 in the reception hall of the Tuileries, followed by a tour of the palace and a repast topped off with "first-rate" champagne ("Queen's chickabobboo"). Subsequently Catlin enjoyed a leisurely breakfast with the royal family in the Palais de St. Cloud and was invited to visit with his latest Indian group, the Canadian Ojibwas. The king also directed that a room in the Louvre display the Indian collection for private viewing

by the royal family and guests, and he came twice himself to inspect it with Catlin and reminisce about his own experiences in the wilds of America.[44]

While in exile during the Napoleonic Wars the twenty-three-year-old future monarch, then the duke of Orléans, sailed to America, where he was joined by his two younger brothers for an extended visit that included three excursions from Philadelphia deep into the American interior. In the spring of 1797 the brothers made a three-thousand-mile circuit southwest to Nashville, then northeast to Pittsburgh, Buffalo, and other points on Lakes Erie and Ontario; that December they made a pilgrimage along the path of former French greatness, down the Ohio and Mississippi rivers to New Orleans. These journeys—arduous by any standard—exposed the Orléans to Cherokees, Chickasaws, and Choctaws and impressed the duke with how inappropriate the word "savage" was to describe some of "the best people in the world," more hospitable than white American back-woodsmen. He smoked a friendly pipe with the Cherokees, learned a few words of their language, and watched a hard-fought ball game. All this was accomplished in the face of daunting circumstances and on a precarious financial footing that Catlin could well appreciate. No wonder, then, he so admired the now portly, still approachable king who never tired of relating his youthful adventures in America.[45]

Because of their shared enthusiasms, Catlin was to Louis-Philippe what Tom Thumb was to Queen Victoria, an object of special curiosity, and he found being doted on by royalty to his liking. The invitation to breakfast without Indians or paintings especially gratified Catlin, and he deemed the occasion "the proudest one of my wild and erratic life." The qualities that made Louis-Philippe so attractive—his accessibility, his solid bourgeois virtues, his affection for family, his evident sympathy for republican institutions, and his enlightened views as a constitutional monarch—were not enough to save him from the tide of discontent that would sweep France and most of Europe in 1848. But the citizen king, a global wanderer in the aftermath of the French Revolution, enthroned by the Revolution of 1830 and dethroned by that of 1848, would remain to Catlin, even in his final English exile, a "wonderful man" and a personal hero possessed of *"great-ness of soul"*: "[I] admire and revere the man whose energy of character and skill have enabled him, with like success, to steer his pirogue amidst the snags of the Mississippi, and at the helm of his nation, to guide her out of the tempest of a revolution, and onward, through a reign of peace and industry, to wealth and power, to which she never before has attained."[46]

For all the pomp and spectacle, the porters "in flaming scarlet livery and powdered wigs," and the elegance of royal living, what did Catlin *gain* from his association with the king? Apparently little, apart from the thrill. Royal favor meant that for a while he was a social lion in Paris. The ambassador of the Ottoman Porte arranged a soirée at which Catlin's

Iowas, as honored guests, mingled with Turks, Greeks, Armenians, and Egyptians, including two grandsons of Mehemet Ali—a double dose of exoticism for Europeans already infatuated with the Orient. The literary and artistic set turned out to admire the Indians, if not Catlin's paintings. Charles Baudelaire, however, struck by his raw colors, the clash of earthy reds and leafy greens, would write the most perceptive commentaries on his artistry to appear in his lifetime. And George Sand, who detected "un grand talent" in his work, with Eugène Delacroix in tow would revisit the gallery and converse with the Iowas in an attempt to understand their religious beliefs, their views on French society, and their customs, which exhibited "un rare cachet d'intelligence et de droiture." The Indians were in the classical mode, she decided, an epic blend of savagery and gentleness, and she ended her interview with questions designed to draw out their deepest feelings. What did they do in their wigwams on long rainy afternoons? Were they bored? They smoked and dozed away the murky hours in indolent contentment, apparently, which led her to conclude that their torporous appearance masked minds ablaze with medicine dreams and vivid reveries. Mere fact could not dampen the romantic's ardor for noble savages, and Sand repaid Catlin for the privilege of the interview by actively promoting his gallery in the press, praising Iowas and artist alike. Delacroix, preeminent among Orientalist painters, was silent about Catlin's merits but sketched the Indians.[47]

Catlin also met Europe's preeminent man of science, Baron Alexander von Humboldt, himself something of a royal keepsake in his capacity as court savant and traveling companion to Frederick William of Prussia; Humboldt would later play a leading role in Catlin's story. The august members of the Royal Academy of Sciences wanted to meet his Indian troupe as well, but their detached curiosity offended the Iowas, who were unwilling to be scrutinized as ethnological specimens without even the compensating courtesy of a glass of chickabobboo. And in 1846 Catlin was elected to membership in the Société Ethnologique de Paris in recognition of his services to science and humanity in forming his "précieuse collection," a monument to the North American Indians "d'un interêt sans égal." Such flattery was heady stuff for an artist who felt himself so unfairly neglected at home.[48]

But the pleasure of keeping illustrious company was always qualified by Catlin's inability to converse in French. And royal patronage, it turned out, did not put francs in the pocket. As soon as his lease expired at the Salle Valentino on the Rue St. Honoré, Catlin carted his collection to the Salle de Séance in the Louvre, where it hung for several weeks, generating royal interest and comment but no revenue. At the same time his latest Indian troupe, the ill-fated Canadian Ojibwas, were idled by the closing of the public exhibition, existing, Catlin complained, "at my expense, which was

by no means . . . trifling." The king did select fifteen of Catlin's paintings to be copied for the palace at Versailles—a royal commission of sorts, except that it brought no income. Catlin had obviously offered them as a token of his esteem; subsequently he wrote that the king had "commanded" the paintings. Either way, no money changed hands.[49]

Nevertheless, Catlin continued to court royal favor and puzzle over how to take advantage of his acquaintance with Louis-Philippe. Success seemed within his grasp; he was literally breakfasting with royalty; the king was personally interested in his subject matter and friendly beyond mere politeness; the Louvre was at his disposal. But each time he tried to convert these advantages into hard coin, success eluded him. In truth, despite the impression created by his *Notes on Europe,* in which meetings and conversations that took place over the course of a year were compressed into a few pages, Catlin was hardly intimate with Louis-Philippe. Usually his audiences lasted half an hour, depending on the king's loquacity when the paintings triggered pleasant recollections. Still, it occurred to Catlin that this might be the opening he was looking for. Perhaps his majesty would welcome a series of pictures illustrating his youthful travels in western New York and down the Ohio and Mississippi rivers.

Protocol prohibited Catlin's approaching the king directly, so he devised a ploy. What he required was a third party, an established American institution, to "commission" such a series. He had been outside the royal orbit for over a year when, on September 20, 1847, he propositioned a representative of the New-York Historical Society:

> The members of your noble society will agree with me that such extraordinary incidents in the life of so extraordinary a man, when so closely identified with the early history of our country, . . . very properly become subjects of interest and excitement to an artist situated as I am, already under His Majesty's patronage, and to whom he has expressed so lively an interest in the welfare and prosperity of our country, whilst relating those scenes and incidents to me. Having been over the whole of the ground travelled by His Majesty in America, and having made my views from Nature, on every River that he navigated, and familiarized myself with all the scenes that presented themselves, I feel myself peculiarly qualified to do justice to the illustrations of those scenes and events he has described to me. Of those scenes (, from his own descriptions, and without his knowledge) I have already commenced and partly painted a series of 10. small pictures in oil, having chosen the subjects myself from his Representations. I feel exceedingly anxious, before completing these works as matters of history, to draw from the King a more minute and graphic account of each subject, for

which I am quite sure he would indulge me in further interviews, and (I believe) with the aid of his portfolio of sketches and notes (, which he told me he made and which is now in existence), provided I could approach His Majesty with an order from your Society to paint such a series, the subjects of which to be designated by him, or to be chosen by myself, subject to his approbation.

Now the object of this communication is to propose—that for such an order, based upon a *Resolution* of your society, in case it succeeds with the King, I will agree to present to the Society my 10. original pictures, or copies from them, as your Society may prefer, preserving for myself only the exclusive right of copying or publishing them in such form as I may think proper.[50]

The recipient of this letter, John R. Brodhead, was in London transcribing documents for the New-York Historical Society. Indebted to Catlin for introductions on his arrival in England, he repaid him by compressing the gist of his request into a draft resolution:

The Society appreciating the high value of Mr Catlin's former labors, as well as the generosity of his present offer, and being desirous to enrich its collection with memorials of so interesting an Historical Character: It is therefore

Resolved That Mr. Catlin be requested to paint for this Society a series of pictures illustrating such scenes and events in the travels and residence in the United States of His Majesty the King of the French as may be designated by His Majesty, or be chosen by Mr Catlin, with the approbation of the King.

In a formal covering letter to the society's foreign corresponding secretary, Brodhead asked that Catlin's request be taken up "at an early meeting." Brodhead's tone was noncommittal, however, and privately he expressed reservations. Catlin wanted any action by the society to appear "*spontaneous* . . . if it can be so managed." His proposition was flagrantly opportunistic, designed to "flatter" the king into granting him "a series of sittings," and personally Brodhead doubted its propriety. Thus he urged a thorough discussion in executive committee before the society proceeded. The executive shared Brodhead's misgivings, and Catlin's memorial lay dormant. In view of "the delicacy of the matter," Brodhead wrote on January 28, 1848, "the delay of the Committee is perfectly proper." No step should be taken without "*general approval*." It was not forthcoming, and another Catlin scheme collapsed.[51]

It is unlikely that Louis-Philippe would have cooperated anyway. His choice of subjects for the fifteen Indian paintings ordered two years before should have served Catlin notice that while he liked to recall his American

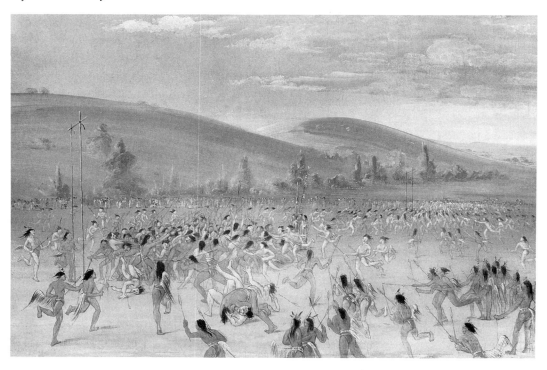

45. George Catlin, *Ball-play of the Choctaw—ball up* (1834–35), a subject admired by Louis-Philippe. National Museum of American Art, Smithsonian Institution; gift of Mrs. Joseph Harrison, Jr.

ramblings, he did not desire a pictorial record of them fabricated fifty years after the fact. Anyway, his brother the duke of Montpensier, an accomplished amateur, had sketched many scenes on their travels and worked several up into finished paintings. Instead, Louis-Philippe selected six portraits of the Iowas and Ojibwas he met in Paris and illustrations of life among western tribes he had never visited, Mandans and Sioux. Only one painting approximated a scene he had witnessed: an Indian ball game similar to the all-day match he watched five hundred to six hundred Cherokees play.[52]

When the king *did* suggest possible historical subjects to Catlin during their breakfast at the Palais de St. Cloud, they dated from the glory years of French empire in North America, the great explorations of La Salle down the Mississippi that he and his brothers had partially retraced. "Mr. Catlin, you are the only man on earth to illustrate the discoveries of Lasalle, which I want done for the Marine Gallery at Versailles," the king supposedly declared, and together they selected from Louis-Philippe's copy of La Salle's *Voyages* the episodes Catlin was to depict. "As soon as they are done," the king said, "send them in a case to Mons. de Cailleux, Director of the Louvre, and I will meet you there and examine them." Such was the commission as Catlin chose to remember it, with subject matter and painting size agreed on, but not the fee. Since Catlin would later set the value of his twenty-seven La Salle paintings at $3,000, a figure of $100

each has been assigned by some scholars. It is more likely that the two men never discussed money, and Catlin's earlier experience applied to this "commission" as well: "The compliment has been a very high one, but what the *emolument* will be I don't yet know: probably, like all *honour,* it will be a costly article."[53]

Catlin tended to put the best face on events in his reminiscences. Was this transaction simply a case of wishful thinking? Why would the king order a series of historical oils from Catlin? Catlin knew Louis-Philippe as an adventurer, not a connoisseur. The common ground they shared was a fondness for the American wilderness and the American Indian, but the king's private collection of Spanish art and his fondness for academicians like Horace Vernet define a conventional taste that Catlin's paintings could never have satisfied.[54] Louis-Philippe doubtless discussed Catlin's doing American historical subjects. But it was Catlin who made the suggestion into a commission. He even wrote directly to Louis-Philippe, a breach of etiquette that drew a stern reprimand from Cailleux, "who said the King wanted nothing historical from me." Cailleux's bluntness failed to deter Catlin. While awaiting a personal audience with Louis-Philippe, he set to work early in 1846 on "scenes of La Salle's life in America." In May he submitted a list of the twenty-five subjects he planned to illustrate to the French antiquarian Pierre Margry, an expert on La Salle's discoveries. Could Margry, drawing on his superior knowledge, suggest alternative possibilities? Catlin had already made a few preliminary sketches, and by the following January he was engaged in the actual painting, resolved to devote the remainder of his life to the task of illustrating the early history of North America, a Parkman in paint. He had nothing else to do anyway and, "without the slightest *help* from any source," might as well pin his hopes on Louis-Philippe's eventual generosity, pending the results of his latest assault on Congress.[55]

Though Catlin was not entirely clear on the subject, he apparently spent most of 1846 filling the first order from the king, the fifteen Indian scenes, and churning out additional copies to meet living expenses. In mid-February, for example, "while 'my hand is in,'" he proposed doing "a pair or two of my Buffalo hunts or other pictures," leaving prospective buyers to pay what they thought was fair. He exhibited his Indian collection that year at the Gallery des Beaux Arts, but he found expenses exceeding revenues and so crated his works and put them in storage in 1847 "waiting the action of a Bill in Congress" for their purchase and working on his second royal "commission," the La Salle oils. Six months to a year—his estimates varied—he labored on the twenty-five, then twenty-seven, historical paintings, with their four to five thousand figures (again his estimates varied). By the middle of 1847 the "Voyages of Discovery by Lasalle" was far enough.advanced for Catlin to publicly announce the royal

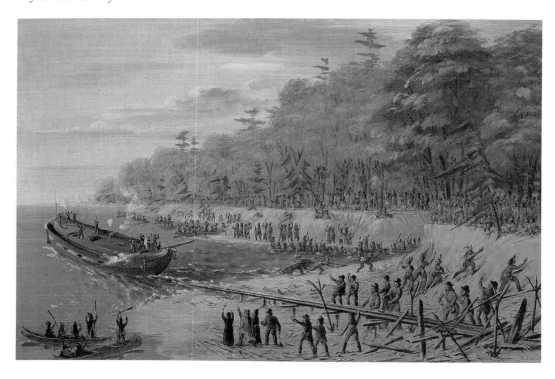

46. George Catlin, *Launching of the Griffin. 1679* (1847–48), a scene typical of the elaborate, densely populated La Salle series. National Gallery of Art, Washington; Paul Mellon Collection.

commission and to preview the series for the Louvre's director, Cailleux, who despite his personal misgivings was expected to serve as Catlin's intermediary with the king. According to Catlin, the finished paintings were at last ready for royal viewing in February 1848 when, once again, disaster struck.[56]

Just days before Louis-Philippe was to inspect the La Salle oils in the Louvre, revolution broke out in France, the monarchy was overthrown, and the king and queen fled to England. The revolution also turned Catlin out "neck and heels," and with "soldiers running through the town, destroying everything," he escaped with his daughters to London. Six weeks later he returned to Paris and discovered to his surprise that the La Salle paintings were unharmed. He left them there, probably until 1852, when he tried unsuccessfully to sell them to the French government.[57] They remained boxed and out of public view until 1870, when they were exhibited in Brussels. Of more moment to Catlin in 1848 was his Indian Gallery—nine tons of paintings and artifacts, which had to be moved to the dock by wagon "at an immense cost" (the railroad having been torn up and main thoroughfares barricaded with rubble) and shipped to London. There Catlin reopened his exhibition at 6 Waterloo Place and rushed out a new two-volume work, this one to dismal reviews, *Catlin's Notes of Eight Years' Travels and Residence in Europe, with His North American Indian Collection.*[58]

This is such a classic Catlin scenario—how misfortune dogged his tracks and universal affairs conspired to frustrate his success—that there is every reason to doubt it. Throughout his career, Catlin was always missing the express train to prosperity by a second or two; wars routinely broke out and national economies crumbled as he was about to board. Certainly his tale about delivering the finished paintings to the Louvre just three days before Louis-Philippe was deposed can be discounted. Alarmed by the unsettled situation in Paris, Catlin was in London at least a week before Louis-Philippe abdicated on February 24. But his account was basically true. In late March, in the safety of London, Catlin reflected on all that had happened of late in a letter to his English patron Sir Thomas Phillipps: "How, & how suddenly, are the mighty fallen, & falling, in Paris and over the Continent! What an age of events . . . [we] live in! What is the world coming to? . . . By the way, I am going in a few days to visit the poor old King & Queen. What do you think they will say? I can't imagine." Sir Thomas was obviously aware of the blow Louis-Philippe's downfall had dealt Catlin's financial prospects and had no doubt the king would see him, "for he might call you a fellow sufferer, since thro him your own good fortune partly fell."[59]

The mighty had fallen indeed—and with them Catlin. Three years later Louis-Philippe would be dead in exile and his art collection auctioned off, testament to the transience of power and the evanescence of an artist's dreams. If ever Catlin perceived a pattern of irony in his life, 1848 offered the moment. He had left the United States for a Europe where, he was sure, monarchs, nobles, and the gentry would vie to acquire his Indian Gallery. But he had spent his years in England entertaining the masses and scrambling for their shillings. France was better; Louis-Philippe appreciated him if he did not exactly offer patronage. And through persistence he had procured a "commission" that could mean both prestige and money—only to have the king dethroned and a republic established with a policy toward the arts as inconsistent as the one he had left behind in America a decade before. Catlin painted Indians, not holy families or allegorical maidens personifying liberty. So he was back again in London, hanging on, still hopeful. For he detected a new stirring in Congress that meant this time he could not fail.[60]

* * *

While Europe was wracked by turmoil, in 1848 the United States was emerging from its own period of turbulence more powerful than ever. The Oregon boundary had been settled with Britain on terms highly satisfactory to Americans: not 54° 40′ or fight, but the 49th parallel *without* a fight. The war with Mexico had turned into a rout, the issue not victory but the settlement the United States would extract in exchange for peace. Texas annexation was confirmed. Northern California and the Southwest stretching

up to the Mormon Zion in the Great Basin—a windfall of a half-million square miles—would be American and, for a time, as much of Mexico below the Rio Grande as expansionist zeal checked by moral revulsion and sectional concerns would care to seize. So much gain came at a price. The presidential election held that November would pit the old Democratic warhorse Lewis Cass—Schoolcraft's mentor, Catlin's acquaintance—against a recent Whig war hero, General Zachary Taylor. But the contest's outcome would be decided by a third party, Free Soilers opposed to the extension of slavery into the new western territories. Emerson had expressed the fears of many of his countrymen when he observed that "Mexico will poison us." Explosive growth exacerbated the emotionally divisive issue of slavery expansion, upsetting the traditional balance between slave and free states in the Senate. Eventually the issue would convulse the Union and propel it into Civil War. But in the summer of 1848 American prospects seemed bright and, Catlin thought, the time propitious to press his case once more.[61]

His front man this time was a loyal and disinterested friend, Ralph Randolph Gurley. Born in Connecticut in 1797, a year after Catlin, Gurley moved to Washington, D.C., in 1822 upon graduating from Yale and died there half a century later, just a few months before Catlin. They were almost exact contemporaries, and both men had a lifelong cause. Gurley, though a licensed Presbyterian minister often addressed as the Reverend, was never ordained and presided over no church; instead, he channeled his moral energies into the cause of African repatriation and, after settling in Washington, began a fifty-year career in the service of the American Colonization Society. The society's goals—the gradual emancipation of the slaves and their removal to a country of their own in Africa (Liberia)—put it in the vanguard of the abolitionist movement in the 1820s, but in its rear by the 1830s as a reactionary throwback whose principles struck more radical abolitionists as a pro-slavery apologia. In countless lectures and during a twenty-five-year stint as editor of the Society's *African Repository,* Gurley consistently espoused the colonization cause. Free blacks could never rise in America. The stigma of color would always limit them to a menial role. To realize their full potential they would have to return to Africa, far from the white man's debasing prejudices.[62]

The isolationist theory at work in the colonization movement had its counterpart in the Indian removal policy. Both were self-serving panaceas that ministered to the desire for a white America, and both rested on a humanitarian rationale: since civilization always corrupts and destroys inferior races, to isolate them from white society was to preserve them. Certainly the logic of vices and virtues was paramount in Catlin's work. It shaped his quest for untainted Indians to paint and infused every page of *Letters and Notes.* He saw no solution in Indian removal. Besides its cruelty,

47. Edward D. Marchant, *Ralph Randolph Gurley* (ca. 1861). Gurley (1797–1872), long active in the American Colonization Society, was Catlin's spokesman in Washington during his years in Europe. The Historical Society of Pennsylvania, 1923.29.

it was too partial, too temporary, and too late. But he shared in the assumptions that made removal acceptable to other, equally concerned Americans.[63]

Their common sentiments about white intolerance and their deep involvement in minority causes provided a bond between Gurley and Catlin, who may have been brought together by Catlin's brother-in-law, Dudley S. Gregory, a friend of Gurley's active in the Colonization Society. Although Gurley was not the adventurer Catlin was, his duties thrice took him to Liberia, and he lectured throughout the United States and, in 1840, in the Egyptian Hall in London. There he definitely met Catlin. After his return to the States Gurley sent a letter to Francis Markoe, Jr., corresponding secretary of the National Institute, praising Catlin's gallery and urging its purchase. "I should be mortified beyond expression could I believe there was a single enlightened man in the country who would not rejoice to see Congress add these memorials of the Indian race to the National Museum," he wrote; ". . . whether regard be had to the patriotic devotion of Mr. Catlin, or to his generous and high qualities as a man, he well merits the patronage of his country." Gurley's letter was circulated in the press and served to keep the virtues of Catlin's collection, by then out of sight for nearly two years, before the American public. A man with political savvy and connections, Gurley served as Catlin's principal advocate in Washington through the 1840s. In the 1850s he would be the intermediary between Catlin and Schoolcraft after their falling-out, and as the 1860s

drew to a close and Catlin contemplated a literal comeback—a return to America with a new collection—it was Gurley he thought of to smooth the way. But never was Gurley's assistance more overt than in 1848.[64]

On July 10 Senator Edward A. Hannegan, an Indiana Democrat, introduced a memorial from Gurley entreating the purchase of Catlin's gallery. Referred to the Committee on the Library on July 18, it consisted of a brief preamble summarizing the accompanying documents: Catlin's 1846 petition, several endorsements, and the favorable report of the Joint Committee on the Library made at that time, along with an 1841 letter from Lewis Cass and a sampling of newspaper testimonials from home and abroad. Basically Gurley was recycling the 1846 file, a sensible move, since he had assembled it. Catlin's 1846 petition had been in Gurley's hand—probably recast from a personal communication—along with the copy of the memorial from American artists in Paris, while the supporting letters from Samuel Morse and George Healy were addressed to Gurley. It was he who badgered congressmen and the chairman of the Senate Library Committee in 1846, sending them copies of Catlin's *Descriptive Catalogue* and urging on them the necessity for haste. Even the Library Committee report was mainly Gurley's doing: he drafted the entire document save the preamble and the concluding paragraph giving the committee's recommendation. In the preamble to his 1848 memorial, Gurley deferred to others on the artistic merit of Catlin's work, lauded Catlin's "distinguished patriotism and philanthropy," and warmly endorsed his enlarged vision of a museum of mankind devoted to the world's vanishing primitive cultures. Putting the Indian's destiny into global perspective naturally appealed to a man of Gurley's convictions.[65]

The Library Committee acted swiftly on the memorial. John G. Palfrey, a Massachusetts Whig, reported a joint resolution on August 8 authorizing purchase. Committee members, some already familiar "from personal knowledge" with the merits of the case, were prepared to offer Catlin $50,000 for his gallery, payable in ten annual installments. Duty to posterity demanded as much, and the opportunity to acquire such a representative sampling of native American culture would not come again. "The advance of civilization, even so far as it does not immediately involve the disappearance and extinction of the Indian races, effaces the existence, and before long the memory, of all that was most distinctive in their character and habits," the committee reported, "and our children's children will know nothing of those once numerous families of men except by means of what we of this age may rescue from the wreck and preserve for their instruction."

Catlin's case could not have been put more economically. Because the Indian cultures had vanished as fast as he painted them, his collection was irreplaceable, and correspondingly valuable. The session ended without

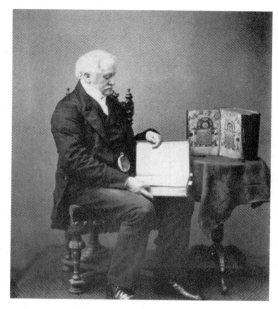

48. Sir Thomas Phillipps (1792–1872), collector extraordinaire, shrewd, cantankerous and obsessed but, Catlin said, "my only patron and benefactor." Photograph taken about 1860.

definite action, however, and Catlin was left to stew over summer and fall. Gurley's prominence in Washington—he served as House chaplain that Congress—was not enough. Catlin needed a prod to *make* Congress move. He had threatened repeatedly that should the American government not purchase his collection he would sell it to any one of a number of eager buyers abroad. Kings, noblemen, art museums, and learned societies were awaiting the word. Congressmen had heard this line before, but the Library Committee bought it in 1848. Catlin's paintings "are now regarded with far more interest in foreign countries than by us," it reported. "It is understood that advantageous proposals have been made to Mr. Catlin for their purchase abroad, but that, with a disinterested patriotism akin to the zeal with which his favorite investigations have been prosecuted, he prefers that, at some sacrifice to himself, his own country should possess their fruits." He would have to force the government's hand, however; before August was out, he had devised his strategy.[66]

What Catlin needed was the cooperation of his English patron, Sir Thomas Phillipps. Four years Catlin's senior and himself a single-minded, driven man, Phillipps was by all accounts an irrascible curmudgeon, "cantankerous beyond the ordinary, silly beyond reason, dictatorial, preposterous, tiresome and fatuous." Collecting was his passion. He accumulated books and manuscripts in a frenzy of acquisitiveness that closed him to the normal range of human emotions. A man who broke off all relations with his own daughter for marrying without permission (she was as good as dead to him, he wrote) and whose bibliomania estranged two wives, was not likely to be swayed by sentiment. But his collecting lust ruled him as it

ruled those around him. Sir Thomas coveted what he did not have. Though notorious for driving a hard bargain and often strapped for funds because his income could not match his wants, he was ever in the chase. His relationship with Catlin was frequently strained, and he did not hesitate to exploit the artist's financial desperation. Nevertheless, Catlin could say with truth that he found in Sir Thomas "my only patron and benefactor." Phillipps had periodically offered to help Catlin out in times of need; on August 25, 1848, Catlin wrote to say he could use help now. Would Phillipps be willing to lend him £600 at 7, 8, or even 10 percent interest, with the Indian Gallery as security? This would satisfy Catlin's immediate cash requirements; the interest rate was of no consequence, since the loan would be repaid fully in a few months time when the United States government, which was "now agitating the question again," realized that the Indian collection was in truth encumbered and about to be lost: "Having in my Memorial to the Congress assured them it shall never leave these Rooms where it is now arranged until they give me the appropriation or some other Instn makes the purchase, it seems a pity that so much time should be lost. . . . Under such an arrangement I could safely say also to the Govt that the collection was *conditionally* sold in England which would be the thing to cause American Congressmen & the Press to make the proper move in the thing."[67]

Phillipps wisely declined, and Catlin suffered through another bleak winter scratching out a living. "My 'orders for pictures' . . . are *none* at all in these hard times," he complained that December. But the new year brought new hope and a well-orchestrated campaign with an edge of desperation to it. Catlin's opening salvo was a letter, circulated in the American press, reporting that the Russians had now entered the hunt for his collection and were prepared to offer $25,000 more than he had asked of the United States government. Patriot that he was, he was holding out pending Congress's early decision. On January 4, 1849, from his rooms at 6 Waterloo Place, he next directed a letter to the members of Congress, along with copies of the 1848 catalog of his Indian collection, his previous memorials, and the Library Committee reports. Gurley's memorial was, Catlin said, the last he could "possibly make" to Congress; it had always been his hope that his collection would one day find a permanent home on American soil; but to his regret he was "not able longer to keep the collection for my Country." His domestic cares and burgeoning debt made an immediate decision by Congress imperative. Indeed—and here Catlin employed the strategy he had proposed to Phillipps—his unfortunate circumstances "alone have induced me to entertain a proposition for the purchase of my collection on this side of the Atlantic, which, from the conditional stipulations already (but reluctantly) made, must at once decide the fate of it if no measures are adopted by the Govt during the present

session, for its preservation in our own Country." Phillipps, of course, had avoided such a "conditional" purchase by refusing Catlin a loan; it is probable, however, that Catlin had since mortgaged a portion of his gallery to another moneylender. His point was that time had run out and his country, "in this golden era of her existence," either extended him its patronage or sacrificed forever the chance to own his Indian collection.[68]

On the evening of February 27, 1849, Senator William L. Dayton of New Jersey, a Whig, moved for an amendment to the civil and diplomatic appropriation bill then under consideration, inserting an item of $5,000— the first of ten yearly installments on $50,000—for the purchase of Catlin's gallery. A lively debate ensued, perhaps because senators wanted some diversion from the contentious issues that had been occupying their time. What was to become of the territory acquired from Mexico the previous year? Should slavery be allowed free access to New Mexico and California? What precisely was the status of a territory in relation to the federal government and the member states of the Union? Beneath the particulars ran the old, deeply divisive question of the relative power of the state and federal governments. The cost of victory over Mexico was, by February 1849, becoming all too apparent.[69]

Dayton led off the discussion, making the case for purchase; he was followed by Daniel Webster, who weighed in with a strong endorsement of Catlin's gallery, then a string of seven southern senators, broken only by the Finance Committee's chairman, a New Hampshire Democrat who disapproved of the Senate's debating such a trivial item when important appropriations bills remained unpassed. In addressing the issue of government patronage of the arts, and specifically the purchase of the Indian Gallery, it was evident that the southern Democrats had in fact never left the states' rights question, here focused on a spreading federalism that would place the arts under the national government's fostering care without, they argued, constitutional provision. Robert M. T. Hunter, a Virginian, feared that acquisition of Catlin's gallery would be "the commencement of a career which is to involve this Government in the pursuit of objects for which it was not designed. I perhaps should have felt less interest in this matter had it stood alone, but I think I have seen evidences . . . of a design to commit this Government, by precedent at least, to a general encouragement of the arts and sciences."[70]

Thus was Catlin's case ensnared by the momentous issues of the day. The speeches by Webster, with Henry Clay one of the most prominent Whigs in America, and Jefferson Davis, a Democrat from Mississippi whose prominence lay in the future as president of the Confederate States of America, pinpointed the concerns that were splitting the nation. Both men admired Catlin's initiative, both had visited his gallery when it was exhibited in New York City in 1837, and both respected his work. But

Webster spoke for purchase, Davis against it. Their reasons were illuminating.[71]

Webster championed Catlin's cause on principle. A New Englander of broad learning and formidable intellect, he had the insatiable curiosity about history and the world befitting a former secretary of state. The money required to purchase Catlin's collection was trifling, and irrelevant anyway, Webster asserted. The question was whether "there should be owned and possessed in the United States this collection of pictures of the principal aborigines of the country; whether it is not a proper case for the exercise of a large and liberal—I will not say bounty—but policy?" The question, in short, was federal patronage:

> Somebody in this country ought to possess this collection of paintings; and I do not know who there is, nor where there is to be found any individual or any society, who or which can with so much propriety possess himself or itself of it as the Government of the United States. For my part, . . . I do think that the preservation in this country of such a gallery as Catlin's pictures is an important public policy. I think it properly belongs to those accumulations of historical matters concerning our predecessors on this continent which it is very proper for the Government of the United States to possess.

Later in the debate Webster added: "I go for this as an American subject; as a thing belonging to us—to our history; to the race whose lands we till, and over whose obscure graves and bones we tread every day; as a thing more appropriate for us"—here, the nationalist in lieu of the cosmopolitan—"than the ascertainment of the ices of the south pole, or any thing that is to be ascertained with respect to the Dead Sea, or the River Jordan." Webster's allusion to explorations abroad brought laughter, since the Senate earlier that day had approved another amendment to the civil and diplomatic appropriations bill providing for publication of the reports of the United States Exploring Expedition, a process that had been dragging on since the ships returned in 1842.[72]

Indeed, an additional expenditure agreed to the same day allocated funds for the alteration of the Capitol building, a project that in the long run would prove a fruitful source of patronage for American artists. Consequently Jefferson Davis, the last speaker on the Catlin amendment, declared himself unafraid of establishing a precedent by acquiring his paintings. "There are precedents enough, for we have not only purchased paintings but statuary, and have in one of our public buildings [the National Institute] a museum of curiosities." The problem, as he saw it, was the scale of Catlin's collection, which "could not be displayed in any room we have. It would require a gallery, an institution for fine arts." He

regretted this fact because unlike some of the other southern senators—notably Andrew P. Butler, a states' rights Democrat from South Carolina who managed to raise the issue of Osceola and the Seminoles again in opposing purchase of the gallery—he had nothing but respect for Catlin, "a great American artist, who was my companion and friend at an early day." They had ridden together on the southern plains in 1834 when Davis was a twenty-six-year-old first lieutenant in the United States dragoons and Catlin a relatively unknown painter obsessed with Indians. The thrill of the chase had faded that summer as typhus and dysentery were added to the expedition's other woes—a shortage of provisions and the blazing heat—to deplete the ranks and produce such misery that even the usually irrepressible Catlin, enfeebled by fever, had more than enough.

Davis vividly remembered the hardships of that summer's march and would not abide lumping George Catlin with artists like Charles Bird King who painted Indian portraits in the comfort of their studios. Catlin had "gone far beyond the frontier settlements of the West. He has seen the Indian in his wild and untutored state. . . . He has painted the Indian as he lives, unfettered by art, untamed and [not] degraded by the contact of the white man." It was a stirring tribute to an old comrade, but it did not change the principle at stake, or Davis's vote: "My objection to the purchase of this collection is, that it is a departure wider than any which has preceded it from the simple republican character of the Government. . . . We have reached a point at which, if we do not pause, I see no limit. . . . Congress becomes the patron of art, the caterer to the tastes and refined pleasures, as well as the law-makers of the republic. For these reasons I shall be compelled to vote against this amendment." Davis's speech closed out the debate; by a vote of twenty-five to twenty-three, the amendment was defeated. Dayton brought it up again the next evening, February 28, and this time it was soundly defeated, twenty-one to fifteen. With the issue decided, on March 3 the House discharged the committee of the whole from further consideration of the joint resolution.[73]

 * * *

Catlin had *counted* on a positive result in 1849, forgetting that his Whig friends in high office were checked by a Democratic majority in the Senate and a near balance in the House. The votes were just not there. We can only guess at his distress, but this much is certain: Catlin had flirted with mortgaging his Indian collection as a ploy in 1848; after the deciding vote in February 1849 ended any hope for congressional purchase, he began to encumber it in earnest. On May 8, as a guarantee for a £100 loan, he deposited twenty paintings from his collection with Sir Thomas Phillipps. It would be five years and many defaults before he would reclaim them, not for cash but for fifty oil copies of Indian scenes chosen by Phillipps. Creditors less shrewd than Phillipps took a percentage interest in the

whole gallery rather than physical possession of specific paintings, as Catlin, still dreaming of a grand coup that would redeem all his debts, mortgaged his only asset beyond its value. In the same period he was rapidly advancing to financial disaster on a second front. California, so recently acquired by the United States, was on everyone's mind by December 1848, when the president's annual message to Congress confirmed the rumors that had been circulating for months of a gold strike of unparalleled richness. The rush was on, and Catlin, who had never been west of the Rockies, saw a fresh opportunity to convert his frontier expertise into cash. "I wish you or I had a deed for a hundred or two acres in the gold mines of California!" he wrote to Phillipps on December 30; Phillipps agreed—had Catlin's wanderings extended to the California tribes, perhaps he would have been the one to discover gold. Given the hard luck story that the actual discoverer, Captain John Sutter, lived out, Phillipps's jest was uncomfortably close to Catlin's reality. At least Phillipps regarded it as a jest; Catlin, unfortunately, did not. If people wanted a California dream, he would give it to them. His Indian Gallery might be old hat, but what English workingman could resist a lecture on "The Valley of the Mississippi, and Its Advantages to Emigration, with an Account of the Gold Regions of California"?[74]

In the version Catlin delivered in the Free-Trade Hall in Manchester on January 5, 1849, he claimed an intimate knowledge of the Far West, though he was vague about his familiarity with California. On a colossal map, he pointed out the major geographical features of the West—the mountain ranges, the river systems, focusing on the Missouri. He was not advocating emigration "to any part of the world," but should any of his listeners care to go to America—a round of applause told him he was on the right track—he would do his best to advise them. The Mississippi valley could hold 50 million more, each with a substantial farm to pass on to his posterity. More applause. Other rivers in other regions were patiently described. Then he turned to California. His pointer traced the Sacramento and San Joaquin rivers, site of the "gold diggings," mecca for the feverish dreamers in front of him. But he did not conclude with California; risking anticlimax, he instead indicated the region between the Great Salt Lake, the Sierra Nevada, and the Rockies, which he claimed to have traversed. This area, so often dismissed as a barren desert, was in fact a well-watered, "beautifully variegated, fine, and fertile" land. Moreover, he allowed—and now the audience was his again—"he believed this tract to be equally rich in gold with that west of the Sierra Nevada, where they were now digging gold. Nay, he believed that gold would be found and worked with equal success east of the Rocky Mountains." Gold had even been discovered near the Great Salt Lake in greater abundance "than upon the banks of the Sacramento." These opinions, of course, he offered as an

amateur mineralogist—but one after whom the red pipestone, catlinite, had been named. Shamelessly, he pressed on. There was a mineral belt stretching across America from the Sierra Nevada to the Alleghenies, and the great geological upheavals that created these ranges and the Rocky Mountains in between broke the crust of milk quartz and shed the ores beneath in the valleys on both sides. Hence the recent accounts from California of miners smashing lumps of quartz "with sledge hammers, and picking out the gold with bowie knives." Having fired the imaginations of the gullible and the greedy, Catlin pressed on. He had personally seen Comanche and Kiowa Indians with necklaces made of "lumps of Gold" picked up, they told him, just seven days' ride west. They were prepared to escort him to the site, but an attack of bilious fever—at last, a nugget of truth!—prevented his going. His listeners, however, *could* go . . . and he predicted they would find the American gold region to comprise an area not less than that of Great Britain, at least a thousand miles square, the long-sought El Dorado, the ultimate source of Montezuma's treasure tapped, but never drained, by Cortez's Spanish conquistadores. Who would venture in quest of it? Who would *not*?

Besides giant maps, Catlin illustrated his lecture with paintings showing the rivers and scenes referred to and typical emigrant activities in the West—logrolling, boating, establishing and improving a claim—men prospering, in short. He concluded with a picture of a "weed prairie" in northern Texas abloom with wildflowers. *This* was where he was steering would-be British emigrants with the gleam of gold in their eyes. Should they wish to settle on this portion of El Dorado he had practical advice for them about organizing a company or colony to minimize costs (not toil or dangers—this was a pitch, after all). He knew where they could "together obtain, at half the cost to individuals, a large tract of good land, with undoubted title," for only five shillings an acre. They would find it, he said, again to applause, not only a superb farming area but "the real, true, and best gold region of the North American continent." Catlin would himself be off to America in a few days, following a final lecture on the Indians at which the interested could again study his views of the Mississippi and California.[75]

In the face of personal adversity, the showman in Catlin had come out fighting. Better to deal in congenial fantasies than to starve explaining Indian pictures. After all, others were cashing in on the California mania. Based on his mineralogical expertise, Henry Schoolcraft had weighed in from Washington with a report heavy on hearsay and light on firsthand knowledge, "Diluvial Gold Deposits of California." And the ultrarespectable Francis Parkman's narrative of his 1846 western travels appeared under the title *The California and Oregon Trail* although, a friend chided, Parkman had not been "within a thousand miles of the inhabited part of

California."[76] Catlin's problem was that he had done more than alter an old lecture to gratify new tastes. He was, in fact, actively engaged in an emigration scheme to attract Britons to Texas and, as a paid agent, was duping ordinary people for personal gain. Having kept company with the king of humbug in his Indian exhibition days, Catlin now was swimming in the same waters with "land sharks" of the sort denounced by the *Times* for preying "upon the simplicity of poor emigrants going out to the United States by pretending to sell them good fertile land in some healthy, thriving locality" which "turns out to be either a sand-hill or a swamp."[77]

As emigration became an accepted palliative for labor's problems in mid-nineteenth-century England, a variety of enterprises sprang up to service the traffic. Agriculture held a special attraction for city-weary workers looking for a healthier outdoor life, and the American West loomed magically as an agrarian paradise. The merger of the Universal Emigration and Colonization Company with the United States Land Company in June 1850 consolidated the two principal agencies encouraging English settlement in Texas. George Catlin, because of his familiarity with the West and his experience in promoting the Mississippi valley's advantages for emigration, was named superintendent of the company's Texas Department and spent the summer of 1850 lecturing throughout the English Midlands. His duties as superintendent went beyond talking up Texas; he was actually to lead the first party of emigrants to the promised land, but shortly before their departure from Liverpool on September 3 he resigned, ending all connection with the company.[78] An Austin, Texas, paper welcomed the first arrivals in November and referred to the proposed colony sixty miles to the north as "the project of Mr. George Catlin," unaware that he was no longer associated with it. The wife of his replacement remarked that her husband accepted the post "when there was that stir about Mr. Catlin"—"the most unlucky thing he ever did." Perhaps he was left to take the blame for the discrepancy between Catlin's word pictures and Texas reality. What the "stir" was about is uncertain, though one can speculate that it had to do with money. The colony itself did not last a year.[79]

The best that can be said for Catlin's involvement with the United States Land Company is that, like most of his financial ventures, it was a failure. At the end of 1850 he told Phillipps his tale of woe. Besides time and energy, he had invested £1,200 in the enterprise. For his services as lecturer and prospective leader of one of the emigrant companies he was to have received an additional £1,500. Instead, all hopes for compensation and return had vanished, and he was virtually a ruined man. Catlin got little sympathy from Phillipps. "I am extremely sorry to hear of your bad success," he replied, "but I always thought it was a wild goose chase." What Phillipps did not know was how close to financial disgrace Catlin, who always claimed to be in dire straits, really was. Reduced to paying off his

£100 loan from Phillipps at the insulting rate of £2 per painting, he still kept on Phillipps's good side, buying time, wheedling, trying to sell him other paintings, and offering alternative deals in exchange for the twenty oils Phillipps held as security on the loan—his model of Niagara Falls, for example, valued at £300. In July 1851 he came up with a new request that could earn Phillipps his lasting gratitude.[80]

To get out from under his onerous burden of debt, Catlin *had* to sell his entire gallery. Congress remained his best hope, and he resolved this time to be in Washington, personally lobbying for his bill. He would have a two-hundred-foot long temporary building erected to display his entire collection. Congressmen could then see what they were voting to buy, and with him there urging them on he was confident they would pass the necessary appropriation. Phillipps figured in his calculations in two ways. To stir up interest, it was imperative Catlin publish the second, long-promised part of his *North American Indian Portfolio,* and this would require £500, with anticipated revenues of £600 to £800. If Phillipps could advance him this amount, he would pay it back in six—or even three—months at 15 percent interest, with a bill of sale for his whole Indian collection as security. Out of the £500 he would at once repay the £100 he already owed Sir Thomas, thereby relieving himself from the "tremendous hard job" of executing fifty small paintings, and at the same time realizing his second aim, the return of the twenty pictures in Phillipps's possession, rendering the gallery intact for its American exhibition. Phillipps begged off. He was himself strapped for funds, he wrote. Left unsaid was the difficulty he had encountered in getting Catlin to honor his existing debt.[81]

It was in this period of severe financial distress that Catlin dreamed up his most implausible money-making scheme yet. Congress had failed him too often to be relied upon. He needed a backup, something that would induce other nations to bid on his Indian collection. And he had a plan.

After his flight from Paris and return to the London exhibition scene in 1848, Catlin had been forced to face facts: he would never recapture the audience and acclaim that had been his at the Egyptian Hall eight years before. In casting about for a new way to promote his collection, and possibly sell it, he had been attracted by the spirit of universal philanthropy astir in England. Perhaps his Indian Gallery could be made the centerpiece of a Museum of Mankind, illustrative of primitive lifeways worldwide, a traveling exhibition that would bring the plight of natives in an age of colonization to the attention of people everywhere. He had advanced this idea a decade before in an address to the Royal Institution of Great Britain and had subsequently incorporated it in his petitions to Congress. But in March 1851 he gave it formal, visionary shape in an address read before the Ethnological Society of London.[82]

"I propose to build or purchase, a steamer, of suitable dimensions and construction . . . , as a *Floating Museum,* and with her collections arranged for exhibition, visit the seaport towns of all countries, thereby teaching the looks and modes of nations *to* all nations, and thus keeping the Collection always a subject new, and consequently one of exciting and remunerative interest," Catlin declared. A steamer could be easily converted to this use, avoiding the expense and delay of erecting a building while ensuring an unlimited audience for its displays. The sum of £52,000 would cover the entire cost of the steamer, his collection (£18,000), and current expenses; to raise that amount, a limited-liability company should be established, with a board of directors and shares valued at £1 each. All stockholders would receive free admission, and large stockholders (fifty shares or more) could have half-price passage on the steamer to any of its ports of call—and, of course, handsome dividends, since the floating museum was bound to turn a profit. Other collections would be added, each modeled on the Catlin prototype with portraits and casts of distinguished native leaders, scenes of ceremonies, dances, and amusements and a sampling of costumes, artifacts, picture writing, relics and—in deference to the scientific interest in skull conformation as a key to individual and racial character—craniums. Science would be further served by the convenient concentration of materials relevant to each discipline, the museum thereby becoming a center for ethnological and physiological studies.

Once launched, the museum would steam from port to port, visiting "the chief cities of the world" and, Catlin said with a trace of irritation at his own difficulties, "stopping no longer in any, than a lucrative excitement could be kept up." Like a snowball the collection would grow, and there would always be aboard ship "living illustrations of the people from the different native tribes" who would—here, a bid for philanthropic support—be educated as they sailed, "free from the contaminating vices" that destroyed them ashore. Catlin envisioned an "ABORIGINES SCHOOL" wherein native students would be instructed in the English language (a rather parochial preference, more in tune with his audience than with the universalism of his plan), Christianity (ditto), and the "useful mechanical arts" (carpentry, blacksmithing, weaving, navigation—they would become apprentice seamen, reducing the need for crew and overhead as well). Catlin wasted no time on sentimental regrets; "every effort" should be made "to impress upon their minds, just ideas of the advantages of civilization," to the detriment of their ethnological interest, presumably, leaving only artifacts and pictures to tell of their prior existence. The grand salon of the vessel would serve as a lecture room, accommodating the experts of each country visited, who would speak in their own languages (though the native troupes would be proficient only in English) on matters of local interest.

The experiment might reach a conventional end, Catlin conceded, since many nations, enthralled by the collections, would doubtless vie for the privilege of housing them permanently. The floating museum would then go "to the Government that would pay the highest price for it, and perpetuate it on land as a National Institution."

So there it was: a two-hundred-foot steamer, piloted by a master mariner with stock in the company and self-interest at stake, light of draft to allow entry into the shallowest port, and fully equipped to safeguard its invaluable cargo against the dangers of fire and the perils of the sea—protected, most of all, by its flexible schedule, which would permit it to move in good weather and remain anchored in bad. Safety and comfort would take priority over speed and profit. Catlin even proposed an itinerary: first the seaport towns of England, Scotland, and Ireland, then the North Sea, to St. Petersburg and other cities on the Baltic. This would expose Russia and Asia to the floating museum and ensure fresh interest when, with its augmented collection, it revisited the English towns en route to the Mediterranean, the Black Sea, and one day the Atlantic coast cities of America.

This scheme, harebrained to put it kindly, sums up Catlin at midcentury. Still earnest, still searching for the main chance, his head was full of plans even grander than those that had failed before. In the published version of his proposal he included flattering extracts from the 1846 Library Committee report and the 1849 oration by Daniel Webster, both mementos of previous defeats. It was as though each setback were to be overcome by mounting a new project twice as implausible. Staring ruin in the face, Catlin dreamed on. He fooled no one as frequently as he fooled himself. In despair one day, his hopes soared the next, and he fantasized not success, but a triumph so complete it would confound his critics, humble his enemies, and shake the world to its foundations. Timing was everything, he convinced himself, and it had been bad timing, not intrinsic flaws, that had doomed his earlier projects. The floating museum could not fail. By one masterly stroke, he would transcend the role of small-time showman pandering for pennies and, as proprietor of a global museum, regain the respect he was entitled to. In fact, his scheme was less persuasive as science than as entertainment. Consequently the Ethnological Society received it with due caution, applauding Catlin's zeal and endorsing his proposal as "of great advantage to Ethnology" but adding, in a resolution passed March 13, 1851, a more attainable consolation prize: "under any circumstances, the Council trust that Mr. Catlin's present valuable *Collection* will not be lost to this country, but will find its way to the Ethnological department of the *British Museum*."[83]

It was a gesture akin to those Catlin had so often received from the American government: polite but meaningless, since it entailed no finan-

cial commitment. Subsequently Catlin claimed that the society had encouraged a subscription drive, "headed by the names of some of the first personages in the kingdom," to purchase his collection for the British Museum. In fact, he championed his own cause by carting two of his costumed Indian figures to the Crystal Palace for display in the American Department of the Great Exhibition of the Works of Industry of All Nations. Press criticisms had alerted him to the opportunity. Aboriginal manufactures were underrepresented throughout the exhibition, the *Illustrated London News* had complained, while the United States display needed bolstering. It was worthy but lean, and the London *Times* had sported with the image of America's huge eagle effigy presiding over an exhibition space as sparsely occupied as the continent itself. Catlin's models of an Indian man and a young Indian woman decked out in tribal finery addressed both concerns; installed on a bridge directly behind the one American display that had occasioned comment, Hiram Powers's nude sculpture *The Greek Slave,* they attracted the attention Catlin now often courted in vain. On average, nearly forty-three thousand visitors a day swarmed through the exhibition hall. No venue would expose more people to Catlin's Indians or his cause, a Museum of Mankind. "These Indians and their works suggest a powerful motive for making the Exhibition *permanent,*" the *Illustrated News* contended. Here was a long-term use for the Crystal Palace. Catlin's collection and similar aboriginal materials from around the globe could be purchased and displayed in "ethnographical galleries." Speakers could lecture school classes and the public at large on aboriginal history and culture while setting out the case for an international code of conduct to protect the remaining native populations. Thus "what began in amusement, will end with instruction."[84]

So promising was the boost given his museum scheme that Catlin pulled out all the stops. Abandoning his scruples about touring with Indian delegations, he squired a party of Iroquois through the Crystal Palace. They did the expected, whooping in astonishment at what they saw and, in turn, astonishing curious onlookers. But there was a bad portent. Catlin's costumed figures were attacked by a drunken woman and knocked to the floor. Gazing down at the broken forms, the Iroquois pronounced judgment on the evils of the white man's firewater. For Catlin, their wanton destruction foretold the dashing of his latest hopes. On October 15 the Great Exhibition closed its doors; no arrangements had been made for a Museum of Mankind. Within six weeks, Catlin was back pleading with Sir Thomas Phillipps for another loan. Never, he lamented, had he been in such financial distress "and never wanted a patron so much." Could Phillipps, or through him someone else, raise the £500 to £600 he had requested in July? "If you can suggest anything, pray let me hear as

soon as possible—I *must* keep my collection to-gether." Poignantly, with the same letter Catlin enclosed a copy of his proposal for the floating museum and invited Phillipps to become a director.[85]

 * * *

Although Catlin might still profess confidence in the future, there was nothing feigned about his growing panic. By the end of 1851 he had exhausted his credit and his credibility; Phillipps frankly advised him that he would be unable to obtain the loan he needed without actually surrendering his collection to the lender. His paper simply was no longer security enough. Compounding Catlin's woes was the impression he had once so assiduously cultivated that he was prospering in Europe. A consort of noblemen and kings, in America rumor had it that he had sold or was about to sell his collection for not a penny under $100,000. Thus his intermittent appeals for congressional patronage warred with the public perception of him as a wealthy artist who had forsaken his homeland for material gain and the pleasure of consorting with the Old World aristocracy.[86]

 Catlin intended to accompany his gallery to Washington over the winter of 1851–52 to plead his case in person, a plan prompted in part by necessity. In January 1851 the Lords of the Treasury had extended the exemption on duties for his Indian collection only through the next exhibition season, "at the expiration of which the collection will be taken from this country." Never was Catlin's presence in Washington more essential, but he did not have the resources to go home. Congress, for thirteen years his main hope for financial success, had become his sole hope for rescue from financial disgrace. The year 1852 would see his last concerted effort to sell the Indian Gallery to the American government. By summer he would have nothing left to sell.[87]

 Catlin began his campaign in 1852 as he had in 1849, with a circular letter to the individual members of Congress, accompanied by a four-page leaflet and an eight-page pamphlet, both reprinting the 1846 Library Committee report and the 1849 speech by Daniel Webster. Since Webster had so effectively stated the case for federal patronage of the arts, his speech set the right tone for Catlin's latest appeal. "I have had no aid from Government or any individual in making this Collection" and have incurred "an almost ruinous expense" in holding onto it, Catlin explained in the letter, dated April 4. As usual he warned that an outside party—this time the Royal Ethnological Society of London—was maneuvering to acquire his collection. It could yet be saved, however, "provided the action of Congress be quick."[88]

 The need for quickness was unrelated to the reason Catlin gave. The Ethnological Society's subscription drive to purchase his collection was

hardly of urgent moment; the real threat was Catlin's English creditors. Their claims made it imperative he sell at once, and in a personal letter to Webster, also dated April 4, Catlin explained why

> The latter part of my life in this Country has been unprosperous, & . . . I have been led into unfortunate speculations which have brought my affairs to a most trying and alarming state. . . .
>
> . . . I actually tremble for the security of my works. I am fighting at this moment with the most unfeeling wretches which the civilized world I have just learned is made up of, to protect my Collection for my Country. . . .
>
> If my Collection comes to the hammer, it would not more than pay my debts, and would inflict an indelible disgrace on our country in the estimation of English people. If it can get the appropriation of Congress, it will have the benefit of my future life in adding to its extent and interest.

Perhaps disingenuously, Catlin twice told Webster that he was sharing with him what he would not tell the world. "I don't know that you can appreciate the position I am in & the feelings under which I am stung at this time," he wrote, "but I trust that you will excuse me for naming them, (in confidence), to you."[89]

Webster could be permitted a grim smile. In the 1830s, while Catlin was hunting Indians to paint, he also had invested in the West, to his regret, since he was caught in the panic of 1837 that sent land prices crashing and wiped out fortunes far greater than his own. Perpetually in debt, beholden to others for financial favors, he knew how pride warred with need when one was hard-pressed. But what could he do? Though Catlin followed the American news in the English papers, he seemed out of touch with domestic politics. In his mind Webster was the same towering figure who had championed his cause in the past; thus he addressed him now at the United States Senate, oblivious to the fact Webster had not sat in that body in two years and would not be present when Catlin's bill came up for deliberation. Webster had his own problems. He was secretary of state in a troubled administration and an available presidential aspirant without, events proved, a chance of winning. Like another Catlin hero, Henry Clay, who died on June 29, in 1852 Webster was old and weary. Protracted frustration and a culminating deep disappointment would be his lot that summer; in the autumn, while Catlin was trying to pick up the pieces of his own life, Webster died. He was a frail reed in 1852, then. But to Catlin he was still the Godlike Daniel, the ultimate Whig, eloquent in debate, learned and profound, a friend in need, and the artist courted him eagerly in the expectation that he would soon crown his "splendid career" with "elevation to that seat which I confidently hope and believe is now preparing for

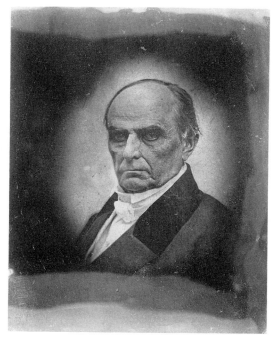

49. Daniel Webster (1782–1852), Catlin's Whig hero and champion in 1849 and his main hope in 1852 though, as this daguerreotype made about 1850 shows, old and worn out by then. Massachusetts Historical Society, Boston.

you." Webster as president—there was a prospect to cheer him in his troubles.[90]

So as his world crumbled about him in England, Catlin continued to appeal directly to Webster. In mid-April the crisis was at hand. "Queen's Bench *prison!* London," Catlin headed his next letter:

> I am filled with sorrow and shame that I must address you from such a place as this—but so it is, and I am only induced to confess it in the hope that something may yet be done to save my Collection, the labour and the ambition of my life.
>
> . . . My Collection is in the hands of and at the mercy of, my creditors, and as you will see by the enclosed placard of the Auctioneer, advertised to be sold—I have not the power to save it—but the Congress of My Country has, provided their action is quick. I believe the sale can be delayed some 5, or 6 Weeks. And within that time it can be saved. . . .
>
> If nothing is voted for *me,* for Heaven's *Sake,* for our *Country's honour's* sake, let the Collection be redeemed and kept together. . . . I have never had an office, or a perquisite or a shilling in any way from our Government, nor asked it—I will give them the works of my life if they will pay my liabilities, and save them—i.e. if they are not willing to vote me the price I have asked for my Collection.
>
> You can imagine me *unhappy.*[91]

When Catlin next wrote he no longer asked confidentiality—he was willing, indeed eager, to go public with his woes. From Paris, on May 8, he notified Webster that he had also written "several others of my friends in Congress" and was sure that "some efficient measure" had been taken since to preserve his collection. "And if not, I *pray that one desperate effort more* may be made to save it." He would have come to Washington in person,

> but by the laws of England, aliens about to leave the Kingdom, are liable to arrest, no matter what amount of property they have, on representation by a creditor that such is a debtor's intention. Such was my case, I was about to embark, and was for several days under arrest for a small amount, until, by the aid of a kind friend I got released, and by attempting again to embark by an American steamer, I might have been liable to the same trouble again; I therefore came to Paris for a few days, 'till I can hear the result of my last application to Congress, and in the mean time I am endeavouring to obtain an audience of the Prince Napoleon with the view of offering him my Collection in case the Congress do nothing effectually for me.

Even with panic evident in every line, Catlin could not abandon his oldest ploy: another buyer was waiting in the wings. The face-saving dispensed with, he continued his plea: "Several friends in London will see to the protection of my Collection and endeavour to get a longer delay of the Sale, until the Congress can be heard from. . . . I am asking of the Government no *bounty* or *gift,* but merely what I think the Collection is well worth." Since it was, as Webster had said in his 1849 speech, eminently an American collection, it would be "a disgrace to the Government" if it were now lost.[92]

The auctioneer's advertisement mentioned by Catlin was crucial to his appeal, substantiating claims that might otherwise be dismissed on the basis of past hyperbole. London was placarded with them, Catlin wrote to the Reverend Mr. Gurley on April 15. Their content was made a matter of public record during the debate over purchase, providing an itemized description of a collection unseen in the United States in more than twelve years and a legitimate reason for Catlin's distress. For once he was not exaggerating. Catlin's letter to Gurley was also made public when Gurley sent a copy to Senator William Henry Seward and published extracts from it in the *United States Gazette.* "I need make no other appeal to the Congress after this," Catlin wrote. "It is now but a simple question, Are my works worth preserving to the country?" The *Gazette,* the *National Intelligencer,* and the *North American Miscellany and Dollar Magazine* thought so and hoped Catlin's appeal would be heeded.[93]

On June 8 the Senate resumed consideration of his case. Seward, future secretary of state in the Lincoln administration, introduced a resolution

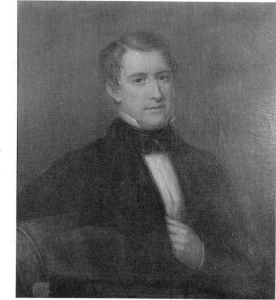

50. Charles Bird King, *William H. Seward* (1839). Seward (1801–72), a leading New York Whig, succeeded Webster as Catlin's advocate in 1852. Redwood Library and Athenaeum, Newport, Rhode Island.

calling on the Library Committee to report a bill for the purchase of Catlin's Indian Gallery, "in danger of being sold and lost to this country." As governor of New York, Seward had viewed Catlin's paintings in Albany in 1837, and on October 4, 1839, he sent a friendly farewell. "If I could do any thing to contribute to your success in your visit to Europe it would make me very happy," he wrote. "I have the highest respect for your talents and acquirements."[94]

Seward was a national figure and one of the Whig power brokers when he succeeded Webster as Catlin's champion, but it was an uphill battle all the way. Congressmen, benumbed by Catlin's barrage of memorials and letters, were unmoved by his latest plea. "We have come to this old acquaintance of ours, who has been here longer than I have been," an exasperated senator remarked during the course of debate. "I met this proposition here four years ago, and it has followed us up ever since. We have heard every session of 'Mr. Catlin and his Indian portraits,' 'Mr. Catlin and his Indian portraits,' until it has to me become almost like a certain patent bill that we had under consideration a year or two ago, which came pretty near running everybody out of the Senate, and we at last got so sore about it that we dismissed it, and would not consider it any further." Given this attitude, Catlin was fortunate in having Seward in his corner.[95]

On June 10 the Senate began consideration of Seward's resolution, amended so that the matter would be referred to the Committee on Indian Affairs rather than the Library Committee. This was challenged as confusing subject matter (the Indian) with committee function. "The mere fact

that a gallery of portraits of Indian chiefs has been collected, with which it is perhaps desired to enrich the gallery of the Smithsonian Institution, or that of the Patent Office, constitutes no reason for referring the resolution to the Committee on Indian Affairs," a member of that committee complained; the Committee on the Library had related inquiries under its purview and was the proper body to evaluate the worth of Catlin's works. But the chairman of the Library Committee saw no reason a committee "charged with the purchase and collection of books" should have to concern itself with "curiosities" not intended for the Library of Congress. The committee structure was not designed to accommodate petitions such as Catlin's, a point made by a Democratic senator from Arkansas who opposed his case "on its merits." "If the Senate is to become, theoretically and practically, by its legislation here, the patron of the professors of the fine arts, . . . we should have a committee of the fine arts." There was no such committee because the fine arts were outside Congress's constitutional jurisdiction, and Seward's resolution was as well. As a states' rights Democrat from South Carolina remarked, "My objection is not whether this resolution should be referred to this committee, or to that committee. . . . I object to matters of this sort coming up before the Senate, and would oppose its reference to any committee."

The procedural wrangle indicated the difficulties besetting government patronage of the arts at midcentury. It also boded ill for Catlin's chances, since the chairmen of the Library and Indian Affairs committees did not support his resolution and, as one put it, did not wish to be "saddled" with it. Seward proposed a compromise. The resolution was redrafted to read that a select committee should inquire into the purchase of Catlin's Indian collection. In this form it was approved by a vote of twenty-one to sixteen. On June 14 the select committee was named: Seward, William M. Gwin, a Democrat from California by way of Mississippi, and Joseph R. Underwood, a Whig from Kentucky.[96]

Seward submitted the committee's report on June 23. During debate two weeks earlier he had defended his resolution obliquely, noting that there was "some considerable merit acknowledged" in Catlin's paintings and that "a large class of the community" attached importance to them. For himself, Seward was most impressed by Catlin's "destitute condition" and advocated purchase as "an act of kindness to one of our countrymen abroad." This seemed to skirt all the significant issues raised by Catlin's case, resting it on the flimsiest of personal grounds. But the select committee report, which Seward probably drafted, did address directly the federal government's responsibility to the arts. "Without either public or private patronage," Catlin had produced a collection of Indian paintings "which gratifies an enlightened curiosity now, and will with the progress of time

acquire an inestimable value as an aid to the philosopher and the historian in the study of human nature in a peculiar stage of development."⁹⁷

Usefulness could be fairly applied as a test of value. Since the late 1830s Catlin had been trying to sell his Indian Gallery to the government. Artists and citizens at home and abroad had attested its importance as an American work; congressional committees had recommended its purchase. Most recently, on June 16 nine New Yorkers—the very cream of the city's intellectual establishment, including the poet William Cullen Bryant, obstetrician John W. Francis, lawyer Maunsell B. Field, publisher of the *Literary World* Evert A. Duyckinck, legislator Gulian C. Verplanck, president of Columbia College Charles King, and clergymen Francis L. Hawks and Thomas De Witt (a kingpin of the New-York Historical Society)— had submitted a petition advocating purchase of Catlin's paintings "not only to reward native genius, but as works of great importance in making up the annals and chronicles of our own early history. As works of Art of their class, they are not surpassed." The select committee concurred:

> Admitting the merit of the collection . . . no argument can be brought against the purchase of it on just and reasonable terms, which would not equally weigh against every appropriation by Congress for the acquisition and preservation of the materials of science and of history; against the deposite of contemporaneous works in the library of Congress; the illustration of grand and interesting events in the national progress on canvass and in marble which grace the chambers, walls and gardens of the Capitol, and indeed against all the treasures of science and art already gathered into the archives of the country. . . . To reject the cultivation and perfection of the arts altogether, would be to concede that in all that makes us differ from the savage tribes, we are neither better nor wiser than they. In all countries, and especially in a republic, the great responsibility of those who are charged with the conduct of the affairs of society is the education of the people in valor, wisdom, and virtue. There is no point at which such education can be wisely arrested.

The report acknowledged state sovereignty in education but argued the federal government's equal duty to instruct its citizens. "Why should not the capital of the United States take on the classic dignity and the refinement worthy of the seat of government of a great people. How shall we better strengthen the bonds of union, than by rendering the Capital an object of pride and interest to the people of every state?" The political excellence of American republicanism would be best shown the world by an active encouragement of the fine arts and sciences.⁹⁸

Catlin had been frantic enough during his imprisonment in London to

offer his collection to Congress in exchange for repayment of his debt, a mere $25,000 instead of the $65,000 he had originally wanted. Safely ensconced in Paris, with the auction postponed from June 22 to July 19, he had returned to the price proposed in 1849—$50,000—which was, he pointed out, still $15,000 less than he had once required. Undoubtedly he had been encouraged by news of Seward's resolution, though when he wrote from Paris on June 24 he knew nothing of the subsequent debate. Thus he addressed his letter to James A. Pearce, a Maryland Whig who chaired the Senate Committee on the Library, unaware that Pearce was unsympathetic and had sidestepped committee responsibility for his bill. Catlin was deluding himself again. Purchase at *any* price would be a victory. Seward's report put matters into perspective. Catlin's financial misfortunes were in themselves no reason to act, he now admitted, but they afforded Congress a unique opportunity to acquire his Indian Gallery at a bargain rate. The accompanying resolution provided particulars. It authorized the president to appoint an agent to visit London, inspect the collection, determine its condition and value, and offer up to $30,000 for it. The terms were not especially generous, and the provision that the president could order Catlin's paintings and artifacts deposited in whatever public buildings in Washington he deemed proper was worrisome. It opened the way to their eventual dispersion. But both drawbacks proved academic anyway.[99]

Nearly a month passed before the Senate got around to debating the select committee's resolution. Meanwhile, politics preoccupied Washington in a presidential election year. The Whig party, Catlin's mainstay in his search for government patronage, had begun meeting in Baltimore on June 18. The slavery question haunted the convention. The frontrunners for the nomination—the incumbent, Millard Fillmore of New York, an "accidental president," since he took office following the death of Zachary Taylor on July 9, 1850, and Daniel Webster—were both committed to the Compromise reached in 1850, a legislative package that attempted to resolve the sectional issues of the day by admitting California to the Union as a free state, leaving the other territories acquired from Mexico to decide on slavery for themselves. A new, more stringent Fugitive Slave Law was also passed, with heavy penalties for noncompliance or interference with its enforcement. Webster had delivered an emotional speech on behalf of the Compromise as "the preservation of the Union," and Fillmore, upon assuming the presidency, had urged acceptance. Other powerful Whigs— notably Seward—had denounced the Compromise, appealing to "a higher law than the Constitution" where slavery was concerned. In proposing that a select committee be appointed to consider the purchase of Catlin's Indian collection, Seward had facetiously remarked that this was a fitting solution to the stalemate over committee jurisdiction "inasmuch as com-

promise is the order of the day." But at the Whig convention he threw his support behind the one candidate opposed to the Compromise of 1850 and thus helped nominate General Winfield Scott on the fifty-fourth ballot.[100]

Webster was so vexed and humiliated by his defeat that he mulled over quitting politics altogether and sailing to England for a change of scene. Had he done so, Catlin might have met his hero face to face and thanked him personally, as he hoped to do, for supporting purchase of his Indian Gallery in 1849. They could have swapped tales over a few glasses of chickabobboo. Both had seen their ambitions thwarted by the great sectional issues of the day. Webster believed that Scott's nomination made the Whigs an exclusively northern party, shackled to an antislavery platform at the expense of his most cherished principles, constitutionalism and union. Seward represented the hardening of the North's opposition to slavery; before the decade was out he would speak of "an irrepressible conflict" between slave and free, and even in 1852 he saw no room for further compromise. Internal cleavages had fractured the political parties that once bound the Union together. "The blast of wars" was distant yet; but war was coming, as surely as it had with Mexico, and Catlin again was hostage to history, his quest for patronage played out against the dominant issues of the day.[101]

On July 20 the Senate debated the select committee's resolution. After reading the accompanying report, Seward again mentioned Catlin's financial distress as having a bearing on the case. His collection was scheduled for auction on the nineteenth; the Senate had already exceeded that deadline by a day. "If, then, this question is ever to be decided at all, (and it has been before Congress many years,)" circumstances rendered it "essential . . . that it should be disposed of now." In Catlin's experience, Congress always deferred what it could; this time procrastination was impossible. Seward read Catlin's appeal from Paris of June 24 and the auctioneer's placard to create the proper air of urgency. And he offered a sop to the economy-minded, consistent with an expedient streak that made him, despite the causes he espoused, more pragmatist than moralist. In drafting its resolution, Seward noted, the select committee had assumed that Catlin would accept $30,000; his letter, however, asked $50,000. This presented the Senate with a no-lose situation. It could offer Catlin up to $30,000, less than half of his original price of $65,000 and substantially below his reduced price. Should he decline, at least Congress would have made the effort and absolved itself of responsibility were the collection subsequently lost to the nation.[102]

Seward was immediately challenged by an Alabama Democrat, Jeremiah Clemens, who designated the resolution "a model in its way" of "barefaced" Whig extravagance. The charge was conventional partisan

politics, drawing on the states' rights concern over expanding federal powers. What followed, however, was decidedly unconventional. Clemens suddenly abandoned the high ground of Democratic principle and championed not fiscal restraint but a rival artist.

This development was not entirely unexpected. Catlin realized that other painters, following his lead, had found in the Indian a congenial subject. Of his contemporaries, John Mix Stanley and Captain Seth Eastman were the most prominent, and though he had sailed to England before either was active in the field, he knew of them, or others like them. What he had not realized was how much ground they had gained in his absence, and how much support they had gathered in Washington, where both were living in 1852. Solon Borland, an Arkansas Democrat with four years in the Senate, had first introduced Eastman's name during the debate over purchase of Catlin's collection in 1849. The captain was unknown at the time, and Senator Henry Foote, a Unionist from Mississippi, had said all that needed saying: "I hope that the artist referred to, if he labors in the same field, will in the course of twenty or thirty years become as favorably known as Mr. Catlin. . . . He may be a very worthy gentleman, following the footsteps of Mr. Catlin. I am willing to encourage him, if circumstances warrant, in an undertaking not *original,* but in imitation of a more distinguished predecessor." Eastman had since formed a circle of friends in Washington who thought him a "capital fellow" and were willing to advance his cause. There is, Borland said in 1852, an army officer qualified "to produce a series of paintings . . . far superior to those of Mr. Catlin." His reputation was now established, and he was willing, Borland understood, to paint an Indian gallery for the government "for no greater compensation than he now receives as an officer. . . . The gentleman to whom I refer is Captain Eastman. . . . I have never seen him, though I have seen his works; and we have on the desks of Senators evidence of his eminent qualifications, in the illustrations which he furnished for Mr. Schoolcraft's book."[103]

The linkage was electric: Eastman and Schoolcraft, with Eastman merely the instrument of Schoolcraft's malice. For in Catlin's mind there could be no mistaking who was behind the opposition. Erstwhile friend and companion in the fight for justice for the Indian, Henry R. Schoolcraft had stepped out in the open as George Catlin's enemy.

Catlin jumped to this conclusion as soon as he read a copy of Borland's speech. It was despicable of the senator to besmirch his reputation and reject his appeal "because an officer in the Army offers to make a Collection for nothing more than the pay that he receives. If the govt. would give me a Captain's commission in the Army I would be glad to present them my Collection, and labour on painting and adding to it all my life." But Eastman was not the real issue. "There is a cruelty" in Borland's tactics,

Catlin continued, "which leads me to believe that there is more personal interest at its bottom than at first might be suspected." The culprit was Schoolcraft, "who is now the Indian historian to the Govt., and of course jealous of my collection and of all interesting information which he cannot be the first to publish." He had determined to block the purchase of Catlin's Indian Gallery so that nothing would "stand in the way" of his subsidized publishing project. "As he can have access to the paintings of Captn. Eastman for his illustrations without cost, a plan is on foot to put those works forward and drive mine out of the Country."[104]

But Catlin's conspiracy theory was confounded by what happened next. The resolution to purchase his collection on July 20 became an open invitation to acquire the works of an altogether different artist. "Let it be remembered, that at the time when this resolution was reported," Senator Clemens remarked, "there was here in the Smithsonian Institution a collection of Indian portraits which the committee have entirely overlooked." Their merit were extolled by none other than Captain Eastman in an astonishing letter to the man who painted them, John Mix Stanley:

> Washington, D.C., June 28, 1852
>
> DEAR SIR: Having been requested by you to express my opinion as to the comparative merits of yours and Mr. Catlin's paintings of the Indians of this country, it affords me pleasure to say that I consider the artistic merits of yours far superior to Mr. Catlin's, and they give a better idea of the Indian than any works in Mr. Catlin's collection.
>
> Very respectfully, your obedient servant,
>
> J. [*sic*] EASTMAN, Capt. U.S. Army.

It was presumptuous of Eastman, to say the least, to serve as judge when he had not seen Catlin's gallery in years, if ever. It was also puzzling. Was he so altruistic that he would promote Stanley's interests at the expense not only of Catlin's, but of his own? Clemens, who read the letter to his colleagues, was prepared to be impressed. He would prefer a collection of Indian portraits painted by Eastman to one by either Catlin or Stanley; but he would take Stanley's as a second choice and strenuously oppose the resolution for purchase of Catlin's gallery.

Borland joined in. He thought the whole "business of buying pictures" a waste of public money and Senate time. But "if we are to pay money out of the Treasury for pictures, I am for having the best we can get." So he offered an amendment that replaced the committee resolution with an entirely new one:

> *Resolved:* That a select committee of three be appointed by the Chair to inquire into the relative merits, and value of Mr. Catlin's and Mr. Stanley's collection of Indian portraits; or whether it may not be

better to employ Captain Eastman, or some other officer of the
United States Army who is a competent artist, to paint a series of
Indian portraits for the Government, than to purchase the collection
of either Mr. Catlin or Mr. Stanley.

Borland then proceeded once again to praise Eastman as an artist of "very
high order of talent," intimately familiar with Indian character, and per-
haps "better qualified than anybody else to procure a series that will be
worthy of the patronage of the Government." Best of all, Eastman would
come cheap.[105]

When Catlin read the June debate, his dismay was tempered with pride.
"I was the first to design such a Collection, and the first to enter upon it,"
he wrote, "and instead of having my expenses borne, and an army to
protect me and a Captain's pay to live on, I devoted eight years of my life,
at an expense of 25,000. $. out-of-pocket, and not a shillings aid from
government, and by my own energies and industry . . . made my collec-
tion." His most passionate defender in the Senate, a Whig from his native
Pennsylvania, James Cooper, sounded the same theme: "Now, I have
nothing to say against the artistic merits of either Captain Eastman or Mr.
Stanley. . . . Both of them have given striking evidence of great talent; but,
according to them all the merit that is due to them, or to either of them, to
say that they are but gleaners after Mr. Catlin is doing injustice to nei-
ther. . . . He was the original in this field." Eastman and Stanley had not
enjoyed Catlin's opportunities. That was the point about the Indians. They
were disappearing daily, and a delay of a few years was fatal to knowing
them as they once were, "lords of the soil." Catlin had caught them in their
prime; his successors had not. But "if Congress should choose," Cooper
added, "I am very willing to extend this patronage both to Mr. Stanley and
to Captain Eastman. I do not think that it would be any very great stretch
of public generosity to purchase the collection of Mr. Catlin, in the first
place, and in the second place, the few scattering works of Captain East-
man, and finally to add to both the collection of Mr. Stanley." Whig
extravagance again, but a nice rebuttal to Clemens and Borland. The
Senate had no chance to explore Cooper's suggestion further. Though
Seward wished to speak to the resolution, debate was cut off by motion of a
Maryland Whig impatient with the discussion of the "relative merits" of
three portrait painters, and on the question to table the vote was twenty-six
in favor, twenty opposed.[106]

The yeas and nays were taken, providing a rare insight into the forces
that thwarted Catlin. Of the twenty-six votes cast against him, four were by
Whigs, two by unaffiliated senators with Democratic ties, and the other
twenty by Democrats. The Whigs were from Massachusetts, Maryland,
Missouri, and Florida; all told, thirteen senators from the South and four

from border states opposed the resolution. Of those voting for Catlin—that is, against the motion to table—five were Democrats, one was a Free Soiler, and fourteen were Whigs. Only three favorable votes came from the South, and one came from a border state. The division, in short, followed sectional and party lines. Three of the five members of the Senate Committee on Indian Affairs voted against Catlin, but his warmest advocate, James Cooper, also served on it. The chairman of the Library Committee to whom Catlin had directed his appeals was absent for the deciding vote but, from all indications, would have opposed him. As it was, the other two committee members split on the motion to table. Support came from Augustus C. Dodge of Iowa, son of Henry Dodge, who was representing Wisconsin in the same body and remembered Catlin from the 1834 dragoon expedition and from 1836 when he witnessed Dodge's treaty with the Sac and Fox Indians near Rock Island. Though both Dodges were Democrats, old loyalties prevailed; unlike Jefferson Davis in 1849, they sided with Catlin when it came time to vote. The other member of the Library Committee, Jeremiah Clemens, not only voted against him but actively opposed his case. Clemens also served on the Military Affairs Committee with Solon Borland, suggesting why these two Catlin detractors reversed their position on federal patronage of the arts to promote Captain Seth Eastman's interests.

* * *

So there it was, twenty-six to twenty—close enough to raise might-have-beens but not to call for a recount. Catlin had every reason to be bitter. He had been knocking on Congress's door for nearly fifteen years; three Whigs prominent enough to serve the nation as secretary of state had championed him in the Senate to no avail; finally some of the southern Democrats who had kept the door shut so long proposed opening it to admit not Catlin, but two rivals relatively new on the scene. July 20, 1852, was Catlin's personal Waterloo. He would never forget what happened to him that day or forgive the man he held responsible.

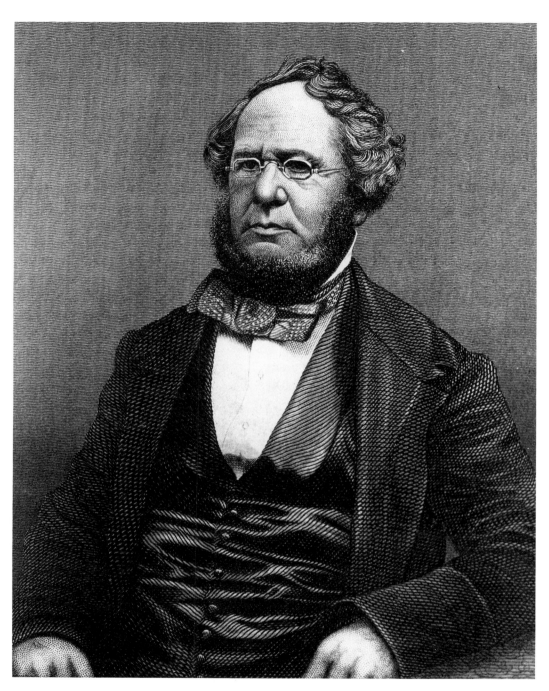

51. Henry Rowe Schoolcraft (1793–1864), Indian Historian to Congress, in the engraved portrait that served as the frontispiece to the sixth and final volume of his great national work—and personal monument—*History of the Indian Tribes of the United States . . .* (1857).

CHAPTER FOUR

The name of SCHOOLCRAFT is one that every American child should be taught to reverence as that of him who has done most to rescue from oblivion the facts relating to the aboriginal tribes of this continent. . . . [His] volume is . . . filled with engravings, from original designs, by Capt. Eastman, of the army, who is another enthusiast in the pursuit of aboriginal lore, and whose long and intimate acquaintance with the Indian tribes has enabled him to use his facile pencil to the greatest advantage. . . . his views of Indian dances and customs are not equalled for grace and fidelity, the latter a quality inseparable from such a work as this.

Review of *Information Respecting the History, Condition, and Prospects of the Indian Tribes of the United States,* vols. 1–3, *Daily National Intelligencer* (Washington, D.C.), March 31, 1854

Indian Historian to Congress

Schoolcraft, Eastman, and the "National Work"

When George Catlin and Henry R. Schoolcraft met in England in 1842, their careers were on opposite trajectories. Catlin was at the height of his popular fame following the publication of *Letters and Notes on the Manners, Customs, and Conditions of the North American Indians.* The reviews were enthusiastic. He was England's resident American Indian expert. But his apparent prosperity rested on expectations, on a patronage that was not forthcoming. Though neither knew it at the time, he was already pointed toward debtor's prison. It was Schoolcraft who seemed to be the loser, a self-made man of letters fallen on hard times, rejected by publishers, unemployed and without prospects, a widower with family responsibilities and burdens enough to discourage

anyone. His financial affairs were in disarray through unwise land specula-
tion, and failure was written all over what had once been a promising
career. To mark his birthday in 1843, he would change his dishonored
surname to Colcraft. But he too had one hope for redemption. Like Catlin,
he aspired to federal patronage; unlike Catlin, he did not aspire in vain.[1]

Upon his return to America late in 1842 Schoolcraft embarked on a
tireless campaign of self-promotion, his ambition, as was said of Lincoln's,
"a little engine that knew no rest." Within a year of adopting his new
surname he dropped it and returned to Schoolcraft, a sign of his growing
confidence in the future. Then, after several false starts, in 1847 he scored a
singular patronage coup, creating a position for himself on the govern-
ment payroll that gave full scope to his literary aspirations and his craving
for recognition as America's foremost authority on the Indian. His success
constitutes a unique chapter in the history of federal government involve-
ment in the arts.[2]

* * *

Schoolcraft turned to the government in the 1840s through force of habit.
He had long thought it incumbent on Congress to encourage the arts and
letters. His first federal appointment, with Lewis Cass's Exploring Expedi-
tion in 1820, brought an eight-week bonus when he prevailed upon
Secretary of War John C. Calhoun to extend his pay while he prepared the
expedition's mineralogical and geological memoir—a subsidy doubtless
prompted by the fact he had already dedicated his own *Narrative Journal* to
Calhoun. But such political astuteness proved of limited value during
Schoolcraft's years as Indian agent, since the federal government simply
did not offer systematic support for the arts. In 1826, after providing data
for Superintendent of Indian Affairs Thomas L. McKenney's book on their
summer's excursion in Indian country, Schoolcraft wrote him that "the
time and labor necessary to collect information on Indian topics, of a
literary character, imposed a species of research worthy of departmental
patronage." He was "quite willing to contribute in this way" and to devote
his "leisure moments to further researches on the aboriginal history and
languages, if the government would appropriate means to this end." That
was the rub; though McKenney had been responsible for building the War
Department's collection of Indian portraits and favored agents' undertak-
ing research, no appropriation was available. Schoolcraft was left to pursue
his extracurricular activities for whatever they might command.[3]

The problem was evident in a circular from the commissioner of Indian
affairs of September 4, 1837, directing officials in the Indian Country to
double as researchers and collectors. If a library and cabinet of natural
curiosities and of native costumes and artifacts were formed in Wash-
ington, he believed, "the public mind would be more interested in our
Indian relations." The commissioner went on to say that while there was

no budget at present, "a good beginning" might induce Congress to "furnish means for enlarging the collection." Schoolcraft, who earlier that year had publicly urged preservation of records of the fast-fading Indian cultures, promptly offered the commissioner "every personal aid" in forming the proposed collection and gave suggestions on how he might proceed. Impressed, the commissioner printed Schoolcraft's communication in his annual report, but Congress ignored his request for a modest appropriation to put the plan into action.[4]

Nevertheless, there was stirring on the patronage front that fall. Catlin, in New York with his Indian Gallery, attempted to cut in on Charles Bird King's near monopoly as the government's designated Indian portrait painter. And George Winter, an artist living in Logansport, Indiana, inspired by Schoolcraft's published letter, wrote the local Indian agent endorsing the plan for an Indian cabinet. Schoolcraft's was a recommendation "worthy the consideration of an enlightened Government" and certain to "elicit the admiration and interest of the civilized world." Were the agent to inspect his own collection of Indian sketches, Winter continued,

> something may present itself, that probably you may deem of interest to the Department. I have understood, that it is the custom of the Department, that when Indian delegations visit Washington, to obtain the portraits of those Indians who will consent to sit for their likenesses [King again].
>
> Being in Indiana, and familiar with the Indians, and possessing facilities of getting the likenesses of those who are distinguished; and among whom there are many, who probably may never visit their "Great Father" at Washington and whose resemblances posterity may never witness, should they not be obtained in the Red man's native wilds—I would therefore under these circumstances through your favour respectfully tender my services to the Department.

As samples of his work, Winter enclosed a portrait of a Pottawatomie and a sketch of an Indian council held the previous summer. Perhaps the agent would forward these to Washington. Should they find official favor and should the government decide it wanted a large painting of the council scene, he would produce a historical record in oil worthy "the importance of the Commission" and his "own reputation as a Painter."[5]

Catlin, whose career Winter claimed to have followed since learning of his Indian paintings while a student at the National Academy of Design in New York in the early 1830s, was given the nod in January 1838 to paint Osceola and the other Seminoles, but Schoolcraft and Winter got nothing from the War Department. Schoolcraft never gave up—a year later he was seeking departmental assistance in preparing and publishing an Algonquian dictionary—and protesting the lack of support for arts and letters in

America. "A man must devote all his leisure in researches, and then finds that there is no way in which these labors can be made to aid in supplying him the means of subsistence," he complained. "He must throw away his time, and yet buy his bread. There is no real taste for letters in a people who will not pay for them. It is too early in our history, perhaps, to patronize them as a general thing. Making and inventing new ploughs will pay, but not books."[6]

This observation gained urgent point after Schoolcraft was dismissed from office in 1841. Hoping to make writing his livelihood, he found no encouragement at home or abroad. Nevertheless, his visit to England left him convinced that the United States government might yet be persuaded to underwrite an authentic work on the tribes that would confound foreign critics and place American Indian affairs in a favorable light. The same expansionist forces that compromised Catlin's case for purchase of his gallery in the 1840s could be turned to Schoolcraft's advantage, since they dictated a rethinking of federal Indian policy. Past policy, based on the theory of isolating the Indians in a country of their own west of the Mississippi River, no longer met the nation's needs, yet no new policy had emerged to replace removal and concentration. Future policy would have to accommodate a transcontinental reality and, Schoolcraft insisted, could be wisely shaped and administered only if the nation's policymakers possessed accurate information on the Indian peoples.[7]

On May 26, 1843, Schoolcraft addressed a letter to the secretary of war, circulated it among influential friends in New York City, and gathered nine endorsements. The repeated inquiries about the tribes relocated west of the Mississippi made it imperative to send "a special Agent, to observe and report the facts . . . for the information of Congress and the people," he stated in what proved to be the first of several proposals he circulated over the next four years, each intended to pressure Congress into creating a job for him. In January 1844 he asked Senator Thomas Hart Benton to introduce a bill authorizing the president to employ a "suitable person of known competence and experience" to survey, map, and report on the western antiquities (or mounds) and to determine the aboriginal geographic names with a view to adding them to the map of the United States. A "moderate expenditure for these objects," he advised Benton, would likely "be sustained by public sentiment." Benton was too busy even to reply, but a Democratic congressman from Michigan, Lucius Lyon, submitted a bill in the House on Schoolcraft's behalf. Prospects were discouraging, Lyon reported. Senator Benjamin Tappan, an Ohio Democrat and a member of the National Institute, had praised Schoolcraft's project but told Lyon he was bound to oppose it because he did not believe the government "could with propriety appropriate money for this purpose."

Other congressmen were of the same opinion, and the secretary of war was never in when Lyon came calling.[8]

Schoolcraft was being stymied by his own party's principles; nevertheless, his appeals to prominent Democrats effectively played on party loyalty. "In the spring of 1841," he began his oft-told tale, he was removed from office on the ground "that I was a democrat, and had exerted my official influence, in an improper manner. The former assertion was true," he told John Calhoun, "the latter untrue." Might he therefore count on Calhoun's help in procuring some "humble" position abroad? His pitch never varied. Party loyalty had cost him his job; the party owed him support in getting a new one.[9]

At home or abroad, however, the United States seemed perfectly able to carry on without Schoolcraft's services. His alternatives, in the face of repeated rebuffs and the absence of private patronage, were the state and city governments—though they were as skittish as their federal counterpart—and learned societies, which applauded all worthy endeavors but were chronically strapped for funds. Schoolcraft was willing to try anything in the desperate year of 1844. He worked on a map showing the aboriginal names in New York State for the New-York Historical Society; offered to help the mayor of New York select appropriate Indian names for the city's streets; and proposed a survey of antiquities (the same bill Lyon had sponsored in Congress) to the New York state legislature. "I can hardly sustain myself & children," Schoolcraft had lamented that January. All he needed was some "temporary employment" to "fill up a blank in the present year."[10]

Nothing substantial turned up in 1844, however, and while he continued to hope for reappointment to his old post at Mackinac and dreamed of being made commissioner of Indian affairs in James K. Polk's newly elected Democratic administration, the spring of 1845 found him still without a position. Perhaps Polk would appoint him commissioner to the Sandwich Islands if nothing came of his applications at the War Department? Indeed—and here he was casting back to his earliest experience with federal patronage—perhaps the secretary of war would appoint him superintendent of mines in the Northern Department of the Union? If Indians would not sell, surely minerals would. One April morning, he wrote, he was reflecting "upon some mode of employing myself, with usefulness to the public, which may at the same time yield a support," when the thought struck him that "there is room and a fitting time, just now, for a periodical, with something like this title: United States Journal of Mines and Practical Mineralogy." *Practical* mineralogy—it had the right ring, but such schemes came and went without action. Schoolcraft's persistence was about to pay off, however. The state government of New York spurred on by the New-

York Historical Society, on May 1845 decided to make an appointment with direct implications for Schoolcraft's federal patronage quest one year later.[11]

That January, the Historical Society had resolved that a committee be struck—with Schoolcraft a member—to draft a memorial to the state legislature urging it to undertake a "Historical & Ethnological Reconnaisance" of New York embracing a "full description of its antiquities." Provision had already been made for a limited survey in the Census Act passed the previous year, and on May 7 the legislature complied with the society's wishes, stipulating that "suitable persons" be named to enumerate the state's Indian population, the acreage cultivated on each reservation, and "such other statistics as it may be in their power to collect." Appointed to the post on June 25, as expected, Schoolcraft was instructed to concentrate on the data requested, keeping his survey of early aboriginal history and antiquities as brief as possible. The state of New York, in short, was not prepared to foot the bill for the broad ethnological survey proposed by the Historical Society, but the Indian census nevertheless was precedent setting. Schoolcraft had until September 1 to complete the enumeration; in fact, it took until October 31, and he was subsequently allowed sixty-eight additional days to prepare his supplementary report, carrying him through to January 7, 1846, and nicely filling in *that* particular blank in his year.[12]

Having secured the state appointment, Schoolcraft wasted no time on gratitude. The compensation of $2.00 per day was inadequate and should be increased to $2.50, while the number of days finally agreed to by the government still did not cover his actual service. The printing of the report—which he supervised through the press between January 8 and February 11—led to further controversy. He dismissed the legislature's demurs over printing costs as "petty" and boasted to the bookseller who was copublishing the report that his portion would be "on best paper, & liberally set up."[13]

Notes on the Iroquois; or, Contributions to the Statistics, Aboriginal History, Antiquities and General Ethnology of Western New-York, issued in February 1846, was well enough received to excuse Schoolcraft's querulousness and justify the notion of the government's subsidizing pure research. Certainly the critical response gave Schoolcraft's case for federal patronage a major boost. In the preface to his report he stated that it was "intended only to shadow forth outlines to be filled up hereafter," and he indicated the full extent of what he had in mind in a letter to the commissioner of Indian affairs. "No measure," he wrote on February 24, would "furnish a better basis for action, in the revision of the intercourse laws, or tend more to facilitate the execution of treaties, and advance the general administration of Indian affairs, than the passage of an act for taking the census of the Indian tribes. Few questions, connected with these tribes, can be ade-

quately discussed, or well understood, without statistical accuracy, and the results of a well digested census would form the best guide for future legislation." Schoolcraft defended his proposal on practical grounds, but his summary of the major objectives of the census implied a broad ethnological investigation, embracing statistics of vitality, geography, occupation, education and morality, fiscal considerations, language, and ethnology.[14]

In part Schoolcraft was reacting to a measure long pending in the Senate. On January 15, 1846, in response to an inquiry made the year before by Daniel S. Dickinson, a Democrat from New York friendly with Schoolcraft, the chairman of the Committee on Indian Affairs had reported a resolution ordering the secretary of war to prepare, or have prepared, "a statement exhibiting a true history of the relations between the United States and the several Indian tribes or nations, from the revolutionary war down to the extinction of the Indian title eastward of the Mississippi." The resolution also called for a tabular statement indicating the sums paid all the removed tribes for their lands, the annuities committed to each tribe, the amount held for each in trust by the government, the amount invested in stock and by whom, and a complete census of each tribe receiving annuities. Debated on January 22, the resolution drew fire from two prominent Democrats, Lewis Cass and Missouri's Thomas Hart Benton. The tabular statement would be redundant—the information requested was all available in the Indian Office reports. Anyway, Benton was "opposed to employing persons to write histories," since the nation's papers were "teeming" with facts already and congressional documents were so plentiful that Washington's grocers and dry-goods merchants were in the habit of buying them up at two cents a pound. Print no more was the message, and while Dickinson defended the need for "a connected history" to correct the false views of American Indian affairs propounded "by Governments abroad and by philanthropists at home"—words no doubt borrowed from Schoolcraft—the resolution was tabled and then withdrawn for further consideration in committee. On February 2, its language modified to satisfy Senator Benton's scruples about financing histories, it reappeared as a joint resolution. Since the secretary of war was still required to prepare "a statement of the treaties and relations" between the United States and the Indians from the 1770s through removal, Benton was not fooled, and when the resolution came up for debate again he moved that it be tabled, this time permanently.[15]

Meanwhile Schoolcraft was advancing on a separate front. His proposal for an Indian census gathered influential support in the year that added Oregon to the Union and first brought Utah and California into the American sphere. The West meant opportunity for ethnologists as well as pioneers. It seemed to John C. Spencer, a Democrat from Albany who had

served as secretary of war and of the treasury in the previous Whig admin-
istration, that "an authentic account of all our Indians, is extremely desir-
able not only to the historian, but to the political economist and the
statesman," and he concluded that "the government of the United States
should perform this truly National work." Judging from *Notes on the
Iroquois,* Schoolcraft was the man to undertake it. "We think a system of
inquiries among the tribes and their agents, and the accumulating of
a body of exact and truthful statistics, somewhat on the plan recently
adopted by the legislature of New York, could not fail to place Congress in
a better position for definite action in relation to changes in the intercourse
laws than it now occupies," a writer in the *Democratic Review* observed. "A
full and complete census of the western Indians is quite a desideratum . . .
we know of no measure which, if committed to right hands and well
carried out, would offer a more fruitful result to guide the legislator and
the philanthropist." As the mouthpiece of Manifest Destiny—indeed, the
term may have been coined by its editor—the *Democratic Review* spoke for
Polk's expansionist administration.[16]

The doors to high offices were opening to Schoolcraft once again. He
visited the commissioner of Indian affairs on March 19, the secretary of
war a week later, the secretary of state on May 15. In each interview he
pushed his plan for a general Indian census. His friends in Congress
concluded in late April that the best strategy was to amend the general
appropriations bill to provide for the census, and by June the tactic seemed
to be working. His project was "yet in abeyance, both hopeful, & doubt-
ful," Schoolcraft wrote on the tenth. "I shall abide the result, be it *soon* or
late." Two weeks later he was confident of success. Without any serious
objection, an amendment providing $10,000 for the census had been
added to the Indian appropriations bill. The House and Senate were to
meet in committee of conference, but there was "no difference" over this
provision. At the request of the commissioner of Indian affairs, he had
already begun preparing forms for distribution to the agents in the field
and was hopeful that a few weeks would "complete all preliminaries. . . . I
shall get as much ethnology, out of the matter, as possible, and if the thing
succeeds to the approbation of Congress, & a good report, & body of facts,
is presented next winter, I do not doubt, that the plan will eventually be
extended to all the American tribes."[17]

As high as his hopes soared, just so far they crashed. On June 27
Schoolcraft drafted a letter recommending he be appointed to take the
proposed census of the eastern Indians. Before he could circulate it for
signature, however, the item was deleted from the appropriations bill.
Congressman Robert C. Winthrop, a Massachusetts Whig, had opposed it
in committee of conference, Schoolcraft heard, though he subsequently
learned that it was the Senate that struck out the provision. Now the census

was to be made by the Indian Office without benefit of a special appropriation. "Thus the matter was knocked in the head, after my *four months attention*," he noted bitterly. "The lord's will be done. It is, doubtless, good to be disappointed."18

But Schoolcraft, pious soul though he was, had no intention of giving up without a fight. He immediately set out to retrieve the situation. On June 29 he met with the commissioner of Indian affairs and argued that the government's $10,000 annual appropriation for Indian civilization should be channeled into projects like his own. Informed that the fund, as always, was fully committed to the missionary societies active in educating and training the Indians, Schoolcraft wrote John Calhoun the next day to protest. Appealing to Calhoun as the man "primarily" responsible for his own decision to study Indian history by the example he had set as secretary of war "six & twenty years ago," when Congress originally approved the civilization fund, he laid out his case. "A good and full report" on Indian statistics—not just population—was needed; Calhoun had said as much when Schoolcraft spoke to him over winter. "There is a favourable disposition to act in the matter, . . . but no fund, out of which, compensation can be made." Schoolcraft drafted two resolutions that Calhoun might introduce in the Senate, one providing that a portion of the Indian civilization fund be applied to the "collection & diffusion" of information on the tribes, the other authorizing the president to appoint someone to undertake this task.19

Schoolcraft spent July gathering support for his proposal, and on the twenty-first he drafted a letter, signed by Senators Cass of Michigan and Dickinson and John A. Dix of New York, Democrats all, urging the secretary of war to extend the Indian census approved by Congress to other "points of information . . . such as their history, languages, & c. which it is important to obtain." The western tribes and some of the eastern remnants who were without agents should be visited by a special agent—Schoolcraft, of course. The irony of three Democrats' urging such an appointment was compounded by the position two of them had taken in the debate over the proposed Indian history six months earlier. Dickinson had defended the idea but insisted he had no one in mind for the job and was opposed on principle to "congressional book-making." Cass, in turn, had declared the plan for an Indian history much too broad. "The quantity of matter required to be published . . . would put the country to a cost of a thousand dollars," and the resulting book would overlap existing publications. Cass was wrong about the money—no Schoolcraft project cost only a thousand dollars. But, again, Schoolcraft was a party faithful. In recommending him as entitled "in peculiar degree, to the benefit of the patronage of the government," the editor of the *Democratic Review* had praised him as "one of the recognized ornaments of our national literature," America's

"first scholar" in ethnology, and—the bottom line—"an old & steady democrat." From 1841 to 1844 he had worked to win the party's presidential nomination for Cass and would be in his corner again in 1848. In such circumstances, loyalty had to override principle.[20]

Schoolcraft's letter and supporting documents landed on the secretary of war's desk in late July along with a draft resolution authorizing the president to employ a "competent person, to make an *ethnological survey* of the Indian tribes," expenses to be paid out of the civilization fund. The secretary passed the file on to the commissioner of Indian affairs. What precisely, the commissioner wondered, was meant by an "ethnological survey?" Schoolcraft replied on the twenty-eighth that the proposed survey would "reach questions of a general character," the census being but part of a larger project:

> Their history, languages, antiquities, and other traits, are essential to be known, in order to separate the dialects & languages into stocks; establish the various purposes of generalization, and determine their capacities of improvement. . . .
>
> The origin & characteristics of the tribes . . . are of less interest, perhaps, in a practicable point of view, than the mode of rightly governing & managing them, considered as wards under a governmental guardianship. But the means of accomplishing this, must be, through this species of information. Nothing, certainly, appears better suited to avoid mistakes, and doubtful experiments in humanity, government, & education.

Schoolcraft had discussed his proposal with the secretary and the commissioner and explained it by letter. Now he awaited their decision.[21]

When both officials procrastinated, Schoolcraft simply went over their heads. In August he prepared a long, self-justifying memorandum to President Polk, accompanied by most of the letters of support he had gathered over the past year. Like a chief haranguing a treaty council with a detailed recitation of old grievances, Schoolcraft ran through his usual litany of complaints. "I was ejected from office . . . within sixty days of the inauguration of Gen. Harrison," he wrote, "and retired to my native state, with the proud consciousness of having done my duty, but without fortune." Presidential intervention to restore him to the public service was not too much to ask. Schoolcraft presented his memorandum to Polk in person on August 17 and had the satisfaction of watching him peruse each page. The supporting letters were not all addressed to the president or of the same date, Schoolcraft pointed out, but they did establish "a *unity*" favoring his case for reemployment. Polk nodded his assent but added that he had no vacancy to offer. Schoolcraft promptly replied that he would "sug-

gest a plan." Polk then detained him for further discussion, and though the interview was inconclusive Schoolcraft was elated. It gave him another crack at the secretary of war, who would want to know, he supposed, that the president himself had taken a personal interest in his memorandum.[22]

Schoolcraft's politicking proved for naught. The Indian civilization fund was already expended, the president could offer nothing, and the Senate on August 7 had passed a resolution directing the Indian Office to collect information "respecting the condition, habits, and progress" of the Indians and report back "from time to time." Although this signaled the final defeat of Schoolcraft's plans in 1846—Congress adjourned three days later—he had successfully prepared the way for a handsome patronage payoff the next year.[23]

* * *

Meanwhile a new target had crossed Schoolcraft's line of fire: the Smithsonian Institution, created by act of Congress on August 10, 1846, after protracted debate. Along with almost every other ethnologist, archaeologist, philologist, and for that matter Indian painter in America, Schoolcraft set his sights on the Smithsonian. Who would be secretary, who librarian? What funds from Smithson's bequest would be made available for fieldwork and publication? What for the purchase of books, artifacts, and works of art? Who, in short, would benefit?

That January Schoolcraft had suggested that a Department of Ethnology be organized in the National Institute; thus he was ready for the Smithsonian, and on August 25 he submitted a memoir on the same subject for consideration at the first meeting of the board of regents, scheduled for September. When he had it printed later that year, it stretched to thirteen pages, descriptively titled *Plan for the Investigation of American Ethnology; to Include the facts Derived from Other Parts of the Globe. And the Eventual Formation of a Museum of Antiquities and the Peculiar Fabrics of Nations; and Also the Collection of a Library of the Philosophy of the World, Manuscript and Printed.* Ethnology, Schoolcraft argued, should have priority for subsidy, given James Smithson's instructions that his bequest be used to promote "the increase and diffusion of knowledge among men." "It is not an inquiry which admits of extempore results," Schoolcraft stated; it is "a labor requiring time and attention." The information that would have to be painstakingly collected was "hardly of a character to sustain popular lectures."[24]

No Catlins, in short, need apply, and the inference was intentional. Catlin's case for patronage had been before the late session of Congress, as "hopeful, & doubtful" as Schoolcraft's own through June and July, when the Joint Committee of the Library recommended an amendment to the Smithsonian bill providing for purchase of the Indian Gallery. In the end,

Catlin too had experienced defeat; undeterred, Schoolcraft sought to further undercut him. "In every view America is an interesting field for ethnological inquiries," he informed the Smithsonian's board:

> A museum of antiquities might be readily collected which would possess great interest to the most casual observer visiting the Institution. To this might readily be added, with the favorable concurrence of the Secretary of War, a gallery of Indian costumes, arts, arms, and portraits, capable of illustrating that branch of the subject. Such a gallery of our aboriginal races, could be made at very little cost, and would be infinitely more valuable, in every respect, than that offered to Congress by a respectable and zealous author now abroad. The portraits [by Charles Bird King] now in the Patent Office [the National Institute], are more numerous and valuable than those of Mr. Catlin.

This gratuitous aside established not only Schoolcraft's animus, but also his proprietorial view of the Smithsonian. It should employ some qualified individual to direct its ethnological researches, he wrote, either by "a temporary appointment or a fixed professorship," with residence at the Institution and free access to its library and collections. However, "without adequate provision for the time, books, and travel incident to the inquiry, no person can be expected to enter upon effective labor in this field."[25]

Having written his own job description, Schoolcraft next sketched out an ethnological research program under the headings "Objects of Inquiry" and "Means of Ascertaining the Facts." The objects included physiology, or the types of mankind, but progressed to material and then intellectual existence—the last, to Schoolcraft's mind, the most important branch of the inquiry embracing his favorite subjects, philology, religion, and oral tales. Schoolcraft trespassed on Catlin's case for patronage in two ways. He urged, as Catlin had in his memorial to Congress that June, the creation of "a museum of mankind" to promote comparative study. And he argued the need for speedy action by the Smithsonian—no small consideration for one seeking immediate preferment—by sounding Catlin's usual theme, the evanescence of native cultures. "Time is essential in making preliminary examinations," Schoolcraft wrote, for ". . . in all over which the tide of modern emigration sets, the evidences of its former occupation are rapidly disappearing. The same may be said of the Red Race, whose language and customs it is wished to preserve. The earlier the labor is done, the more easy will be its execution. . . . By adopting the plan suggested, or some plan of this nature, we shall rescue from the oblivion of past generations matter for thought and reflection for the future." Copies of Schoolcraft's plan, distributed to all members of the Smithsonian board and his usual coterie of congressional friends, received more than courtesy replies. Con-

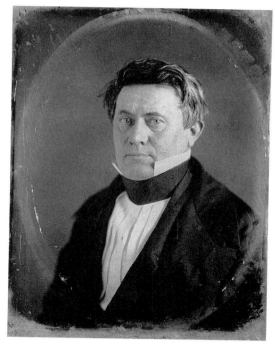

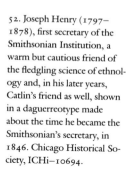

52. Joseph Henry (1797–1878), first secretary of the Smithsonian Institution, a warm but cautious friend of the fledgling science of ethnology and, in his later years, Catlin's friend as well, shown in a daguerreotype made about the time he became the Smithsonian's secretary, in 1846. Chicago Historical Society, ICHi–10694.

gressman Robert Dale Owen, chairman of the committee to prepare a plan of operations for the Smithsonian, wrote to Schoolcraft in November that he would "especially advert" to ethnology in his report, "fully agreeing" with him "as to its importance & appropriateness. . . . I do not doubt the concurrence of the Board."[26]

The speculation over who would be made first secretary of the Smithsonian—John R. Brodhead, Catlin's intermediary in approaching the New-York Historical Society in 1847, had been in the running, and Schoolcraft nursed ambitions of his own—ended on December 3 with the appointment of Joseph Henry. A renowned Princeton physicist, Henry was unfamiliar to the ethnologists; the venerable Albert Gallatin, founder of the American Ethnological Society in 1842, could not even remember his name. Was it Henry Alexander or Alexander Henry, he asked a correspondent, getting the reversible principle right at least. But the new secretary proved a warm, if cautious, friend of ethnology. Henry was a stickler for methodological precision and was not prepared to exempt ethnology from the high standards of the older sciences, particularly in view of the enthusiasms and ulterior concerns besetting archaeology and physical anthropology in the race-conscious, emotionally charged years before the Civil War. Thus Henry's appointment had important implications for ethnological research in America. It satisfied both a Schoolcraft and his future adversary in antiquarian disputes, Ephraim George Squier, though each would have his differences with Henry. Schoolcraft presented a printed copy of his plan

for ethnological researches to the secretary pro tem of the Smithsonian the day Henry was appointed, and two days later he applied for the position of his assistant. Squier, whose monograph on the western antiquities would be the Smithsonian's first memoir, welcomed Henry's appointment. The board could now turn "their attention to an Ethnological Museum, for private enterprise finds its limits, especially in cases where the longitude of the purse is 'nothin' to speak on.'" And Brodhead, who had dropped out of the running for the secretarial post a few months earlier and accepted the position in London that would bring him into contact with Catlin, expressed the conventional wisdom that Henry's name would lend prestige to the fledgling institution.[27]

Schoolcraft continued to wonder what the Smithsonian could do for him. Would it, he inquired, pay for contributions? This was a practical concern with others as well. Henry found himself "overwhelmed" with requests for money, but by the time he replied, on March 6, the answer no longer mattered to Schoolcraft. Three days before, Congress had passed an act that continued the Indian Office census and appropriated $5,000 "to enable the said department, under the direction of the secretary of war, to collect and digest such statistics and materials as may illustrate the history, the present condition, and future prospects of the Indian tribes of the United States." This was the payoff Schoolcraft had been awaiting since 1841. How had it come about?[28]

* * *

Schoolcraft's visits to the president, the secretary of war, the commissioner of Indian affairs, senators, and congressmen in the wake of his defeat the previous year had borne fruit after all. He wrote to a friend in New York at the time that he intended "to renew the object, to which *my* attention was to have been particularly given, by a petition & resolution before the Senate, in which body, as well as the House, are many intelligent individuals warmly in favour of the plan." He had the memorial, with twenty-nine signatures and an appended explanatory note, ready for presentation when Congress reconvened on December 7, 1846.[29]

The signers were New Yorkers all, several prominent in the New-York Historical Society and the American Ethnological Society. Schoolcraft, active in both, through 1846 had maintained a high profile. On August 14 at Rochester he addressed the third annual council of the Was-ah Ho-de-no-son-ne, or New Confederacy of the Iroquois, whose members included Lewis Henry Morgan, later recognized as the preeminent student of the Iroquois, on the need to investigate American prehistory. The living Indian was himself "an attractive *monument* to be studied," the essence of America for cultural nationalists, Schoolcraft said. "Shall we neglect him, and his antiquarian vestiges, to run after foreign sources of intellectual study? Shall we toil amid the ruins of Thebes and Palmyra, while we have

before us the monumental enigma of an unknown race? Shall philosophi-
cal ardor expend itself, in searching after the buried sites of Ninevah, and
Babylon and Troy, while we have not attempted, with decent research, to
collect, arrange and determine, the leading data of our aboriginal history
and antiquities?" Schoolcraft returned to the same stirring theme in an
address before the Historical Society three months later on "Incentives to
the Study of the Ancient Period of American History." Ethnology, he told
the assembled members, "has arisen to hold up the light of her resplendent
lamp, . . . to guide the footsteps of letters, science and piety." It "promises
in its results, to unravel the intricate thread of ancient migration, and to
untie the gordian knot of nations. Shall we not follow in this path?" After
issuing his challenge, Schoolcraft gathered more signatures for his peti-
tion; it went forward to Congress bearing the virtual imprimatur of the
New-York Historical Society.[30]

Such petitions were not spontaneous outpourings, after all, but calcu-
lated ploys. The beneficiary drafted them, then strong-armed friends to
strong-arm others into signing. A cynical senator in 1852 analyzed the
process. "Whenever there is a project before Congress for the purpose of
taking money out of the Treasury," he explained, "Mr. A. helps Mr. B. If A
writes a scientific work, on any subject, and B writes a work on another
subject, they write puffing articles in the press for each other." The senator
might have added that they also signed one another's memorials.[31]

As soon as Schoolcraft's project soured in 1846, for example, he had
called on John R. Bartlett, a member of the Historical Society and the
Ethnological Society, foreign corresponding secretary of the latter and an
avid student of ethnology, to circulate a copy of his petition in New York
"as early as possible." Schoolcraft wanted a dozen signatures; Albert Gal-
latin's should head the list, and Bartlett should sign too. Bartlett obliged—
he was indebted to Schoolcraft for the contract to copublish *Notes on the
Iroquois*—but he hit an unexpected snag when Gallatin proved reluctant.
The pressure was always on friends to set aside personal qualms and do as
asked. Gallatin was different. In his eighty-sixth year, a much-honored
national figure, he was especially venerated in New York City, where he
served as president of both the Historical Society and the Ethnological
Society. Admired for his exacting standards, he was still at work on a
classification of the Indian languages, a straw hat shading his eyes from the
light's glare as he pored over his word lists, the image of a devoted
scholar.[32]

His reputation was precisely why Schoolcraft needed him, but Gallatin
did not casually lend his name to projects. He had helped Schoolcraft in the
past, but flattery was unnatural to him, and he could be restrained even in
making an endorsement. Schoolcraft had appealed to him for assistance in
1844 when he decided to write a book, linked to his *Cyclopedia* and the

later federal project, on the history, manners, customs, languages, and institutions of the Indians. It might run a thousand pages, he had noted, but he could finish it in a year, requiring only "the stimulus of some pecuniary reward, for it is hard to spin away one's time & brains for the mere empty shadow of applause." Perhaps the state of New York could be persuaded to underwrite it? Gallatin had dutifully made the rounds, calling on the governor and the appropriate legislative committees. But the response was the same: "All those to whom I have spoken, say 'The object is praiseworthy—We as individuals would subscribe for a work like that contemplated, but the *Treasury* is low &, we cannot, at this time, report a resolution, involving an outlay of public money.'" Gallatin regretted that Schoolcraft might thus be unable to publish, "but if it must be so, *so must it be.*"[33]

Such candor did not always endear Gallatin to others, but it was consistent with his character. Thus his coolness toward Schoolcraft's petition in 1846. Since his signature was indispensable, Bartlett spelled out Gallatin's reservations for Schoolcraft. Gallatin thought there was "too much said in your memorial—You know he is very explicit and condenses his ideas, or, at least his manner of expressing them." Schoolcraft, prolix at the best of times, was doubtless guilty as charged. But Gallatin may have harbored rival ambitions as well. About the time he received Schoolcraft's memorial, he was setting into motion a plan of his own. On July 21 he wrote the commissioner of Indian affairs for help in obtaining more Indian vocabularies for comparative study. He would personally bear the expense of printing the results of his investigation and asked nothing but a commitment from the Indian Bureau to provide every agent with a copy should it "appear to be useful for the public service."[34] He was in competition with Schoolcraft, in short, and though Bartlett stepped in quickly to soothe ruffled feelings and Gallatin eventually signed the memorial, Schoolcraft felt betrayed. He took his revenge by sniping at Gallatin's philological reputation, attacking his linguistic classifications as overambitious and in part ill founded. "Mr. Gallatin, amused the bright mind of an old age, by inquiries about the languages & history of the Indians, which he did not well understand," Schoolcraft wrote to Bartlett, "but was, evidently, opposed secretly, to my plan, and declined, as you know, to do any thing, *directly,* to further it." The incident illustrates Schoolcraft's persistent pettiness, certainly, but it also testifies to the strains caused by a patronage process that, lacking system, relied on individuals to generate sufficient pressure to move Congress. Misunderstandings and personal rivalries were bound to follow.[35]

With Gallatin's signature among the twenty-nine, Schoolcraft's petition moved through the congressional mill. Invaluable for scientific and administrative purposes, the proposed investigation should be undertaken by the

Indian Office and, Schoolcraft's accompanying letter stressed, must be separately funded. The head of the bureau, he wrote, would have to be "authorized to employ, for the time being, a competent person, to devote himself exclusively to the inquiry, to visit the agents, superintend their labors herein, and take in hand the generic parts of the work, and report the results to government, in a complete form. For this, Congress should specifically provide." The commissioner of Indian affairs agreed. In a letter to the chairman of the House Committee on Indian Affairs, where the petition had been referred, he pointed out that though the bureau had conscientiously begun the census ordered by Congress the previous year, the results were superficial. More than a population count, what was needed was a broad survey of Indian progress, "a well digested and arranged body of information" to guide policymakers. With the means at its disposal, the bureau could not do the job itself; two years and a special appropriation of $5,000 annually would be required to complete the ambitious investigation outlined in the petition. Such precisely was the recommendation of the Indian Affairs Committee in the omnibus bill reported back to the House on February 9 and signed into law on March 3.[36]

On March 18, 1847, Secretary of War William L. Marcy officially notified Schoolcraft of his appointment in the Indian Office at a salary of $1,600 per year (he should get no less, he had insisted, than the highest grade of clerk) to gather materials to illustrate the "history, present condition, & future prospects" of the Indian tribes. He would serve under the commissioner of Indian affairs and be "guided and governed" by his instructions, his appointment to continue at the pleasure of the secretary of war. These stipulations would engender controversy later. In 1847, however, Schoolcraft, happy to be employed again, accepted the position at once, packed up in New York, and was at his desk in the Indian Office by March 25 churning out the paper that marked the early stages of his investigation, including a long letter to the commissioner detailing a plan of operation.[37]

His primary task, Schoolcraft believed, was practical. Congress wanted neither a history nor a philosophical treatise of the Indian tribes, but a compendium of authentic data to guide it in its responsibilities. Thus the first order of business would be to place the census begun the previous year on a systematic footing by circulating a printed form to the agents. (This he had ready and out before mid-May.) Second, a more extensive list of queries should be sent to agents, teachers, and "men of learning and experience." "Our actual knowledge of the Indian tribes is exceedingly fragmentary & imprecise," he observed. "Nearly all we know is derived from the pens of hasty travellers, who have often misapprehended what they saw, & were frequently more intent on the picturesque & amusing, than more serious traits of Indian character." It was even more obvious

who was meant when Schoolcraft went on to say that the government did not need more descriptions of the Indians' manners and customs, it needed information on their "moral constitution." A reference library of books, maps, and works translated into native tongues would be desirable. Vocabularies should be solicited and antiquities investigated, though neither was a priority. Finally, "reports of these inquiries should be laid before Congress periodically, that a proper judgment may be formed by the public of its utility & value." Within this framework, Schoolcraft set to work.[38]

* * *

That Schoolcraft had scored a patronage coup was clear in 1847; the extent of his good fortune was not. His appointment was temporary, subject to congressional review and, in terms of its objectives, time limited. Schoolcraft was to collect and digest information and report his findings to Congress through the usual channels, congressional documents addressed by him to his superiors, the commissioner of Indian affairs and the secretary of war. The $5,000 Congress allocated having been exhausted, Schoolcraft's position would terminate. His immediate goal then would be to renew the appropriation for another year in order to permit collation of the returns to the questionnaires circulated during his first months in office. But this end of the proceedings could not be dragged out indefinitely; Congress would demand the information it had been promised and at least a preliminary report.

Schoolcraft whipped two circulars into shape by summer and had the second, an ethnological survey 348 questions long, on its way to officials and other worthies by July 10. This method came naturally to him out of his long-standing admiration for Cass's 1822 inquiries and the importance he attached to "asking aright." While awaiting the returns Schoolcraft issued an "executive address" to the western tribes urging their compliance in the data gathering. But a greater problem was getting reluctant Indian agents to cooperate. One who described the questionnaire as lunacy received a furious reprimand from Schoolcraft threatening dismissal from office for dereliction of duty. The agent must have been as dumfounded by this blast as the assumption behind it, that agents, beyond their regular duties, should gladly collaborate on an ethnological survey conducted under official auspices.[39]

Schoolcraft's calculations were also hostage to political fortune. When Lewis Cass went down to defeat in the presidential election in 1848 Schoolcraft would face a major crisis, since he had actively supported Cass, writing campaign propaganda on his behalf and staking his future on victory. His predicament was compounded in the spring of 1849 as he awaited the inauguration of Zachary Taylor's Whig administration. Congress had created a new executive department, Interior, and put the Indian

Office under its jurisdiction. It did not seem possible that Schoolcraft could survive two such administrative changes. Consequently, by the end of 1848 he was actively looking for another position, having accepted his dismissal from the Indian Office as a foregone conclusion. But his good fortune held.[40]

For one thing, the Democrats' defeat in the presidential poll was offset by their continuing dominance in the Senate and gains in the House that gave them a narrow margin of 112 seats to the Whigs' 109, the balance of power resting with 9 independents. Patronage would not be an exclusively Whig prerogative, then, and Schoolcraft, who had spent January angling for the governorship of Minnesota Territory, by February had also put his name forward for commissioner of Indian affairs, all the while working to ensure that the merits of his Indian investigation were understood by the incoming administration. He even urged that the original scope of his inquiry be expanded. Personal visitations to the western tribes would hasten progress, particularly in the purely scientific work of collecting vocabularies for comparative study. On May 11 he informed the new commissioner of Indian affairs, William Medill, that he had received 233 replies to his questionnaire exclusive of the census returns, ranging in length from 2 to 130 pages. A personal visit would bestir tardy agents and complete the work of data gathering. Then would come the more appealing phase of the project: arrangement of the data and publication to permanently preserve the thousands of pages of information at his command. If the administration and Congress would go along with this next step, all would benefit. Books were the lure he held out. Would Congress let him turn his research project into a major publishing venture?[41]

Already an acquaintance had assured Schoolcraft that Congress would. George Gibbs at thirty-one was a confirmed cynic where politicians were concerned. Frustrated in his desire for an appointment to the Military Academy, he had studied law at Harvard instead, embarking on a career that satisfied neither his intellectual curiosity nor his yearning for adventure. He would find adventure enough in May 1849 when he left for Oregon with a mounted rifle regiment and once there strung a series of government appointments into a twelve-year residence that took him from Puget Sound and far up the Columbia River down to northwestern California, sketching much of what he saw—Indians, artifacts, scenery, frontier towns and posts—and collecting extensive vocabularies. Gibbs would become a recognized anthropological fieldworker through his contributions to Schoolcraft and the Smithsonian, which he served as resident expert in linguistics after his return from the West Coast in early 1861.[42]

But in 1847 George Gibbs was still a New York City lawyer bored with his profession and, increasingly, with his dissolute, unproductive bachelor

ways. He had a saving love for natural history and a disdain for the powers that be in Washington who, by controlling the purse strings, controlled scientific research in America. As an active member of the American Ethnological Society, which had effectively endorsed Schoolcraft's appointment that March, Gibbs felt free to offer his advice in a remarkable letter that became a blueprint for the second stage of the Indian investigation. Schoolcraft had been given a glorious opportunity and must make the most of it, Gibbs wrote. Congress wanted him to collect and digest information on all the Indians. Concentrate on new materials, then—data about the western tribes. And avoid Indian vocabularies. "The southwestern and western barbarians [in Congress] will not care a d––n for all the results of your labors if they find it only a Shawnee or Sioux dictionary." Of course Schoolcraft should collect vocabularies, but they should not form a part of his official report. The "grand secret" of his success would be the "cupidity of the members." They would covet an expensive "picture book," theirs for free, and would vote "any amount of public money" to obtain it. Gibbs was a controversialist without a shred of discretion, according to an acquaintance. But this was his shrewdest piece of advice as he mapped out the strategy that Schoolcraft two years later adopted:

Make your reports to each Session upon the material & the tangible, and above all things have them full of plates. Congress will print them of course & pay for the engraving without writhing. I should if possible give them a small taste at the commencement of the very next session, just to make their mouths water for more, as you bait round your intended fishing place while you fix your lines. One of the elementary powers at Washington, the government printer, is of course easily propitiated. You need no instruction on the *modus*.

But plates & ground plans take time. Can you not get the regents of the Smithsonian to send with you a good draughtsman. Make an agreement with them to collect objects of curiosity for their museum in consideration of their paying the piper. . . . The West Point men are all good draftsmen & would do it with pleasure to have their names on the plates & receive a copy from the war department. . . .

You are to make from this work your real celebrity. . . . therefore make it cover as much ground as can be done thoroughly. Your reports to Congress will of course be only the prelude to a larger & more complete work, the Ethnography of America, a work which should be as splendid in its execution as the large works of the Exploring Expeditions. . . . these reports to Congress should I think be as full of meat as you can make them, in order that inducement may be given to spin the work out. So long as those devils can count

on an illustrated work every session, so long will they make the appropriation. . . . Your great work should be your *"final* Report"— and for this I should take as much time & demand as many draughts-men from the office as I could get.

While Schoolcraft could not keep to the proposed schedule—a book a session—almost everything else he did beginning in 1849 conformed to Gibbs's plan. (Eventually, between 1851 and 1855, he met the schedule as well.)[43]

The issue hung in the balance through the spring of 1849 as Schoolcraft fought to have his appropriation renewed under the Whig administration. Joseph Henry doubted the outcome, but he broke with his usual practice of keeping the Smithsonian above politics to endorse the scientific value of Schoolcraft's project and urge its continuation. Peter Force and Matthew F. Maury, president and vice-president of the National Institute, headed the list of signers of a joint letter to the secretary of the interior arguing that the new department's reputation would largely depend on how generously it interpreted its mandate. Just as the secretary would have to mold the *"raw materials"* under his jurisdiction into a coherent whole, so Schoolcraft was shaping the raw materials of Indian ethnology into a comprehensive work that would ornament the department, advance American science, and attest to "the national character of the present administration"—*if* that administration could see its way clear to provide the requisite support. Schoolcraft laid his case before the secretary on June 21, with evident success. By July he was engaged in a final push to collect outstanding questionnaires and urge early publication not in the routine reports to Congress envisioned by Gibbs, but in a series of volumes of such splendid design that all the "barbarians" would be delighted.[44]

The key precedent before Schoolcraft was the one Gibbs cited, the pub-lications of the United States Exploring Expedition. Lieutenant Charles Wilkes, peppery, tyrannical, and difficult, had waged war with Congress after the expedition's return in 1842. The cruising and specimen gathering were finished, but the serious scientific work had only begun, he insisted. Methodical study of the data and publication of results would take years, and it was Congress's duty to foot the bill. In December 1842 Congress complied, allocating funds for the publication of the scientific treatises— and Wilkes's official *Narrative* of the expedition—under the supervision of the Joint Committee on the Library. Few congressmen at the time realized what a long-term commitment they were making. By 1853 Congress was out of patience with "book-making," and the publication appropriation that year was for the *completion* of the series, not its continuance. But even the Civil War did not halt publication. Money was still being spent and a report issued in 1874 before the series finally bowed to congressional

inertia, short of completion, but at nineteen substantial volumes a lasting testament to Charles Wilkes's perseverance and the vicissitudes of government patronage.[45]

The Exploring Expedition would be Schoolcraft's model, albeit on a smaller scale. As with *Notes on the Iroquois,* good paper and attractive type were essential; so too were illustrations. It was to obtain the best Indian pictures available that Schoolcraft allegedly visited Catlin in London—an impossibility, as we have seen. But he did set out to obtain the services of a painter nearer home, one who would come cheaply and serve as his assistant in preparing the work for the press. George Gibbs had suggested a West Pointer trained in draftsmanship to execute the maps and plans; better yet, an officer who was also an artist with extensive experience in Indian country. One man fit that description: Captain Seth Eastman of the First Infantry, long stationed at Fort Snelling, Minnesota Territory, now on Comanche patrol in Texas and, from all reports, desperate to be reassigned to Washington.

* * *

A native New Englander, born in Maine in 1808, Eastman entered the Military Academy at West Point at sixteen, a youth of good moral character from "respectable family." Graduating in 1829, he was assigned as second lieutenant to the First Infantry, his regiment through most of his career. He served at Fort Crawford, near Prairie du Chien, and Fort Snelling, built in 1819 at the junction of the St. Peters (Minnesota) and Mississippi rivers, gaining an initial exposure to Indian culture before he was reassigned in January 1832 to the Topographical Bureau, precursor to the Corps of Topographical Engineers. His artistic ability brought him back to West Point a year later when Thomas Gimbrede, the professor of drawing whose position Catlin had coveted in vain in 1829, died suddenly. Eastman would serve as assistant professor of drawing until 1840, a busy and successful period in which he was promoted to first lieutenant in 1836 and captain in 1839, having published a standard classroom text, *Treatise on Topographical Drawing* (1837), in the interval. And in June 1835 he married Mary Henderson, a Virginian from a family steeped in naval tradition, her father at the time serving as assistant surgeon at West Point.[46]

Seth Eastman was by all accounts reliable and competent, trusted by fellow officers and genuinely likable, though judging from his correspondence chary of words, as befitted a man from Maine. He rarely committed himself to paper and more rarely revealed himself that way. His professional correspondence was factual and to the point. As an officer, he perhaps felt constrained about showing his artistic side. He preferred to let his wife handle most of his nonmilitary correspondence, and she did, with panache. A self-confessed gossip with an acerbic tongue, on paper Mary Eastman was as loquacious and comfortable as her husband was concise

53. *Left*. Seth Eastman (1808–75) after he was made brevet brigadier general in 1866. Minnesota Historical Society.

54. *Right*. Mary Henderson Eastman (1818–87), the mild expression concealing what the eyes betray: a calculating, determined, intelligent woman who was both a popular writer and her husband's most persistent booster. O. L. Ruh photograph; Minnesota Historical Society.

and formal. Though she raised five children, she found the time to write poetry, fiction, and light nonfiction, and her work enjoyed some popularity. True to her southern roots, she was soft on slavery and death on abolitionism. But her principal cause was her husband's advancement. She badgered congressmen, senators, the military brass, and high-level administrators—even the secretary of war—on his behalf. In a typical letter she recalled how the captain, transferred to Florida in 1840 during the Seminole war, then back to Fort Snelling the next fall, became, like Catlin, an artist with a mission:

> After Capt. Eastman's graduation at West Point, and while on duty there he devoted the time at his command to the study of painting, looking forward to making a collection of pictures, that would at some future day form an Indian gallery. When his scene of duty was changed to our Western frontier, he commenced to put in operation his long cherished plan. He was not satisfied with drawing the scenery of prairie and river,—he studied closely the peculiar history and customs of the interesting peoples who were yielding their territory to us. This study was not a mere occupation; it became a

179

55. Seth Eastman, *Fort Snelling from Two Miles Below* (1846–48), a watercolor displaying Eastman's skill as a topographical artist. Minnesota Historical Society.

passion with him; thus, he was, in all respects, fitted to be the delineator of the Indians.[47]

Eastman did use his almost uninterrupted seven-year stint at Fort Snelling to record the life and customs, though rarely the individual likenesses, of the local Sioux. He was no master at anatomy, and his few portraits are undistinguished. Catlin, a professional portrait painter when he turned to the Indian, continued to specialize in Indian heads; Eastman, a trained topographical artist, populated scenes with rather lumpish figures. With private tutoring during his years as drawing instructor at West Point, he had refined his draftsman's skills—an observant eye, a meticulous line, and an easy grasp of detail, perspective, and scale—and branched out into landscapes in the manner of the Hudson River school. His Indian paintings, replete with dramatic cloud effects, gnarled trees, and precisely rendered leaves, pebbles, and blades of grass, bear little resemblance to Catlin's with their splashes of pure color and minimal articulation. Eastman's work, in short, conformed to conventional taste. His approach was both sentimental and detached. A comparison of his oil *Osceola as a Captive, in a Tent Guarded by a Sentry* with Catlin's *Osceola* establishes their differences. Eastman's painting is not unsympathetic. Osceola, with a plate of bread and a jug of water beside him, slumps despondently, dejection written on his face. But he could be any Indian, any prisoner; nothing of Catlin's tragic young warrior of effeminate smile and blazing eyes distinguishes him.[48]

Beginning in 1836, Eastman exhibited at the National Academy of Design, and in 1838 he was elected an honorary member with amateur standing since he was, and remained, a career officer. A decade later he sold six paintings to the American Art-Union, which distributed them by lottery to lucky members. Opportunities beckoned. Perhaps he would publish a book of his watercolor views along the Mississippi between the Falls of St. Anthony, seven miles above Fort Snelling, and the mouth of the Ohio. Or perhaps he would collaborate on a giant panorama of the Mississippi of the sort so popular in the late 1840s. He outlined both options in a letter of November 1, 1847, but added: "I dislike to leave my Indian pictures—my long residence among the Indians has given me a knowledge of their habits and character." His reluctance was understandable. He had just completed an oil, *Indian Burial,* and was elated. Though it contained "but nine figures" it was "very highly finished" and, he understood, would easily fetch $500 in St. Louis. He was about to start on a sequel showing Indian mourning rites. Things were stirring for him. "Several artists" had come calling that year. His reputation was spreading. The St. Louis papers were uniformly complimentary, called him America's premier Indian painter, and seemed eager to forget George Catlin, by then nearly a decade absent.[49]

Respect, financial success, creative productivity—Eastman had them in 1848, but to achieve all he hoped for it was essential he be transferred East, preferably to the seat of government, where he would be nearer the New York art markets and strategically positioned to press Congress for a special appointment that would give free rein to his artistic ambitions. Schoolcraft's Indian work, then in the making, offered a perfect opportunity—a way, as Mary Eastman put it, for the captain "to perpetuate his labors" and realize "his favorite project," the creation of an Indian gallery far finer than Catlin's. But events foiled Seth Eastman. Effective the end of September 1848, the First Infantry was reassigned to Texas, even more remote, more dangerous than a post on the Mississippi, and his family would not be going along.[50]

It was this change of station that brought matters to a head for the Eastmans. The seven-hundred-mile steamboat trip from Fort Snelling to St. Louis, the first leg of a two-month journey for the captain, and the wrenching farewells there fixed Mary Eastman's resolve. She would get her husband back by every means at her disposal, formal calls and pleading letters to the powers that be to arrange a transfer to Washington or, failing that, an extended furlough in the East. She was, she admitted, a meddlesome woman, but she always forgave herself on the grounds that family came first: "However one may love art—however one may love one's own race, and be curious as to its origins and destiny—one must eat and be clothed, and so must one's children—and wife." She needed the captain at

home. It was essential he fulfill his paternal responsibilities, time also that he receive proper recognition for his labors at the easel. With her first book written and placed with an established New York publishing house—a book on Dakota Indian lore "illustrated from drawings by Captain Eastman"—Mary Eastman enlisted her pen in his cause.[51]

Two possibilities had suggested themselves over the summer of 1848 as the transfer to Texas loomed nearer. George Catlin's appeal for early action on the purchase of his Indian Gallery had been making headway in Congress and would undoubtedly be decided at the next session. Catlin was asking $50,000 for his collection; Eastman would paint a better one at a fraction of the cost, a mere captain's pay. And then there was Schoolcraft's Indian compilation, brought to Eastman's attention when he received a copy of the questionnaire circulated by the Indian Office. John S. Robb, a St. Louis journalist who spent ten days with the Eastmans at Fort Snelling in July 1848, admired the captain's Indian paintings and proposed in the *Weekly Reveille* that Eastman be appointed to the government work. "We cannot well understand how they could give a proper history of this character without illustrations; and if such is the purpose, Capt. Eastman possesses more ability for such a task than any man in this country." Robb's nomination of Eastman was a calculated ploy. Besides enjoying "the kind hospitality of Capt. Eastman and his amiable and talented lady," Robb had spent a few hours with Henry Hastings Sibley, American Fur Company agent at Mendota on the St. Peters by Fort Snelling. For Robb's benefit Sibley, an Eastman intimate, had disparaged earlier "vagabondizing scribblers . . . who look at a solitary Indian half an hour, bore a fur company agent, an interpreter, or old resident, with innumerable questions, beg curiosities, and then write histories of the tribes and early white settlers." Robb did not mention names, but there was no mistaking that Catlin was intended. In contrast, Eastman lived surrounded by Indians. He spoke the Sioux language and knew tribal customs so well that he taught Robb "to read the private history of a chief or brave by the ornaments which decorate his person." By all means have Eastman illustrate the government's Indian work, Robb wrote, "and our country will possess a history of its original inhabitants which will reflect credit upon the administration under whose direction it is produced." Since the work was being prepared under the War Department's aegis, the captain could readily be assigned to Washington on this duty.[52]

On September 28, two days before Eastman's departure for Texas, five prominent citizens of Concord, New Hampshire, including Congressman Charles H. Peaslee, urged Secretary of War William L. Marcy to detail Eastman to Washington to "paint an Indian Gallery for Government." Marcy was understandably perplexed. The request was roundabout and most irregular, suggesting the haste with which the Eastmans had mounted

56. A seated Henry Hastings Sibley (1811–91) on the left with two business associates in Washington, where he served as a catalyst in the Schoolcraft-Eastman collaboration and continued his personal vendetta against Catlin. Brady Studio photograph; Minnesota Historical Society.

their campaign. Captain Eastman's father, a friend of Peaslee's, lived in Concord, and Mary Eastman's father, Dr. Thomas W. Henderson, was now assistant surgeon general of the United States Army stationed in Portsmouth. New Hampshire was thus a natural base of operations, but distance hampered communications between Fort Snelling and Concord. In his letter to Marcy endorsing Eastman's request for a transfer, Peaslee failed to mention Schoolcraft's work and Eastman's special qualifications as illustrator for it, probably because the captain's father had neglected to mention it to him. And what was Marcy to do with the request he did receive? Wisely, he passed it on to the adjutant general, who determined that Eastman's services were required with his company in Texas, a decision that Marcy endorsed in mid-November.[53]

Meanwhile, a welcome development had strengthened Eastman's position in Washington. On October 30 Henry Sibley was elected territorial delegate for that portion of Wisconsin outside the new state's boundaries, and he had promised, if elected, to get Eastman reassigned.[54]

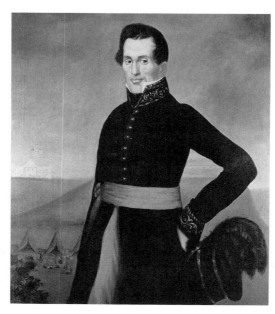

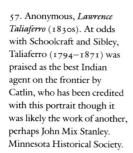

57. Anonymous, *Lawrence Taliaferro* (1830s). At odds with Schoolcraft and Sibley, Taliaferro (1794–1871) was praised as the best Indian agent on the frontier by Catlin, who has been credited with this portrait though it was likely the work of another, perhaps John Mix Stanley. Minnesota Historical Society.

Sibley seemed an ideal advocate. A veteran fur trader, he had been associated with the American Fur Company since he was seventeen, first as a clerk at Sault Ste. Marie and Mackinac, 1828–34, then as a partner at St. Peters and cosutler at Fort Snelling. He knew Schoolcraft from Mackinac and Eastman from his years in Minnesota. All were long-term frontier residents—fur trader, Indian agent, and army officer—and all, according to "the custom of the country," had formed liaisons (Schoolcraft's sanctioned by marriage) with native women that produced children. They shared a suspicion of "hasty travellers" who, posing as experts, presumed to make strong judgments based on a nodding acquaintance with the West and its inhabitants, red and white alike. All three were Democrats, Eastman the least public in his affiliation, though his wife was outspoken in her southern Democratic principles. There was another bond: each, for his own reasons, considered George Catlin an enemy, and each would work against him.

* * *

Catlin had added to his list of enemies over the years by praising some but not all who assisted him on his western tours. In *Letters and Notes* he singled out as an exemplary Indian agent Major Lawrence Taliaferro, since 1820 headquartered at St. Peters. Catlin first met Taliaferro in June 1835 on his excursion up the Mississippi with his wife. It would be her only western tour, and Catlin was doubly grateful for Taliaferro's "polite hospitality," praising him as probably the only "public servant on these frontiers, who has performed the duties of his office, strictly and faithfully, as well as

kindly, for fifteen years. The Indians think much of him, and call him Great Father."⁵⁵

Those were fighting words. Had Catlin deliberately set out to offend Schoolcraft he could not have chosen better. As agent at the Sault, Schoolcraft had been engaged in a jurisdictional squabble with Taliaferro since 1827, when the Indian Office, at Schoolcraft's prompting, decided to lump the Mississippi River Chippewas with the other Chippewas under his charge. This would be "*folly* and of no *avail*," Taliaferro exploded; Schoolcraft dismissed him as "*a young fool.*" The exchange of insults continued, to the amusement, one suspects, of the Indians who got to play go-between. Taliaferro maintained that *his* Chippewas still regarded him as their great father, turning to him for advice in their disputes with the Sioux "as if indeed," he informed Schoolcraft in 1831, "*all* the powers of the govt had been delegated to me." The Chippewas must have wondered about *both* their great fathers after Schoolcraft three years later accused Taliaferro of having incited the Sioux to war with the Chippewas in order to extend their territory and thus his jurisdiction. Schoolcraft, Taliaferro confided to his journal, with a conniving hypocrite, a "self elected envoy of Heaven" who had feathered his "*filthy* nest" at Chippewa expense. He took revenge two years later in a public letter exposing Schoolcraft's 1836 treaty with the Indians of Michigan as "a fraud upon the Treasury."⁵⁶

At the time Catlin met them, then, Schoolcraft and Taliaferro were estranged, and to side with one was to risk alienating the other. Catlin had not yet visited the Sault and Mackinac when he concluded that Taliaferro was the ablest Indian agent on the frontier, but this opinion broadcast in his *Letters and Notes* would not have escaped Schoolcraft's notice.

Catlin also made enemies among the fur traders by, as they saw it, accepting their hospitality and then castigating their business practices in print. His first published letters were hedged round with platitudes (Pierre Chouteau, Jr., was "a gentleman of great perseverance" and "indefatigable zeal"), and this attitude carried over in his book's early chapters in which Kenneth Mackenzie was a "kind-hearted and high-minded Scotchman," Francis A. Chardon of "unfaltering courage" and "liberal heart," and the American Fur Company itself renowned for its "unconquerable spirit of trade and enterprize."¹¹¹ But doubts surfaced even in these reports—when, for example, Catlin remarked that the Indians, meeting no white men but traders, applied "to us all, indiscriminately, the epithet of 'liars.'" And the rumor that an Omaha had obtained arsenic from a trader and ministered it to his unsuspecting people prompted Catlin to observe that, if true, it was "to the everlasting infamy of the Fur Traders" and "conclusive proof of the incredible enormity of white men's dealings in this country." Catlin went on to lay the wasteful slaughter of buffalo for their

hides at the company's door and to point out that the Indians lost land at every treaty council *and* their cash compensation as well, which went to satisfy fur-trade creditors who flocked, vulturelike, to press their claims. They were at the treaty council he witnessed in 1836, anticipating a $50,000 share of the Sac and Fox settlement. But these reflections on fur trade morality were mere preliminaries. As the first link in a causal chain, Catlin charged, the fur trade led directly to Indian decline: "White men—whiskey—tomahawks—scalping knives—guns, powder and ball—small-pox—debauchery—extermination." *That* was the end result of fur-trade abuses, and the government that licensed the companies was a party to the crime.[57]

The fur-trade interests struck back. They at least knew Indians, had daily dealings with them. Catlin was a moonstruck romantic sheltered from frontier reality who peddled half-truths as facts and dealt in distortion—a "liar" indeed. Henry Sibley led the attack.

Sibley was in charge of the Northern Department of the reorganized American Fur Company headquartered at St. Peters when he met Catlin in 1835. Sibley's predecessor had provoked Taliaferro by flagrantly flouting the federal Trade and Intercourse Acts banning whiskey in Indian country; Sibley was more discreet, and Taliaferro reserved judgment on him. But their relationship was strained during Catlin's visit and deteriorated completely that fall. Sibley regarded the agent as an obstacle to legitimate commerce who, "notwithstanding his fair professions," was known to be "a bitter enemy to the Am F. Co and all connected with them." Taliaferro hotly denied the charge, but it was accurate. He considered fur traders as a class unconscionable thieves who debauched the Indians the more easily to rob them, and the American Fur Company in particular a "*giant*" monopoly guilty of "*gross frauds* upon the Treasury" and "diabolical" in its unfeeling exploitation of the Indians.[58]

Catlin agreed. A modicum of discretion might have saved him a world of woe, but discretion was not his style. Other travelers, recognizing the strains between Taliaferro and Sibley, kept a delicate balance and maintained cordial relations with both. None of that for Catlin. Under Taliaferro's tutelage, he honed his anti-fur-trade views. When he left Fort Snelling bound for Prairie du Chien in a bark canoe on July 27, 1835, he carried with him certificates of authenticity for twelve of his Sioux and Chippewa portraits signed by Taliaferro and a set of shared convictions that subsequent observation only confirmed. Prairie du Chien had a noxious reputation. The soldiers stationed there at Fort Crawford—"drunken, dissipated, and abandoned scoundrels"—were more savage than the Indians they routinely plied with liquor, an eyewitness reported in 1827. Things had not improved when Catlin visited, Prairie du Chien presenting "one continual scene of wretchedness, and drunkenness, and disease

58. George Catlin, *Ball-play of the women, Prairie du Chien* (1835–36). Though this group scene is like others by Catlin, its added feature—the drunken men in the foreground—expresses his disgust at the debauchery he attributed to the fur traders and found particularly pronounced at Prairie du Chien. National Museum of American Art, Smithsonian Institution; gift of Mrs. Joseph Harrison, Jr.

amongst the Indians, who come there to trade and to receive their annuities."59

Catlin pointed an accusing finger at the American Fur Company, which maintained a post there, incurring more ill will. It surfaced the next summer when he sought aid for his trip to the pipestone quarry. "*Your friend* Catlin the Painter," the trader at Prairie du Chien reported to Sibley with sarcastic emphasis, "goes up with this conveyance. . . . there is an English man (Wood) who accompanies him . . . they rely on you for Horses &c—I gave no encouragement, & told them I knew it to be utterly out of your power to assist them in that way."60

Sibley would remember differently. Twenty years after the fact he portrayed himself as the soul of hospitality, Catlin as an ingrate:

Of all the men who have traversed the wilds of the North-West no one was received with more kindness and attention by resident white men than was Catlin, and by none were they repaid with so much ingratitude. . . . they all vied with each other in endeavoring to afford him facilities for penetrating the different parts of the country he desired to visit. I furnished him horses for his trip to the Pipe stone Quarry without charge and a trusty Indian guide, and I gave him letters to Louis Provencalle in charge of my trading post at Traverse des Sioux, and to Joseph Laframboise also a clerk of mine at that time trading at a station about thirty miles from the Quarry,

instructing them to afford him every aid in advancing the objects of his visit. . . . The letters written by Catlin for publication . . . were filled with so many misstatements, and with details of adventures of so fabulous a character, that officers and traders were alike astounded, and it was even urged by some of the most indignant among them that he should be exposed in the public journals. The voluminous work he subsequently produced, abounds with errors, so much so, that it affords no true indication of the state of things in the Indian Country, or of the condition and manners of the wild tribes whose character he pretended to understand. The only redeeming feature in his book is to be found in his sketches of Indians faces and of scenes connected with Indian life which are sufficiently faithful representations, inasmuch as he was somewhat skilful in that line, and his pencil could not very well when used for that purpose vary much from the truth.[61]

Sibley's enmity mattered because he was a powerful figure in early Minnesota—territorial delegate to Congress and first governor of the state. Throwing his support behind Seth Eastman in 1849, he deliberately damaged Catlin's case for congressional patronage, and his accusations were part of the record that weighed against the expatriate artist in 1852 as well. Specifically, Sibley challenged Catlin's claim that he was the first white man to visit the red pipestone quarry.

In his writing, Catlin was often guilty of exaggeration. He admitted as much in the preface to *Letters and Notes* when he begged his readers' indulgence: "If some few of my narrations should seem a *little too highly coloured,* I trust the world will be ready to extend to me that pardon which it is customary to yield to all artists whose main faults exist in the vividness of their colouring, rather than in the drawing of their pictures." The distinction was important. Catlin embroidered, but he did not invent: what he said he had done, he did. But he continually fostered the misleading impression of an extended residence in Indian country. He claimed to have devoted eight arduous months to visiting the pipestone quarry in 1836, for example, though his entire return trip from Buffalo took only half that time. Such an exaggeration, perhaps forgivable in a popular narrative like *Letters and Notes,* was inexcusable in the scientific journal in which he originally published it, casting doubt upon his other claims, including the one Sibley seized upon, that he was the first white man ever to visit the quarry.[62]

In *Letters and Notes* Catlin actually said only that the Sioux told him he and his companion, Robert Wood, were the first to make the trip. "*Brothers,*" Te-o-kun-hko warned, "we know that no white man has ever been to the Pipe Stone Quarry, and our chiefs have often decided in council that no

white man shall ever go to it." The assembled Sioux muttered concurring "Hows," Catlin reported. Taken at face value, this meant that he and Wood were the very first to make the trip. Subsequently Catlin qualified even this secondhand claim to primacy. He had originally learned about the quarry in 1835 from an American Fur Company trader, Joseph La Framboise, whose post was less than fifty miles from the site (thirty, Sibley said) and who provided Catlin with a map and actually guided the two travelers there. La Framboise was a mixed-blood, however, so the reader could still conclude that Catlin and Wood were the first *white* men on the scene.[63]

The Mississippi River traders, some of whom had personally inspected the quarry, scoffed at Catlin's pretensions. They filled the ears of later travelers with denunciations that eventually filtered back East. Benjamin Silliman, professor of chemistry and natural history at Yale from 1802 to 1853 and a revered scientific eminence in America, was disturbed to learn in 1841 from a former student that Catlin's geological report on the pipestone quarry, published in Silliman's own *American Journal of Science and Art* two years before, was a tissue of lies. The *Journal* had been a leading repository of scientific information since 1818; Schoolcraft, for one, had communicated his findings in its pages at a time when he was more student of "mineralogical science" than of ethnology and found the deposits of copper along Lake Superior's southern shore and the limestone of the Missouri lead mine region more fascinating than Indian mythology. It was in the pages of Silliman's *Journal* as well that Dr. Charles T. Jackson, a Boston chemist and mineralogist, pronounced the specimens from the pipestone quarry sent him by Catlin "a new mineral compound" and named it catlinite in his honor. Silliman had been impressed enough to invite Catlin to contribute a paper setting forth his views on the formation of the valley of the Missouri and provided him a glowing reference (datelined "U. States Nor. Am. Yale College New Haven") on his departure for Europe, calling him a "gentleman of great intelligence, respectability and worth." Silliman's own reputation was on the line with Catlin's, and in the fall of 1841 he specified the charges against him.[64]

Catlin, "mortified beyond expression, as well as incensed," sent Silliman an impassioned point-by-point rebuttal. He had never knowingly deceived anyone; his description of the pipestone quarry was before the world and would "stand the test." The charges against him were so "ignorant & peurile" that Catlin doubted Silliman's unnamed correspondent had ever visited the quarry. No, the pipestone was not dug up in a soft state and dried under leaves to prevent its cracking in the sun. That was an outright fabrication. As for the assertion that the Indians entertained no superstitions about the red pipestone, Catlin was sure Silliman's correspondent had learned even less of Indian legends than of minerals at Yale. The designation "catlinite" was not Catlin's doing. He invariably referred to

"pipe stone" in his writings—which should satisfy the young man's "envious feelings" in demanding the honor be retracted. And no, he had never claimed to be the first white man to visit the quarry, though some had misunderstood him. After all, *Letters and Notes* mentioned La Framboise's prior familiarity with the site and his services as guide. The charge of wholesale misrepresentation was motivated by malice, Catlin believed, and could be traced to its source, "a seller of whiskey & buyer of muskrat skins." Catlin did not name him, but an article in a Cincinnati paper did: Henry H. Sibley.[65]

A leisurely piece in the Cincinnati *Daily Gazette* describing a visit to the falls of St. Anthony above Fort Snelling devoted a paragraph to the red pipestone quarry. Since the writer persisted in describing the quarry as the "Pipe-stone Cave," it was evident that he, like Silliman's student, had never seen it for himself. But he was prepared to denounce Catlin:

> Catlin remarks in his celebrated work—which has elicited so much attention from Europeans as well as Americans, and drawn from Professor Silliman an acknowledgment of its veracity and intrinsic worth . . . —that he, after innumerable hardships, and subsequently being taken prisoner by the Sioux, at length succeeded in visiting the Pipe-stone Cave, the *first* white man that ever beheld this natural curiosity. Mr. Sibly, the agent of the Fur Company, and a gentleman to whom I, with others, am much indebted for many kindnesses, has proven to my satisfaction that Catlin never was taken prisoner by the Sioux, and was not the first white man who visited this cave. "For ten years," said Mr. S., "we have had a company established within 20 miles of the Pipe-Stone Cave [it was getting closer in the telling]. So far from Mr. Catlin's meeting with opposition in reaching this cave, I myself gave him letters of introduction to this company, with orders to provide him with a guide. As for his being taken prisoner, when afterwards mentioned to the Sioux, they ridiculed the idea." This portion of Mr. Catlin's journal can, therefore, be considered in the light of fanciful imagination.

No wonder Catlin was suspicious of Silliman's correspondent. He too was in cahoots with Sibley and company. "I hope your young friend has a more harmless and less malignant motive for impeaching me than they have," Catlin wrote, "& hope also that he has got something better to stand on than hearsay from them."[66]

The traders, Catlin explained, were his avowed enemies. They had branded him a liar for saying he was imprisoned by the Sioux, a simple fact. Robert Wood, at present residing in Philadelphia, could be reached anytime to verify the story. (In fact, immediately upon his return from the quarry Catlin had reported the surly, threatening behavior of the Sioux to

their agent, Taliaferro, noting that they looked "with a jealous & watchfull eye" on all who inquired of the pipestone and were "very much incensed" at his insistence on going.) But Catlin's veracity was not the issue anyway. The American Fur Company traders, aware that his book was about to appear, had set out to blacken his reputation before he blackened theirs. Their concern that he would tell the unvarnished truth was why they had had the Sioux "arrest" him in the first place and shoot at him subsequently and why at the time he was carrying in his pocket "several anonymous letters warning me to leave the country & of the danger to my life." In his book he had been circumspect and told "vastly less" than he knew, for had he "told all or a half my life would hang upon a nick if I were to traverse the Rocky Mountains, as I hope yet to do. I have no object in fighting with those people yet, & may never wish to do it, but if driven to it I have a Book yet to write . . . that will sicken the hearts of the philanthropic world at the depravity & cruelty of their own species."[67]

Silliman was persuaded. He had received his complimentary copy of *Letters and Notes,* read with special care the section on the pipestone quarry, and gave "full credit" to everything Catlin had averred in conversation and in writing. He had informed Catlin of the charges against him not because he believed them but because it was Catlin's right to know. Clearly Silliman's informant, "an ardent youth having little experience in the journey of life," had been deceived. "Consider yourself therefore as in no way or degree injured in my estimation. I repose full confidence in all you state as to matters of fact and if you have a good trace of enthusiasm it is no more than belongs to an artist."[68]

Sibley also read *Letters and Notes,* though to a different end. It confirmed his suspicion that Catlin was an inveterate foe of the fur trade who must be exposed. In September 1849 Sibley urged the territorial council of Minnesota to ignore the usage "catlinite" when it shipped a slab of pipestone to the nation's capital as its contribution to the Washington Monument. Since Catlin was not the first white man to visit the quarry, he deserved no special recognition; instead, refer to the stone by its Sioux designation, "Eyanskah." Petty vindictiveness was merely an indicator of Sibley's animosity. That same year he served as the catalyst in bringing Eastman and Schoolcraft together in potent alliance against George Catlin.[69]

* * *

Congress met on December 4, 1848, and within a week Captain Eastman had written Sibley from the infantry camp near Fredricksburg, Texas, to remind him of his promise "to do something . . . in regard to my painting those Indian pictures." The exchange of favors was a way of life at an isolated post like Fort Snelling–St. Peters. Asked by the superintendent of Indian affairs at St. Louis in July 1848 how best to combat the frontier

whiskey traffic, Eastman had replied that "summary punishment" of drunken Indians was the answer—twenty days at hard labor for a first offense, forty for a second, and whatever the arresting officer might think proper for a third. This nicely skirted the issue of fur trade culpability. Ignoring the long-standing provisions of the Trade and Intercourse Acts, which slack enforcement had rendered ineffectual, Eastman wrote, "As the white man who sells whiskey to the Indians cannot be reached by the present laws, some means should be taken to prevent the Indians from drinking or purchasing it." Put differently, as long as the Indians demanded whiskey, they had to be supplied—such was the law of fur-trade competition. Therefore compel them to stop demanding it. Go after the user, not the supplier. "It is my belief, and also of those who have resided a very long time in this country," Eastman concluded, "that if this course of punishment be taken with the Indians, that it will be effectual and the whiskey trade be broken up." In short, business as usual for the American Fur Company.[70]

It was this reasonable attitude, so unlike Catlin's, that endeared Eastman to Sibley. They were social friends and hunting companions who had shared many a pleasant day in the field and duck marsh. Acting as a government agent for the sale of the military reserve at Fort Snelling a decade later, Eastman accepted the first offer tendered, a violation of competitive bidding procedures that invited controversy and a congressional hearing. Under questioning he denied any special familiarity with the buyer, Franklin Steele, Sibley's brother-in-law. Quid pro quo was the rule, and Eastman expected favors in return. Before departing Fort Snelling in 1848, he presented Sibley with an oil painting of the American Fur Company post at Mendota, an appropriate reminder of what he wanted of his friend.[71]

As a territorial delegate, lacking voting rights in the House, Sibley did not have sufficient clout to deliver on his promise, he admitted to Mrs. Eastman; he would need an ally. "I know political influence does every thing now-a-days," she replied, suggesting Peaslee again. He would do "any thing in his power" to advance Eastman's interests. She also took the matter into her own hands. Without notifying Sibley or her husband, she wrote directly to Senator Stephen A. Douglas for his support. "Do not accuse me of being forward—not even in your own mind," she lectured Sibley. "Remember the *startling* fact that I have *five children,* to set forward in the journey of life." The day she wrote, February 5, Sibley and Peaslee collaborated on a joint letter to the secretary of war. They urged that Eastman be granted a leave of absence "for a period sufficiently long to enable him to complete the Indian Gallery of paintings, which he has commenced, for the use of the Government, and in illustration of the Indian History, now in process of compilation by H. R. Schoolcraft Esq.,

under the supervision of your Dept. Capt. E., we believe, to be of all men living, most capable of doing justice to such an undertaking." Again, the Adjutant General's Office rejected Eastman's application. With both lieutenants absent, his services were still required with his company in Texas.[72]

Left unmentioned was the impending transfer of the Indian Bureau, and thus Schoolcraft, from the War Department to the proposed Department of the Interior. When it happened, the case for detailing Eastman to the Indian history would be weakened. But Eastman's congressional friends were not idle that February. Catlin's case for patronage was moving toward a major test in the Senate; here was a chance to advance Eastman's interests at Catlin's expense; during the lively debate on February 27, that is precisely what was done.

Stephen A. Douglas was not on hand to introduce Eastman's name, but someone spoke to a senator who was—Solon Borland of Arkansas. The opportunity presented itself when a Virginian opposed to the purchase of Catlin's gallery remarked: "This is not the only collection of paintings of this description. There is another, I am informed by the Senator from Arkansas, of greater extent and of superior execution." Borland probably preferred to stay uninvolved, since he had a southern Democrat's suspicion of all government patronage. But he could not decline such a direct invitation to be heard. He would offer no amendment to the Catlin bill, he said, but his statement was made on "good authority":

> There is a captain in the army, a very distinguished artist, who has made a number of paintings of the Indians, and who has a large collection of sketches of the distinguished chiefs of various Indian tribes, who is prepared to make a gallery of this style of paintings, even more extensive than that of Mr. Catlin; and he is accounted by many competent judges to be greatly superior as an artist. All he asks is, that Government will continue to him an amount of pay equal to that which he receives as a captain, and he will, if necessary, resign his commission and proceed to prepare the paintings. I speak of Captain Eastman.

This was something of a bombshell. It was unlikely Borland meant to drop it and certain that Eastman, who could well be compromised by such a revelation, had never sanctioned it.

Borland added quickly that Eastman had "no knowledge whatever" that his name would be brought up. At the same time, he revealed something of his source, "a friend . . . well informed on this subject," who in conversation the day before had mentioned the captain's willingness to paint an Indian gallery that would put Catlin's to shame. Borland did not name his "friend," but Mary Eastman knew who was meant. After Sibley returned to Minnesota, his term as delegate having expired with the

session on March 3, she wrote to thank him for "the kind interest" he had taken "in Capt- Eastman's affairs—it was through you I know that he was so handsomely spoken of in the House and Senate also—and our family will always feel towards you the warmest gratitude." Indeed, her gratitude found public expression in *Dahcotah; or, Life and Legends of the Sioux*, in press since December 1848, which was issued with a lengthy dedication to Henry Sibley dated March 1, 1849. Mary Eastman had intended to dedicate the book to her parents, but Sibley's "many acts of kindness" had persuaded her to name him as well. Of course it could do no harm to place a copy in Sibley's hands, where her text and the captain's pictures would keep their cause fresh in his mind.[73]

Eastman did not get a government commission to paint an Indian gallery in 1849, nor was he assigned to illustrate Schoolcraft's *History*. He did get his six months' furlough, however, with orders to report to the adjutant general in Washington, perhaps to explain his apparent willingness to resign from the service. While in Washington, he would have the opportunity to promote his interests in person. Congress had approved the bill establishing the Department of the Interior on the last day of the session; thus the Indian Bureau was now under new executive jurisdiction, and Schoolcraft's project was very much up in the air. Schoolcraft had exerted himself on Eastman's behalf, pressing the commissioner of Indian affairs to have him appointed illustrator of the work. But with his own position at risk, he was prepared to settle for some other "intelligent person at a moderate compensation, who realizes a strong interest in the measure." The important thing was to continue the inquiry and get the results before Congress. Schoolcraft's self-serving pragmatism would one day erect a wall of mistrust between himself and Eastman; in late May of 1849, however, his stance was reasonable. It was no time to be stubborn on someone else's behalf.[74]

* * *

Though he was disappointed at not obtaining Captain Eastman's services, Schoolcraft could count several blessings that spring. For one thing, he was still employed, his position having survived the turmoil of an administrative change. For another, he was a married man again. In anticipation of his appointment by Congress in 1846 he had wooed and won the hand of, his biographer has written, "a bitter old maid from South Carolina." Certainly Mary Howard, with her southern principles, stern piety, and haughty demeanor cut a formidable figure, and their courtship was stormy despite their carbon-copy characters. Having "crushed" her with the icy formality of one note describing his ethnological ambitions, Schoolcraft excused himself as "a searcher after truth, and to this end, *a fact-hunter*, all my life." Besides his disconcerting lack of ardor, his poor health worried Mary Howard. Schoolcraft had long complained of a partial paralysis of his right

arm (it had driven him to seek medical advice during his stay in England in 1842), and the condition had worsened over time.[75]

But with dimming matrimonial prospects herself, Howard married Henry Schoolcraft in January 1847. In a fictionalized portrait drawn thirteen years later, she erased all doubts and depicted her husband as a romantic hero. He was when they met, she wrote, "perhaps fifty years of age, though his very long, waving, affluent, chestnut-colored hair, was scarcely tinged with envious grey; his features were large, his complexion florid, his eyes a brilliant blue, and his forehead was so white, broad, and high, that Musidora [her fictional persona] was on the tenter-hooks of curiosity to find out who the majestic stranger was. His height measured six feet; his hands were aristocratically small, and delicately white . . . she had never seen so noble, so lordly, so commanding a head, and she was reminded . . . of the god Jupiter." He in turn was captivated by her "noble person, bearing and manners," fine figure, graceful carriage, queenly air, classic features, dark, intellectual, soulful eyes, and especially her "extraordinary power of conversation," reflecting her natural eloquence, moral sense, and clear logic. How could the one resist the other? When Jupiter asked his queen for her hand in marriage, she had naturally consented.[76]

This self-flattering recollection did not mean that all was harmony in the Schoolcraft household. Rather, it suggests that Mary Schoolcraft had made a virtue of her resignation. For in August 1849, in the third year of their marriage, Schoolcraft was paralyzed by a stroke. Although not entirely disabling, it cost him the use of his right hand for several months and confined him to his study where, after a recurrence in 1852, he was sentenced to live out most of his days, Mary Schoolcraft by his side. Such was her quick transition from new bride to nurse, companion, and amanuensis—or in her version, from southern belle (much admired, much courted, but too proud to marry) to martyr and, one might even say, saint. The discoverer of Lake Itasca after 1849 was literally an armchair antiquarian save when political survival compelled him to call on a committee chairman or the need to supervise another volume of his compilation through the press took him to Philadelphia for a spell.

There were compensations. Schoolcraft's paralysis delayed progress on the Indian work, but it also explained the delay. It garnered sympathy. And it justified retaining extra help. His son John, who had clashed with his stepmother and, by his father's standards, become a dissolute ne'er-do-well, was taken on as a copyist, and eventually Mary Schoolcraft as well. Schoolcraft's ailment also meant that a full-time assistant would have to be employed to manage the office in his absence. Who better than Captain Eastman, who now could double as artist and, as befitted a soldier, second-in-command?[77]

For his part Eastman was willing, and this time able. His furlough was

the key. It gave him the chance to be in Washington, where presence was everything when it came to patronage. He arrived in the capital in late December 1849 and immediately called on an old friend, Charles Lanman, who had plucked a "tip-top" patronage plum of his own that spring as librarian in the War Department. Lanman also wrote "*subrosa*" for the city's most influential newspaper, the *National Intelligencer*.[78]

On a trip West in 1846 Lanman had enjoyed Eastman's hospitality at Fort Snelling and in an account of his tour, *A Summer in the Wilderness,* had enthusiastically dubbed Eastman "the American soldier-artist of the wilderness." The day Eastman dropped in to visit Lanman, December 21, the *National Intelligencer* carried this item:

THE SOLDIER ARTIST

We are informed that Captain SETH EASTMAN, of the U.S. Army, who has the reputation of being an artist of superior ability, has arrived in Washington, where it is expected he will remain for the winter. Having spent some twenty years of his life on the frontiers, and devoted all his leisure time to portraying upon canvas the manners and customs of the Indians, his collection of pictures and sketches is said to be particularly valuable and interesting, and it is expected that his pencil will be employed in illustrating the forthcoming report by Mr. SCHOOLCRAFT upon the aborigines of this continent.

Lanman then went on to quote from his own book, wherein he had written that Eastman's collection

numbers about four hundred pieces, comprising every variety of scenes, from the Grand Medicine Dance to the singular and affecting Indian grave. When the extent and character of this Indian Gallery are considered, it must be acknowledged the most valuable in the country, not even excepting that of GEORGE CATLIN. But, what adds greatly to the interest called forth by these pictures, is the use to which they are to be applied. Instead of being used as a travelling exhibition to accumulate gold, this gallery is to be presented to a distinguished college, from which the artist will only demand the education of his children. There is some thing in this movement so foreign to the sordid passion of our age, and so characteristic of the true spirit of art, that the heart is thrilled with pleasure as we remember the American soldier artist of the Wilderness.[79]

Eastman could have asked no more. In contrast to Catlin, he was an altruist serving his country. Lanman, with a creative bent that went beyond dabbling in watercolors and literature, had blithely transformed Eastman's drawings and pencil sketches into an Indian gallery of "four hundred

pieces." During his entire residence at Fort Snelling (1842–48) Eastman had actually painted fewer than eighty oils. Since one-third of them went to the American Art-Union in New York, he did not have much of a "gallery" on hand in 1849. Lanman also exaggerated the "character" of this purported gallery. Until his tour of duty in Texas two years after Lanman's visit, Eastman was familiar only with the Seminoles and the Indians of the Upper Mississippi, and his Texas sketchbook evinces minimal interest in the southwestern tribes. What his work lacked in representativeness it made up for in depth of knowledge acquired during almost a decade's experience with the Sioux, Chippewas, and Winnebagos around Fort Snelling. But Lanman, ignoring fact, praised Eastman's collection precisely where it was weakest, in "extent"—again to Catlin's detriment. Accurate or not, Lanman's warm public endorsement was just what Eastman needed.[80]

Eastman also touched base with Henry Sibley, back in Washington as the delegate from Minnesota Territory. Sibley had asked him to work up a design for the new territorial seal to show civilization's triumph over savagery or, in the conventional imagery, a white pioneer plowing his field and an Indian fleeing toward the setting sun. Eastman dropped his sketches off for Sibley's approval on the evening of December 3. But though Sibley described his old friend as a talented artist, in forwarding the designs to Governor Alexander Ramsey he favored one by another officer, Colonel J. J. Abert of the Corps of Topographical Engineers. Ramsey disagreed. Abert had made the forces of civilization too dominant. "In Capt. Eastmans design the equilibrium is better preserved; his is also more bold, grand & striking." Ramsey left the decision open and turned instead to the problem of choosing an appropriate motto in Latin, French, or good plain English. English lost out—garbled Latin, *Quo sursum velo videre,* was the order of the day—illustrated by an equally garbled blend of Abert and Eastman's ideas that had the fleeing Indian galloping *eastward* into the setting sun! But if Eastman botched the symbolism, Sibley botched the Latin. And he would be in his friend's corner all the way when it came to the collaboration with Schoolcraft.[81]

Schoolcraft had just begun to make the collaboration public. He and Eastman had obviously conferred before Lanman's announcement appeared in the *National Intelligencer.* Indeed, Lanman had reported on the advanced state of Schoolcraft's work the previous month, noting its comprehensiveness, the wisdom of the Department of the Interior in continuing it, and the fact it would be ready for presentation to Congress at the next session. Lanman may have learned of Schoolcraft's intention of procuring Eastman's services as illustrator during their interview, though the arrangement was not made final until Eastman's arrival in Washington in December. On the twenty-fourth, writing with his left hand because of his

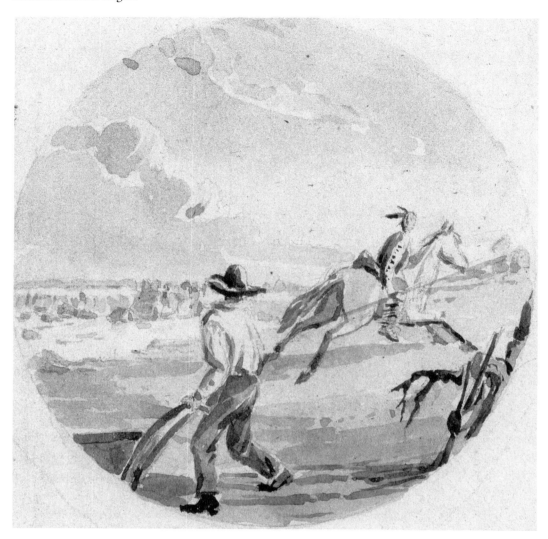

59. Seth Eastman's design for the Minnesota Territorial seal, sketched in 1849, symbolizes Indian displacement by white civilization. Minnesota Historical Society.

paralysis, Schoolcraft jubilantly informed John Bartlett that "within a few days, Captain Eastman of the U. States Army, has been detailed to furnish illustrations for the work." Eastman, he continued, "has spent twenty years on the frontier, in close contact with the Indians from St. Anthony's falls to the Rio Grande. He is an artist, and has a fine portfolio of drawings, of Indian life & customs, which he will communicate. He is every way qualified to illustrate the antiquarian & historical papers collected, & his employment in this department is deemed quite an acquisition." Thanking Schoolcraft for his "*left handed* document," Bartlett congratulated him on acquiring an illustrator. "This will add exceedingly to the interest of the report." But, he added, "it is of the utmost importance to have it well printed and on good paper." As an antiquarian, a book collector and dealer, and a sometime publisher, Bartlett was speaking from knowledge.

Public documents were printed in a "miserable manner." Schoolcraft must insist upon a better fate for his own labors—not just good paper, but an enlarged format, in quarto, like the Smithsonian publications. "This size will admit of larger engravings maps and tables, and make it more valuable to everyone. . . . Think of this; for I dont want to see such valuable matter as you have collected, buried among the voluminous Congressional Documents."[82]

Schoolcraft agreed. He had fought to have his portion of *Notes on the Iroquois* printed in handsome style and had boasted to Bartlett of his victory over the penny-pinchers in the New York state legislature. Now the stakes were higher, a multivolume national work. It would be his monument, and it must not be a shabby one. Bartlett also had something at stake. He had been copublisher of Schoolcraft's *Notes,* and in his capacity as a book dealer had already filled a $250 book order for Schoolcraft's congressional inquiry. A specialist in foreign titles, he hoped to tap into the Smithsonian fund of some $20,000 a year designated for "collections in books, natural history, and works of art." A survey he had undertaken on his own indicated that a minimum of $1,000 would be required to build a basic library in ethnology. In all his capacities, then—publisher, book dealer, and man of letters—Bartlett was a patronage seeker at arm's length. He deemed it the government's duty to encourage the arts and learning, and thus he took Schoolcraft's cause to heart.[83]

Bartlett also had something more immediate in mind by 1850. Since the previous spring he had been actively seeking an appointment with the new Whig administration. He was in his middle forties; if he was ever to leave commerce behind and make antiquarian studies his priority, the time was ripe. Long intrigued by the possible link between the Welsh, the Norsemen, and North America, he thought a position with the United States consulate in Copenhagen would be especially advantageous for his research.[84] Frustrated in this ambition, he dismissed Secretary of State John M. Clayton as too indecisive and turned to another prospect: an appointment with the commission running the boundary line between the United States and Mexico. The Rio Grande was not the North Sea, nor was Mexico Denmark; but the official survey under the auspices of the Interior Department would take him into New Mexico and California, where the archaeological materials were said to be rich. Would Schoolcraft write to the secretary of the interior on his behalf?[85]

He would and did. After all, Bartlett had backed his Indian history, declaring it truly a "national work," and by the rules of the patronage game was owed a favor in return. A few years later Schoolcraft would have occasion to regret his decision, but in the early months of 1850 he was too engrossed in the task of ensuring his own researches were published in an acceptable form to worry about possible conflicts of interest. He had to get

a resolution through Congress making a special appropriation for printing, and Eastman's illustrations were critical to his case. The logic was circular. The expanded scope of Schoolcraft's project justified retaining Eastman; Eastman's involvement justified expanding the publication's scope. The illustrations became the primary reason for insisting on a well-printed quarto volume. To achieve his ends, Schoolcraft turned to a proven ally. "The object desired is, to present the report, with its illustrations, in a printed form," he wrote Henry Sibley on February 1. "For this purpose, it is essential to have the Senate call for the information, to be sent in from time to time, and printed perhaps under the general direction of the Library Committee. I believe this is the Committee that superintends the work of Capt Wilks [*sic*]."[86]

Schoolcraft could not await Sibley's reply. On the seventh the Indian Office requested a progress report, since the Senate Committee on Indian Affairs wanted to know if additional legislation was required. By return mail Schoolcraft estimated that his manuscript would run about a thousand printed pages, necessitating more than a single volume. He would not know the approximate cost until he had consulted a printer, but one thing was certain: "No part of the existing appropriation can be applied to the printing. It will require a specific appropriation." And something else: Captain Eastman's services, offered for the duration of his furlough, were indispensable. If he drew the illustrations on stone himself, the cost would be negligible; otherwise the 160 engravings, at $10 each for the simple ones and $50 each for more complex scenes, would cost about $5,000.[87]

Schoolcraft's immediate superior, the commissioner of Indian affairs, was duly impressed. It was, he wrote, "essential to the public interest" that Eastman be retained as illustrator after the expiration of his leave "should the Hon. Secretary of War agree to detail him on special duty for that purpose." The War Department had twice turned down similar requests from Eastman and his friends. But with Eastman already in Washington at work on the illustrations and with the commissioner of Indian affairs and others backing him, the War Department relented. On February 27 the adjutant general, who had incurred Mrs. Eastman's displeasure by rejecting the captain's applications in the past, signed Special Order No. 13: "Captain *S. Eastman,* 1st Infantry, will, at the expiration of his present leave of absence (March 1, 1850) report for duty to the Commissioner of Indian Affairs, for the purpose of completing the work on which he has been of late engaged, relating to the Indians." With this much accomplished, the rest was up to Congress.[88]

Schoolcraft consulted one of the government printers, who came up with an estimate of $6,500 for 3,000 copies of a thousand-page work, in quarto and on fine paper—or "*much less*" were he awarded the contract. Schoolcraft ignored this suggestion and passed the estimates on to the

commissioner, adding in the cost of the illustrations and binding for a total of $10,300. They were in the hands of the chairman of the Senate Committee on Indian Affairs the next day, February 14, though two months went by before he introduced a resolution calling on the Library Committee to "inquire into the propriety" of having Schoolcraft's work printed "in suitable form."[89]

Things seemed to be progressing smoothly for Schoolcraft, Eastman, and the Indian history, but as the session wore on and appropriation time neared, strains appeared. The Senate resolution was merely a ploy to ensure that the report would not be printed as an ordinary government document; it did not provide a separate allocation for publication. That would have to be included in the Indian appropriations bill. Orlando Brown, commissioner of Indian affairs since May 31, 1849, had in one year shown himself a warm friend of Schoolcraft's project. But he left office on June 30, 1850, to be replaced by an unknown quantity, Luke Lea, who struck Henry Sibley as lacking in force or "vim." Schoolcraft immediately sounded Lea out, formally transmitting the first part of his report on July 22. Delays, he explained, were the fault of others—uncooperative Indians and agents—but through diligent effort he had procured "a mass of information" of great value. The native tribes might be doomed to disappear, but posterity would expect the government to provide a reliable record of their existence. Thus more reports would follow, and it was imperative that he personally superintend their publication. "I have the honor therefore to suggest, that Congress to whom I request you will refer this communication, be solicited to order that the present manuscripts and the succeeding portions of them, together with their illustrations and engravings, be printed under the special charge of the Bureau of Indian Affairs, acting for the Library Committee." Essentially, this was a reaffirmation of the Senate resolution then pending. Would Lea go along with it?[90]

Lea had reservations. Sibley spoke to Lewis Cass, Cass to the chairman of the Senate Committee on Indian Affairs, and Schoolcraft continued to hammer away at the point that his history, as a national work, should be "an exception to the ordinary mode of printing." Lea capitulated, and on August 7 he transmitted the report along with Schoolcraft's recommendations for its printing to the acting secretary of the interior, who two days later relayed both to the president. He in turn sent a message to the Senate, which on the thirteenth approved Schoolcraft's report for printing.[91]

Meanwhile, the Indian appropriations bill cleared the House and was before the Senate by September 2, where it was referred to the Committee on Finance. On the eleventh, Schoolcraft paid a call on James A. Pearce, chairman of the Library Committee, to discuss the printing order for the history. Schoolcraft thought that 3,500 copies would be needed. George Gibbs had advised him that the best way to ensure the continuation of his

appropriation was to shower Congress with volumes; 2,400 copies of each book would satisfy every senator, representative, and delegate from the Thirtieth through the Thirty-sixth Congress (that is, until 1861, revealing the outer limits of Schoolcraft's patronage aspirations). The remaining 1,100 copies would go to those with a less selfish interest in the venture— the Indian Bureau and its agents, college and state libraries, national institutions like the Smithsonian and the Library of Congress, American consulates, and deserving foreign bodies.[92]

It was fortunate that Schoolcraft conferred with Pearce, since their conversation touched on a related matter pending before the Finance Committee, on which Pearce also served. The Indian appropriations bill passed by the House had included no provision for continuing the Indian investigation—an oversight, no doubt, but one that had to be rectified. Pearce, who would prove no friend to Catlin, obliged Schoolcraft, reporting the amended bill out of committee on September 25. Schoolcraft had wanted $10,000 for publication; the Senate amendment called for $10,000 for collection *and* publication—a cut, but not as drastic as it appeared, since Schoolcraft's projection was based on an edition of 3,000 (down from 3,500) copies, while the Senate imposed a limit of 1,200. The book would be printed under the direction of the commissioner of Indian affairs, one clear-cut victory for Schoolcraft.[93]

There was frantic scrambling yet to come when the House rejected several Senate amendments, including the Schoolcraft provision. At one point the appropriations bill was declared "dead" before a second committee of conference resurrected it on September 28. The bill was signed into law two days later, and Schoolcraft's immediate worries were over. His Indian project had survived the transition from collecting and gathering information to publishing it. Moreover, Congress had renewed the appropriation for what was now acknowledged to be only the first in a series of volumes.[94]

There was still the matter of a publisher to decide. Here Schoolcraft had leeway. Since his government-sponsored history would be a prestigious and profitable job for any house, he could use the contract to procure a few personal concessions as well. His accumulation of unpublished work, dating back to before his futile trip overseas in 1842, might yet see print. And he would want a firm understanding that the plates of the national work were his for future private editions, a precedent set by Lieutenant Wilkes when he began selling his own edition of the *Narrative* of the Exploring Expedition almost as soon as the official series was completed.[95]

By October 1, his appropriation in hand, Schoolcraft was ready to shop for a publisher. He had $7,000 to spend on the book and wanted Eastman to accompany him to New York or Philadelphia. He ended up making the trip to Philadelphia with his wife instead and lost little time in deciding on

a house, Lippincott and Grambo. Though the firm had been established less than a year, it had Joshua B. Lippincott's two decades' experience as bookseller and publisher behind it, and in 1850 it was hardly the fledgling concern both Schoolcrafts would later portray it as being. Indeed, School-craft was probably attracted to it in the first place by Lippincott's reputation as the "bible publisher of the country." An embodiment of the Puritan ethic, Lippincott fused religion and shrewd business practices to make his house one of the nation's largest publishers, issuing more than a hundred titles annually by 1853. Lippincott personally enjoyed all the rewards hard work was said to bring—social prominence, civic recognition, board memberships, and a fortune estimated in the millions at the time of his death in 1886. In October 1849, however, he had to be gratified by his coup in landing the Indian history. Schoolcraft was equally pleased. The contracts with publisher and engravers were all signed before the month was out.[96]

Eastman's services were supposed to effect a substantial savings; either the captain realized his limitations or the pressures of deadline dictated a different course. The lithography was farmed out to three concerns: James Ackerman in New York and Peter S. Duval and J. T. Bowen in Phila-delphia, the latter two veterans of earlier illustrated works on the Indian. Duval, who was trained in France, came to Philadelphia in 1831 and was involved with James O. Lewis's amateurish *Aboriginal Port-Folio* and Mc-Kenney and Hall's distinguished *History of the Indian Tribes of North America*. When Duval's partnership withdrew from the project, Bowen moved from New York to take over, completing the last six plates for the first volume and all the lithographs for the remaining two. Bowen employed as many as forty people full time on the job, twenty-five of them as colorists, giving an idea of the scale of his operation. By 1850 Duval's firm operated twenty-six steam-driven lithographic presses and occupied the whole second floor of the Artisan Building. Lithography was a big-time business, and a lucrative one as well. For Schoolcraft's first volume, the plates alone cost $5,361, more than half his entire appropriation. The three lithogra-phers agreed to carry a portion of their charges over to the next budget year when, Schoolcraft hoped, a deficiency appropriation would cover the shortage. He was not happy about the cost overrun, but fine illustrations had all along been one of his priorities, and with other costly series such as the reports of the Exploring Expedition in press, experienced lithogra-phers enjoyed a seller's market for their services. Charles Lanman put the best possible light on the situation when he congratulated Schoolcraft on selecting Lippincott and added: "Success to Capt Eastman and the trio of engravers."[97]

Although the economic advantages Eastman was expected to provide did not pan out, Schoolcraft had every reason to be pleased. Eastman was a

model subordinate—polite, compliant, and industrious. His duties varied and were not always elevated, but he was short on artistic temperament and long on common sense. He did what he was asked to do. While Schoolcraft passed the fall and winter of 1850 in Philadelphia superintending the printing of the text, Eastman held the fort in Washington, correcting engravings as the proofs arrived from the lithographers, passing on the latest Indian Bureau news, and handling routine office chores. For the benefit of the eminent craniologist Samuel George Morton, a prospective contributor to Schoolcraft's compilation, he personally packed a crate of skulls obtained by the Exploring Expedition in Oregon, California, and the South Pacific and shipped them to Philadelphia, having first cut his way through the red tape imposed by the National Institution's custody of a collection still owned by the Exploring Expedition, which meant Charles Wilkes. Through it all, Eastman even managed to practice his art. On December 5, 1850, he reported to Schoolcraft that he had started on the illustrations for the second volume.[98]

In the preface to the first volume, written just days before, Schoolcraft had paid tribute to his assistant:

> To illustrate the work, the pictorial art is, it is conceived, appropriately appealed to; and it is made one of the points relied on to give its pages subsidiary interest and value. This department of American art is placed in charge of Captain S. EASTMAN, U.S.A. . . . who has served these twenty years, in peace and war, on the American frontiers, always carrying with him his easel and brushes, to while away leisure moments in camp; and who now returns from the West with his portfolio filled with views of American scenery, and objects of Indian life and art, delineated on the spot, or drawn from specimens.

Author and artist provided a contrast in personalities: Schoolcraft was a didactic man with a penchant for ponderous philosophical discourse; Eastman, a laconic, even terse individual who betrayed scant emotion in his correspondence whether he was reporting on a clause in a contract or a desperately ill child. He did exhibit a streak of hypochondria, but then health was a common preoccupation in midcentury Washington, where stagnant ponds, summer heat, and epidemic diseases took their annual toll. Mary Eastman referred to the captain as her "respected lord and master" with just enough sarcasm to imply she was the one in command, though as an officer he was used to giving orders and being obeyed and had lived a life that belied his bureaucratic blandness. Regarded as an all-around good fellow in his circle of friends, he was a minor fixture on Washington's social scene, meriting inclusion in Benjamin Poore's gossipy *Reminiscences of Sixty Years in the National Metropolis*. For all their differences, Schoolcraft believed he and Eastman made a good team. What better than an Indian

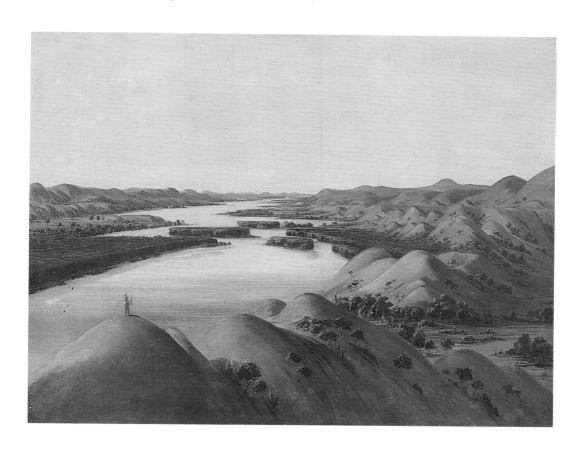

1. George Catlin, *River Bluffs,
1320 miles above St. Louis*
(1832), embodying Catlin's
vision of the West as "a vast
country of green fields, where
the *men* are all *red*." National
Museum of American Art,
Smithsonian Institution; gift
of Mrs. Joseph Harrison, Jr.

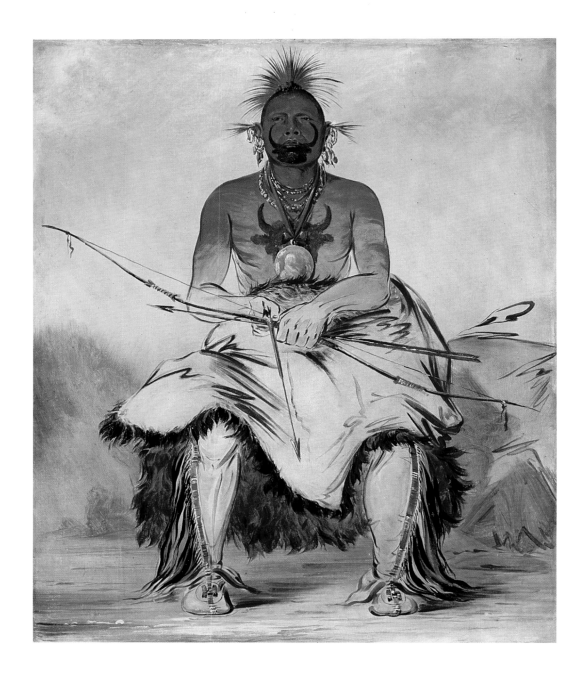

2. George Catlin, *Buffalo Bull,
a Grand Pawnee warrior* (1832),
a stunning example of the ef-
fects Catlin achieved with a
limited palette on his first, fe-
verishly productive trip west.

National Museum of Ameri-
can Art, Smithsonian Institu-
tion; gift of Mrs. Joseph
Harrison, Jr.

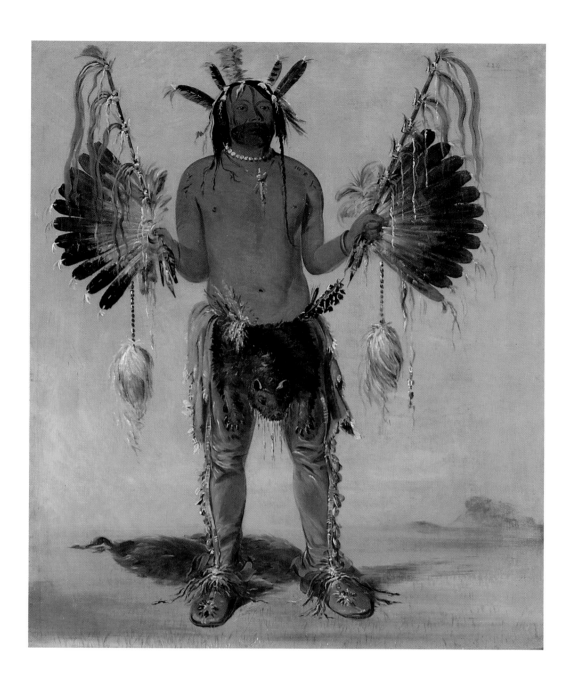

3. George Catlin, *Old Bear, a medicine man* (1832). This standing figure, as fine as any Catlin would paint, captures the mystery and power of the Mandans five years before smallpox decimated the tribe. National Museum of American Art, Smithsonian Institution; gift of Mrs. Joseph Harrison, Jr.

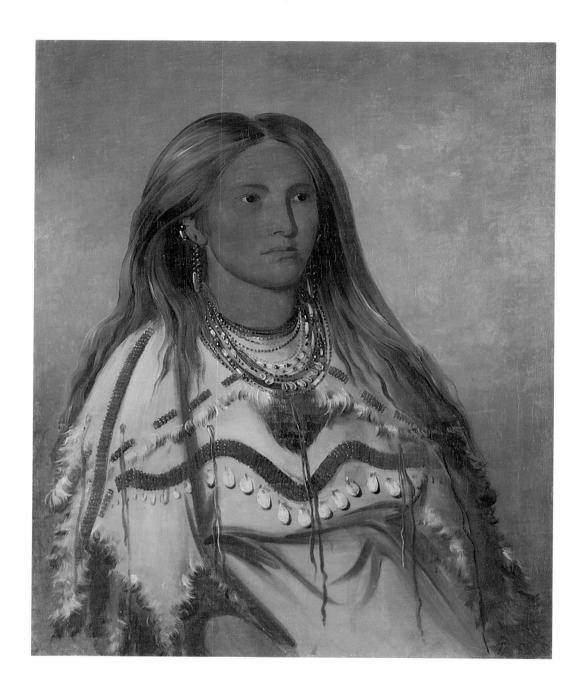

4. George Catlin, *Mint, a pretty girl* (1832). This charming likeness of a young Mandan is typical of the majority of Catlin's Indian portraits, which consisted of three-quarter busts facing right. National Museum of American Art, Smithsonian Institution; gift of Mrs. Joseph Harrison, Jr.

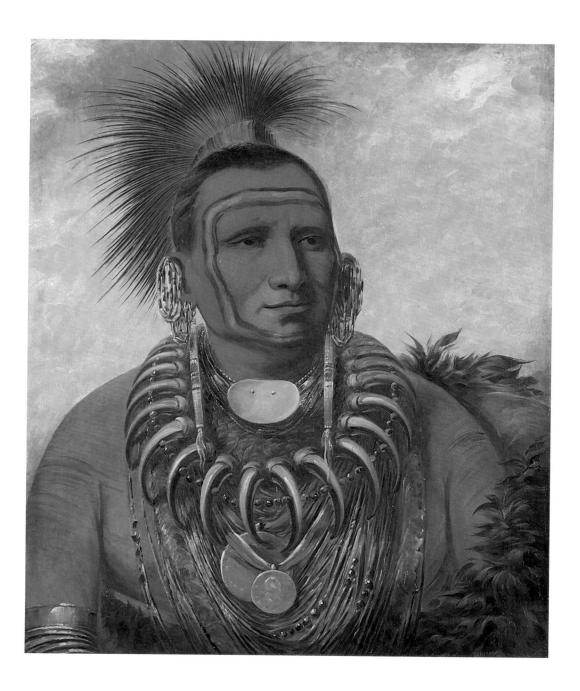

5. George Catlin, *Little Wolf, a famous warrior* (1844). Painted while abroad, Little Wolf was one of the party of Iowas "just arrived from the Upper Missouri, near the Rocky Mountains, North America," as Catlin's publicity put it, who so impressed English audiences and French royalty. The far-away look in Little Wolf's eyes must have struck a responsive chord in Catlin, five-years expatriate at the time. National Museum of American Art, Smithsonian Institution; gift of Mrs. Joseph Harrison, Jr.

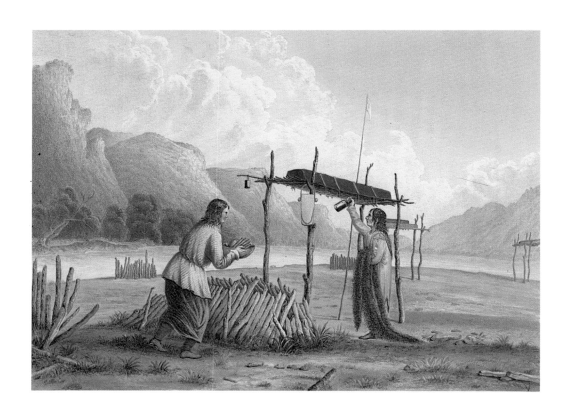

6. After Seth Eastman, *Indians Offering Food to the Dead*, lithographed by J. T. Bowen for the first volume of Henry R. Schoolcraft's *History, Condition and Prospects of the Indian Tribes of the United States* (1851), the only one of the six volumes to include costly chromolithographs. Thereafter Eastman's work appeared in uncolored engravings.

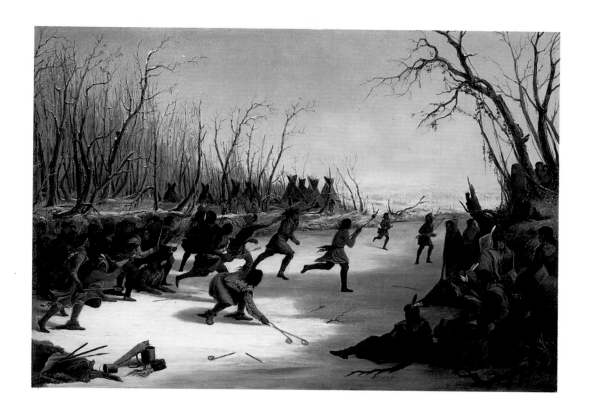

7. Seth Eastman, *Ballplay of the Sioux on the St. Peters River in Winter* (1848), shows Eastman's characteristic massing of elements in the foreground corners, creating an oval frame for the figures in the middle distance. Perhaps because of the strong contrast provided by the sheet of ice—a contrast often lacking in Eastman's oils in this period—*Ballplay of the Sioux* was chosen for engraving by the American Art-Union and appeared in its *Bulletin* for December, 1850. Amon Carter Museum, Fort Worth, Texas.

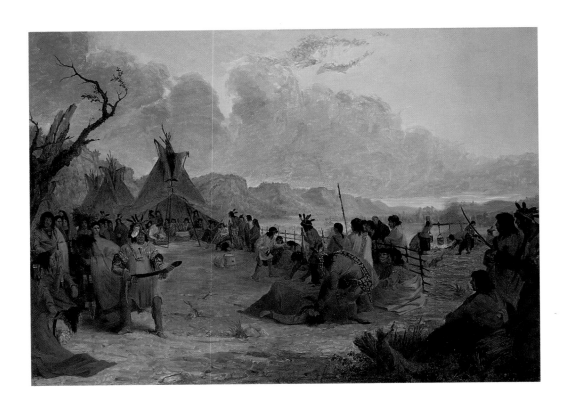

8. Seth Eastman, *Medicine Dance* (1848), is indicative of Eastman's unromanticized approach to native culture. Its drab tones complement its theme, reminiscent of Catlin's in *Ball-play of the women,* *Prairie du Chien* (figure 58), where alcohol's destructive influence on the Indian is his real subject. Private collection, on loan to the Buffalo Bill Historical Center, Cody, Wyoming.

9. Seth Eastman, *Indian Mode of Traveling* (1869). Typical of the nine Indian scenes Eastman painted for the government between 1867 and 1870 (and virtually identical to one completed in the same year), this oil shows the continuing importance of landscape and cloud effects in Eastman's late-life work. The John F. Eulich Collection, Dallas, Texas.

10. After John Mix Stanley, *Fort Benton*, a hand-tinted lithograph by Sarony, Major & Knapp, N.Y., for *Reports of Explorations and Surveys, to Ascertain the Most Practicable and Economical Route for a Railroad from the Mississippi River to the Pacific Ocean*, vol. 12, book 1 (1860).

11. After John Mix Stanley, *Shyenne River*, a hand-tinted lithograph by Sarony, Major & Knapp, N.Y., for *Reports of Explorations and Surveys . . . ,* vol. 12, book 1 (1860). Though Stanley could be the most prosaic of men, these plates, based on his last trip west in 1853, with their delicate blues and greens and hot oranges, still speak to us of a magical land, and springs and summers long ago.

12. John Mix Stanley, *Last of Their Race* (1857). In forming a gallery of Indian paintings, Stanley, like Catlin before him, subscribed to the notion that the Indians were a vanishing race, here literally driven into the western sea, where the setting sun completes the allegory. After fire destroyed Stanley's gallery in 1865, such sunset skies took on a personal meaning for him. Courtesy Buffalo Bill Historical Center, Cody, Wyoming.

13. John Mix Stanley, *Gambling for the Buck* (1867), exemplifies the highly polished set pieces in which Stanley specialized in his last years. He drew on his experiences in the West and introduced documentary details to validate purely imaginary scenes. Stark Museum of Art, Orange, Texas.

14. John Mix Stanley, *Blackfeet Card Players* (1869). The Indians are transported out-of-doors and shuffled around, but the direct repetition of two of the figures from *Gambling for the Buck* shows how Stanley simply redealt the same cards to create a new composition. The John F. Eulich Collection, Dallas, Texas.

15. George Catlin, *Shore of the Essequibo,* based on Catlin's first trip to South America in 1854. National Gallery of Art, Washington; Paul Mellon Collection.

16. George Catlin, *Tapuya Encampment*. In South America in the 1850s, Catlin found a new lease on life, new rivers to explore, and Indians galore to paint in a new green land. National Gallery of Art, Washington; Paul Mellon Collection.

agent–scholar and a soldier-artist to counteract the pernicious influence of "hasty and imaginative tourists and writers" and provide an official version of events?[99]

The winter of 1850–51 was the honeymoon period in the Schoolcraft-Eastman relationship as they impatiently awaited the appearance of their book. Schoolcraft's excitement was understandable. This would be only the first in a continuing series of triumphs that would erase the memory of his long struggle for reinstatement after dismissal in 1841. And it would provide him a living for years to come. When at last the volume was out, its title page was the payoff: *Historical and Statistical Information Respecting the History, Condition and Prospects of the Indian Tribes of the United States: Collected and Prepared under the Direction of the Bureau of Indian Affairs, per Act of Congress of March 3d, 1847,* by Henry R. Schoolcraft, LL.D. As for Eastman, the title page was his reward as well. "Illustrated by S. Eastman, Capt. U.S.A.," it read, and below that words dear to both men's hearts: "Published by Authority of Congress. Part I." As often as he had come begging, Catlin had scarcely received a crumb, let alone a banquet at government expense.[100]

The book contained seventy-six color plates from Eastman drawings and, since most illustrated Indian artifacts or reproduced pictographs, showed his strengths as a meticulous draftsman. Subsequent volumes, utilizing his original work, would also show his limitations. Eastman's basic Indian experience was with the Mississippi River tribes—Sioux, Chippewa, and Winnebago—and the vast majority of his plates depicting Indian camp life were based on his Fort Snelling sketches, not a representative sampling of native cultures. Volume 1 included only two Eastman originals, both from Minnesota: *Indians Offering Food to the Dead,* lithographed by Bowen, and *A Medicine Man Curing a Patient,* by Duval. A modern student of chromolithography has judged the color work in Schoolcraft's volume a failure by the standards of the day. Tones were garish, shading unsubtle. But Bowen's chromolithograph worked well, its colors vibrant without being jarring, the overall effect pleasing. The pictographic reproductions also worked well, since the colors were naturally bold. Nevertheless, dissatisfaction can be measured by the second volume: engravings, less expensive and done under the supervision of Lippincott and Grambo, replaced the colored lithographs. This delighted Lippincott, who now had control over the entire production, and Schoolcraft as well, since lithographers retained their stones and had to be paid for subsequent runs whereas engravers turned their plates over to the publisher or author.[101]

Faithful to Wilkes's example, Schoolcraft all along had it in mind to issue a cheaper edition of his work for private sale, using the government plates to turn a nifty personal profit. The engravers would exact no addi-

tional toll (when volume 1 was reprinted, the colored lithographs were all redone as engravings), and the entire property would be concentrated in his hands. The snag here would be ownership of the illustrations. Why should Eastman's engraved drawings become Schoolcraft's property? The question would come to haunt their relationship, but it did not arise in 1851. Besides receiving recognition, Eastman was enjoying life with his family in a house on the Potomac instead of isolation at a post on the Pedernales. He was being paid his salary to work full time on his art and might yet be commissioned to paint an Indian gallery "by authority of Congress."

By February, copies of Schoolcraft's first volume were on their way to congressmen, worthies, and reviewers. Its 568 pages were divided into seven sections: "General History"; "The Mental Type of the Indian Race"; "Antiquities"; "Physical Geography of the Indian Country"; "Tribal Organization"; "Intellectual Capacity and Character of the Indian Race"; and "Population and Statistics." An appendix rounded out the compilation.[102] The organizing principle pleased Schoolcraft, though it eluded others then and since, suggesting a miscellanea more than a scientific treatise. But it gave him ample scope to print extracts from his previous writings, curious documents, responses to his questionnaires, and anything else he had on hand. It resembled the long-contemplated Indian encyclopedia, which he was still trying to place as an irregular periodical—twenty-five numbers, one hundred pages each, alphabetically arranged—under the title "Encyclopedia Indianensis." The lifelong "fact-hunter" had found nirvana. In 1823 he confessed that his "chief pleasure" in reading was "the acquisition and treasuring up of facts"; the United States government had given him carte blanche to indulge his passion.[103]

Schoolcraft might have noted the disturbing tendency of recipients of what Joseph Henry referred to feelingly as "his *book*" to praise it as a monument to the Indians, its illustrator, and its author, certainly, but even more to American publishing. It *was* physically imposing, an elephant quarto measuring ten inches by thirteen, its heavy wine boards embossed with an Indian design around the borders front and back and, gilded on the front, an Eastman drawing of a warrior holding aloft the scalp of a slain enemy, a revealing choice for a work intended to correct popular misconceptions about the native tribes. The president's reaction to his presentation copy was typical: "The illustrations and typographical execution do great credit to the publishers." The press agreed. Journalists were dazzled by the book's bulk, the color plates, the sheer labor involved in its production. While many noticed, however, few lingered to review. Newspaper puffs had their value, but Schoolcraft wanted to see the work discussed "on high & general principles" in the serious literary quarterlies.[104]

That acquaintances scattered like quail when they were approached to

undertake the task was also an ominous portent. Schoolcraft had to settle for flattery heaped on in the "diurnal press," as he called the papers. "The plan of the work is complete and comprehensive, and it could not have been confided to more capable hands," the *Pennsylvania Inquirer* commented; and Francis Lieber, an eminent political philosopher writing in the *Southern Patriot,* allowed that "no superior man" could have been found for "this extensive undertaking." Schoolcraft wanted more from Lieber—preferably an extended review in the *Southern Quarterly*—but Lieber "shrank" from the task, leaving Schoolcraft to ensure that his *Patriot* notice at least was inserted in the *National Intelligencer,* where congressmen could read that their original decision to underwrite the project was wise, just, and "what duty demanded": "The expenses cannot be trifling; but it is the white man's duty to put on record all that relates to the evanescing race, and no one else, neither individual nor public body, can do it. Works such as Mr. Schoolcraft has given and is promising to give to the world belong to those which are eminently wanted, and yet cannot be undertaken by the private scholar, nor be published by the individual bookseller." Let us hope, Lieber concluded, "that Congress will not stop short with this first excellent volume, but will liberally aid in the publication of the following ones."[105]

★ ★ ★

In an expansive mood following the appearance of his "excellent first volume," Schoolcraft allowed that the history might extend to fourteen volumes or more. When an astounded Lieber questioned the figure, Schoolcraft backed off; he meant only that there were materials enough on hand to sustain a series of that length. Realistically, the series he was compiling for Congress would stop at seven volumes. But with accolades pouring in from recipients of the first volume—some of the most distinguished men in the land—and with the press enthusiastic about his venture to date, why not dream? Lieutenant Wilkes, battle-scarred veteran of his own appropriations wars, was the model, after all. Upon receiving his copy of the Indian history, he wrote to Schoolcraft praising it as "worthy of the country" and "highly creditable" to those responsible. And, he had continued enticingly, "as an American I feel proud of such a work and offer you my congratulations on the accomplishing the *first part* of your labours so successfully."[106]

Wilkes had stretched his own *Narrative* out to five substantial volumes, to the dismay of many reviewers, and was still aiming at an official series twenty-four volumes long; like the Exploring Expedition's findings, the native tribes of North America were an inexhaustible topic. Wilkes had also been criticized for extensive unacknowledged borrowings from subordinates' journals—a charge justified by his claiming authorship, but irrelevant where Schoolcraft was concerned, since his volumes were clearly

identified as compilations, though the issue of proper credit to contributors would plague him as well. So would another criticism directed at Wilkes: he had used the pages of what was supposed to be a "national work" to avenge himself on those he blamed for past slights and fancied wrongs, engaging in a bickering unbecoming in any publication but inexcusable in one bearing the authority of Congress. George Catlin would be skewered in the pages of Schoolcraft's Indian history, but he was not alone. The revered Albert Gallatin and the mighty Humboldt would take their lumps, and Eastman's name would be conspicuously absent from the title page of the final volume. But Schoolcraft would pay for his vindictiveness as those he attacked struck back. In particular Ephraim George Squier, whose rise to prominence as an American archaeologist dismayed Schoolcraft for both religious and scientific reasons, used the public press and private allies to devastating effect in prosecuting his side of their paper war. Big issues and sometimes small people caught up in a competition for inadequate patronage made an explosive combination that would stop Schoolcraft's Indian history, his monument to himself, short of completion, granting those he had wronged along the way their own measure of revenge.

It is my aim,—*an aim which nothing can divert me from,* to publish correct & authentic information . . . without impugning the statements or motives of any body.

Henry R. Schoolcraft to John R. Bartlett, November 28, 1853

You are and have been for years . . . an object of pity.

E. G. Squier, draft of a letter to Schoolcraft, ca. July 22, 1854

Mastodons among Our Books

Bartlett, Squier, and Schoolcraft under Siege

"I am, now, easier in my position, as Congress, & the government here, have, very favorably received the first part of my investigation," Henry Schoolcraft wrote in March 1851. With the appearance of the first volume of his "great national work" the previous month, he was entering on the palmiest period of his life. His salary was raised to $1,800, an indication of official pleasure, though he had wanted more, and when Congress reconvened that December new members clamored for *their* copies of the Indian history, just as George Gibbs had predicted. They also wanted to be assured of all subsequent volumes, which boded well for future appropriation requests.[1]

Seth Eastman, next-door neighbor and social companion off the job,

60. *Idols at Zapatero.* Ephraim George Squier sketches antiquities in Nicaragua, where he served as the United States chargé d'affaires to Central America, 1849–50. E. G. Squier, *Nicaragua: Its People, Scenery, Monuments . . .* (1860).

continued to perform admirably as all-purpose assistant. With Schoolcraft housebound by lameness, Eastman ran the office. He handled routine correspondence, solicited contributions, took down the occasional vocabulary from visiting Indian delegations, minded the shop during Schoolcraft's absences in Philadelphia, attended to the shipping of complimentary copies, and found the time to turn out suitable illustrations. As a team, Schoolcraft and Eastman were about to hit their stride: a book a year over the next four years and more to follow, presumably.[2]

Mary Eastman seemed pleased with the arrangement, no small consideration given her influence over the captain and her willingness to voice their collective dissatisfaction. She even pitched in enthusiastically, inviting one party of Sioux to evening tea and, an unexpected treat, conversation in their own tongue. She flattered Schoolcraft with teasing letters appealing to his vanity and showed Mary Schoolcraft the sunny side of her nature in reports from Washington that were gossipy but cheerful—a "dose of nonsense" as she called them. Her only complaint was that the Schoolcrafts were not at home more. "I have a great mind to move out of the neighbourhood," she scolded. "To pay $300 a year to live next door to you (at the risk of going to the jail) and then to have you live in Philadelphia!" It was a nice way of saying we miss you. It was also an arrow aimed straight at the heart: Washington was expensive, and the captain was not being adequately compensated. For now, the rebuke was flippant; but the cause of their later estrangement had been spelled out.[3]

It was satisfying occupying Schoolcraft's chair in the early 1850s. People paid him court, coming to call or writing to share information and seek advice. His pronouncements now bore the added authority of his title, congressional historian of the American Indian. Army officers dropped by to report on their western expeditions, offering observations on the natives and, if scientifically inclined, vocabularies, sketches, and a wealth of ethnographic data. The literary lions of the age with an interest in aboriginal topics (William Cullen Bryant, Washington Irving, William Gilmore Simms, Henry Wadsworth Longfellow) were all in correspondence and effusively grateful for free copies of the government work.[4] Historians Francis Parkman, Lyman C. Draper, and George Bancroft, art critic Henry T. Tuckerman, and scads of high-ranking government officials, journalists, ethnologists, and other doyens of the scientific community paid their respects. So did a few less orthodox souls, including two Indian converts, George Copway, the Canadian Ojibwa who impressed some as a heartwarming symbol of native progress, others as a pious fraud; and Maungwudaus, also Ojibwa, erstwhile leader of Catlin's last Indian troupe.[5]

Copway came to promote his scheme for a permanent Indian state out west, an old idea, consistent with the government's isolation policy, updated and made novel by the fact that its advocate was Indian. All he

61. Seth Eastman, *Washington D.C. from E. St.* (1851), showing the neighborhood where the Eastmans and Schoolcrafts resided while working on the Indian History—two patronage seekers who had found Mecca. M. and M. Karolik Collection; courtesy, Museum of Fine Arts, Boston.

needed was government support, and the tribes of the Great Lakes region would be rescued from extinction and turned into prosperous citizens on their own land. Copway oozed selflessness—his motto, he said, was *"My Poor People"*—but he was adept at self-promotion, sponged off his admirers, and made his living on the lecture circuit, where he used his personal transformation from Kah-ge-ga-gah-bowh into George Copway as a parable for the conversion of the savage to Christian truth. "Pray for us," he exhorted in a little book about his life, "that *religion* and *science* may lead us on to intelligence and virtue; that we may imitate the good white man, who, like the eagle, builds his nest on the top of some high rock—*science;* that we may educate our children, and turn their minds to God. Help us, O help us to live."[6] "My Poor People" was but an objective variation on Maungwudaus's portrayal of his unconverted tribesmen as orangutans back when he was still the earnest Methodist missionary George Henry. Copway and Henry—the two were like one; but Maungwudaus preferred to exploit his Indian name, no doubt for its publicity value, when he came calling on Schoolcraft in 1855, a new family in tow, having remarried since burying his first wife and children in England at the conclusion of his disastrous tour abroad. He had also since abandoned his scalping demonstrations for a more salable commodity, an Ojibwa translation of the New Testament, which garnered him lecture dates in several eastern cities. As types of the progressive Indian, Copway and Maungwudaus were minor celebrities, and their homage was quite acceptable to

62. Maungwudaus, slick master of the "operation of scalping," still clutching his tomahawk in a daguerreotype made about 1850. International Museum of Photography at George Eastman House, Rochester, N.Y.

Henry Schoolcraft, further inflating his not inconsiderable ego. All told, he was, as Mrs. Schoolcraft put it, "happy, truly happy" in "a world of his own creation."[7]

Many would have been content with such singular good fortune. Not Schoolcraft. In his hands the national history was an instrument of retribution to settle old scores and destroy adversaries. Some had engaged him in acrimonious disputes. Some were pretenders, parvenus, who had failed to pay proper respect. And some were unwitting victims of a malice they could not comprehend. Schoolcraft might feel safe in assailing easy targets, but his own position, time showed, was also vulnerable.[8]

* * *

Congress had become openly impatient with its book-publishing commitments by 1852. First there had been Charles Wilkes and his plea in 1846 that the Exploring Expedition's reports be published in a form commensurate with their scientific stature—say, in a series of books like those published by the French government in connection with the voyage of the *Astrolabe*. Then David Dale Owen and Henry R. Schoolcraft, both citing the Exploring Expedition as precedent, had lured Congress into costly publishing ventures. Owen, the son of British philanthropist Robert Owen, who planted his model socialist community, New Harmony, in Indiana in 1825, came to the United States two years later and would

maintain close ties to Indiana throughout a distinguished geological career, still serving as state geologist at the time of his death in 1860. A congressional appointment in 1847 to survey the Chippewa Land District had broadened into a full-scale geological survey of Wisconsin, Iowa, and Minnesota and a portion of Nebraska Territory. It was the report on this survey that Owen wanted published "with those advantages of style and form that careful and skillful workmanship and deliberate proofreading can alone hope to effect." In short, he did not want his book in the hands of the public printers. For political purposes he stressed the report's practical value as a source on the "great mineral resources of the West & its agricultural capabilities"; but his heart clearly was with the survey's scientific findings, notably the fossil remains of giant mammals discovered in the badlands of Nebraska Territory. All he desired could be nicely accomplished by Lippincott's in a huge quarto (638 pages crammed with maps and plates) of the sort they were publishing for Schoolcraft for just under $50,000. His strategy paralleled Schoolcraft's. Owen had his report published under the direction of the General Land Office; Schoolcraft, adhering to the Exploring Expedition precedent, prepared his within the sponsoring department (the Indian Office) and had it published under the auspices of the Joint Committee on the Library, whose chairman had exerted himself annually, and successfully despite congressional reluctance, on behalf of Lieutenant Wilkes and his scientific corps. Both strategies permitted circumvention of the Committee on Printing and gave the authors a key to the public coffers. Thus Congress's restiveness.[9]

Expenses mounted, and the continuing series never seemed to reach completion. Schoolcraft's Indian history, begun with a modest $5,000 appropriation, had cost $20,000 by the time the first volume was issued. And when would it end? There was always material enough to fill another book, and there were always delays—from the inevitable fires in publishing houses and binderies, to tardy contributors or artists or engravers, to sickness and death. Things did not go on schedule, and schedules were impossible to draw up anyway when objectives, indefinite at the outset, danced off like motes in sunlight when Congress sought to exert control. The only thing that was certain was the annual appropriation request, often accompanied by a promise (but not a formal proviso) that it would be the last.[10]

These considerations were in congressmen's minds through the spring and summer of 1852 as all three projects—Owen's, Wilkes's and Schoolcraft's—got a rough ride through Senate. It was Catlin's misfortune to have the climactic vote on the bill for purchase of his Indian Gallery come up in the same session. Senator William Seward, in speaking for Catlin, cited as a precedent proving the government's interest in preserving "memorials of the aboriginal races of this country" Schoolcraft's Indian his-

tory, "a work which is going through the press at a vast expense, and is exceedingly creditable to the arts, as well as to the literature of the country." At the time his colleague from Arkansas, Solon Borland, replied that the government had no right going into "the business of buying pictures." He felt pretty much the same about the business of making books. A states' rights Democrat, born in Virginia in 1808 and educated in North Carolina, Borland was a longtime resident of Little Rock, where he practiced medicine until the Mexican War and then appointment to the Senate in 1848 called him away. Committed to strict construction of the Constitution, he was suspicious of all attempts to plunder the Treasury on behalf of projects outside the federal government's stipulated jurisdiction. He defined his position in a debate over expenditures for the expansion of the Capitol building. The sums were trifling, really, but not the constitutional principle at stake. "There is," he insisted, "no concealing or avoiding the fact that *the* dangerous tendency of our system of government, is that towards *centralism* and *consolidation*." His party, the Democratic party, opposed both, and "all measures which are attainted of that tendency." Federal patronage, "in the protean shapes of *large moneyed expenditures*," was "the most facile and fearful instrumentality" of centralism. It must be opposed in the name of states' rights, a preoccupation with Borland, who in 1861 would lead a company of cavalry in the Confederate cause, attaining the rank of brigadier general before dying early in 1864. To his combative way of thinking, then, the Whigs were guilty of carelessness with the people's money and, far worse, their constitutional rights. Seward, in defending purchase of Catlin's gallery, was true to the type.[11]

By 1852 Borland had been four years in the Senate and had honed his voice to a bellicose edge. Since he had chaired the Committee on Printing, charged with the routine publication of congressional documents, he may have harbored resentment toward the open-ended series proceeding outside normal channels. He also had a populist's disdain for those who were all too willing to accept public funds for projects they deemed beyond the grasp of mere politicians. In turn, artists, writers, and scientists were sensitive about their relative powerlessness. A painter like Washington Allston simply refused government commissions rather than suffer the scrutiny of the uninformed.[12] Congress knew little enough about science and scholarship, less yet about poetry, painting, and sculpture. It was too much to endure some country bumpkin's standing up in chamber and proclaiming his ignorance even as he pronounced on the merit of one's work. Mutual distrust was built into the structure of patronage politics. Schoolcraft in 1854 would assert his unwillingness to be named "with the class of public beggars. If I must beg any thing, it is to let me finish the work in quietness." But as Borland had argued, Congress's duty was not to the few who got funds and then demanded to be left alone; it was to the

many whose money was being spent. No congressman should shrink from judging literary, artistic, or scholarly merit and questioning closely the worth of a given book or painting.[13]

In this spirit Borland in 1852 attacked Catlin, urged the Senate to fill its existing financial commitment to David Dale Owen's *Report of a Geological Survey of Wisconsin, Iowa, and Minnesota* (useful, at least), and lashed out at the request for another $25,000 to continue "the preparation and publication of the works of the Exploring Expedition," which, he complained, had "been in progress almost ever since I was born." More than $185,000 had already been expended and the end, as Charles Wilkes well knew, was not yet in sight—not by two decades and another $165,000. To Borland's mind it was an outrageous waste of public funds to pay someone "to draw pictures of bugs and grasshoppers" in order to "gratify the taste of gentlemen of leisure." And what use was to be made of the reports after they were in print? Congress should unhesitatingly give priority to practical projects, even if it meant being labeled "coarse" and "demagogical." Anyway, true genius would out whether or not Congress contributed a cent. Had Audubon not produced his monumental work without federal aid? The United States should not compete with foreign systems of government in supporting the arts.[14]

On March 25, 1852, the House considered an appropriation for $6,575 to print an extra six hundred copies of the first volume of Schoolcraft's Indian history (for new members) and $17,000 to continue the series. The second item provoked debate. A Democrat from Indiana protested the expenditure of what would amount to $50,000 on a history of limited usefulness; the government should not be turned "into an immense book concern." Others loyally stood by Schoolcraft. The next day the Senate took up the debate, adding a proviso indicative of its testy mood: the work was to be completed in five volumes, at the rate of at least one a year. This set both schedule and limit. Borland requested an estimate of per volume cost—$20,000 plus salaries, he was told—before attacking this magnificently packaged, beautifully illustrated—what? "The whole work will cost $100,000. Can any one say, from examination of the work, or from his knowledge of the materials, that it is worth that, or will be worth one half of that? . . . It does not consist of matters which are necessary for our legislation." Others made jokes about "this book of 'pictures,'" as bored senators were wont to do.[15]

Schoolcraft was indignant. In the end he got what he wanted—$17,000 for the next fiscal year, $5,300 to cover arrears in the preparation of the first volume, and $6,575 for reprinting. He also got what he did not want—a five-volume limitation, meaning he would be out of a job in 1855 if he met the proposed schedule. And he had endured the humiliation of being publicly mocked by those he considered his inferiors. Borland had paraded

his "gross misapprehension of the facts" with the self-important air of the truly ignorant, and no one in Senate had been "sufficiently posted up" to challenge him, Schoolcraft fumed. But when he protested his treatment to William Gilmore Simms, he got little sympathy. "I note what you say of the Politicians," Simms replied, "but truly, my dear Sir, I have learned well the maxim, that he who toucheth pitch is sure to be defiled." The price one paid for congressional patronage was Congress.[16]

In this delicate state of affairs the last thing Schoolcraft needed in 1853 during his next appropriations ordeal was someone drawing attention to his project's cost. But someone did—his old friend John R. Bartlett, in a resolution debated in the Senate on April 5:

> *Resolved,* That John R. Bartlett, late Commissioner, and A. B. Gray, the late United States Surveyor of the Mexican Boundary, be authorized to furnish a report and plans to the Senate of the explorations made by them and by others connected with the Commission under them, on the topography, geography, and natural history of the regions adjacent to the line, with such information as was collected relative to the Indian tribes through Texas, California, and New Mexico; and that the work be executed under the supervision of the Department of the Interior in a style and form corresponding with the publication of "The History, Condition, and Prospects of the Indian Tribes," of H. R. Schoolcraft, now in course of publication, and Owen's Report on the Geology of Lake Superior.

Bartlett's report was to be published in two volumes, 1,000 copies, costs to be paid out of the Senate contingency fund.[17]

Schoolcraft was distressed by Bartlett's attempt to "force" his report on the Senate. It might harm his own cause and could do Bartlett's no good. But Bartlett had come back from the Southwest trailing controversy, fierce-looking in his bristly beard, a friend reported, and in a mood to match. After an absence of two and a half years, he was too caught up in self-vindication to give more than a couple of days to his family in Providence. Then he was off to Washington to clear himself with the secretary of the interior and get on with publishing his report. His wife would be dead before year's end, and doubtless Bartlett, like the forever absent Catlin left alone with his grief and regrets after Clara died, would reflect over winter on the price of ambition. But there was no time for sentimental reflections in the spring of 1853. Bartlett was a man on the prod, with something to prove.[18]

From the quiet of his home he had dreamed of adventure and relief from the severe headaches that plagued him at his desk. His yearning to tramp through unknown country, visit far-flung frontiers, and see ethnology as it was lived had become a compulsion fed by the California mania, a

63. John Russell Bartlett (1805–86), his restless years behind him, looking every inch the bookman in this pho-tograph taken about 1861. Courtesy of the John Carter Brown Library at Brown University.

siren call to a man of restless middle years, and the periodic reports of Ephraim George Squier from the jungles of Central America—enough, Parkman told Squier, to kindle "in me a burning desire to get among fevers and volcanoes, niggers, Indians and other outcasts of humanity, a restless fit which is apt to seize me at intervals and which you have unmercifully aggravated." It was in this mood that Ishmael took to the sea. In a world on the move, it was torture to stay behind, worse by far than "physical pain," Parkman said, "the position of being stranded and doomed to be rotting for year after year." Thus the appointment as chief commissioner of the Mexican Boundary Commission in 1850 had seemed a godsend to Bartlett, though the portents to caution were unmistakable. It was a post already thrice subjected to different kinds of defeat—death, controversy, and peremptory resignation—since its creation in 1848 with the signing of the Treaty of Guadalupe Hidalgo.[19]

Bartlett soon learned that he had exchanged one set of headaches for another. The challenge was daunting—a two-thousand-mile border to be negotiated and surveyed with his Mexican counterpart, stretching from the Gulf of Mexico along the Rio Grande to an imaginary point just north of El Paso, then to the Gila, down to the Colorado, and on to the Gulf of California just south of San Diego, with only the western portion drawn. If it was adventure Bartlett wanted, he found it over the next few years— murder and mayhem enough to fill a dime-novel library. Almost none of it involved the Indians, who, with the exception of one Apache attack, according to Bartlett comported themselves like gentlemen, which was more than could be said for certain Boundary Commission employees. He passed uneventful nights with up to fifteen Apaches sleeping on his floor, the celebrated Mangus Colorado among them, and found them for all their ferocious reputation receptive to kind treatment and persuasion, and far too often the victims rather than the perpetrators of crimes. As an antiquarian with high expectations, Bartlett was disappointed with the miserable Indian ruins he saw and concluded that the semicivilized tribes who produced them were unrelated to the Aztecs. On the other hand, he collected some twenty vocabularies between the Rio Grande and the Pacific, many new to philology. He made, or had made, portraits of the more distinguished Indians he met along the way, sketched village life, and gathered a representative sampling of artifacts for presentation to the government upon his return. Natural history study had been curtailed by Congress's unwillingness to provide the Boundary Commission with funds for trained scientists, but Bartlett and his staff had made botanical, mineralogical, and zoological collections, the latter biased toward "the order *reptilia*." Given leisure and financial encouragement on his return, he would write a proper ethnological treatise.[20]

But controversy swirled around his endeavors and threatened to termi-

64. John R. Bartlett, *Casa Grande, Rio Gila* (1850). Bartlett found no evidence of Aztec influence in the disappointing ruins he saw on the Mexican Boundary Commission survey. Courtesy of the John Carter Brown Library at Brown University.

nate the entire enterprise. A dispute over one of the key reference points, El Paso, complicated by a faulty map and ambiguity in the wording of the treaty, led Bartlett in December 1850 to accept a northerly line favorable to Mexican interests. This embroiled him in dispute with his own scientific staff and, when his decision reached Washington, exposed him to attack by southwestern interests furious that a "diplomatic blunder" might cost the United States the fruits of the treaty and a desirable railroad route to the Pacific. The Mexican commissioner was adamant about retaining the advantage he had gained. Civilian-military squabbles on the American side only made Bartlett more vulnerable. Charges of waste, mismanagement, and incompetence, some of his own doing, dogged him. But the architect of his downfall was a former commissioner of the Boundary Survey, John B. Weller, who as a neophyte Democratic senator from California launched an attack that succeeded in encumbering the commission's appropriation and halting all work on the survey. Thus Bartlett took a drubbing in the same chamber as Catlin, Owen, Wilkes, and Schoolcraft in 1852. The attack was politically motivated—Bartlett served as a whipping boy for the Whigs who had dismissed Weller. But the Democratic victory that November made his own dismissal inevitable. Before the year was out,

the Boundary Commission had been disbanded and Bartlett was on his way home.[21]

With exoneration from the Democratic charge of "corruption of all kinds" uppermost in his mind, Bartlett was in Washington by February 5, 1853. First, he wanted to defend his boundary line to the outgoing Whig administration. A friend like Brantz Mayer, with diplomatic experience in Mexico before the war and two books on Mexico to his credit, was frank to say he disagreed with Bartlett. So did the accumulated weight of expert opinion. But Bartlett stuck to his guns. His boundary was correct, and his published report would constitute his defense. Congress owed him that much.[22]

The Senate resolution on his behalf kicked up a controversy of its own. Schoolcraft grumbled but could do nothing. Bartlett had been a steady ally in the past. When Schoolcraft early in January 1850 was trying to find a "more eligible way" than the public printer to publish the results of his Indian inquiry, it was Bartlett who urged him on. While on the Mexican border he still followed the progress of the Indian history, pleased to learn that it was being issued in attractive quartos. The two men had supported one another's patronage bids and together plotted ways around the Committee on Printing. In 1853 it was too late for Schoolcraft to have second thoughts. What he had, Bartlett understandably coveted.[23]

But Schoolcraft was justified in worrying about the congressional response. Borland, still riding his states' rights horse and waving the banner of fiscal restraint, led the attack. All reports should automatically be submitted to the appropriate department for approval, he argued. Only then should Congress get involved. Anyway, the Senate's contingency fund was inadequate to publish books of the sort proposed:

> The cost of the publication alone of the works of Schoolcraft, to which the resolution refers, was something like $100,000. We have got three volumes, and they have not cost less than that amount. And Dr. Owen's book, which is a very valuable one, I think cost over $30,000, and it is perhaps the cheapest book ever published by Congress. . . . He has gone in person to examine the engraving establishments, so as to procure the engravings and wood-cuts on the best terms, and in the best manner, and made contracts lower than anybody else has ever done. Then if we look at the publication of Mr. Wilkes's book, which has been in progress for some ten or twelve years—I say look at the cost, not at the book, for I believe very few have an opportunity to see the work at all—we have been paying $25,000 or $30,000 for that. I mention this . . . not to assail the work or its character, but as an instance of the expense of publication.

This was bad enough—figures plucked from the air, Schoolcraft complained—but the debate that followed quickly degenerated into another exchange of jokes, punctuated by the kind of laughter that chilled the hopes of patronage seekers.[24]

Congressmen were wearisomely predictable on the arts and learning. Besides the bumpkins, gentlemen of considerable refinement and culture were given to playing to the galleries, figuratively donning coonskin caps and buckskin hunting shirts and dispensing streams of Crockettisms light on larnin' but shrewd about human nature, all to the general amusement. When they grew tired of applauding their own humor, someone was bound to rise and solemnly protest such frivolity when Congress had important matters to attend to. So, wiping away the tears of laughter, members turned back to the serious business of the day, leaving some artist or writer to simmer at a distance. Samuel Houston of Texas, who introduced Bartlett's resolution, allowed that since the Senate was "in the habit of spending money" on other things, he saw no reason why it "should not be making books, for I find a great demand for them." Copies of Owen's *Report,* he had been told, rarely reached their destination. "They were stolen out of the mails. That proves the great value of the works, and the great anxiety of the people for intelligence, and urges the necessity of getting a bountiful supply of books by the Senate." Though Bartlett was a pioneering student of the American vernacular, it is unlikely he appreciated this display of senatorial wit. Anyway Houston, like most southwesterners, was vehemently opposed to the Bartlett boundary line, and his defense of the resolution was so halfhearted and mocking that it constituted an exercise in subversion. In the bitter preface to his *Personal Narrative* published a year later, Bartlett thanked "the learned Senator" from Texas, with malice implied.[25]

The laughter had hardly died down following Houston's sally when it rose again as another senator puzzled out loud over the mystery of how so many volumes distributed to congressmen came to rest on the shelves of local bookstores. Buy a loaf of bread in Washington, he said, and likely it would be wrapped in the pages of a Senate document. These books "do not even go to the mail. They leave the hands of members of Congress and go into those shops." Houston admitted that he personally did not read many Senate documents, sticking "pretty much to the Patent Office Report," excluding the section on mechanical devices, "for I do not understand that." Another southern senator, less amused, saw in the proliferation of government-subsidized books "a great deal of mischief" and more than a little vanity on the part of authors eager to be published at public expense. Borland went further. Bartlett, a book publisher, no doubt thought to award himself a lucrative contract for bringing out his own report. This

was predictable partisan slander, akin to the charge that Bartlett's performance in the field did not justify publishing any report he might make. James A. Pearce, as chairman of the Joint Committee on the Library, had a more pertinent objection. Bartlett's request was premature. The boundary survey, though temporarily in abeyance, was not finished. In due course it would be, and the matter could be dealt with then. Stephen A. Douglas, deeming it best to "put an end to this discussion," moved to table, and the motion was approved.[26]

Bartlett was left to prepare his *Personal Narrative,* as he now called it, unaided. Since it would be his vindication, he bent to the task at once. By August he had made arrangements with a New York publisher and was in touch with Seth Eastman to provide a supplementary illustration of Mission Concepción. Bartlett labored through the fall, passing the manuscript on for correction to a Washington friend, who in turn recommended a young French artist as illustrator. The death of Bartlett's wife and assorted family problems delayed progress, but advance notices for the *Personal Narrative* were in the press in December, and by June the book was out. It was not what Bartlett had wanted: two fat octavos, indifferent in appearance and illustration, but readable enough, as his editor friend noted, in a "quiet & instructive" way. Bartlett had been forced to omit the ethnological matter that to him was essential; perhaps Congress would yet authorize a fuller report in which the Indians could play a part. He clung to this hope despite its implausibility. How could he persuade a Democratic administration bent on repudiating him and acquiring "glory by pulling another handful of hair out of poor distracted Mexico's head" to give him a public hearing? He was ignored, and before decade's end he received another slap in the face when his successor on the Boundary Commission, Major William H. Emory, was allowed three substantial quarto volumes, handsomely illustrated, all at Congress's expense.[27]

Despite such defeats, Bartlett could look back with satisfaction on what he had accomplished. The deskbound bookman had thrown off the shackles of commerce, left behind the comforts of sedate old Providence, and journeyed, as Francis Parkman said, to the "outlandish and unheard of corners of the world." He was one with his age.[28]

 * * *

Vindication for Bartlett would come with time, as he reflected on his accomplishments after passions had cooled. In 1853, still embroiled in controversy, he had pushed too hard. His resolution in the Senate was premature. From Schoolcraft's embattled perspective, it was much worse than that. The congressional banter it engendered in April was nothing compared with the humiliation he suffered that July when the *North American Review* devoted eighteen pages to the first three volumes of his

Indian history. The long-awaited major review in a prestigious quarterly turned out to be a blistering attack.

At thirteen inches long, eleven broad, and three thick, each volume weighed in at ten pounds, the reviewer calculated, "enough to daunt even a painstaking critic, who has scruples about the practice of reviewing books before reading them." "Sumptuous" in their paper, typography, and illustration, they were every bit as expensive as they looked, having cost the public treasury $80,856.50 to date, roughly $26,000 per volume. At the same rate, and assuming the series would stop at five volumes, the total expenditure would reach $130,000. What, the reviewer asked, was the government getting for its money?

Volume 1 was mainly devoted to Indian antiquities and contained "little or nothing that is new." Worse, it was wretchedly organized and filled with irrelevant matter; yet in comparison with the subsequent volumes it was "order itself":

> The want of system is the more conspicuous, as Mr. Schoolcraft seems to have a clear idea of the benefits of a scientific arrangement, and prints, at the commencement of the volumes, a list of the generic divisions of the subject. . . . But the arrangement seems to be made only for the purpose of being departed from. The whole work forms only a huge repertory, in which are jumbled together all the materials that the editor can lay his hands upon,—letters from correspondents, abstracts of old books, vocabularies, statistics, independent essays on general subjects, any matter to illustrate a fine engraving, etc. A reference, near or remote, to the North American Indians is generally perceptible, but not always.

The grand census that Schoolcraft had promised as his principal contribution was nowhere in sight. He had produced figures only for the Iroquois whom he had earlier surveyed for the state of New York, as well as scattered data about the Algonquians, his specialty. His statistics were mostly "fished up . . . from old Congressional documents," errors intact. These "mastodons among our books," these "three ponderous quartos," these "bulky and pretentious volumes" were not merely embarrassing failures to be shut "with a feeling of impatience and disgust," they brought the entire notion of congressional support for research into disrepute:

> In order that this source of patronage for science and letters may not be wholly dried up, its treasures should not be drawn off without a careful scrutiny of the character of the work to which they are to be devoted. The appropriation of nearly thirty thousand dollars a volume for the ill-digested and valueless compilation that lies before us, rich though it be in its exterior and costly in its illustrations, is

enough to discredit the whole system of publishing works at the government expense. We have done our share in exposing the nature of the evil; it is for Congress to do the rest.[29]

Schoolcraft had never received such a public roasting before. That it was delivered in the *North American Review* was especially galling. Here was a journal esteemed in the highest intellectual circles in America, a product of the nationalistic fervor following the War of 1812, quarterly proof that a wilderness people need not neglect the arts and sciences and the pleasures of informed discourse that were everywhere the marks of a civilized people. It was in the *North American* that Schoolcraft, as Lewis Cass's protégé, had first established himself as an Indian expert in the late 1820s, launching the career that would secure him the government appointment in 1847—and it was the selfsame journal that by holding him up to public ridicule was placing that appointment in gravest peril. George Gibbs had warned Schoolcraft at the outset to go easy on the vocabularies and arcane ethnology lest he arouse the "barbarians" in Congress who would not "care a d––n" for all his labors if he produced "only a Shawnee or Sioux dictionary." Schoolcraft had accordingly mapped out his strategy: he would work "quietly & diligently" to bring the Indian Office up "to further & higher efforts in history and ethnology." But congressmen given to Senator Borland's utilitarianism had seen through the ruse. What in Schoolcraft's first three volumes would be of assistance to policymakers and Indian agents? Nothing. An investigation intended to be practical was in actuality of only antiquarian interest. And if the *North American's* reviewer was to be believed, it was a miserable failure on that score as well.[30]

Mortified and furious, Schoolcraft sought revenge. But who was to blame? Eager to be reviewed seriously in a serious journal, he had walked into an ambush. In April 1852 he sent a copy of the second volume of the Indian history to Edward Everett, a longtime contributor to the *North American,* and requested he undertake a "general and leading notice." Everett had declined, pleading unfamiliarity with recent developments in the field, but had promised to approach the editor, Francis Bowen, to find someone "able to do it justice." Bowen, a native Bay Stater educated at Harvard and since 1843 in charge of the *North American,* had elected to review the first three volumes himself. Since contributions were published anonymously, authorship was a matter of guesswork. Officially, Bowen was credited with the piece; but Schoolcraft was certain such a biting, maliciously personal attack could not be the work of so conventionally pious a man. The review was almost certainly by someone else, a fellow member of the American Ethnological Society credited by Francis Parkman with single-handedly lifting "the clouds and darkness of a midnight

era" in American archaeology, but in Schoolcraft's judgment a mere "pretender, who exercised the vocation of a tailor in Phila[delphia] a few years ago"—Ephraim George Squier.[31]

Squier, born in 1821 a quarter of a century after Schoolcraft, represented the new ethnological order as surely as Schoolcraft represented the old. He was a man of many parts and many vocations, though tailor was not among them, nor was he from Philadelphia. Son of a Methodist Episcopalian preacher, he was a native New Yorker who thumbed his nose at religious orthodoxy and drank hundred-year-old wines while his father led temperance crusades. His pedigree stretched back to the earliest settlement of Puritan Massachusetts, and he could boast a grandfather, his namesake, who like Schoolcraft's father was a Revolutionary War veteran. With a wide-ranging intelligence, a literary instinct, and a scientific curiosity, Squier was poet, art lover, journalist, editor, politician, diplomat (though the least diplomatic of men), railroad and mining promoter, travel writer, lecturer, and serious student of American prehistory with a knack for popularization. A cosmopolitan, he was at home in Paris, London, or Berlin, where he swapped ideas with the luminaries of world science, including his personal hero Alexander von Humboldt. He was also a super patriot, representative of young America in full-throated cry yet opposed to slavery expansion and war in Mexico—a Whiggish proponent of Manifest Destiny, who during his short-lived career as United States chargé d'affaires to Central America (1849–50) not only saw something of the area at a time when it was emerging prominently on the map of American ambitions following the discovery of gold in California, but managed to goad the British lion at the zenith of its imperial power.[32]

The issue was interoceanic transit, with its vast commercial potential, and the diplomatic maneuvering was fierce as the British and American ministers on the scene, mutually suspicious and rendered relatively independent by distance and poor communications, jockeyed for position. Squier, from his arrival in Nicaragua in June 1849, was in the thick of things, determined to assert an exclusive American right to build a canal from San Juan del Norte on the Atlantic coast through Lake Nicaragua to the Pacific. He signed treaties securing the monopoly by heading off a British countermove to control a rival western terminus in Honduras and belligerently condemned British meddling on Nicaragua's Mosquito Coast. Reprimanded for his confrontational approach to diplomacy, he was recalled the next spring when the administration changed with the death of Zachary Taylor and a more conciliatory tone prevailed in high-level Anglo-American negotiations. Squier returned home unchastened. While publicly disavowing his actions, the secretary of state was said to have privately enjoyed a swashbuckling performance greeted with rapturous applause by many Americans. "How bravely Squiers [*sic*] goes on!"

the editor of the *Literary World* had exclaimed: "A man must brush up his geography to keep pace with his annexations! . . . Imagine the glorious little fellow tilting himself over on a newly unburied idol in the depths of a Nicaraguan jungle, . . . enjoying the [London] *Times* thunder with his American cigar; puffing John Bull's mosquitoes to the winds."[33]

Squier embodied the American fact at midcentury. Nothing seemed to faze him. Dismissed from the diplomatic service, he wrote popular travel books and fiction about Central America, defended his position in the dispute with England, mocked the alliance between "their Britannic and Mosquitian majesty"—and took his case with him, along with his archaeological credentials, to London. Thwarted in his official attempt to secure an American monopoly on a Nicaraguan canal, as a private citizen in the 1850s he went on to advocate a superior interoceanic route, a railway across Honduras for which he served as front man.[34]

Squier was a short man with a short fuse—self-important, bombastic, utterly lacking in a sense of proportion. "E. G. *Sqquhigher*, small voiced and picayunish as ever," Pliny Miles reported after an encounter. Parkman, who understood Squier well, shrewdly characterized him in 1850. "He has shown a little disposition to bluster and make himself too common in the public prints; and of anybody else I should say that he was dissipating his talents by having too many irons in the fire, but under all his skirmishing he generally contrives to have some heavy piece of ordnance loading for a grand discharge." It was the qualifying "but" that saved Squier, redeemed him beyond mere acceptability; for the furies that drove him made him a compelling force in his own right, and his wit, style, and manic energy drew people to him even as they shook their heads. A religious friend prayed for his impious soul and hoped he might one day join "in the profession of a faith which I regard as my chief blessing." Squier was difficult at times, but his acquaintances tinged their reservations with affection and worried over him. "Why, the deuce, are you fagging yourself to death," Parkman demanded in 1851. "Take a trip to England or anywhere else that will set you up. Nature has made you tough as a pine knot, but a pine knot won't stand fire."[35]

They were right to worry. There was something preposterously extravagant about Squier's appetite for work. He wanted to be a young Humboldt, to swallow the cosmos whole; nothing less would do. And he would gladly wade into any foe in open combat—the greatest imperial power of the age, or the Indian historian to Congress ensconced in an office in Washington, the epitome of the establishment in American antiquarian studies.

* * *

Squier and Schoolcraft crossed paths by dint of one of Squier's sudden enthusiasms. Having cut his teeth on a workingman's paper and the

Hartford *Journal*, in early 1845 he assumed management of the *Scioto Gazette*, published in Chillicothe, Ohio, "delightfully situated in the midst of the magnificent valley of the Scioto, 45 miles from the Ohio. . . . Nothing like it is to be seen East of the Alleghenies; it is even the garden of the West." This veritable Eden had been occupied before, however, and Squier found his curiosity piqued by the antiquities nearby. "We are here in the midst of the ancient remains of [a] race, highly advanced in the arts as their works show, but which is now extinct, leaving no records, save the thousand monuments scattered around us," he wrote his parents shortly after settling in Chillicothe:

> That they were long anterior to our present race of Indians is certain. We find mounds, some square and eliptical; some covering but a few square yards at their base and but a few feet in height, to those which cover acres, and one a hundred or two hundred feet high! There are circles too, and stranger and mysterious squares and crescents, some a few rods, others miles in circumference. Some of these works are evidently designed for defense, the uses of others are unknown and can only be guessed at. Many strange articles of pottery, and wonderful carving in wood and metal are found in mounds, some of which contain myriads of decayed human bones.

By year's end Squier had formed a sizable cabinet of curiosities and was thinking of writing a book on the western mounds; before another six months elapsed he was traveling in the East, an accepted authority on the western antiquities, looking for funds to support further excavations and the publication that had become de rigueur.[36]

Schoolcraft, who was in Washington seeing to his own bid for congressional patronage, missed Squier when he passed through New York in June 1846, drawings and relics in hand. But he alerted John Bartlett as corresponding secretary of the American Ethnological Society, "We should not suffer any thing to escape us, which we can obtain." Later he was "rejoiced" to learn that Squier had agreed to contribute a paper on the western mounds to the society. Squier in turn rejoiced in the flattering reception accorded him. He was unanimously elected a corresponding member on June 8, placing him in excellent company. Though only four years old, the society was already at the center of ethnological studies in the United States, with Albert Gallatin as president, Schoolcraft as vice-president, and a membership that included William H. Prescott, Samuel George Morton, Richard H. Dana, Francis Lieber, Charles Wilkes, and Humboldt himself.[37]

Squier's patronage quest took him north from New York to the American Antiquarian Society at Worcester, Massachusetts, the Boston Academy of Science and Art, the Connecticut Academy of Science, and a gathering

of the Yale faculty at Professor Benjamin Silliman's home. Along the way he was learning some hard truths about patronage in America: interest abounded, but you were on your own when it came to money. "You ought to have some public encouragement & if Worcester can aid you it will be an honorable patronage," Silliman sympathized. But the Antiquarian Society said only that it might be able to "do something by-and-by," while the best Yale could come up with was prestige by association and Silliman's suggestion: "Would not some effort [to publish] procure you an extensive subscription?" Schoolcraft and Catlin had heard those words before. The Boston Academy was rumored to have an $11,000 fund at its disposal, and Squier hoped to tap it; failing that he considered lecturing, but a contemporary had already defined what "FAME" as a speaker meant: "Fifty And My Expenses."[38]

Only the American Ethnological Society promised direct assistance, and then only for publication. Plans were firm enough by February 1847 for Bartlett to caution Squier against scooping himself in an advance notice he was preparing for Silliman's *American Journal of Science and Art,* where Schoolcraft and Catlin had also published. "Excite the curiosity of the public on the subject [of the mounds], but do not satisfy it," Bartlett warned. "We want to be first to announce your explorations, and the volume will not sell if too much is made known before hand."[39] The society wanted the credit for introducing Squier's discoveries to the world, but it balked at overcommitting itself. The memoir, with its plates and diagrams, would be a costly venture (the engraving alone was estimated at $3,500), and the Ethnological Society was as strapped for funds as any other learned body. Squier was in straitened circumstances too. His swing through the East had taken him away from the *Scioto Gazette,* where his salary was tied to an increase in circulation, and left him scrambling for an income. Election in December as clerk to the Ohio House of Representatives would tide him over the winter, but it stymied his antiquarian ambitions. New Year's Eve found him buried in legislative paperwork and pinning his hopes for relief on another body, the Smithsonian Institution, which under its secretary Joseph Henry had taken an active albeit cautious interest in ethnology.[40]

Caution was advisable. The mid-nineteenth century was a credulous time. People on both sides of the Atlantic were prepared (indeed, eager) to believe the most improbable things. Perhaps the romantic rebellion against the Age of Reason had released imaginations long fettered; intuition seemed logic's superior as a guide to the truth. People were willingly gullible, disbelief was happily suspended. As exploration filled in the map and hounded the last vestiges of make-believe and mystery off the face of the globe, hunting it down in the remotest jungles and to the earth's very poles, pseudoscience stepped in to provide a zany final fling with the

65. Richard H. Kern, *Smithsonian Institute from Capitol grounds* (watercolor, 1852). Great hopes would repose in the Smithsonian, shown in this watercolor rising like a castle from a forest, fit symbol for a wilderness people's first ongoing commitment to science and research. Amon Carter Museum, Fort Worth, Texas.

fabulous. "Wonders of the world" were all the rage, providing the competition Catlin had found so formidable during his years as a London showman. Crowds flocked to gawk at freaks and exotic primitives; mesmerism and the occult flourished. It was "the epoch of rapping spirits," Hawthorne wrote. Charlatanism was rampant, and the line between science and pseudoscience as indistinct as that between craniology and phrenology. Serious investigations were coupled with preposterous theories. It is not surprising that George Catlin would freight an enduring ethnography of the Mandans with the idea that they were the pale-skinned descendants of a Welsh explorer. Nor is it surprising that when he was publicly discredited—a subject I will discuss later—it was less for his theories (easily forgiven) than for his observations (condemned as outright lies).[41]

In an age that readily confused the two, who could tell? Schoolcraft saw himself as a model of scholarly sobriety in a world drunk on absurd notions. "The era of speculations & balderdash" in antiquarian studies "has fairly passed," he wrote in 1846; but even as he dismissed the idea of ancient civilizations indigenous to the New World, he championed the idea of an Old World presence in America before Columbus. The mounds and their builders were at the heart of the puzzle. Empires sprang up in overheated imaginations, rivals to the doomed civilizations of Meso-America. Exploiting the interest aroused by William H. Prescott's *History*

of the *Conquest of Mexico* (1843), two dwarfs from Central America toured the States and England in 1853 billed as the last of the Aztecs. A boy-girl set, Maximo and Bartola, they amused royalty, intrigued savants, and beguiled the public. How wonderful, one English writer thought, "that Providence had deigned to grant the favor, that before the Aztec race had wholly passed away, two of them should visit England, to be the witnesses of palatial splendor as great, perhaps, as that which their forefathers had looked upon." North America too had a long-lost race, the Mound Builders. Their cattle lowed in forgotten fields along the Mississippi and Ohio rivers, and their lovers, as the poets said, wooed in unremembered tongues. Then they were gone, vanished from the earth, leaving no trace save the mounds. Thus the excitement occasioned in 1846 by the reports out of the Scioto: What was the reality behind the romance? The fluid and uncertain state of antiquarian knowledge at midcentury also explained Joseph Henry's skittishness about involving the Smithsonian, though he would write in 1855 that "the Institution from the first has given particular attention to antiquities, philology, and other branches of the new and interesting department of knowledge called ethnology." Squier's monograph on the ancient monuments of the Mississippi valley would be the Smithsonian's trial balloon.[42]

Squier was as relieved as the American Ethnological Society and as pleased as Henry by the agreement struck in May 1847. The Smithsonian was to publish his report on the western mounds, costly plates, diagrams, and all, as the first in its "Contributions to Knowledge," the Ethnological Society passing on the report's acceptability. This was similar to the role the society had played in endorsing Schoolcraft's bid for congressional patronage. The honor of inaugurating the Smithsonian series did not elude Squier; at the same time, he anticipated a liberal financial return. There was, however, a final hurdle to be cleared. Despite the impression he fostered, Squier had not excavated in the Scioto valley alone. All along he had a partner, a Chillicothe medical doctor named Edwin H. Davis, who had been digging in the local mounds for over a decade. But Squier was in no mood to share credit or expected royalties. Testy about the personal sacrifices he had already made to science, he claimed the Smithsonian memoir as "wholly and exclusively" his own. Though apparently more hobbyist than serious scientist, Davis could not be so easily dismissed. Thus ensued what Squier would dub "the Davis affair."[43]

 * * *

Davis had been in correspondence with the American Ethnological Society before Squier's eastern tour and would remain moderately involved in archaeology through the 1860s. It was his letter to Bartlett that got Squier a first hearing and membership in the society. At one time the two men had functioned as a team: Davis, fieldworker and source of funds; Squier,

66. *Left*. Ephraim George Squier (1821–88), confident, relaxed and full of himself in an 1850 portrait. National Portrait Gallery, Smithsonian Institution.

67. *Right*. Edwin Hamilton Davis (1811–88), medical doctor, amateur archaeologist, and Squier's onetime partner, looking properly suspicious in this George Rockwood photograph. National Portrait Gallery, Smithsonian Institution.

writer and publicist. Together they had planned to conquer the world. Davis's letters of encouragement while Squier was on his mission in the East bristled with military metaphors. Bombard the learned societies with information, he advised, but conserve ammunition for the all-out assault, their published report. "You deserve promotion," he congratulated Squier on a successful foray. "It shal [*sic*] be Genl. S. hereafter." While Davis manned the home front, Squier stormed targets in the East. But as Squier gave papers and basked in the antiquarians' esteem, what had been their project became *his* project, their report, *his* report. He wrote every line of it, after all, even drew the plans of the mounds. He alone organized a hodgepodge of information into a coherent narrative. And he presented *his* conclusions to the learned societies, answered their questions, dealt with the press, and became in effect the solitary expert on western antiquities, while Davis gradually faded out of the picture.[44]

The end was in view by the spring of 1847. With Squier unaccountably silent, Davis found himself cut off from news about their joint venture and "getting nervous." "I shall have to do something to keep up my end of the rope," he wrote with jaunty bravado in August. "I wonder if I could not divide my old college address upon antiquities into about ten paragraphs, and give three a week for some time—*ha!*—ha!—ha!" Hollow laughter, greeted by more silence, and then the thunderclap: a copy of the American Ethnological Society report to the Smithsonian naming Squier as sole author of the memoir came to hand. "I can't conceive that you desire to

appropriate the whole credit of the work, as the resolution does, to yourself," Davis protested. Squier intended just that. Davis had become a drag on his ambitions—"I shall get the 'A.M.' in less than two years without extracting Greek roots for it!" he had crowed after meeting the Yale faculty at Silliman's. Anyway, he was too frustrated by his failure to secure patronage to feel charitable. What began as a squabble erupted into a full-scale feud once Davis ascertained the extent of Squier's betrayal. His partner had been performing on the road as a solo act. Now their guns were aimed at one another, with the Smithsonian caught in the crossfire. An elaborate compromise was negotiated. Both names would appear on the title page, Squier's first, with their respective contributions spelled out in the preface. The division of relics was like any property settlement after a rancorous divorce. Davis hired a "jackass lawyer," and litigation continued until 1850 when Squier, by then United States chargé d'affaires to Central America ("peace be to his ashes," Davis sniffed), was advised to settle the suit.[45]

Financial disappointment had played a major role in the Davis affair. Squier had launched into archaeology fully expecting to make money. Early setbacks had discouraged him, but the promise of a decent "pecuniary arrangement" with the Smithsonian had rekindled his spirits in 1847. He threw himself into the work. Before leaving Chillicothe for good that May, he devoted seventy consecutive days to the report on the mounds—"an incredible labor," he observed—and he was still not done. A tentative publication date of November 1 kept him in New York over the summer working full blast. The deadline came and went, and in March 1848 he claimed to still have three months' work ahead of him. By then his expectations of generous support had evaporated; the Smithsonian was like every other learned body in America—short of funds and chary of those it had at its disposal. The liberal terms promised him turned out to be $150 to cover expenses, with even this grudgingly advanced. Subsequently Henry abandoned the principle of compensating authors and took the position that free publication by the Smithsonian was reward enough. Squier's only hope for making a little money from the book would be a private edition, but the publishers "all *'fizzled out'*": "The Harpers thought they might allow a dollar a copy for an edition of a thousand, *provided* no other edition was published. Appletons ditto. This is all very funny, particularly as I have the credit of being *patronised* by the Smithsonian Inst.! I rather like this new, patent plan of encouraging science! *Rich men* can possibly afford to be patronized!" To realize something on his exertions, Squier was forced to negotiate with Davis to share the expense of a private edition to be published by Bartlett and Welford. Their 250 complimentary copies from the Smithsonian would underwrite the cost of an additional printing of 800, and these, sold through the booksellers on consignment (Davis to

have exclusive distribution rights in the West, Squier in the East) might yet bring in $7,000 to $8,000. Meanwhile, Squier was in debt to Albert Gallatin for $350 and reduced to asking his parents for an additional loan to cover immediate outlays.[46]

In such a "forlorn" state, Squier was uncommonly prickly. When Henry continued to press him for revisions of the memoir, he exploded. A friend intervened, returning Squier's angry letter to Henry undelivered and enlisting Bartlett to prevent "an outbreak." Subsequently the Smithsonian reneged on another understanding. It allowed only one hundred copies of the memoir as compensation, again arousing Squier. He toyed with a lawsuit for breach of contract. But by then *Ancient Monuments of the Mississippi Valley: Comprising the Results of Extensive Original Surveys and Explorations,* volume 1 of the Smithsonian Contributions to Knowledge, was a reality, the "pains of parturition" behind and strong reviews streaming in to cheer its arrival.[47]

Squier and Henry had survived *Ancient Monuments'* traumatic birth because they needed each other. The memoir caused a sensation in learned circles, shedding luster on the Smithsonian as the sponsoring body. In turn, Squier had the prestige of an institutional affiliation, an unearned master of arts degree not from Yale but from the College of New Jersey, arranged by Henry (it "will have a good effect on the reception of the work abroad and will detract nothing from its readability at home"), and an invitation to publish his future researches through the Smithsonian. He was still angry over the Davis affair. Henry was a "nervous old lady" who, having met Davis without discovering "he is a fool and knave, must be a noodle indeed!" Squier was "only sorry" he had agreed to parley with "Davis & Co." "Hereafter I shall act towards dogs as dogs deserve to be treated." But Squier's bluster did not prevent him from undertaking a survey of the mounds of western New York for the Smithsonian in September 1848 or accepting the paltry $100 offered to offset excavating expenses.[48]

* * *

Squier and Henry's relationship was a matter of mutual convenience. Besides the immediate benefits they shared from the publication of *Ancient Monuments,* they had something else in common: a commitment to the science of anthropology. It was at midcentury as new and amorphous a science as Henry would assert. Its scope, its purpose, even its theoretical foundations were uncertain. When Schoolcraft dismissed Squier in 1853 as a "pretender," he meant he was a newcomer to antiquarian research. But the Smithsonian itself was only seven years old in 1853, and the American Ethnological Society a venerable eleven. The science of man was young, in short, and its direction immersed in controversy.

Traditional Americanists like Schoolcraft had engaged in a comparative

ethnology geared to tracing New World/Old World connections, principally through philology. Schoolcraft gravitated toward the study of oral tales but routinely insisted that language held the key to the mystery of Indian origins. Nothing else, he wrote, "has had so great a tendency to reveal the tangled thread of . . . [aboriginal] history." While not "undervaluing physical or philological researches," Squier believed that archaeology would best enable scholars "to trace the outlines of Early American history with some degree of exactness" and establish "the grand fact which lies at the basis of all our inquiries, . . . the *unity* of the American race, and its radical difference, in respect to all the other great families of the globe." That assumption was what made archaeology so appealing to Squier's generation. Its data seemed as hard as the artifacts unearthed. It promised to set anthropology on the same empirical foundation as the natural sciences. And it appealed to both the romantic imagination and nationalistic pride, conjuring up images of the Mound Builders' America while arguing that the Mound Builders and their Indian descendants were a native race, original to the New World. Here was the bombshell that lay beneath the surface of the mounds: Squier and the others were digging toward a conclusion contrary not only to scientific orthodoxy but to religious orthodoxy as well, a theory of polygenesis or multiple creations that contradicted the Bible and challenged the unity of the human species. The preacher's son was in the vanguard of a revolution leading the way to a science of man freed from its metaphysical and theological trappings.[49]

His mentor was the respected Philadelphia craniologist Samuel George Morton, whose 1839 masterpiece *Crania Americana* "proved" that the races had been distinct since Creation, skull conformation having been a constant throughout human existence.[50] Physical anthropologists added their say. They ranged the gamut from serious if eccentric investigators like Peter A. Browne, who believed that microscopic examination of hair follicles would establish conclusively the types of mankind, to racists anxious to affirm white superiority, who drew on Morton's measurements of cranial capacity and whatever else bolstered their conclusion: "None but the white type has ever forced its way and maintained its position in that high order of civilization where moral virtue, clad in intellectual light, rules society." Most polygenesists denied any capacity for change; racial character was set at the beginning of time and was unalterable. The theory of multiple creations offered a bleak prognosis for blacks. Endowed at Creation with a servile disposition, they were natural slaves. Emancipation would bring them only "want, misery and barbarism." "It is evident," one of the leading southern polygenesists wrote in 1851, ". . . that if the negroes in the Slave States are permitted to exist at all on this continent, it can be no where but in *Slave States,* and no where *but in slavery.*" As for the Indian, "He can no more be civilized than the leopard can change his spots.

His race is run, and probably he has performed his earthly mission. He is now gradually disappearing, to give place to a higher order of beings. The order of nature must have its course."[51]

Such were the conclusions that made physical anthropology a minefield at midcentury and caused the ever-cautious Joseph Henry to steer clear. Philology was time honored and archaeology rock solid by comparison. But Squier's brand of archaeology tended to the same conclusions as physical anthropology. As a journalist, Squier was used to taking strong stands and arguing them passionately. His archaeological procedure was similar. Once he accepted the theory of an indigenous American race, the rest of his career constituted a sustained defense; his last book, on "the land of the Incas," concluded, "That the civilization of the ancient Peruvians was indigenous admits of no reasonable doubt." Thus Squier allied himself with the respectable—Samuel Morton, Louis Agassiz, John Bartlett, Francis Parkman—and the radical—George Gliddon, a lecture-circuit Egyptologist, and Josiah C. Nott, a Mobile, Alabama, medical doctor who declared himself a student of "*Niggerology*" and, like Gliddon, relished a little "*Parson-skinning.*" In shepherding *Ancient Monuments* through to publication, Henry's role had been to avoid such extremism, thereby protecting the Smithsonian's reputation and Squier's into the bargain. The Smithsonian was nothing but a "'moyen age' *nunnery,*" Gliddon hooted; but in the end Squier did as instructed, and the monograph appeared purged of theorizing and as soberly scientific as Henry had wanted.[52]

Nevertheless Squier's position was well known, and when the debate over polygenesis split the American Ethnological Society he was to be found with the proponents of multiple creation, Schoolcraft with the orthodox faction committed to the Mosaic account. The pages of Schoolcraft's Indian history were open to physical anthropology, but he preferred to leave the subject to others. Morton and Browne were contributors, balanced by clerics. When Schoolcraft did enter the discussion, his position was predictable. By denying the brotherhood of man, polygenesis undercut missionary effort; monogenesis, in contrast, attributed human variety to climate, thereby affirming the unity of the species and the value of missionary work. The Indian tribes, Schoolcraft wrote, rebutting Morton's theory of races created for specific environments, "are manifestly of oriental origin." Yet "there are persons in America . . . whose intellects or fancies are employed in the contemplation of complicated and obscure theories of human origin, existence, and development—denying the very chronology which binds man to God, and links communities together by indissoluble moral obligations."[53]

Schoolcraft and Squier were natural adversaries, then, as different in personality as in philosophy. They were, respectively, champion of orthodoxy and brash challenger. Even their outlooks on Indian destiny varied,

though not along predictable lines. Committed to religious orthodoxy, Schoolcraft abhorred polygenesis; yet his reading of the Indian's future was as bleak as any polygenesist's. Since he had at one time been reasonably optimistic, personal experience may have been a factor, his estrangement from his two part-Indian children (and his first wife, for that matter) darkening his hopes and attracting him to the theory of Indian degeneration over time. Squier, in contrast, though an advocate of multiple creations, detected a progressive principle in every type of mankind and would not consign a race to permanent inferiority—or extinction. The two men had been circling one another, content to spar at a distance, almost from the moment Squier was voted a member of the American Ethnological Society with Schoolcraft's backing. The first real flurry came in 1848.[54]

* * *

A stone had been found in a mound on the banks of the Ohio in western Virginia, about eleven miles below Wheeling. The Grave Creek Mound, as it was known, had been reported as early as the 1730s, but it had never been systematically explored because, it was said, the owner of the property had refused permission until 1838, when popular interest fanned by the general curiosity about the tumuli and the hypothetical pre-Indian race of Mound Builders made its excavation attractive as a paying proposition. The digging that summer turned up nothing out of the ordinary—skeletons, beads, some ceremonial artifacts. But then rumors began to circulate in the press of a wondrous discovery, fraught with significance for the prehistory of America, a small stone bearing what was apparently a crude alphabetic inscription. Did this prove the existence of a race anterior to the Red Indians? Did it establish an Old World presence in America long before Columbus? Or did it mean that the native Indians had actually evolved a form of writing previously lost to history? Scholars gravely bent to the task of translating the inscription or, barring that, determining its derivation through comparative study. Old World analogies abounded, but the closest parallels might indicate the inscription's source and thereby rewrite the story of ancient America.

Among those caught up by Grave Creek was Henry Schoolcraft. He announced the discovery to learned societies abroad in 1841 and made a personal inspection of the site two years later to obtain a "true and exact copy" of the stone's inscription, reporting his observations to the Ethnological Society, which published them in its first volume of *Transactions* in 1845. Schoolcraft considered the stone a discovery of paramount importance, the first artifact found in America with an "authentic inscription . . . which holds out the hope of establishing . . . [a] connexion of races, through the light of an alphabet." A minute description of the relic followed (it was an elliptical sandstone, $1\frac{3}{4}''$ x $1\frac{1}{2}''$), along with a list enumerating the similarities between its twenty-two inscribed characters

68. The Grave Creek stone (obverse/reverse), a small relic that ignited a big controversy in antiquarian circles, pitting Squier against Schoolcraft. *Transactions of the American Ethnological Society,* vol. 1 (1845).

and those in ancient alphabets. Fifteen corresponded with the Celtiberic, fourteen with the old British or Anglo-Saxon, ten with the Phoenician, seven with old Erse, six with ancient Gallic, five with old northern or Runic, and four each with ancient Greek and Etruscan. Such an embarrassment of riches presented a dilemma but supported Schoolcraft's contention that the Grave Creek stone opened "a new mode of ethnological inquiry, which it may not be too much to say, elevates the history of the mound period to a branch of literature."[55]

A claim so sweeping demanded corroboration—or refutation—and members of the Ethnological Society had avidly followed the progress of antiquarian research in the West through communications from the field. In calling Squier's work to Bartlett's attention, Schoolcraft said it was time that the question of the continent's being visited and "to some extent *settled* & *cultivated*" before Columbus be critically examined. Squier, he thought, was the man to do it. These sentiments boomeranged when Squier published a paper in the second volume of the Ethnological Society's *Transactions* (1848) on the aboriginal monuments of the Mississippi valley. Its conclusions were "offensive to the truth," Schoolcraft complained, and as a founding member of the society he should have been spared such an insulting attack. His reference was to Squier's discussion of the Grave Creek Mound. In it, Squier twitted those who had rushed forward to interpret the inscription without first verifying the stone's authenticity. And he poked fun at their learned hypotheses, particularly Schoolcraft's shopping list of analogies, in a footnote citing *Hamlet:*

POL. By the mass! and 't is like a camel indeed!

HAM. Methinks it is like a weasel.

POL. It is backed like a weasel.

HAM. Or like a whale?

POL. Very like a whale!

238

Squier's point was valid: any uncharacteristic find must be skeptically regarded, especially one with such far-reaching implications as the Grave Creek stone. Why *assume* its authenticity? Such a procedure was "contrary to the rules which regulate philosophic research." If no similar relics were to be found in other mounds, surely the "presumptions" were "all against it." Squier had a theory of his own. When the mound, excavated for commercial purposes, was found deficient in tourist interest, its owners "salted" it. Squier reached this conclusion because of the unexplained two-year delay between purported discovery and public disclosure. Perhaps the owner was himself the victim of a hoax; almost certainly Schoolcraft and his fellow antiquarians were.[56]

Members of the Ethnological Society who had pronounced on the stone's importance were embarrassed; some scrambled to distance themselves. William B. Hodgson had served as Schoolcraft's authority on similarities between the stone's inscriptions and certain ancient African alphabets. Confronted with Squier's argument that "this pierre gravée" was a hoax, he allowed, "I have always suspected it." Schoolcraft, accustomed to deference, was ill prepared in his mid-fifties to deal with challenges by younger scholars, especially when their tone betrayed more than a trace of disdain. At best, Squier had characterized Schoolcraft as a gullible dupe, and a pompous one at that. Immersed in his own dispute with Dr. Davis over the Smithsonian memoir, Squier was unrepentant. "I beg you will endeavor to sooth Mr. Schoolcraft's troubled spirit," he wrote to Bartlett. "He is old enough to know that a joke is intended to be laughed at, and not to get angry over." But Schoolcraft neither laughed nor forgave. Thereafter he set his sights on the high-flying "pretender."[57]

Ever prolific, Squier continued to challenge the mistaken tendency, which he traced to the Royal Society of Northern Antiquarians in Copenhagen and their American devotees, of using Indian relics as proof of an early Norse occupation of America—an offshoot of the general tendency to see the mounds and other aboriginal monuments as non-Indian in origin. Dighton Rock in Massachusetts, for example, was touted as a Scandinavian monument, but its supposed Norse inscriptions were obviously Indian picture writing, Squier argued. Corroboration included the hieroglyphics Catlin reported at the red pipestone quarry (indeed, Catlin had gone on record that the Dighton Rock inscriptions were "the work of Indian hands"). Squier broadened his inquiry to include all Indian picture writing, "upon rocks, as well as skins and the bark of trees." The Walam Olum, a Delaware tribal history on bark that had come into his possession, established the complexity of such pictographic records, and he read a paper offering a translation to the New-York Historical Society in June 1848. When it was published the following February, he sent a copy to Schoolcraft and, adopting a conciliatory tone, solicited his reaction as an

expert on the northwestern tribes, signing himself "your friend and colleague." Schoolcraft's reply was superior, appreciative of a junior scholar's efforts, and skeptical about the significance Squier attached to the Walam Olum.[58]

Squier's attempt at a reconciliation was partly successful. He obtained copies of Schoolcraft's 1847 inquiries and his list of words and suggestions for travelers visiting new areas of ethnological interest when he left for Guatemala; in return he was to relay pertinent philological information to Schoolcraft for inclusion in the Indian history. But the reconciliation ended abruptly in 1851 when Schoolcraft extracted clumsy revenge for Squier's Grave Creek paper by referring in his history to the Smithsonian memoir "by Dr. E. H. Davis, assisted by Mr. Squier." Schoolcraft also defended the Norse interpretation of the Dighton Rock, noting that the inscriptions consisted of Indian pictographs *and* Icelandic characters, "of which it is evident that the Icelandic is the most ancient." As for the Grave Creek stone, Schoolcraft, who dismissed eyewitness observations when they clashed with his own views, took the high road: "We are not at liberty to deny record to any well attested report." Indian writing never aspired above rude pictography, and "wherever an alphabet of any kind is veritably discovered, it must have had a foreign origin. By granting belief to any thing contravening this state of art, we at first deceive ourselves, and then lend our influence to diffuse error." This exposed another philosophical difference between Squier and Schoolcraft. Polygenesists attributed cultural developments to parallel or independent creation by separate types of mankind; monogenesists, to diffusion as inventions radiated outward from a common center.[59]

Schoolcraft did not stop with the Grave Creek stone. In order to put the pretender in his place, he tried to suppress Squier's second Smithsonian monograph, on the mounds of western New York, at least until certain errors he detected in it had been corrected to his satisfaction. His stiff exchange with Squier was polite to the point of parody. Having had the "pleasure" of reading Squier's paper, Schoolcraft felt obliged to notice two errors, one involving the antiquities of Onondaga County, the other in geography. Squier replied that he would "at once endeavor to correct them, if important," and if Schoolcraft would be good enough to inform him "in what the errors you refer to consist." Schoolcraft was good enough—at length. The geographical error related to the alleged extinction of the Mandan Indians and resulted from Squier's following George Catlin too closely, while the other resulted from a failure to distinguish between native and early French missionary relics in Onondaga County. Schoolcraft trusted Squier was "too much the friend of a true knowledge of our antiquities" to misinterpret his motives. But when Squier failed to acknowledge the errors promptly, Schoolcraft went on the warpath. He

complained to Spencer F. Baird, Henry's assistant at the Smithsonian, about Squier's apparent intransigence and drafted a letter indicating his intention to go public on the subject. He kicked up enough fuss that Henry himself wrote Squier about Schoolcraft's complaints.[60]

Squier sensibly ignored Schoolcraft, though there could now be no mistaking his malice. The first volume of the Indian history spelled it out. Squier had pounced on the Ethnological Society's copy as soon as it arrived and was aware of its content. He must have been sorely tempted to respond. George Gliddon sneered at Schoolcraft's section on archaeology and allowed he could annihilate it in three pages—except what was cribbed without credit from his own work on Egyptology. "He merits h——l at your hands," Gliddon wrote. "Such a chance for a slashing *review*!!"[61]

Here in a few words was Gliddon's greatest failing. "Controversy is not science," an acquaintance observed. "Gliddon confounded the two, and failed." But Squier shared in this failing; his polemical style resisted restraint. And he had blind spots of his own. "In all cases avoid exaggerations," he had been warned in preparing *Ancient Monuments* for press. It would be "improper," as Henry put it, "to admit into the memoir any theoretical matter except in a very subordinate degree."[62]

In 1847–48 Squier had accepted this advice, muting his conclusion that the mounds were the work of an autochthonous American race. But he still entertained a theory that had become something of an obsession with him, the universality of the snake as a symbol of the priapic principle in nature. During their honeymoon period Davis reported that "my friend Mr. Squier, is so enthusiastic upon this subject, that he goes off half cocked sometimes"—perhaps the only unintentional pun Squier's obsession ever inspired. Bartlett suggested Hindu parallels; Brantz Mayer lent illustrations of the "venemous reptyles" in ancient Mexican art and chortled over the annoyance Squier's discussion of the snake's "theological virtues" would cause the clergy; Gliddon, who had long amused his leisure moments "with *Priapic* worship! i.e. the *study* thereof!" and delighted in "new confirmations of Lancé (?)," egged Squier on: "I can produce from the pharaonic hieroglyphics nothing directly to connect *phallic* worship with the solar emblem of *Serpent;* but biblically, and historically, it would be easy to attribute to the Egyptians." As for priapic worship, it was, "at one period of every Nation's phases, *universal*."[63]

Squier was about ready to unleash "Phallic Worship and the Sarpient" on the world in 1850, but Henry proved cool, advising him to write up his Central American experiences first. When *The Serpent Symbol, and the Worship of the Reciprocal Principles of Nature in America* did come out, through a commercial publisher in 1851 at Squier's expense, a friend declined to review it for the *North American,* and William Gilmore Simms judged from the title that there would be "much more of the fanciful than

69. *Great Serpentine Earth-work, Adams Co., Ohio,* graphic evidence for Squier's controversial serpent-and-egg theory. E. G. Squier, *The Serpent Symbol, and the Worship of the Reciprocal Principles of Nature* (1851).

the philosophical" in it, though the *Southern Quarterly Review* carried a notice. Parson baiting had its price, and in setting out to offend, Squier had achieved his goal. One Schoolcraft correspondent dubbed him "the 'Serpent Symbol' philosopher," and Schoolcraft wrote that he hated "infidels & free thinkers, like snakes." He mentioned others as well—Nott, Gliddon—but meant "little Mr. Squier" of course.[64]

Since Schoolcraft was writing shortly after his Indian history had been savaged in the *North American,* and since he was sure Squier was the hatchetman, his motives were transparent. He claimed to be above the fray, serene and full of charity toward his enemies. But there was murder in his heart, and he sought footnote revenge in the next volume of his history: "Mr. Ephraim G. Squier . . . abruptly entered the field of American archaeology, by a paper for the Smithsonian Institution, published in its contributions for 1838 [*sic*], which created high expectations of future promise. These are not sustained by his work on the Serpent Symbol, which there is no possibility of considering a contribution to American archaeology." Years later, Schoolcraft admitted this note was intended as a reply to Squier's "ribald attack" in the *North American Review.*[65]

But did Squier write that particular "slashing *review*"? His style, always lively, could be sarcastic and brutal. Indeed, it was distinctive enough that a correspondent, thanking him for a copy of a recent "racy article," added: "I

had previously read it with profound interest, & was simple enough to wonder who the author was. I shall now *guess* that every spicy thing I find in that Magazine is yours." The harshest portions of the *North American Review* essay on Schoolcraft *sounded* like Squier and were echoed in his later writings, while long passages attacking Schoolcraft's information on antiquities—the Dighton Rock, for example—were consistent with Squier's known positions. Finally, in the way of circumstantial evidence, through Francis Parkman Squier had struck up a friendship with Charles Eliot Norton, a regular contributor to the *North American* assigned to review *Ancient Monuments*. Norton relied on Squier for the information that appeared in his review—indeed, described the review as a summary in Squier's own words. He adopted Squier's position on the Grave Creek "hoax," filled in speculations absent from the memoir (the Mound Builders and the Mexican civilizations constituted a single "Toltecan family of races"), argued for the primacy of archaeological investigations in throwing "new light on the ante-Columbian history of America," and urged learned societies to support Squier's continuing researches. One other point: Norton's review dismissed Davis with the remark that he "aided" Squier—relegating him to the role of having "filled inkstands and washed antiques for that *great Antiquary*!!!" Davis exploded.[66]

The close collaboration between Norton and Squier was common practice at the time. Schoolcraft had proposed the same arrangement with Edward Everett had he agreed to undertake a review of the Indian history for the *North American*. More important, Norton provided Squier access to Francis Bowen, raising the possibility of another, secret collaboration. The evidence is not conclusive, then, but there is much to suggest that Squier was behind the offending review.[67]

Schoolcraft never had a moment's doubt. The review was "really too low and unjust to deserve notice," but he nevertheless drafted a long reply intended to net "this disappointed little gar fish." Evert A. Duyckinck, editor of the *Literary World,* warned Schoolcraft against engaging in personalities. Schoolcraft had received a "very shabby review," no doubt, but his rebuttal would be strongest if he concentrated on his own merits, "which do not need the demerits of Squier nor anybody else to set them off." Duyckinck had previously courted Squier, soliciting his archaeological contributions and reveling in his actions as chargé in Central America. No point in provoking him needlessly. Thus when Schoolcraft's rebuttal appeared as the lead essay in the August 20 number of the *Literary World* under the pseudonym "Curtius," Squier went unnamed. Bowen, as the putative author, was excused on the grounds he knew no better, having depended for his information on sources "of a very low, doubtful, or ignoble character." There was no doubt who was meant, since Schoolcraft singled out for condemnation "a class of observers in the United States

who are for ever harping on the mounds and earth-works, and so-called 'fortifications' of the Mississippi valley." The Smithsonian had foolishly lent itself to "this antiquarian pseudo-philosophy," "this species of ill-judged and slip-shod archaeology." The only valuable portion of *Ancient Monuments* was Dr. Davis's research; yet his "draftsman," who contributed little save "false theory" to the work, had attempted to publish it under his name alone. Having vented his spleen, Schoolcraft had little to offer in defense of his own archaeology. The *North American* reviewer had particularly taken him to task for his "untenable" hypothesis that the inscriptions on the Dighton Rock were both Algonquian and Icelandic. Schoolcraft conceded the point. His deference to other opinions explained his prior view. But he had since had the rock's inscription daguerreotyped, "which completely removes all the disputed points, and shows it to be a uniform piece of Indian pictography." This was less a defense than an admission of error.[68]

Schoolcraft had drafted another article, intended for one of the Washington newspapers, in which he touched on the matter of greatest moment to him personally. Assaults like that in the *North American Review* endangered his position or, as he put it, might deprive the Indian of an "honourable record . . . as is about being done in this work. And we trust it will be sustained . . . by Congress." The critic in the *North American* had gone on at length about the generous support given Schoolcraft's project when so many, more deserving (the Exploring Expedition's scientific reports, for example), went begging. "What lucky accident or skilful management has rescued Mr. Schoolcraft's Indian researches from a similar fate, we cannot tell." Schoolcraft responded that his work was comparatively cheap. He chose Owen's reports to make the point, but any would have done since the issue behind the specifics was a constant: meager resources, massive demand. Was the *North American Review*'s "tirade" the envious whimper of another disappointed patronage seeker who had toured the East Coast seeking funding in vain and then linked up with a national institution more niggardly than government? The work of "a piqued individual, who was, rather summarily but not unjustly, we think, ejected from office *here?*"[69]

Meanwhile, Schoolcraft had heard from John Bartlett, just returned from the scene of the crime. He had been in Boston, where the *North American Review* was published, and had some disquieting news. Chatting with one of the partners at Little and Brown's bookstore, he was asked if he had read the Schoolcraft review. Bartlett replied in the negative.

He said "It is very severe. I wish you would read it." . . . He handed me the number, and asked me to read a paragraph to which he pointed. I did so, and said "this is indeed severe.—Who wrote it?" He replied "the editor, Mr. Bowen." I asked him if he was certain, as

I had heard it attributed to another. He said "I know Mr. Bowen to be the writer."

On my return from Mexico, in passing through N. York, I spent a couple of hours with Mr. Squier. He did not speak of your book to me; and I know that he left N.Y. for Central America the Saturday after I saw him, which was the first week in February. He had not returned a few days since when I was in New Yk. You can judge from the foregoing whether or not he is the writer of the article; I am inclined to believe he is not.

Schoolcraft chose to believe he was, and he took his usual revenge in the one outlet always open to him, the "national work" on the Indians.[70]

The fourth volume of the Indian history went through the press that fall. Schoolcraft made some last-minute changes. He described Squier as "an ardent advocate" for the insupportable theory that the western mounds were the work of a civilization higher than that of the modern Indians. He elaborated in the footnote in which he spoke of Squier's *recent* entry into the field of archaeology and dismissed his *Serpent Symbol* as nonsense. Schoolcraft rounded out his attack with an oblique reference to a hoax in the New Orleans *Picayune* reporting the discovery of a Greek inscription in the Mississippi valley. Squier, he said, was duped because he "entertained theories of a far higher antique civilization in that quarter than are inferable from even his own testimonies of the 'Monuments.'" This was a willful misrepresentation of their respective positions on Grave Creek at least, and since Schoolcraft could not conclusively pin the *North American* review on Squier, it was a provocation with little point. An ally in the fight against the infidels, Wills De Hass of Moundsville, Virginia, congratulated Schoolcraft on "touching up" Squier in his footnote—a telling blow delivered at last by the champion of orthodoxy. "Your scathing notice will have good effect in Europe where the charlatan is not fully known and understood." In fact, Schoolcraft had led with his chin. Squier was now free to retaliate, making his long-standing private contempt for Schoolcraft public.[71]

On July 22, Squier drafted an eight-page reply. A rapid examination of the second, third, and fourth volumes of Schoolcraft's extraordinary compilation, "which evidently belongs to the '*Monster Period*' of which it so profoundly discourses" (the *North American* reviewer, on the same theme, had referred to these "mastodons among our books"), compelled him to address what he had ignored before. He had allowed Schoolcraft's mention of him as Dr. Davis's assistant to pass unnoticed and had overlooked "the course of disparagement which you have been pleased to pursue towards me, in conversation and by correspondence since the issue of the first volume of your compilations." Schoolcraft's "infirmities, and the

morbid irritation consequent upon a want of public appreciation," explained his conduct, "if they did not excuse the *animus*." The "splenetic ebullitions" of unhappy old men could be ignored in the press of more serious concerns.

But Schoolcraft had gone too far in volume 4. The footnote was a libel. Squier had never reported the discovery of Greek inscriptions in the Mississippi valley or been the advocate, "ardent or otherwise," of the theory of an ancient high civilization in America. Far from accepting the New Orleans *Picayune* report as true, he had described it as an example of "the clever hoaxes common to our newspaper press" and asserted, accurately, that documents of the same sort existed in Mexico, the work of pedantic monks who had translated portions of the Bible into hieroglyphics and graced their manuscripts with a few phrases in Greek. Indeed, the only person he was aware of "who ever deluded himself with the idea that he had discovered a Greek, or any other kind of Alphabetic inscription, in the Mississippi Valley," was Schoolcraft, who at Grave Creek "found not only Greek, but '*ancient* Greek,' besides Etruscan, Erse, Phoenician, Gallic, and the Lord only knows what other kinds of letters!" Squier did not care in the least what opinion Schoolcraft held of *Serpent Symbol;* that was his business. "But," he insisted, "you have no right to transpose names, misrepresent facts, or publish falsehoods." The misstatements in volume 4 should be corrected "as publicly as they were made, and by the same means." Were this done, the matter would be dropped; were it not, "I shall make such a public exposition as the commission of an injury and a refusal to redress it would authorise."[72]

Squier circulated his letter among friends in Washington before mailing it to Schoolcraft on August 30. The delay, he explained in a postscript, was to give him time to reflect coolly on the letter's contents; having concluded they were just, he sent it. The formal requirements of such an exchange muted Squier's sarcasm. He deleted the sharpest barbs from an earlier draft ("Of course you cannot concieve, and will not credit, that you are and have been for years . . . an object of pity") but his closing threat remained. Three years would elapse before he delivered on it. Meanwhile, with an unerring instinct for his opponent's vulnerabilities, he attacked indirectly by tapping into the grievances of others. His objective was constant: an end to what he regarded as Schoolcraft's government sinecure.[73]

* * *

Desperate for preferment, Schoolcraft had rushed off to Washington to assume his new position in 1847. Between sessions, however, the capital was cramped, sleepy, and dull. Philadelphia and Boston were veritable Athenses in comparison, while a city like New York offered commercial activity, the diversity and stimulation that came with size, and a thriving intellectual life. The New-York Historical Society, venerable and distin-

guished, was a haven for established thinkers, while the American Ethnological Society combined the old and the new and was a young, vigorous institution. "Are not the ethnologists accumulating in Manhattan?" the proprietor of the *Literary World* marveled in 1849. Schoolcraft missed the "literary society" he had left behind. "There is nothing *here,* as an equivalent. The Smithsonian affair, has not, as yet, rallied any thing of this kind. A man must labour alone, with his books. The city, you know, is a mere vortex for politics."[74] But because it was the capital, the cost of living in Washington was high. Schoolcraft annually pled his case for increased compensation:

> By living at an expensive capital, I am subjected to three-fold the expence, which would be incurred in the country. Rents, fuel & living are enormously high, and I am necessarily obliged to spend a part of each year at a still more expensive locality [Philadelphia, seeing the book through the press]. . . . With the sums now received, it requires the most rigid economy, to live, and several hundred dollars of means, elsewhere obtained, to keep out of debt; and this is done, by an almost total seclusion from society. . . . I have also, from the inception in 1847 furnished the best room in my house for a study & writing room—the office having been unable, from close quarters, from assigning me an appropriate room, where I could, uninterrupted by business calls, pursue the investigations. For this incidental expense, no compensation has ever been tendered to me. I am struggling, with painful efforts, for existence.

Congress responded to Schoolcraft's pleas, bumping his salary up to $2,000 by 1853. But having made the case for himself, Schoolcraft showed no concern for his illustrator, who was in the same predicament. The great thing about Seth Eastman was that he came free; the War Department paid his salary. But the War Department did not provide him extra compensation for his assignment to Washington, and by 1854 there was mutiny afoot.[75]

It was not that Eastman disliked his situation. He too had welcomed the transfer to Washington and the opportunity to pursue his art full time in the one city where his larger ambition—a government commission to paint an Indian gallery superior to Catlin's—might be realized. Eastman had relished the privilege of illustrating the great national work on the Indians. But recognition was not enough. Prices in Washington were impossible for the Eastmans too. A captain's pay would stretch only so far. Just as Schoolcraft had been forced to dip into private funds to support his family, Mrs. Eastman had been forced to write books to see her family through. And just as Schoolcraft brought to his task a literary expertise unrecompensed by government, Eastman brought to his illustrations "a

247

life time of labor." He had studied art at his own expense and purchased Indian artifacts and the right to witness certain forbidden rituals in order to perfect his knowledge of native culture. He too should be fairly compensated for the years of preparation that secured him assignment to the Indian history. "Capt. Eastman expected to receive extra remuneration, as is usual under such circumstances, and he was assured he would receive it," Mrs. Eastman recalled. "He not only desired it, but he needed it." It was "hard work" to live in Washington and "support a large family, on so small a salary." Money was an issue that would not go away.[76]

In the past Mary Eastman had bantered with Mary Schoolcraft about the high cost of living in Washington. They were neighbors, after all, and presumably in the same boat. But jealousies were unavoidable when Schoolcraft, prompt to plead his own case for salary increases, conceded that Eastman's services were indispensable because he came so cheap. "No other artist, competent to the same line of work," could be hired "short of $2.000.—or $3.000.—pr annum, which the appropriation does not admit." Schoolcraft's unpardonable sin, however, was his assumption that the government plates were his to use as he saw fit without respect to Eastman's claims as artist.[77]

Relying again on Charles Wilkes and the Exploring Expedition precedent, Schoolcraft had all along intended to issue a private edition of the Indian history. In the spring of 1853, with a new Democratic administration in office, he chose to press his case. He negotiated simultaneously with his publisher, J. B. Lippincott, for terms ($2 per copy sold), and his superiors in the Interior Department for permission. Determined to assert control over his operations, on April 6 he drafted a tactless letter in the name of the secretary, Robert McClelland, to the commissioner of Indian affairs, George Manypenny, effectively setting himself up as an independent fiefdom within the Indian Bureau, with full budgetary discretion. His letter also ordered the commissioner to place the stereotype and steel plates for the history at his disposal so that he might "print, & publish, a private edition of the same, agreeably to the intention of Congress, originally expressed through the Library Committee." Alarmed by such presumptuousness, McClelland refused to sign the letter.[78]

Foiled in one attempted end run around Manypenny, Schoolcraft tried another. He appealed to his old Senate ally James Pearce, chairman of the Library Committee, to inform the secretary and the commissioner that he had the committee's permission to issue a private edition. No extra copies of the public edition had been assigned him for sale—a form of compensation granted Squier and Davis by the Smithsonian, for example. When Pearce pointed out that his committee never had jurisdiction over the Indian work, Schoolcraft agreed; what he wanted was Pearce's recollection of their conversation on the matter for the *"convenience"* of the commis-

sioner. That Pearce provided. A private edition, he wrote, would be entirely consistent with Congress's intention in ordering the history, which was "to preserve & diffuse the information it contained of a people fast fading away." In no time the private edition was out, with two of the volumes newly dedicated to Schoolcraft's friends Lewis Cass and Washington Irving. So the government work was made his own.[79]

How valuable was the property at issue? Requests for *free* copies had always exceeded the number available for distribution. But was there any demand for a cheaper edition at $5 to $7 a copy? Obsessed with making a profit, Schoolcraft overrated the appeal of his work. Lippincott was willing to go along with the private edition, a kickback of sorts for the lucrative contract to publish the government work. But he had little faith that it would make a penny. Reviews like that in the *North American* were disastrous, and Schoolcraft's defense, that the history was a "perfect Thesaurus," was hardly conducive to sales.[80]

Meanwhile, by his stridency in the spring, Schoolcraft had used up the limited fund of administrative goodwill for his project; thereafter he was at odds with his superiors. In September the secretary of the interior clarified his position within the department. His appointment placed him under the commissioner of Indian affairs, and he must operate through that officer at all times. Expenditures must be "manifestly for the accomplishment of the object" contemplated by Congress in funding the work. His request for an increase in his per diem while in Philadelphia supervising publication of the fourth volume was denied.[81]

With a five-volume limit already imposed by Congress and an unsympathetic administration over him, Schoolcraft could see the end coming. He rushed the fourth volume through the press. It would put Squier, his principal detractor, in his place and would satisfy congressmen that the work was progressing rapidly to completion. As usual he took Mary Schoolcraft with him to Philadelphia in October and, as he had done since 1851, paid her $3 a day as copyist. To speed things up, he employed his son John as well as an extra copyist for a $50 fee. The arrangement sat poorly with the Indian Office, but the commissioner eventually approved Schoolcraft's account after a personal interview satisfied him the expenses were legitimate. The secretary remained unhappy, and his relationship with Schoolcraft was adversarial. Schoolcraft's springtime offensive had backfired, alerting the new administration that the "Indian Historian to Congress" was something more than a fussy old pedant poring over his books and papers; he was an experienced patronage seeker who would fight hard to protect his position. A year later, with the fourth volume out and the end in sight, he was proposing an extension. Seven or eight volumes were needed to complete the series properly, if only he could find congressional support to sustain him in his "labour of love."[82]

Schoolcraft's dogged persistence was one sign of the veteran patronage seeker; his claim to a monopoly on the stereotype and plates another. By his own estimate, nearly two-thirds of the cost of publication had gone to the engravers. If there was anything of popular appeal in the Indian history, it was the plates—the chromolithographs in the first issue of the first volume, the engravings in the rest. That engravers surrendered their steel plates and woodcuts had appealed to Lippincott and Schoolcraft alike, since it gave them total control over all printings of the book. But the engravings, after all, were based on Seth Eastman's original illustrations. What right did Schoolcraft have to treat them as his own?

Indeed, Eastman had proceeded on the assumption that the plates were *his,* to use as he saw fit. His assignment in Washington had offered a valuable perquisite: it put his wife in friendly contact with a major publisher. Mary Eastman's first book of Indian sketches, *Dahcotah,* had been published by a New York firm. But after taking up residence in Washington she made Lippincott her publisher, rewarding him in 1852 with a commercial success, her "reply" to *Uncle Tom's Cabin, Aunt Phillis's Cabin; or, Southern Life as It Is.* Slavery, she wrote, was "authorized by God, permitted by Jesus Christ, sanctioned by the apostles, maintained by good men of all ages"; abolitionism, "born of fanaticism, nurtured in violence and disorder," ignored "the institutions and commands of God, treading under foot the love of country, despising the laws of nature and the nation." Her tract for the times, judged by one Washington paper scripturally sounder and "less reformatistic and transcendental" than Harriet Beecher Stowe's, sold 3,000 copies on the day of publication, 10,000 in two weeks. The Indian tales that were her bread and butter would never enjoy such sales, but Mary Eastman was a valuable addition to Lippincott's stable of authors as one of that "mob of scribbling women" Nathaniel Hawthorne deplored in 1855.[83]

In *The Iris,* an illuminated gift book or annual issued by Lippincott the previous fall, both Eastmans made a strong showing. Mary contributed verse and prose, the captain, eight Indian scenes reproduced in color by Peter Duval, who had done some of the chromolithographs for the first volume of the Indian history as well. These illustrations typified Eastman's free-lance activity while on assignment in Washington: like the drawings contributed to Bartlett for use in his *Personal Narrative,* they were independent of his work on the Indian history but a result of the opportunities it afforded. A reviewer who had praised Eastman's illustrations in *Dahcotah* and hoped for more confessed himself entirely satisfied by the selection in *The Iris,* which would be reissued with other matter in 1853 as *The Romance of Indian Life.*[84]

That year as well, Mary Eastman, Seth Eastman, and Lippincott collaborated on a slender gift book, *The American Aboriginal Portfolio,* reproduc-

ing twenty-six plates from the Indian history. Although Schoolcraft was too late to prevent its publication (the preface was dated July 27), his flurry of activity in the spring to establish ownership of the plates suggests he knew the *Portfolio* was pending and was not happy about it. A reviewer's observation that Eastman's plates constituted "one of the most attractive features" of the Indian history was also something he did not need to hear. "It was well thought of to separate them from the more didactic topics of those volumes," the reviewer continued, "and bring them within the power of all to possess and appreciate." Schoolcraft was being anticipated, his expectations for profit from the private edition undercut, since the *Portfolio* sold "remarkably well" at home and abroad. Consequently, when he later learned of a new Eastman collaboration in the works, he acted quickly to head it off, further straining what was by then a poor relationship.[85]

All this came at a time when the War Department was having second thoughts about its selflessness in detailing Eastman to Washington. As a general rule, the secretary of war wrote in June 1854, captains should be "habitually with their companies." Eastman had been absent since 1849, a fact noted in an inspector's report the previous year. Were there compelling reasons for him to remain on duty with the Interior Department? Economy was one reason, his peculiar qualifications another, the acting commissioner of Indian affairs replied. A request for specifics brought Schoolcraft into the picture. Eastman's artistic skill was unmatched, Schoolcraft wrote, and "his long service on the frontiers, between Texas, & Minnesota enables him to apply this skill to the particular manners and customs and arts of the Indians, with a truthfulness, which a strange artist, whatever be his talent, could not do." The captain was in the midst of preparing drawings of Mexican and Peruvian antiquities for the fifth volume, and his services simply could not be dispensed with.[86]

The War Department backed off, assured that since Congress had limited the series to five volumes Eastman's task would soon be completed. He could rejoin his company by the beginning of the new year. This reprieve only underscored the fact that the entire project was drawing to a close, increasing the desperation with which author and artist scrambled to secure some lasting advantage from it. Access to the plates was critical.[87]

* * *

At this tense juncture in the Schoolcraft-Eastman relationship, Ephraim Squier intervened. He had found the disgruntled insider who could aid him in his vendetta, and there were some nice ironies in his choice. As the dutiful subordinate, Eastman had shown an expedient streak. When he cut Catlin down in 1852 he simultaneously served Schoolcraft, appeared to help the relatively obscure John Mix Stanley, and looked after his own interests by removing the chief obstacle to his plan to paint an Indian

gallery for the government. That same year he aided Schoolcraft in discrediting William Pidgeon, a Virginia antiquarian who, inspired by the Squier-Davis monograph, claimed to have done extensive investigations of the mounds of the Upper Mississippi. Schoolcraft judged his findings ignorant fabrications that made every bump of earth into a monument of wondrous origin (Roman, Greek, Persian, Egyptian, Phoenician, Danish, Hindu) and marvelous shape (tortoise, sun, moon, men, elk, and snakes galore). The last fit Squier's theories about phallic worship so well that Pidgeon's renderings of snakes, stretched out or coiled, occupied a prominent place in *Serpent Symbol*. Pidgeon situated several of the most interesting at the junction of the St. Peters and Mississippi rivers; but Eastman, who had spent years at Fort Snelling, testified that the "antiquarian remains" in the vicinity were "few & uninviting." His evidence buttressed Schoolcraft's case: Squier was either as ignorant as Pidgeon or terribly gullible.[88]

Another irony in the impending Squier-Eastman alliance was the undisguised pleasure Schoolcraft had taken in Squier's quarrel with Dr. Davis. He had followed it through reports from Joseph Henry, relishing Squier's discomfiture, harrumphing over his pettiness in denying credit to his collaborator. But Schoolcraft had no cause to gloat. He was himself a poor one for acknowledging debts. With Eastman, he shared credit but not his stipend; with some contributors he shared neither. "My plan is, simply, to give the name of the writer of each memoir," he announced early on. In practice this might mean a passing mention in the text or a note rather than a credit line—a failing that delivered willing allies into Squier's hands.[89]

After drafting his long letter of rebuke to Schoolcraft in July 1854, Squier circulated it among acquaintances who had been involved with the Indian history and nursed resentments. "Your assault on our venerable Schoolcraft is too atrocious," William W. Turner wrote him in mock horror on August 15. "We are in daily expectation of a copy of your apology." A self-taught philologist competent in Latin, Greek, Hebrew, Arabic, and certain Oriental languages, Turner trained as a printer, assisted the librarian at Columbia and in 1842 was elected to the chair of Oriental literature at Union Theological Seminary, a position he held for ten years. Constrained by his duties, he sought a move to Washington, and in 1852 he accepted a position with the Patent Office Library. It satisfied his bibliographical propensities but not his philological ones; thereafter he worked on his vocabularies in his spare time, serving as the Smithsonian's resident linguistics expert and making a little pocket money on the side as John Bartlett's editor. Joseph Henry always referred to him with collegial respect as Professor Turner and viewed him as the victim of a patronage system that rewarded political acumen rather than merit. Henry's high personal regard for Turner was not reciprocated; he sided with Henry's

assistant in the internecine squabbles at the Smithsonian, perhaps out of frustration at having been denied his own rightful station in life. Thus an individual Henry esteemed as "a ripe scholar, a profound philosopher, and an honest man," could in his private correspondence show a malicious, gossipy side. Turner's quarrel with Schoolcraft, like most in the small, jealous world of antiquarian researches, began with a slight: Schoolcraft had "shabbily" ignored his discovery of the linguistic link between the Apaches of the Southwest and the Athapaskans of Canada. Thus Turner was a ready recruit to Squier's cause.[90]

Buckingham Smith was more circumspect. He represented the class of scholar-pedants dependent on government who turned to the diplomatic service for postings abroad that would facilitate their research. Because the arts and letters were so inadequately endowed, such government positions were a sine qua non. William B. Hodgson had pursued his studies in the Berber language while with the American consulate in Algiers in the 1820s; George Gliddon apprenticed as an Egyptologist while serving as United States vice-consul at Alexandria in the 1830s; John Stephens established himself as something more than a popular travel writer when, on a diplomatic mission for the president in 1839, he explored some of the ancient ruins of Central America and brought them to public notice in 1841 in the first of two widely read books. Schoolcraft had hoped for a post in Manchester, presumably to permit access to historical records housed in England, and Bartlett had tried to obtain an appointment to the court of Denmark in Copenhagen to advance his researches into the North Sea–American connection before settling on the position with the Mexican Boundary Commission that persuaded him from firsthand observation of the unlikelihood that Aztec civilization sprang from the American Southwest. Squier, in applying for the post of chargé d'affaires to Central America (and before becoming absorbed in the row with England), had made archaeology his first priority:

> Should I be successful the obstacles in my way will be at once removed, and an opportunity offered for conducting my explorations under the most favorable circumstances. I should thus have Government protection, without which, in the present and prospective condition of affairs in that quarter, it is doubtful whether much could be accomplished. It is only in this indirect manner that we can hope to secure Government aid in enterprises of this kind. It was thus that Stephens succeeded in his visit to Yucatan, &c.; his official position was given him in order to secure precisely what I desire,— aid and protection.
>
> I shall base my application upon strictly scientific grounds; . . . and should certainly not think of seeking an appointment under

the government, if I saw any other feasible method of accomplishing my cherished objects,—a satisfactory explanation of the ancient monuments, and an investigation of the Archaeology of America.[91]

Buckingham Smith was another whose diplomatic career was geared to archaeological ends. A southerner trained in the law at Harvard, he secured postings as secretary of legation in Mexico City (1850–52) and Madrid (1855–58) that allowed him to delve into the Spanish archives and transcribe documents pertaining to the early history of Florida, where his family owned an estate, and the American Southwest. Smith was the genuine article, a true antiquarian, and when he stepped into patronage politics he was out of his element. He was beholden to Bartlett, Squier, and Schoolcraft for letters to the secretary of state endorsing his appointment to Madrid and to Turner, Squier, and Hodgson for a report urging the Smithsonian to publish a collection in Spanish from the royal archives in Mexico City. Indirection was his style, and despite a rancorous falling out with the American minister in Madrid that sent him home in a huff, he was no controversialist. Smith doted on his documents and seemed flattered by any show of interest, viewing himself as handmaiden to others' historical researches. His elegantly printed limited editions were viewed with some bemusement by his friends; Turner likened his *Letter of Hernando de Soto* (1854) to Schoolcraft's compilation: "pretty to look at—Of course no one will ever read it." Parkman for one did. With an insatiable appetite for manuscript materials, he readily perceived the value of Smith's industry and the merits of his argument that his documents were essential to an understanding of "the Spanish Colonial history of this country, upon which . . . we have now only some accidental & at best reflected lights." In this spirit Smith contributed to Schoolcraft's history and was rewarded in the third volume with a note identifying him as the translator of the narrative of Alvar Núñez Cabeza de Vaca and, preceding ten pages of Spanish relations, a textual lead-in noting that during his residence in Mexico City he had "copied sundry documents from a collection of thirty-two manuscript volumes in the Archivo-General," from which Schoolcraft had made a selection. Perhaps the pleasure of gathering documents and seeing them in print was reward enough for Smith. But when the attack on Schoolcraft was mounted over the summer of 1854, he too would serve as an informant for Squier.[92]

If Smith was oblique, another Schoolcraft contributor was noisily direct in voicing his dissatisfactions. Like Turner and Smith (and for that matter Squier), Brantz Mayer had pulled strings to be among the recipients of the Indian history. It was a handsome publication, after all, handsomely endowed. Each made overtures to be included on Schoolcraft's gift list and hinted at possible contributions. Mayer outdid the rest in unctuous flat-

tery. After working through Charles Lanman and friends at the Smithso-
nian, he wrote to Schoolcraft directly in 1851. His excuse was that he
wanted the views of "so distinguished a scholar in Aboriginal history as
yourself" on a recent address Mayer had made on the Iroquois Logan. He
also mentioned some old family papers in German that might interest
Schoolcraft. The ploy worked. Mayer received a copy of the history and
Schoolcraft a translation of Captain Lewis Brantz's journal of a 1785
expedition into Indian country. Subsequently Mayer offered Schoolcraft a
translation of "Castañeda's Journal of the 1st visit paid from the Capital of
New Spain to New Mexico" with the proviso that it appear exactly as he
submitted it, introduction, illustrations, and all.[93]

Mayer's interest in Spanish documents reflected his service as secretary
of legation in Mexico in the early 1840s. Like Smith, Mayer made his
living as a lawyer, but his passion was antiquarian research and his "pet,"
the Maryland Historical Society, founded in 1843. Unlike Smith, he was
self-important. His Mexican experiences not only set the course of his
antiquarian studies but made him an expert on the region. He published a
controversial book, *Mexico as It Was and Is* (1844), that caught the rising
tide of popular interest as Manifest Destiny turned southward. And he
freely disagreed with Bartlett about the boundary line drawn by the com-
mission under his direction. Upon hearing of Squier's appointment to
Central America, he advised him to learn Spanish well and stressed that a
letter of introduction to the Roman Catholic churchmen there would
prove worth its weight in gold. After Squier's abrupt dismissal, he re-
minded him that "I was fully impressed with the idea that you would have
much more to do there than to unearth cities & their ancient monuments.
You thought otherwise." A know-it-all, Mayer was inclined to be legalistic
in his dealings with others, and Schoolcraft was no exception. Perhaps
Mayer had been alerted to Schoolcraft's disregard of contributors; cer-
tainly he was precise in stipulating *his* terms for publishing through him.[94]

"*How* & *when* do you propose printing Castañeda?" Mayer demanded
in August 1852. He insisted on reading proof, which would provide
answers to both questions and would ensure that his work was free from
the typographical errors that, he informed Schoolcraft, had marred the
volumes already issued. His requirement that he be consulted resulted in
an acceptable presentation of the Brantz journal in the third volume, down
to a full-blown title page that specified his role in preparing it for publica-
tion. But Schoolcraft was evasive about the Castañeda narrative; when the
fourth volume appeared in May 1854, Mayer learned why. It was supposed
to appear as submitted "*or not at all.*" Instead, Schoolcraft had recast it into
a history of Spanish explorations on the Gila, Colorado, and Rio del
Norte, botching it in the process. Even Castañeda's name was misspelled.
Livid, Mayer turned to Seth Eastman for an explanation, but the captain

declined to interfere. It was "rather a delicate subject" for him to broach with Schoolcraft, and he "would rather not say any thing to him about it— When you come to Washington again—would it not be better for you to call on him . . . ?"[95]

Eventually Mayer sent a stiff note to Schoolcraft that brought only "a humbug letter of apology," "altogether unsatisfactory." It would take another paper just to correct the errors Schoolcraft had introduced in his Castañeda, Mayer complained to Squier: "I hope Congress will not allow any more volumes from Him, but will put the subject in the hands of really fair men. How would you like a bureau in Washington with a good corps of decent workers, & Eastman as your co-adjutor. If I were a *bachelor,* and a man of leisure, I would go to work there in three months from this Date, and organize an Indian Historical Department, which would be of credit to the governt." The casual reference to Eastman was the tip-off. That August the grievances Eastman shared in silence with Turner, Smith, and Mayer had been coordinated by Squier into an all-out assault on School-craft's suddenly precarious position.[96]

* * *

The plan of attack was simple. Squier's letter, when published, would publicly expose deficiencies in Schoolcraft's history. Eastman would provide inside information about the operation of the "Chambers Histo-riographical and Statistical Inquiries," as Schoolcraft grandly called the office on F Street. In his confinement at home, Eastman actually ran it. Visitors conferred with him, exchanging gossip and news. He was privy to the views of Schoolcraft's superiors in the Interior Department and aware of their impatience with the history. He knew, for example, that the commissioner of Indian affairs shared the skepticism of many congressmen about its utility, and he conversed freely on the subject with Buckingham Smith. When Smith showed him Squier's "almost Christianlike note" to Schoolcraft, Eastman was "indignant—that you mean to spare him so long," Smith reported back to Squier.[97]

Congress had dismayed the conspirators in late July by passing an Indian appropriations bill that provided $20,900 for Schoolcraft to con-tinue collecting and publishing his materials though June 1855. Eastman's fear was that Schoolcraft would purposely delay "the literary portion of the Vth vol., so that it will be long coming out, and the salary, as a conse-quence, will have to continue into another year." That must not happen. Thus he was ready to supply the ammunition for an early attack by Squier, whose other allies were also eager for the fray.[98]

Turner ("the Apache," as Smith called him, apparently because of his philological spat with Schoolcraft) thought it important that Squier have a "fair field" for the coming fight. Eastman would be the key to securing the advantage. Smith, in turn, proposed to serve as a peacemaker. He would

deliver Squier's conditions to Schoolcraft. How about a chapter in the Indian history "purely apologetic—which shall open with a picture in the Captain's best style of the Statuary [the Indian relics collected by Squier in Central America] in the Smithson & close with a water view of the Encargado [chargé] on a visit to H.B.M. gunship at San Juan?" Brantz Mayer, still smarting over the Castañeda paper, entered the fray in mid-September. He had a head-to-head meeting with Squier in Philadelphia to set up a "joint effort," then continued on to Washington for a three-hour conference with Eastman. They went over the entire story of Schoolcraft's project. "We know a heap you wish to understand," Smith wrote Squier, "*all the facts*," but Turner wanted Squier to come to Washington to learn them. "He is contriving," Smith added, "for he thinks he cannot get the six pounders [copies of the history] out of the Potomac into the boat without your assistance." With the battle about to come off, Smith gave up on peacemaking but would remain "only an unconcerned spectator—just a bottle holder—. . . until I can see how matters are going." He would help "either party for fairness," he said, "& will gladly do anything that might tend to stiffen up the legs of the 'old cock' to give him a good stand in the pit, & would even sharpen as well as tie on his gaffs."⁹⁹

Schoolcraft was unaware of the conspiracy brewing in his chambers historiographical. But he was aware of Squier's intention to go public, since the letter of July 22 was finally mailed on August 30. Schoolcraft feigned indifference and did not deign to reply. But he immediately dug in for the assault, lining up allies of his own. He set his wife to nudging the religious press to come to his defense against the attacks of the "infidels" and sought the particulars of the Davis affair from Joseph Henry. Wills De Hass of West Virginia, still obsessed with proving the authenticity of the Grave Creek stone, had recently concentrated his fire on George Gliddon, who had gone out of his way to thumb his nose at the clergy in declaring the relic a fake. Schoolcraft put De Hass back on target; soon he was assailing "the immortal Ephriam," "the 'Serpent Symbol' philosopher," "the defunct Chargé," who, as the "cracking force" of Schoolcraft's sarcasm in the Indian history showed, had "clearly, fully and emphatically 'written himself down an ass.'" Schoolcraft's troops were also ready for the fray.¹⁰⁰

In truth, Schoolcraft could spend only so much time on disappointed little gar—he had bigger fish to fry in the fall of 1854. The intention of Congress, judging from the language of the appropriations act, was to *continue* the collection and distillation of information on the Indians. The five-volume limit, he notified the commissioner of Indian affairs, was apparently negotiable. Schoolcraft might postpone the inevitable by dragging out the fifth volume; in fact, he had a bolder strategy in mind. He would try to persuade Congress to withdraw a limitation imposed in the

first place because of Senator Borland's ignorance and thereby extend the life of the Indian history. He rightly saw Squier's letter as the product of envy—patronage would be another issue between them. "Younger aspirants," he wrote Lewis Cass, "such as the disappointed & inflated charlatan* who attacked my character & my book in the North American Review in July, 1853, may feel envy at the work, being placed in my hands, but to insure success, they must address something besides assertion, misrepresentation & ribaldry." The asterisked footnote read: "Ephraim G. Squier the recalled chargè to Nicaragua."[101]

Schoolcraft had the accent wrong, but he had his enemy right. Still penurious, Squier was casting about for opportunities to make a quick dollar that fall. Perhaps he would join Gliddon in a popular ethnology that would stir up the pious some more, ensuring good sales. He also had a dream—which owed something to John Stephens—of establishing a fiefdom larger than Schoolcraft's, all Central America. He wanted Brantz Mayer to serve as United States consul; he, meanwhile, would continue to boost the Honduras Interoceanic Railway Company, his major project since 1853. Mayer was not in the least interested and chided Squier for "wasting a great deal of precious life on this project." As for himself, "I see very little to be gained by any ambassador who shall establish his legation on the back of a mule, and, after the fashion of poor Stephens, wander over the land in search of a government!"[102] De Hass also observed Squier's distraction that fall, and he reported to Schoolcraft that the sometime archaeologist was now devoted "to the less abstract but doubtless more profitable vocation of 'Secretary' to some moonshine rail road." Certainly Squier, for all his threats, had no time to do battle with Schoolcraft; on November 25 he sailed for Europe to promote his railroad, breaking off the engagement before it began. Mayer, having got his complaints about Castañeda off his chest, was prepared to lend illustrations of Mexican antiquities for inclusion in the final volume of the Indian history. Smith and Turner, Washington residents with too much at stake to get involved, had never done more than yell from the sidelines. At best Squier's army had caused Schoolcraft some worry while he was trying to wrest additional concessions from Congress.[103]

Eastman was left to soldier on alone. His relations with Schoolcraft had been at the breaking point since spring, when Schoolcraft faced a new challenge to his right to publish a private edition of the Indian history: some congressmen had argued that the government itself should reprint the national work for general distribution. Ownership of the plates was again thrown into confusion. Consequently Schoolcraft was unusually sensitive about the Eastmans' latest attempt to capitalize on the captain's illustrations. *Chicora and Other Regions of the Conquerors and Conquered,* another Mary Eastman miscellany embellished with plates from the Indian

history, was entirely unauthorized, Schoolcraft complained to J. B. Lippincott, "got up" without his knowledge or that of the Indian Bureau. Mrs. Eastman's text was a tissue of errors that shamed the illustrations. "Should Congress get wind of your having made such a use of the public plates," Schoolcraft warned, ". . . it is impossible to predict what the result would be." As long as he had a congressional appropriation, he had Lippincott under his thumb. The publisher could only profess the innocence of his intentions. There was "no secrecy in getting the work up on our part nor that of Capt or Mrs E. to our knowledge," he wrote Schoolcraft in late October. "We supposed it was done by a mutual understanding with you." Schoolcraft had addressed Lippincott in confidence, knowing full well that word would reach the Eastmans.[104]

With Schoolcraft still claiming a monopoly on the plates and his assignment to the Interior Department drawing to a close, Eastman would make his first personal bid for congressional patronage in late December, a resolution timed with Catlin-like calculation to coincide with the public excitement over the Kansas-Nebraska Act. It ordered the House to purchase for distribution to members a map of Kansas and Nebraska territories drawn by Eastman and published by Lippincott. The resolution failed in committee, inducting Eastman into the realities of patronage politics. He had a second item pending, however, providing compensation beyond his officer's salary for his services as illustrator to the national work. Intended as an arrears provision in the Indian appropriations bill, it was killed in the Committee on Ways and Means. *Someone* told Mary Eastman that Schoolcraft, afraid it would encumber his own case, had personally seen to its defeat. He hotly denied the charge. It went against his character and his known sentiments. He had recommended to the previous commissioner of Indian affairs that Eastman receive an additional allowance, and throughout the budgetary process in the spring of 1855 had not "the remotest idea" that Eastman's claim for compensation was being considered in committee.[105]

That Eastman believed Schoolcraft would sell him out spoke volumes about their relationship. He knew how desperate Schoolcraft was to protect his position; he had even ventured from his study at home to pay a rare personal call on Stephen A. Douglas. Only emotional appeals to Douglas, Lewis Cass, and other prominent Democrats, playing on party loyalty, saved the day.[106]

Schoolcraft's contract with Lippincott had specified a publication date of March 1 or at latest July 1, 1855, for the fifth volume of the Indian history. Eastman had predicted that Schoolcraft would drag it out, and in fact the book was not ready for distribution until December. Pressed to account for the delays, Schoolcraft had pled the difficulty of condensing his materials for what he had originally presumed would be the terminal

volume. But to his great relief, the Indian appropriations bill passed March 2 obviated the need to go slowly. Congress, ignoring its earlier provision, had extended the Indian history to six volumes and allocated $17,200 to see it through to completion. Schoolcraft now had two years more to condense his materials and get the book out. A second proviso read: "That said compilation should be subjected, before publication, to revision by the Secretary of the Interior, with a view to the curtailment . . . of all matters useless, irrelevant, or inconsistent with the objects of the work." The tone was insulting, but Schoolcraft had cause to celebrate; Eastman had none.[107]

His claim for extra compensation denied, Eastman was merely serving out his stint in Washington. A direct plea to the secretary of war on December 15, 1854, that he be allowed to stay on till the illustrations for the fifth volume were finished had brought a final reprieve. His leave was extended until April 1, 1855, a deadline he exceeded only slightly. War Department Special Orders No. 85 relieved Eastman of duty in the Department of the Interior effective May 11. As his last weeks in Washington slipped away before he was to rejoin his regiment in Texas, Eastman avoided Schoolcraft, refusing to drop by his study to exchange farewells. Eastman was no Squier; silence, not abuse, was his chosen weapon, and the snub hurt. Soon the captain would be back among the cactus and the Comanches, dreaming of softer days in Washington as illustrator for the great national work. His wife, on her own once more, would have plenty to say for both of them. Within weeks of the passage of the appropriations bill extending the Indian history to six volumes, she had turned her viper's tongue on the Schoolcrafts. There would be no more nonsense; with her gift for gossip she would make them pay.[108]

For Schoolcraft, March 2, 1855, marked an amazing comeback in the face of what had appeared just months before to be insuperable odds. He had seen the Squier threat evaporate and had won Congress over to an improbable concession. No more miracles would follow, no seventh or eighth volume. He remained on the outs with his superiors, McClelland and Manypenny, and got no sympathy from Lewis Cass when he wrote to complain. And he would be without the services of the illustrator who had assisted him through five full years. But Schoolcraft wasted no time on regrets. On April 26, before Congress agreed to extend the series, he wrote Manypenny: "I wish some person to complete the illustration of the present volume, as I am, probably, to have no further aid from the pencil of Capt. Eastman." Indeed, Eastman's transfer from the Indian history served Schoolcraft as a handy excuse for delays in issuing the fifth volume—a nice touch given the captain's prediction of the previous September.[109]

When the fifth volume did appear, the text, as Eastman had also predicted, was longer than usual and mostly the product of Schoolcraft's own

pen. The illustrations, described on the title page for the first time as the work of "Capt. S. Eastman, and Other Officers, u.s.a.," included drawings by Captain A. A. Gibson and Lieutenant John C. Tidball with the Coast Survey Office, added to round out the usual complement of plates. By Eastman's standards they were crude and amateurish, but a planted review in the Washington *Daily Union* praised them as "more than usually characteristic and instructive." In truth, Schoolcraft knew the plates were inferior and subsequently shopped around for a new illustrator to replace Eastman. When the sixth volume appeared, at the end of December 1857, many of Eastman's plates were reused (a contractual violation, Lippincott pointed out), but his name was entirely absent from the title page, replaced by the words "eminent artists." And so the captain was denied the one thing the Indian history had given him, national recognition. But neither were his replacements recognized by name, though both had hoped to use the history as a step up in their careers: Frank Blackwell Mayer, a young artist recommended to Schoolcraft by his uncle Brantz, and John Mix Stanley, Catlin's rival in the wings and, by the mid-1850s, another increasingly desperate applicant for government support. His story, and Catlin's miraculous rise from the depths of despondency, form the final chapters in this history of the politics of patronage.[110]

 * * *

And what of Ephraim George Squier? On January 2, 1858, he notified Schoolcraft that, no public retraction having appeared in the sixth and concluding volume of the Indian history, he had no choice but to deliver on the threat made more than three years earlier. Indeed, Schoolcraft had actively persisted in his course of disparagement. In the fifth volume he expounded on the snake in Indian cultures; it was dreaded for its subtlety and respected for its wisdom, "but it was never worshipped, as it is represented by a recent writer." He also made reference to the errors he had detected in Squier's monograph on the mounds of western New York and published a series of letters from George Gibbs denying the reports (repeated in Squier's *Serpent Symbol*) of mounds in Oregon. In his final volume, Schoolcraft had again dismissed Squier's work on the ancient monuments with footnote sarcasm: "We are indebted to a very erudite writer in the Smithsonian Transactions, for telling us that these rude arts, and vestiges of mounds, are the remains of ancient civilizations." Squier would publish his 1854 letter, then, "with such other observations as your conduct merits, throughout this country & Europe, without further delay." Schoolcraft scribbled on the back of Squier's note, "he, & his little knot of skeptics [a pun on J. C. Nott, presumably] are utterly unworthy of my notice." But he waited in suspense for the attack, "a piece of rude ribaldry" in the New York *Herald* of January 17.[111]

 Titled "Wasteful Extravagance in Public Printing," it was a general

condemnation of the expensive, multivolume series published by a government that ordinarily shunned the arts and letters. Wilkes, Owen, and Schoolcraft were alike charged with "public plunder," but Schoolcraft took the brunt of the attack:

> Year after year massive quartos . . . fall like mud avalanches upon an unoffending public, provoking infinite mirth amongst those acquainted with aboriginal subjects at home, and astonishing scientific men abroad by their crudity and incoherence. They are printed on costly paper, in luxurious type, and are full of sprawling outlines of beast and bird, smeared with bright yellow or dirty red, which, for any scientific value they may possess, might be copied from the walls of a country schoolhouse [a parallel passage in the 1853 *North American Review,* clinching Squier's collaboration at least, read: "Children and savages are equally fond of gaudy pictures. . . . Sheet after sheet, covered with sprawling outlines of man, bird, and beast, smeared with bright yellow or dirty red, add nothing to our knowledge of Indian character or Indian history"] . . . Indian "spook stories," old wives' tales, scraps of bad geology and worse grammar, profound disquisitions on "material matter," and unctuous piety of the camp meeting order, make up the bulk of these costly tomes. Nearly $200,000 have been drawn from the pockets of the people to pay for thus blazing abroad the "shimabams" of some garrulous old man, who should have been left to mumble his rubbish to the urchins at the fireside, or under the porch of the corner grocery.[112]

The text was Treasury leeches, but the subtext was more revealing: such work "never falls into the most competent hands, but is invariably awarded, as part of the spoils, to the greatest bore or most assiduous partizan." Where the government had erred was in those it employed. If it wanted something on the New Mexican ruins, it should publish the ethnological portion of the report by "our late Mexican Boundary Commissioner," John R. Bartlett. And "if it desires to entertain the public with grim-visaged idols from Central America, no doubt the executors of Messrs. Stephens and Chatterwood [Frederick Catherwood], or the portfolios of Heine, Squier, Waldeck and Aubin would gladly give up their unpublished 'treasures' in that line." There followed a detailed examination of the cost of several ongoing series in which the word "swindle" was tossed around. But at bottom the issue was the old one: public patronage, and who got it.[113]

In his January 2 letter, Squier wrote that while his impending attack might expose Schoolcraft "to ridicule & contempt," it could not deprive him "of the bread your leech-like hold on the public treasury for so long a time, has, no doubt, enabled you to secure." When he originally drafted

these sentiments, Squier broke off midsentence: "Congress has finally put a stop to your impostures & disreputable drain on the Treasury, so that your Exposure will not deprive you of the bread which I hope you have secured, which I do not envy you, & which." Where patronage was concerned, envy was the word to end on.[114]

70. John Mix Stanley, *My Prairie Home,* a self-portrait probably sketched on the Pacific Railroad Survey in 1853. National Anthropological Archives, Smithsonian Institution, photo n.37, 147.

It is, we understand, in contemplation by our government to establish a national gallery illustrative of the Indian tribes of America. Mr. Stanley, we learn, will offer his collection at a fair price, and we doubt not but that Congress will sustain the noble undertaking, and commence at once the foundation of an "aboriginal museum and portrait gallery."

"The Historical Portrait Gallery at the Smithsonian Institute," unidentified clipping [1850s], Stanley Scrapbook

If I had known then [1842] the extent of the task I had assumed, the adversity, the privations and the fatigues to which I was to be exposed and the frequent despondencies that were to come over me, I should no longer have prosecuted the work upon which I had embarked.

John M. Stanley, quoted in "Stanleys Indian Gallery," *Washington Daily Telegraph,* undated clipping [1850s], Stanley Scrapbook

Far Superior to Catlin's

Stanley and His Indian Gallery

George Catlin's Indian Gallery "may safely be pronounced to be not only *unique* in its kind, but to be destined forever to remain so," the Joint Committee on the Library reported in 1848. "There is not one chance in millions that such an enthusiasm, for an object so peculiar, will again take possession of any mind of such capacity for the undertaking." In fact, Catlin had never lacked for rivals. Thomas McKenney's Indian portrait gallery, featuring the paintings of Charles Bird King, stood before him as inspiration and as competition in 1832. James O. Lewis was small fry, but he was out West painting Indians seven years before Catlin ascended the Missouri, and Peter Rindisbacher was actually resident in Indian Country. Two other artists were hot on Catlin's trail in the 1830s,

Karl Bodmer and Alfred Jacob Miller. Since both accompanied private patrons, however, they were not rivals for government support. Seth Eastman and John Mix Stanley were. They came onto the scene after Catlin left America for Europe in 1839, and in his absence they actively advanced their own interests. Both were living in Washington when Catlin made his futile bid for patronage in 1852, and together they opposed him.[1]

Catlin, helpless to control events or stem their rivalry, denounced Seth Eastman's impertinence in discounting his Indian Gallery and offering to paint a better one for the government for nothing—nothing save an army officer's full pay. It is easy to view Eastman in a positive light as Catlin's opposite: quiet, modest, self-effacing, efficient. He went about his business with soldierly dispatch and a minimum of fuss. Catlin created a commotion; he was noisily adept at self-promotion and slick showmanship verging on sham, according to some contemporaries. As for their art, Eastman was technically more proficient; his superior training showed especially in his large oils. Compared with Catlin's snapshots they were formal photographs, taken in the studio where the lighting and every detail could be carefully planned out. But the comparison is academic. Simply, Seth Eastman never painted an Indian gallery. He sought and found government patronage within the secure confines of a system he already belonged to as an army officer. He had nothing to sell but himself. John Mix Stanley, on the other hand, did. In 1852, shortly before Catlin's bill for purchase of his Indian Gallery came up in Congress, Stanley arrived in Washington with his own Indian collection, over 150 paintings in oil. "Learning that it was agitated by some judicious and patriotic members of Congress to purchase Catlin's collection, which is now in Europe, and perhaps will always remain there, Mr. Stanley brought his to the metropolis that members might see for themselves and judge of its fitness to become the foundation of a great national gallery," the *National Intelligencer* reported. No need to hanker after what was far away and long unseen; the public could view Stanley's paintings at the Smithsonian for free.[2]

In later years Stanley would be remembered as an unassuming man, courteous, affable, and dedicated to the advancement of art as a profession in America. "His nature was so frank and open and the impulses of his heart so warm and generous," one tribute went, "that the circle of his acquaintances was the measure of his friends." Another tribute described him as "a thorough artist, . . . who always had a good word for his fellows." Catlin never saw that side of Stanley. Instead, he saw only a tough competitor determined to get ahead and willing to scramble over the backs of others if need be. In Stanley, Catlin had met his major rival in the quest for patronage.[3]

* * *

John Mix Stanley was born on January 17, 1814, near Canandaigua, New York, within weeks of Britain's "December blitzkrieg" on the Niagara

frontier and a year before the battle of New Orleans gave the gloss of victory to a dismal war. Stanley would always have an uncanny knack for being where history was being made. Yet, retiring by nature, he remained a cipher who lived adventures without bringing them to life for the public. Catlin's supreme gift was a vision: he created himself and his gallery in his mind, then projected them onto the world. Stanley passed through stirring events with a reticence that made his challenge to the flamboyant Catlin all the more unlikely.[4]

Judging from his infrequent letters, Stanley never felt entirely comfortable expressing himself on paper, perhaps foreclosing that avenue for self-promotion. His brush did his talking for him. But he had received a rudimentary education before he moved to Naples, New York, at the age of fourteen to apprentice as a wagon maker. Family tradition holds that his father frowned on his artistic aspirations, though Stanley acquired some proficiency as a sign painter before he moved again, to Detroit, in 1834. There his ability brought him to the attention of an established artist, James Bowman, who encouraged him to quit house and sign painting for portraiture. They pushed west in the late 1830s, visiting remote communities in search of commissions; though their travels together and separately have not been traced, it is possible that Stanley got to Chicago and Green Bay. He can definitely be placed at Galena in the northwest corner of Illinois, where he was based from 1838 to 1839, and at Fort Snelling in June 1838, where he may have painted Lawrence Taliaferro's portrait as well as "views in perspective of this Post, and its vicinity," done under Taliaferro's direction for the use of the Office of Indian Affairs.[5]

After leaving Galena, Stanley apparently polished his skills in the eastern cities before settling in Troy, New York, in the spring of 1841. Perhaps the advent of daguerreotypy convinced him that his days as a portraitist were numbered; his biographer suggests several factors that might have influenced his decision to create a gallery of Indian paintings, but certainly the principal factor, always before him, was the example of George Catlin.

Catlin served as the role model for several artists who acknowledged their debt by dismissing his pioneering gallery as shoddy art and shoddier observation. But in the process of denunciation, by demonstrating their familiarity with his achievement they made their debt the clearer. Though Stanley was silent on the subject, his career is a testament to Catlin's influence. He and a young friend, Sumner Dickerman, set out from Troy in 1842, ten years after Catlin steamed up the Missouri in pursuit of unspoiled Indians. They were bound for Indian Territory, and the letter they carried from the secretary of war introduced them as "respectable citizens" intent on visiting the different tribes "for the purpose of taking the portraits of the most prominant chiefs among them." They were at Fort Gibson by December 1842, three years after Catlin sailed for England with

71. John Mix Stanley, *International Indian Council (Held at Tallequah, Indian Territory, in 1843)* (1843). Stanley favored such static subjects and compositions, perhaps reflecting his interest in daguerreotypy. National Museum of American Art, Smithsonian Institution; gift of the Misses Henry, 1908.

his Indian Gallery. The evidence is murky, but Stanley may have seen Catlin's collection, in Washington in 1838 or elsewhere earlier. It is just as likely, however, that Dickerman was the leading spirit in the decision to go West and paint a rival Indian gallery.[6]

The partners hit their stride in early spring 1843 when they hooked up with Pierce M. Butler, former governor of South Carolina serving as agent at Fort Gibson and the United States commissioner in negotiations with some of the skittish Texas tribes. A council in March near present-day Waco yielded a "rich harvest of 'subjects'" and a lesson in the protocol of painting Indians. Stanley found himself obliged to do portraits of three guides before the less-civilized tribesmen would consent to sit. "This was whipping the D–– around the stump," he wrote, "but there was no alternative, and I complied with apparent willingness to their wishes." When no harm befell the sitters, "they all came forward in order according to rank, and were delighted with the idea of being painted, considering it a great honor." Catlin had encountered the same problem a decade before (and would have to overcome it again on the Amazon); indeed, much about Stanley and Dickerman's wanderings seemed old hat.[7]

They pushed on from Texas to a council convened by John Ross at

Tahlequah in the Cherokee Nation in June. Nine years earlier Catlin had painted Cherokees, Creeks, and Choctaws at Fort Gibson, and Ross himself in Washington in 1838, where he was fighting further removals to Indian Territory and like Catlin, whose gallery he visited, experiencing only futility in trying to win Congress over to his cause. Thus the council at Tahlequah witnessed by Stanley—Ross's accommodation to the new reality created by removal. It was an attempt to revive "here in the west the ancient talk of our forefathers," Ross said, "perpetuating for ever the old fire and pipe of peace brought from the east, and . . . extending them from nation to nation." Stanley was hunting the same Indians as Catlin with sketch pad and pencil and, a new wrinkle, a daguerreotype apparatus. After the council adjourned, he and Dickerman spent four days with Ross's brother filling an order for family portraits that suggests just how conventionally American these Cherokees were. They made ten miniature daguerreotypes during their stay, an insight into the technique Stanley, Eastman, and other painters had begun using to record impressions subsequently worked up into finished oils. They also both contributed articles to the Arkansas papers reporting their Indian adventures, such as they were—emulating Catlin's letters to the New York *Commercial Advertiser* in the 1830s.[8]

From Louis Ross's house the two artists—Dickerman appears to have been a landscapist, Stanley the portraitist—visited the Upper Creek town on the Arkansas River where they decorated a mammoth muslin flag with an eagle, thirteen stars, and "E Pluribus Unum" on one side, symbols of peace and friendship on the other. It flew over the annual green corn busk or dance they witnessed, their first sustained encounter with a native ceremony, though hardly as gripping as Catlin's introduction to the Mandan O-kee-pa ten years before. A Van Buren, Arkansas, paper reported their return, sketches and notes in hand, and claimed they had visited twenty-five tribes by then: "Their studio is an interesting sight, containing some two or three hundred subjects—but few of which, however, are finished. The talent and perseverance of these gentlemen merit great applause and pecuniary reward." More than anything else, the last sentiment suggests how closely Stanley and Dickerman were imitating Catlin: the profit motive loomed as large for them as it had for him in forming his original Indian Gallery. Stanley still had much to see and do before he exhibited his collection in the East. He thought he might attend a Choctaw council at Kiameechee in October, and he did attend another meeting organized by Butler with plains Indians, including a few Comanches, on the Red River in December.[9]

Stanley and Dickerman knocked around Indian Territory through 1844, Stanley presumably doing portraits to raise money. He would have found subjects aplenty in the area; a Van Buren paper noted that many

citizens wanted their likenesses taken "by Mr. Stanley's magic pencil." But the bulk of his time was devoted to working up his Indian sketches, which were displayed in Van Buren as the "Stanley & Dickerman Gallery of Indian Portraits":

> We all have heard of, and many have seen, "Catlin's Gallery," how he spent time and money, and meanderings among our aboriginal specimens, collecting subjects, traditions and sketches. But he has a fair rival in the field, who in the opinion of connoissieurs will bear the palm away from the Catlin, although the latter is the originator of the scheme. We allude to Messrs. Stanley and Dickerman, artists from Troy, N.Y. who are now in the Indian country, assiduously engaged in talking portraitures, sketches and designs of, and among the principal Indians. . . . Their intention is to frame [form?] a "Gallery of Indian Portraits and scenes," and their genius and skill are fully competent. . . . Mr. Stanley *is* an artitse of fine talents, and the specimens of his own labor which are exhibited in his studio, are well worthy a genius ranking of the first order: and why not? Why not a great American, as well as an Itaiian artist? Why not Stanley as well as Ruben?

The overheated prose was probably by Dickerman, the duo's publicist. Items planted in the western papers frequently sounded this note of rivalry with Catlin. Stanley, the argument went, was the superior artist. He did not pretty up his Indians, and he was resolutely an American in his loyalties, unlike the expatriate Catlin. But his gallery, in early 1845, contained little that was novel. His portrait of John Ross had been singled out for special commendation, but Catlin and others had already done Ross. To make a commercial success, the collection would need some spicing up.[10]

Thus Stanley and Dickerman parted at St. Louis, the latter to accompany their collection to Cincinnati, where the sketches made in the field would be finished in the studio. Stanley—again dogging Catlin's tracks—hoped for permission to take the American Fur Company steamer up the Missouri to see some of the northwestern tribes. Perhaps remembering Catlin and the unfavorable publicity his letters engendered, the company turned him down. Undeterred, with Catlin's 1834 tour with the dragoons into Comanche country providing another precedent, Stanley turned to the army. General Stephen Watts Kearny, a lieutenant colonel when Catlin rode with him, was said to be mounting an expedition into Indian Country at that very moment. If possible, Stanley would join the soldiers and perhaps see things that might yet startle the world. Had he accompanied Kearny's dragoons, he would have followed the Oregon Trail from Fort

Leavenworth to South Pass via Fort Laramie before dropping down to Bent's Fort on the Arkansas for a rapid return march to Leavenworth— 2,200 miles in ninety-nine days, and an opportunity to meet Sioux, Cheyennes, and Arapahos in council. But this plan also fell through, and Stanley was left to board a later steamer for Cincinnati, where he rejoined Dickerman and set about polishing his portraits.[11]

* * *

The two partners emerged publicly on January 14, 1846, with the announcement that they were ready to open their gallery to Cincinnatians. When they left Indian Territory the previous spring, they had 124 portraits, landscapes, and sketches on hand and the materials for another 175 pictures. According to the catalog sold at the door in Cincinnati, the collection now comprised 83 finished works, suggesting that most of the paintings brought back were in the category of rough sketches.[12]

Stanley and Dickerman counted on a good turnout at twenty-five cents admission, one dollar for a season ticket, since they hoped to finance another three years out West from the receipts. They advertised with appropriate brio in the local press and received the usual newspaper puffs urging Cincinnatians to turn out: "Far superior to Catlin's far famed portraits" . . . "The day will come when this collection will command an extravagant price, for a national or great public museum" . . . "*go and see for yourselves.*" But no amount of ballyhoo could overcome the public's reluctance to part with its quarters, and within a week of opening the exhibition was in trouble. It closed on February 14, after a run of less than a month. A scolding editorial in the *Evening Journal* told the story:

> Stanley & Dickerman's exhibition closed on Saturday. They about paid expenses. As *things go,* this was very well. It was, shame to us that it should be so . . . if things go so much longer the last artist will be starved and the last author discouraged. We crowded Masonic Hall last week and this, to hear the Sable Harmonists. All very good. People must have amusements. But near by, a young artist who, after several years of preparation and toil, had made his first attempt to gain the public eye, had, doled out to him, a patronage of some half dozen visitors at a time, dropping in at lingering intervals. . . .
>
> We wish Stanley & Dickerman a more generous appreciation than they have met with here.[13]

The partners decided to try their luck in Louisville next, raising their admission price to fifty cents and shortening their hours. But people still stayed away in droves. Anticipating this, the local papers harped on the public's indifference from the opening of the exhibition on March 3. Turn out, the *Daily Journal* urged, and "gladden the artist with the knowl-

edge . . . that he has not cast his pearls before swine." But such admonitions were to no avail. The turnout was again dismal, and though the exhibition was extended by three days, it closed on March 11.[14]

Perhaps Catlin had mined out the Indian theme after all. Perhaps a subject of poignant interest in the decade of removal was irrelevant in one marked by rapid national expansion westward. Perhaps the Indian had simply gone out of fashion, in art as in literature. Stanley and Dickerman had opened their gallery in the same year Francis Parkman traveled the Oregon Trail and experienced firsthand the surging energy that saw the United States acquire Oregon by diplomacy, California and much of the Southwest by war—the "Year of Decision," according to Bernard DeVoto, in which the Mormon migration to the Great Salt Lake signaled the opening of the interior and the United States became a continental nation. A New Year's editorial in the *Democratic Review,* the journal that coined the phrase "Manifest Destiny," assessed America's future in 1846 and concluded that the "great mission" of every citizen was to extend "that noblest of experiments for the social welfare of mankind, for which Heaven seems to have reserved his country and his race." Would Americans realize their "glorious destiny"? A year later the *Review* had its answer: "The busy and enterprising settlers have descended from the Alleghenies, occupied the plains, pushed across mighty streams, traversed the prairies, penetrated the passes of the Rocky mountains, and are even now loading vessels in the harbors of the Pacific." It was not an auspicious moment for Stanley and Dickerman's gallery to make its bow before the public. Expressing a preference for Charles Deas's melodramatic scenes of white frontiersmen, the *Broadway Journal* in 1845 had observed that "pictures of pure savage life, like those by Mr. Catlin, cannot excite our sympathies as strongly as do the representations of beings who belong to our own race."[15]

Stanley and Dickerman had a choice. They could abandon their enterprise, writing off three years of travel, work, and outlays. Or they could press on, trying to reawaken public interest by expanding the gallery and adding to its novelty. They were aware that likenesses of John Ross, George Lowrey, Stand Watie, and other Cherokee and Creek notables dressed in frock coats and starched collars were short on the exotic. Attempting to inject a note of excitement into a pretty tame exhibition, a Cincinnati paper told how Stanley had braved perils in the forest and on the prairies gathering his portraits; references to warlike Seminoles of "repulsive" face were calculated to send the same shiver down the spine as Sioux and Apaches would in later generations. But there was no escaping the humdrum reality of Stanley's accomplishment to date—even his Seminoles had been subdued and sent to Indian Territory before he painted them, a far cry from Catlin's defiant and doomed Osceola. It was the year of decision for the partners, too. Stanley chose to press on ("On, STAN-

LEY!—on!" Dickerman exhorted), and the second chapter of his western roamings would prove as thrilling as the first had been mundane. Like Parkman, John Mix Stanley made himself a part of the epic events of 1846.[16]

* * *

The new start still seemed mired in the old when Stanley, en route to St. Louis, attended a Sac and Fox medicine dance and painted the oft-portrayed Keokuk and the widow of the even more famous Black Hawk. But through the agency of Josiah Gregg he broke new ground when he accompanied a wagon train along the Santa Fe Trail, arriving in what was now the American town of Santa Fe in late August. This time Stanley successfully hooked up with Stephen Watts Kearny for an adventurous three-month trek to San Diego.[17]

War with Mexico had been declared on May 13, and Kearny's Army of the West was assigned the task of securing New Mexico and California. Lacking a draftsman, Kearny hired Stanley, enabling him to see the remnants of a Pueblo culture that he assumed to be Aztecan (a conclusion John Bartlett would reject a few years later) and to be with the packtrain during a fierce hand-to-hand encounter with Californian lancers less than forty miles from San Diego. The battle of San Pasqual left seventeen of Kearny's men dead on the field, Stanley reported, and another fourteen wounded. Three officers were killed, three (including Kearny) wounded. Only the arrival of American reinforcements permitted Kearny's tattered army, which had survived on mule and horse meat, to straggle into San Diego on December 12. The adventure was more than Stanley had bargained for, but he used the opportunity to make sketches of landscape, flora, and Indians. They illustrated Lieutenant William H. Emory's official report *Notes of a Military Reconnaissance, from Fort Leavenworth, in Missouri, to San Diego, in California,* published in 1848. Stanley, working in San Francisco through the previous spring, had completed his first commisssion as an expeditionary artist, the one form of patronage the federal government still offered would-be Indian painters.[18]

By summer Stanley, riding the tide of Manifest Destiny, was in Oregon, ceded to the United States by treaty with Great Britain the previous year, but in transition from Hudson's Bay Company rule. He would spend fourteen months there, based at Oregon City, where he attracted the attention of another artist on a mission to paint the western Indians, the Canadian Paul Kane. The two men likely knew one another already, since Kane, a professional portrait painter, had chummed with James Bowman in Toronto before joining him in Detroit in 1836. From there Kane had drifted south to Mobile and New Orleans, then sailed to Europe in 1841. He studied art in France and Italy, picking up some bad habits (a fondness for leaden skies, dull colors, and stiff, formal groupings) without im-

Map 2. The West of Seth Eastman and John Mix Stanley.

proving on his rudimentary skills at figure composition. He was at his best when most spontaneous—in quick field sketches in pencil, watercolor, or oil. This talent served him well after his return to America in 1843, because Kane, before sailing from Liverpool, had visited Catlin's Indian Gallery and been instantly smitten. He would become the Canadian Catlin, make the vanishing tribes his life's work. At thirty-three, he had a purpose to animate his art. It took time to get under way—a few years in Mobile doing portraits to pay off his debts, an inconclusive probe from Toronto in June 1845 to paint the Indians of the Great Lakes. He was on his way to the Pacific, but winter found him still in Toronto, aware that his resources were inadequate to support his ambitions. But he had made contacts in the Hudson's Bay Company that paid off handsomely in March 1846, when the company's governor, Sir George Simpson, granted Kane permission to wander freely as the company's guest throughout its vast western domain, sketching as he pleased. In addition, Simpson commissioned twelve oils on Indian subjects of Kane's choosing. Under such favorable auspices Kane accompanied the governor from Toronto to Sault Ste. Marie in May 1846, launching a two-and-a-half year sojourn that would take him to the new Hudson's Bay Company post at Fort Victoria the following spring and find him back in Toronto by mid-October 1848. There an exhibition of his Indian sketches attested to his enterprise and secured him public and private commissions of the sort Catlin only dreamed of.[19]

Toward evening of July 1, 1847, Kane left Fort Vancouver to begin his meandering journey home; he may have bumped into Stanley, who was en route to Oregon City at the time. Kane kept track of him through a mutual acquaintance, Peter Skene Ogden, chief factor at Fort Vancouver. Indians were "in great demand" with Stanley, Ogden reported in September, adding in mock despair: "What with Artists, Archbishops, Bishops, Priests, Nuns, Deacons and Fathers, 22 having lately arrived direct from *Brest* the country will be lost forever." Ogden was under the impression that Stanley had been "employed by Catlin, a friend of yours, to sketch for him," an understandable confusion that Kane must have savored, since both were imitators after Catlin. Stolid, truthful, a little dull, they lacked his showman's flair. One of Kane's patrons thought his personality a sufficient guarantor of the accuracy of his Indian scenes: he was too unimaginative to invent what he painted. No one accused Catlin of excessive literalism; nor did Stanley or Kane ever publicly acknowledge their debt to him. He had popularized the idea of an Indian gallery; they hoped to excel him at his own game. Thus their simultaneous visits to Oregon Territory in 1847.[20]

Kane ascended the Columbia to Fort Walla-Walla, where he spent the second half of July sketching Indians and the local scenery and visiting the Whitman mission at Waiilatpu. Then he struck out overland to intersect the Columbia three days' journey from Fort Colvile. By his accounting, he

remained at Colvile a month, until September 9, then spent a week at the Elkanah Walker and Cushing Eells Presbyterian mission among the Spokanes, Tshimakain, then a few days more at Colvile, where he drew a Chualpay scalp dance and learned on the evening of September 21 of the murder of Marcus and Narcissa Whitman and twelve others at Waiilatpu.[21]

It is evident that Kane shared something else with Catlin besides an obsession to paint Indians: he was not to be trusted with dates. The Whitman massacre actually took place on November 29, more than two months after Kane departed Fort Colvile. But if Kane was not in the thick of things, as his account implied, Stanley was. Having left Fort Vancouver in September "in quest of Scenery," he traveled to Fort Walla-Walla by boat and made a brief visit to the Whitman mission. He continued on by horseback, reaching Fort Colvile on November 1. After two weeks at the Walker-Eells mission at Tshimakain, he began the six-hundred-mile trip back to the Willamette. Deep snow made travel fatiguing, but eight days brought Stanley and his Indian guide Solomon within a few miles of the mission at Waiilatpu. Their progress was interrupted when an Indian girl and boy warned them that the Whitmans had been murdered two days before. What followed was a nightmare.[22]

Stanley and Solomon, in the heart of Cayuse country, would have to "run the gauntlet" to Fort Walla-Walla. They had not gone far when a Cayuse intercepted them and, pressing a cocked pistol to Stanley's breast, demanded to know if he was a "Boston"—an American. Confused, Stanley

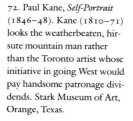

72. Paul Kane, *Self-Portrait* (1846–48). Kane (1810–71) looks the weatherbeaten, hirsute mountain man rather than the Toronto artist whose initiative in going West would pay handsome patronage dividends. Stark Museum of Art, Orange, Texas.

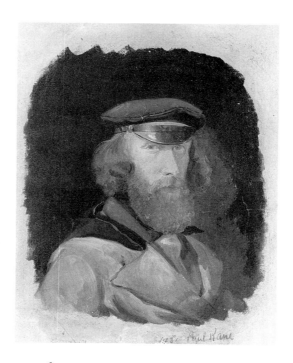

73. Paul Kane, *Chualpay Scalp Dance—Ft. Colville* (1846). Kane, like Stanley, was a near witness to momentous events in the history of Oregon Territory. Stark Museum of Art, Orange, Texas.

replied that he was a "buckeye," which the Indian took to mean a Hudson's Bay Company employee or a Frenchman. He lowered his pistol but, still suspicious, started to raise it again. Stanley grabbed the barrel and frightened his assailant off by reaching for his own pistols. They were unloaded, a fact that Stanley, upon calm reflection, concluded had saved his life. Otherwise he might have shot the Cayuse, bringing "a horde of these murderous hell-hounds at my heels." Stanley's ordeal was not over yet, however. He and Solomon left the main trail and "took to the hills and ravines" for eight miles, certain they would be pursued. Three Indians did come after them but failed to discover their hiding place. Following a tense night, they encountered a lone Cayuse the next day who gave the war whoop but was cut off by a river; in making their escape, Stanley and Solomon nearly blundered into a small village. With the Indians mounting to give chase, they again took to the hills, prepared to fight to the death. Two warriors followed but never approached nearer than a hundred yards, and in the early afternoon of December 2 Stanley and Solomon finally reached the sanctuary of Fort Walla-Walla, "perfectly unnerved and bewildered."[23]

Throughout the winter, rumors flew around Oregon of tribal alliances and an impending general Indian war. Militia companies organized for defense, and an army was mounted to punish the culprits and nip hostilities in the bud. Walker and Eells were persuaded to leave Tshimakain and take refuge at Fort Colvile. Panic was in the air. Privately, Peter Skene Ogden thought the American settlers largely responsible for the unsettled state of affairs. Four thousand of them, he wrote Paul Kane, had flooded

into Oregon, disturbing the Indians and bringing with them "their pleasant travelling companions the Measles, Dysentry and Typhus Fever." The Indians had suffered heavily. Whitman's failure to effect a cure and the suspicion that he was actually administering poison had precipitated the massacre in November. Even the Reverend Mr. Walker, who dismissed the notion the Indians were a "Noble race," thought them more sinned against than sinning. Nevertheless, "humanity dictated" that the officers of the Hudson's Bay Company intervene on the settlers' behalf. Upon receiving news of the murders at Waiilatpu, Odgen set out at once with fourteen men from Fort Vancouver to negotiate the release of the nearly sixty women, children, and men held captive by the Indians. Combining persuasion with ransom payments, the veteran fur trader struck a bargain and earned the gratitude of the American community by escorting the party of survivors downriver from Fort Walla-Walla to Vancouver. They landed on January 8, 1848, safe at last from danger.[24]

Stanley was with them and, having recovered his composure, was remembered for the solicitude he showed the frightened children on the voyage. Grateful to be alive and impressed by what he had seen in the interior, he was eager to push on. But the Indian unrest had effectively isolated western Oregon, suspending overland travel. "Time will determine my route," Stanley wrote upon arriving at Fort Vancouver; "if necessary, I will have means to go by sea." March found him back in Oregon City, enjoying a mild spring and the sight of peach trees in blossom. He was resolved to linger awhile in southern Oregon then return East by steamer, stopping at the Hawaiian Islands before crossing the Isthmus of Panama.[25]

Time had restored Stanley's confidence. His hairbreadth escape from the Cayuses was one adventure he would not neglect to publicize, and he soon had his story polished to a sheen. Sometimes he forgot to mention that he was accompanied throughout by the man he in other circumstances referred to as "my faithful friend Solomon." Ogden noted the tendency of Stanley's story to improve with the telling and twitted him for not announcing to the first Cayuse he met that he was a Boston man. "Let those laugh who win," Stanley retorted.[26] The Whitman massacre and his desperate dash to Fort Walla-Walla could prove to be his Osceola portrait, properly managed. He might be no Catlin when it came to self-promotion, but he recognized that he had passed through extraordinary times. When he next exhibited his Indian gallery, it would have something more than a few tame Seminoles or the venerable Keokuk to entice the public. Among the portraits would be the grim visages of Wai-e-cat, or One That Flies, Shu-ma-hici, or Painted Shirt, and Telo-kikt, or Craw Fish Walking Forward, Cayuses he would identify in his catalog as the chief perpetrators of

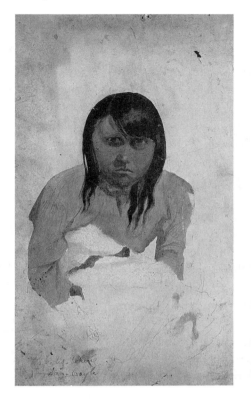

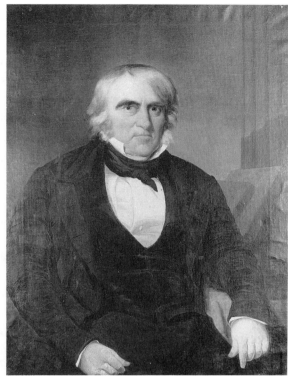

74. *Left.* John Mix Stanley, *Wap-tis-tokene, War-Eagle,* an oil sketch of a Cayuse (ca. 1847) whose searching expression radiates hostility. Stark Museum of Art, Orange, Texas.

75. *Right.* John Mix Stanley, *Peter Skene Ogden* (1848) a formal portrait of the Hudson's Bay Company factor (1794–1854) who befriended both Kane and Stanley; Ogden's right hand bears comparison to Wap-tis-tokene's, showing a Stanley convention in posing his subjects. Photograph courtesy Provincial Archives of British Columbia, Victoria (PABC–HP 4274).

the Whitman massacre. And among his sketches would be pictures of the murders and abductions at Waiilatpu, based on the harrowing tales of the survivors, and a scene from his December travels based on personal experience. There would also be a likeness of Peter Skene Ogden, the steadfast Hudson's Bay Company factor who, for all his joshing, wrote a letter on July 3, 1848, attesting to the accuracy of Stanley's Indian pictures and expressing the wish that he might reap a "rich harvest" from them in the future.[27]

On August 1, a week before the Joint Committee on the Library concluded there was not a chance in a million that anyone besides Catlin would ever paint an Indian gallery, Stanley left Oregon City by steamer. Two weeks later he was in Honolulu to begin a year's stay in Hawaii that found him keeping company with royalty, King Kamehameha III and Queen Kalama, whose portraits (at a fee of $500) were among his many commissions. Measles had invaded this paradise too, however, and Hawaii's commerce had been undercut by the gold rush fever that was already making California a magnet to the world. Having explored another exotic corner of the globe and exhausted his own commercial prospects, it was time to push on. Stanley caught the steamer *Montreal* at Honolulu on November 17, 1849, and was back in Troy, New York, by the spring of 1850, working

279

with Dickerman to ready his expanded Indian gallery for exhibition that September.[28]

* * *

Stanley and Dickerman's North American Indian Portrait Gallery opened in Troy on September 2, 1850, to enthusiastic reviews. On display were 134 paintings representing fifty tribes, all for a quarter. "The Pictures are much larger than those painted by Catlin, while they are altogether more elaborate," the *Daily Whig* observed. Both Stanley and Dickerman were on hand to relate graphic stories about the scenes depicted and the faces shown. But two weeks after the exhibition opened, the papers were carrying notices that it would be continued only a week longer, then, in response to a petition signed by thirty-five local gentlemen, until the end of the month. Orphans from the Troy Asylum were admitted free, generating more favorable publicity, but the partners were clearly at another crossroads. It was reported that they planned to put their gallery on permanent display in New York City after leaving Troy. Or it might be hung in Boston—or perhaps Albany, and then New York before a national tour.[29]

In fact, Albany was the next stop. There publicity stressed not only the scenes of the Whitman massacre, but the gallery's superiority to Catlin's in size, execution, and representativeness, since it included "many specimens of the races beyond the Rocky Mountains, parts of which Catlin never reached." See it now, the papers advised, before it found a permanent home in Washington—a new addition to the possible destinations. The gallery opened to the public on October 7, went unappreciated despite the addition of a nightly lecture, and closed November 9. A reporter for the *Evening Journal* confessed himself "unfashionable enough" to have visited the exhibition "and sufficiently unsophisticated to have been entirely delighted"—cold comfort for an enterprise that obviously was once again in deep trouble.[30]

Stanley's Indian gallery opened at the Alhambra in New York City on November 28. Business was slow. Stanley was no showman. Cornered in his gallery, he would talk with some enthusiasm to an interested patron, but he was too retiring to lecture, an essential part of the Catlin routine. Thus his Indian gallery lacked an identifiable personality to stimulate publicity and bring out the crowds. Desperate, the partners, like Catlin before them, hooked up with a touring Indian, the Ojibwa evangelist George Copway. Just returned from Europe, he agreed to lecture on "The Religious Belief, Poetry and Eloquence of the North American Indians." His presence was said to have filled the Alhambra to overflowing, but one listener judged him a speaker of limited ability, given to pleasantries and big words "lugged in by the shoulders, and without much reference to the sense they may make." Neither Copway nor an offer of free admission to

public-school children could save the day. The exhibition closed in mid-February after another disappointing run.[31]

March brought New Haven and Thomas L. McKenney, a voice from the past, with his own ringing testimonial. "If you have a chance, see Stanley's Gallery," he wrote from New York on March 20: "Stanley has immortalized himself by the reflex he has given of this down-trodden race. Nothing can be more life-like than are these portraits. The costume, also, is perfect. It is all a reality—truth is at the foundation of all. . . . I consider it the last and the best offering of the sort which will ever come to us from the wilderness home of this people. Their destiny as a race, is sealed. They will soon be lost to our sight and forever. Go and see the Gallery." It was quite a tribute from the progenitor of Indian portrait galleries, but the exhibition lasted less than three weeks in New Haven and fared no better in Hartford, where inclement weather was blamed for the poor turnout. An endorsement by George Abernethy, provisional governor of Oregon Territory during Stanley's visit, was thrown into the publicity hopper, along with letters from local citizens (including three artists) recommending Stanley's as "the *finest collection in the world.*"[32]

But the exhibition, and with it the Stanley-Dickerman partnership, had run its course. When the gallery next went on public display—in the nation's capital the following year—Stanley would be the sole proprietor, he and Dickerman having parted company in Troy on June 19, 1851. Determined to dethrone Catlin, Stanley might well have empathized with his rival after so many tribulations of his own. He would have been bemused, for example, had he been privy to a letter Peter Skene Ogden sent Paul Kane in March, while he and Dickerman were struggling for survival in New Haven. "I hear Stanley is massing a rich harvest from his travels in Oregon, the Islands and California," Ogden wrote. "He is a worthy young Man and I heartily wish *you* every success." Rich harvests were Kane's lot, not Stanley's. Kane had returned to Toronto a celebrity. After completing his commission from Sir George Simpson he launched into the hundred-picture cycle that was to be his crowning glory, his Indian gallery. Emboldened by praise, he approached the Canadian House of Assembly in 1850 for financial support to allow him to finish his paintings and prepare his notes on his western travels for publication. Modified in committee into a commission for twelve oils, Kane's petition was debated in early August 1851. The occasion was a two-hour love fest as parliamentarians vied to praise their countryman. The twelve subjects were agreed upon by August 30, and Kane, £500 richer, was free to concentrate on painting up the results of his tour of Indian Country. How different the reception Stanley would meet in Washington, mecca of false hopes, where like Catlin before him he would learn the bitter lesson of unfastening hands.[33]

* * *

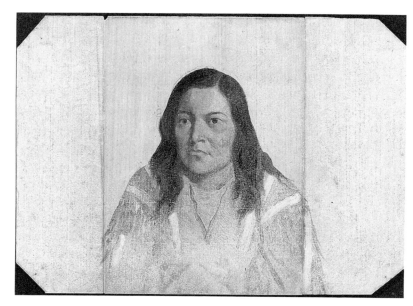

76. John Mix Stanley, *Indian Man (Cayuse Man)* (1847–48), indicative of the more elaborate Indian portraits in the Stanley gallery. Stark Museum of Art, Orange, Texas.

On its circuitous way to Washington, Stanley's Indian gallery had often been favorably compared with Catlin's, and the federal government had been urged to purchase it as the basis for a national collection. With Catlin about to make a major push in Congress, Stanley arrived in the capital early in 1852 determined to meet the challenge head on. He had his pictures hung in the Library Hall of the Smithsonian, where they ran fading recollections of Catlin's gallery direct competition. One visitor thought Stanley's Indian paintings the first that could really be called art, "well worth the patronage not only of the Government, but of private taste in any one who has national pride."[34]

By the time the bill for purchase of Catlin's Indian Gallery reached the floor of the Senate in July, Stanley's exhibition had achieved its desired effect, confusing the matter at hand by introducing extraneous considerations, shifting the debate from acquisition of Catlin's collection to acquisition of works by Stanley and Eastman—or none at all. Naturally Stanley took the defeat of Catlin's bill as an invitation to introduce his own at the next session, confident of ready approval. With his paintings already in place in the Smithsonian and every indicator positive, he petitioned Congress that December to purchase his collection as a lasting memorial to the vanishing Indian. The 154 paintings in it included 140 portraits taken among forty-two different tribes ranging from Indian Territory and Texas to New Mexico, Utah, and Oregon—all recent additions to the Union. Stanley claimed to have devoted ten years to the gallery, "nearly the whole of which period" was passed "in those remote regions where the nature and habits of the Indians are found in their greatest purity and originality"—a Catlin-like exaggeration, followed by an evocation of a people

"silently retreating or melting away from before the pace of civilization like exhalations from the sunlight." Stanley urged his collection on the government as a sacred duty owing the ethnologist, the historian, and the Indians themselves that their memory might be preserved in paint.[35]

Attesting to the fidelity and merit of his work were letters from officers and agents in the West (Peter Skene Ogden's among them) and the testimonials of Thomas McKenney and Seth Eastman. Eastman's, of course, had been particularly damaging to Catlin's case the previous summer, since it directly compared the two Indian galleries and judged Stanley's "far superior." But no endorsement was more compelling than the Smithsonian's. Stanley's paintings hung in its quarters, and he had donated dyed porcupine quills, jaguar and peccary skins, and two sets of deer skulls with interlocked horns to the institution, securing a lock of his own on official favor. Joseph Henry stopped short of recommending that Congress purchase Stanley's collection, but he lavished praise on it in his annual report. And in late December, coinciding with Stanley's petition to Congress, the Smithsonian published a seventy-six-page descriptive catalog of the collection "at its own expense," Stanley wrote, thereby evincing "its appreciation of these paintings." The momentum for purchase appeared irresistible.[36]

On December 28 John B. Weller, the California Democrat who had been such a thorn in Bartlett's side during the Mexican boundary controversy, introduced Stanley's petition in the Senate and recommended its

77. John Mix Stanley, *Ko-Rak-Koo-Kiss, a Towoccono Warrior* (1844), one of the oils in the Stanley gallery. The Indian's features are strikingly similar to those in the portrait identified as a Cayuse man; the horse is of the fanciful variety evident also in Catlin's equestrian study of Keokuk (fig. 29). National Museum of American Art, Smithsonian Institution; gift of the Misses Henry, 1908.

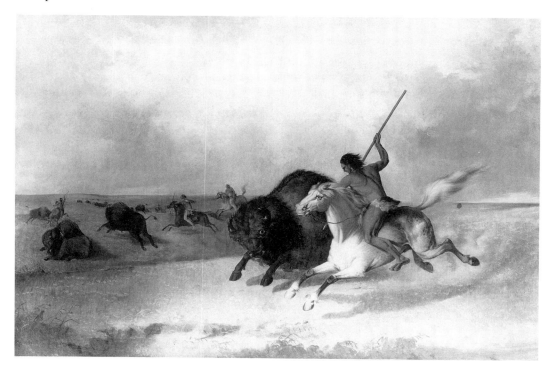

78. John Mix Stanley, *A Buffalo Hunt on the South-western Prairies* (1845), another of the original Stanley gallery oils. National Museum of American Art, Smithsonian Institution; gift of the Misses Henry, 1908.

referral to committee. Like Catlin's champions, he was unsure which committee was appropriate, but he settled on Indian Affairs. The Indian Affairs Committee under its chairman from Arkansas, William K. Sebastian, had successfully ducked Catlin's petition the year before, but Sebastian was more amenable to Stanley's petition and promptly asked him to set a value on his collection. In his petition, Stanley had claimed $12,000 out-of-pocket expenses in forming the collection. That covered "expenditures incident to the work of sketching, painting, and obtaining the material," he explained to Sebastian, but not the $5,000 spent on "framing, transportation, insurance, storage and general superintenace of the paintings." Of course his gallery, which was a national one, should not be measured by money alone. "The nation must have these portraits for the gratification of public curiosity, and from motives of an elevated State policy." Sebastian also approached the commissioner of Indian affairs, who declined to offer an opinion on the paintings "as works of art" but was prepared to recommend the creation of a "National Portrait Gallery of distinguished Indians" and thought that Stanley's collection might provide a nucleus. Memories apparently were short in the Indian Office, the McKenney precedent having already been forgotten. But such bureaucratic amnesia could strengthen Stanley's case.[37]

Instead of reporting back to Senate, the Indian Affairs Committee on March 3 added a minor amendment to the Indian appropriations bill. It

provided for purchase of Stanley's paintings "now in the Smithsonian Institution, at a rate not exceeding $150 each, $19,200." Apparently the Smithsonian catalog, distributed to all members of Congress, had done its job. But showing worse memories than the Indian Bureau, two veteran senators went off on a tangent. An Indiana Democrat recalled the Senate's turning down the Indian gallery "for several sessions past," and a North Carolina Whig who supported the amendment embarrassed it further by conceding, "It is true that the Senate has heretofore decided against this proposal to purchase the Indian collection of Mr. Stanley." He asked only for a "sober second thought." Even James Cooper, the Whig from Pennsylvania who had spoken so warmly of Catlin's work the previous July and characterized Stanley and Eastman as "but gleaners after Mr. Catlin," failed to point out that purchase of Stanley's collection had never before been formally debated. It was rough justice that Stanley, who had done so much to hurt Catlin's case in 1852, should find his own haunted in 1853 by the ghost of galleries past. Cooper, as a member of the Indian Affairs Committee, went on to point out that only a portion of Stanley's gallery—the portraits, not the historical scenes—would be purchased. But the damage had been done, and on a roll-call vote the amendment was defeated twenty-seven to fourteen.[38]

Stanley drew support principally from northern Democrats (ten Democrats, four Whigs; ten from the North, two from the South, and two from border states); opposition was about evenly divided, southern Democrats predominating (sixteen Democrats, eleven Whigs; fourteen from the South, twelve from the North, one from a border state). The pattern indicates that voting followed sectional rather than party lines, with southerners consistently opposing federal government involvement in the arts. A comparison with the Senate vote on Catlin's bill in the previous session is revealing. Four Whigs and two Democrats, all northerners, supported purchase both times, while eleven Democrats and three Whigs, drawn nearly equally from both sections, were opposed both times. Finally, five Democrats who supported Stanley's bill opposed Catlin's, while four Whigs and a Democrat who supported Catlin voted against Stanley. The comparison suggests that northerners were more likely to favor federal patronage than southerners. Although sectional lines cut across party affiliations, Whigs were more inclined to support the arts than Democrats. Finally, principle was modified by personalities: *whose* gallery was being considered entered into individual decisions.

Defeat, when it came, caught Stanley by surprise. He had *assumed* a favorable vote in Congress. Strapped financially, he started down the same ruinous path as Catlin. On March 15, less than two weeks after the Senate rejected his petition, he signed over one-quarter undivided interest in his Indian gallery for the sum of $2,500—$2,000 to be paid immediately, the

balance owing. His creditor was none other than John R. Bartlett, who must have been confident that Congress would eventually buy the gallery at a figure in the $20,000 range, thereby doubling his investment. Bartlett also assumed that his own bill, providing for publication of his Mexican boundary report "in a style and form" corresponding to Schoolcraft's Indian history, would find congressional acceptance; presumably Stanley would then become his Seth Eastman, the gallery serving as a ready source for illustrations. Whatever his thinking, Bartlett also experienced defeat in the Senate, on April 5. Now two men owned 100 percent of a white elephant pending future action by Congress.[39]

* * *

But Stanley landed on his feet. The Pacific Railroad surveys, authorized by law just the day before Congress turned him down, were even then mounting, and sometime near mid-April he was chosen to accompany Isaac I. Stevens as artist-draftsman on the northern survey out of St. Paul. Seth Eastman almost certainly had a hand in Stanley's appointment. Stevens considered Eastman "one of the most meritorious officers in the Service," with years of frontier experience and an enviable reputation as the pictorial historian of his country. "I feel under obligation to Capt. Eastman for his success in inspiring me with some little love for art as my teacher at the Military Academy," Stevens wrote that very April. In Washington making preparations for his survey, he would naturally have consulted his old mentor. Eastman's expertise in topographical drawing and his current duties as illustrator to Schoolcraft's Indian history made him the perfect judge of what an expeditionary artist should be. Having already praised Stanley as Catlin's superior in every respect, Eastman would not have hesitated to recommend him to Stevens.[40]

Stanley was caught up in the rush of events as soon as he joined the survey. There was no time to waste, since Congress had set an impossible ten-month limit for the War Department to conduct separate reconnaissances along four parallels and report back. Stanley was packed and on his way to St. Louis for advance preparations by the first week in May. The salary, $125 per month, would not make him rich, but it would tide him over. The only shadow on his happiness was the necessity of leaving behind in Washington a young lady, Alice English, whom he had hoped to marry before year's end. Their wedding plans would have to be postponed. Alice was of mixed emotions: she consented to his going, but his impending departure elicited a poetic remonstrance on April 29:

> . . . I shall have sweet thoughts to cheer me
> When thou art gone,
> For, in my dreams, will linger near me
> The absent one.

286

And as those dreams at pensive even
 Steal over me,
I'll lift my melting heart to heaven
 In prayer for thee.
Through the deep gloom that darkens o'er thee
 The star of fame
Shines like a beacon light before thee
 Go!! win a name.

Oh cruel Baby.

Baby, as Alice called her fiancé, was incapable of replying in kind. Though on occasion Stanley came near waxing poetic himself, he preferred to give practical proofs of his devotion. Before departing Washington he drew up a will leaving Alice his three-quarters interest in the Indian gallery and the remnant of his estate after satisfaction of another $2,000 debt. On the first leg of his westward journey he sent her a bead necklace, flowers, a crate of pineapples, and, she complained, a letter so "frozen" it must have passed over the North Pole. Was he too "sobersided" to share in her vision of their future together? While she dreamed of love and music and flowers all he ever thought about was "Pictures—Pictures—& Pictures &c." Schoolcraft had faced the same charge from his imperious Mary during their courting days: men tended to talk about things instead of feelings, and Stanley was no different. He tried to satisfy Alice's insatiable appetite for endearments, but his letter from St. Louis on May 16 focused on the task at hand as he described "all the annoyances of preparation."[41]

That day he had selected camp furniture for the party of eighty he was to accompany (a separate party would survey west to east) and had assisted in the purchase of four hundred blankets and small stores for his mess, which was to include Stevens. Though Stanley was impatient to reach "the quiet solitude of Nature's garden, surrounded only by God's own work," where he could gaze undisturbed upon a favorite star and think of Alice, he had not neglected pictures in the rush of preparation, having that day acquired a daguerreotype apparatus. Experience in Indian Territory had familiarized him with its operation, and he looked forward to using it in the field. "There is no doubt but we will have a large council of those northern Indians," he wrote Alice, "and with the facilities in my power I will make many captives—on paper & plate."[42]

Stanley had particular reference to Stevens's plans for meetings with the Indians near Fort Union and then Fort Benton, at the head of steamboat navigation on the Missouri. Getting there took time; Stevens did not leave St. Paul until June 7, nearly a month behind his original schedule.[43] His party traveled overland to Fort Union, 715 miles, arriving August 1. There Stanley employed the daguerreotype among the Assiniboines. The sur-

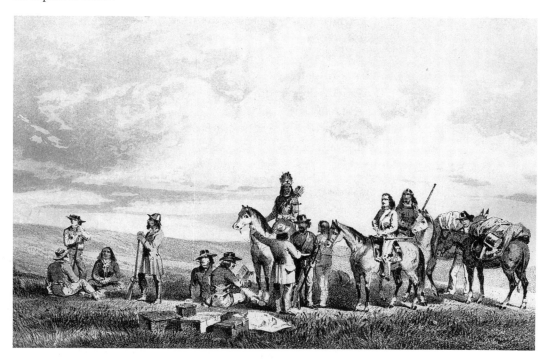

79. After John Mix Stanley, *Lieut. Grover's Despatch— Return of Governor Stevens to Fort Benton,* the incident that launched Stanley (mounted on the right) on his Piegan trek. *Reports of Explorations and Surveys . . . ,* vol. 12, book 1 (1860).

veyors next proceeded up the Missouri to Milk River, which they followed due west before cutting south to Fort Benton, a distance of 377 miles. Elements of the expedition stayed there from September 1 to September 22. Stanley, after an arduous exploration of the Bear's Paw Mountains that delayed his arrival at Benton until the third, was off again on the ninth on a side trip north to the Cypress Hills. He and four others accompanied ninety lodges of Piegans from their camp in the hills to Milk River—an experience to savor for a painter of Indians as they advanced in "two parallel lines on the plains, forming one of the most picturesque scenes I have ever witnessed: . . . this heterogeneous caravan, comprised of a thousand souls, with twice that number of horses and at least three hundred dogs, fell into line and trotted quietly until night, while the chiefs and braves rode in flank, or rear, ever ready for the chase or defence against a foe." From Milk River Stanley escorted thirty chiefs and their families to Fort Benton, having covered 163 miles in all, for a council with Stevens on the twenty-first. "In my absence I made many interesting sketches of their customs—and daguerreotypes of their chiefs," he reported to John Bartlett. "Thus far my trip has been very successful in subjects."[44]

The main expedition (Eastern Division) had already met the eastbound Western Division, and smaller survey parties were even then fanning out to map additional routes westward. Accompanying Stevens, Stanley made a relatively direct passage to the Pacific, survey chief and artist reaching Fort

Vancouver on November 16. They had descended the Columbia from Fort Walla-Walla in a canoe, passing by the scenes of Stanley's hair-raising adventures in 1847. Though Alice English worried incessantly lest the "heathen savages" literally raise his hair this time out, the expedition had in fact proved relatively tame. Stevens praised Stanley for his artistry, his willingness to double as surveyor-explorer and Indian diplomat when the occasion demanded, his all-round "satisfactory discharge of duty." He even named a pretty mountain lake for him. But despite intimate personal contact with him on the trek west, Stevens revealed little about Stanley the man. Stanley's original tentmate, physician and naturalist George Suckley, said only that Stanley "paints fish, birds & flowers, while I preserve them." But if Stanley's personality failed to register strongly on his peers, both Stevens and Suckley respected his professional competence and referred approvingly to the daguerreotypes he had made along the way.[45]

With this, his last western tour, concluded, Stanley was impatient to reverse his direction and be home again. There someone waited who knew him as the others never would. It took time to wrap up his affairs in Oregon, however, as he wrote Elkanah Walker on November 26 in explaining why he had failed to visit his old Tshimakain friend. "Owing to a multiplicity of business with our parties, which have been daily arriving up to this date, it has been impossible for me to leave," he noted, and now he was hourly expecting to take his departure for the States.[46]

Stanley had hoped to be back in Washington for Christmas (once his tentative wedding date), certainly for New Year's. But it was December 16 before he sailed from San Francisco, glad to leave behind a city "made up of a heterogeneous throng in whose faces is plainly written—nay stamped gold—gold—*more* gold." The ship scudded along "with full press of steam & sail," the sunset sky as soft as those in Italy; by day, pods of porpoises sported before them. "The Earth, Sea & Air are full of sunshine like my own idolatrous heart—sweet one I am coming to thee." But the excitement of beginning the return voyage was qualified by the realization that weeks still separated him from Alice. Stanley tried to read but could not concentrate; he gazed at the stars they shared, mooned over her miniature, snoozed, played whist and euchre, paced the deck remembering their strolls arm-in-arm to the Capitol grounds and the "dear little evergreen tree" from which he had plucked a sprig while struggling to express his love. Separation had made the phlegmatic Stanley a poet after all, vowing in a variation on Poe that, once he returned, "*'Never More'*" would they part. The trip seemed interminable, the portage and steamship passage through Nicaragua almost devoid of interest as he brooded on the fact that the Christmas he had longed to spend with Alice had been passed instead on the Pacific, while New Year's Eve would find him on the Atlantic.

Stanley wished only to "annihilate time" and end his "long pilgrimmage." On January 8 the steamship *Star of the West* put into New York harbor. True to his vow, one western wanderer aboard had come home to stay.[47]

Return brought realities, pleasant and otherwise. Alice English and John Mix Stanley were married on May 3, 1854. Making a living from his art was now a dual concern. From Fort Benton the previous September he had written Bartlett urging him to sell the Indian gallery if Congress was disposed to buy, and after his return to Washington he had continued to court the Smithsonian, this time donating the dress and war club of a Blackfoot chief. He also tried to exert a little pressure on the institution by removing the gallery in September for exhibition at fairs in Baltimore and Richmond. Apart from a few hundred dollars in fees, however, he gained nothing. The pictures were back on the Smithsonian's walls before year's end, and despite Joseph Henry's recommendation favoring purchase, the board of regents at its meeting on January 27, 1855, declined to make an offer. Stanley's principal asset was still not yielding a cent. But the artist had something else on his mind, a sure-fire money-making scheme that would capitalize on the gallery while drawing fresh inspiration from his recent western travels.[48]

* * *

Back when Stanley's Indian gallery was touring, visitors had often paused to praise his landscapes, particularly the views along the Gila made on the Kearny expedition in 1846. Perhaps the scenes he had recently sketched on

80. After John Mix Stanley, *Chemakane Mission,* a view of the site that figured so prominently in Stanley's adventures in 1847, the Presbyterian mission at Tshimakain. *Reports of Explorations and Surveys . . . ,* vol. 12, book 1 (1860).

81. John Mix Stanley and his bride, Alice Caroline English, a daguerreotype made about the time of their wedding in 1854. Courtesy of Mrs. Alice Stanley Acheson, Washington, D.C.

the Stevens survey could be worked up into an immensely popular form of entertainment that combined art, mechanical contrivance, special effects, and a voice-over narration, the moving panorama. Panoramas—or more correctly cycloramas—had been all the rage since the late eighteenth century. Biblical scenes, seascapes and cityscapes, battles and other disasters all lent themselves to cycloramic treatment. Viewers stood on a platform entirely surrounded by "a picture without boundaries"—perhaps four hundred feet in circumference, fifty feet high, its sky dissolving into the natural light flooding through a glass roof, the illusion of reality heightened by the dioramic device of blending painting into matching foreground strewn with three-dimensional objects and figures.[49]

The moving panorama, an American wrinkle on the cyclorama, was a natural for travelogues. As an immense canvas, perhaps a thousand feet long, rolled by between giant cylinders, enthralled viewers experienced the sensation of taking a trip by train or steamboat with, the publicity pointed out, all the dreary stretches omitted. In a few hours you could travel up the Mississippi, for example, and see every scenic high spot. Backlit canvas glowed and flickered with an eerie light especially suited to grand conflagrations, scudding clouds, and the rippling effect of flowing water. Since panoramas toured from city to city competing for public patronage, there

were financial risks. But at least one would not have to coax people out; panoramas were an established draw, and there was ample precedent for what Stanley proposed to do.[50]

The first of several Mississippi River panoramas, John Banvard's, played New York City from December 1847 through September 1848—ten months, not the paltry two and a half Stanley's Indian gallery had managed. Some 400,000 Americans were said to have paid to see it unreeled. Banvard took his "three-mile painting" abroad shortly after closing in New York, and by Christmas 1848 was showing at the Egyptian Hall, scene of Catlin's original triumph. He did not have the field to himself for long. By the following March John Rowson Smith was in London with a "four-mile painting" of the Mississippi running Banvard direct competition, even to a coveted command performance. To counter Banvard's claim to primacy, Smith claimed superior truthfulness, and when their rivalry spilled over into the pages of the *Times,* he brought in George Catlin as an expert witness.

Both Banvard and Smith had sketched along the Mississippi in the 1830s preparatory to painting their panoramas. Their landscapes, dotted with Indian camps and white towns, complemented Catlin's Indian Gallery, since each offered an implicit commentary on white progress in the West. And each was a grandiose conception on a scale to match an expansionist age. Like Smith, Catlin had rested his case for public patronage on the historical and educational importance of his work. Thus he supported Smith in his dispute with Banvard. Indeed, Catlin said, he had "repeatedly" advised Banvard of defects in the Missouri River portion of his panorama. A full twenty-eight significant landmarks ("the leading and conspicuous objects of interest and permanency on the banks of that river") were missing, and there were major errors in what was shown. Such "glaring omissions and incongruities" forced him to conclude that Banvard's Missouri was "the work of some one's imagination." Catlin had neither the time nor the resources to get into panoramas himself in 1849. But his large California pictures displayed for the benefit of would-be emigrants suggest the inclination, while the scenes he would paint along the Amazon a few years later, viewed in succession, have the feeling of a moving panorama—Indians, villages, jungle, and creatures observed from a boat drifting by.[51]

Seth Eastman in 1847 had seriously considered accepting an offer from Henry Lewis to join him in painting a Mississippi panorama. A trained topographical artist, he would have been a natural, and his sketchbooks were already filled with minutely detailed drawings of landscape along the river. In the end he declined, but Lewis went on to paint a panorama of his own—12 feet wide, 1,300 feet long, and ready for exhibition by the fall of 1849. It might seem a considerable comedown from the three- and four-

mile paintings, but it almost certainly outdistanced either, their press agentry having greatly exceeded their actual length. Nevertheless, this latest panorama lacked novelty, and despite a testimonial to its merit signed during its Washington engagement by the president, congressmen, Catlin's nemesis Henry Sibley, and Seth Eastman, only St. Louis proved a profitable venue. So Lewis headed north to Canada, striking up an acquaintance with Paul Kane while exhibiting in Toronto in 1851. That fall he took his "Great National Work" to England to begin a European tour and there bumped into Henry Schoolcraft's ne'er-do-well son John Johnston Schoolcraft. A drinker, gambler, and shameless sponger, John had sailed to England about the same time as Lewis, ostensibly to take a job, though spring still found him unemployed and chumming with Pliny Miles, manager of Banvard's panorama in Britain.[52]

There were times when London seemed a small world full of big schemers. Ephraim George Squier was in town promoting his book on Nicaragua, and that John mentioned him favorably in a letter home showed how out of touch he was with his father. Catlin was there, of course, in the process of losing his Indian Gallery to creditors and facing possible imprisonment, certain disgrace. John did not look him up. He did seek out Henry Lewis, however, since his father had advised Lewis on the scene showing the source of the Mississippi, making him a prime candidate for hitting up. John reported that Lewis had just completed a swing through the interior cities and done "very well indeed." Lewis in turn frankly referred to his panorama as a "speculation." It was in this same spirit that Stanley entered a crowded field in 1854.[53]

The innovation Stanley proposed was to illustrate not just the western rivers but all the "Western Wilds" traversed by the Stevens survey. The local papers cooperated with planted stories about his progress on the gigantic work. A Choctaw at loose ends in the nation's capital, Peter Pitchlynn, had stopped by to find solace in familiar scenes; Alexander Culbertson, the fur trader who had served the survey as an intermediary with the Blackfeet, thrilled to Stanley's lifelike views of Fort Benton and the party of Piegans Stanley led there; Sioux chief Little Crow, delighted with the depiction of his own village in the woods, was moved to somber silence by the realistic rendering of a scaffold burial.[54]

Stanley announced his intention of exhibiting his panorama in England, but it opened in Washington on September 1, 1854—a year after he arrived at Fort Benton. Since the panorama illustrated forty-two separate episodes and required two hours to view, it was obvious Stanley had been hard at work since his return from the West. A skeptic who professed an aversion to panoramas and sympathy for the audience and the men at the cranks, since they suffered in common the fate of being bored by the loquacious lecturers, thought Stanley's "Western Wilds" of more than

passing interest. It is unlikely Stanley ever addressed the audience himself, since his retiring nature is well attested. "Like most men of true genius and direct purposes, his bearing and demeanor are exceedingly modest and unobtrusive," a reporter noted, "and the admirable fruits of his silent labors are only produced to the public gaze after their discovery by discriminating friends, who overrule his timid misgivings."[55]

Stanley appealed to Congress and the public as a modest man of merit, presumably in contrast to Catlin. But the fact remains that the failure of government patronage had driven him to a showman's life. Hyperbole was written all over the pamphlet *Scenes and Incidents of Stanley's Western Wilds,* sold at the door for a dime on top of the quarter admission. For twelve years Stanley had resided among the Indians, customers were told, and his gallery would ensure his fame long after "the 'poor Indian' shall have passed away." The spirit of the panorama was conveyed in a poem:

> Over the mountain, the prairie, away!
> To the Land of the Red Man, come with me,
> Where the grisly bear lurk, where the buffalo stray:
> And the WESTERN WILDS to thy soul will be
> A new found life, that shall render thee
> Strong again, like an Eden-birth,
> When man, indeed, was the Lord of the Earth!

The episodes were grouped in four sections: the first (which included the mandatory conflagration, "The Prairie on Fire!") showed spectators Seth Eastman's old stamping grounds around Fort Snelling; the second, heavy on buffalo and Indians, retraced the survey's steps west of Fort Union and ended with a stampede; the third showed more buffalo, as well as Fort Benton and Stanley's Blackfoot adventures, and ended at the Coeur d'Alene Mission in present-day Idaho; the fourth covered Oregon and ended with an Indian eulogy represented by scenes of a Chinook burial place and "The Happy Hunting Ground":

> Weary Red Man, rest! No longer
> Sad and bleeding doomed to roam,
> Hate was strong, but Love was stronger,
> Love hath called thy spirit home!
> Home, where evermore shall be
> Plenty, peace, and joy for thee!

For all the trumped-up enthusiasm in the Washington papers, it is unlikely the panorama turned a profit. After exhibiting in Washington and Baltimore, it was said to be bound for Boston, then London. But Stanley's "Western Wilds" had dropped out of sight by January 1855, even as the Smithsonian's regents were declining to buy Stanley's Indian gallery.

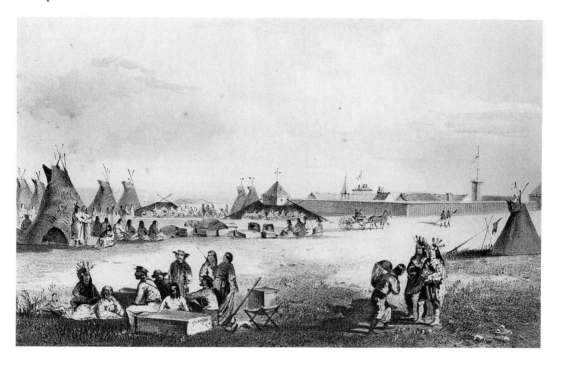

82. After John Mix Stanley, *Fort Union, and Distribution of Goods to the Assinniboines,* a view Stanley may have worked up from a daguerreotype. *Reports of Explorations and Surveys . . .*, vol. 12, book 1 (1860).

(Stanley did not abandon panoramas, however; in 1862 he produced a sixty-seven-scene [each scene 16′ x 18′] panorama chronicling the first year of the Civil War. Evidently it was a success.)[56]

✳ ✳ ✳

Stanley could afford to gamble on a speculation in 1854. That September he was rehired at $125 a month to prepare illustrations for the official report of the Stevens survey. The next April he requested an extension of five and a half months and enclosed a list of fifty-seven additional subjects for consideration. This indicates the magnitude of the bonanza the Pacific Railroad surveys provided eleven different artists. Twelve volumes of *Reports of Explorations and Surveys, to Ascertain the Most Practicable and Economical Route for a Railroad from the Mississippi River to the Pacific Ocean* appeared between 1855 and 1860. Stanley was a major beneficiary, contributing more illustrations than any other artist. He combined Seth Eastman's eye for topography with a superior ability to portray figures. "Sketches of Indians should be made and colored from life, with care to fidelity in complexion as well as feature," he wrote. "In their games and ceremonies, it is only necessary to give their characteristic attitudes, with drawings of the implements and weapons used, and notes in detail of each ceremony represented." Catlin used shorthand in his group scenes too, leading a critical but generally fair artist to remark: "What astonishes one in Catlin's sketches . . . is that the faces are grotesque; what is more, they are the faces of the same Indians whom he extols constantly, and justly, in

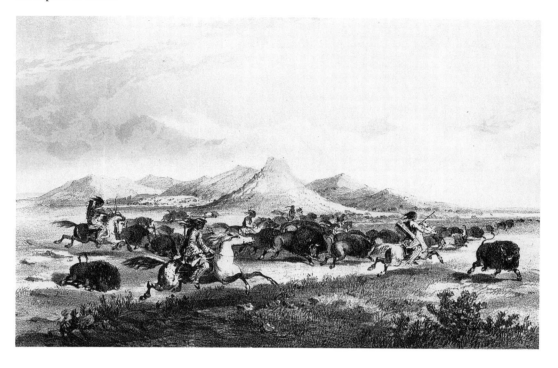

83. After John Mix Stanley, *Blackfeet Indians—Three Buttes,* proof Stanley could produce a spirited action scene. *Reports of Explorations and Surveys . . . ,* vol.12, book 1 (1860).

the text for possessing the rare beauty of the antique." If Catlin's group scenes were peopled with homely caricatures, Stanley's suffered a different defect: most were static. The councils with Assiniboines, Gros Ventres, and the Blackfoot chief White Man's Horse, illustrated in volume 12, exhibit all the earmarks of having been worked up from daguerreotypes. Stanley's Blackfoot buffalo hunt, in contrast, was necessarily from memory and makes a lively picture. We can only regret that his offer to illustrate the principal chiefs as well (four Gros Ventres, three Blackfeet, two Crows, two Assiniboines, and a Cree, a Wallawalla, a Spokane, a Bannock, and a Pend d'Oreille) was not taken up. We are grateful for what we have, however. In the absence of most of Stanley's original work, the survey plates, tinted in the green and blue of a long-ago spring and the ruddy oranges and browns of a sunstruck summer, offer indelible impressions of an earlier West. Though Stanley completed his assignment in the period 1854–55, the Stevens survey volume was the last to appear, in 1860. Given the congressional grumbling over this latest bookmaking project, it was fortunate to appear at all.[57]

In debates reminiscent of those that eventually cost Henry Schoolcraft his position as Indian historian, congressmen made their usual objections to government-subsidized picture books. A debate in April 1856 over an item appropriating $49,200 for the engraving of maps and drawings to accompany the survey reports touched on familiar themes: Why expensive quartos instead of cheaper, more accessible octavos? Why commitments to

multivolume publishing projects of indeterminate expense? (The full series would cost the government over a million dollars, more than twice what the surveys themselves cost.) Where did the government receive constitutional authority to become a "book-making machine"? And why pictures? The maps could be justified given the intention of the surveys, but why the many plates, the costliest portion of the reports? A Missouri Democrat singled out "any drawing illustrative of Indian life or habits, or any drawing representing that country" as needless embellishment. A Marylander elaborated: "Elegant views of scenery, disquisitions and personal incidents, descriptions of the red men, and of the shooting of flying buffaloes, and all the matters of summer tours, which crowd the pages of all those reconnoissances which have been published during the last four or five years, have no business in Government publications, and ought not to be sanctioned." This pretty well covered Eastman's work for Schoolcraft and Stanley's for the survey reports, including sixty illustrations in the twelfth volume showing scenery, Indians, and buffalo. Doubtless some of the opposition was politically motivated, part of the sectional jockeying over future railroad routes. After all, the reports themselves were hardly neutral, and artists like Stanley contributed to their propaganda value by portraying noble savages inhabiting a "hospitable landscape." If advocacy by word could not be stopped, perhaps that by image could be.[58]

Still, the Stevens survey had been a godsend, carrying the Stanleys through 1855 and the birth of their first child, a son, on November 8. Stanley, busy with portraits and in the market for bounty land, wanted a parcel for his boy. In an upbeat mood, he was confident Congress could now be persuaded to buy his Indian gallery, and he confided to John Bartlett a scheme to put their cause in the hands of lobbyists who assured him of a positive vote. These "reliable agents of influence" would require 20 percent of any offer over $20,000, 10 percent of any below that figure. By Stanley's calculation, they could not go wrong. "I think it can be sold for $25,000 and perhaps 30—If we can realise $20,000 I will feel perfectly satisfied." He sought Bartlett's concurrence, and it seems likely he got it, since Bartlett made an effort to pay down the $500 outstanding on his quarter interest in the gallery. He gave Stanley a voucher for $324 made out to one James Henning and approved by Bartlett in February 1852, as commissioner of the Mexican Boundary Survey. It had subsequently been receipted back to him by Henning, and it was this well-traveled paper that Bartlett now proposed to sign over to Stanley for collection from the Comptroller's Office. It bogged down in the bureaucracy, even as Stanley's memorial reappeared in Congress after a three-year hiatus.[59]

On April 2, 1856, Senator John J. Crittenden of Kentucky, a former attorney general in two administrations who would play a prominent role in the last-ditch effort to forge a compromise over the secessionist winter of

1860–61, moved that Stanley's memorial, dormant in the Senate files since 1853, be dusted off and referred back to the Committee on Indian Affairs. Perhaps Crittenden acted out of altruism; perhaps he was one of those who would benefit if the gallery was sold to government. It is hard not to see influence peddlers behind the memorial's return. Stanley promptly wrote William Sebastian, still chairman of the Indian Affairs Committee, enclosing the Smithsonian catalog. He hoped Congress would buy his collection entire, landscapes and scenes of Indian life as well as portraits, and that the price offered would be adjusted upward from the $19,200 proposed in 1853 for the portraits alone. Stanley capped his case with an excerpt from Joseph Henry's report for 1852 praising his work and begged Sebastian's "favorable consideration."[60]

Apparently Sebastian again agreed to champion Stanley's cause despite refusing to do the same for Catlin. But the Indian Affairs Committee did not want to be encumbered with the memorial a second time, and on July 10 Sebastian moved for discharge. The Senate concurred. This was a major disappointment. Just the day before, Stanley had written to Bartlett that he was "much in want of money." The Comptroller's Office had in effect strung him along month to month only to decide that it could not honor the Henning voucher. Consequently Stanley would have to draw upon Bartlett at once for the full $500 owing on his quarter interest in the Indian gallery. From his timing it seems that Stanley had advance notice of the committee's opposition; thus the rush to collect from Bartlett, who would be understandably reluctant to pay the balance on what was again going to look like a bad investment. But Bartlett foiled Stanley. He refused to meet the demand note and instead proposed a modification in their agreement of March 15, 1853. He would take a one-fifth rather than a one-quarter interest in the Indian gallery, wiping out the $500 owing.[61]

Stanley had no choice but to accept. He sheepishly explained that he had been unaware of the form the Indian appropriations bill would take when he wrote Bartlett on the ninth. His tone was bitter:

> In reference to the prospect of selling the Gallery I will say that, up to the final passage in Senate of the Ind appropriation Bill I had entertained a strong hope that the Ind. committee would put it upon the Ind Bill, but I am informed the Committee *refused to entertain it—* Mr Sebastian the Chairman is favourable and now thinks he can induce Mr [James B.] Ricaud of Md. to put it upon the Library or General appropriation Bill—
>
> *I have no confidence now, that the Bill will go through—*If it should not—I propose Boxing the whole collection up and removing it from the Smithsonian

> Hereafter if Congress should desire the [to] preserve memorials
> of the In'd Tribes they will come to me—it is my *last* effort—

Stanley's exasperation was understandable. Bartlett had managed to wan-
gle out of his financial commitment even as a creditor was pressing Stanley
for repayment of a $200 debt and was furious that Stanley had not
honored his draft—no doubt because Bartlett had not met the $500
demand note.[62]

The incident shook some of the flowers and music out of Alice Stanley's
head. Being an artist's wife really was a matter of pictures, pictures, pic-
tures—and what they would bring. Though Stanley continued to paint
genre scenes and portraits, the bills came faster than the sales. The iceman
had to be paid. The church required $5.50 for pew rental. And now
another $200 owing. "Oh! I do wish we were free from old debts. . . . I
think then we might stand some chance of getting a house, for our little
family." That house had never seemed more remote. On August 11 Sebas-
tian, true to his word, had moved to have Stanley's memorial withdrawn a
second time from the Senate files for referral to the Committee on the
Library. But the session had adjourned on the eighteenth without further
action. Stanley, also true to his word, would not approach Congress again
until 1863. Instead, he turned his attention to the institution that had
housed his gallery for four years without paying any compensation. And he
made contact with Henry R. Schoolcraft—Catlin's nemesis, estranged
from Seth Eastman and, in 1856, still in need of an artist to illustrate the
sixth and final volume of his Indian history.[63]

* * *

Things started out promisingly. Stanley visited Schoolcraft sometime in
March and gave him a list of "subjects illustrative of Indian manners and
customs." He supplemented it by letter on the twenty-fourth, adding an
additional eleven possibilities mainly drawn from his experiences in the
Pacific Northwest. One at least appealed to Schoolcraft—"Chinook Burial
and Mourning"—since it would appear in the history. But as Stanley
pointed out, all the subjects named could be "made very desirable, combin-
ing peculiar customs with natural scenery—I could extend this list to any
number of illustrations you might desire." He especially recommended the
Upper Creek green corn busk that he witnessed in 1843 as a ceremony of
unusual pictorial interest "requiring some half dozen plates to illustrate." It
seemed as though the artist Eastman recommended as Catlin's superior
would now become Eastman's successor. But Stanley, assuming he would
be Schoolcraft's sole illustrator, assumed too much. Eastman had soured
Schoolcraft on artists in general. They were an unreliable lot, tardy and
given to whims, he would complain to the commissioner of Indian affairs

in 1857. They had delayed his work while using up most of his appropriation. The expense, of course, was in the lithography and engraving; illustrators, as Eastman could testify, had been poorly enough paid by the project. But Schoolcraft made no differentiation and saw no reason to extend Stanley any special courtesies. Thus he encouraged a second artist as well to contribute illustrations.[64]

Frank Blackwell Mayer, a native of Baltimore, came to Schoolcraft's attention in 1856 by way of an introduction from his uncle Brantz Mayer, a Schoolcraft critic and contributor. At the time, Frank Mayer was a twenty-eight-year-old with a background in the arts but without the accomplishments to match his pretensions. An aspiring history painter, he had read Bancroft, Prescott, and Irving for ideas—*Isabella Signing the Treaty with Columbus* would be a good possibility, he thought. His uncle had earlier found him employment as librarian with the Maryland Historical Society, but Frank chafed at the stultifying routine and considered the compensation ($150 a year) insultingly low. On a visit to Washington in November 1848, he went shopping for a position with one of the government exploring expeditions, preferably to California. The secretaries of the navy and war were not interested, but the Topographical Bureau offered encouragement, and Mayer left his application on file. Hearing nothing back, he spent his spare time the next year laboring for a fee of $375 over nearly a hundred drawings to illustrate his uncle's book *Mexico: Aztec, Spanish, and Republican*. The desire to make art his priority (and an apparent drop in his librarian's salary to $100) convinced Mayer to resign his position with the Maryland Historical Society in November 1850. "Work hard!" he exhorted himself in his journal. "I *must* succeed."[65]

Rather than reapplying for appointment as an expeditionary artist, Mayer resolved to go West on his own, and in the spring of 1851 he seized the chance to accompany a treaty commission departing Fort Snelling in late June for a major council with the Indians at Traverse des Sioux. A visit with Seth Eastman in Washington cemented his decision. The captain, then at work on the illustrations for the second volume of the Indian history, was "exceedingly polite" and furnished Mayer with letters and advice. Mayer thought Eastman's sketches "beautifully drawn" and superior to his finished pictures, reversing his own priorities in going West. He wanted to store up raw materials for subsequent refinement into polished works of art. Instead of Isabella signing the treaty with Columbus, it would be the American commissioners signing a treaty with the Sioux, but it was a priceless opportunity nonetheless. Mayer's diary indicates he took full advantage of it, making a leisurely return tour of the Great Lakes, Niagara Falls, and the Hudson River.[66]

Mayer's western observations did not free him from the grind of illustration and portraiture as he had hoped. Though his circle of artist

84. *Left.* Ashton White, *F. B. Mayer,* a companion's sketch of Mayer (1827–99) at the Traverse des Sioux treaty council in 1851. Courtesy of the Edward E. Ayer Collection, the Newberry Library, Chicago.

85. *Right.* Alfred Jacob Miller, *Self-Portrait* (ca. 1850). Miller (1810–74) looking much as he would have when Mayer visited in his Baltimore home. Walters Art Gallery, Baltimore.

friends still expected to see Baltimore become the cultural center of America, Mayer turned to daguerreotypy in the absence of patronage for the historical paintings he wanted to do. But an evening tea in 1854 with one of Baltimore's established artists, Alfred Jacob Miller, rekindled his enthusiasm for the Indians as subject matter. Miller, after all, was a pioneer among western painters. With his Scottish patron Sir William Drummond Stewart, he had ventured to the Rocky Mountains in 1837, seen frontier life and the Indians "in perfection," and returned with sketches "among the best ever executed." Miller had had the opportunity to work them up into a "gallery of Indian Scenes" for Sir William's castle in Scotland, and while the exertions of the western expedition had left him lame with rheumatism, he had done with his life what others only dreamed of doing. He was an inspiration. "The evening passed in very pleasant chat on Art and our mutual artist friends, the dead and the living," Mayer wrote. If Catlin's name came up in their conversation they would have discovered another bond. Tired perhaps of Sir William's tendency to defer to Catlin as the first among Indian painters, Miller in 1842 denounced him as a "humbug," his *Letters and Notes* as a collection of "extraordinary stories." This reversed Miller's earlier judgment, based on hearsay, that Catlin's pictures were "as especially bad, as his letters are admirable." Catlin was a failure both as artist and as observer.[67]

Mayer concurred. Although he named Catlin (and Stanley for that matter) among those who had painted Indians, he fell under the sway of Henry Sibley on his tour of Minnesota in 1851 and noted in his diary that

301

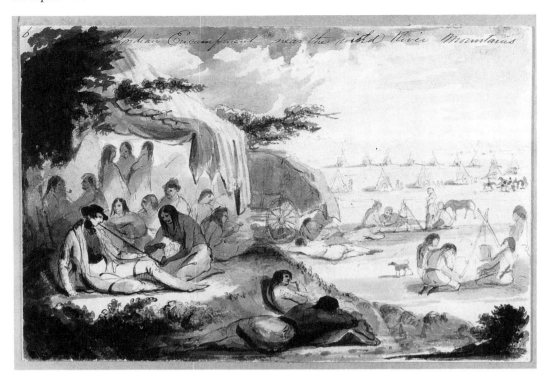

Indian Encampment near the wild River Mountains

86. Alfred Jacob Miller, *Indian Encampment Near the Wind River Mountains,* a vision of Indian country as romantic paradise, with a languid Sir William Drummond Stewart (1796–1871) being attended hand and foot. Courtesy Buffalo Bill Historical Center, Cody, Wyoming.

Catlin was considered an *"exceedingly* questionable authority." This confirmed his opinion that Miller was the best painter of Indian life, superior to both Eastman and Catlin. He turned to the subject himself with a feeling for its artistic pedigree; but he may not have realized he was going to be running John Mix Stanley direct competition when he approached Schoolcraft with an offer to illustrate Indian scenes for the sixth volume of the history.[68]

In fact, for all his youthful exuberance, Mayer was not really suited to the task. He would finish two drawings, *The Feast of Mondamin* in January 1857 and *Ceremony of the Thunder Birds (Sioux)* two months later. These were not sketches of the sort Eastman and Stanley provided the engravers, but detailed composition studies for major paintings. Mayer solicited Schoolcraft's suggestions, sought information to incorporate in his drawings, and generally created the impression that he was an eager learner looking for a break. In fact, he was as fixed in his artistic principles and as adamant about his rights as his lawyer-uncle Brantz. When he forwarded *Feast of Mondamin,* it came with a demand for $200, copyright, and early exhibition in Washington and Philadelphia, where the engravers were cautioned to handle it with extreme care. Mayer had received training as an illustrator and knew the rules for drawing for engraving (*"cleanliness & sharpness of outline with strong contrast of light & shade or rather of black &*

white"), but he defied them all, to the despair of Lippincott's engravers. However, since he aspired to be a fine art painter, with the distinctions that implied, he was not offended by the complaints about his work as illustrator, and his relationship with Schoolcraft remained cordial, if limited to the two plates for the sixth volume of the Indian history.[69]

In 1871, with the backing of Sibley and others, Mayer would petition the Minnesota legislature for a commission for $10,000 to paint the Sioux treaty council he had witnessed twenty years before. This would be the fulfillment of his original aspirations. Turned down, he tried again, reducing his price to $8,000, then $3,000. In 1885 he prepared an oil sketch for the proposed mural—all to no avail. The Indian had proved an artistic dead end; the modest fame Mayer did achieve would be principally as a painter of historical scenes and genre pictures with an allegorical twist. After his death in 1899, his sketch of the Sioux council, sold to the Minnesota Historical Society for a token $200, was worked up into a mural for the new state capitol by another's hand.[70]

Stanley would have understood Mayer's frustration. He was himself involved with Schoolcraft only because government patronage had proved so elusive. He too would be represented by two plates in the sixth volume

87. After Frank B. Mayer, *Feast of Mondamin,* faithful to Mayer's artistic ideal but an unwonted challenge for the engravers. Henry R. Schoolcraft, *History of the Indian Tribes of the United States . . .* (1857).

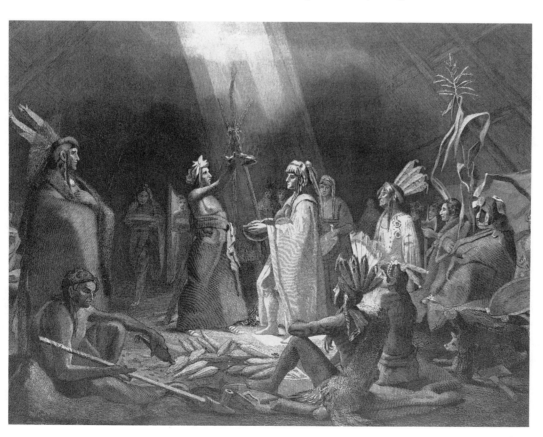

of the Indian History, *Gathering Tepia Root in the Prairies* and *Chinook Burial*. But his parting from Schoolcraft was more in keeping with Eastman's than with Mayer's. Mayer had been interested in the history because he wanted exposure, and he left it without hard feelings; Stanley needed money, not publicity, and abruptly ended his involvement when he realized that Schoolcraft intended to deny him the exclusivity Eastman had enjoyed while offering him minimal compensation. "It was understood between us that I should furnish all the illustrations, and that in doing the smaller, and less important ones I would be remunerated for the larger," he complained to Schoolcraft on October 8. "The prices were to be twenty—forty, and sixty dollars—Now while twenty dollars will not compensate me for historical plates—and as you have determined to select the majority of your illustrations from some other artist I must respectfully beg to be relieved from the work." Schoolcraft, niggardly, pompous, and unpleasant, had managed to alienate America's three most important Indian painters in the course of compiling his history. He was fortunate his series ran out at the same time as the supply of artists.[71]

It had not been a happy experience at the end. Schoolcraft's paralysis confined him to his study where, by correspondence, he learned what a nuisance he was considered by the latest secretary of the interior. His superiors viewed his compilations as costly annual embarrassments, and they strove to wrap up their involvement with him and get him off the public payroll.[72] Congress had limited the series of collections to five volumes; the sixth was meant to be a grand summation. To prove it was

88. Frank B. Mayer, *Treaty of Traverse des Sioux* (1885), the oil sketch Mayer hoped would secure a major public commission. Minnesota Historical Society.

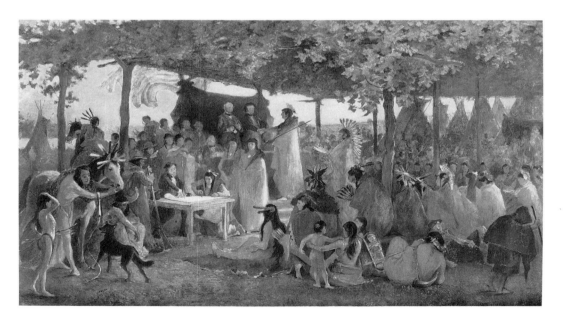

89. After John Mix Stanley, *Chinook Burial. Oregon,* one of two plates Stanley contributed to Schoolcraft's *History of the Indian Tribes of the United States . . .* (1857).

not just more of the same, Schoolcraft retitled it. *Ethnological Researches Respecting the Red Man of America,* the running title in the previous volumes, was replaced by *General History of the North American Indians.* Schoolcraft wrote most of the *General History* himself, and his habit of self-citation reached epidemic proportions. When he could not find a Schoolcraft work to footnote, he threw in a chatty scrap of Schoolcraft family history. His portrait served as the frontispiece; Congress had unwittingly subsidized a private monument. But it was not a finished monument. A self-confessed fact grubber, Schoolcraft was in well over his head. The required synthesis eluded his abilities, and he could not deliver on the promise that had secured him the commission in the first place: to produce through scientific ethnological inquiry a practical guidebook for Indian policymakers. Almost eleven years of federal funding had produced six huge volumes that were a puzzle to antiquarians and of no conceivable assistance to government. Schoolcraft was aware of the unfinished state of his monument; he included in the table of contents to the sixth volume two sections "precluded by the limitation of the work." The last, the capstone, was to have been "Indian Policy and the Indian Future." Its absence was an

admission of defeat. Schoolcraft's self-assessment in the preface was un-characteristically acute. "If assiduity merited success," he wrote, I "might claim it."[73]

As an episode in the story of American patronage, Schoolcraft's Indian history was no triumphant success. It remains an ethnological curiosity—vast, disorganized, uneven, with valuable information crowding against the worthless. As a repository of midcentury attitudes, however, it is a primary source for cultural historians, and its illustrations are chief among its virtues. The Indian history had provided a showcase for Seth Eastman's artistry and, in its last hurrah, an opportunity for Frank Mayer and John Mix Stanley to enshrine samples of their work in the most elaborate series on the Indian the federal government had ever sponsored. Here, truly, were to be found the pictures of Indian life and flying buffalo that, de-plored by some contemporaries, have come to be treasured by posterity.

* * *

Stanley continued to paint portraits, genre scenes, and historical oils based on his western experiences. Eventually his long residence and his active involvement in local artistic affairs made him a fixture in Washington. A daughter was born in 1858, adding to his family responsibilities, and though he was said to command so much for a portrait that only the rich could afford him, his debts continued to mount. One senses a crisis at hand that year. Stanley could no longer afford to let his principal asset, the Indian gallery, sit idle in the Smithsonian. In his annual report of January 1857, Joseph Henry had again urged action on Congress, warning: "Mr. Stanley, though possessing much enthusiasm and liberality in regard to his art and commendable pride in this collection, will feel compelled, in justice to his family, to dispose of it to individuals, unless Congress becomes the purchaser." Henry was serious, but Congress was not. Consequently he launched a major initiative in 1858. The Stanley gallery was still on display at the Smithsonian, augmented over the past year by new pictures; it was now "the most extensive in existence, of Indian portraits," and visitors to Washington always sought it out. Unless the government acted at once to fulfill its "sacred duty . . . to the civilized world," however, the collection would have to be broken up. "Such an event would be a lasting source of regret," Henry reported, confident Congress would not allow it to come to pass.[74]

Henry's plea was part of a coordinated effort. On January 23, 1858, Stanley himself addressed the Smithsonian's board of regents. His message was the same as always—purchase my collection or it will be lost—but his price had changed. The entire collection cataloged in 1852, 152 paintings, was the Smithsonian's for $12,000—one-third down and the remainder in two equal annual installments, or a quarter down and the rest in three equal annual installments. It did not matter to Stanley; he needed money,

and his letter was in effect an admission of defeat. Since 1852 he had been hoping in vain that Congress would buy his gallery. From "a national point of view" no other collection was of comparable interest. The price asked would merely defray expenses incurred in its creation, profiting him nothing. "His ardent desire that they should be preserved, as a national work, in some place at the capital of our country," Stanley wrote, "his failure heretofore to induce Congress to agree to their purchase, and the more pressing reasons of *liabilities* now maturing, impel him to make this proposition." The use of the third person conveys the impression that Stanley was dissociating himself from such a bargain-basement price: only $12,000 for his entire Indian gallery! But practical concerns were pressing enough for him to set a deadline. Either the board acted before May 1 or he would auction the paintings off to meet debts maturing that day.[75]

Artists were given to crying wolf, but the board was sufficiently impressed by the urgency of Stanley's letter (and follow-up notes addressed to each member individually) to strike a three-man committee at its meeting of January 28. It reported back on May 19. The committee members sympathized with Stanley, recognized that the suggested price of $80 per painting was "much below their real value," and agreed that the collection should be "preserved entire" for posterity. And they concurred with Henry in urging that Congress purchase it for permanent display in the nation's capital, where it rightfully belonged. But rhetoric did not conceal the disappointing fact that the board would not recommend buying the Indian gallery out of Smithsonian funds, intended, as Henry always insisted, for the increase and diffusion of knowledge. The Smithsonian best advanced ethnology by subsidizing the publication of research reports and grammars of the Indian languages, not by buying pictures.[76]

No one was more surprised than Joseph Henry. Anticipating a favorable report by the select committee, he had done something entirely out of character. The May 1 deadline had come and gone. Alice had got her little family home after all, but Stanley could not meet the payments. Moved by his plight, on May 12 Henry had borrowed $800 and lent it to the artist along with $400 of his own funds. The loan was secured by a deed of trust to "all & singular the paintings known as the Stanley Gallery of Indian Portraits." The negative report to the board of regents thus came as a shock to Henry. "I was induced to make the advance with the idea that the Regents would assume the debt & thus have a hold on the pictures until such times as the Govt shall be induced to purchase them," he wrote, "but it was not thought advisable to advance money in this way & therefore I assumed personally the debts after taking a judgment on the property." Henry's intervention was a poor business decision but a noble-hearted gesture attesting his faith in the value of Stanley's gallery. When he next recommended its purchase, self-interest was also at stake, since any pros-

pect of recovering his money depended on favorable action by Congress. That became clear on December 31, 1858, when the first of two $600 installments on the loan fell due. Stanley defaulted.[77]

Henry had cause to be upset. While he worried over summer about paying his own $800 loan, the Stanleys vacationed for six weeks in New Jersey, and on their return began redecorating two spare rooms upstairs in the house that had precipitated their financial crisis in May. Henry's money probably paid for the new wallpaper. But if such extravagance in the circumstances was tactless, it was their private business. The same could not be said of Stanley's failure to disclose in the deed of trust that his collection was already one-fifth encumbered. Stanley had managed to forget about John Bartlett, but Bartlett had not forgotten about Stanley or his $2,000 investment. An inquiry in May 1859 brought an evasive reply from Stanley. He had done his best to dispose of the gallery to the Smithsonian the previous year for, he claimed, $15,000. A committee was appointed, "but I believe no written report has, as yet been made—Prof Henry— however informed me that the Inst could not of itself, entertain the proposition—but would appeal to Congress in my behalf." Bartlett could easily enough check out the actual offering price—$12,000—which, if accepted, would have given him only a $400 profit on his $2,000 share instead of the 100 percent profit he had originally anticipated or the $1,000 profit Stanley was now suggesting he had been willing to settle for. Bartlett could also easily learn that a written report had indeed been submitted to the regents. What he did not know was that the gallery he co-owned had for one year been securing a personal loan to Stanley.[78]

Stanley continued in a disingenuous vein. He was "quite as anxious" as Bartlett to realize something from the gallery, but he had exhausted the possibilities in Washington. Could Bartlett approach the New-York Historical Society or the Aboriginal Museum said to be forming in Boston? The gallery had expanded since Bartlett last saw it, and even if the historical society and the museum in the end turned it down, any show of interest on their part might be enough to induce the Smithsonian to "interpose,—& purchase." Stanley urged Bartlett to move "*speedily*"; if his creditors were on his heels once more, Henry probably led the pack. Stanley had paid neither principal nor interest on the $1,200 loan, a situation that was unchanged that December 31 when he was supposed to make the final installment.

It must by then have dawned on Henry that he was probably never going to see his money again. But if his principal was out of reach pending sale of the gallery, he at least wanted the interest owing. And since he had made the loan to save the collection for the Smithsonian, it was up to the Smithsonian to enable Stanley to pay that interest. At a meeting of the board of regents on March 17, 1860, Henry made an extraordinary request: an allowance of $100 annually to be paid Stanley to cover the

interest "on a debt he had incurred to prevent the sacrifice of the paintings by sale." In other words, Henry proposed to pay himself; and since it was the board's unexpected stinginess in 1858 that had put him at financial risk, he expected them to provide. The members must have shared his sentiment. The Smithsonian had enjoyed free use of the paintings nearly a decade by then, and $100 a year was little enough in way of compensation. Consequently Henry's request was referred to the secretary—himself—and the executive committee for a favorable decision. That May 14, on the second anniversary of the loan, Stanley made his first interest payment—a double payment, in fact ($144 at 6 percent per annum), to cover the previous year's interest as well. Thereafter he met his annual obligation more or less on schedule, prompted by an allowance that permitted him to pocket $28 each year for his own use. Such was the net yield of John Mix Stanley's Indian gallery.[79]

* * *

The contrast between his reputation and his financial situation, a constant irritant, must have struck Stanley with particular force in 1860. He was a respected member of Washington's artistic community, exhibiting frequently, moving with ease from portraiture to genre and, increasingly, to landscape. Landscape painters abounded in Washington, Charles Lanman among them, bringing a touch of the Hudson River to the Potomac, and Stanley benefited from exposure to their work. "Wedded to his art as a lover to his mistress," he was also devoted to the idea of art as a legitimate profession. In mid-June 1860 he joined Seth Eastman, their mutual patron William W. Corcoran, and a select list of others in incorporating the National Gallery and School of Arts, and thereafter devoted a portion of his time to its affairs.[80]

Such activities offered a welcome relief from the runarounds that were so much a part of doing business in the nation's capital—"a shaking off of responsibility except in *very large matters*," as Stanley put it. Indeed, his mounting frustration was shared by other local artists. He and Eastman both held office in the Washington Art Association, founded in 1856 and, along with the National Art Association, dedicated to securing commissions for native artists to decorate the Capitol building. There was self-interest at work here—anger that federal patronage was going to foreigners, as well as nativistic bluster and an awareness that artists formed a distinct professional group government ought to consult. This professional consciousness had been evident in 1846 when Catlin's bid for congressional patronage was supported by artists as eminent as Asher B. Durand, who in 1858 would sign a memorial to Congress drawn up by the Washington Art Association protesting the "injustice" of employing foreign artists to decorate the United States Capitol and urging the establishment of an art commission to advise Congress upon future patronage

decisions. The three-man commission appointed the following year included John F. Kensett, who signed the letter from Paris in 1846 supporting purchase of Catlin's gallery, and Henry Kirke Brown, who as a young sculptor resident in Florence in 1843 had consulted Catlin as "the fountain head" of information on the Indian. Stanley used a similar image in congratulating Brown on his appointment to the commission: now Washington would be in truth "the fountain of our brightest hopes." Patronage, he meant. The commission did use its mandate to press the case for congressional support of native artists, but it was dissolved after a year, and with it Stanley's "brightest hopes."[81]

Stanley never gave up on his Indian gallery, however. With Bartlett and Henry pressing him periodically for repayment, he could not. Despite past failures, he was actively thinking of appealing to Congress again as it prepared to convene for the critical session of 1860–61. Stanley sent a draft memorial to Bartlett for his suggestions, and while acknowledging that it would probably be "a bad season for a favorable consideration of the subject," determined to go ahead. In the event of another negative decision, he would remove his gallery from the Smithsonian and exhibit it in the quarters formerly occupied by the Washington Art Association on Pennsylvania Avenue, where the public would have to begin paying for what it had always seen free. He hoped Bartlett, in Providence, would bring pressure to bear on the Rhode Island senators; Stanley felt more confident of his ability to sway members of the House, and if the memorial could be introduced jointly and a select committee of those friendly to the measure formed, "speedy action" would follow. At the least, the Smithsonian might be prodded into action. The election of Abraham Lincoln and the secession crisis over winter rendered Stanley's plans nugatory, and by the summer of 1861, with the Civil War a reality, he was looking abroad to sell his collection and perhaps to relocate.[82]

Disloyalty or a desire to escape the ravages of a war that had proved unpredictable in its early months played no part in Stanley's plans. Indeed, he spent a few days in June with a camp of Ohio volunteers close to the action as General Robert C. Schenck attempted to take a Confederate battery near Vienne in Virginia. What he saw fired his lust for adventure and left him eager to serve. He had his application for an appointment, endorsed by Schenck and a few friends, before the secretary of war, but at the age of forty-seven he was realistic about his chances. He was more concerned that his commander and comrade on the 1853 railroad survey, Isaac I. Stevens, be shown the respect due his record and "get a place commensurate with his merits" in the army. Stevens did—he was appointed colonel of a volunteer regiment and the next year died a major general leading a charge at the battle of Chantilly.[83]

Stanley was neither so fortunate nor so unlucky. His interest in England

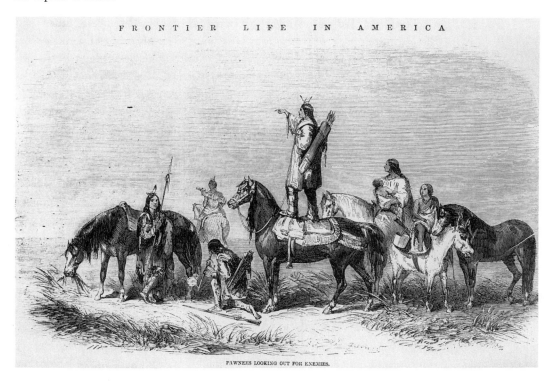

FRONTIER LIFE IN AMERICA

PAWNEES LOOKING OUT FOR ENEMIES.

90. After John Mix Stanley, *Pawnees Looking out for Enemies,* provided Stanley some exposure abroad. *Illustrated London News,* April 3, 1858.

was a commercial calculation. He had talked about exhibiting his Indian gallery there for years. London had lured McKenney and Catlin, Schoolcraft and Squier, Barnum and a raft of panoramists. Why not Stanley? His work had received flattering attention in the London press when the *Illustrated News* in 1858 reproduced his painting *Pawnees Looking out for Enemies* as one in a series on "Frontier Life in America." Perhaps the market that Catlin had never found in England existed for *his* gallery. And in the present distressed state of affairs in America, the British Museum was a better prospect than the Smithsonian. The Smithsonian's board would not sit during the special session of Congress scheduled for the summer, and Henry was frank to admit that even were it to sit "nothing would be done" about Stanley's gallery. Although Henry thought the decision to sell abroad regrettable, he agreed to exert his influence on Stanley's behalf.[84]

Stanley involved John Bartlett in his plan as well. He wanted to set the asking price low enough to win "favourable consideration" and was prepared to accept $8,000 for his share. Bartlett presumably would receive $2,000 for his one-fifth interest—the very sum he had sunk into the gallery eight years earlier. It was larger now than then, about 160 oil paintings, all framed. But Stanley was so desperate to sell to the British Museum that he was willing to throw in a collection of Indian costumes as a sweetener. Stanley wanted Bartlett to work through Henry in approaching the museum. This was in keeping with his strategy of pressuring the Smithsonian,

311

and it could do no harm for Henry to hear from someone other than himself that the gallery really was going to be offered, and perhaps sold, overseas. By 1861 Henry was likely aware that Bartlett held a one-fifth interest in the paintings, though Bartlett may still not have known that Henry held title to the whole collection as security on a loan amounting to only 60 percent of Bartlett's investment. Even if he did know, Barlett may not have been bothered, since Henry would never foreclose on Stanley, and the question of ownership of the gallery was thus academic pending its sale. Indeed, with Stanley meeting the interest payments on his loan out of the $100 annual allowance provided him by the Smithsonian, Henry was quite prepared to outwait his own board. And if, in the meantime, Stanley sold the collection abroad, Henry's regret at its loss would be tempered by the recovery of his $1,200.[85]

Stanley was serious enough about selling to the British Museum to angle for an appointment that would take him to England, where he could make his pitch in person. Perhaps he could be United States commissioner to the international exhibition scheduled for London in May 1862. He would represent America's industrial interests to the best of his abilities. He understood the compensation would be meager, but that might prove an advantage, discouraging other applicants. Should he succeed, he would be "in a position to effect a sale of the Gallery to some gentleman of fortune" (perhaps another Sir Thomas Phillipps) in the event the British Museum turned him down. What he needed was Bartlett's backing. As a resident of Washington, Stanley had no representatives in Congress he could call on for favors, but Bartlett did. A few words to Rhode Island's senators might still do the trick.[86]

As one who had sought a diplomatic posting to further his own antiquarian research, Bartlett sympathized. Indeed, he had already taken the initiative in writing to the British Museum about the Indian gallery. The reply offered "some ground of hope," Stanley thought, though the museum was concerned that his collection include a representative sampling of Indians from the British colonies. Stanley tried to bluff his way around the problem: "The type of the tribes inhabiting the Atlantic & Pacific coast—with the intermediate tribes from Florida south, to the British possessions north," could be found in his gallery—the *type,* but not individual Canadian Indians. Paul Kane had the monopoly there. By the time Bartlett heard back from the museum, Stanley had already abandoned the idea of seeking an appointment abroad. He would soon be immersed in his Civil War panorama. Meanwhile, portraiture continued to provide a reliable income. Stanley's recent sitters included the first secretary of the interior, Thomas Ewing, and the current secretary, Caleb B. Smith. Smith had taken a personal interest in Stanley's gallery. With help like his, it might yet find a permanent home in the United States.[87]

We have no idea how Bartlett responded to this abrupt about-face or, indeed, what became of his partnership with Stanley. Apparently, they did not correspond again. Perhaps Stanley found some means of paying Bartlett out. In January 1863 he got around to presenting the long-promised memorial to Congress. His timing was inauspicious, with the nation entering on the third and, events would prove, the bloodiest year of the war. Still, Stanley must have received some assurances that his petition would be taken up; perhaps he hoped to capitalize on the interest in his Civil War panorama. The Indian gallery was another patriotic project that deserved recognition. Stanley's latest memorial was essentially unchanged, though presented in a more sophisticated form. It was printed for distribution to each member of Congress, and the appended testimonials were augmented by excerpts from Joseph Henry's annual reports and that to the board of regents, tabled in 1857.[88]

A New York Republican introduced Stanley's memorial in the House on January 22. It was referred to the Joint Committee on the Library and promptly forgotten, hardly surprising in the midst of war. But not just momentous events on the scale of the fall of Vicksburg and the battle of Gettysburg doomed Stanley's appeal. Even the Indian situation was inauspicious. The day his memorial was introduced in the House, the Senate debated compensation to white settlers in Minnesota for loss of property in a devastating Sioux uprising the previous year. Little Crow, whose camp Stanley sketched in 1853, and who reportedly paid tribute to the verisimilitude of Stanley's panoramic view, was in hiding and would be dead by summer. There never seemed to be a right moment when it came to selling an Indian gallery. Empires collapsed on Catlin, and wars were always raging. As Joseph Henry noted in February 1863, "it is to be feared that by reason of the present condition of the country Congress will not think it advisable" to purchase an Indian gallery. Though no one knew it at the time, Stanley had made his last bid to Congress and Joseph Henry his final endorsement. The Indian gallery was a dead letter. That April Stanley paid Henry the usual $72 interest owing on the loan; he would not make another payment.[89]

Fed up with the rebuffs he had been meeting since 1852, and unhappy with the high cost of living in Washington, Stanley had resolved to move his family elsewhere. The death of a new baby that year may have contributed to his decision. By September 1863 he was settled in Detroit. His family joined him shortly after. He would live out his days there, basking in the praise that came with local pride. Detroit would appreciate him as Washington had not.[90]

 * * *

Stanley left behind his Indian gallery, but not his desire to sell it. Detroit brought a fresh perspective, shifting his attention from the federal govern-

91. A portion of Stanley's Indian Gallery on display in the Smithsonian; in the foreground, a copy of the *Dying Gladiator,* appropriate in an age prone to link the noble savage and the classical ideal. *Annual Report, Smithsonian Institution, 1924.*

ment. He thought of the New-York Historical Society as a matter of course, though their resources were never adequate to the demands upon them. Disposing of the gallery became an issue as the anniversary of the loan from Joseph Henry drew near and Henry pressed for repayment in full, not just for interest owing. He did without either in 1864, Stanley's allowance from the Smithsonian having apparently ended with his move to Detroit. But by the next year a breakthrough was in sight. The University of Michigan wanted Stanley's Indian gallery, and citizens were circulating petitions urging purchase by the state legislature. In response, the legislature delegated a Detroit woman to inspect the collection in Washington and confer with Henry about its possible acquisition. Success appeared imminent when disaster struck.[91]

About three o'clock on the afternoon of January 24, 1865, a fire broke out under the roof of the main building of the Smithsonian Institution. In a matter of minutes it destroyed the upper story, including the gallery of art in which the Charles Bird King Indian portraits and Stanley's entire collection hung. A stovepipe mistakenly inserted into an opening under the rafters instead of the chimney flue was the culprit. Workmen charged

314

92. John Mix Stanley, *Black Knife, an Apache Warrior* (1846). One of the few paintings rescued from the fire that destroyed Stanley's gallery in 1865, it appears top right in fig. 91. National Museum of American Art, Smithsonian Institution; gift of the Misses Henry, 1908.

with the task of rearranging the paintings in the gallery had used a coal stove to fend off the chill January air. The main building was assumed to be fireproof, but the wooden rafters were not, and when they caught fire the slate roof collapsed, showering the rooms below with burning debris. A workman perched on a ladder had tried to remove the larger pictures but was forced to abandon the rescue attempt when the roof caved in. Only five paintings were saved—a "sad catastrophe," Henry wrote Stanley, offering the cold comfort that he had himself lost records, correspondence, and manuscripts.[92]

Stanley was despondent. The day his paintings went up in flames he had written Henry about the move afoot in the Michigan legislature to acquire his Indian collection for the university at Ann Arbor. And only minutes before the first alarm sounded Henry had escorted the legislature's representative around the gallery while she made her inspection. "It seems as if its destruction came at the moment when the artist's dearest hopes were about culminating and the loss is correspondingly greater," a Detroit paper commiserated. Stanley's loss was literally irreparable. King's pictures had been copied in oil and reproduced in McKenney and Hall's Indian history,

but no copies existed of Stanley's portraits. His financial loss was also absolute. He had never insured the paintings that, as Henry delicately phrased it, he "principally owned." Another owner, of course, was Henry himself, since the $1,200 loan had never been repaid. He still held some security, however—the five paintings rescued from the flames. In his official report on the fire, Henry evaluated the collection at $20,000, Stanley's highest estimate and the best figure to float in case of congressional compensation.[93]

Indeed, there was an initial rush of sympathy for Stanley. Petitions were circulated in Detroit and in the nation's capital. Augustus C. Baldwin, a congressman from Michigan, was prevailed upon to introduce a memorial in the House on February 20 asking that Stanley be employed by Congress to paint two or more Indian scenes. John Ross, principal chief of the Cherokees, the commisssioner of Indian affairs, and his assistant were among those who signed, "impressed with the conviction that the pencil of the artist, as well as the pen of the historian, should be employed to commemorate the aboriginal race of our country." The proposed resolution called for a single painting "to be placed at the head of one of the grand staircases in the Capitol," the subject to be determined by the Joint Committee on the Library and Stanley, who would receive up to $25,000 for the commission, $2,000 in advance and the rest in yearly installments. The proposal coincided with Stanley's current project. He was working on a huge historical oil, six feet by nine, *The Trial of Red Jacket*. It was already half-finished and would ideally suit the purposes of the resolution. But as Henry pointed out, the session was too far advanced to expect action. A petition introduced in the next session would have a better chance, and Henry promised to throw his full weight behind it.[94]

As Henry had predicted, no action was taken on Stanley's memorial. Stanley's suppressed anger over (as he now saw it) having been led on for years to believe that Congress intended to acquire his gallery came boiling up, and he put a face to his frustration by blaming Henry, "the illustrious secretary of that Institution," as he sarcastically referred to him. It was Henry who had annually indicated that purchase was imminent. Trusting his judgment, Stanley had for fourteen years exhibited his collection at the Smithsonian "without fee or charge of any kind whatever." It was Henry who had insisted on moving the paintings from the West Wing Library Room to the art gallery in the main building to give the public "a better opportunity to see the pictures and to add an additional feature in the attractions of the Institution." It was Henry who had assured him that the art gallery was fireproof and his pictures safe, convincing him insurance was unnecessary. Thus Stanley's "entire loss" could be laid at Henry's door.[95]

Stanley argued his case in a memorial introduced in Congress on Janu-

ary 8, 1866. This time he asked not for a commission to execute a new painting, but compensation for those lost in the fire. His case turned on what he considered a moral obligation, though he tried to imply more. He had "consented to allow" his paintings to be displayed in the Smithsonian art gallery on the tacit understanding they would one day be purchased. At the time of their destruction, then, they were "on exhibition in a Public Building immediately under the control of the Government and where they had been freely enjoyed by the public for a period of 14 years." It was a public employee who misconnected the stovepipe; and the building instead of being fireproof was constructed partially of combustible materials. This, to Stanley's mind, added up to a case of negligence justifying "remuneration for the great loss" he had sustained.[96]

Stanley's memorial caught Henry unawares. He may have heard of a move in Michigan the year before seeking direct compensation for the Indian gallery, but in his annual report of January 1866 he alluded only to the possibility that Stanley would be commissioned to paint an Indian picture for the Capitol. Stanley's case for compensation turned on negligence, something Henry would not willingly bear, and it was pretty flimsy after all. The Committee on Claims, to which the petition was referred on January 8, promptly rejected it. Stanley had placed his pictures in the Smithsonian on the speculation that Congress would buy them. This was his decision alone, and the United States was not "in any manner responsible." Sympathy left off where compensation began.[97]

If Stanley was bitter, he should not have been surprised. The year before he had candidly admitted, "I had no insurance, no guarantee—no claim that I *yet* know, upon the Institution for damages—or loss." Subsequently he would seek a different form of redress; for the time being, the Detroit *Post* put a cap on the matter: "Political boobies may have forgotten his great loss; *his countrymen never.*"[98]

93. George Catlin in Brussels
in 1868, the epitome of pride,
fortitude, and indomitable
will. Who could doubt he
would one day rout his detrac-
tors and win lasting renown?
Photograph courtesy of Na-
tional Museum of American
Art/ National Portrait Gallery
Library, Smithsonian Institu-
tion.

No one but myself, yet knows the difficulties I had to encounter—and the circumstances under which a great portion of my paintings were made. . . .

I have half a dozen times exhausted all my earthly means, and as often "picked up" again by the labours of my brush. My Indian paintings, if I live to get them all together, will count over *12,00*. I hope to show them awhile before I leave the stage.

George Catlin to William Blackmore, April 28, 1871

Now I Am George Catlin Again

Exile and Return, 1852–1871

John Mix Stanley had reason to resent Joseph Henry. The "illustrious secretary" of the Smithsonian was unduly slow in informing him of the circumstances of his loss by fire in 1865 and, cut and dried by nature, was capable of a wounding objectivity. Henry even managed to find an improbable blessing in the disaster: it would make better fireproofing mandatory, thereby safeguarding the institution's future holdings, which were certain to greatly exceed those of 1865 in extent and value. In Henry's view the "most irreparable loss" was his own records. As for the Indian gallery, he sympathized with Stanley but was "gratified to learn that the extensive collection of Mr. Catlin, of a similar character, has been

purchased in Europe by Mr. Harrison, of Philadelphia, and will be rendered accessible to the student of ethnology."[1]

The irony was perfect. Stanley had seen in Catlin's congressional defeat of 1852 the pathway to his own preferment; thus the decision to leave his pictures in the Smithsonian, where thirteen years later they went up in flames. Dame Fortune, so often fickle, had smiled at last on George Catlin. Fire had eliminated his only serious competitor, permitting his hopes to rise from the ashes of another's despair. His collection might yet find a permanent home in the seat of government, and he that personal vindication that alone could justify the sacrifices of his "erratic career."

This chapter chronicles the rise of George Catlin after his precipitous fall in 1852, his amazing second career as an Indian painter, and his continuing quest for patronage. It culminates in his decision in 1871 to return to his native land to live out his days—and see if by chance Congress or some American institution was in the market yet for an Indian gallery. Or two.

* * *

When the Senate rejected the bill for purchase of Catlin's Indian Gallery in July 1852, George Catlin was a ruined man. With three English creditors holding notes secured by an interest in his gallery and Catlin hiding out in Paris, it seemed a certainty his collection would be dispersed. This would not be one more in a series of disappointments; it would be the end to all his hopes. Nothing could recreate his collection once it was scattered. Where would he get another decorated Crow tipi, a collection of red pipestone calumets, weapons and drums, necklaces and moccasins, shields and headdresses, men's and women's outfits from every tribe? Where would he get another Mandan robe, illustrated with pictographic scenes recounting the principal exploits in the career of the lamented Four Bears? When they were lost they could never be replaced, nor could his gallery be reassembled.

At this critical juncture in the Catlin story, a hero appeared. Joseph Harrison, a fellow Pennsylvanian fourteen years Catlin's junior, was passing through London after nearly a decade in Russia. A mechanical engineer with a flair for invention and an aptitude for business, Harrison had just built the fleet of cars and locomotives for the railroad from St. Petersburg to Moscow and, richly rewarded by a grateful Emperor Nicholas, was returning to his native Philadelphia, the kind of success Catlin only dreamed of being. A patron of the arts, Harrison had also lent Catlin money. With a part interest in the gallery as his security too, he attended the creditors' meeting. To everyone's surprise, he offered to satisfy all claims on the collection—an offer quickly accepted. Harrison then packed up the paintings and relics and shipped them home for storage in Phila-

94. Dennis B. Sheahan, *Joseph Harrison, Jr.* (1874). Catlin thought Harrison (1810–74) a rescuing angel in 1852, but in time he came to see him as something less than the noble republican patron portrayed in this bust. Courtesy of the Pennsylvania Academy of the Fine Arts, Philadelphia; bequest of Mrs. Joseph Harrison, Jr.

delphia, beyond the reach of other creditors who might subsequently surface. In "the explosion of my pecuniary affairs in London," Catlin wrote, "I was lost; but *my collection* was saved to my country by an American gentleman,—an act so noble and so patriotic that I cannot believe my country will forget it." Harrison's was not disinterested philanthropy. Catlin's debt remained, $8,000 to $10,000, interest accruing; he could reclaim his paintings when he could repay Harrison, and not before. Meanwhile his collection was intact, and Harrison, in Catlin's fond recollection, a rescuing angel who had closed the unhappiest chapter of his life on the happiest note imaginable.[2]

George Catlin came out of 1852 empty-handed but much wiser. From the debates in Congress, he knew of his two rivals in Washington, Seth Eastman and John Mix Stanley. And he knew who to blame for all his troubles. No longer operating sub rosa, Henry R. Schoolcraft had openly declared himself Catlin's enemy. Official historian and ethnographer to Congress, he was determined to be America's sole Indian expert. More than Eastman with his phantom gallery and Stanley with his real one, Schoolcraft was a dangerous rival. He had found parts of Catlin's *Letters and Notes* offensive, and so he concluded they were offensive to truth. His government-sponsored Indian history was intended to rescue the subject "from a class of hasty and imaginative tourists and writers, whose ill-digested theories often lack the basis of correct observation and sound

deduction." "Hasty," "imaginative," "tourist"—code words for George Catlin. Two issues gave focus to Schoolcraft's attack.[3]

 ✶ ✶ ✶

Catlin organized both volumes of *Letters and Notes* around a major "discovery." Over half of the first was devoted to the Mandans of the Missouri, climaxing in an account of their annual religious ceremony, the O-kee-pa, and several chapters of the second to the Indians' great mystery place beyond the Upper Mississippi, the red pipestone quarry. Catlin claimed primacy in describing them and implied he was the first to see them as well. His pretensions were attacked on two separate fronts. The Missouri River traders disparaged his account of self-mutilation and torture among the Mandans, while the Mississippi River traders, following Henry Sibley's lead, ridiculed his report on the pipestone quarry and his tale of having been "arrested" by the Sioux en route. Catlin responded in *Letters and Notes* by inserting the story of Wi-jun-jon, the Assiniboine martyr to ignorance, before discussing the Mandans and by including the parable about Wi-jun-jon's tragic fate in a chapter on the red pipestone quarry. During public lectures, he waved Wi-jun-jon's scalp at the audience as he was lauching into his description of the O-kee-pa. He made no bones about the parable's personal applicability.[4]

Wi-jun-jon's tragedy had been precipitated in part by bad luck. His Assiniboine companion on the eastern tour having died in Washington over winter, Wi-jun-jon was left on his return without anyone to verify his stories. Thus he was branded a liar. Similarly, Catlin's Mandan observations were unverifiable (he believed) because the tribe and its ceremonies had been wiped out by smallpox five years after his visit. Because what he had seen could not be seen again, like Wi-jun-jon he "suffered persecution" and was sacrificed to "the demon of ignorance." Henry Schoolcraft was chief persecutor.[5]

Originally Schoolcraft had accepted Catlin's word. When he reviewed *Letters and Notes* in 1842 he singled out the section on the Mandans for commendation as "one of the most interesting, original, and valuable parts of the author's observations." And he believed Catlin was the first white man to have visited the pipestone quarry—"that hitherto unexplored elevation," as he called it after listening to Catlin's enthusiastic description in 1836. Why not believe him? Schoolcraft in the same period had made a controversial discovery of his own. Under the orders of Lewis Cass, then secretary of war, he had set out in 1832 to locate what he and Cass together had not found twelve years earlier, the true source of the Mississippi River. On June 7 he left Sault Ste. Marie with a physician, a missionary, an interpreter, a small military escort, and twenty boatmen; should he again fail to discover the river's source, he wrote Cass, "it will not be from a want

95. After Seth Eastman, from a sketch by Henry R. Schoolcraft, *Itasca Lake,* commemorating Schoolcraft's claim to be the discoverer of the true source of the Mississippi River. *History of the Indian Tribes of the United States . . .* (1857).

of the intention." But on July 13 the party met with success: "What had been long sought, at last appeared suddenly. On turning out of a thicket, into a small weedy opening, the cheering sight of a transparent body of water burst upon our view. It was Itasca Lake—the source of the Mississippi." Addicted to neologisms, Schoolcraft combined two words, *veritas caput* or true source, to give the lake its name. He published the story of his exploration in 1834, *Narrative of an Expedition through the Upper Mississippi, to Itasca Lake, the Actual Source of This River,* and thereafter kept a jealous eye on his "crowning geographical discovery."[6]

Such watchfulness was necessary. The envious were out to deny him due recognition—"He discovered the true Source of the Miss. where others had been fifty times," Lawrence Taliaferro scoffed. And the pretenders had to be put in their place. When a later traveler, Seth Eastman's friend Charles Lanman, claimed to have visited Itasca Lake in 1846, Schoolcraft dismissed his book *A Summer in the Wilderness* as "pure fiction." He was probably right. Mary Eastman coined a word of her own, "Lanmanize," to characterize the tendency of western tourists to tell fabulous tales. Schoolcraft remained proud of the explorations of his active,

323

vigorous years, and at midcentury, immobilized by paralysis, he still ag-gressively asserted his claim: "No person has gone over the ground trod by me, above St. Anthony's Falls."[7]

In the same spirit, as late as 1842 Schoolcraft accorded Catlin recogni-tion as the pipestone quarry's "first actual explorer," adding: "If any other traveller or curiosity-hunter had ever before visited this locality, it is utterly unknown." A neat distinction could be drawn here. Others may have preceded Catlin, but none had left a written record; thus he was the "actual" discoverer. But Schoolcraft had his doubts. He kept the clipping from a Cincinnati newspaper in which Henry Sibley denied Catlin's claim, and in the second volume of his Indian history he published a critical letter from Philander P. Prescott. An interpreter at the St. Peters agency ac-quainted with both Sibley and Eastman, Prescott concluded a discussion of pipe manufacture among the Mississippi River Sioux with an aside: "Mr. Catlin claims to be the first white man that visited the pipe-stone, but this is not so. In 1830 I found a 6 lb. cannon-ball there." More of the same followed from another Schoolcraft contributor, William W. Warren, a self-described "quarter breed" Ojibwa interpreter at Crow Wing, Minnesota, connected to the American Fur Company through his father. Though Warren was all of eleven in 1836 when Catlin visited the pipestone quarry, he unhesitatingly branded him a fraud: "Mr. Catlin claims in his book (and is believed by all who do not know to the contrary), to have been the first white man who visited the Dakota pipestone quarry, when in fact, that same quarry had been known to, and visited by white traders for nearly a century before Catlin saw it."[8]

Catlin was left to defend himself as best he could. He never meant to imply that he was the first white man to visit the quarry. He *was* the first to carefully examine it, procure specimens, and provide a correct mineralogi-cal description of the pipestone. But while this explanation satisfied Ben-jamin Silliman, it served notice that Catlin had been caught out; if he "Lanmanized" about something so easily disproved, could he be trusted to tell the truth where few could contradict him? Could he be believed when it came to his incredible revelations about the Mandan religious rites?[9]

* * *

In late July 1832, while residing at Fort Clark near the Mandan village below the confluence of the Knife with the Missouri River, Catlin wit-nessed the annual ceremony known as the O-kee-pa (okipa), a four-day rite intended to ensure a plentiful supply of buffalo and thus tribal well-being. It was the most elaborate of the Mandan ceremonies—indeed, the most complex on the northern plains—held each summer when the water wil-lows were in full leaf.[10]

Accompanied by three others, Catlin watched in fascination, too ab-sorbed to bother with his meals. What he saw was simply sensational: the

96. George Catlin, *Interior view of the medicine lodge, Mandan O-kee-pa ceremony* (1832). Courtesy of the Anschutz Collection.

enactment of the Mandan creation myth, the personification of spiritual forces, birds, snakes, and other animals by distinctively painted and costumed men, an expanding cycle of dances in front of a large medicine lodge, and explicit sexual elements befitting a fertility rite. But it was on the fourth day that Catlin witnessed what no one had previously reported: the torture and mutilation of power-seeking O-kee-pa candidates or "penitents," as he called them.

This spectacle began inside the medicine lodge. After days of fasting, each youth in turn approached and knelt before the center pole. A knife was worked through the skin under a portion of the shoulder or chest muscle and out again, a splint was inserted, and with an attached cord the young man was raised upright till nearly off the ground; additional splints inserted in arms, elbows, thighs, and legs bore the burden of his weapons, medicine bag, and buffalo skulls. So encumbered, he was then hoisted clear of the ground and left dangling up to an hour. His skin stretched half a foot from the splints while a "bull" hooked him with a stick, twirling him round until he fainted from pain and was lowered again. Upon recovery, he

sacrificed a finger joint or two on a buffalo-skull chopping block. When all the candidates had endured the torture, they were led outside to the large clearing in front of the medicine lodge, still trailing the buffalo skulls, and by a wrist strap were pulled, then dragged rapidly around a "curb," Catlin called it, a sacred cedar post symbolically equivalent to an ark representing the Lone Man's intervention to save the Mandans from flood after they had offended the buffalo spirit. When most of the skulls were torn free and the last young man had collapsed, the drumming stopped. Gifts were set beside the successful candidates, who lay unattended until they could regain their feet and stagger off to salve their wounds, the ceremony concluded for another year.

"That a scene so much like a dream is reality" strained credulity, Catlin knew. Consequently he kept full notes on what he saw, carefully drafting the usual certificate of authenticity to accompany his four paintings of the O-kee-pa:

97. George Catlin, *Bull Dance, Mandan O-kee-pa ceremony* (1832). Courtesy of the Anschutz Collection.

> We hereby certify that we witnessed, in company with Mr. Catlin, in the Mandan village, the ceremony represented in the four paintings

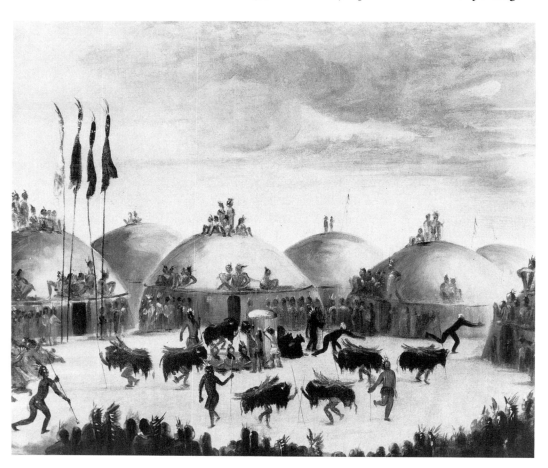

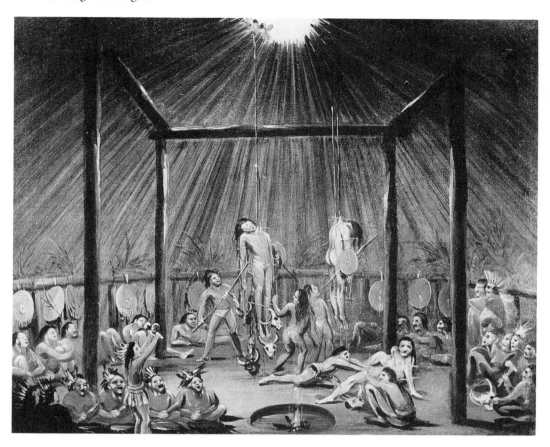

98. George Catlin, *The Cutting Scene, Mandan O-kee-pa ceremony* (1832). Harmsen Collection, Tucson.

to which this certificate refers, and that he has therein represented those scenes as we saw them transacted, without any addition or exaggeration.

J. KIPP, Agent of the American Fur Company.

J. CRAWFORD, Clerk.

ABRAHAM BOGARD.

Mandan Village, 28th July, 1833.[11]

Thereafter Catlin rested his reputation, and his expectations of financial success, on his Mandan revelations. They were what his audiences turned out to hear, and see, and be shocked by as he conjured up a nether world inhabited by chanting, dancing apparitions in bits of plummage and animal skins, glistening head to toe with paint in dazzling patterns of black and white, vermilion, and ocher—demons in human form who had floated up from the nightmare depths of the subconscious to inflict unimaginable suffering on their own kind with a stoicism matched by that of the willing victims. Catlin spared his listeners little in the way of gruesome detail, though he skirted the O-kee-pa's phallic rituals, titillating through inference while wringing his hands over a benighted barbarism that could

327

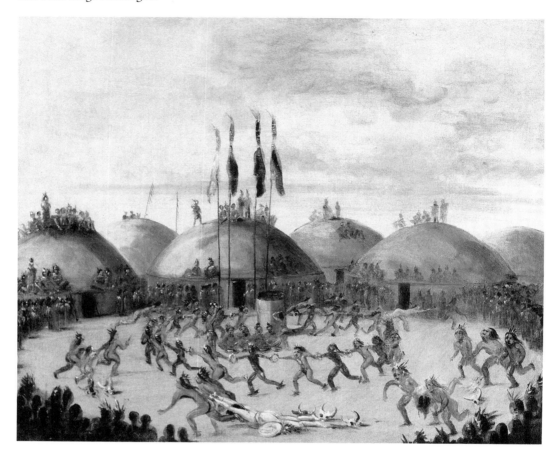

99. George Catlin, *The Last Race, Mandan O-kee-pa ceremony* (1832). Courtesy of the Anschutz Collection.

sanction such practices in the name of religion. No one who heard him or inspected his paintings seemed unmoved; detailed accounts of his lectures appeared in the press and were circulated in draft form by attentive listeners.[12]

The O-kee-pa was Catlin's greatest "discovery," and he exploited it shamelessly. What was strange and appalling in New York and Boston was disgusting and revolting by the time he reached London. His original report on the O-kee-pa, dated Mandan village, August 12, and published in the *Commercial Advertiser* the following January, was relatively objective. It mentioned "horrible scenes of cruelty" and described the events of the fourth day as "almost too shocking and appalling to be related"—almost, but not quite, for though they "sickened" him "to the heart and stomach" Catlin related them at length in reasonably restrained language. The same could not be said of his account of the O-kee-pa in *Letters and Notes,* written after nearly eight years of pandering to his audiences' prejudices. The opening lines of letter 22 warned the reader of what lay in store: "Oh! '*horribile visu—et mirabile dictu!*' Thank God, it is over, that I have seen it,

and am able to tell it to the world." Catlin's overheated rhetoric never let up: "that horrid and frightful scene" . . . "I shudder at the relation" . . . "alas! little did I expect to see the interior of their holy temple turned into a *slaughter-house,* and its floor strewed with the blood of its fanatic devotees" . . . "a house of God, where His blinded worshippers were to pollute its sacred interior" . . . "truly shocking" . . . "will almost stagger the belief of the world" . . . "too terrible and too revolting to be seen or to be told, were it not an essential part of a whole" . . . "shocking and disgusting" . . . "ignorant and barbarous and disgusting customs" . . . and so on.[13]

Catlin insisted that the Mandans, though "an ignorant race of human beings," were also an "honest, hospitable and kind people." But his own sensationalism argued to the contrary. A phrenologist who attended his lectures on the Mandans in Boston observed that "the horrible scenes of cruelty and superstitions which he has represented contrast strangely with the virtues which he ascribes to them." By making the Mandan rites seem so strange in order to lure the public to his gallery, Catlin had made them seem almost *inconceivably* strange. Were they, perhaps, products of his imagination?[14]

This question assumed critical importance after the summer of 1837. Catlin prided himself on his prophetic powers and delighted in pointing out how many of his predictions in *Letters and Notes* had come true—from the fate of the Indian tribes to the creation of a national park in the West. But on one subject he was utterly wrong. Captivated by the sights that met his eye along the Upper Missouri and by Indians that met his every expectation, at the end of a letter published in 1832 he had bragged about the healthfulness of the country and declared it immune to disease. But five years later, on June 19, 1837, an American Fur Company steamer docked at Fort Clark, its captain unaware that some of the passengers had smallpox. The boat became a messenger of death to each tribe it visited on its upriver journey. The first Mandan died of smallpox on July 14, and before the disease ran its course most of the tribe had perished. How many succumbed is still controversial, since the preepidemic population estimates range from 1,500 to 2,000, the postepidemic, from 31 to 133 (the latter discrepancy perhaps the result of confusing thirty-one families with thirty-one individuals).[15]

Whatever the exact figures, the Mandans were decimated in 1837, and when Catlin spoke in Boston the next year he left his listeners with the firm impression that the tribe was "now extinct." He stuck to this opinion despite evidence of survivors and even of the continuance of Mandan ceremonial life, the O-kee-pa included. Catlin's delusion was perhaps partly willful. Mandan extinction meant that his pictorial record could never be duplicated, an incredible stroke of good fortune from the standpoint of

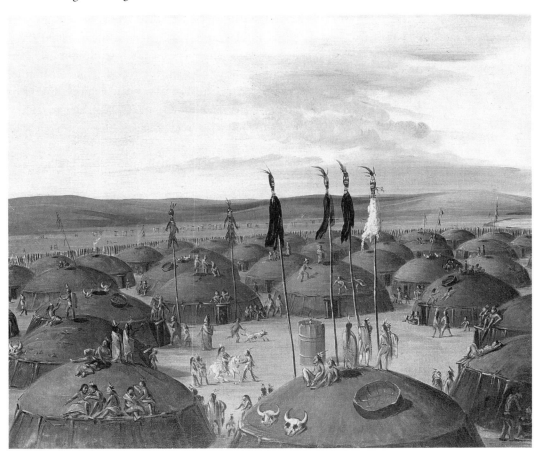

100. George Catlin, *Bird's-eye view of the Mandan village, 1800 miles above St. Louis* (1838). National Museum of American Art, Smithsonian Institution; gift of Mrs. Joseph Harrison, Jr.

self-interest, which alone might account for Putnam Catlin's callous comment that the "shocking calamity" that had befallen the Mandans would "greatly increase the value" of his son's gallery. Mandan demise might be George Catlin's financial salvation. In early 1838 he was so busy exploiting a similar kind of good fortune—the death of Osceola, whose portrait he had just taken—that he did not immediately capitalize on the smallpox epidemic. The first catalog of his collection, printed in New York in the fall of 1837, was reprinted the next spring with the Seminole and Yuchi pictures added, but nothing more on the Mandans. That changed before the year was out as Catlin made up for lost time. He added a major new painting to his collection, a bird's-eye view of the Mandan village, and his revised catalog informed readers that this tribe, "about 2400 in number when I was amongst them" (Catlin later settled on a more realistic 1,600 to 1,800), had "recently been destroyed by the small pox. It is a melancholy fact, that only thirty-one are left," merged with the Arikaras, "so that their tribe is extinct, and they hold nowhere, an existence as a nation, on earth."

Given the exploitation involved, it was fitting that a typographical error in the catalog had the four paintings of the "Mandan Religious Ceremonies" hung in "guilt frames." By the time Catlin opened in the Egyptian Hall in 1840, the frames were merely gilded, but the exploitation of the Mandans' misfortune continued. Now placed at 2,000 souls, they were said to have *"all perished by the smallpox and suicide, in 1837, (three years after I lived amongst them,) excepting about forty, who have since been destroyed by their enemy, rendering the tribe entirely extinct, and their language lost, in the short space of a few months!* The disease was carried amongst them by the traders, which destroyed in six months, of different tribes, 25,000!"[16]

Understandably, English reports on Catlin's gallery emphasized the importance of his Mandan paintings—"the only evidence" of their existence, a correspondent for the *Athenaeum* reported even before Catlin's arrival in London—and after, drawing on his catalog, the same journal declared that "not one now exists!" Subsequent clarifications and modifications did not alter Catlin's basic position. A note in the first volume of *Letters and Notes* advised readers of the destruction of the Mandans subsequent to his visit; an appendix to the second volume elaborated: "Although it may be *possible* that some few individuals may yet be remaining, I think it is not probable; and one thing is certain, . . . as a nation, the Mandans are extinct."[17]

Indian decline was a touchy, emotionally charged subject for Americans at midcentury. It led to recriminations, since it could always be traced back to the white man—in this instance, American fur traders and the American government. When the prestigious London *Quarterly Review* discussed Catlin's gallery in its March 1840 number, the Mandans were cited to condemn the "horrible system of violence and invasion" still practiced in the United States. Catlin had scarcely left their village, the reviewer noted, when smallpox *"caused the death of the whole tribe!* Not an individual has survived; and had not Mr. Catlin felt deep and honourable interest in their fate, it is more than probable it never would have reached the coast of the Atlantic, or been recorded in history." Embarrassed by this and the assertion he knew more about Indians than any other white man on the globe, Catlin issued a public disclaimer. The Mandans, he said, "have had the sympathy of the whole Am. Nation," not just himself, "and as a matter of *Official* duty" the toll taken by the epidemic "was communicated by the Indian Agent, in due season, to the Indian Department of the U. States and by order of the Congress, the Annual Report of that Department was, as usual, transferred to the published Archives of the Government." Catlin was so worried about the "severe animadversion" to which he would be subjected when his countrymen read that a disease inadvertently introduced among the Indians was part of a *system* of Indian extirpation that he

sent a copy of his public disclaimer home by steamer even before it appeared in the London papers and begged a friend in Philadelphia to have it inserted in the local papers upon receipt.[18]

Catlin should have been worried. Although he was not responsible for the *Quarterly Review*'s "blunders," he had set the tone that invited them. His book, invariably vague about dates, left the impression that he *lived* among the Mandans for an extended period, not a mere three weeks (just as his catalog placed him in their village three, instead of five, years before the smallpox epidemic). And he did imply that the fur traders were responsible for the ravages of the disease, that the fate of the Mandans was in microcosm the fate awaiting all the western tribes—they were the type of their race, British reviewers noted—and that the American people were somehow to blame. Catlin might deny this was his meaning, but it was certainly how his remarks were construed.[19]

* * *

Henry Schoolcraft once accepted Catlin's assumptions about Mandan mortality, though not his assignment of blame. He followed Lewis Cass on that score: Indian decline resulted from a defective racial character. Anyway, the United States government had been attempting to vaccinate the western tribes ever since the Lewis and Clark expedition, sporadically in response to periodic smallpox outbreaks (1801–2, 1815–16, 1831–32), then as policy after May 5, 1832, when Congress allocated $12,000 per annum for that purpose. Schoolcraft's own treaty with the Ottawas and Chippewas in 1836 made provision for their vaccination. It was not as though the government had ignored Indian susceptibility to white disease. Nevertheless, Schoolcraft accepted Mandan extinction as a fact. A letter in the St. Louis *Bulletin* of March 3, 1838, reporting only thirty-one alive served as his source for years. Nor did he initially question the accuracy of Catlin's account of the O-kee-pa.[20]

But Schoolcraft had misgivings. Even before his trip to England he implied there were inaccuracies in *Letters and Notes*. Ordinarily he limited himself to pointed comments on tourists in general. When he had a clear interest at stake, however, he would assail Catlin by name—in trying to sell Duff Green on his "Cyclopedia Indianensis," for example, and the Smithsonian on his "Plan for the Investigation of American Ethnology." But Schoolcraft did not spell out his reservations until 1851. In an unpublished monograph on the antiquities of western New York, Ephraim George Squier had stated that the Mandans, a "remarkable tribe," no longer existed. Schoolcraft pounced on the error. Smallpox had indeed wasted the Indians along the Missouri and reduced Mandan numbers to "about 31," he explained. But Catlin, "who had described that tribe as possessing customs & a history, & language, such as no Indian Agent or Indian trader from that quarter will admit to have, or to have had, an existence out of the

realm of pure imagination," reported the tribe extinct. "Dreadful as was their loss," the Mandan remnant had regrouped in their old village and in 1851 numbered about 300. By relying on Catlin, Squier had fallen into error. Since Schoolcraft detested Squier, his letter was mainly an attack on him. But it expressed the doubts he had long harbored privately about Catlin as well.[21]

Catlin never knew he was being slandered as long as Schoolcraft operated "in silencio." He had recognized the alliance of convenience when Schoolcraft and Seth Eastman had teamed up to oppose him in Congress in 1849. But he was groping in the dark; he sensed Schoolcraft's animosity without being able to assign it a cause. The appearance of the first volume of the Indian history in 1851 forced Schoolcraft into the open and made his allegations public; indeed, they had been circulating in questionnaire form under Indian Office auspices since 1847. The final question, query 348, asked potential contributors, "ARE YOU ACQUAINTED WITH ANY MATERIAL ERRORS IN THE GENERAL OR POPULAR ACCOUNTS OF OUR INDIAN TRIBES?" Catlin was the example:

> [The United States Indian] policy had been deeply censured, in high quarters, in the foreign literary world, on the bases of books of travels, whose least severe censure it is believed to be, to declare, that their authors have relied, in some instances, on hastily gathered, or ill-digested, or unworthy materials. One writer represents the Mandans as practising the arts of self-torture of Hindoo devotees, by hanging from hooks, or cords fastened into the nerves, so as to sustain the whole weight of the body. This, together with the general account of the Mandan religion, by the same author, is contrary to the facts, as understood here. The same writer will also have this tribe to be descendants of the Welch, who are supposed to have reached this continent in the twelfth century. Yet the British Druids imposed no such self-torturing rites.[22]

Catlin had made himself vulnerable by his indulgence in hyperbole and his adherence to the popular but discredited theory of Mandan descent from Welshmen who, under Prince Madoc, visited America in 1170. Later students have had no difficulty in separating Catlin's speculations from his observations, nor did Schoolcraft when he reviewed *Letters and Notes* in 1842. But his 1847 questionnaire, reprinted as an appendix to the first volume of the Indian history, implied that both were equally suspect.[23]

It is likely Catlin learned of this attack as soon as Schoolcraft's volume reached England early in 1851. He promptly prepared "an exciting paper on the physical peculiarities and peculiar customs of the *Mandans*" for presentation at the Ethnological Society of London, and invited Sir Thomas Phillipps to attend since it contained "an unknown account of them"—the

sexual rites associated with the O-kee-pa, necessarily omitted in his published reports—as well as an elaboration of his case for the Welsh connection. The damage done his reputation at home could not be so easily contained, however, and on August 1, 1852, Catlin wrote Senator William H. Seward an agitated letter.

Schoolcraft's animus could be explained only by a desire to monopolize Indian subjects and thus preserve his patronage post in Washington. He "has shown his disposition towards me in the last page of his large work recently published at the expense of the govt. by unequivocally giving my statements the lie, relative to the Mandan Religious Ceremonies." His book had been sent out "at the govt. expense, but in his own name, to most of the learned Societies in the U. States—England & on the Continent of Europe," where Catlin's *Letters and Notes* had been "read with deep interest." It was galling to think that Schoolcraft, who had "never been within 1000. miles of the Mandans," would dismiss evidence Catlin had placed before the public when it could still be verified. "This most *unjust* & malicious libel" was an obvious attempt to discredit Catlin's work "that nothing may stand in the way of the works that are to be put forth by the historian of Congress." Catlin begged Seward to stand firm in the Senate, unaware that his bill for purchase had already been defeated.[24]

When news of his latest congressional defeat did reach him, Catlin concluded that Schoolcraft was behind it. Through a familiar intermediary, his eyes and ears in distant Washington, he would demand an explanation. Thus in mid-September 1852 the Reverend R. R. Gurley, still active in the American Colonization Society, still robust despite twice being subjected to "the pestiferous breath of the Congo," paid a call on the Schoolcrafts. They were not at home on E Street, having left for Philadelphia to attend the third volume of the Indian history through the press. "I was the more desirous of seeing you," Gurley wrote Schoolcraft on the twenty-first, "in consequence of an earnest request of my friend Mr George Catlin, that you would inform him, whether in your remarks on the religious ceremonies of the Mandans, . . . you designed to call in question his statements." Gurley, wanting to prevent a breach between such steadfast friends of the Indian, confided that Catlin was in financial difficulty "& feels perhaps too keenly his misfortunes." Surely Schoolcraft would do all he could "to alleviate his disturbed sensibilities."[25]

Schoolcraft replied at once. He had no desire to enter into a controversy with "tourists." Their accounts were outside the scope of his investigation. Congress had commissioned him to prepare a compilation of authentic information only. Anyway, he had no copy of the 1847 questionnaire at hand in Philadelphia and thus could not check the query at issue. But he was positive that in pinpointing errors in the existing literature on Indians his "intentions were general, and had respect to the whole body of popular

information." This was an improbable defense, but Gurley relayed it to Catlin on January 27, 1853, along with the belated news that purchase of his Indian Gallery had been blocked "by the friends of a rival artist (Stanley) and Captain Eastman, who is associated with Mr. Schoolcraft in the publication of the Indian History."[26]

Sitting in the Hôtel des Etrangers in Paris, with ample time to brood over the events of the previous summer, Catlin had already decided to address his traducer directly. Unless a satisfactory "explanation & apology" were forthcoming, he wrote to Schoolcraft on January 30, he would go public with his story. Schoolcraft took him seriously enough to draft an eight-page reply on the last day of February in which he abandoned the pretext of attacking error in general. Yes, he did doubt Catlin's account of the Mandan O-kee-pa; indeed, he denied it was possible. Was he, then, calling Catlin a liar? Not quite. What Catlin *thought* he saw was due, no doubt, to a mind overstimulated by the sights and sounds of the Mandan ceremony. But why doubt Catlin? Because, Schoolcraft explained, he could find no corroboration in the literature. Henry Brackenridge visited the Mandans in 1811 and saw "no such extreme rites." Lewis and Clark passed the winter of 1804–5 near the Mandans and became "familiar with them, but do not state they practice any peculiarly severe rites." A Canadian, Mackintosh, supposedly visited even earlier, in 1773, and while he considered the Mandans unusual in many of their practices, mentioned no "bloody rites." Finally, David D. Mitchell, superintendent of Indian affairs at St. Louis, the position once held by William Clark, thought Catlin's description was "penned under excited & mistaken views."[27]

This was infuriating. What did Schoolcraft *know* about the Mandans? How dare he cite those he chose to believe and deny what Catlin had seen with his own eyes? Yet he did exactly that, even when his authorities were at second hand, like the elusive Mr. Mackintosh, whose history was given him by Mitchell. Schoolcraft's personal critique was lame. All tribes "cut & scarify themselves" to some extent, he had conceded, but not to "the very extreme & superhuman [aberration?] to which, in your description, this practice is carried." Recognizing how weak this sounded, Schoolcraft turned to easier targets. Catlin's theory of the Welsh origins of the Mandans was "pure conjecture, . . . unsupported by an archaeological, or linguistic fact." And what was to be made of his insistence on Mandan extinction, the "hallucination which you are even now under, that they have passed away?" Mitchell, having replaced the St. Louis newspaper story, was Schoolcraft's authority for saying that 105 Mandans actually survived the 1837 epidemic and 385 were now alive. A retraction by Catlin was long overdue.[28]

Schoolcraft concluded his letter to Catlin with a lecture on the need to take disinterested criticism to heart. "We are exalted by the capacity to see

& acknowledge our errors & misconceptions," he explained, unaware of the Squier in his future:

> No writer of history or imagination is so perfect, but what he can improve his own work; but when we enter the fields of geography, statistics, language & other topics, involving a close chain of figures & facts, there is perpetual need of such revisions. You have been out of the United States so long that the number of our Indian tribes has more than doubled since you left it, and we are just beginning, as a government, to collect by authentic agents, between the Atlantic & Pacific their actual statistics, history, antiquities & traits, and to put them on record in such form that posterity may properly judge of the race. I am of opinion that you should rejoice at this, & not cavil.

It was Catlin's fault if he misinterpreted Schoolcraft's motives and found in his criticisms what was neither there nor intended. Artists were like that— capricious fellows, unreliable by nature and quick to take offense when administered a dose of fact.

Schoolcraft's strategy was nearly perfect. It allowed him to play the disinterested friend of truth even as he applied the knife. He had done his best to help Catlin, receiving only cuffs for his kindness. The Reverend Mr. Gurley had come calling. Catlin was demanding an apology and threatening to publicize his grievances. Even Congress's unfavorable decision on purchase of the Indian Gallery was laid at his feet, as though *he,* with problems enough of his own, could dictate congressional policy. He was innocent, in short, of Catlin's most serious charge, an unchristian malice, and "of all men in America, should have been spared the necessity of this examination." Catlin's complaints were best understood as the bleats of a disappointed patronage seeker.

Having drafted his letter, Schoolcraft held back on mailing it while he pondered his next move. Perhaps he should beat Catlin to the punch and go public first. With that in mind, he added an explanatory note divulging his intention to have his letter printed for circulation among "a few friends." In the note Schoolcraft reaffirmed the innocence of his motives and wished Catlin "unqualified success" in his future endeavors. Then, inexplicably, he returned to the transparent ploy of denying that query 348 referred specifically to Catlin. Anyway, the whole flap could be blamed on the commissioner of Indian affairs. It was his idea, not Schoolcraft's, to end with the offending query, though Schoolcraft had approved it as consistent with his task of compiling a body of reliable information. "But it was deemed proper to couch the inquiry in the most general terms, & by no means, to introduce the names of authors living or dead, who had exposed themselves to criticism."[29]

In fact, the 1847 questionnaire was circulated under Commissioner

William L. Medill's name, but responsibility for it was Schoolcraft's alone. Six days after accepting his appointment as Indian historian, on March 25, 1847, Schoolcraft had advised Medill of his plans to prepare "a list of queries, historical & illustrative, to be answered by agents, teachers, men of learning & experience & other persons. Our actual knowledge of the Indian tribes, is exceedingly fragmentary & imprecise. Nearly all we know is derived from the pens of hasty travellers, who have often misapprehended what they saw, & were frequently more intent on the picturesque & amusing, than more serious traits of Indian character." The rest of Schoolcraft's explanatory note was similarly lacking in candor. To prove that he had not meant to single Catlin out, he named others he considered just as unreliable—Carver, Charlevois, Adair, and the charlatan John Dunn Hunter, who had "fabricated adventures among the wild tribes . . . quite as imaginary as the apocryphal history of Formosa by Psalmanazar." What else Schoolcraft might have said is lost, since the only copy of his letter, in the Catlin papers, breaks off abruptly as if in embarrassed silence.[30]

The spring of 1853 saw a Democratic administration return to the White House. Schoolcraft was elated. Preoccupied by the events surrounding Franklin Pierce's inauguration and the responsibility of hosting guests in town for the celebration, Schoolcraft permitted his letter to Catlin to languish on his writing table. After the excitement abated he took it up once more and sent it, with the explanatory note, to the Reverend Mr. Gurley. Catlin might dispense with Gurley's services; Schoolcraft preferred an intermediary. Besides, it was Gurley who had involved him in the first place. Would he, then, read the letter and forward it to Catlin? With that gesture on March 10, 1853, Henry Schoolcraft broke off personal communication with George Catlin. However, he did not let up on his public attacks.[31]

Copies of the third volume of the Indian history were on their way to congressmen, savants, and libraries around the world even as Schoolcraft dithered over mailing his letter. The new volume contained the severest condemnation to date of Catlin's account of the O-kee-pa, and it named names. The author was not Schoolcraft himself, but David D. Mitchell, a Schoolcraft friend. Active in the fur trade since 1828, Mitchell was appointed to "the most important administrative post on the plains," superintendent of Indian affairs at St. Louis, in 1841 with American Fur Company backing. He was dismissed two years later when he fell out of favor with the fur-trade interests but was restored to office in 1849 when the Whigs were reelected. He had the long official experience in Indian Country Schoolcraft favored, and he negotiated the Fort Laramie Treaty in September 1851, the first major federal initiative to bring the western plains tribes into formal relationship with the American government. The next January he

accompanied a delegation of Omahas to Washington and spent a few months in the capital, where he found the leisure to write a short description of Mandan history for Schoolcraft. Mitchell corrected the usual statistics of Mandan mortality, setting the figure for survivors of the smallpox epidemic at 125 and their population in 1852 at 385. As for an annual religious ceremony featuring torture rites, "the scenes described by Catlin, existed almost entirely in the fertile imagination of that gentleman."[32]

Catlin years later would link David Mitchell to Henry Sibley, fur traders both, peddlers of whiskey and debauchers of the Indians, his principal defamers on the Missouri and Mississippi, respectively. But really Mitchell had said nothing that Schoolcraft had not previously implied. He might go on expressing surprise at Catlin's taking query 348 to himself and insist Catlin was "entirely mistaken" in assuming him "unfriendly." But he had begun his investigation by launching an attack on Catlin's integrity that "astonished" one neutral observer by its vehemence. "You have doubtless received a Circular from Mr. Medill . . . with a thousand questions to be answered," William B. Hodgson wrote a fellow member of the American Ethnological Society in 1847: "Mr. Medill throws doubt upon the report of Catlin, that the Mandans practice self-torture like the Hindoos. If he cannot be believed, we had better throw up the matter at once. Catlin, a gentleman of honor, relates what he saw with his own eyes. The writer of this circular denies it—In this state of the case, there can be no history." Hodgson was right. Ethnology was finished as a science when eyewitness reports were denied because one chose not to believe them. Something would have to be done about Schoolcraft.[33]

* * *

In June 1856 the distinguished German naturalist Alexander von Humboldt called Catlin's attention to Schoolcraft's assaults on his integrity:

An immense *Scrap-book* on the North American Indians, written by Schoolcraft, for the Government of the United States, in three huge volumes, has been sent to me as a present; and I find, in looking into it, that he denies the truth of your descriptions of the *"Mandan Religious Ceremonies,"* distinctly saying that they are contrary to facts; and that they are the works of your imagination, etc.

Now, my dear and esteemed friend, this charge, made by such a man as Schoolcraft, and *"under the authority of the Government of the United States"* to stand in the libraries of the scientific Institutions of the whole civilized world, to which they are being sent as presents from your Government, is calculated, not only to injure your hard earned good name, but to destroy the value of your precious works, through all ages, unless you take immediate steps with the Government of your country to counteract its effects.[34]

Humboldt's call to action has figured prominently in Catlin lore. It establishes the esteem in which he was held by the preeminent naturalist of the age. In the second volume of his magnum opus *Cosmos: A Sketch of a Physical Description of the Universe* (1845–59), Humboldt had praised Catlin as "one of the most admirable observers of manners who ever lived among the aborigines of America." Artist and scientist met in London in 1842, in Paris in 1845, and in Berlin ten years later. Humboldt, as intellectual in residence to the court, introduced Catlin to the king and queen of Prussia that September and sat for his own likeness in pencil. His letter of June 1856 has thus been seen as the disinterested act of an admiring acquaintance. It has also been construed as Catlin's first inkling that he was being publicly defamed by Schoolcraft, though Catlin had known that for four years by then. What has not been remarked on is Humboldt's peculiar timing.[35]

The third volume of Schoolcraft's compilation was published in 1853, and the fifth had reached those on the official mailing list by February 1856, four months before Humboldt made contact with Catlin. Yet his letter implies that he had just received the first three volumes and, alarmed by their content, had written immediately. In fact Humboldt had received the volumes in question as they were issued, the first in 1851 with Schoolcraft's respects, and had perused them carefully enough to offer a blunt denunciation prominently quoted in the *North American Review* in 1853: "Baron Humboldt, having had occasion to examine the work, expressed in strong terms his opinion that it was a crude and worthless compilation, and his great surprise that it should be allowed to appear with the sanction and at the expense of the government of the United States." Schoolcraft was decidedly upset by this "*on dit*"—Humboldt's was a name to reckon with in many fields, anthropology among them. His opinion could not be ignored.[36]

Humboldt had visited the United States only once, in 1804 at the age of thirty-four, following five years in Spanish America. He had conversed at length with Thomas Jefferson at Monticello and steered Albert Gallatin to the study of Indian languages. His own work on the civilizations of ancient Mexico remained standard—Prescott confessed himself Humboldt's grateful debtor—and his influence straddled generations. Samuel George Morton's 1839 *Crania Americana* brought a warm letter from Humboldt, who valued its empirical data and broached the conclusion that no single creation could account for the diversity of the human races, endearing him to later polygenesists like George Gliddon and Ephraim George Squier. Gliddon called him the "Nestor of science," Squier, "the illustrious Humboldt." Humboldt had made the cosmos his subject, the continents his categories, each to be understood as a separate totality. His range was dazzling, "from the details of science to the morality of the universe," a

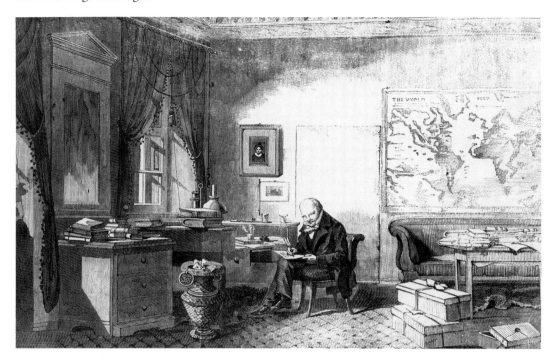

101. Alexander von Humboldt (1769–1859), advanced in age and vast in fame, still at work in his study, the world that he had made his intellectual playground spread out behind. *Illustrated London News,* October 18, 1856.

typical tribute went. He contributed to astronomy, botany, physiology, and zoology and was a seminal thinker in the fields of geography, geology, geophysics, and oceanography. Climatology, volcanology, and ecology trace their roots to his work. He discussed penology with Francis Lieber, an interoceanic canal with an American waterways expert (he advocated a southerly route), the coastal survey, the California gold rush, and (flatteringly) the *American Journal of Science and Arts* with its founder, Benjamin Silliman. Fluent in several languages and surrounded by an immense library in his modest residence in Berlin, he pored over maps, gobbled books whole, and socialized during the day; many evenings he led discussions at the palace in Potsdam on whatever topic had captured the royal fancy—aqueducts, penal reform, Catlin's Indians (the Crows, he had concluded from an examination of their portraits, were indisputably Toltecs); and in the middle of the night he labored on his own scholarly studies, racing against mortality to complete *Cosmos.*[37]

Even in his middle eighties, stooped with the years, his face framed with wispy white hair, he talked brilliantly, his eyes bright, his conversation an uninterrupted stream flowing from "the fountain of his immense stores of knowledge." Lieber would not say he was "the greatest man of the century," but he thought him one of the great men of all time. Squier had no such niggling reservations. He forwarded copies of his publications, effusively inscribed: "To Baron von Humboldt, First Philosopher of the Age,

and the Pioneer in American Archaeological Science, From his admirer and emulator, the Author." He visited him in Berlin, cultivating his friendship, and when Humboldt's library was sold off after his death in 1859, he was an eager buyer. Squier's acquisitions included three leather-bound volumes containing Humboldt's honors (180 certificates and diplomas from governments and learned societies around the world) and another six huge quartos, Schoolcraft's Indian history, inscribed to Humboldt from Schoolcraft and the commissioner of Indian affairs.[38]

The journey of these books into Squier's hands completed a transAtlantic exchange fraught with irony. Schoolcraft, of course, blamed Squier for the *North American Review* attack, but the opinions attributed in it to Humboldt were a matter of some delicacy. Schoolcraft too had tried to curry the baron's favor. He visited Prussia on his trip abroad in 1842 but did not get an audience with Humboldt; he did, however, send him a copy of the prospectus for his "Cyclopedia Indianensis" and nine years later put him on the mailing list for the Cyclopedia's offspring, the Indian history. Apparently his gift had been poorly received. So eminent was Humboldt that Schoolcraft checked his anger. He had an acquaintance sound Humboldt out about the views ascribed to him in the *North American* in 1853. Were these indeed his own? Then, through the Prussian minister to the United States, he addressed Humboldt directly on July 30. Schoolcraft's letter was a dissertation on American philology intended to establish his own erudition and indicate why he had been chosen to compile the government work on the Indians. Humboldt's brother, the linguist Wilhelm, had understood the value of collecting Indian vocabularies, Schoolcraft observed, and he was of a mind to send several unpublished word lists to the Royal Library in Berlin. He backed this bribe with a clipping from one of the Washington papers highly laudatory of the Indian history and promised to send Humboldt all future volumes, as he had those in the past "without being apprized of their reception."[39]

Schoolcraft hoped Humboldt would rush forward to repudiate the opinions attributed to him. When it became apparent that no denial was forthcoming—indeed, that Humboldt would not even deign to reply—Schoolcraft went public. Noting in the *Literary World* that the attack on his history had closed with a "pronunciamento" allegedly by Humboldt, he derided the American tendency to bow before "foreign modes and authors," as though a monopoly on truth was to be found on "the winding banks of the Spree." Why assume that because Humboldt generalized well on the natural phenomena of two hemispheres that he knew anything in particular about the Indians of the United States? Who could take him seriously knowing he believed with the Danish antiquarians that there were aboriginal monuments in America inscribed with Icelandic characters

(an interpretation Schoolcraft had once endorsed)? "However eminent this learned gentleman is on his favorite topics," on subjects "which he is not acquainted with, his opinions are worth just nothing at all."[40]

While it was too late to get back at Humboldt in the fourth volume of the Indian history, the fifth, which reached Humboldt in the early spring of 1856, offered ample opportunity:

> William Humboldt placed himself in the front rank of the philologists of Europe, but never visited America; Alexander, his distinguished brother, devoted himself almost exclusively to natural history and climatic and philosophic phenomena, and confined himself to the southern hemisphere. . . . It does not appear that he made inquiries into the character, languages, or condition of the aborigines of the United States. In his Cosmos, we are astonished at the general learning and research. . . . But we look in vain for any thing that may be used to solve the question of Indian origin . . . we rise from the perusal with no new light on a topic which, it was thought, only he could illustrate. Of the United States tribes, and their history and languages, he has probably never made a study. . . . The small charlatans, who, from this country, have teazed the Literary and Scientific Lion of Berlin with misrepresentations respecting myself, and then spread the precious scandals in American circles, may have exalted themselves by putting their hands on the shoulders of Ajax, and thereby given themselves claims to pity!

"With all his affluence of libraries and powers of deduction," Humboldt had contributed nothing to North American Indian studies. He was attempting the absurd task of trying to ascertain from books the course of human social development "long before the invention of printing." When it came to the United States he was an armchair historian, and his opinion that the "American race" was the same throughout the Western Hemisphere should be judged accordingly.[41]

This attack was very probably what aroused Humboldt in the spring of 1856. A direct reply would have been beneath his dignity, but he enlisted a willing ally in George Catlin. In his letter, Humboldt made no mention of Schoolcraft's fifth volume. But if Catlin looked into it as well, he would have discovered that Schoolcraft was still going on about the Mandans:

> To prepare warriors in the trial of endurance, there are some of the barbarous tribes, on the Upper Missouri, who make incisions on the tendons of the arms, by which they assume the hardihood to drag a buffalo hide. . . . This rite is rare, even among the most barbarous tribes, and has not often been witnessed. But where it exists, it has no connection with religious rites. It is a mere test and boast of bravery

and hardihood. It has been described by Mr. Catlin, a well-known author (vide Vol.III, p.254), as practised within late years among the Mandans. Yet the same writer ascribes the origin of this people to the adventure of the Welch prince Madoc, in the twelfth century.

Because Catlin's theories were suspect, his observations could be ignored. "It is known," Schoolcraft conceded, "that the Mandans put their young warriors to great trials of their strength and capacity of endurance on certain public occasions, during which the weight of skins is sometimes dragged by thongs of deer's sinew inserted behind the solid parts of the larger muscles of the arms." "Similar practices" were reported "on unquestionable authority" among other Missouri River tribes. But "what appears to one observer, whose mind is filled with a certain class of preconceived ideas, in one light, may seem to another, who is relieved from such theories, in a different phasis."[42]

So there it was once more: George Catlin had invented the entire O-kee-pa ceremony. With Alexander von Humboldt urging him on, he would one day demand redress. But it would take time—years, in fact. Catlin was more than usually distracted throughout the 1850s. Having lost his gallery, he was suddenly free, free to be again the Catlin of old, braving perils, enduring hardships, questing after unspoiled natives, free to pursue the goal that first fired his imagination over twenty years before. Some day, he had promised James Hall in 1833, he would paint the natives of the Pacific coast, and perhaps even of the islands in the Pacific. In 1852, facing certain ruin unless Congress came to his rescue, he still confided to Daniel Webster a global vision, embracing all "the dying Races of Man." He would yet visit "every native tribe in Central & South America, and . . . illustrate their personal appearance & modes." "I am young enough," he insisted, "and the practice I have had has taught me exactly *how*—and my ambition would lead me to face any danger or difficulties in completing my great design." All this, if only he could find the means.[43]

But Congress, of course, failed Catlin in 1852 as it had so often before, stranding him in "voluntary exile," desolate and financially disgraced. He was never without hope, however. A friend examining old Spanish records in the Bibliothèque Impériale in Paris had unearthed an account of a lost gold mine "of marvellous richness" in the Tumucumache (or Crystal) Mountains of northern Brazil. Nuggets filled Catlin's dreams, schemes to get at them his waking hours. "The wealth of London was to be at my command if I succeeded," he remembered with amusement. "A company, with unbounded capital, was to be formed, and a concession was to be obtained from the government of Brazil for the right of working the mines and *carting* the gold away; and I had yet the stimulus of an unexplored country before me." Fortune now came before the fame that might be won

painting Indians in "unexplored country." Otherwise Catlin was as much the visionary as ever. Like the Spanish conquistadores in the sixteenth century, like Squier and those other Americans whose enterprise had taken a "tropical direction" in the 1850s, Catlin would pursue Dame Fortune all over South America. He had been reborn in a fever of hope. The Amazon would be a new Missouri, a new highway to adventure, and he would ride it, sloughing off the accumulated disappointments of the past two decades as though they had never been.[44]

 * * *

Catlin's chronologies of his wanderings in the 1850s are vague and replete with impossibilities.[45] He was never to be relied upon for dates. To him they were a matter of convenience, something to be used to excite an interest, create an impression, *sell*. From his rooms in Manchester on September 7, 1860, he wrote to the editor of the *Guardian* promoting an invention he hoped to patent. Since he had sent the pamphlet to others "purporting to come from Brazil . . . it may seem a little awkward if I am announced as *arrived*," he added in a postscript; ". . . do me the favour to say—'Mr. Catlin has written or communicated from Rio Grande to a friend in Manchester & ——— you will oblige me very much." *Letters and Notes* had purposely distorted the length of his western tours, contributing to suspicions about his accounts of the O-kee-pa and the pipestone quarry. His two books on his travels in the 1850s, written with an eye to sales and directed at a younger audience, simply dispensed with chronology altogether and scrambled events for the sake of the story. A single trip down the West Coast had him in Kamchatka in 1853, Victoria on Vancouver Island in 1857 or 1858, and en route to Santa Fe in 1855. When Catlin produced an itinerary of his "Rambles" in 1871, he admitted "there may be some little errors in it, . . . though, as far as it goes, the matter is all correct." As far as it went, it was mostly all wrong, notably in stretching his South American adventures out over eight years. Closer to the events, in 1863, Catlin claimed to have made "a campaign of more than six years in South & central Am^a as well as on the N.W. coast and Kamskatka." This conforms more closely to one of the few contemporary sources for his doings in the 1850s, his periodic letters to his English patron Sir Thomas Phillipps.[46]

 Catlin fueled his dreams himself, but others had to fund them. With his financial collapse in 1852, those who had accepted an interest in his Indian Gallery as security on loans were victimized and furious. But Phillipps had been too prudent to be victimized. He had secured a loan in 1849 with physical possession of twenty paintings; naturally the loan went unrepaid, but he still held a tangible security. Thus he remained one of Catlin's few patronage prospects in 1853. The artist was on the move that year, his restlessness palpable. From Folkstone in October he finally sent the fifty

small oils promised Phillipps in full satisfaction of the debt, requesting that his twenty Indian Gallery originals be returned. Phillipps had dealt severely with the artist's importunings earlier in the year, brandishing the word "dishonour" to characterize his conduct, but he relented with payment in hand and offered him quarters in his home. "I can let you have a Bedroom, Kitchen & large Room for the Gallery gratis & you can hang these Pictures up there and lecture upon them." Charge a small fee, perhaps a shilling, Phillipps suggested, and people would come to see the new miniature Indian Gallery. Catlin would be welcome to stay until January, saving on expenses while pocketing a few pounds.[47]

To a man who had received precious little gratis, this was a tempting offer. But Catlin turned it down in a letter from Brighton. His personal affairs were still too harassing; he would be returning to Paris shortly and hoped to be in Washington by the first of the new year. He still believed that Congress would buy his collection, redeeming it from storage in Philadelphia and putting him back on track. He would then return to England, repay his debts, reestablish old friendships, restore himself to respectability, and raise his daughters, who had been taken into care by his in-laws, the Gregorys, after his financial disgrace. He had no other plans at the time or when he wrote Phillipps from Paris in mid-February 1854. Now he was the one doing the waiting: Phillipps had not yet returned the twenty oils. Since they were part of his original gallery, he would need them when he approached Congress. A few weeks later he was in Liverpool, his plans up in the air, a new enthusiasm mounting. He would not go to Washington after all; Congress would not get around to his bill until August or September anyway, and in the meantime he just might be able to sweeten the pot. Two scientific men, a German botanist and a French naturalist, were leaving for Rio de Janeiro on March 19, and he hoped to go along with them. They would travel to the headwaters of the Rio Paraná, descend it 1,800 miles, and traverse the Pampas and Patagonia to the very extremities of the continent. The last portion of the journey would be "over a country of wild Indians not described." Catlin might be gone for years—if only he could come up with the money. His traveling companions were willing to cover half of his expenses, but he still needed £150. Could Phillipps provide it, in exchange for permanent possession of the twenty oils from his gallery, the twenty-five paintings of La Salle done for Louis-Philippe, and the promise of "exciting" descriptions of their search for old Spanish and Portuguese missions, the contents of a future book? Even £100 would do, anything, in order that Catlin might avail himself of this singular opportunity, "this second starting point of my life."[48]

On the twenty-fourth he wrote Phillipps again, from Le Havre, where he had watched his companions sail, and he not with them. "*I do not know how* to relinquish my plans of tour to S. Am^a, not do I yet see *how I am to*

102. After George Catlin, *A Mid-day Halt on the Rio Trombutas, Brazil,* the first published result of Catlin's South American rambles. *Illustrated London News,* April 11, 1857.

go," he admitted, but he would leave for Southampton the next day, then Liverpool where he might yet catch a steamer, overtake his friends, and join them in Rio. Since he might have to go to the United States first and sell his collection in order to raise funds, he wanted the twenty oils crated and sent to Liverpool at once. Catlin was still in Brighton on April 14, wondering why he had heard nothing. Exasperated, Phillipps replied that if he would stay put long enough perhaps letters could catch up to him. But Catlin was antsy with excitement and impatient to be off. His plans were final (though where he got the money is unknown) when he wrote from Le Havre on May 3. He would be starting for South America in a few days' time. His companions were loitering about Cuba or Rio awaiting his arrival. Then would commence their "arduous and perilous enterprize." "I wish you were free to take this splendid Tour with me," Catlin added, returning Phillipps's invitation of the previous fall: "I have procured a chain mail tunic to wear under a blanket capot, out of sight, and a perfect protection against knives, arrows or Tigers claws, & also Colts rifle with six shots & pistol with 5. We are all armed & equipped alike, and form almost a match for a Rupian Regt." The thrill of adventure that had shaken Bartlett and Squier free from their desks and depressed a Parkman chained to his own by blindness was Catlin's once again.[49]

Over the next six years Catlin made three separate trips to South America. How he financed them remains a mystery. Still ingratiating in his

enthusiasm, he was ever on the lookout for patrons. The Colts that he carried, for example, were gifts from Samuel Colt himself. After displaying his guns at the Great Exhibition in London in 1851, Colt had put his argument for the mass production of revolvers to the test, opening a factory in London the next year. Eager to make the case for their adoption by the United States Army, he had Catlin paint a series of twelve pictures showing Colts being employed in the field. The terms of their agreement are unclear, but Catlin completed the order by 1857, and the Colt's Patent Fire-Arms Manufacturing Company subsequently used the paintings in its advertising. Many of the scenes were based on Catlin's North American adventures, but a few had South American settings, including *A Mid-day Halt on the Rio Trombutas, Brazil.* Reproduced in the *Illustrated London News* for April 11, 1857, it marked the earliest appearance of any Catlin South American painting. The Colt commission provided Catlin with an essential part of his equipage. It also suggests the kind of patronage that facilitated his travels in the 1850s.[50]

Catlin joined his companions, the German doctor at least, in Havana in May and, after exploring the area below Caracas, they boarded an American steamer for Demerara (Georgetown) in modern Guyana. The itinerary he sent to Phillipps in March had obviously been altered by the imperatives of treasure hunting. The search for the three-hundred-year-old Spanish mines took the party up the Essequibo, over the Tumucumaques and down the Trombetas to the Amazon. From Óbidos Catlin descended the Amazon to Pará (Belém), near the Atlantic, expecting to set off again. He may have done so, but his tour was cut short. Letters to New York requesting funds had brought replies "*actually ordering* me home as quick as possible." Congress at its last session had appointed a committee to negotiate the purchase of his Indian Gallery (a pipe dream) making his presence in Washington over the winter imperative. So Catlin landed at Le Havre in mid-November, fatigued but stimulated by a journey "much shorter than I could have wished." He wrote Phillipps from Southampton on the twenty-seventh still seeking return of his twenty oils, which he would need when he sailed for the States. Meanwhile he had brought a few sketches made along the Amazon for Phillipps and planned a series of illustrated letters in one of the weeklies if the news of the Crimean War did not deny them space, international events still conspiring to frustrate his success.[51]

Catlin's activities between November 1854 and September 1855 are obscure. According to his later chronologies he was ascending the Amazon, gold hunting in the Acaraí Mountains, ascending the Ucayali, wandering the Pampa del Sacramento, trekking to Lima, steaming up the West Coast past the Aleutian Islands to Siberia, wandering in Oregon Territory eastward to Fort Hall, catching another steamer from Portland and then, by horseback, traveling from San Diego in California over the mountains

103. George Catlin, *Excavating a Canoe—Nass River,* probably painted in 1857 when Catlin was on the Northwest Coast. National Gallery of Art, Washington; Paul Mellon Collection.

to San Diego on the Rio Grande del Norte (Derry, New Mexico, today) and by dugout canoe to El Paso and Matamoros, a journey of eight hundred miles. From Matamoros he sailed southeast to Sisal on the Yucatán peninsula, saw some of the ruins that so impressed the antiquarians, painted a few Maya descendants, and sailed from Sisal to Le Havre, preparatory to visiting Humboldt in Berlin in September 1855. Catlin and Humboldt did discuss analogies between the Toltecs and the Crows (whom Catlin claimed to have revisited in the Salmon River valley), as well as the ornamentation of certain tribes along the Paraguay and Uruguay rivers. Yet the published letter Catlin sent Humboldt before their visit in September 1855 was dated at Pará on the mouth of the Amazon, consistent with the 1854 itinerary already outlined. Because the confusion of dates was intentional, almost anything is possible.[52]

With letters of introduction from Humboldt to Aimé Bonpland in Santa Ana on the Uruguay River, Catlin may have left Berlin directly for South America. Humboldt's warning about Schoolcraft's slanders, dated June 9, 1856, was sent to Catlin in care of Bonpland, indicating that Catlin was abroad by then on what would prove his longest New World ramble. He was back before November 1857 and wrote Phillipps a letter outlining his travels. He had sailed from Liverpool to Lisbon, Madeira, and Tenerife,

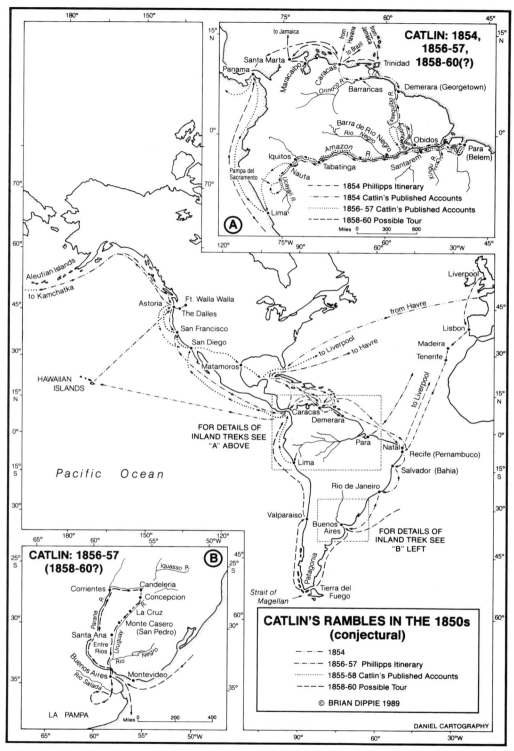

Map 3. Catlin's rambles in the 1850s (conjectural).

crossed the Atlantic, landing at Pernambuco (Recife) and continued down the coast of Brazil to Bahía (Salvador) and Rio de Janeiro, painting portraits along the way to raise money. From Rio he sailed to Buenos Aires and visited Bonpland. He later described a loop up the Paraná to Candelaria and over the mountains to the Uruguay, which he descended in a pirogue, paddling himself to the mouth of the Río Negro before returning to Buenos Aires. Each stop, he recalled, was the departure point for a plunge into the interior in search of exotic Indians. He island hopped from Antigua to St. Thomas, crossed Panama, steamed west to the Sandwich Islands (Hawaii) and northeast to the mouth of the Columbia, then up the coast to Vancouver Island and the Queen Charlottes. He may have visited Kamchatka in Russia, though he did not mention it to Sir Thomas, before returning via San Francisco, Panama, and Cuba to Le Havre, Paris, and finally Brussels, where he passed the winter of 1857–58.[53]

As late as June 1858, Catlin would still be painting up the results of his recent travels and trying to hawk what he called "albums uniques," pencil outlines of his Indian pictures accurate down to "a trinket & a toy," with a handwritten text assuring buyers a one-of-a-kind memento, a personal North American Indian gallery augmented by examples of Catlin's recent work along the Pacific coast. He wanted £300 for an album, and while he recognized that Phillipps might not be interested, hoped he could suggest another buyer. Phillipps did his best—he deposited the album with Lord Northwick, but no offer followed.[54]

Besides the price, Lord Northwick may have been deterred by the quality of the album offered. Catlin always described these collections of drawings as unique, though he admitted to a correspondent who had bought one a few years earlier that he had made "several albums of Indian portraits for English noblemen, some in one vol. and others in two vols." Clearly tracing was involved, and while Catlin got the details right, he lost the human qualities of his original portraits, leaving the ethnography but not the artistry. The bits of dress are there, and ornaments, paint, and paraphernalia, but instead of individuals Catlin offered look-alike Indians with long, broad noses, and flared nostrils, and fixed expressions. They could just as well have been the dummies on which he used to drape his Indian costumes for display. Young or old, they are the same, while the clarity of the outlines casts a pitiless light on Catlin's struggle with anatomy: missing shoulders, shortened trunks, elephantine hands, a complete failure to articulate musculature. In some drawings straight objects (like pipestems) bend as they pass through a subject's hand. There is haste here, and lack of interest, suggesting how far Catlin was removed from his original inspiration and how heavily practical concerns pressed on his artistry. Linked to his *Portfolio* of 1844 and a comprehensive work he contemplated near the

104. George Catlin, *Ostrich Chase, Buenos Aires—Auca* (1856), one of Catlin's most exotic hunting scenes. National Gallery of American Art, Washington; Paul Mellon Collection.

end of his life, the albums were merely a way of capitalizing on his lost gallery and financing his ongoing expeditions.[55]

Over the winter of 1857–58 Catlin worked away at his paintings and routinely complained about his deafness—what we would today call tinnitus, since he did not enjoy the relief of total silence but was tortured by an incessant cacophony in his head. "If it were only deafness that I have to submit to, I feel as if I could sit down in silence for the rest of my life, with the material I have now gathered and be contented in my daily employment—but the disease is attended with a sound in the ear, not unlike the drawing of a violin bow across one of the strings, and that with each pulse exactly." In this condition, Catlin found writing difficult. "My sketches *and* notes on South & Central Am[a] are with me, but in a sort of chaos, which I am working at like a mountain to be removed before me," he wrote in late November. By then he had completed twenty to thirty paintings from his last trip, which presumably included his visit to the pampas, since he was portraying Indians chasing wild horses with bolos and hunters shooting ostriches. He had been able to support himself on this extended excursion by returning to his roots, becoming an itinerant portrait painter in a region where there were no rivals. Now he needed income again, and since Lord Northwick declined to buy the album of his entire collection, perhaps

Phillipps might be interested in a shorter version, a selection. Catlin wanted £100 for it, but would take £50 as security on a two-month loan; when Phillipps countered with an offer of £25, Catlin snapped at it. He was awaiting money from the States for the sale of some real estate he owned and expected to redeem the album shortly. But the funds never materialized, and two months later, on June 11, 1858, he wrote Phillipps to say that the album was now his. Thus ended another transaction with Catlin's "only patron," marked as usual by mutual benefit: Catlin got the money, Sir Thomas more art at a bargain price.[56]

Catlin then slipped from view again, not to resurface until September 1860. Where he had been and what he had been doing are matters of conjecture. He always said that he spent eight years in South America, from 1852 to 1860; if his dates are advanced two years, however, putting his first voyage in 1854 where it properly belongs, then a trip he placed in 1856 can be assigned more plausibly to 1858. Having received a £300 windfall from New York, presumably from the sale of real property, he returned to Buenos Aires and, by sailing packet, coasted the entire length of Patagonia, at last viewing the southern extremity of the continent. He passed through the Straits of Magellan, up the backside of South America to Panama and down to Caracas, Venezuela, near his original point of entry into South America, once again searching for a fortune, this time in precious stones. He traveled in Colombia studying not Indians but geological formations (a curiosity stimulated by Humboldt, who was an enthusiast on the subject). Perhaps immortality was easier to achieve in such explorations: no Indian tribe had ever been named after George Catlin, but the red pipestone was.[57]

By early September 1860 Catlin was in Manchester, implying that he had only recently returned from Rio Grande do Norte (Natal) in Brazil. This much is certain: he was back for good. "I consider I have now all the materials for the work which it has been the ambition of my life to bequeathe to the world when I leave it—the Ethnography and Ethnology of the two hemispheres of America. My roaming propensities are now satisfied, as I should see but little new if I went again. And for the remainder of my life, I have enough to work upon in my studio, if I ever get to it." *If* he ever got to it—because Catlin, of course, had returned broke and, as he wrote Sir Thomas, needing £40–50 to redeem several hundred pounds of Brazilian amethyst and topaz stored in his luggage in Antwerp. He expected to sell them in Amsterdam, but first he had to pay his hotel bill and expenses in Liverpool. The three-volume album unique of his entire collection was Phillipps's, if he wanted it, for just £100, not the £300 asked three years before. Failing that, Catlin would sell him eight oil paintings in gold frames of Indians and scenery along the Amazon, easily worth £15 to £20 each, his for only £65. Phillipps declined but graciously

105. George Catlin, *A Mura Encampment—Boat Sketch.* Catlin paints the unsuspecting natives, about 1854. National Gallery of Art, Washington; Paul Mellon Collection.

accepted Catlin's usual gift in this period, a portrait of Humboldt done, Catlin said, in 1856, a year after he actually took the baron's likeness and indicative of his accuracy with dates.[58]

It remains for someone to clarify the chronology of Catlin's South American travels. These are truly lost years. The well-known artist-traveler of the 1830s, a minor celebrity in the 1840s, sank from sight in the 1850s. I have not found a single letter he sent from the Americas in the 1850s, nor have I located a contemporary reference conclusively placing him on the West Coast. Catlin claimed to have traveled incognito, on an English passport under an assumed name—a man without an identity, eerily reminiscent of Schoolcraft during his brief, embarrassed passage through life as Mr. Colcraft. In the 1850s Catlin left few reliable guideposts and many that are misleading, but when his chronology is unscrambled and his actual itinerary traced, the lost years of America's greatest Indian painter should be full of revelations—like his lovingly recounted sketching expedition down the Amazon, sixty-nine days of dreamy drifting, in 1854.[59]

Catlin wrote that he first ascended the Amazon from Pará, intending to visit Catholic missions along the way and paint the natives. But he encountered difficulties. Two weeks at the first mission cost him money and did not bring a single sitter. The Indians were friendly but superstitious, too

acculturated and much too curious for his taste, plying him with questions in Spanish and "Lingua Geral" that he could not handle with his customary aplomb, since he was experiencing the ear problems he described to Phillipps three years later. He could hear voices but was unable to distinguish a single word and consequently preferred solitude to society, a preference denied him at the missions. The curiosity about who he was and what he was doing worried him the more since his passport was falsified.[60]

So Catlin returned to Pará, hooked up with an Englishman named Smyth who had accompanied him from Guyana to Pará, and steamed up the Amazon all the way to Nauta, in Peru, where he hired a cupola trading boat whose Portuguese captain was familiar with the tribes along the upper river and willing to descend the thousand miles to Óbidos, giving Catlin ample opportunity to sketch the Indian villages along the way. The three men could sleep comfortably on the boat, and the cupola provided Catlin "a good *atelier*" in which to refine his drawings as they moved along. Some ten thousand Indians, one hundred tribes, were said to inhabit this stretch of the Amazon, a prospect Catlin found "exhilarating." Employing his tactics from the 1830s, he invited a headman aboard at the first stop, intending to paint his portrait and then record his name. But a "medicine man" warned the chief that, having already surrendered his skin from the crown of his head to the bottom of his feet to Catlin, in yielding up his name as well he would become "*a man without a name,*" condemned to early death. This frightening prospect set off a chain reaction; as the travelers continued down the river, the Indians they met refused to sit for their portraits. Seeing his plans collapsing, Catlin devised a ruse. The boat was anchored four or five yards offshore, and the Indians were enticed to the water's edge by theatrical demonstrations of the Colts Catlin had brought along—a practical use for all those firearms!—and a little fiddle music provided by the captain. While the Indians gawked, Catlin sketched surreptitiously, "screened from their view by the bulwark of the boat or by the transparent sides of the cupola." His sketches were made at a few yards' distance, but he had his pick of subjects, full length, and entirely unselfconscious; what he did not have was any way of determining who they were, since questions about their names would have aroused suspicion.

For sixty-nine days the boat continued its leisurely descent, poking around in coves and lagoons while Catlin painted the scenery and likenesses of some thirty tribes in oils thinly applied to pasteboard panels to facilitate drying in the tropical humidity. "Done at a dash," these were, he said proudly, "the best works of my life." The technique pioneered on this cruise served Catlin on the rest of his South American wanderings, imposing anonymity on his Indian subjects and further blurring the specifics of time and place. His pictures of natives undifferentiated in their nakedness save by hairstyle and ornamentation, unaware of having their likenesses

106. George Catlin, *Four Mura Indians,* unselfconscious and unawares, painted about 1854. National Gallery of Art, Washington; Paul Mellon Collection.

taken, mirrored Catlin's own anonymous voyage through life in the 1850s. Even had the Indians been willing to pose, there was no one like the fur traders of old to fill him in on their personal histories, permitting him to make individuals of the men and women before him. These paintings are candids of strangers, hypnotic in their repetitiveness. Some scenes of jungle foliage—emerald fronds and giant starbursts—anticipate Henri Rousseau's tropical fantasies. Catlin had found another verdant world peopled by red men in which to lose himself.[61]

Reality reasserted itself on his return to Europe in 1860. He was beginning his third and final decade in exile from his native land, a period marked by isolation and a continuing anger over his government's neglect and the slanders of Henry Schoolcraft. But it would also be a decade marked by success as he capitalized on his "second starting point" in life, the South American and West Coast notes and paintings, and began to recreate his "Old Collection" in a new Indian gallery of "cartoons" in oil. Catlin had copied most of his original portraits between 1848 and 1852 using a photographic lens (camera lucida) to reproduce heads and torsos, adding the bottom halves from sketches made, he claimed, from life. These outlines of standing figures, often grouped several to a page, were stored

355

107. George Catlin, *Encampment of Cocomas—Looking Ashore,* showing the jungle as a fantastical garden. National Gallery of Art, Washington; Paul Mellon Collection.

separately from his original Indian Gallery and thus escaped his English creditors—apparently a matter of good planning rather than good luck, since he later brought them to Paris where, traced in albums uniques, they were his bread and butter after 1852. In the 1860s he transferred the outlines to pasteboard panels consistent in size and style with his South American cartoons; thus Catlin's "new" or second Indian collection, numbering over six hundred paintings when he exhibited them in 1870 to signal his return from obscurity.[62]

On a personal level, the 1860s for Catlin would be marked by reconciliation as he renewed contact with a brother not seen in nearly thirty years and with daughters who had been told he was the same as dead, having sacrificed honor to a failed ambition. One of them recalled following his wanderings in the 1850s through reports from Joseph Henry at the Smithsonian. But Henry did not know where he was, nor did Ralph R. Gurley, who tried to keep tabs on him through Dudley S. Gregory, who may have known. On April 22, 1861, Catlin finally broke his silence. He wrote his youngest daughter from Ostend, Belgium, his first direct communication with any of his children in nine years. A heartrending apology, his letter was also the defiant declaration of a fighter who had never given up:

The labours and fatigues I have been through since we parted have been many, as well as my successes & my misfortunes. . . . I have seen much and I have done much. . . . I have stood upon the crater of the two volcanos in the Koriak mountains of Siberia. I have been to the Aleutian Islands, & Kamskatka, traced the Pacific Coast to the mouth of Columbia—ascended that and crossed the Rocky mountains to Santa Fé—from that to Matamoras, by the Rio Colorado—from that to Cuba—to the Amazon, (the second time) to Venezuela—to Bolivia—to Peru—to Equador—to Central Amª—to Yucatan—Palinque—to Uxmal, &c. &c.

The names rolled off his tongue as they always had, sending people scurrying to their atlases to trace his travels and shake their heads in wonder. Where had Catlin *not* gone in pursuit of the exotic? Almost sixty-five when he wrote his daughter, he was still full of vinegar if a little worse for wear:

I have had nothing but my own hands, with the talent which the Almighty gave me (perhaps for that purpose) to pay my way. You can imagine, my dear child—that I have travelled to a disadvantage. . . . If my life had been thrown away in idleness or dissipations during these long years of absence there would be no excuse for me, I would be a *monster,* and I should have no right to ask forgiveness of my dear little angels, but I have been constantly at work, and still am so, even when lying on my back, or hobbling about on crutches.

Crippled by his exertions and suffering torment through the night, he was still the driven Catlin, sitting in a small room recreating his latest adventures on paper, then taking the promenade on the parapet between town and beach, hopeful that the sea air might cure the volcanic eruptions in his knee, deliberately giving himself "*pain* in walking in order to prevent a crooked leg."[63]

If willpower were enough, one day George Catlin would win over the world. Sustaining him would be the comforting thought that while he had lost everything, he had lost nothing; his gallery, which might have been dispersed by his creditors, awaited him in storage in Philadelphia, even as he awaited the government's decision to acquire it. Time was his ally. The passing years would only make his paintings more valuable as change eliminated what he alone had preserved for posterity.

* * *

To those who saw Catlin in Ostend and Brussels in the 1860s his ultimate vindication seemed a remote prospect. He was an eccentric living a hermitlike existence, gray, unimposing. He dressed cheaply. Gone were the showman's vanities, the brown dress coat, fancy satin vest, and doeskin

357

trousers ordered from a Dublin tailor in 1843, though he still had his caps custom made. Catlin had not gone to seed. With a stock of old-fashioned collars and ties on hand, he was always tidy and presentable. He might sigh over "the solitary hours of my *hermitage*," but he had the ear of the American minister to Belgium, Henry S. Sanford, scion of a wealthy Connecticut family and a patron of the arts always good for a small loan or favor. Catlin shunned society not because he was without invitations, but because of his deafness. He could not join in repartee and tended to speak too loud. But he remained fluent and witty. Sipping a sixty-three-year-old port at a Thanksgiving dinner hosted by the Sanfords, he pronounced himself older but the port richer. He easily slipped into the role of raconteur, relating anecdotes polished by his years before the public, and kept a pad at hand to answer inquiries. Conversation was a bother, however, and he preferred to work and read in silence, undisturbed.[64]

In Brussels Catlin followed an unvarying routine. He passed the daylight hours in his modest studio rooms working on outline drawings of his entire collection. Each evening at six, "rain or shine," he repaired to a local café where he took his supper and, oblivious to the other regulars playing dominoes and backgammon, sat alone reading the American news in the London and Paris papers and writing by a good gaslight. The air was blue with smoke; dogs stretched, scratched, and strolled around the room; the din rose as the evening wore on. Nothing perturbed him. His deafness sealed his isolation in a land of strangers.

To all appearances Catlin was merely living out his days. His rooms struck a visitor as a "dungeon" where, like a bored prisoner, he had rigged up a contraption, a glass cylinder with a trapdoor, to catch mice. What a study in pathos: a proud American original, neglected and forlorn, reduced in his old age to the company of his caged collection of "little pets." But appearances were deceiving. The old Catlin fire still burned within as he plotted his comeback and tirelessly schemed. Literally living by his wits, he was the man who had invented a better mousetrap—and much else besides.[65]

Perhaps his inspiration was Samuel Colt, whose patent revolver had made his name a household word, or Joseph Harrison, whose improvements in locomotive technology had so impressed the Russian emperor. Or perhaps it was the Great Exhibition of 1851, where Cyrus McCormick's Virginia reaper and Charles Goodyear's India rubber fabrics were prizewinners and Colt's revolving firearms received honorable mention. The point was that mechanical ingenuity paid better dividends than art. So George Catlin, intent on turning a fertile imagination to profitable ends, became a part-time Yankee tinkerer. His long ocean voyages in the 1850s had exposed him to the dangers of travel at sea and persuaded him that any device that would reduce risk to life would make its inventor a fortune. He

came up with a plan for a steam raft, detailed in a pamphlet printed in Manchester in 1860 and touted in the English press at the time. The public, he was sure, would be receptive, but shipowners accustomed to mingling "cargoes and human flesh in the same hulks" would doubtless oppose it, and there would be the usual difficulties in forming and capitalizing a company to put his plan into action. "It is too much the misfortune of inventors of the present age that new capital and new capitalists are not as plenty as new inventions," he admitted. Nothing discouraged, he announced new inventions as they popped into his head. In 1864 he came up with a submarine battery for protecting harbors and towns from bombardment by warships and a steamboat slipper for extricating vessels run aground on mud or sand. The harbor defense system, inspired by the American Civil War, was forgotten when the war concluded; the steamboat slipper had general application, and Catlin was still boosting it in 1869. That January he granted power of attorney to a brother to apply for an American patent on the invention, and he continued to believe that, properly handled, it would someday make somebody rich "even if *I did* make it."[66]

Catlin had always been a dreamer—Indian galleries, floating museums—but his last years were his crackpot years. The pattern had been there to see—implausible theories firmly embraced and never relinquished, including the notion of the Welsh origins of the Mandans. It was not that Catlin lost his hold on reality in the 1860s, but that his schemes multiplied in the isolation of his rooms. During his South American rambles his own infirmities had fostered an interest in remedies, and in 1861 he published a hand-lettered pamphlet, *The Breath of Life; or, Mal-Respiration,* that enjoyed a curiosity success among the hypochondriacs of the world. They were legion, judging from its many printings. Catlin's message was simple. Sleeping with the mouth open and straining the lungs with impure air exposed civilized people to the full range of fatal diseases as well as to "Curvature of the Spine—Idiocy—Deafness—Night-mare—Polypus in the Nose—Malformation and premature decay of the teeth—toothache—tic-doloureux—Rheumatism—gout . . . to which the brute creations are strangers, and to most of which the Savage Races are but little subject"—a message he compressed into a pithy slogan that gave title to later editions: "*Shut—your—mouth.*" His proposed remedies included strapping infants Indian fashion on cradleboards so that they slept on their backs immobile and fettered, but with mouths closed in blissful rest. Pen drawings of open-mouthed sleepers and slack-jawed imbeciles illustrated his point: "*Idiots asleep* cannot be *Angels awake.*"[67]

It would be easy to chalk the pamphlet up as just another Catlin quirk had it not enjoyed such popularity. Charles Dodgson was said to have drawn inspiration from it in preparing his own manuscript of *Alice in*

level of his spine. The gastric juices commence their work upon the fresh contents of a stomach, on the arrival of a good dinner, with a much slighter jar upon the digestive and nervous systems, when the soothing & delectable compound is not shocked by the unwelcome inhalations of chilling atmosphere.

And this tender and affectionate mother, blessing herself and her flock of little ones with the pleasures of Sleep!

— how much might she increase her own enjoyment with her pillow under her head, instead of having it under her shoulders; and that of her little gasping innocents, if she had placed them in cribs, & with pillows under their heads, from which they could not escape — —

The contrast between the expressions of these two groups

108. A page from Catlin's hand-lettered 1861 pamphlet *The Breath of Life; or, mal-Respiration,* illustrating its blunt advice: "*Shut—your—mouth.*"

Wonderland. A leading London physician endorsed its conclusions, and Thomas Carlyle declared it "a sane voice in a world of chaos." Such judgments remind us again that in an age when any antiquarian theory could fly on the wings of Mound Builder mania or a showman's hype, Catlin on the importance of proper sleeping was right at home with the phrenologists, physiognomists, and peddlers of magical nostrums. Perhaps in the hope of repeating *The Breath of Life*'s success, he prepared a manuscript titled "A Cure for Influenza." It told how Indians overcame the affliction by prompt action at its onset through violent exertion to increase circulation and open the pores, followed by tightly wrapping the entire body in a robe and lying prone, the palm of the left hand (that nearest the heart) cupped over nose and mouth while deeply reinhaling the heated breath, inducing a heavy sweat that at once expelled the fever. "It may seem incredible that in the palm of the hand there should be a soothing and healing balm," he wrote, but so it was. Catlin attested to the treatment's efficacy from personal experience, even as he had told readers of *The Breath of Life* how in middle age he had conquered his own habit of sleeping open mouthed. The sweating complete after an hour or so, "My head is then

uncovered, (no matter how cold the weather) and sleeping until morning, with my mouth shut, the day before me is without pain, and delightful, and my influenza is finished." One can almost see it—"In the Palm of the Hand; or, A Cure for Influenza," but this tract was never published.[68]

These calculated bids for popularity harmonized with the received tradition in America that the natives possessed secret medical lore and knowledge of curative procedures unknown to civilized man. Catlin had a disturbing tendency to speak of three "creations—the Brute—the Savage—and the civilized Races," even as he advocated the example of "the Savage." But there was a relativism in his deference to native customs. As he explained to an English correspondent in 1860 in defending the practice of dirt eating among certain Indian tribes, it was "like a thousand other things seen but not understood," the clay serving not as food but an effective antidote to stomach cramps.[69]

* * *

The old American recluse bent over his papers and manuscripts in a Brussels cafe was an enigma to those who saw him. But his inventions and his cure-alls tell us something of what was going on inside his head. So do his letters. They are verbal explosions from out of an enforced silence, rambling harrangues that in their loquacious intensity remind us of the ancient mariner's tale of woe. Catlin too was bursting to have his story heard. His letters were querulous, truculent, paranoid, self-justifying blasts at a modern world he experienced secondhand, through the newspapers, a world pale in comparison to that of "my younger days" recalled with often vivid imprecision. Apologizing for one especially long letter, he explained that "old recollections rush into my mind." He railed against the English, who took unconscionable pleasure in America's Civil War, ignoring their own deep complicity in planting human slavery in the New World and their own ill treatment of the permanently disadvantaged in a class-structured society. "Their Parliament enacts on one day that a poor man who kills a pheasant or a hare on his neighbour's ground to feed his children, is a felon," he wrote, "and on the next, they pass an act authorizing the *stealing* of *human beings* and then *robbing* them of a lifetime of *hard labour*—the one degrades and sends a poor man to a penal settlement; the other makes a gentleman and a Nabob!" He had never forgotten the shadow of debtor's prison that had once fallen over him.[70]

But condemn the English as he would, every subject took him back to his own cause: the American Indian. He had finally figured out the pattern of events that had repeatedly frustrated his efforts to sell his Indian Gallery to the federal government. Slavery itself was wicked. The slaveowners' conspiracy to expand the institution was a monstrous evil. As he played back the events of the 1830s, he could see that the Jackson administration's commitment to Indian removal was part of that conspiracy. Slavery expan-

sion would brook no obstacles. The Indians would have to go. Catlin's gallery, a constant rebuke to government, must never find a home in Washington, where it would arouse a sentiment favorable to the Indians. When Catlin approached Congress in the 1840s the passions of the removal debate had subsided, but not those over removal's underlying cause, slavery expansion. Thus the constant opposition to purchase by southern representatives unfriendly to Indian rights; thus the betrayal by Jefferson Davis during the crucial vote of 1849. With the Civil War everything had become clear. After delivering "the most complimentary eulogy that has ever been passed on my works," Catlin recalled, Davis voted against their purchase "from *principle*" and so defeated the bill. This "principle" Catlin construed to be not states' rights but that "adopted and proclaimed by President Jackson many years before, of removing all the southern tribes of Indians west of the Mississippi River, that their two hundred and fifty millions of [acres of] rich cotton lands might be covered with slave labourers."[71]

Thus Catlin came to identify his own misfortunes with those of the southern tribes removed in the 1830s. His letters from Belgium recounted heroic efforts on their behalf. Having learned that President Jackson had ordered his arrest if he followed through on his intention to visit Chief John Ross, Catlin went directly to the White House and demanded an explanation. "*It is none of your business, Sir,*" Jackson exploded, obviously angry at his opposition to Cherokee removal. And having on a different occasion gone to Washington to plead for the release of Osceola and the other Seminoles imprisoned at Fort Moultrie "as the means of obliterating a disgrace from the pages of Am[n] history," he was told by Jackson "*that it was none of my business*—the captives were too important to be let loose—history will take care of itself, and I will take care of the Indians." At least Jackson was consistent in Catlin's recall, and so was Catlin in standing up for Indian rights.[72]

The Civil War, in ending the slave conspiracy, seemed to have eliminated the reason for the government's aggressive Indian policy. But from his perspective abroad, Catlin in the late 1860s reached the alarming conclusion that the western tribes were more imperiled than ever. He detected a hardening of American hearts preparatory to, he shuddered to say, the ultimate crime of Indian extermination. In the past, private enterprise—fur merchants, whiskey peddlers, and the like—had callously sacrificed Indians to profit. Now the lust for gold was a fever in the land, and prospectors swarming onto the reservations were aided and abetted by a government intent on nothing less than the Indians' "rapid decimation and final extinction."[73]

Catlin's growing alarm can be traced in two books he published in the 1860s. The first, *Life amongst the Indians* (1861), was intended as a trove

"of facts for youthful readers on the character and condition of the American Indians." It incorporated chunks of *Letters and Notes* and *Notes on Europe* and added information on some of Catlin's South American wanderings, dispensing with a "connected narrative" for the sake of brevity and pace. This permitted the topical treatment Catlin preferred. He took the opportunity to denounce Indian removal as "cruel" and the ruse whereby Osceola was captured as "a stratagem too disgraceful to have ever been practised by an Indian tribe." But his tone was generally restrained, his jibes delivered in the past tense. In his next book for "young folks," *Last Rambles amongst the Indians of the Rocky Mountains and the Andes* (1867), he denounced perfidy in the present and expressed his fears about the government's future intentions. "Who is the *savage,* and which the *brute?*" he asked his young readers, and though his heart "bleeds at this," he answered:

> It is said that an army of men sufficient to protect all the white inhabitants in the mountains and in the plains is on the move, and that *"extermination to the savage"* is to be the "watch-word." I do not believe it—I think better of my country than this.
>
> What! the government that has just gained everlasting honour before the civilized world by giving *freedom* and rights of citizenship to two millions of Africans, now, at the point of the bayonet, to *disfranchise* and *enslave* a *free* and *independent* people—to *disinherit* her *"red children,"* whose lands she holds, and (to protect a set of murderous adventurers in the Rocky Mountains), to dispute their existence! I *cannot* believe this, and I *will* not, for I wish yet to lay my bones in my native land.

But the crisis was at hand. The final act in Indian resistance to white encroachment would be a bloody one. Its outcome was not in doubt. Soon a second classic age, that of the American Indian in his native wilds, would pass from the stage, "the last of the race . . . tracked by bloodhounds, and sent to the dust with 'Sharp's rifles!'"[74]

Subsequent events only confirmed Catlin in his fears. George Armstrong Custer first gained notoriety as an Indian fighter on November 27, 1868, when the Seventh United States Cavalry routed a camp of Cheyenne Indians on the Washita River in Indian Territory, killing over 100 and taking 53 women and children prisoner. Then on January 23, 1870, Major Eugene M. Baker and four companies of cavalry and infantry attacked a camp of friendly Piegan Indians on the Marias River in Montana, killing 173 and taking 140 prisoners while suffering a single casualty. The western settlers and the army brass cheered such victories, but eastern humanitarians pronounced them brutal massacres and condemned General Philip H. Sheridan, since 1869 commander of the military Division of the Missouri,

for visiting total war upon the Indians. "I only know the names of three savages upon the Plains," Wendell Phillips protested from Boston: "Colonel Baker, General Custer, and at the head of all, General Sheridan."[75]

From his base in Brussels, George Catlin joined in. He denounced Baker's "unwarlike and cowardly act" as, "in the strictest sense, horribly criminal." For thirty years he had been trying to convince the federal government that white avarice was behind every Indian war, only to be told (again!) "that it was none of my business." Now his prediction of Indian extermination was coming true. "What a spectral picture have we before us when we close our eyes, of well fed soldiers entering the wigwams of these starving and unsuspecting people, with sabres in hand splitting down the heads and mangling the bodies of women and children, crying and imploring for mercy! What a school of practice, these slaughter houses for American soldiers." Now it was easy for all to see "the reality of *Extermination* . . . the going down of the sun (and the last glimmering rays) of the North American Indians."[76]

These were strong words, Catlin admitted, but it was time to speak out "on the side of policy and humanity, and not of blood and butchery." Assessing what this meant, Catlin's brother was blunt: "I don't know anything about the value of his works, but know there is no love for Indians in this country in these times." Nevertheless, Catlin's juvenile books enjoyed success in America as well as England. He described *Last Rambles* as a sequel to *Life amongst the Indians* and urged his readers to acquire both. Otherwise they would be "coming in at the play at the end of the second or third act." He claimed to have sold 60,000 copies of the first book by 1867. The second may not have fared so well. It covered more new ground, being devoted entirely to his travels in the 1850s. But its tone was shriller, its moralizing more overt, and Catlin could not resist introducing extraneous material documenting his personal mistreatment by the American government. In his mind the Indians' cause and his own (as their truest friend) had become one. "My works are done," he wrote in the brief valedictory that concluded *Last Rambles:* "I have had no government, society, or individual aid, but travelled and laboured at my own expense. In my writings and my paintings I have *quoted* no one; but have painted and written of things that I saw and heard, and of nothing else."[77]

Catlin's young readers could have no idea what he meant, but the inference is clear. With ample time to replay events in his head, George Catlin in the mid-1860s was at last ready to settle old scores. He would take up the challenge issued by Alexander von Humboldt a decade earlier, write to Prince Maximilian of Neuwied, as Humboldt had suggested, and arm himself with evidence to engage Henry R. Schoolcraft in open battle. At issue was the veracity of his eyewitness account of the Mandan O-kee-

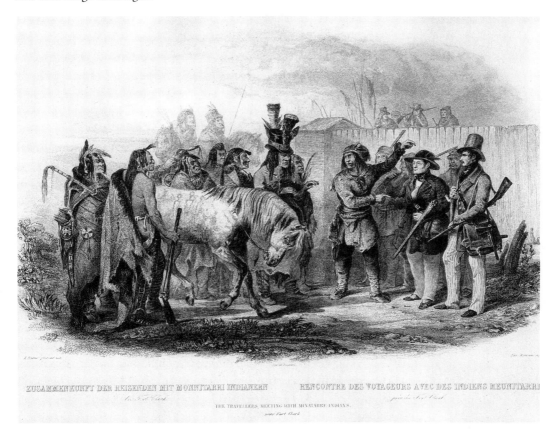

ZUSAMMENKUNFT DER REISENDEN MIT MONNITARRI INDIANERN RENCONTRE DES VOYAGEURS AVEC DES INDIENS MEUNITARRI

THE TRAVELLERS MEETING WITH MINATARRE INDIANS.

109. The Travellers Meeting with Minatarre Indians Near Fort Clark, an engraving after Karl Bodmer (1808–93) in which the artist included himself standing on the right beside his shorter patron Prince Maximilian (1782–1867). Joslyn Art Museum, Omaha, Nebraska.

pa. During the years remaining to him, absolute vindication would be his goal, taking precedence over even his desire to sell his Indian collection. Indeed, he had come to believe that the one was a precondition to the other.

* * *

On December 2, 1866, George Catlin wrote to Prince Maximilian. He came right to the point:

> Since we travelled together on the upper Missouri, Mr Schoolcraft, who has published a large work on the North American Indians for the United States Government, and who never had the industry or the courage to go within 1000 miles of the Mandans, has endeavoured to impeach my descriptions of the Mandan religious ceremonies, which, as the tribe has become extinct, he has supposed rested on my testimony alone. In his great work under the authority of the government, and presented to the literary and scientific institutions of the whole civilized world, he has denied that those voluntary tortures ever took place, and has attributed them to my

"very fertile imagination" tending therefore, to deprive Ethnology of the most extraordinary custom of the North American Indians, and to render my name infamous in all future ages, unless I can satisfactorily refute so foul a calumny.

Catlin sent four paintings and a detailed description of the O-kee-pa along with his letter, and asked Maximilian's endorsement.[78]

With his manservant and a hired artist as company, Maximilian, a dedicated naturalist in the Humboldtian tradition, had set sail from Prussia in May 1832, arriving in Boston on July 4 to begin preparations for an expedition to study the western Indians. His artist, Karl Bodmer, a Swiss, had just turned twenty-four and was unknown to fame; he would live another sixty years without ever eclipsing the splendid sketches he made on this expedition. Maximilian's party tarried in St. Louis in the spring of 1833, where they were able to preview some of Catlin's Indian paintings and, a few months after him, visit Black Hawk and the other Sac and Fox prisoners at Jefferson Barracks. Maximilian debated accompanying Sir William Drummond Stewart, later Alfred Jacob Miller's patron, on an overland excursion to Santa Fe, but he eventually accepted the advice of the American Fur Company and retraced Catlin's route up the Missouri to Fort Pierre on the same steamer he had taken the year before. Maximilian's entourage continued upriver, passing the Mandan village shortly after mid-June, and reached Catlin's final destination, Fort Union, a year and a week after him, on June 24. They remained only briefly before pushing on to Fort McKenzie in the heart of Blackfoot country. Maximilian and Bodmer enjoyed one great advantage over Catlin. He was driven to see and paint as much as he could as fast as he could; they had the luxury of time, including a two-month stay at Fort McKenzie, where the post factor, David D. Mitchell—Schoolcraft's authority for discrediting Catlin's account of the O-kee-pa—was their host. On September 14 Maximilian's party began its descent of the Missouri to winter at Fort Clark, the American Fur Company post by the Mandan village. The company showed the prince—as it had Catlin—every courtesy, and he and Bodmer passed five months studying the Mandans at leisure. With the breakup of the ice in the spring, they continued their return journey to St. Louis and eastward, departing New York for Europe on July 16, 1834, after a stay of two years in America.[79]

On first arriving in the States, Maximilian had been struck by the lack of curiosity about the native Indians. He had scoured the bookshops of Boston and Philadelphia without turning up much worthwhile, the writings of Schoolcraft, Cass, and McKenney among the few "honourable exception[s]." At the time of his visit, McKenney and Hall's ambitious

110. Karl Bodmer, *Mandeh-Pahchu (Eagle's Beak), Mandan Man* (1834), a watercolor portrait evincing Bodmer's technical skill. Joslyn Art Museum, Omaha, Nebraska.

illustrated series was only in the planning stage, and while Maximilian wished it well, he perceived a need for a work of the sort he contemplated, an ethnographic description of the western tribes, fully illustrated by his hired artist.[80]

Indeed, Karl Bodmer's precise, beautifully detailed renderings of scenery, animals, and Indians complemented the scientific spirit of Maximilian's tour in the same way Miller's misty, idyllic views of fur traders, Indians, and the annual rendezvous would serve Sir William's nostalgic purposes in visiting the Rockies three years later. Francis Mayer, as a Miller acolyte, preferred his soft-focus romanticism; he admired Bodmer but found his Indians "too *brutal*." Certainly Bodmer's hard-edged realism made Catlin's work seem slapdash by comparison. Miller considered Catlin a humbug; Bodmer thought him a charlatan. Nevertheless he welcomed Catlin's success in the 1840s in England and France, where he was serving as agent (on commission) for Maximilian's *Travels in the Interior of North America, 1832–1834.* Perhaps the interest in Indians Catlin aroused would boost sales. Thus Bodmer dissuaded Maximilian from publishing a critique in French of *Letters and Notes;* instead he tried working the same patch as his rival, approaching both Humboldt, Maximilian's friend, and King Louis-Philippe. His efforts at cultivating Humboldt were rebuffed, and Louis-Philippe granted him a single half-hour audience. The king did order three copies of Maximilian's work with its splendid atlas of eighty-

one aquatints after Bodmer, but in marked contrast to the warm reception he accorded Catlin, he took no special interest in the Swiss artist. Years later, Mayer met Bodmer in a Paris bistro where, he told Miller back in Baltimore, they swapped Indian tales. But apart from an 1852 collaboration with Jean François Millet, Bodmer, a Barbizon fixture, never painted Indians again.[81]

If Bodmer's objections to Catlin's work were aesthetic as well as scientific, Maximilian's were principally scientific. Sometimes they were mere quibbles. Catlin's phonetic renderings of Indian names and words in *Letters and Notes* were inaccurate and his Mandan vocabulary was deficient—the result of haste and (perhaps literally) an ungifted ear. His Indian portraits Maximilian judged vastly inferior to Bodmer's. He found exaggeration in Catlin's work, a pandering to popular taste that might charm kings but would not stand up to scientific scrutiny. Catlin was guilty of overenthusiasm for his subject, noble savages and fairy-tale landscapes alike. But Maximilian did not disagree with his assessment of the Indian's ultimate fate, and he certainly did *not* think Catlin dreamed up the O-kee-pa. *Travels in the Interior of North America* provided a secondhand description of the same ceremony, and the German first edition (1841) reprinted Catlin's original report of August 12, 1832. It was deleted in the English translation, published in 1843, Catlin's fuller account having appeared by then in *Letters and Notes*.[82]

Knowing as he did that Catlin had simply described what he saw, Maximilian put aside his reservations in 1866 and unequivocally endorsed Catlin's account of the O-kee-pa:

> Not having been, like yourself, an eye-witness of those remarkable starvations and tortures of the *O-kee-pa,* but having arrived later, and spent the whole of a winter with the Mandans, I received from all the distinguished chiefs, and from Mr Kipp (at that time director of Fort Clarke, at the Mandan village, and an excellent interpreter of the Mandan language), the most detailed and complete record and description of the *O-kee-pa* festival, where the young men suffered a great deal; and I can attest your relation of it to be a correct one, after all that I heard and observed myself.

Schoolcraft "knows well the Indians of his own part of the country," Maximilian continued, but "if he should doubt what we have both told . . . of the Great Medicine festivities of the *O-kee-pa,* he would be wrong, certainly."[83]

There it was in writing: an incontestable refutation of Schoolcraft's libels. Understandably, the prince's letter was prominently showcased in Catlin's next book, *O-Kee-Pa: A Religious Ceremony; and Other Customs of*

the Mandans, published in London and Philadelphia in 1867. Catlin had a double motive in writing it. First, he wanted to expose Schoolcraft and the Missouri River fur traders who had willfully misled him. Second, he wanted to publish his own fully detailed report on the O-kee-pa to correct a "gross and mangled" version that had been published in 1865 by the Philobiblon Society of London. Titled *An Account of an Annual Religious Ceremony Practised by the Mandan Tribe of North American Indians,* it was based on a manuscript by Catlin acquired by a "literary friend" who turned it over to the printer without his knowledge. When Catlin first learned of the pamphlet through a bookseller's advertisement, he acted immediately to suppress it. He threatened legal action, sent sharp letters of protest to the Philobiblon Society's officers, and covered a set of printer's proofs with notes on the "forged additions" to his work. But he was too late to prevent publication. What had riled him was more than the impropriety of publishing the pamphlet without his permission; the improprieties contained within could be misconstrued as an affront to decency.[84]

In making the O-kee-pa the centerpiece of his Indian experiences, Catlin had only hinted at the phallic rituals involved. He had been willing to satisfy the curiosity of certain gentlemen as a paying proposition, however, and in the period 1864–65 made eight watercolors explicitly illustrating the particulars of the buffalo-calling ritual. They circulated in London before being purchased and eventually donated to the British Museum. The Philobiblon Society pamphlet likely derived from the accompanying text. It was more explicit than the corresponding discussion in *O-Kee-Pa*'s three-page "Folium Reservatum." But the crux of Catlin's protest may have related to a personal embarrassment. In the 1865 account, he witnessed the lascivious dance in which Mandan matrons offered themselves to the invited guests; in the 1867 version, he toned down his description of the dance and claimed to have learned of it at second hand—an improbable concession to propriety for one who usually prided himself on firsthand observation. In this instance he did not want to be thought a participant-observer.[85]

Catlin could hardly take the long view in 1865, but the premature publication by the Philobiblon Society forced him to get on with his own book. Perhaps the society provided some funds by way of an apology; *O-Kee-Pa* would be an expensive undertaking with thirteen colored plates. It was intended as the cornerstone of his campaign for vindication, reminding contemporaries that George Catlin was something more than a former showman. Stripped of the melodramatic hand-wringing of *Letters and Notes,* it established him as a close observer with a discerning eye (if not ear) and a knack for clear exposition. *O-Kee-Pa* would prove a work of enduring ethnographic importance, reissued in a new edition on the cen-

tennial of its first publication. Buoyed by its appearance and Maximilian's testimonial, Catlin experienced a revival of hope and enthusiasm. He was ready to take on the world again.

* * *

The year 1868 marked Catlin's turnaround. *Last Rambles amongst the Indians* and *O-Kee-Pa* were both fresh off the press; plans (including the steamboat slipper) were crowding his mind. He had been at work on two Indian projects that were nearing completion: a comprehensive collection of outline drawings of all his North American Indian paintings ("378 full length *Indian Portraits* and 5,000 full length figures in action, in their DANCES—GAMES—RELIGIOUS CEREMONIES &c.") to be exhibited and then published; and a new Indian Gallery embracing his South American wanderings.

The drawings—two feet by two and a half—would be mounted on screens eight feet high and seventy-five feet long on both sides of a room. Easily transportable, they could be promoted "Barnum fashion" in America and Europe. All the press and "Big Bugs" would have to be invited; their acclaim would bring out the public, and the exhibition would turn a profit while recruiting subscribers for Catlin's proposed portfolio, "The North Americans in the Middle of the Nineteenth Century Fast Passing to Extinction, and Leaving No Monuments of Their Own Behind Them"— the ultimate "album unique" to be made generally available at £20 per copy. Mercenary calculation was involved. "The approaching awful war against the poor Indians never to be ended until they are all exterminated," Catlin wrote in September, "is going to produce exactly the excitement in the public mind for the success of . . . [the] Exhibition."

Once the outlines were finished Catlin would pick up his brush and complete the second phase of his comeback, a new Indian Gallery in oil to replace the one in storage. This cartoon collection, as he called it, would augment the original with scenes from the 1850s and the La Salle paintings done for Louis-Philippe. With something substantial to exhibit and perhaps sell, Catlin would be "a showman again." He would also have the means to redeem the old gallery from Joseph Harrison. This brought him full circle back to his nemesis, Henry Schoolcraft.[86]

Catlin had never gone out of the Indian business during his years in exile. He had produced volumes of tracings as a source of income; repainted individual scenes that were in demand; created specialty items like the watercolor portfolio showing the O-kee-pa's phallic rituals, and, in the same period, an album of twenty-three oils illustrating Indian pipes and their manufacture and usage for a Sheffield collector interested in the history of tobacco. But the principal event of the mid-1860s in his recollection was the continuing damage done his prospects by Schoolcraft's libels.[87]

The French government, years after the fall of Louis-Philippe, had come around by 1864 and was prepared to buy Catlin's Indian Gallery outright. As proof, Catlin cited a letter from Adrien de Longpérier, an official in the Surintendance des Beaux Arts, Musées Impériaux, who wrote in October that he wished to visit him in Ostend and discuss purchase of his collection for the Louvre. The plan was "spontaneously proposed by the French Government," Catlin recalled—though in fact Longpérier's visit was the result of Catlin's lobbying Prosper Mérimée, distinguished author and a senator of the empire active in the Commission of Historical Monuments. Mérimée had tried putting Catlin off gently. The resources of the Louvre would not permit acquiring his collection in oils at present, and the emperor, Napoleon III, was unavailable to view his drawings. Mérimée did agree to forward Catlin's letter to Longpérier, however, with the results that Catlin chose to perceive as a virtual commitment to purchase. He was still waiting around in late December for the emperor to "close" the deal, but he had "no faith in him." His court was notorious for its corruption. "Amidst such licentiousness and blackguardism what encouragement for Arts or Science is to be expected, except by the *adopted* and *privileged* few?" Catlin also attributed the long delay, as was his wont, to international events—the distraction provided by Napoleon III's "Mexican hobby," his imposition in the name of Catholic unity, political stability, and French economic interests of a puppet ruler, Ferdinand Maximilian Joseph, on Mexico in 1864. With the outcome of this dubious enterprise still pending, the emperor had adopted a "wait and see" attitude to paying out money "for collections." When Maximilian was deposed and executed in 1867, Catlin had to find a new explanation. Schoolcraft was the answer. "Though I have not been informed by the French Government from what cause," Catlin wrote in 1868, "I have learned through a reliable correspondent in Paris, that the negotiation was stopped from information received, that the Government of my country had condemned and rejected my works, as deficient in truth!" Having already exposed Schoolcraft's poisonous slanders through correspondence with Maximilian of Neuwied, Catlin would now have to confront them publicly.[88]

Catlin's outlines, his cartoon collection, his need to take direct action against Schoolcraft—even his desire to patent his inventions—all came together in October 1868 when, after several months' wooing through the mail, he lured his youngest brother, Francis P. Catlin, over to Brussels for a visit and a business proposition. In exchange for rights to the steamboat slipper and all exhibition proceeds, Francis would become his representative in America. He would tour with Catlin's outlines, securing subscriptions for the proposed book. His first stop would be Washington, where the exhibition was bound to attract congressmen and alert them to Catlin's

cause. Francis would capitalize on their sympathy by arranging for a new memorial to be introduced in both House and Senate, this time not a plea for a favor, but a *demand* that the United States government make amends for the damage done Catlin. Francis was inexperienced in such matters, but he could look up his brother's old ally, the Reverend Mr. Gurley, and get his counsel. The key was to push, and push hard.[89]

Francis must have listened mystified as his older brother rehearsed this strategy and returned obsessively to Schoolcraft, who had become the embodiment of a lifetime's grievances. In his little pocket diary, Francis recorded George Catlin's obsession:

> Copies of Schoolcraft's work sent by Gov.ᵗ to the heads of every Gov.ᵗ on earth &c.

> What number have been circulated by Gov.ᵗ & by Schoolcraft—

> 3 years ago the french Govt. sent an Envoy to get from G. the terms upon which his whole Collection could be obtained—Afterward they declined buying it, having seen a large work sent [out?] by Schoolcraft in which the religious ceremony as delineated & described by Geo. was only in imagination, no such scenes occurred. Schoolcraft never within 1000 miles of Mandans. This has worried Geo more than any thing else.

> Find some members who were opposed to Schoolcraft. Why did Govt sanction the work of Schoolcraft knowing what Mr C had published. . . . Why not call on Mr C. to prove his representations before allowing and sanctioning the Libel of Schoolcraft. What better Evidence of the truthfulness can be demanded than the letters of Humboldt & Max—

> Mr. Gurley can ascertain from *Indian Bureau* how many of Schoolcrafts Indian work has been circulated to the different Societies & Institutions. Trubner [English publisher of *O-Kee-Pa*] says 4 to 6 Thousand.

> Schoolcraft work published under authority of the Gov.ᵗ on every page. Look at book. Cant ask Govt to buy his Col—Since it has suffered the publishing him as a liar—

These diary entries encapsulate the main points in the printed *Memorial of George Catlin* that Francis was to carry back to America.[90]

If Francis Catlin thought the memorial had a chance of succeeding in Congress, he must have been inexperienced indeed. Henry Sanford read it over but apparently reserved judgment out of affection for his old friend; *someone* should have persuaded him to revise it. Six pages long, the memo-

rial was a rambling harrangue demanding redress from the government, though it was vague as to the form redress should take. Catlin's outline drawings, "the concentration of all my works," would be on display in Washington by the time the memorial was introduced. Members of Congress owed him a viewing to appreciate what he had accomplished "without ever having eaten a meal of victuals at the expense of the Government of my country." He wanted the outlines published, "But what prospect have I?" Even *O-Kee-Pa,* issued the previous year, had not been immune to Schoolcraft's baleful influence. It gathered dust on the publisher's shelves because potential readers had been told "by *'authority of the Government of the United States,'* that it is a fiction." What Congress must do, then, was pass an act authorizing purchase of as many copies of *O-Kee-Pa* (at $2.50 each) as had been circulated of the Indian history. Catlin put the figure at 4,000. These should be presented to "the same institutions and libraries" as had received Schoolcraft's book, thereby enabling truth to "stand by the side of malicious falsehood." Four thousand copies of *O-Kee-Pa* would also mean $10,000 in sales. "I ask for no *emolument,* but for *justice* only," Catlin insisted, "a correction of the most damning and the most *effectualy* and the most *perpetually published* libel that history will record."[91]

Prince Maximilian had died on February 3, 1867, two months after Catlin wrote to him about the O-kee-pa. David D. Mitchell had been dead five years by then, and Henry Schoolcraft two. Catlin was dueling with ghosts but did not know it. Francis was instructed to inquire into Mitchell's whereabouts and ascertain how long he had served as superintendent of Indian affairs in St. Louis. Should Francis bump into him, Catlin advised, "keep cool—dont irritate him, it will do no good. You may tell him plainly that he has done me great injury & that now (after he reads Maximilian's letter) he should turn in and help in advocating my cause. Dont *fight* him—but *laugh at* him." As for Schoolcraft, Catlin denounced him in his memorial as "a man who has for more than 40 years, fed upon the Government crib—for whom a *New Office* was *created* by his friends in the Congress; whose every task was to sit in his parlour in Washington, and in the enjoyment of a salary with perquisites, to compose a book from the gatherings of others." Out of "jealousy," and "in conspiracy with a whiskey seller"—Mitchell—Schoolcraft had "wickedly endeavoured" to deny Catlin's veracity and destroy the value of his works. Catlin was railing to the indifferent, but his own obsession convinced him that others would listen. It was Francis Catlin's unenviable task to make them.[92]

Catlin was in an ebullient mood as 1868 drew to a close. He finished the last of the outline drawings on Christmas Day and exclaimed to his brother, "Now I am G. Catlin again, look out for the paint." Within five minutes he had his colors mixed and his brushes in hand, ready to go to work on the oil cartoons. He would exhibit this "New Collection" on the

Continent, sell it for $50,000, and only then, with financial success at last crowning his endeavors, return home to die. "If my life is spared I shall do all this," he told Francis feelingly, "if not, why my bones will be carried home to rest in my native land." George Catlin had traipsed the "winding path" of his life through desolation and shame, driven "almost to despair"; now he was himself again.[93]

* * *

Francis Catlin, as he boarded the steamer in Ostend on December 30, had less cause for celebration. His was a mission impossible if ever there was one. He had dug deeply into his meager financial resources to make the trip to Belgium, convinced that George could actually deliver on the promise to make him rich. Now he was burdened with the cartoons, the memorial, and his brother's expectations.

Upon reaching Washington, Francis, with a letter of introduction from Henry Sanford, was to approach the chairman of the Library Committee for permission to exhibit the outlines on screens in the library of the Capitol. He was to present the chairman with a copy of Catlin's memorial, returning for a commitment to have it introduced. Then he should see that every congressman received a copy. Finally, the memorial should be published in the papers. While Congress sat, it was imperative that Francis occupy a table in the exhibition room and show relevant evidence, such as the Maximilian letter, to visitors. He should also have copies of *O-Kee-Pa* for sale, and the subscription book open to take orders on "The North Americans," which would reproduce all the outlines on display. Catlin had promised his brother 20 percent on all orders received, but "on mature consideration"—and without consultation—had reduced the commission to 15 percent. This was a troubling portent. The two brothers were in a business arrangement without having reached a firm understanding, and Catlin's habit of confusing wishes with facts was increasingly evident. He had promised Francis chromolithographs of six paintings exposing the fur trade's seminal role in debauching the Indians. He sarcastically referred to the series as his "Monument" to the fur company—a dig at Henry Sibley, David Mitchell, and the others, certainly, but a particular reference to the monument erected to John Jacob Astor by his paid lackey, Washington Irving, in *Astoria*. For *his* monument, Catlin said, "I get no annuity (or even good dinners)." But it was due the poor Indians. The chromos were to be available for sale during Catlin's Washington exhibition, and Francis was to have exclusive North American distribution rights at 33 percent commission. In fact, they were never published.[94]

Events failed to follow Catlin's script. He had worried that visitors to his exhibition would learn there were now two Catlin Indian galleries, the original in Harrison's possession and the cartoon collection in oil he was even then completing. Francis should avoid mention of this fact, though

he was free to accept offers on either. Catlin need not have worried. With Sanford's letter as an entrée, Francis managed to get the memorial introduced in the Senate on March 11 by Timothy O. Howe, a Union Republican from Wisconsin and a member of the Library Committee, to which it was referred. The patronage granted Schoolcraft by the government, Howe explained, had "seriously injured" the sale of *O-Kee-Pa,* and Catlin asked compensation "as a matter of justice." But Francis was denied permission to exhibit in the Capitol and ended up too far away to attract congressional visitors. In their absence, the memorial and subscription book were alike doomed. That meant no distribution of *O-Kee-Pa* at government expense, no subsidy for publication of "The North Americans" (hinted at in Catlin's memorial), no chance that Congress would be so impressed by the exhibition of outlines it would spontaneously pass an appropriation for purchase of his Indian Gallery (old or new). By March 1869 the whole "programme" Catlin had so confidently outlined just seven months before had collapsed, leaving Francis in debt and looking for a job.[95]

For his troubles Francis had only the right to patent the steamboat slipper and one tangible asset: the outlines themselves. They were his to dispose of as he saw fit, since Catlin's attempts to effect a suitable arrangement with an English publisher had fallen through, the publisher being "afraid that the Indian subject is getting too old" to risk the outlay. Catlin apologized that his "visionary plan" had brought Francis so much grief but noted his own lost investment in "labour and time." Therein was a clue that he still maintained an interest in the outlines, a fact Francis would learn belatedly, to his regret.[96]

Based on repeated assurances, Francis had assumed the outlines really were his to do with as he pleased. Catlin had described them as a present and recommended that Francis, through his brother-in-law Dudley S. Gregory, approach the Smithsonian, the Astor Library, or the Boston Free Library to purchase them. Gregory was unwilling to get involved but turned the matter over to another in-law, the husband of his wife's youngest sister, Henry Steele, "a very good fellow," Catlin thought, though down on his luck.[97]

Steele seized the opportunity and that October approached Ezra Cornell, president and principal owner of the American Photo-Lithographic Company, at his fledgling university in Ithaca, New York. Catlin had been so often rebuffed by the government, Steele wrote, that he would prefer to see Cornell's institution *"enriched"* by the drawings. Steele went further. The outlines, he told Cornell, were *"all ready for the publisher"* and "eminently suited to the process of Photo-Lithography." Steele apparently did not realize that though Francis Catlin had physical possession of the drawings, Catlin retained publication rights, and it was toward publication

that Steele's negotiations with Cornell tended. By October 18 plans were firmed up, and Steele needed only Cornell's final go-ahead. The American Photo-Lithographic Company would print 400 copies, in two volumes, for $16,000 (Catlin had estimated $20,000 in the prospectus Francis displayed in Washington), and Steele was persuaded there would be a "fair margin" of profit for all involved. Cornell was to stand as guarantor, retaining the entire edition as security until the cost of publication was met, the balance of the profits going to Steele. Cornell would keep the plates and the original drawings and manuscript which would, for official purposes, be donated to Cornell University courtesy of George Catlin.[98]

Cornell was cautious. A business associate at the New York *Tribune* warned him off any active participation: "Don't you undertake to carry on your shoulders the Catlin job. You have enough work before you, now. . . . Let Mr. Steele manage this affair, you subscribing for the copies you need. . . . I beg of you that you do not promise to him to become a working horse or the treasury." Cornell, in turn, was concerned that the proposed publication be something more than a picture book. Steele assured him that the work was in a finished state, requiring no text apart from descriptive captions. But the delay caused by Cornell's qualms allowed Catlin, through Francis, to catch up on developments and bring them to an abrupt halt.[99]

In his enthusiasm, Steele had failed to consult the author. He did not want a book got up from his outlines after all. Rather, he wanted his brother and Steele to hire an experienced operator to make plates directly from his paintings. In return, he would assign to them, "jointly & forever," American copyright to his whole collection. "If you and he take up the work on the plan I have laid out," Catlin wrote Francis, "and can have Cornell to back you up, you will have enough to occupy you all your lives & you may both make your fortunes by it. With a photographic establishment of your own, in a cheap place in the country, and all the works of my life to copy, large and small—for sale in the book and for retail sales, if you choose, (and coloured if you like) you may fill the American world with them, and the more you spread them the better I shall like it." Only days before he received Catlin's instructions to this effect, Steele had pressed Cornell for "*prompt* action." The publishing plan had been cleared with Francis, who owned the originals, and "so far all is harmonious." Then Catlin's letter arrived, followed by another in late January addressed to the American Photo-Lithographic Company, ordering the work stopped. Steele's intentions were good, no doubt, but he had acted without authority. Catlin could hardly approve publication of his outlines without at least a page of text accompanying each plate—just as Cornell had thought. The papers would have dismissed Steele's book with a sarcastic, "What a splendid illustrated catalogue—price *100* dols."[100]

Rarely successful in getting his own grandiose projects off the ground, Catlin was completely successful in quashing Steele's. Notified of the artist's opposition, Cornell withdrew and the publishing venture folded. Having pulled the rug from under Francis the one time his outlines might have paid a dividend, Catlin (playing the role of their father to perfection) proceeded to lecture him:

> Mr. Steele *will* have to "back out" of the affair which he has so rashly and so imprudently entered, though he says . . . that he cannot do so. I regret exceedingly the awkward state it leaves you in, but to struggle longer, trying to "push the thing through," . . . might be to place you in a worse condition than you now are in; . . . I dont believe that you would have got your 100 good subscribers in one year, nor half that number; you would have worn out my name and fame in putting out a bad work, and forever have prevented me from publishing a better one.

Better that Steele lose a little money than Catlin his reputation. As for Francis, "if you are disappointed in the fate of the 'great work,' there will be this advantage, it will not be 'donated' to the College, and it is still your property, and certainly will be enhanced in value by *not ever being published*."101

Francis had not acquiesced silently. Perhaps George could write a text to accompany the plates and save the day. Why, if Francis owned the outlines and American rights, was George blocking their publication? But his brother was adamant, and Francis was left to sell the drawings for a piddling $750 to the New-York Historical Society, absorbing the losses incurred in the trip to Brussels, the Washington venture, and since. Catlin remained suspicious that the entire Steele-Cornell affair had been a scam to dupe Francis while acquiring the outlines for Cornell University gratis. In his experience true benefactors were rare, and in the preface to the contemplated work he had poured out his frustrations: "My labours commenced and have been carried out entirely at my own expense and no helping hand from the Govt. or Institutions or individuals of my country has been extended to me." "*'Home*' (as you call it)," he wrote Francis, was no longer home to him. But still he dreamed of returning in triumph. The outlines in oil that he had begun during Francis's visit in 1868 were finished, he claimed, and ready for display, one year later. But exhibition space was at a premium, and it was late summer of 1870 before his works were again "before the world." They covered "every inch of the walls" in a spacious hall in Brussels. "Unfortunately"—in Catlin's world, there always had to be an "unfortunately"—"on the very day that I opened, commenced the public excitement of the first bloodshed in the awful battles about Metz, and the same excitement is still kept up, materially affecting the success of

my Ex'n." This time fate had conspired to frustrate him by whipping up the Franco-Prussian War.[102]

This may have been the decisive factor in turning Catlin's eyes westward to America. He was nearly seventy-five years old, and mortality was on his mind. "I have anxieties of a peculiar kind which trouble me in the closing years of my life," he wrote, referring to the fate of his Indian Gallery in storage in Philadelphia "and the higher value I set on my *name* and *fame* than on *money,* in my old age." He wanted to die knowing that his works were secure, and with them his reputation. Their permanent display in some public institution would be his immortality, his "self raised Monument." In 1870 Joseph Henry at the Smithsonian seemed receptive to his pleas, and the New-York Historical Society, of its own accord, had expressed an interest in acquiring his Indian collection. Perhaps his countrymen were coming around at last.[103]

* * *

The Smithsonian had always seemed the proper resting place for Catlin's life's work, and the destruction of John Mix Stanley's Indian gallery in the fire of 1865 provided an opening. If the Smithsonian was in the market for a replacement, Catlin's collections were available. Henry, in his capacity as secretary, was aware of the original Catlin gallery. What he had not realized until he heard from one of Catlin's daughters in 1866 was that it had been repatriated by Joseph Harrison and was even then in Philadelphia. Harrison was a man of "wealth and liberality," Henry wrote. "His possession of the collection assures its preservation as a whole, and the final deposit of it, in some public Instn." Despite the fire, ethnology in the United States would yet be served. Catlin's daughters were of like mind: Stanley's misfortune might be their father's redemption. In January 1866 Elizabeth Catlin approached their uncle and guardian, Dudley S. Gregory, to bring the matter before government again, "particularly since the rebuilding of the Smithsonian was suggested by yourself, first, and since then by others, as a good opportunity." Gregory was well connected—he had served as a congressman in the 1840s, kept abreast of politics, and was on friendly terms with Henry, whose support would be invaluable. Elizabeth revealed an ulterior motive in addressing her uncle at this time: the children hoped to lure their father home with the reasonable prospect of a sale to the government. Harrison was amenable to any purchase plan; the collection was theirs to dispose of so long as he was repaid in full. The time to act was now, while their father could still benefit from a decent settlement.[104]

This was a matter of some delicacy. Gregory, who had buried a sister and nephew shipped back from France and seen the Catlin name smeared by foolish speculations, declined to act as intermediary. But he turned Elizabeth's letter over to Catlin's staunchest ally in Washington, the Reverend R. R. Gurley, who placed it in Henry's hands. "I have no hesitation in

saying that your father's valuable collection of Indian portraits ought to be purchased by the General Government and carefully preserved," Henry replied. Congress should also assist Catlin in the publication of the large Indian portfolio he had long contemplated. But while it would give him "much pleasure" to advocate Catlin's case, Henry feared the times were unpropitious. The national finances were chaotic, and Congress was absorbed in the politics of Reconstruction. With Gregory tepid and Henry counseling delay, Elizabeth yielded. She had, she wrote Henry, been laboring under "the mistaken idea" that the Smithsonian "having now lost its Indian Collection would be willing to secure that of my father," and had supposed it financially able to do so. "I hope still to see my fathers collection occupying an honoured position there," she continued, promising to avail herself of Henry's services "when the proper time comes for applying to Government." True to her word, she and her sisters would look to Henry for support in the years ahead.[105]

From his outpost in Belgium Catlin may have accepted Henry's brush-off philosophically in 1866, but he was in an entirely different frame of mind when he addressed the secretary four years later. Nicolas Trübner was just publishing his latest book, *The Lifted and Subsided Rocks of America, with Their Influences on the Oceanic, Atmospheric, and Land Currents, and the Distribution of Races.* As the title suggests, it was an homage to Humboldt based on Catlin's South American wanderings, and another entry in the debate over multiple creations. Catlin, who had made trouble for himself by adhering to the theory that the Mandans were descendants of the Welsh, now peremptorily dismissed the notion of a Bering Strait migration—there was no physical resemblance between the Mongols and the Indians—and asserted that the natives of North and South America were part of one great family created by the Maker "from the dust of the country in which they live, and to which dust they are fast returning." He seemed unaware that polygenesis had faded with Charles Darwin's evolutionary explanation of the creation of life forms, *On the Origin of Species,* published in 1859, the year Humboldt died.[106]

Then again, perhaps America was the real cradle of humankind. *Lifted and Subsided Rocks* was written under the spell of another besides Humboldt, an Americanist as controversial as Catlin himself, his friend the Abbé Charles-Etienne Brasseur de Bourbourg. Brasseur was a profound scholar of the Mesoamerican civilizations who appealed to Catlin most when he was at his least scholarly, in his free translation of the Maya Codex that he called the Manuscript Troano and in his *Quatre lettres sur le Méxique,* published in Paris in 1868. Catlin believed Brasseur had cracked the code of the ancient Mexican languages and thus breached the silence of the ages. Especially arresting was Brasseur's argument for a New World antiquity greater than the Old World's, in which he correlated the geological catas-

trophe that separated the hemispheres and the diffusion of the races. Catlin was enthralled: "The Americans should embrace him in their arms." The compelling sweep of the Abbé's theories—which cost him dearly in antiquarian circles—was reminiscent of Humboldt's own cosmic reach and could only dazzle a man whose personal observations had been dismissed because of accompanying speculations. Perhaps the Welsh were actually Mandans! If there was to be only one source for mankind, let it be American. And either way, let the scoffers beware. Catlin ended *Lifted and Subsided Rocks* with an appendix reprinting entire his 1868 memorial to Congress. Twelve years before, Humboldt had urged him to "take immediate steps" with the American government to counteract the baneful effects of Schoolcraft's attacks on his credibility; now it was a matter of public record that he had, albeit belatedly, answered Humboldt's charge.[107]

Rehearsing these old wars may have aroused Catlin to write to Joseph Henry on February 4, 1870. He enclosed a copy of his memorial "compliments of the author," though his letter was hardly complimentary. The Smithsonian, Catlin claimed, had been in league with his detractors. Specifically, Henry had joined Schoolcraft in opposing purchase of his Indian Gallery back in 1852, a charge Henry indignantly denied. "So far from endeavouring to defeat this proposition," he insisted, "had my opinion been taken as to its propriety I would have advocated its adoption." In the past the Smithsonian had accepted pictures on loan—Stanley's, for example—but it had never itself purchased a collection. Henry had been consistent on this point. James Smithson's bequest was never intended to support a national library or museum. That responsibility was the government's, not the Smithsonian's, and there were signs the government was beginning to accept it. In that event, Henry would be "glad" to see Catlin's pictures bought by Congress. But, he warned, "economy" was the watchword around Washington in 1870, and Catlin was unlikely to meet a positive reception. As for Catlin's dispute with Schoolcraft, Henry, who knew both men, offered platitudinous consolation: truth "is mighty and will finally prevail." Francis Catlin hand delivered a follow-up letter from his brother urging Henry's cooperation in pushing the memorial that had accompanied his first letter through Congress. "Made no definite promise as to this," Henry scribbled in the margin, and there the matter rested.[108]

The Smithsonian Institution offered Catlin the usual encouragement in 1870, then, and nothing more; but another institution with which he had a lengthy relationship stepped forward in the same period to cause a flurry of excitement. The New-York Historical Society, approached by Francis Catlin as a prospective buyer for the outline sketches, surprised him with a query: Might Catlin's original Indian Gallery be had? By 1858 the society had become a major repository of American art, having acquired the

Luman Reed collection (107 paintings) and the remnant of the American Art-Union's holdings six years after its dissolution. Local and state institutions had shown more concern for native art than the federal government ever had. Thus the Historical Society's polite interest in Catlin. Francis alerted his brother, who responded with a long, self-deluded letter to the society offering to sell his life's work—Indian Gallery, cartoon collection, La Salle oils (that link to Louis-Philippe and an earlier proposition to the New-York Historical Society)—for $120,000, reserving the right to exhibit the cartoons for a year or two pending completion of a suitable facility. Should the society prefer, the old collection alone could be had for $100,000, or the cartoons and La Salle oils for $60,000.[109]

Instead, the Historical Society opted to acquire the outlines from Francis for less than $1,000. Convinced that he had granted terms "which will not be objected to," Catlin was baffled by the silence that greeted his letter. "It seems very strange that they should . . . now drop the affair thus," he wrote Francis at the end of August. He tried to recover lost ground that fall by explaining his earlier demands. His cartoon collection was finished and on public display where it had earned general acclaim; it was his original collection, stored in Philadelphia in who knew what disarray, that worried him. Harrison, the rescuing angel, wore horns. He had treated Catlin's letters "with contempt," and in the absence of any payment on principal or interest since he took possession of the collection in 1852, now presumed to own it outright. Unless Catlin could find a buyer—the New-York Historical Society—he would have no legal way of challenging Harrison's pretensions by forcing him to render up an exact accounting of what was owed him. Harrison floated a figure of $40,000; Catlin doubted him but could not prove otherwise. If the society would buy the collection from Catlin for $50,000—half the price quoted in the spring—he could redeem it and see it properly displayed in a public institution. In his old age he was "trembling with fear" for his gallery's fate. Harrison was threatening to sell it off or present it to the city of Philadelphia, thus putting it permanently beyond his reach. Would the New-York Historical Society now act the role that Harrison had abdicated and play rescuing angel?[110]

In pleading his case, Catlin offered information on the final form his gallery had taken. It had been expanded through the 1840s with the addition of the portraits of the touring Iowas and Ojibwas and purchase in London of small collections of Indian manufactures gathered by Hudson's Bay Company traders. Catlin mentioned that he had managed to withhold some of his original portraits from his creditors—no doubt the twenty paintings redeemed from Sir Thomas Phillipps in 1854. These he would gladly add to those in Harrison's possession, reuniting his gallery at last. But in purchasing the outline drawings from Francis Catlin the New-York

Historical Society had exhausted its interest in George Catlin. He could not ignore the meaning of its silence a second time. Nevertheless, he continued to regard the society as a prospective buyer.[111]

* * *

"*Live in hope,*" Catlin wrote, and sometime near the middle of 1871, his Brussels exhibition long since closed and nothing to detain him, he packed his bags and, more than thirty-one years after sailing out of New York harbor, boarded a vessel bound for America, to begin the last act in his quest for patronage. He was in truth George Catlin again.[112]

CHAPTER EIGHT

I would respectfully urge the impor-
tance of purchasing these valuable
records of the previous inhabitants
of North America, which, if not
secured at this time, will be dissipat-
ed and lost to the world. They will
grow in importance with advancing
years, and when the race of which
they are the representation shall
have entirely disappeared their value
will be inestimable.

Joseph Henry to the Chairman of
the Library Committee of Congress,
December 13, 1873

If lost to us, they are lost forever.
We can hardly look for another
Catlin.

President and Faculty, Dartmouth
College, to the Chairman of the
Library Committee of Congress,
February 14, 1874

Who Doth But Patient Wait

Last Quests and Lasting Legacies

In December 1873 Joseph Henry, in his capacity as secretary of the Smithsonian Institution, wrote to the Library Committee of Congress urging purchase of George Catlin's Indian collection. It was not the first time he had tried to convince government to buy an Indian gallery, but there was a new desperation in his plea. If not secured immediately, he warned, these "valuable records" would be "dissipated and lost to the world." By then Catlin was a year dead. Henry R. Schoolcraft had died, and John Mix Stanley too. Seth Eastman had less than two years to live. Ephraim George Squier would live till 1888, but his would be the saddest fate of all: a mental breakdown in 1874 that left him a survivor in body alone.

383

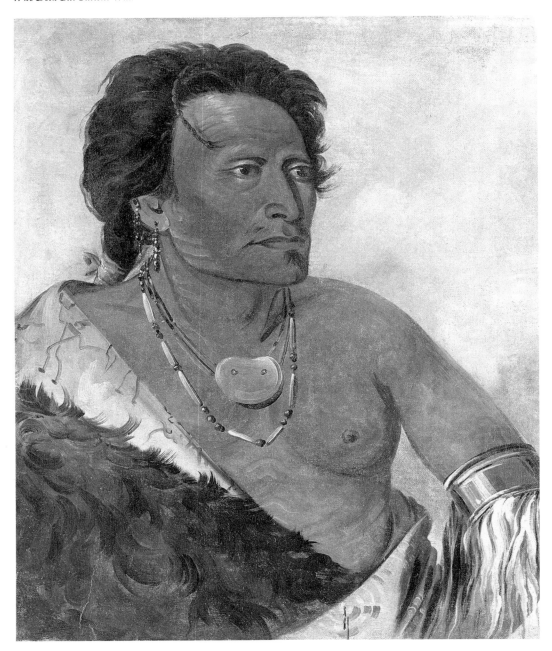

111. George Catlin, *Sky-se-ró-ka, second chief of the tribe* (1834). At his best, Catlin painted not colorful exotics but individuals like this strongly modeled Wichita with the penetrating eyes. National Museum of American Art, Smithsonian Institution; gift of Mrs. Joseph Harrison, Jr.

384

They were all of them, in less than a decade, removed from the scene. But their patronage quests went on, the work now of widows, children, and siblings who continued the struggle for recognition and just compensation. The politics of patronage enjoyed a longevity that the patronage seekers did not.

Rocked in the cradle of a restless century, they had been peripatetic adventurers. Wanderlust and opportunism mingled, carrying Schoolcraft over the Great Lakes and into the wilderness to the true source of the Mississippi; Catlin to the earth lodges of the Mandans and the spectacle of the O-kee-pa, the sacred red pipestone quarry, the emerald beauty of the Amazon, down even to the southernmost tip of South America and up to Russian Alaska; Squier to the mounds of the Ohio and Mississippi, the Mosquito Coast, and Peru to experience the awesome rise of the Andes; Stanley into the thick of the Mexican War, to the site of the Whitman Massacre within days of its occurrence, and for a ride across the open plains with the Blackfeet; Eastman to the heartland of the Santee Sioux, the swamps of Florida where the Seminoles held out, and the bleak outposts of Comanche country. But age had tamed them, these tireless travelers. The discoverer of Itasca Lake died a sedentary cripple; Catlin at the end was impoverished, lame, and deaf, though still game for adventure; Squier drifted through a long twilight of mental impairment; and Stanley was left despondent and in poor health following the destruction of his Indian gallery by fire. Eastman, after strenuous service in Indian Country, had been forced to retire from active service because of a parade-ground disability suffered while inspecting troops under a hot August sun.

In time their passions and rivalries and their practical preoccupation with making a living from their work faded from memory. But their curiosity about America's native cultures, the sense of urgency that called them to their varied tasks and propelled them to surmount imposing obstacles, their desire to leave records in words and pictures of what they all deemed a vanishing race, produced lasting legacies. The books are still there to be read, the pictures to be seen. None shaped his life more completely to the exigencies of a special mission, or identified himself more closely with the Indians, than George Catlin. He had always counted time his ally. His paintings of the western tribes, as Henry agreed, would only "grow in importance with advancing years." One day America would realize what Catlin had been saying all along: their value was "inestimable." In this conviction in 1871 he had boarded a steamer in Ostend bound for home after an absence of thirty-one years. The image of him at seventy-four, stiff-kneed but resolute, clambering up the gangplank to make this final voyage appears a fitting one to begin a chapter of endings, and his story seems the proper one to conclude it.[1]

* * *

When Seth Eastman put away his pencils, strapped on his sword, and set off to rejoin his regiment in Texas in June 1855, he left behind his wife, his children, and a passel of resentments. Service at Fort Chadbourne was a return to isolation duty, 225 miles north of San Antonio, "a miserable country and no white, black or red folks in it—Still it is kept as a military station, for that very fact, I presume." As the cold winter set in a disconsolate Eastman, his health failing him again, looked forward to sick leave, or promotion, as a way out. Like Mr. Micawber, Mary Eastman was hoping "that something may turn up, that will enable him to leave the army, for I cannot bear the thought of giving up my home in Washington." With the return of summer, the captain's spirits rose. He unpacked his pencils and began sketching. He had recovered his health and now found the climate "delicious."[2]

Fort Chadbourne was still isolated, its quarters primitive, but it no longer lacked for Indians. There were Comanches all around, and in July Eastman had a brush with them that made the newspapers and left him "much the worse for wear." A "severe illness" followed, bringing the coveted sick leave.[3] He reunited with his family in Philadelphia (where Mary Eastman deplored the rampant Free Soil sentiment), recuperated for a month in the mountains of Virginia, and that October celebrated his promotion to major. On the expiration of his sick leave in April 1857, he was back in Washington for a stint with the Quartermaster General's Office. It is unlikely he saw the Schoolcrafts before he left again in January 1858 for duty in Utah. But he would have been a more than casual observer as the last volume of Schoolcraft's Indian history issued from the press. And it is certain that Mary Eastman used their time together in Washington to smear Mary Schoolcraft as a heartless stepmother to her husband's children.[4]

By the end of 1854 Schoolcraft had broken off relations with his profligate son John, washing his hands of one of life's disappointments. Few could blame him. The issue was his daughter Jane, born in 1827 and two years John's senior. Jane had been a favorite of the Eastmans, sharing their company in her parents' absence in Philadelphia in 1851 and 1852. But her marriage plans had thrice caused distress, once because the prospective groom was beneath her, once because he was mentally unbalanced, and once because he was the race-proud Mary Schoolcraft's own youngest brother and thus above her. Henry Schoolcraft was overjoyed at the third prospect, his wife aghast. According to Mary Eastman she purposely set out to drive Jane away from her father and her home.[5]

Mary Schoolcraft did not quite deny this version of events. Instead, she emphasized her patient efforts to wean her stepchildren from their native prejudices. But race was an absolute, and nothing could overcome their mother's blood. All who knew Schoolcraft knew that he had come to

regard his marriage to an Indian woman as "the cardinal mistake of his whole life. His domestic torments were so great, that nothing but the restraining grace of God, prevented his blowing his brains out." It was only after their wedding that Mary Schoolcraft discovered his two children had been raised to fear and hate him, and only after she reluctantly acquiesced in the marriage to her brother that Jane became openly insolent to her. When Schoolcraft demanded Jane show more respect, with "plausible Indian cunning" she took rooms with a family her father could not abide, thereby severing relations with him and separating Mary Schoolcraft from her brother. "Mr Schoolcraft says these children, have so cruelly 'brought his grey hairs, in sorrow to the grave,' that if they were both dead, he should not feel it, any loss." Perhaps she was right. When a correspondent inquired after his children in 1856, he did not mention John and said of Jane only that she was "married & gone." This was the Schoolcraft gossip Mary Eastman served up with the biscuits at her "spicy 'tea-table toastings.'"[6]

Had Mary Schoolcraft known more of Seth Eastman's past, she would have had grist for her own gossip mill: the captain had raised some Cain in his younger days and left a Sioux woman to raise a little daughter. In 1831, as a twenty-three-year-old bachelor stationed at Fort Snelling, then a remote frontier post, Lieutenant Eastman had cohabited with the third daughter of Man in the Clouds; when a baby resulted, he named her Nancy. He was tight-lipped on the subject, but such marriages according to the "custom of the country" were commonplace enough to raise few eyebrows.[7]

Lawrence Taliaferro, as agent at St. Peters, doubted the wisdom of such liaisons because they bred familiarity, disrespect, and children who had to be cared for; domestic wrangles and misunderstandings were inevitable. Eastman, for example, had quarreled with a young Sioux in 1831, grabbing him by the hair in the presence of other Sioux and Chippewas and nearly precipitating an outbreak; pressed to explain, he said that a drunken Sioux had shot his dog a few months before, provoking his ire. "*If Officers* of the Army Identify themselves with Indians & become *as it were allied* to their families—results of the kind . . . alluded to may be expected sooner or later," Taliaferro jotted in his journal. Despite his prim tone, he had a half-Sioux daughter of his own, a cousin to Nancy Eastman, and was Nancy's guardian in 1838 during the disbursements for half-blood claims under a treaty negotiated the previous September.[8]

Nancy was an open secret at Fort Snelling, then. After consulting with Seth Eastman in Washington, Frank Mayer sketched her likeness during his trip to Minnesota in 1851. He showed her as an exceedingly pretty young woman (she would have been about twenty, and a wife and mother); and he may have been thinking of her when he wrote that mixed-

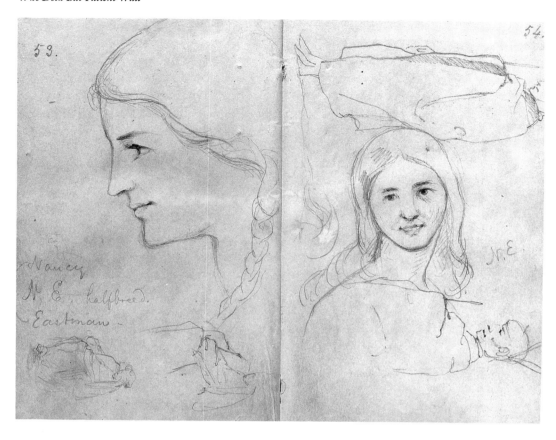

112. Frank B. Mayer, *N. E. halfbreed (Nancy Eastman),* Seth Eastman's daughter, and one of the lovely mixed-bloods who captured Mayer's fancy in 1851. Courtesy of the Edward E. Ayer Collection, the Newberry Library, Chicago.

blood women "are almost invariably comely, tall, and graceful." Mary Eastman must have been aware of Nancy, but in her writings based on life at Fort Snelling she never mentioned her, though she did name Man in the Clouds. Nancy died in 1858, sparing Mary Eastman the embarrassment of public disclosure and ending the possibility that she would ever have to endure the "fiery trials" Mary Schoolcraft's children put her through. But there would be public disclosure eventually—Nancy died after giving brith to her fifth child, Charles A. Eastman, destined to fame as a medical doctor and popular writer who, in his turn-of-the-century reminiscences, would draw attention to his grandfather Seth Eastman's liaison with Man in the Clouds' daughter seventy years before.[9]

In 1859, however, Mary Schoolcraft knew nothing about Seth Eastman's past. "I respect your husband, as a good man," she wrote Mrs. Eastman, "I love your interesting children, & I pity *you*." Bad enough that Mary Eastman dished up the Schoolcrafts' most intimate domestic details at her "toastings"; far worse that she actually carried the story to President Franklin Pierce in 1856, or so Mary Schoolcraft had heard. What could account for such maliciousness? It was not that Mary Eastman was less attractive. Indeed, she was fairer of face and superior in genius and learn-

ing, Mary Schoolcraft conceded. But Mrs. Eastman lacked "physical majesty of stature" and affected a bent-necked humility that was actually moral cowardice, for under the skin she was vastly inferior in goodness and virtue. She was also six inches shorter. Did she resent Mrs. Schoolcraft's proximity to heaven? Had Mrs. Schoolcraft inadvertently given offense by blocking out the sun? Had Mrs. Eastman forgotten that when her boy lay near death it was *she* who comforted her, rocked her in her arms to quell a mounting hysteria that could have cost the life of the unborn child she was then carrying? Had she forgotten that Mrs. Schoolcraft had been both good neighbor and forgiving friend, despite her "chronic viciousness of temperament" (likely the result of a diseased liver) and the knowledge that Mrs. Eastman was her "most adhesive, mercurial, inventive, and nimble tongued detractor?" Jealousy, then, and envy accounted for all.[10]

The truth was hardly so spicy: money had come between the Schoolcrafts and Eastmans, and the women were voicing family resentments. Writers and artists were rarefied types, according to tradition, and Mary Schoolcraft despaired of Henry's impracticality. Fame "cannot butter our parsnips," she wrote, nor provide the creature comforts that even otherworldly men like her husband enjoyed—"a nice warm study—loose dressing gown—recherche books, & flowers, comfortable easy chairs, & a sensible energetic sweet tempered wife." Never trust a poet with a purse; it took someone wise in the ways of the world to get by, and she made no apologies for pushing her husband's claims to ownership of the plates of the Indian history. Publishers and booksellers were necessary evils, but former illustrators could be safely ignored. Mary Eastman, in turn, frequently began letters protesting how odious she found discussing business before plunging in to argue her husband's latest case for compensation. Not surprisingly, the women's relationship followed the curve of their respective financial fortunes, and Mary Eastman's jibe in 1851, at a time when they were still on good terms, that she welcomed bad news from Mary Schoolcraft, "for what should I have to console me, if my next door neighbour were better off than myself," proved prophetic.[11]

Frustrated in his appeal for extra pay in 1855, Seth Eastman the next March had petitioned Congress for a sum (said by Mary Schoolcraft to be $10,000) in payment of his services as illustrator for Schoolcraft's history. The captain was still in Texas at the time, leaving Mary Eastman to carry on. "So far away, he can not, with you, plead his own cause," she wrote to a Whig congressman from New York, Benjamin Pringle. "I have undertaken to do so for him. . . . As to whether his claim may be a just one, the very many pictures that adorn the five volumes of the Indian work will attest." Despite her efforts, however, their bill was again buried in committee; meanwhile, the $2,900 annual provision for Schoolcraft "and his copyist"—his wife—sailed through committee to passage.[12]

389

The year 1858 found the two families on an equal footing. Schoolcraft had exhausted his last congressional allocation, and the final volume of the Indian history was out. With a career in patronage politics behind him, he naturally turned to Congress for succor. In April he petitioned the Senate for compensation dating back to 1841, when he was unjustly replaced in office as superintendent of Indian affairs for Michigan by his archenemy Robert Stuart; he had covered public debt with his private means and was owed over $30,000. Now that the Indian history on which he had been laboring since 1847 was complete and he had time to pursue his claims, he intended to collect. The next month Mary Schoolcraft carried another memorial to the Senate, this one seeking compensation for "the collection of the facts and materials" embodied in Schoolcraft's history. The government had reimbursed his expenses but never really paid him a salary for his labors, which was owed him. The first petition was routed through the Committee on Claims, the second through the Committee on Indian Affairs. Though Indian Affairs reported a bill in June, neither petition was successful.[13]

Since both claimants had been stymied, a temporary truce was possible. One morning in the autumn of 1858 Mary Eastman paid an unexpected social call on Mary Schoolcraft, her first since their falling out three years before; perhaps they commiserated over Mrs. Eastman's "honest conclusion that when a man becomes a politician his heart turns right away into a stone." Mrs. Schoolcraft returned the visit, but this was only a lull in the fighting, for in January 1859 Schoolcraft's compensation claim for the Indian history was reframed in the House and in six days rushed through Congress and signed into law. Mary Schoolcraft was substituted for her husband as the petitioner, and all claims for monetary payment were dropped. Instead, Mrs. Schoolcraft requested that a copyright be issued "securing to her . . . the exclusive right to republish" the Indian history or "any abridgement or compilation thereof, for the term of fourteen years." The plates used in printing the book were to be transferred to her "in full satisfaction of all manner of claim for compensation for work, time, or money expended in the collection of materials for the book, by Henry R. Schoolcraft." Schoolcraft would later see a loophole here: he had been fully compensated for *collecting,* but not for *preparing* his materials. For the time being, however, he and his wife were jubilant. The secretary of the interior secured their copyright, and acceptable terms were struck with Lippincott that would pay them $15 per set sold at $66 each.[14]

But the Indian history, as Lippincott had feared it would, proved a white elephant. Despite circulars distributed through the Smithsonian, library orders for odd volumes were slow, and potential buyers were deterred by the price. Agents could not enlist subscribers, bookstores returned their copies, and Lippincott found so little demand that it was not

worth the expense of binding several sets, yet too costly to bind only a few. Within a year Schoolcraft's account was in arrears. Apart from the sets he purchased at the author's price ($21), not one had been disposed of; indeed, the only credit to his account was $17 for other titles. "Seventeen dollars, as the copyright on the brains of one of America's most noted historians," Mary Schoolcraft fumed, "while Mrs. Eastman, with the use of the 'United States Plates,' has obtained the where withal to buy a nine thousand dollar house, rumour says." Clearly, Schoolcraft had made a terrible choice in selecting Lippincott as his publisher back in 1850. There would be no butter for her parsnips after all, no round-the-world tour on the proceeds, no miracle whereby "an author can become *rich*." It was all such a flop that by March 1860 Schoolcraft was again petitioning Congress for action on the claims emanating from his service as Indian agent two decades before.[15]

The Eastmans might have found satisfaction enough in the School-crafts' disappointment. But there before them, the proverbial flag to the bull, was Lippincott's circular announcing what was now grandly titled *Archives of Aboriginal Knowledge*, "Schoolcraft's Great National Work" in a popular edition at $11 per volume, its illustrations "executed in the most complete and finished style, literally 'without regard to expense'; . . . one of the proudest monuments of American art." Congress had done what it never had the right to do; it had given Seth Eastman's illustrations to an individual without "the shadow of a claim to them." Distracted by the major's transfer to Utah in 1858, and doubtless caught off guard by the uncharacteristic dispatch with which Congress passed the bill compensating Mrs. Schoolcraft, they had been unaware of the deed until it was already done. Eastman was back in Washington on special duty that July, but well before his return Mrs. Eastman was letting her displeasure be known.[16]

Mary Schoolcraft taunted her. "Your jealousy & rage, at my obtaining the copyright of my husband's book, when *you* failed to get from Congress, ten thousand dollars extra pay, for Capt Eastman, you must settle with *them*," she wrote, but she was obviously worried her rival would do just that. An inquiry to Lippincott brought reassurance that Mary Eastman's *Romance of Indian Life* was out of print; since it contained no plates from the Indian history, it is likely Mrs. Schoolcraft had confused it with a title that did. She also inquired of the War Department whether Eastman had been assigned to the history before February 27, 1850, presumably to counter Mary Eastman's argument that most of his illustrations were based on sketches and paintings made before he was detailed to Washington, and thus before the Schoolcrafts could have the slightest claim on them. A search of the captain's record back to January 1845 failed to turn up the hoped-for rebuttal.[17]

Meanwhile the Eastmans had drawn up a petition of their own requesting restoration of copyright to the illustrations at issue. Dated December 5, 1859, it consisted of a letter from Seth Eastman accompanied by a breakdown of all the plates in the Indian history based on drawings he had made before his assignment to the Interior Department (sixty-seven) and those done while in Washington but derived from previously gathered data (twenty-eight). An accompanying letter from the commissioner of Indian affairs written in 1856 confirmed Eastman's original understanding that though there was no appropriation to pay for his services, one would be secured. Certainly the Interior Department had valued his contribution enough to fight to retain him. In justice, he should be compensated for the expertise he brought to the Indian history. The commissioner recommended a per diem payment of $3 from January 1, 1850, through Eastman's reassignment in 1855. However, his letter did not address the issue that occasioned Eastman's petition three years later: a copyright lost through congressional inadvertence.[18]

Prospects for reversal of the act granting Mary Schoolcraft copyright of the plates were encouraging, though the brevity and tenor of the debate at the time of its passage were not. According to one congressman who had voted to give the plates to Mrs. Schoolcraft, they were "worth nothing" to anybody else, and according to another, would be "thrown away" unless she took them. There was the usual flippancy about such matters. Move swiftly on transferring the plates, an Ohio Republican had urged, "for that will make it certain that the Government will publish no more of this work." But those who had amused themselves giving away another's property in January were duly reprimanded by Mary Eastman. They had betrayed the trust reposed in them by an officer serving his country on the savage frontier. Badgered congressmen expressed their "infinite regret," admitted they had not realized the consequences of their action until too late, and promised to make amends at the next session. Charles Lanman was apparently prepared to go to the newspapers on Seth Eastman's behalf. It seemed for a time as though the Eastmans would win.[19]

The petition, referred to the Senate Committee on Indian Affairs on December 21, was reported back favorably on March 23 with a bill offering Eastman $5,025 in compensation for his lost copyright. The sum had been arrived at by multiplying the paintings in Eastman's collection at the time of his assignment to Washington by what was admittedly a low estimate of their copyright value, $75 each. Thus Congress proposed to redress its error in transferring his property to another. The bill passed first reading, and the committee report was ordered printed. There matters stood; the Civil War would intervene before Congress again got around to deliberating Seth Eastman's case.[20]

The record is silent, but there is little doubt the Schoolcrafts played a part in stopping passage of Eastman's bill. Congress was informed that the major had already made liberal use of the government plates in the past, and someone put a copy of *Chicora* in the appropriate hands. Members of the Committee on Claims scrutinized it closely after the 1859 petition was referred to them in January 1866. Eastman's list of the sixty-seven illustrations completed before he went to Washington and the twenty-eight others made from his own data while on the job was matched with the plates in *Chicora*. Nine in the first category, three in the second, were checked off, indicating that twelve of the twenty-one illustrations in *Chicora* were taken directly from Schoolcraft's history. In light of this information, the Committee on Claims overruled the favorable report of the Committee on Indian Affairs. At the very time Eastman was in the government service "receiving the full pay his station entitled him to," he had "selected from his sketches and pictures such of them as he wished to use, and, . . . in all probability, he got the use and benefit of those twenty-one plates for his wife's work without any cost to his wife, or to himself." He had already been sufficiently compensated.[21]

The report, submitted to the Senate on February 7, 1867, was disappointing, but Mary Eastman was undeterred. If copyright to the plates was a dead issue, justice was not. The government *owed* Seth Eastman for his extraordinary services, and she would see him paid. Within days of the defeat in the Senate, she had mapped out a new strategy, spoken to General Ulysses S. Grant and the clerk of the House of Representatives, and written to the chairman of the House Committee on Military Affairs, Robert C. Schenck. Being a patriot, Seth Eastman had not pressed his claim for compensation while his country was at war; instead, he had served the Union cause at further expense to his health. His wartime assignments were hardly perilous: mustering and disbursing officer for Maine and New Hampshire, April 1861 to January 1863, military governor of Cincinnati to January 20, 1864. He would have preferred to "be useful in the field," but in his fifties was obviously unfit for more active duty. While mustering in a volunteer regiment at Concord, New Hampshire, on a hot August day in 1862, he had suffered a severe sunstroke from which he never fully recovered. Thereafter he was predisposed to apoplexy, and on December 3, 1863, was retired from active service for disability resulting "from long and faithful service, and sickness and exposure incurred therein." But he remained on duty status, serving as commandant of the military prisons at Elmira, New York, and Fort Mifflin, Pennsylvania, and the military asylum at Harrodsburg, Kentucky, where he would be stationed until September 1867. Between his last two postings, he had spent most of 1866 in Washington on the Board for the Examination of

Candidates for Promotion in the Army. A lieutenant colonel himself since 1861, in August 1866 he was appointed brigadier general by brevet, an honorific rank that entitled him to be addressed as General Eastman.[22]

General Eastman's dignity would not allow him to be thought "a beggar and ask for money," Mary Eastman wrote Schenck in mid-February 1867, but she would willingly place herself "in that attitude towards the Committee on M. Affairs":

> I entreat your influence, that Gen. Eastman be again ordered to duty under the direction of Congress. Let him illustrate the room of the Committee on Indian affairs—Let him paint there, in oils, the history of the Indian races, or such part of it as the Committee may desire. Give to him and his children, the pride and joy of seeing his genius recorded on the walls of the Capitol of their Country. Saving the price of the paint and Canvass, a small affair, it will cost Congress nothing. Gen Eastman will desire nothing more, ought to desire nothing more, than to receive his pay while on this work. All of his pecuniary loss, and all his chagrin, will be forgotten, in the happiness of seeing his paintings in the Capitol. It will be a noble Copy right, given by this Congress, even a nobler one than the one taken away by the other, that the same pictorial history of our Aborigines enlarged and improved shall be written or painted on the walls of the Capitol. General Grant approves it—and I can but hope, that the Committee will prove to General Eastman, and to the many friends thus interested in him, that
>
> "All things do come to him, who doth but patient wait."

It was a remarkable plan, reaching back to 1848 when Seth Eastman first offered to come to Washington and paint an Indian gallery for the government, superior to Catlin's, and all for a lieutenant's pay. But Grant had endorsed it, at least to the extent of observing that if it was Congress's desire to have Eastman's services on such a project he could be detailed to it without detriment to the service. The president would have to approve full pay, "but that I will freely recommend." The problem, of course, was that it was Mary Eastman and not Congress who wanted the general assigned to paint the pictures. Another possibility would be to have the secretary of the interior, at the request of the Committee on Public Buildings and Grounds, request Eastman's services to decorate the committee rooms. He would then be paid out of the Capitol extension appropriation. Alternatively, Congress could pass legislation making a special allocation for Eastman to do the job.[23]

The joint resolution Schenck attempted to introduce in the House on February 21 was muddled and verbose. It adopted the first option and provided that, should the president deem it proper to put Eastman on

113. Seth Eastman in his general's uniform shortly before his death in 1875. Minnesota Historical Society.

active duty with the full pay and perquisites of his rank, he would be employed to paint, under supervision of the architect of the Capitol, his own designs to decorate the rooms of the Senate and House Committees on Indian Affairs and Military Affairs. Unanimous consent being withheld, the resolution was reintroduced in the next session, on March 26. Schenck stressed that it had the unanimous approval of the Committee on Military Affairs; the congressman who had objected to its introduction before was now entirely satisfied that it was important and should be passed. (Perhaps Mary Eastman had been on his trail.) Schenck defended the resolution's Americanism: better by far to employ a native talent than some Italian artist to decorate the United States Capitol. With the possible exceptions of George Catlin and John Mix Stanley, Eastman had no superior in depicting Indian scenes. At the same time, his assignment would honor an officer retired for disabilities incurred in the line of duty. He would draw his full pay as lieutenant colonel, about $1,200 to $1,500 a year above his retirement pay, which was a bargain in view of the tens of thousands lavished on foreign artists for sometimes tawdry work. Schenck wound up by inviting members to examine a book of engravings he happened to have with him—*The American Aboriginal Portfolio*—to confirm all he had said about Eastman's merit. The House passed the resolution, but when it went to Senate the same day it was referred to the Committee on Military Affairs, which did not report back for another year, and then adversely.[24]

A deal had been cooked up on the side, however, since by special orders

114. Seth Eastman, *Fort Snelling,* one in a series of seventeen paintings of forts Eastman commenced in 1870. Architect of the Capitol; photograph Library of Congress.

of August 28, 1867, Eastman had already been assigned to duty under the secretary of the interior, who had jurisdiction over the Capitol building, and was at work on a series of oil paintings. He had received a second patronage appointment, again made possible by the fact he was on the government payroll already, though the difference between his retirement pay and full salary did constitute a direct subsidy to the arts. So too did his expenses. He was prompt to inform his immediate superior, the architect of the Capitol extension, of his right to an allowance for travel, fuel, and quarters; nearly $1,300 in 1868, it answered the old grievance about the high cost of living in Washington. Eastman's army record simply noted that he was on special duty from September 1867 to February 5, 1870, two and a half years in which he finished nine oil paintings of Indian subjects for the House Indian Affairs Committee room and began another series of seventeen oils of American forts, including West Point, Snelling, and Mifflin, where he had served. They brought Seth Eastman back to his roots in the Topographical Bureau and drew on his original strengths, a good sense of perspective and an eye for the contrasting lines of nature and man, of landscape and structure. Intended for the rooms of the House Committee on Military Affairs, the forts occupied him until his death on August 31, 1875, of apoplexy, attributed by his physician to the sunstroke that had disabled him in 1862. Since he was officially unemployed after

February 5, 1870, this series was done without subsidy, serving as an artistic valedictory to his half-century association with the United States Army.[25]

Seth Eastman has been called the "pictorial historian of the Indian" and praised as the most reliable of the lot; but it was right that at the end of his life he reverted to the more accurate designation "the soldier-artist." His best multifigure Indian scenes were exceptional—*Sioux Indians Breaking up Camp* (ca. 1848), *Ball Play of the Squaws on the Prairie* (1848), *Ballplay of the Sioux on the St. Peters River in Winter* (1848), *Medicine Dance of the Dahcotah or Sioux Indians* (1848), *Lacrosse Playing among the Sioux Indians* (1851)—though one quickly recognizes his patented effects, the figures clustered in the foreground, particularly on the right where, seated and standing, they form an oval frame around the action set in the middle distance. Ever the landscape artist, he allowed the human activity he was portraying in his oils to open out toward a distant vista of bluffs or tree-fringed water under a dramatic umbrella of cloud. His watercolors and sketches were freer of studio conventions, but they also tended to minimize the human element. Eastman essentially populated scenes with small figures. The nine oils he did for the Indian Affairs Committee room were all rehashes, based on earlier works including his illustrations for School-craft's history. Indirectly, Eastman had reclaimed copyright to his own designs after all. But the works in oil speak even more directly to his weaknesses. Indifferently composed, in three only do the figures dominate, and in each there are glaring weaknesses in anatomy and physiognomy. *The Death Whoop* is especially inept. The triumphant warrior holding aloft the scalp of a foe lying at his feet is awkwardly rendered, with an elongated torso, misshapen arms, and small, soft hands and face that belie the blood-thirsty theme—weaknesses all the more evident by comparison to the strongly modeled figure in the watercolor that provided Schoolcraft's history with a plate so in line with popular prejudices that it was embossed on the boards of the original volumes.

Seth Eastman remained to the end aloof from the cultures he portrayed. Lacking Catlin's empathy, he was alternately the detached observer and the soulful romantic straining after emotional effect, fit companion to his novelist wife. Mary Eastman survived him by twelve years, making do on thirty dollars a month of pension money and whatever else her writing could bring in. She contributed to the magazines and published a book but never recaptured the popularity she enjoyed in the early 1850s. Washington remained her home, as she had wanted, and Eastman's artistic legacy a continuing though not major factor in her life. In 1884, three years before she died, the assistant secretary at the Smithsonian made overtures to have the paintings in her possession put on public display. Mary Eastman was tactful, but she declined. "I can not just now remove

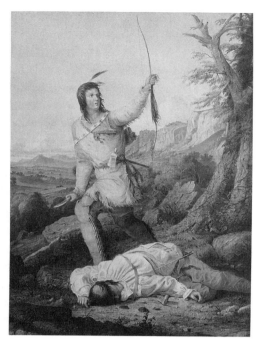

115. *Left*. After Seth Eastman, *Scalp-Cry,* an engraving in Schoolcraft's *History of the Indian Tribes of the United States . . .* (1857).

116. *Right*. Seth Eastman, *Death Whoop* (1868), the awkward reprise of *Scalp-Cry* included in the series of nine oils on Indian themes commissioned for the House Committee on Indian Affairs room. Architect of the Capitol; photograph Library of Congress.

them from their present place, unless I could dispose of them which I should be very glad to do." She hoped that they might one day be preserved in the National Museum, but until then would abide by the rule that payment would have to precede delivery. In light of the experiences Stanley and Catlin had with the Smithsonian, hers was a shrewd stance. Others did not learn the lessons of patronage politics nearly so well.[26]

* * *

Mary Schoolcraft had literary ambitions of her own, nurtured in rivalry to Mary Eastman's. In 1852, the year Eastman's *Aunt Phillis's Cabin* scored a signal success, she published *Letters on the Condition of the African Race in the United States*. It proved that where abolitionists were concerned, the two were southern sisters under the skin. "I can feel sympathy for a great many classes of sinners," Mary Schoolcraft wrote, but for "the faithless, heartless, wicked smuggler[s] of our slaves, . . . I hope never to feel any sympathy, except that of wishing them converted to Christianity, and then immediately transported to heaven." Her *Letters* could not match the popularity of Mary Eastman's fictional polemic, but she still contemplated a proslavery novel of her own, *The Black Gauntlet: A Tale of Plantation Life in South Carolina*, and in 1860 approached Lippincott to publish it. She got a cold reception. Frankly, he could see no market for her book; the people were "weary of the subject, though politicians continue to agitate it." But Lippincott outlined the costs and, when she agreed to pay, took it on as a subsidized publication. Mary Schoolcraft wrote her novel on the

Dickens plan, the compositor nipping at her heels for copy, and wrapped it up in a month and a half. *The Black Gauntlet* cost her $741.69 to publish and enjoyed a brief, modest success—1,500 copies in four small printings, the last in March of 1861 finding no market.[27]

But something more than profit was at issue anyway: Mary Schoolcraft had composed a panegyric to herself and presented it to the world. As a novel, *The Black Gauntlet* was a shapeless, grotesquely self-indulgent exercise in conceit; it had no plot, no point, no characters. But it had a heroine, Mary Schoolcraft disguised as Musidora, and it had a cast of knaves and fools as counterpoint to her virtues. Most of all, it was pure wish fulfillment, a vision of the correctly ordered universe in which she and her long-suffering husband, "Mr. Walsingham," were triumphantly vindicated. The envious were foiled, her stepdaughter and brother repentant, her own family rapturous to receive her back and consecrate their lives to her and the memory of their parents on the family plantation in South Carolina. The United States of America would become two countries—the United States North and the United States South—bound by true brotherly affection now that the cloud of coercion had lifted and both faithful to the spirit of the Constitution. Slaves in the United States South would continue to flourish under kindly masters who instructed them in Christianity, thus elevating them, within their capacity, from barbarism to civilization. As for Mr. Walsingham, he would take the advice of his friend Baron Bunsen of Prussia and after a few months' bathing in the medicinal springs of Germany would return to America fully recovered from his paralysis, to live out his days in contentment with his adored Musidora, who was a little too self-absorbed to do much adoring in return.[28]

That was the world as Mary Schoolcraft scripted it in the spring of 1860. In fact, Henry Schoolcraft remained racked by pain, immobilized, bitter that his monument to himself had been stopped short of completion, alienated from son and daughter, though he reclaimed John in his service in the Union cause, and Jane through her wartime correspondence with her stepmother. J. B. Lippincott, the lure of the government contract no longer holding him in line, grew distant. He had published enough Schoolcraftiana in the early 1850s to last a lifetime, including the *Memoirs* and a "corrected series" of reprints of Schoolcraft's early travel narratives, one to accompany each volume of the Indian history. The reprints had sold poorly; Schoolcraft himself admitted that "it is like a resurrection from the dead, to get up a new excitement on an old book." So he proposed to put out some new ones. In 1855 he had suggested a collection of Indian legends rendered in poetry; Lippincott countered with a promise to push the private edition of the national work. But in October 1856, during contract negotiations for the final volume, Schoolcraft had extracted a commitment from Lippincott to publish three volumes of "a lighter char-

acter," to commence with *Records of a Wigwam*. What Schoolcraft had in mind was a series, "The Literary Papers of Henry Rowe Schoolcraft," that would pay him homage in his twilight years. Elsewhere he suggested the books be titled *Onändiwin* ("choosings"), *The Algonquin Philosopher,* and *The Literary Voyager;* or as just two volumes, *Honae India; Consisting of Miscellanies of the Forest and Study;* or just *Lanosh; or, The Indian Philosopher.* Doubtless dismayed by what his last, $10,000 dollar gulp of federal patronage might cost him, Lippincott put Schoolcraft off: "We hardly feel prepared, immediately to enter into definite arrangements for its publication, so *exceedingly unpromising* are the prospects in the commercial world." In time the Schoolcrafts convinced themselves that, out of benevolence, they had contracted with a fledgling house in 1850 to publish the Indian history and had thus single-handedly made it into a thriving national concern; but despite his persistent importunings, Schoolcraft had lost his hold on Lippincott.[29]

Through Henry Wadsworth Longfellow, who owed him a favor for borrowing freely from *Algic Researches* in writing *Hiawatha,* Schoolcraft tried to locate a new publisher in Boston, but without success. His aim was to make a few dollars from his miscellaneous writings while putting the finishing touches on his literary monument, the history. Now almost entirely confined to bed, in January 1864 Schoolcraft turned a final time to the federal government for aid. Amazingly, the commissioner of Indian affairs responded favorably. "It would seem a misfortune after so much has been accomplished to leave the work incomplete," he wrote to the secretary of the interior. "I understand that Mr Schoolcraft is unable to finish the work by publishing the two additional volumes without an appropriation from Congress for that purpose." The secretary, perhaps better posted than the commissioner, was unmoved, but Schoolcraft was encouraged enough to petition Congress once more for a subsidy, $20,000 to publish the final two volumes and provide Congress with 500 copies of each. Forgetting past differences, he approached Lippincott and learned that for $11,400 he could have the two volumes published "to correspond in character of matter and style of execution with the 6th vol. of the same work—but to contain no illustrations." This too was heartening, leaving $8,600 for himself and his wife who, more than a copyist, now styled herself his amanuensis. Schoolcraft remained hopeful into the summer, but the matter died of its own accord—it was hardly a priority in the midst of a civil war—and Schoolcraft himself died shortly afterward, on December 10, 1864.[30]

By her own account, Mary Schoolcraft was heroic to the end. Though "young enough to have been his child," she had devoted her life to Henry Schoolcraft, and on his final morning as usual she brought him breakfast at daylight. Ever the scholar, he promised to critique an article she had

written for the papers the evening before. But when she drew his morning bath, he found himself too cold to take it, though the fire had burned all night. "I thought he was only nervous, but he grew colder, & colder, & colder, and whilst I was striving to soothe the ague, he breathed his last in my arms, calling my name, as long as his tongue could move." She locked the door, bathed him, perfumed him with rose, dressed him in a suit of black, and only then sent for two physicians "who stretched his limbs back to their natural positions." Henry Schoolcraft, who had been unable to lie supine in his bed for years, now lay comfortably in his coffin. The Reverend R. R. Gurley, the go-between in the dispute with Catlin, officiated at the service with two others. The funeral oration touched on Schoolcraft's wives, Jane Johnston, who "seemed especially fitted to be the handmaid and interpreter . . . most needed by him in the mission to which he had devoted his life," and Mary Howard, who seemed, "to the day of his death, providentially sent to him to be his associate in the higher mission of giving a scientific form and a literary finish to the results of his former explorations."[31]

The wifely pecking order duly established, Schoolcraft was lowered into the ground—but not to rest. This was the age of Victoria, after all, that exemplar of extravagant mourning who, since the death of Prince Albert in December 1861, had made "a sort of religion" of bereavement. Five days after he was buried, Schoolcraft was raised from his grave. His widow had selected his final resting place. Accompanied by a photographer, she had the coffin opened and his portrait taken, "looking so natural, that I could not refrain from talking, & telling him that it was his own idolized, & idolizing wife that was near him. Every wrincle had disappeared from his face, though he was 72 years of age." So the return to youthful vigor, imagined in *The Black Gauntlet,* was realized in death. Ignoring the cold, Mary Schoolcraft sat by her husband in the "ice bound grave yard" for six hours, gazing at his features, "assured that *now* the image of God, had been restored to man." As she kissed his "marble brow," the odor of rose engulfed her, and the sun that had been hidden behind a cloud "burst forth in splendor."[32]

Such a man must never be forgotten. At the end of *The Black Gauntlet* Mary Schoolcraft consecrated her life to the memory of her dead parents; now it was evident that her remaining years, like the eighteen before, would be devoted to her husband instead. She relished the role of Henry Schoolcraft's widow, tending his grave and reputation, sifting through the accumulated papers of his long career, chiding Lewis Cass for his late-life neglect, and spearheading a one-woman drive to erect a suitable monument, "a collosal image of *himself,* cut in marble, with the Red Man's friend, & Indian historian of the United States Government, inscribed on it." She hounded congressmen and state senators and petitioned the state

legislature of New York to rear a monument where scholars in future centuries might come to pay their respects. A friend gently advised her it was unlikely the legislature would consider her request, adding that Schoolcraft's "most substantial memorial are the books he constructed & which we may well hope & expect will out live any statue of brass or marble." But something was due him, a poetic tribute at least, and on the tenth anniversary of his death she surprised Longfellow by asking him to write one. He did not reply.[33]

The "Widow of the late Indian historian of the United States Government," as she styled herself, should have known by then that the world had already forgotten her husband, and no monument of paper or stone would recall him to future generations. Even her copyright to the *Archives*—a useless enough legacy, as she had already learned—was as transient as fame. It would expire after fourteen years according to the act of Congress granting it. Lippincott refused to purchase her rights when she approached him in 1866, and he steeled himself for the inevitable letters berating him for various betrayals and duplicities. Some confusion over the actual ownership of the plates to volumes 5 and 6 fueled her indignation, stopping a sure sale of the *Archives* in 1871, she charged. "You can make atonement now by buying all the plates and copyright yourself. And this is your solemn duty." Duty played no part in business, however, and the "widow of the late Indian historian" now styled herself an "impoverished widow" who had been wronged.[34]

Mary Schoolcraft ran a boardinghouse in Washington until her death in 1878, wringing rents from her roomers and occasionally tormenting herself with fantasies of another's success. Mary Eastman had been J. B. Lippincott's pet. That $9,000 house bought with the proceeds from her books might have been a pipe dream, but his favoritism was not. Doted on by Lippincott, granted access to the government plates to illustrate her Indian sketches, entertained at his villa, showered with attentions, Mary Eastman in turn had doubtless entertained him with tales of the Schoolcrafts' misfortunes, told in her inimitable manner. But in truth both women had experienced disappointment, their shared hopes for the South dashed by civil war, their dreams of prosperity from the labors of their husbands by the rush of postwar events. Brantz Mayer, who had known Schoolcraft and Eastman, in 1869 pronounced his verdict on the new order then emerging: "There is a general *intellectual decline,* I think, every where in America. Gold and shoddy . . . are the things. The indiscriminate plunder & squander system, is the time of day. Babies have it on them a[s] strong, as measles, or chicken pox. . . . 'Hold out your hands,' and receive, *or,* grab! The stage,—the current saleable literature,—club talk,—parlor talk,—men, women, children,—all show the materialistic absorption of

America, since the war." Indians, like slavery, were passé in the Gilded Age.[35]

＊ ＊ ＊

And what of Ephraim George Squier, with enough railroad and mining stock stuffed in his pockets to make him a parody of the Gilded Age entrepreneur? It was to him that Mayer had confessed his misgivings, his conviction that antiquarian studies were in decline and the American Ethnological Society a ghost of its once vigorous self holding monthly wakes over the corpse. Surely if anyone could inject new life into it Squier was the man. He had never slowed down, never slackened the killing pace he had been maintaining for twelve years when he fired his parting salvo at Henry Schoolcraft and bid good riddance to his Indian history. That was in January 1858. Two months later he had a comeuppance of his own, and the issue was an old one: the Grave Creek stone.[36]

A decade after Squier first cast doubts on the stone's authenticity in a paper read before the Ethnological Society, arousing controversy and the lasting enmity of Schoolcraft, Wills De Hass finally presented his rebuttal before the same body. There had been no suspicious delay in reporting the relic's discovery, contrary to Squier; thus his case fell apart. William B. Hodgson, who had switched sides to be with Squier in 1847, switched sides again. William W. Turner remained level-headed: whether this "Rosetta Stone of America" was "spurious or genuine, it has nothing to do with the history of American civilization . . . before the arrival of the whites." But others got in their digs. George H. Moore, librarian of the New-York Historical Society, reported that Squier, in attendance when De Hass read his paper, was "as completely floored . . . as ever any man was, who undertook to make a theory and a prejudice to serve instead of investigation and facts." De Hass was triumphant. Squier, he told John Bartlett, "carried himself most gentlemanly. He receded from his former position, and admitted the genuineness of the Inscription." Even Edwin H. Davis checked in from New York to chortle with Schoolcraft. De Hass, he wrote, "has most effectively used up Mr. E. G. Squier. The time was, when many, hereabouts considered Mr. S. to be the only Ethnologist of the Country. But quite a change has taken place for he has now left but few worshippers besides himself." Schoolcraft happily agreed: it was inevitable that such a man would find "his true level." Squier had fallen into disrepute.[37]

The reports of Squier's demise were premature. In 1858 he was at the height of his powers. Though distracted from pure archaeology, which had proved unprofitable, he was immersed in his Central American investigations and already an established authority on the region. There had always been something frenzied about his productivity, his impatience to make his

mark and collect his rewards. Besides scores of papers, articles, and newspaper pieces, he had continued to churn out books in the 1850s. "Is anybody—are you—going to read all you write," a friend wondered. In 1852, a year after *The Serpent Symbol* appeared, he published a popular work based on his experiences as chargé d'affaires in Central America, *Nicaragua: Its People, Scenery, Monuments, and the Proposed Inter-oceanic Canal.* Nearly seven hundred pages long and written in four months, it went against his grain, Squier complained to Francis Parkman, and deserved to be damned. Still, Parkman hoped it would prove "a Californian gold mine" to him, though he had earlier cautioned Squier against letting politics "swallow up science." The *National Intelligencer* was disappointed that *Nicaragua* lacked "those antiquarian researches and scientific disquisitions" for which Squier was justly famed but thought it a valuable introduction to the country and directed readers to its case for an interoceanic canal. In truth the book was mainly a travel narrative with a defense of his tenure as chargé appended; the two antiquarian expeditions he did describe suggest that Squier was more intent on treasure hunting (and looting) than serious archaeology—indeed, had had no time for anything more. *Nicaragua* was followed by *Notes on Central America* (1855), which concentrated on the Hondurases, San Salvador, and the proposed Honduras Interoceanic Railway; a novel, *Waikna; or, Adventures on the Mosquito Shore* (1855), published under the pseudonym Samuel A. Bard and meant to make some money while sustaining Squier's position in his dispute with the British; and *The States of Central America* (1858), an overview that also ended with a ride on the Interoceanic Railway. Squier would publish monographs as well, but these titles constituted his claim on public attention in the 1850s. "Not among the least of the results which have followed upon the acquisition of California . . . is the tropical direction which has incidentally been given to American enterprise," he wrote in the middle of the decade. He personally expected to pocket "a cool $100,000" from certain land and mining speculations in Central America. Archaeology had been understandably upstaged.[38]

But Squier's scientific curiosity never abated—only the means, and time, to satisfy it. About 1860 he became an editor at Frank Leslie's Publishing House, a position that, with interruptions, saw him through the decade, while the pages of *Leslie's Illustrated Newspaper* introduced him to a wider audience. The major interruption was a stint from 1863 to 1864 as United States commissioner to Peru, a plum assignment for one of Squier's tastes that brought his archaeological interests to the forefront again. If he disappointed readers of *Nicaragua,* it was perhaps because he was himself disappointed in what he found there. The Mosquito (Miskito) Indians on the coast, he wrote within days of arriving at San Juan in 1849,

were "the most miserable, squalid, and stupid beings conceivable." He held out hopes that those to the south and farther inland, and certainly the antiquities buried under their feet, would be more inviting. But his scientific communications on the archaeology of the area were never characteristically expansive. He was impressed by the ruins of Tenampua, even did a little excavating, and was able to measure, describe, and illustrate what he found. But he could not astonish. He was walking in the shadows of Humboldt and Stephens and a legion of savants who had made the civilizations of Mexico and the Yucatán familiar; explorations in the Hondurases and Nicaragua were essentially continuations. Peru was another matter.[39]

Nothing Squier had seen in the Ohio valley or Central America fully prepared him for the awesome spectacle of ruined cities in the Andes. He set out at once to make himself an expert. "When I tell you that all that has been published about Peruvian Antiquities is only to be compared with what was known about those of our own country, before they were taken up by Davis & myself, you will appreciate what I have got before me," he wrote in October 1863. By the end of the next year he proclaimed success: "I have 'done' Peru as thoroughly as any man could do in the same time & with my limited means." Papers followed, and a course of twelve lectures at the Lowell Institute in Boston in 1866; but though Squier claimed to be $16,000 out of pocket for expenses, no book on his Peruvian researches appeared.[40]

The frantic pace of Ephraim George Squier's life was catching up with him. What he longed for most, he confessed to his parents in 1869, was quiet. "I am by no means sure when my somewhat troubled life with its reverses begins to break me down." When *Peru: Incidents of Travel and Exploration in the Land of the Incas* appeared at last, in 1877, it was not so much written by Squier as coaxed out of him by a persistent brother who spent three years arranging the materials for publication. By then Squier was a shattered man, only intermittently lucid, beset by present furies that made contemplation of the ancient past impossible.[41]

Back in his feisty salad days, when the Ethnological Society was going strong and he, one of its most recent members, was also one of its most audacious, a cautionary tale raced the rounds. The hottest piece of gossip in 1849 was also the saddest: poet Charles F. Hoffman, a favorite of the New York literary set, had proposed marriage to Jane Schoolcraft and then plunged into hallucinatory madness. Squier was in Nicaragua at the time but received reports from friends back home. Everyone had a theory. Since 1844, when Henry Schoolcraft asked him to put some Algonquian love songs into verse, Hoffman had been daft about Indians. His approach to translation was free, to say the least:

Fairest of flowers by fountain or lake,
Listen, my fawn-eyed one, wake, oh awake!
Pride of the prairies, one look from thy bower
Will gladden my spirits like dew-drops the flower.

In late April 1849, having secured a clerkship in the State Department, Hoffman moved to Washington and boarded with the Schoolcrafts. He had a history of mental instability and, under the delusion that a woman was out to poison him, had recently been institutionalized. But he seemed recovered, of frail health for a man who once enjoyed woodsy excursions but, Schoolcraft believed, bright of "mind and spirits." Smitten with Jane and, Francis Parkman theorized, wanting to make the Indian cause literally his own, he got it into his head that he must marry her (his "fawn-eyed one") and thereby save the race. The Schoolcrafts abetted his delusion by giving their permission—the wedding was set for mid-October—thus precipitating Hoffman's culminating tragedy. Haunted by strange voices and convinced he had again been given a slow-acting poison by his tormentor, he slipped back into madness in September. The prognosis was discouraging. "Phantoms still appear to cloud his brain," Schoolcraft wrote to Jane at her retreat in Ontario, where she passed the winter recuperating from her disappointment. "To me, it appears that all thought of a future union should be abandoned. . . . All that gave prominence to Hoffman was his *intellect,* and if this is gone, all is gone." Years later, rumor had him chained to the floor of the Insane Hospital in Baltimore, or perhaps it was Harrisburg, "a hopeless maniac."[42]

Charles Hoffman's tragedy was a cautionary tale that worked on two levels. It was in line with the belief that all red-white unions were inadvisable, though tolerable when the man was white, the woman red. And it told of the obsessive power of love. Upon learning all the details, Squier sighed, "Alas poor Hoffman!" unaware that his life would follow a similar path. Overwork and ennervation would contribute to his breakdown, but the precipitating factor for him too would be a woman who stole his heart and then his mind.[43]

In his bachelor days Squier had been a bon vivant and something of a ladies' man. He had an eye for "*les poulets*" and was a peacock himself. Self-assured, worldly, and charming, his handsome features, trimmed beard, and natty grooming made him an attractive catch. When he gave up his long, flirtatious bachelorhood in 1857 and, at the age of thirty-six, married an exotic beauty with a shadowy past, Miriam Florence Follin, his friends welcomed him "into the Benedictine order" and commiserated with his bride. "Well," Josiah Nott wrote, "if you really have a wife, & she is a decent respectable woman please give her my kind sympathies . . . men

117. Ephraim G. Squier and his wife, the former Miriam Florence Follin (ca. 1836–1914), about seven years after their marriage in 1857 and about a decade before their stormy divorce. From *Purple Passage: The Life of Mrs. Frank Leslie,* by Madeleine B. Stern. Copyright © 1953 by the University of Oklahoma Press.

sometimes reform on the *gallows*." In fact, it was Squier who would need the sympathy.[44]

Miriam Squier was also a vain, restlessly ambitious soul, twenty-one when they wed, multilingual, vivacious, capable, and pure iron at the core. She had fended for herself since a childhood in New Orleans, trod the boards with Lola Montez as her "sister" Minnie, had been married briefly once before and would marry twice again. Divorce was her chosen means of disposing of outworn husbands, and after nearly sixteen years together she would cast off Squier to marry his friend and employer Frank Leslie. One day she would manage the entire Leslie publishing empire herself. That was all far in the future; in 1858 the Squiers seemed well matched, their prospects assured. Both Leslie editors, they worked hard and played hard through the 1860s. Trapped in a loveless marriage and unable to obtain a divorce, Frank Leslie boarded with them, forming a convivial trio. They flouted convention and flirted with scandal as they cut a swath through society in New York, Saratoga, the Lincoln White House, and the capitals of Europe, which they twice toured together.[45]

Through it all Squier attempted to maintain his reputation as a scholar. The collapse of his interoceanic railway scheme had freed him up a little, and he was eager to return to the field. Miriam accompanied him to Lima on his Peruvian mission but not on his antiquarian excursions into the Andes. He still described himself as a student of "Indianology," still professed archaeology his first love. But where in his busy schedule at Leslie's was there time to play scientist? He might see himself as an Indianologist, but in reality he was a journalist with a hobby—and increasingly the third wheel in a relationship about to career into real scandal. For while he locked himself in his study and pored over his Peruvian notes, Miriam and Frank Leslie continued to do the town. And when he failed to give them time alone together by voluntarily absenting himself, they simply got rid of him. On their first voyage abroad, in 1867, Frank Leslie wired ahead to notify a creditor in Liverpool of Squier's impending arrival; upon docking, he was arrested as an "absconding debtor" and jailed for two weeks while Miriam and Leslie frolicked in London. A man of the world, Squier may well have accepted the logistics of a triangle, but he would never have suspected such perfidy of a friend.[46]

On June 17, 1871, he and Miriam hosted a huge, old-fashioned "Rhode Island Clambake" to celebrate his fiftieth birthday. The delicacies on the bill of fare were named after milestones in his career: Clams à la Nicaragua, Aboriginal and Monumental, Inter-Oceanic, Serpent Symbol, Mosquito; Chowder à la Ulysses (Grant), Cheops, Anthropological; Lager à la Waikna, Anglo-Americaine, Archeology, Peru. A punning postscript to the invitation invited guests to another clambake fifty years hence, at the expense of their "un-*shellfish* host," when "we hope to meet you all looking younger and lovelier than ever." It was a nice thought, unexpectedly wistful. Within two years the Squiers would be divorced, and in three he would be committed to an asylum for the insane.[47]

The Leslie situation had turned nasty earlier in 1871 when Frank Leslie's wife charged him with adultery and named Miriam Squier as his mistress; Ephraim Squier stepped forward to indignantly deny the charge and exonerate his wife and friend. But in July 1872 Frank Leslie got his divorce at last, and he and Miriam set out to remove Squier from the picture again, this time for good. He was a willing dupe, overly fond of the bottle and all too ready to be led astray. Some acquaintances, "by arts as diabolical as man's contrivance could compass," took him on a drinking spree that ended in a brothel. Squier was not unknown to the staff and soon had a naked girl named Gypsy bouncing on his knee. These were grounds for divorce. Squier's drinking companions that night, both artists with *Leslie's Illustrated*, were prepared not only to describe but to *show* what they had witnessed. Squier raged at this entrapment but, threatened with disclosure, granted Miriam her divorce on May 31, 1873. There was one

condition: she must not fling his humiliation in his face by marrying Frank Leslie. When she did, the next year, Squier snapped. A month after their wedding he was declared a lunatic, "not having lucid intervals," and was committed to an asylum for the insane on Long Island.[48]

In time his fury and frustration abated, leaving him curiously passive. The brash confidence and driving ambition that had set him apart simply vanished. Like the Andes he had traipsed, Squier had been all peaks and valleys, soaring hopes and plunging despair; now he was as flat as the plains, without a flicker of the old enthusiasm. Unsparing in his own polemics, he was painfully sensitive to criticism himself and could not abide the thought of others laughing behind his back or, worse yet, pitying him. So he placed himself above the fray by removing himself from the field. That November he was discharged into the care of his half-brother Frank in Brooklyn, where he remained except for vacations at the seaside and visits with his parents in the country. At first he dreamed of getting better and rejoining the bustling world. As soon as he felt his "intellectual pins a little firmer" he would finish his book on Peru, he promised his publishers in New York. "A little wholesome mental exercise" was all he needed to get better. Perhaps a few days with friends in the city would do the trick. "I want to feel myself a part of the moving world, even while resting on my oars." But the slow passing of the days, the enforced idleness and mental calm (the only cures known for nervous exhaustion), the dependency created by letting others make decisions until he could no longer make them for himself—all took their toll, establishing a rhythm of their own. He waited patiently for the fruit trees to blossom in spring, watched the weather, wandered his parents' orchards, and kept tabs on the years as they drifted by. Occasionally his brother prevailed on him to write a letter, but the pen, once his ally, now was alien. Brief comments on the seasons, the apple crop, somebody's health, and he would lay it down, exhausted. In 1876 his ethnological library was sold off; Ephraim George Squier would not be going back to work again.[49]

When the end came on April 17, 1888, there was general relief. His father received the news stoically; it was not unexpected. Some recalled him fondly, remembering the Squier of old—his wit, his verve, his extravagant hospitality. To him, more than most, Edgar Allan Poe's lines apply:

Thank Heaven! the crisis—
The danger is past,
And the lingering illness
Is over at last—
And the fever called "Living"
Is conquered at last.

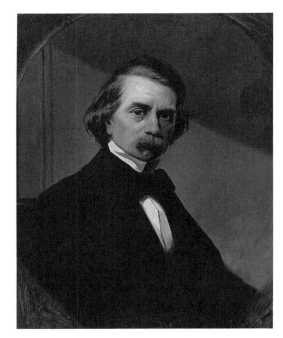

118. John Mix Stanley, *Self-Portrait,* the haunted eyes and drooping mustache suggesting how disappointments had aged him. The Thomas Gilcrease Institute of American History and Art, Tulsa, Oklahoma.

At last indeed the troubled spirit of the preacher's son who could not believe was at rest. The theory of an autochthonous American race that he had consistently championed died with his generation of polygenesists, but his pioneering survey of the western mounds, *Ancient Monuments of the Mississippi Valley,* stands a monument itself in the history of American archaeology.[50]

* * *

The destruction of John Mix Stanley's Indian gallery in the Smithsonian Institution fire of January 1865 was a personal disaster comparable to Catlin's loss of his gallery to creditors in 1852. Both artists had suffered devastating misfortune. And both, in a peculiar sense, had been liberated by their loss. Catlin had gone aroaming again and seen parts of the Western Hemisphere he might never otherwise have visited. His indomitable spirit had carried him through. Stanley too had faced his tragedy squarely. "I know I have the Sympathy of this *whole* community," he wrote at the time, "and feel that if my life and health are spared—a few years will enable me to leave, perhaps enough to educate my children—My life has been one of hard toil My heart is yet strong—My ambition is not crushed." He could still wield a brush to paint portraits for a living. And his artistic energies, since his move to Detroit in 1863, ran in a different channel. He would work on an epic scale with historical subjects and landscape. And he would exploit his western years and his knowledge of Indians in scenes loosely based on memory, with enough fiery sunset skies to suggest a psychologi-

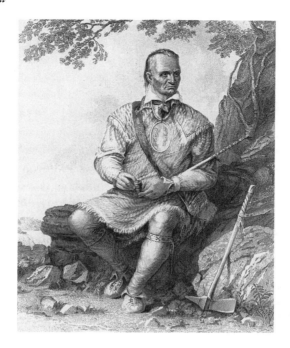

119. After Seth Eastman, *Red Jacket, or Sagoyawatha,* a plate in Schoolcraft's *History of the Indian Tribes of the United States . . .* (1857).

cal dimension. He was freed from the literal to go roaming too, though his realm would be the imagination.[51]

In the initial rush of sympathy after the Smithsonian fire, friends had petitioned Congress to commission an Indian scene or two from Stanley. He was at the time already at work on a huge oil, *The Trial of Red Jacket,* and claimed to have it half-finished. A year later, it was little advanced. "I have been so occupied in fighting the wolf from the door that I have not been able to spend the time & money necessary to complete the painting," he wrote a friend. "It requires some five months work yet." The composition involved seventy figures, Stanley estimated, and its completion late in 1868 was a cause for rejoicing.[52]

Red Jacket (1758?–1830) had attracted all the Indian painters. Catlin portrayed him head and shoulders, then full length, in the 1820s. These were his first Indian portraits and looked like none other of Red Jacket, indicating that he still had much to learn. On the other hand, it could be that Catlin's contemporaries idealized the old Seneca orator. Robert W. Weir's standing figure, a little less theatrically stiff than Catlin's, proved popular with contemporaries. Painted about 1829, it and the bust portrait executed by Charles Bird King in the same period influenced most subsequent interpretations. Eastman, who had assisted Weir as drawing instructor at West Point in the 1830s and taken private lessons from him, incorporated elements of Weir's figure, especially the backdrop, in a seated portrait of Red Jacket whose features owed something to King as well. Subse-

quently Eastman included Red Jacket in *Indian Council* (1868), one of the oils executed on commission for the government in which he promiscuously mixed Iroquois chief and plains Indian costume. Stanley's *Trial of Red Jacket* was the most elaborate treatment of all. King's head (which once hung near Stanley's portraits in the Smithsonian) topped a standing figure shown in full oratorical flight, since historical painting required a dramatic or narrative element.[53]

The Detroit papers had been monitoring Stanley's progress on *Red Jacket*. Over four years in the making, involving some fifteen months' sustained work, grand in conception and execution, it was hailed upon completion as a masterpiece, the ultimate tribute to the American Indian in the days of his former glory. The *Free Press* directly linked Stanley's painting to the idea of a vanishing race. "The romantic legends and the strange history of the aborigines of our own country are allowed quietly to sink into oblivion, while scarcely a bubble floats on the dark rushing tide of years to mark the place where—not a nation—but a race sunk from among the living and was lost from sight forever." American artists had all too often neglected the tragic saga unfolding around them, reworking old themes in old ways while ignoring America's legends, "fresh, wild, and full of the richest fancies." In the passing of the Indian was a theme worthy of the ages, and John Mix Stanley had proved equal to it. Every figure in *The*

120. Seth Eastman, *The Indian Council* (1868), with Red Jacket making a cameo appearance at a Sioux gathering. Architect of the Capitol; photograph Library of Congress.

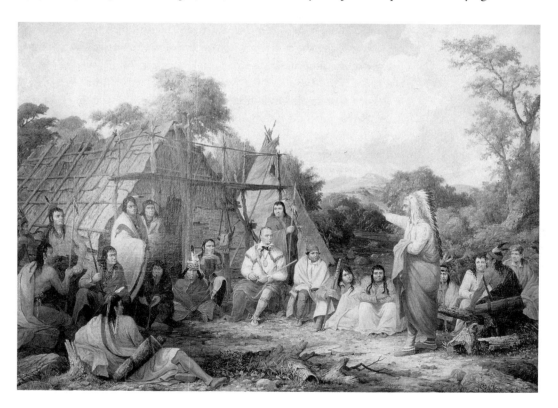

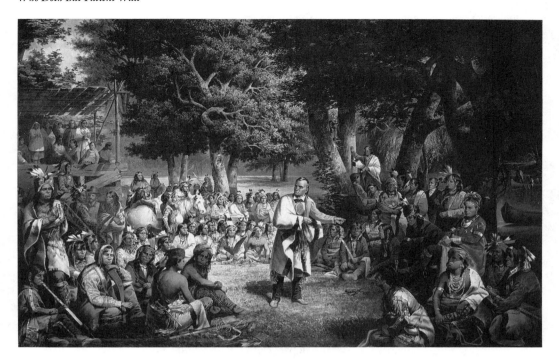

121. John Mix Stanley, *The Trial of Red Jacket* (1868), an ambitious bid for popular acclaim and public patronage. Buffalo and Erie County Historical Society, Buffalo, New York.

Trial of Red Jacket was distinctive, every expression individualized. Trees provided a canopy of green; Indians and setting were "simply nature, nothing more nor less." In scope heroic, in detail meticulous, the effect of the painting was "fairly stereoscopic. . . . it is almost impossible for the beholder to conceive that he is looking at a plain surface." Simply, *The Trial of Red Jacket* was Stanley's "greatest work" and "a most important event in the history of the fine arts in America." It also constituted his latest bid for patronage. Instead of a gallery, he would tour a single painting; instead of trying to interest some public-spirited body in purchasing a whole collection, he would have one epic canvas to sell; and instead of watching the work of many years go up in flame, he would protect his investment of time and effort by having his masterpiece chromolithographed for national distribution.[54]

Just when Stanley discovered chromolithography is uncertain. The loss of his gallery was a lesson in life's vagaries that may have made him the more protective of his artistic legacy. He had set out to surpass Catlin, and Catlin had made publication handmaiden to his ambition. Catlin was known as a writer as well as a painter and showman; Stanley was known only as a painter, and fire had demonstrated how fragile that claim to fame might be. Even the taciturn Seth Eastman had seen his Indian scenes showcased in an elaborate album, *American Aboriginal Portfolio* (1853), and had promised a larger work, "a pictorial history of the Indian tribes," that with Mary Eastman's text would rival Catlin's *Letters and Notes*. It was

413

at the heart of his dispute with Schoolcraft. Eastman had long planned "a complete pictorial history of our Aboriginal tribes," his wife wrote in 1867. All his preparation in the arts (and a good deal of his own money) had been dedicated to this end. He had declined an offer for the rights to his illustrations in the Indian history "that would have made his large and dependant family, *independant*" because he always assumed the government plates would be his and that, with little additional expense, he could have his "collection engraved, issued in numbers, and thus realize the means to educate and provide for his children."[55]

Stanley's thoughts after the Smithsonian fire ran in parallel grooves. To preserve a record of his labors and a memento of a vanishing race, he proposed to work up an album of from fifty to one hundred paintings illustrative of Indian life. In 1869 he got as far as sending three sketches with accompanying text and introduction in letterpress to London in search of a publisher. He planned to leave the writing to another (W. P. Morris), working the paintings up from rough drawings or from memory. The three he sent (*Prairie Indian Encampment, Chinook Burial Grounds,* and *Buffalo Hunt*) indicate that he was not planning to recreate his portrait gallery and would depart from Catlin's albums uniques by doing full-scale scenes. Had his project come to fruition, a contemporary believed, it would have "yielded a large income to the artist's family from the royalty on the sales during many years to come; for the value of the work was sure to increase as the American Indian became either civilized or extinct." The constant appeal to the vanishing race—paramount in Eastman's proposed album as well—was pure Catlin, though Stanley planned a second departure: his illustrations "were to have been in oil and then chromoed." Publishers in London were deterred by the prohibitive costs, however, and American publishers were no more receptive. But Stanley carried out part of his plan. In May 1868 he sailed to Europe bound for Berlin, where the finest chromolithographers in the world plied their trade.[56]

Berlin's broad avenues, imposing public buildings, and wealth of statuary and art impressed Stanley. But he was in town on business carrying the Indian paintings that he proposed to have chromolithographed. Arrangements with Storch and Kramer were satisfactorily concluded, and over the next few years five prints appeared ranging in size from twelve inches by eighteen to twenty-two by twenty-eight, and in price from $6.50 to $14.00. Sales (handled by Stanley personally) were brisk enough to encourage him in 1869 to undertake the task of copying *The Trial of Red Jacket* on a reduced scale (2' x 3') for chromolithography. The six foot by nine original, exhibited in Detroit, Buffalo (where the subject had particular local appeal), and points east, had built up an appreciative audience. Thus though the chromo was priced at a whopping $30 it was soon subscribed to $8,000, a popularity "without precedent."[57]

Stanley seemed to have hit on a profitable speculation at last. All that was needed was the government's cooperation in waiving import duties on the prints. Catlin had faced the same problem in 1842 when the duty on imported letterpress limited profits on the American edition of his *Letters and Notes*. Congress had turned down his request for waiver, but Stanley had a claim that Catlin never did. The destruction of his Indian gallery may not have constituted a moral *obligation* on Congress, but it had left a reservoir of sympathy. So in January 1868 Stanley approached an old friend, Isaac Strohm, to seek a candid opinion on the merit of his petition for compensation. Should the conclusion be that he had no claim "in justice or equity" upon Congress, he would "abandon the hope in that direction." But he was persuaded that responsibility for his loss "must rest with some one." At the time Stanley was planning his trip to Berlin and informed Strohm that any Indian paintings he did in the future would likely be executed with an eye to chromolithography. Compensation and chromolithographs—the two dovetailed in his case for relief from import duties.[58]

On February 7, 1870, Michigan's Zachariah Chandler, long friendly to Stanley's cause, introduced a joint resolution in the Senate providing that up to 20,000 copies of Stanley's Indian chromos be admitted to the United States duty free in "full settlement" of any claim against the government for losses suffered in the Smithsonian fire. Stanley had done advance work to ensure passage; Detroit's district attorney was to "engineer" the bill through Congress, and others were lined up to exert influence on its behalf. Since no funds were to be appropriated, the bill was quickly passed and before the House, where Robert C. Schenck, who had returned from the battlefield in 1863 to represent Ohio in Congress, took charge of it. It is quite possible that he first recommended this form of redress to Stanley in 1868. Schenck's defense of the joint resolution on June 17 was cut short by words Stanley had longed to hear. "It is all right," a colleague said. "Let us have the previous question." Six days later the bill was signed into law, and the last obstacle to Stanley's commercial success removed. Although the first chromo (*Uncas, the Young Chief*) was ready for distribution in the spring of 1869, mass importation of the next four (*The Deer-Slayers, The Indian Telegraph, Gambling for the Buck,* and *Snake in the Grass*) was probably delayed until after passage of Stanley's bill. *The Trial of Red Jacket* joined the list in 1871, and Stanley entered on a period of unaccustomed prosperity. It would, for him, prove tragically brief.[59]

Though Stanley said little about it, his health was poor. Some friends speculated that the loss of his gallery in 1865 "gave him a physical shock from which he never fully recovered." He spent much of the winter of 1867–68 confined to bed, "right gloomy" about his prospects. The trip to Berlin buoyed his spirits, though the sightseeing left him "perfectly worn

415

out" and anxious to "hurry home." January 1870 found him gloomy again and musing on mortality. "Deaths visitations in the homes of friends throws its growing shadows across my own pathway—for I know ere long its icy touch must come to me—At best I have but few years left, perhaps only months—perhaps only days—though I hope for years." The next year he was in Chicago superintending the hanging of *The Trial of Red Jacket* at the spring exhibition of the Academy of Design. "I am feeling much better than when I left home," he wrote to his wife. "I shall return refreshed—& thoroughly rested—ready for application to business."[60]

Business was improving even as Stanley's health declined. Sales of his chromos had brought a good return, and the family built a handsome three-story house on Woodward Avenue at a cost of $16,000. Stanley basked in appreciation. The Detroit papers never failed to notice his latest production, and the city's artistic community considered him its doyen. He lacked only the kind of national recognition his enterprise merited—the kind of recognition, for example, showered on Paul Kane in Canada.[61]

If Stanley continued to keep tabs on his acquaintance from Oregon days, he would have learned from the papers that Kane died on February 20, 1871. After his return from the Northwest, Kane had been honored as Canada's pioneer painter, his pictures praised as a priceless record of the native race. When he completed his contemplated Indian gallery, a cycle of one hundred oils, a private patron bought it for $20,000; today it forms the nucleus of the largest public collection of the artist's work, that of the Royal Ontario Museum. Kane did endure a few annoyances. His parliamentary commission for twelve oils delayed completion of the hundred-picture cycle that he regarded as his magnum opus. Too, the illustrated narrative of his western travels—intended to equal Catlin's *Letters and Notes*—dragged on for a decade after his return from Indian Country. Kane's search for a favorable publishing arrangement had brought him into touch with John R. Bartlett in 1848. Bartlett, who had experienced his own difficulties in finding a publisher for his narrative of the Mexican boundary survey, pointed Kane to the Smithsonian Institution. *Ancient Monuments of the Mississippi Valley,* he said, exemplified what the Smithsonian could do for an author (Squier would have begged to differ). Kane probably approached Joseph Henry, but in the end he made his own arrangements. When *Wanderings of an Artist among the Indians of North America* appeared in 1859, it was received as a Canadian classic.[62]

Indeed, Kane's success was so complete that he was deprived of the restless drive that propelled his American peers, certainly Catlin, to the end of their days. Semiretired through the 1860s, his great adventure behind him, his vision impaired by snowblindness, Kane was comfortable but without an animating purpose. It would be an exaggeration to see him as a victim of the very success American artists hankered after in vain. But he

was pampered in comparison with a man like Stanley, whose equal initiative had paid no dividends and whose frustrations were aptly symbolized by an incident in his relations with the Smithsonian. Intent on minimizing the seriousness of the loss to the nation in the destruction of Stanley's gallery, Joseph Henry in his official report for 1865 had referred not only to Catlin's recently repatriated collection, but obliquely to Paul Kane's as well: "There are in existence, particularly in Canada, other portraits, sufficient in number and variety fully to illustrate the characteristics of the race." That summed up a neglect whose memory even late-life prosperity could not erase.[63]

Stanley's health, bad throughout the winter of 1871–72, failed him entirely in the spring. A heart attack in March left him housebound, but he recuperated sufficiently to begin planning a family vacation abroad. He took a carriage ride downtown on April 9 and that evening entertained company, remarking that he was beginning to feel better at last. He went to bed about 10:00 and slept soundly until midnight, when he was awakened by an intense pain in his chest. He passed out and was dead by 12:30. Years later his wife recalled how his final painting foretold his end. It showed two figures walking down a winding road through the woods toward a clearing flooded with sunlight. He titled it *The Pleasant Way Home*.[64]

Alice Stanley found solace in 1872 as she always had, in religious meditation and in poetry about death and Christian reconciliation. She needed all the spiritual strength she could muster. An infant born the previous October died that July, and her oldest daughter died the next year at age fifteen. Stanley left no will, but his widow inherited property and the rights to the chromos and his unsold paintings. *The Trial of Red Jacket* was a potentially valuable asset: the state of Michigan was said to want it for its new capitol. And there were the paintings from the Indian gallery that had survived the fire and remained at the Smithsonian. What Alice Stanley did not know was that they belonged to someone else, a fact that came to her notice in 1883 when in her capacity as executor of the Stanley estate she requested their return for an art-loan exhibition in Detroit that September. Shortly before his death in 1878 Joseph Henry had assured her the pictures were "subject to her order," she stated. But her request in 1883 was denied: Henry's daughters had a claim on them, and their permission was required.[65]

The unpaid loan of 1858 had never been forgiven. Alice Stanley professed ignorance. "Will you kindly tell me what is the claim? and on what founded? Strange that Prof. Henry did not mention it to me." But what followed suggested she knew all about the loan: "I have never brought any claims for the loss by fire of the large Gallery. It certainly was a shameful piece of neglect. . . . And anyone can readily see that we are the losers, and

we are the rightful owners of the remaining few paintings of the large Gallery.—my husband's life work." Subsequently her son, Louis C. Stanley, corresponded with Mary A. Henry directly and then through an attorney. Whatever the law of limitations, he insisted, his mother had a "moral claim" on the pictures. Mary Henry was equally certain of her legal rights, instructing her attorney to set a price of $1,200 on the five paintings—the amount of the unpaid loan. "They cannot take the pictures and unless we wish to sell them there is no need of our having a better title to them than we now have," she observed, and with that the matter was dropped.[66]

But Alice Stanley was not finished yet. In 1888 she tried a different approach. Resolutions were introduced in Congress directing the Library Committee to look into purchasing "from the administratrix of the late John M. Stanley"—Alice Stanley, that is—the historical paintings "in the custody of the Smithsonian Institution." Two years later she threw in *The Trial of Red Jacket* as well. The one was hers and in her "possession"; the others were hers and in the Smithsonian's "custody." But the distinction proved meaningless, since Congress again declined to act, and the Misses Henry, secure in their legal title, made a gift of the five paintings—the residue of John Mix Stanley's Indian gallery—to the National Museum in 1908.[67]

The Trial of Red Jacket was legitimately Alice Stanley's. It had reportedly been insured for $30,000 during its exhibition tour, and it remained a considerable asset in both size and potential value, the former qualifying the latter by effectively restricting its sale to a public institution. A painting six feet by nine in a massive frame was not exactly a portable asset. A reporter, stirred by the news of the Sioux ghost dance war in the West, looked Alice Stanley up in January 1891. She had aged well. Gray-haired, stately, and hospitable, she showed the reporter Stanley's portrait (it reminded him of General Custer) and his palette with the paint dried on it just as he had left it nearly twenty years before. She had consecrated her life to his memory, surrounded by his paintings. *The Trial of Red Jacket*, conspicuous by its absence, was then hanging in the directors' room of the Citizens' Bank of Detroit. It was "of considerable historical value," the reporter wrote, "and ought to be in a better light." In 1895 it found a public home in the Buffalo Historical Society's Indian Room. A home, but not a buyer. During the Great Depression Stanley's surviving son and daughter tried to sell the painting without success. Then in 1947 a private gallery offered $1,600; the Buffalo Historical Society agreed to meet the price. Subsequently a New York dealer upped the ante to $3,000; again the Historical Society matched the offer. It was at a tenth of the value Stanley placed on his painting and eighty years after the fact, but *The Trial of Red*

Jacket had found the kind of public patronage that eluded John Mix Stanley in his lifetime.[68]

* * *

At the time of Stanley's death, a Michigan paper reported that George Catlin was still living in Belgium and "said to be almost imbecile." In fact, in April 1872 Catlin was living near the Smithsonian Institution in Washington, in full possession of his faculties and trying once more to sell his Indian collection to the government. How he came to be there rounds out his remarkable story.[69]

When Catlin left Brussels sometime in mid-1871, he was banking on a positive reception in America after his long absence. There would be a new generation of viewers for his paintings and a willing patron in the federal government or one of the learned societies, he was sure. After disembarking in New York, he was reunited with his family and visited his now-grown daughters. But it is unlikely he lingered long. His head was popping with plans. In his absence he had tried to work through intermediaries. The Reverend Mr. Gurley, his brothers, and others had done their best. But no one could convey his intentions as well as he could or bring his experience with press and opinion makers to bear. He would take personal charge of his affairs, play showman and salesman and use the stored-up energies of thirty years to promote his cause. He was in New York City by late October, seventy-five years old, stone deaf, badly out of touch, but brimming with enthusiasm.[70]

"Always invite the 'Press' & 'Big Bugs'—& Millionares," he had instructed his brother Francis during the abortive exhibition of the outline drawings in 1869, and true to his own advice Catlin cultivated those who could advance his cause. Printed invitations invited the influential to a private viewing of "Catlin's Indian Cartoons" at the Somerville Gallery on the evening of October 23. The papers issued their usual praise. Everyone should see his paintings, but schoolchildren especially should not miss them. "It is truly like a visit to the red man to get among Mr. Catlin's pictures, for we feel at once that all is simplicity and truth," the *Herald* averred. When, they asked, as the New York papers had asked in 1837, would the government act to make them a permanent national legacy? When the *World* was slow to add to the accolades, Catlin courted its proprietor. "One of the principal ambitions" of his life would be "obtained in the examination of my works by men so capable of appreciating them, and their value to the history of our country as yourself." But he could not gainsay facts: his show was losing money. It was a source of irritation to him that public patronage did not extend even to providing an exhibition hall. In Brussels, for example, he had help from the minister of the interior in securing quarters at a reduced rate (only, he might have added, after

enduring the insults of local officials before the former American consul, Henry Sanford, intervened). In New York, rent alone exceeded receipts, and his exhibition, opened with fanfare and high expectations, was closed early in December.[71]

Catlin's complaints had been heard, however, and a public institution was about to make him a proposition. The Smithsonian's Charles Rau had visited the New York exhibition in November and been impressed by the artist. Catlin, he recalled, was "a man of medium height and good proportions, exhibiting a physique well calculated to endure the hardships encountered by him in the course of his long wanderings." At seventy-five he "still presented a remarkably vigorous appearance." His deafness obliged him to take questions in writing, but he answered Rau's "promptly and intelligently," convincing Rau not only of his truthfulness—"he invariably states exactly what he witnessed"—but also of the justice of his complaints about his reception in America. Whether Rau put the word into Joseph Henry's ear or not, Catlin had already sounded the secretary out about the availability of a hall in Washington should he decide to exhibit his collection there. At the time, he expressed no interest in approaching Congress again but was "anxious to have the Collection seen and appreciated" in the nation's capital. Should he not be encouraged to bring the cartoons to Washington, he would ship them back to Europe. Henry replied at once, offering Catlin use of a large hall, recently completed and, he assured him (with Stanley in mind), fireproof. Catlin would not be permitted to charge admission but could realize some revenue through sale of his catalog.[72]

Catlin was grateful for the offer but noncommittal. His New York exhibition would close in a week, he wrote Henry on November 26, and he would decide then what to do next. Perhaps he would try Boston again in the hope of reigniting the excitement of 1838. He may also have had prior commitments—he told one correspondent he would be reopening in New York on Christmas Day for a final three-week run. His uncertainty was evident on December 12. He had decided to take one more stab at selling his life's work—the original collection stored in Philadelphia and his cartoon collection—to the federal government. Thus he wanted to display what he could, the cartoons, in Washington at an opportune time to attract congressional interest. He was ready to start for Washington at once, set up the screens in the Smithsonian hall, and await reaction. "If no move for its purchase is speedily made, I shall pack it up and be on the ocean with it for the other side of the Atlantic." This echoed his unheeded threat of 1839. Would Congress be any more receptive in 1872? Since the session was about to adjourn for the Christmas holidays, Henry suggested that Catlin wait until mid-January to set up his screens.[73]

Thrown back on his own resources for a month, Catlin was left in a quandary. There was one recent prospect he had barely tapped, an English

antiquarian and collector, Sir William Blackmore. For a while Catlin thought he had found in Blackmore a new Sir Thomas Phillipps. When that particular well ran dry in 1860, communication had ceased. But publication of *O-Kee-Pa, Last Rambles,* and *Lifted and Subsided Rocks of America* in quick succession had reminded Phillipps of his old associate, and in September 1870 he dropped a note to Catlin's publisher, Nicolas Trübner, inquiring for the artist's whereabouts. Aware that Catlin was still ducking creditors in England, Trübner demurred: "May we tell this?" The decision was apparently in the negative, closing in silence Catlin's only sustained patronage relationship.[74]

Blackmore seemed an even more promising prospect. His collecting interests, unlike Sir Thomas's, were strictly ethnological and focused on the North American Indians. A successful solicitor and stock promoter with substantial holdings in the American West, Blackmore made his first visit to the States in 1863 at age thirty-six and his first major purchase as well, the Squier-Davis collection of antiquities from the Ohio valley mounds. In September 1867 he opened a private museum (the Blackmore Museum) in Salisbury to showcase his collection of primitive manufactures from around the world, organized to promote comparative study and teach "one great lesson," human progress.

Although Blackmore was serious about his hobby, particularly the acquisition of photographs of the American Indian, he retained some of the dilettante's curiosity about the sensational. When Catlin's explicit O-kee-pa portfolio circulated in London in 1864–65, Blackmore had five of the descriptive captions copied and may have been responsible for the Philobiblon Society's unauthorized publication of *An Account of an Annual Religious Ceremony Practised by the Mandan Tribe of North American Indians.* Eager to learn all he could about phallic worship, Blackmore invited the "serpent philosopher" himself, Ephraim George Squier, to the *conversazione* marking the opening of his museum, and he later broached the subject directly with Catlin only to have it brushed aside. "Neither in North or South Amª have I witnessed (or learned of) any custom or ceremony, which deserves the title of 'phallic worship,'" Catlin replied. He had heard rumors of it—and cannibalism, for that matter—but "both (strictly as such) vanish when closely pursued."[75]

With the means at his disposal and the desire to augment his collection, Blackmore made several trips to America between 1863 and 1874, forming friendships with army officers stationed in the West, men of science (Joseph Henry among them), and artists like George Winter of Indiana, who, flattered by the unexpected attention, kept trying to distract Blackmore from his preoccupation with Catlin and sell him his own work. Blackmore's passion for photographs, not paintings, set his priorities; but he was interested enough in the earlier pictorial record to visit Catlin in

Brussels and buy one of his albums in 1871, thereby cementing their relationship. Grateful for the timely sale at £125, Catlin sent Blackmore copies of his recent books—*Last Rambles, Lifted and Subsided Rocks, Shut Your Mouth*—and an original portrait of Humboldt, his all-purpose thank-you in this period. Doubtless Blackmore's check helped cover his passage to America that year, and the two men kept in touch thereafter.[76]

Reviving the publishing scheme that had collapsed when Ezra Cornell withdrew his support the year before, on December 12, 1871, Catlin wrote Blackmore from New York about the cost of putting out a limited edition of his "great work," one hundred copies at £10.14 each should phototypography be employed. Catlin actually favored an alternative plan, prints taken directly from the negatives and bound with a text. The initial outlay would be limited to the cost of procuring the negatives and setting type; the plates could be made and the books bound to fill orders as they came in—an early version of "on demand" publication. Catlin provided no estimate of cost but warned Blackmore it would be "fully double" if the job were undertaken in America rather than in Antwerp, where he had made preliminary inquiries. There was a more serious impediment to Blackmore's involvement. He and Catlin were potentially at cross-purposes, since Blackmore was toying with publishing his own "Indian Gallery"—the more than two thousand photographs he had commissioned and collected. Were he to proceed, Catlin wrote, "I am at a loss to know how it may affect the 200 photos which I am anxious to put out."[77]

122. William Blackmore (1827–78), the image of philanthropic paternalism, shakes hands with a bemused Red Cloud in this Alexander Gardner photograph made in Washington in 1872. Catlin hoped Blackmore would prove a late-life patron. National Anthropological Archives, Smithsonian Institution, photo no.3243–A–1.

123. Catlin's improbable plan for an Indian museum in Central Park, front page news in *Frank Leslie's Illustrated Newspaper* for March 2, 1872.

Their deliberations went no further. Blackmore had discussed Catlin's situation with the assistant secretary of the Smithsonian, prompting a renewed offer of the institution's facilities. Discouraged by his reception to date, Catlin told Blackmore he was contemplating a return to England instead. Forgetting he had spent most of the Civil War railing against John Bull, he confided that he was "very tired" of his own country "and would much rather undertake responsibilities in a foreign land than in it." A £100 loan, and he would be on his way. Since Catlin wrote to the Smithsonian the same day thanking them for their offer, he evidently was more interested in wangling the loan from Blackmore than in leaving. Despite his protestations to the contrary, the "complete disappointment of receipts" from his exhibition at the Somerville Gallery had not soured him on New York. Perhaps the newly established Metropolitan Museum could be persuaded to purchase his cartoons. One admirer thought so, and Catlin allowed that if he could arrange a sale to the Met for $50,000, there would be a $5,000 commission in it for him, to be paid "in strictest confidence." But this scheme was nothing compared with another Catlin project announced in February 1872, coinciding with the reopening of his exhibition for a short run at the Somerville Gallery. When public interest had flagged during his first New York City exhibition in 1837, he erected a gorgeously decorated Crow tipi in the Stuyvesant Institute as a new attraction; now, mired in the reality of failure, he made another of his glorious flights into fantasy and proposed the construction of a tipi of thin sheet iron, seventy-five feet in diameter, seventy-five feet high, in the middle of Central Park. Painted in the Crow style, with colored bands and huge pictographs, its windows, concealed from the outside, would cast light on the original tipi within and on Catlin's cartoons, hung in rows

around the room. Should the park commissioners bridle at the cost of erecting this permanent memorial to the American Indian, Catlin vowed to raise the necessary funds—and the tipi—himself.[78]

The press loved it. *Frank Leslie's Illustrated Newspaper,* Squier's employer at the time, gave Catlin's plan front-page coverage on March 2. A drawing showed fashionable carriages pulling up beside the gargantuan building's open flap and captured the symbolism of a tipi in a forest in the middle of Manhattan—America's past meeting its future. Instead of dismissing the whole idea as absurd, a fellow artist actually debated the merits of modeling the structure after a Mandan earth lodge instead. The attention was all Catlin could have asked. He may have given up on floating museums, but he was still at sea when it came to practicality. His grand scheme came to naught, of course, but it served notice that an American original had returned with a flourish.[79]

Only after he had exhausted his possibilities in New York City was Catlin ready to take up the Smithsonian's offer. On February 13 he conceded defeat. Central Park's Board of Commissioners was "in complete disorganization, and nothing will be done by them at this present time," he wrote to Joseph Henry. His collection was already crated, and he would start for Washington on the fifteenth. Four days later he was bustling about the exhibition hall, ordering stoves and arranging his screens. On February 27, 1872, a warm, springlike day, he opened for the last time. Henry was pleased with the turnout and with Catlin himself. As he got to know the artist better, he was charmed and increasingly sympathetic. The sole purpose of Catlin's exhibition was "to induce the Government to purchase the whole collection of Indian paintings," Henry reported, an object he wholeheartedly endorsed. Catlin's was "the only general collection of the kind in existence" and thus of inestimable historical value. But the congressmen stayed away from the Smithsonian's hall, preoccupied, Henry concluded, by the fall election. Frustrated, Catlin nevertheless sought Henry's advice in drafting a memorial to Congress; on May 6 it was introduced in the House of Representatives.[80]

The petition was the first direct appeal to Congress to purchase his collection that Catlin had made since 1852. Little had changed in twenty years. Catlin told how, following congressional inaction in 1852, his Indian Gallery was nearly lost to his English creditors but was rescued by Joseph Harrison and returned to America. His cartoons—the paintings currently on view in the Smithsonian—were of less immediate concern to him than the original gallery. Would Congress purchase it at the price set by the Library Committee back in 1846—$65,000—thereby giving him and his heirs "a small pittance" after his debts were settled? If so, he would devote his remaining days "to clean, to retouch, and finish and arrange the whole for perpetuity." It was as though time had stood still for Catlin.

Accompanying his petition was a leaflet reprinting the supporting memorials and the Library Committee report from 1846, Lewis Cass's 1841 endorsement, Daniel Webster's 1849 speech, and the original certificates—including always Henry Schoolcraft's—attesting to the veracity of his Indian portraits. This was in truth "the last appeal" Catlin could ever make to Congress; he entrusted his cause to their deliberation.[81]

Congress handled Catlin's case in 1872 by referring his petition to the Library Committee. Knowing this meant slow death, Catlin had the petition reintroduced twice, on May 24 and 27, but his saturation campaign failed to alter House procedure or hurry the committee along. No action had been taken when Congress adjourned on June 10. When it reconvened in December George Catlin was just weeks from death, though not beyond caring.[82]

The bitterness of continuing congressional neglect was assuaged by Henry's kindness and the memory of the New-York Historical Society's overtures two years before. Better the Historical Society should own his life's work than it should fall into the "unfastening hands" of government, he had written, and before submitting his petition to Congress in 1872 he offered both his collections to the society for $20,000 less than he would demand of Congress, or $80,000, half to be paid at once, the balance over up to five years.[83]

Awaiting a favorable reaction that was not forthcoming, Catlin resigned himself to Washington, "this horrible place." There were compensations, including a visit by a delegation of Sioux under Red Cloud in late May. They were in the capital to plead their own cause with government; since Blackmore and his wife were squiring them around, Catlin was included on the itinerary. He admitted to never having visited the Teton Dakotas in his wanderings but was thrilled by the contact with real western Indians. More than ever, his mind was running in old channels. A letter from a fur trader who had first ascended the Missouri in 1858 brought a flood of recollections and a wistful wish. "If the Govt. take my Collection," Catlin wrote his correspondent on the day he started from New York for Washington, "perhaps you and I may make another tour to the 'Far West,' together. There is much yet to be seen and to be discovered, in the Indian Country: And though somewhat old, I am yet quite able to hunt it up and relish it."[84]

Catlin remained irrepressible in spirit, but age was now stalking the hunter. Over summer he boarded more than a mile from the Smithsonian, exposing himself on his daily rounds to "the intense heat of that season." Henry, who was vacationing in the north to escape the unusually hot weather, returned to Washington in late September to find Catlin unwell and complaining of shortness of breath. Henry immediately sent for a physician, who diagnosed a heart ailment and concluded that Catlin's

kidneys were failing as well. The doctor held out no hope of recovery. "He considers it the breaking up of his constitution," Henry informed Catlin's family. After his exhibition, Catlin had been assigned a painting room in one of the Smithsonian towers; after the doctor's visit it was converted into a bedroom, and the Smithsonian literally became Catlin's home.[85]

Henry spared Catlin the doctor's verdict through October. Catlin could no longer paint or write, but he shuffled around his room, and he still talked. His paintings weighed on his mind. Henry cheered him with the news that the librarian of Congress was confident of a positive vote on purchase at the next session. He also promised to confer with Joseph Harrison in Philadelphia sometime in November, a promise that afforded the opportunity for a frank discussion. The truth, Henry told Catlin on October 31, was that his health was so precarious the end could come at any time. It was imperative he put his affairs in order and arrange for the legal transfer of his paintings to his daughters. Since the future of his collections was his overriding concern, Catlin accepted this news philosophically. "He is, although somewhat desponding, not in an unhappy state of mind," Henry reported. "His life, on the whole has been a successful one."[86]

It was a bit early for eulogies, but Catlin even then was preparing to leave for Jersey City. Dudley S. Gregory had relented at last. Catlin had not wanted to bother his daughters while he was lying ill in Washington, since they could do nothing for him anyway. Now he would join them instead. About eight o'clock in the evening of November 2, Catlin was assisted into a closed carriage drawn up outside the Smithsonian. He left his cartoons behind, some in boxes, others scattered in the dust, awaiting Congress's decision; he thought he might return in a few weeks to touch them up, "but there is scarcely any hope of this," Henry observed. Catlin still resisted what he knew to be true. The end was at hand. Rain fell as this tireless traveler began his last journey.[87]

With his daughters gathered about him offering what comfort they could, Catlin continued to fret over the future. "He was full of hope in Washington of a favorable issue to his endeavors to sell his Collection, hoping to get his bill through Congress this session, and his inability to continue his efforts in that great wish of his life, has added much to his mental suffering," Elizabeth wrote on December 18. It was in character that Catlin punctuated his self-concern with concern for another. He had been distressed to learn in October that Mary Blackmore, traveling with her husband in Montana, had suddenly taken ill and died, and he was more distressed on his own deathbed that he could not offer his condolences to Blackmore in person or by pen. Elizabeth, his amanuensis, did. Even as his daughters comforted him, he stared away their sympathy, turning his face

and sitting by the hour stoical as an Indian, they said. Among his last words was a question: "What will become of my gallery?"[88]

Death came to George Catlin two days before Christmas 1872, at half past five in the morning. The papers noted that its visit was expected but delayed by the "extraordinary vigor" of his constitution. The New York *Times* had him dying of dropsy, which had "complete possession of the lower part of his trunk, and mounting slowly killed him by inches"—a death by slow torture for the Indian painter. Now that he was gone, the *Herald* admitted that his cartoons displayed the previous year at the Somerville Gallery were the work of a hand "grown weak from inappreciation." But his historic contribution could not be dismissed. Were an allegory painted to his memory, it might show "art as smoking the calumet over his remains and criticism as burying the tomahawk beside them." The *Tribune* chose to praise him: "Art was his idolized profession," and he a practitioner of uncommon ability. Spirited fidelity was the hallmark of his work. Most obituaries noted Catlin's neglect by Congress; the Jersey City *Times* deplored it. He had worked "unaided, nay, discountenanced by the United States government, which should have fostered and aided him." But he was destined to receive the tributes of posterity. His remains were buried in an unmarked grave in the Gregory plot in Greenwood Cemetery, Brooklyn, beside those of his wife and son; but his soul, the *Times* predicted, would ascend to "the grand Elysian hunting grounds," where vanished Indians would welcome him as a kindred spirit.[89]

The press send-off—ambivalent, hesitant about artistic stature—was prelude to a new campaign to make the American government the patron in death it had never been to George Catlin in life. With the added motive of honoring their father, his daughters immediately petitioned Congress to buy the cartoon collection. Their memorial, introduced in both House and Senate at the end of January 1873, obscured the distinction between the collection they had inherited and the original gallery still in Harrison's possession. The cartoons were said to have been painted "on the spot," and the testimonials from the 1830s and 1840s were applied to works completed for the most part in Brussels in the 1860s. No price was set, but the Library Committee, to which the petition was referred, was in turn referred to the 1846 committee report favoring purchase of the original gallery at $65,000.[90]

The session ended without action, but the daughters petitioned Congress again that December. They could outwait the Library Committee—a luxury their father had not enjoyed. And Joseph Henry was in their corner, just as he had promised he would be. He had brought the matter before the Board of Regents at its January 20, 1873, meeting, producing a motion of support introduced by future president James A. Garfield, and his own

1871 report urging purchase had been the one recent endorsement accompanying Catlin's petition on its first go-around. That December, Henry wrote directly to the Library Committee. Science, he asserted, needed Catlin's pictorial record; since all civilized societies had passed through savagery in their evolution, Catlin's was actually a record of white civilization's own remote ancestry. "Our Government would be justly censured by the intelligence of the world" were it to permit Catlin's "valuable documents . . . to be lost by the failure to grant the small appropriation necessary to procure them." The daughters had Henry's letter printed for distribution, but even his stirring words could not move Congress. Something more was needed.[91]

In 1874 the three daughters began gathering testimonials from university faculties and learned societies across the land. Henry was their adviser on protocol. Should recipients of their appeal be asked to address the Library Committee directly, or should the Catlins compile a dossier to present to the committee? That is, "would these letters have as good an effect, going in at random," or if collected, "would they be apt to lose their effect, by being presented in such a mass as to lose their individual influence?" Henry counseled a different strategy. Have the responses sent to appropriate senators or representatives for presentation in Congress and referral to committee. "In this way a general feeling in regard to the matter will be excited." But while Henry advocated this strategy he admitted to no special skill at lobbying and recommended that the daughters also consult friends in Congress. They decided to collect the letters themselves and set about soliciting them in February 1874. Citing the possibility of a sale abroad, they requested recipients to join in recommending purchase of Catlin's pictures as "scientific treasures." Henry's letter to the Library Committee was enclosed and provided a charmed entry into faculty circles, judging from the responses. Professors of Latin and Greek, zoology and botany, mathematics, chemistry, intellectual philosophy, and political economy agreed that it would be "discreditable," a "disgrace," a "cause of national reproach," were Catlin's works lost to America. Ripon, St. Xavier, Columbia, Bowdoin, Dartmouth, Lafayette, Union, Princeton, Cornell, Northwestern, Alabama, Williams, Vermont, and Amherst weighed in with letters of support. The governor of New York, members of the Arcadian Club, the New-York Historical Society, and influential individuals, including another future president, Chester A. Arthur, concurred. But this blitz proved no more effective than Henry's solitary endorsement.[92]

The matter came up in the Senate on February 27, 1875, as an amendment to the House bill making appropriations for the sundry civil expenses of government. Carl Schurz, a Missouri Republican who would preside over Indian affairs as secretary of the interior in the Rutherford B. Hayes administration (1877–81), offered the succinct amendment: "For the

purchase by the Smithsonian Institution of Catlin's gallery and museum, illustrating the types and customs of the North American aborigines, fifty thousand dollars." The item was rejected in committee, ending the Catlin daughters' campaign to sell their father's collection to the government.[93]

Anyway, by 1875 Catlin was in competition with Catlin. The sisters had always obscured the fact that what they had for sale was Catlin's second collection. Joseph Harrison owned the original. Henry had tried to see him in November 1872, as he promised Catlin he would, to persuade him to include his paintings with the cartoons in a single offering to Congress. Harrison was seriously ill, however, and though Henry was a friend he could not "gain access" to him. Subsequently Harrison had been adamant that he wanted payment for the collection. His death on March 27, 1874, changed everything, raising the possibility that his widow would donate the lot to the federal government. Whether or not this was a factor, Catlin's daughters two years later removed their cartoons from the Smithsonian, where they had been stored under lock and key since their father's departure for Jersey City. In 1879 Sarah Harrison made a gift of the original George Catlin Indian Gallery to the United States National Museum. On June 11 the secretary of the Smithsonian, in charge of the museum, acknowledged receipt of ten bundles of crates, "Paintings of Indians by Catlin." And so at last the federal government acquired what it would not buy.[94]

Joseph Henry was not on hand to witness the transaction—he had died the previous year. But his successor, Spencer F. Baird, offered a flowery thanks to Mrs. Harrison and promised her that the president of the United States would be informed of her generosity. She wanted no fuss or fanfare. "My mother," her son-in-law replied, "wishes me to state she would prefer not to write a letter to the President making a formal presentation, but that she is perfectly satisfied to have the Smithsonian Institution receive the collection and take care of it for the government." Thus passed in formal silence the consummation of George Catlin's dream. No fortune had ever been realized from his work, but under the auspices of the Smithsonian Institution his fame would grow each year. And vindication would be his at last.[95]

 ★ ★ ★

When Catlin wrote to Henry in 1870 complaining about his treatment by Henry R. Schoolcraft, Henry read the rambling memorial to Congress outlining Catlin's grievances, then put him off with the platitude about truth winning in the end. But after getting to know the artist during the course of the Smithsonian exhibition in 1872, Henry confessed that he had become "very much interested in Mr. Catlin." Together they examined the Smithsonian's Indian holdings, and Henry listened politely when some Mandan implements stirred Catlin to reminisce about his experiences

among that doomed people. Henry read a copy of *O-Kee-Pa* and finally grasped the magnitude of Catlin's anger at a government that had consistently denied him patronage yet subsidized the works of Schoolcraft in which he was denounced as a liar. Henry could not persuade Congress to make amends by buying Catlin's pictures, but he could help right old wrongs, lending Catlin's work the Smithsonian's institutional prestige. The presence of his paintings in its halls was a standing rebuke to his detractors, a form of advocacy that Henry made explicit. Catlin, he wrote shortly before the artist's death, "has succeeded in identifying his name with the history of the early inhabitants of this country, and is frequently referred to in foreign works as the celebrated American ethnologist, and in the line of this branch of knowledge is esteemed above any one that has given attention to this subject." *Above any one*—that was the key.[96]

Henry Sibley and the Mississippi River traders had dismissed Catlin's reports on the red pipestone quarry and branded him a liar; but Charles Rau, the Smithsonian's resident expert on Indian manufactures, prepared an essay titled "Ancient Aboriginal Trade in North America" in which he repeatedly cited Catlin, "the zealous ethnologist and painter," as an authority. He "was the first to give an accurate account" of the pipestone quarry and the first to relate the traditions connected with it. Rau doubted that the quarrying operations there were as ancient as Catlin implied but conceded that the stone had been used in pipes for many generations. As for contemporary Indian customs, Catlin's account was based on "personal observation" and therefore unimpeachable, and his drawings of the red pipes could be relied upon for accuracy. This was vindication of the sort Benjamin Silliman had hoped for back in 1841, appearing as it did in the Smithsonian's *Annual Report* for 1872. The same report—too late for Catlin's eyes—carried an even more compelling vindication.[97]

In seeking corroboration for his account of the O-kee-pa in the 1860s, Catlin had turned to Prince Maximilian of Neuwied—a valuable ally, no doubt, but one whose information was secondhand. There was, however, someone who had actually *witnessed* the O-kee-pa with Catlin, a long-term resident among the Mandans, fluent in their tongue and accepted as the final authority even by Catlin's severest detractors. James Kipp, Montreal born, had entered the Upper Missouri fur trade by 1822 and served most of a career that stretched to 1860 with the American Fur Company. He had been almost ten years in the Mandan trade when Catlin visited in 1832 and was Catlin's principal informant. He sat with him through the O-kee-pa, interpreting its rituals; certified his paintings of the ceremony as accurate; and over the winter of 1833–34 served as Maximilian's major source on the Mandans, providing him the secondhand account of the O-kee-pa that corroborated Catlin's own. David D. Mitchell deferred to Kipp when it came to the Mandans, and he told Schoolcraft as much in 1852. But

though Kipp contributed vocabularies to Schoolcraft's history and received complimentary copies for his troubles, his knowledge that Catlin's description of the O-kee-pa was correct somehow failed to register with Mitchell or to deter Schoolcraft from publishing Mitchell's unfounded charges.[98]

Catlin had always hoped to reach Kipp for an updated confirmation of his account. Convinced that the Mandans were wiped out by the smallpox in 1837, it did not occur to him that there were other, more recent authorities. In fact an army officer had witnessed the O-kee-pa as late as 1860, and a new employee of one of the American Fur Company's rivals, Frost, Todd and Company, had seen part of it in 1858. Henry A. Boller was not even born when Catlin made his visit to the Mandans; but he had grown up in Philadelphia fascinated by Indian stories and devoted to the writings of Catlin, his hero and role model. Thus Boller, unlike a jaundiced John James Audubon, had ascended the Missouri fully expecting to see Catlin's western scenes spring to life. He was not disappointed. "I have found the reality exactly as I expected," he wrote his father; ". . . I can bear testimony to the *fidelity* of Catlin's pictures—both of views, and Indian life. Of the latter he has only given the bright side, but he has done it well." And then in August 1858 the news that Boller had witnessed the Mandan "Religious Ceremony": "I assure you that Catlin has truthfully painted and described it. I have seen the 'bulls' dancing round the 'big tub' in the center of the Village, the young men fasting in the Medicine Lodge, and also the fearful hanging to poles."[99]

Catlin did not realize in 1871 that his description of the O-kee-pa was capable of such independent verification, but he had the pleasure late that year of receiving a copy of Boller's account of his western experiences, *Among the Indians: Eight Years in the Far West, 1858–1862* (1868), a chapter of which was devoted to what Boller called the Bull Medicine ceremony. The book was sent courtesy of the author and stimulated a brief correspondence that excited Catlin all the more when Boller confirmed that James Kipp was still living. When Boller first met Kipp in 1858 he was in charge of Fort Union; he left the Indian country in 1860, Boller reported, "& retired to his farm near Parkville, Mo. where I believe, he still lives." Catlin had tried to reach Kipp there earlier, without success; could Boller provide an "actual address"? Whether or not Boller did, Kipp heard from Catlin a few months later. Aware that an injustice had been done and no longer muzzled by employment by the American Fur Company, Kipp decided to set the record straight once and for all.[100]

On August 12, 1872, Kipp addressed a letter to Joseph Henry at the Smithsonian, "important to science and to the ethnology of our country" and to "the reputation of one who has devoted much of a long and hazardous life in portraying and perpetuating the customs of the dying

races of man in America." Kipp defended Catlin's description of the O-kee-pa, deeming it "a great pity" that Schoolcraft, "who never visited the Mandans, should have put forth such false and unfounded assertions." He praised Catlin's four paintings of the ceremony (sent to him for his comments) as "exactly what we saw, and without addition or exaggeration." Kipp's tone was so unequivocal, his prose so uncharacteristically fluent, that there is reason to believe Catlin dictated the letter's content. Nevertheless, Henry published it in the Smithsonian's *Annual Report* for 1872 under the title "On the Accuracy of Catlin's Account of the Mandan Ceremonies." In a diplomatic prefatory note Henry defended Schoolcraft's skepticism as the result of a sincere desire to get at the truth, but he lined up with Catlin: "We publish the following letter as an act of justice to the memory of the late Mr. Catlin, and as a verification of the truth of his account of a very interesting ceremony among the Mandan Indians, a tribe now extinct."[101]

The Smithsonian did even more for Catlin. It published a flattering obituary restating his importance to American ethnology and, in 1888, a massive catalog-cum-biography by Thomas Donaldson, *The George Catlin Indian Gallery in the U.S. National Museum (Smithsonian Inst.) with Memoir and Statistics*. Written in consultation with the artist's daughters, it contained letters and reminiscences, itineraries, bibliographies, and miscellanea. It also had a section that rehearsed the Schoolcraft-Catlin controversy from a decidedly pro-Catlin perspective, though it imputed no malice to Schoolcraft, settling for the observation: "The rivalry amongst the early American Indian writers, was intense." The daughters were thrilled by the volume. Nearly a thousand pages long, it was a great slab of Catlin, a monument in print. In a girlish letter fairly bubbling with gratitude, Louise Catlin Kinney urged Donaldson to visit the sisters, who were in Paris for the Exposition Universelle, where Eiffel's thousand-foot tower made Catlin's plan for a seventy-five-foot tipi seem moderation itself. Donaldson had, Kinney wrote, lifted George Catlin out of the "dust of neglect." With the Smithsonian behind him, he now belonged to the world.[102]

As Catlin's star rose, Schoolcraft's fell. The "Indian Historian to Congress" was routinely dismissed by turn-of-the-century ethnologists as an amateur dabbling in what he did not understand, and his huge government-subsidized volumes, snidely characterized as "mastodons" in his time, were viewed as relics from a bygone era, valuable for some of their firsthand reports but not their anthropology. As Schoolcraft's weighty tomes languished in desuetude on library shelves, Catlin's *Letters and Notes* still found a ready audience, and his strange, vivid renderings of an earlier America gained a growing acceptance.

On a Saturday evening in April 1889, Dr. Washington Matthews, army

surgeon, ethnologist, and an authority on the Hidatsa Indians, addressed an audience at the National Museum on Catlin's Indian Gallery. Catlin made mistakes, Matthews acknowledged, but "I can not speak too highly of his general truthfulness." His scenes among the Mandans—neighbors to the Hidatsas—"were his glory." Because they were so unusual, however, they had been discredited by "jealous scientific contemporaries," notably Schoolcraft, whose dictum once "seemed to settle all questions." In particular Schoolcraft had challenged Catlin's version of the O-kee-pa, apparently unaware that others could corroborate it. One such eyewitness, Matthews declared dramatically, "has the honor of addressing you this evening."

In 1868, while stationed near Fort Berthold on the Missouri, Matthews had inquired into the ceremony described by Catlin. The local whites knew nothing of it. "Had I been one of the doubting know-alls, how easily could I have cast another stone," Matthews said." But in time I found some old Mandans to consult. These put their astonished hands over their open mouths and groaned in wonder when they beheld the etchings." The next summer Matthews observed part of the fourth day's performance of the O-kee-pa in the Mandan village, "and to the accuracy of Catlin's descriptions and delineations of this I am prepared to testify." As he spoke he drew the audience's attention to Catlin's O-kee-pa paintings, which he had brought along. Instead of the forty to fifty youths who underwent self-torture in Catlin's day, only four took part when he saw the rite in 1869. The ceremony's diminished scale, Matthews concluded, presaged the eventual disappearance of native culture everywhere. Then, truly, as Catlin had prophesied, his Indian Gallery would assume its rightful place among the nation's treasures.[103]

With the course of events running in Catlin's favor, his daughters were reminded of their inheritance, the cartoon collection, and its potential value. After retrieving it from the Smithsonian and displaying a portion at the Centennial Exposition in Philadelphia in 1876, they had found storing five cases a bother and availed themselves of the Smithsonian's facilities again in 1885, when Thomas Donaldson's impending monograph on the Indian Gallery reopened communications. Donaldson had been instrumental in procuring the original gallery for the Smithsonian from Joseph Harrison's widow; perhaps the daughters hoped he could effect an advantageous arrangement for the cartoons as well. They set strict conditions on access to the collection, requiring written permission for anyone save Smithsonian officers to examine the paintings, and in 1892, with no sale in the offing, they requested its return again. More than a decade later, Catlin's two surviving daughters still hoped the Smithsonian might be in the market. Their representative referred to the cartoons as the "second portion" of the Catlin collection already housed in the National Museum;

it made sense to bring both parts together under one roof. But the $40,000 price tag (open to offers) was as much a barrier to purchase in 1904 as it had been in the middle 1870s—indeed, as the various figures Catlin quoted had been throughout his life. "It is feared that Congress cannot be induced to expend the sum required in purchasing a second collection of Catlin paintings," the chief of the Bureau of American Ethnology in the Smithsonian replied, "but before any action can be taken we should know something of the history of this collection and its relation to the collection already in the National Museum, for if it duplicates that collection to any extent it would of course not be desirable to acquire it." He invited Catlin's youngest daughter, Louise Catlin Kinney, to respond, but since the cartoon collection in fact recapitulated much of the original gallery (300 of the 603 cartoons cataloged in 1871 were essentially copies), she remained silent. On October 12, 1905, the file was closed with a terse notation, "Mrs. Kinney does not seem to have replied."[104]

The story did not end there. With a $10,000 grant, the American Museum of Natural History bought the cartoon collection in 1912; most of it was sold to Paul Mellon in 1965 and is now in the National Gallery of Art in Washington, bringing the two collections together in one city, if not under one roof. Notably, both are now in the public domain through private generosity. For Catlin, federal government patronage had proved like the West itself, "a phantom, travelling on its tireless wing."[105]

 * * *

Catlin had always been frank about his motives in going West to paint Indians. He was, he said, after fame and fortune. Fortune eluded him as it did his contemporaries who, with similar aspirations, created the existing visual record of unconquered Indians dwelling beyond the Mississippi. Scientists in spite of themselves, the artists depicted what their romantic sensibilities told them must soon perish, extinguished by the progressive spirit of an age too busy to care. Catlin cared and was convinced he could make the world care as well; failing that, time's passing would. One day his perspective would be ours, and we would imagine that green land and its red peoples exactly as he showed them. For Catlin was always a memorialist. He saw the skull beneath the skin. Men and women stood before him, posing in their paint and plumes, sometimes solemn, sometimes amused, vital in their human vanity; he knew they were ghosts in the making. Cultures paraded past, robust and confident, even arrogant in their pride; he knew they were bound for the grave. Catlin's art cannot be understood apart from the assumptions that informed it. More than any of his peers, he was certain that a great epic was being played out in America. Because his vision was retrospective, because he looked back on what was in front of him, he speaks to us in contemporary terms.

In his lifetime Catlin with rare exceptions was admired as a reporter, not

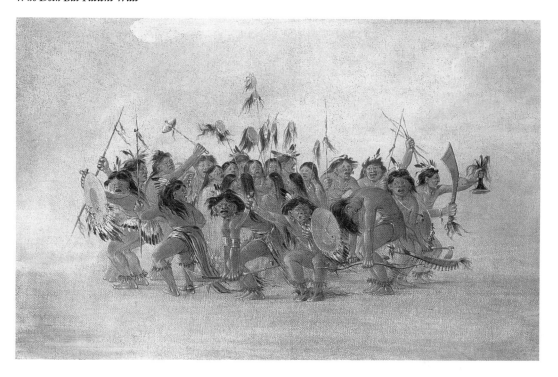

124. George Catlin, *Scalp Dance, mouth of the Teton River* (1835–37), a group scene of the sort that some felt contradicted Catlin's case for Indian nobility. National Museum of American Art, Smithsonian Institution; gift of Mrs. Joseph Harrison, Jr.

an artist. His artistic skills, the judgment went, were rudimentary; only his subject matter gave him prominence. "Mr. Catlin was essentially a portrait painter, but by no means one of the first class," the New York *Herald* stated in his obituary. "Aside from his identification with our Indian traditions, he would probably have failed to make any great impression upon the public." This consideration loomed large in Catlin's original decision to go West. He wanted to escape the drudgery (and obscurity) of conventional portraiture and had been clear from the outset about his artistic goal: the Indians were to be the means to an end, providing him a schooling in historical painting. They became, of course, an end in themselves. And the artist who in his mid-thirties boasted, "Thank Heaven, I am *totally* divested of all desire for money, or ambition for wealth," spent most of his life chasing after both, willingly accepting the judgment of his contemporaries that the *content* of his gallery was its primary merit, certainly its chief claim on the government. An obituary notice in an English scientific journal concluded that while Catlin's paintings were "far from being unexceptionable as works of art," they were "of very great value as ethnological representations." With his collection hanging in the Smithsonian and praised by the likes of Louis Agassiz for its scientific importance, that seems to have been the judgment of the ages.[106]

But Catlin's artistic stock has risen in our century. His limitations are self-evident. Some of his portraits are perfunctory, slipshod. He was capa-

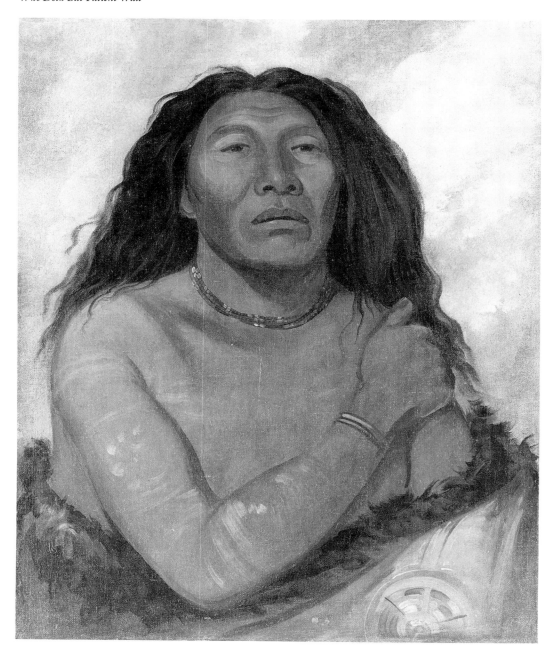

125. George Catlin, *Red Bear, a distinguished warrior* (1832). This splendid portrait of a Crow, unadorned, self-assured, and monumental, sums up Catlin's achievement. National Museum of American Art, Smithsonian Institution; gift of Mrs. Joseph Harrison, Jr.

ble of compressing the torso and limbs absurdly, as though the only consideration was to squeeze everything in, whatever the cost to anatomy. Sometimes he mounted small heads on elongated trunks. Legs seemed to sprout from stomachs; tiny arms folded across giant chests. There is a tendency to forgive Catlin such lapses. He was working under impossible conditions, at a killing pace, rushing to record what he saw. There is also a saving reassurance built into the body of his work, portraits in which his modeling of facial structure is sure, his brushstroke fluent, his colors elemental and rich. It is as though one is being reminded that Catlin could do much better if he chose to, or had the time to—as though his best paintings were the norm, his careless ones the exception, reflecting circumstances, not skill. Yet when Catlin did have time to polish, and ample reason to put his best foot forward—during his long years abroad, for example—the results were often a catalog of his weaknesses, devoid of color harmony, composition, and conviction. His group scenes had always been peopled with caricatures, leading Swiss artist Rudolph Friederich Kurz, who had gone West in 1846 to study in the same school of nature as Catlin, to accuse him of inconsistency: he extolled the Indians for their classic beauty yet painted grotesque caricatures. Kurz's verdict: "Yankee humbug!" But Catlin's best portraits retain their power to astonish. They show individuals, not merely exotics in colorful costumes. Catlin captured personality in a way the talented Karl Bodmer never did. Hairstyles and accessories aside, his faces are those of ordinary human beings, and this seems a substantial triumph for an artist so committed to romantic theory on the vanishing Indian.[107]

Twentieth-century eyes accustomed to experimentation with color and form and to admiration for naive artists, have been receptive to Catlin's work. In 1918, as American painters turned away from a war-torn Europe to concentrate on the native fact in their own Southwest, Edwin Swift Balch delivered a paper before the American Philosophical Society titled "The Art of George Catlin." Basing his judgment mainly on the cartoon collection, Balch concluded that Catlin "drew well; not academically but accurately," had a "splendid sense of proportions," "an inborn gift for composition," and the ability to convey "simplicity and a look of out of doors." His palette was "limited but complete." Balch undermined his case a bit at the end by reverting to Catlin's subject matter ("the paramount value of his pictures") but finished strongly: Catlin's lack of formal training, the naive or primitive quality of his work, its naturalness, make it unmistakably *his,* "a sure test that he had real underlying art powers." Balch's views are echoed to this day. When a historian in 1948 dismissed Catlin's paintings as "crude," "childlike," and aching with "technical incompetence," directors and curators from the Museum of Modern Art, the Brooklyn Museum, the Whitney Museum, and the Federal Art Project

rushed to the defense. Catlin was important "in any general view of the American tradition of painting" and "great in the field of his chosen subject matter." Given what Catlin had set out to accomplish in 1829, it seems he had succeeded. He might not be a great painter, but a century after he fled Louis-Philippe's collapsing France to begin his own collapse in England, members of America's artistic establishment had proclaimed him "a great painter of Indians," joining content and artistry in fitting epitaph.[108]

＊ ＊ ＊

When John Mix Stanley's *The Trial of Red Jacket* sold to the Buffalo Historical Society in 1948, one of Stanley's grandchildren remarked, "How curious I am as to what has sky rocketed interest in old Indian paintings." In his last catalog, published to accompany his New York exhibition in 1871, George Catlin had provided an answer. His paintings, he wrote, were made "from nature, in the Indians' countries," in the conviction of their "approaching extinction":

> It has been with that conviction, and without any assistance, Governmental or individual (but, on the contrary, discountenanced by both), that he was the first to commence a *pictorial history* of these people, and has devoted the best part of a long life in endeavoring to save from oblivion the types and customs of a numerous and purely American race, decimated and driven from their countries by civilization, and who will soon be known only in history.

His work would be the means of their preservation, posterity his grateful debtors. Denied patronage, he had still accomplished something that would endure. His valedictory could serve for a generation of writers and painters who had made the Indian their subject and founded, as a contemporary critic said, "*the* school of American Art."[109]

AAA: Archives of American Art (number refers to microfilm roll)

Bancroft: The Bancroft Library, University of California, Berkeley

Bartlett Papers: John R. Bartlett Papers, John Carter Brown Library, Brown University, Providence, Rhode Island

Donaldson, *Catlin Gallery:* Thomas Donaldson, *The George Catlin Indian Gallery in the U.S. National Museum (Smithsonian Inst.) with Memoir and Statistics, Annual Report, Smithsonian Institution, 1885,* Part 2 (Washington: GPO, 1886).

EGS: Ephraim George Squier

Freeman, "Schoolcraft": John Finley Freeman, "Henry Rowe Schoolcraft" (Ph.D. diss., Harvard University, 1959).

GC: George Catlin

Gilcrease: Thomas Gilcrease Institute of American History and Art, Tulsa, Oklahoma

GPO: Government Printing Office

HRS: Henry Rowe Schoolcraft

HRS Papers: Henry R. Schoolcraft Papers, Library of Congress (number refers to microfilm roll)

Huntington: The Huntington Library, San Marino, California

Information: Henry R. Schoolcraft, comp., *Information Respecting the History, Condition and Prospects of the Indian Tribes of the United States,* 6 vols. (Philadelphia: Lippincott, Grambo, 1851–57). The first volume had *Historical and Statistical* in front of the title; the last was retitled *History of the Indian Tribes of the United States: Their Present Condition and Prospects, and a Sketch of Their Ancient Status.*

JMS: John Mix Stanley

L&N: George Catlin, *Letters and Notes on the Manners, Customs, and Conditions of the North American Indians,* 2 vols. (London: Author, 1841).

LC: Library of Congress, Manuscripts Division

Letters: Marjorie Catlin Roehm, *The Letters of George Catlin and His Family: A Chronicle of the American West* (Berkeley: University of California Press, 1966).

Memoirs: Henry R. Schoolcraft, *Personal Memoirs of a Residence of Thirty Years with the Indian Tribes on the American Frontiers* (Philadelphia: Lippincott, Grambo, 1851).

NA, RG: National Archives, Record Group

NAR: North American Review

NI: Daily National Intelligencer (Washington, D.C.)

Niles': Niles' National Register

Notes Europe: George Catlin, *Catlin's Notes of Eight Years' Travels and Residence in Europe, with His North American Indian Collections,* 2 vols. (London: Author, 1848).

NYCA: New York Commercial Advertiser

NYHS: New-York Historical Society

NYPL: New York Public Library, Manuscripts Division

Reports: Reports of Explorations and Surveys, to Ascertain the Most Practicable and Economical Route for a Railroad from the Mississippi River to the Pacific Ocean, 12 vols. (Washington: Beverley Tucker et al., 1855–60).

Sanford Papers: Henry Shelton Sanford Papers, box 134, folder 7 (reel 90), Henry Shelton Sanford Memorial Library and Museum, Sanford, Florida

SE: Seth Eastman

SI: Smithsonian Institution

SIA: Smithsonian Institution Archives

Sibley Papers: Henry Hastings Sibley Papers, Minnesota Historical Society, St. Paul (number refers to microfilm roll)

Taliaferro Papers: Lawrence Taliaferro Papers, Minnesota Historical Society, St. Paul (number refers to microfilm roll)

Truettner, *Natural Man:* William H. Truettner, *The Natural Man Observed: A Study of Catlin's Indian Gallery* (Washington, D.C.: Smithsonian Institution Press, for the Amon Carter Museum of Western Art, Fort Worth, and the National Collection of Fine Arts, Smithsonian Institution, 1979).

PREFACE

1. GC to [George Moore, NYHS], [February 1872?], NYHS.

2. "Exploring Expedition to the South Seas," *Evening Star* (New York), July 8, 1836.

3. Edward Livingstone (1803), quoted in Lillian B. Miller, *Patrons and Patriotism: The Encouragement of the Fine Arts in the United States, 1790–1860* (Chicago: University of Chicago Press, 1966), p.95; *Niles'*, March 21, 1812, quoted in J. Meredith Neil, *Toward a National Taste: America's Quest for Aesthetic Independence* (Honolulu: University Press of Hawaii, 1975), p.89. See Neil, *Toward a National Taste,* chap.3; Miller, *Patrons and Patriotism,* parts 2–3; Neil Harris, *The Artist in American Society: The Formative Years, 1790–1860* (New York: George Braziller, 1966), pp.108–16, 261–82; and for the high-minded rhetoric that substituted for action, "American Artists" (March 3, 1859), *House Rep. No. 198,* 35th Cong., 2d sess.

4. "A Plea for the Fine Arts," *NI*, March 8, 1852.

5. *Cong. Globe,* 32d Cong., 1st sess., p. 2254 (August 19, 1852).

CHAPTER 1

1. GC, Yellow Stone, June 17, 1832, *NYCA*, July 24, 1832; Fort Gibson, Arkansas Territory, June 12, 1834, *NYCA*, July 23, 1834 (*L&N*, 2:37); Mouth of Yellow Stone, July 15, 1832, *NYCA*, October 20, 1832. The physical description of Catlin is based on William Harvey Miner, "George Catlin: A Short Memoir of the Man, with an Annotated Bibliography of His Writings: Part I— Memoir," *Literary Collector* 3 (October 1901): 23–27.

2. *L&N*, 1:3.

3. Timothy Pickering to Putnam Catlin and to John Calhoun, December 31, 1819, *Letters,* pp.426–29; Putnam Catlin to GC, March 26, 1821, AAA: 2136; to Abra Bradley, May 11, 1827, *Letters,* pp.24–26; and to

George and Clara Catlin, May 30, 1828, ibid., p.33. The biographical data here is drawn from Marjorie Catlin Roehm's introductory chapters in *Letters;* Truettner, *Natural Man,* chap.1; and family histories and genealogies, Catlin Family Papers, AAA: 3023.

4. *L&N*, 1:2; Putnam Catlin to GC, August 4, 1817, January 21, 1818, *Letters,* pp.16, 19–20. The importance of Catlin's youthful wilderness experiences to his mature development is a particular theme of Loren Wilson Hall, "Portrait of a Mind: A Psychological-Intellectual Biography of George Catlin" (Ph.D. diss., Emory University, 1987).

5. *L&N*, 1:2; GC to Theodore Burr Catlin, Sunday [September 1, 1839?], AAA: 2136.

6. Putnam Catlin to GC, March 26, 1821, AAA: 2136.

7. Benjamin Latrobe to D. W. Boudet, September 26, 1810, and to C. W. Peale, July 17, 1805, in J. Meredith Neil, *Toward a National Taste: America's Quest for Aesthetic Independence* (Honolulu: University Press of Hawaii, 1975), pp.126, 72; and Neil Harris, *The Artist in American Society: The Formative Years, 1790–1860* (New York: George Braziller, 1966), pp.108–9, 69–71.

8. Francis Hopkinson to GC, February 18, 1824, AAA: 2136; Thomas Collier to David L. Collier, 1824, quoted in Hall, "Portrait of a Mind," p.48; "References to George Catlin in Exhibition Catalogues of the Pennsylvania Academy of the Fine Arts—1821–1829," typescript, Pennsylvania Academy of Fine Arts Collection, AAA: P73. The academy's stature is assessed in Lillian B. Miller, *Patrons and Patriotism: The Encouragement of the Fine Arts in the United States, 1790–1860* (Chicago: University of Chicago Press, 1966), chap.9. See Harry B. Wehle, *American Miniatures, 1730–1850* (Garden City, N.Y.: Garden City Publishing Company, 1937), plate 35, pp.59–

60, for an assessment of one Catlin miniature.

9. GC to James B. Longacre, June 15, 1825, James Barton Longacre Papers, Library Company of Philadelphia; William Dunlap, *History of the Rise and Progress of the Arts of Design in the United States,* ed. William P. Campbell, 3 vols. (New York: Benjamin Blom, 1965 [1834]), 3:172; GC to Major Worth, March 29, 1828, Gratz Collection, AAA: P22; and Marilyn Anne Kindred, "The Army Officer Corps and the Arts: Artistic Patronage and Practice in America, 1820–85" (Ph.D. diss., University of Kansas, 1980), pp.118–22. Sully provided Catlin a reference when he went to London (Sully to J. Wright, June 12, 1839, AAA: 2136), and his work evidently influenced Catlin's own (Truettner, *Natural Man,* pp.81–82).

10. Eliza Dart to Mary Hartshorn, June 6, 1828, Catlin Family Papers, AAA: 3024; Putnam Catlin to George and Clara Catlin, May 30, 1828, *Letters,* p.34.

11. "An Ill-Fated Artist," *Rochester Daily Advertiser,* September 22, 1828, *Letters,* pp.430–31. Julius Catlin's West Point appointment and his attempts to make art a career are covered in ibid., pp.21–22, 31–32, 35–37. John Catlin, eight years Julius's junior, described him as "a distinguished miniature & Portrait Painter." John would die in 1834, at age twenty-two, the third of the Catlin brothers to die before reaching twenty-five. John Catlin's Album, 1832, Catlin Family Papers, AAA: 2707.

12. Thomas S. Cummings, *Historic Annals of the National Academy of Design . . . from 1825 to the Present Time* (Philadelphia: George W. Childs, 1865), p.33; Dunlap, *History,* p.172; Cummings, *Historic Annals,* p.80; Denon, "The Two Academies," *Evening Post,* May 17, 1828, reprinted in ibid., p.84; Dunlap, *History,* p.172;

Truettner, *Natural Man,* pp.14–15, 83. Dunlap softened his tone considerably after hearing Catlin lecture in 1837: his skill as an artist, he wrote, "is immeasurably advanced; and we hope to see, at his leisure, some great compositions from his pencil" ("Mr. Catlin's Lectures," *New-York Mirror,* 15[October 14, 1837]: 126).

13. *L&N,* 1:2–3.

14. Oliver W. Larkin, *Samuel F. B. Morse and American Democratic Art* (Boston: Little, Brown, 1954), pp.31–32; Harris, *Artist in American Society,* p.247; *Philadelphia Evening Post,* in *A Descriptive Catalogue of Catlin's Indian Collection* . . . (London: Author, 1848), p.72. See Harris, *Artist in American Society,* chap.9; and Lucille Wrubel Grindhammer, *Art and the Public: The Democratization of the Fine Arts in the United States, 1830–1860* (Stuttgart: J. B. Metzlersche, 1975), pp.2–3. The phrase "expectant capitalists" is Richard Hofstadter's, *The American Political Tradition and the Men Who Made It* (New York: Vintage Books, ca. 1948), p.57.

15. Truettner, *Natural Man,* pp.82–83, 86, 200–202, 216–17; and see Elizabeth McKinsey, *Niagara Falls: Icon of the American Sublime* (Cambridge: Cambridge University Press, 1985), pp.111–13.

16. Walt Whitman, "One's-self I Sing," in *Leaves of Grass and Selected Prose,* ed. Sculley Bradley (New York: Holt, Rinehart and Winston, 1949), p.1; and see John William Ward, *Andrew Jackson: Symbol for an Age* (New York: Oxford University Press, 1955), chap.1.

17. See John C. Ewers, *Artists of the Old West* (Garden City, N.Y.: Doubleday, 1965), chap.2; John Francis McDermott, "Samuel Seymour: Pioneer Artist of the Plains and the Rockies," in *Annual Report, SI, 1950* (Washington: GPO, 1951), pp.497–509; Jessie Poesch, *Titian Ramsay Peale, 1799–1885, and His Journals of the Wilkes Expedition,* Memoir 52 (Phila-

delphia: American Philosophical Society, 1961), pp.22–35; Richard H. Dillon, "Stephen Long's Great American Desert," *Montana, the Magazine of Western History* 18(Summer 1968): 58–74 (and for earlier usages, Terry L. Alford, "The West as a Desert in American Thought prior to Long's 1819–1820 Expedition," *Journal of the West* 8[October 1969]: 515–25); William H. Goetzmann, *Army Exploration in the American West, 1803–1863* (New Haven: Yale University Press, 1959).

18. For King, see Herman J. Viola, "Washington's First Museum: The Indian Office Collection of Thomas L. McKenney," *Smithsonian Journal of History* 3(Fall 1968): 1–18, and idem, *The Indian Legacy of Charles Bird King* (Washington: Smithsonian Institution Press and Doubleday, 1976); John C. Ewers, "Charles Bird King, Painter of Indian Visitors to the Capital," in *Annual Report, SI, 1953* (Washington: GPO, 1954), pp.463–73; Andrew J. Cosentino, *The Paintings of Charles Bird King (1785–1862)* (Washington: Smithsonian Institution Press for the National Collection of Fine Arts, 1977).

19. "Artists in Washington," *American Organ* (Washington, D.C.), undated clipping (ca. 1854), Stanley Scrapbook, p.44, AAA: OAM.

20. GC, Yellow Stone, June 17, 1832, *NYCA,* July 24, 1832.

21. GC to Peter B. Porter, February 22, 1829, Peter B. Porter Collection, Buffalo and Erie County Historical Society, Buffalo, N.Y.

22. For an elaboration of the ideas that follow, see Brian W. Dippie, *The Vanishing American: White Attitudes and U.S. Indian Policy* (Middletown, Conn.: Wesleyan University Press, 1982), parts 1–2.

23. "The American Aborigines," *Niles'* 15(November 14, 1818): 185.

24. William Tudor, Jr., "An Address Delivered to the Phi Beta Kappa Society at Their Anniversary Meeting at

Cambridge," NAR 2(November 1815): 19–20, 32.

25. John Bristed, *America and Her Resources* (1818), quoted in William Ellery Sedgwick, "The Materials for an American Literature: A Critical Problem of the Early Nineteenth Century," *Harvard Studies and Notes in Philology and Literature* 17(1935): 147; James Fenimore Cooper, *The Last of the Mohicans* (New York: Signet, 1962 [1826]), pp.119–20, 336; [Lewis Cass?], "North American Indians: Cursory Remarks . . . ," *U.S. Literary Review and Literary Gazette* 2(April 1827): 45; Cooper, *Last of the Mohicans,* p.414; *American Quarterly Review* 16(December 1834), quoted in Geoffrey Rans, "Inaudible Man: The Indian in the Theory and Practice of White Fiction," *Canadian Review of American Studies* 7(Fall 1977): 105. See G. Harrison Orians, *The Cult of the Vanishing American: A Century View, 1834–1934* (Toledo: H. J. Chittenden, 1934); Benjamin T. Spencer, *The Quest for Nationality: An American Literary Campaign* (Syracuse: Syracuse University Press, 1957), pp.201–4; Burl D. Grose, "'Here Come the Indians': An Historical Study of the Representations of the Native American upon the North American Stage, 1808–1969" (Ph.D. diss., University of Missouri—Columbia, 1979), chaps.3–4; and Priscilla F. Sears, *A Pillar of Fire to Follow: American Indian Dramas, 1808–1859* (Bowling Green, Ohio: Bowling Green University Popular Press, 1982).

26. L&N, 1:5–6.

27. John Vanderlyn to Thomas Sully, August 6, 1820, quoted in Miller, *Patrons and Patriotism,* p.246, n.5; John Trumbull to Mrs. Trumbull, February 10, 1819, quoted in Harris, *Artist in American Society,* p.72; Truettner, *Natural Man,* p.86; and see Irma B. Jaffe, *John Trumbull: Patriot-Artist of the American Revolution* (Boston: New York Graphic Society, 1975), chap.14, for Trumbull's

commission; Viola, *Indian Legacy of Charles Bird King,* pp.41–42; *A Catalogue of the Collection of American Paintings in the Corcoran Art Gallery,* vol.1, *Painters Born before 1850* (Washington: Corcoran Gallery of Art, 1966), pp.52–53.

28. Putnam Catlin to GC, February 15, 1830, *Letters,* p.46.

29. Wendy Wick Reaves, "Portraits for Every Parlor: Albert Newsam and American Portrait Lithography," in *American Portrait Prints: Proceedings of the Tenth Annual Print Conference,* ed. Wendy Wick Reaves (Charlottesville: University Press of Virginia for the National Portrait Gallery, Smithsonian Institution, 1984), p.85; GC, Subscription Book (prospectus dated March 25, 1825, Litchfield), AAA: 2136; GC to General Lafayette, August 1, 1830, Cornell University Library, Department of Rare Books, Ithaca, N.Y. See Fred Somkin, *Unquiet Eagle: Memory and Desire in the Idea of American Freedom, 1815–1860* (Ithaca: Cornell University Press, 1967), chap.4. Copies of Pickering and Reeve are in the Mary Bartlett Cowdrey File, AAA: NY59–29; the Clinton is in William L. Stone, *Narrative of the Festivities Observed in Honor of the Completion of the Grand Erie Canal* (New York, 1825), and its history can be traced in four Catlin letters to the engraver, James B. Longacre, Longacre Papers, Library Company of Philadelphia.

30. GC to General Lafayette, May 4, 1832, June 20, 1833, Cornell. Similarly, in his instructions to the engraver of his DeWitt Clinton miniature, Catlin conceded that Clinton's hands required correction but was insistent that the face be rendered as he showed it, with all the "strength" of the original preserved. GC to James B. Longacre, June 15, July 5, 1825, Longacre Papers, Library Company of Philadelphia.

31. *Evening Star* (New York), February 24, 1837. John Vanderlyn, Henry Inman, John G. Chapman, and Robert

Weir were the successful candidates, though Inman did not live to complete his commission. Miller, *Patrons and Patriotism,* pp.51–57.

32. Bernhard, Duke of Saxe-Weimar-Eisenach, *Travels through North America during the Years 1825 and 1826* (1828), quoted in John C. Ewers, "William Clark's Indian Museum in St. Louis, 1816–1838," in *A Cabinet of Curiosities: Five Episodes in the Evolution of American Museums,* ed. Whitfield J. Bell, Jr. et al. (Charlottesville: University Press of Virginia, 1967), p.58. Ewers is my source for this paragraph.

33. Truettner, *Natural Man,* pp.16–20; and see chap.2, pp.61–63 below.

34. McKinsey, *Niagara Falls,* pp.72–74, 80, 82, 141–44 (two of Catlin's views were probably painted later, presumably from sketches made in 1827); *Missouri Republican* (St. Louis), July 10, 1832. See William E. Lass, *A History of Steamboating on the Upper Missouri* (Lincoln: University of Nebraska Press, 1962), pp.9–11; and Donald Jackson, *Voyages of the Steamboat Yellow Stone* (New York: Ticknor and Fields, 1985).

35. GC, Mouth of Yellow Stone, July 15, 1832, *NYCA,* October 20, 1832; GC to Mr. Munn, February 18, 1833, Knox College, Archives and Manuscripts Collections, Galesburg, Illinois.

36. John C. Ewers, "George Catlin: Painter of Indians of the West," in *Annual Report, SI, 1955* (Washington: GPO, 1955), p.493; and Truettner, *Natural Man,* p.23; GC, St. Louis, —— 4th, 1833, *NYCA,* June 20, 1833; GC to J. H. Hook, December 20, 1832, NA, RG 92: Quartermaster Consolidated file, Records of the Office of the Quartermaster General, entry 225. Catlin's newspaper letter of the fourth could not have been written later than January 4, 1833, about the time of his departure for Cincinnati. He summarized the contents of this yet unpublished letter in GC to [Pierre

Chouteau, Jr.], January 29, 1833, Chouteau Maffitt Collection, Missouri Historical Society, St. Louis.

37. GC to [Chouteau], January 29, 1833; GC to Mr. Munn, February 18, 1833, Knox College; Certificates, account books, receipts, and miscellaneous financial material, AAA: 2136; *Pittsburgh Gazette,* April 23, 1833, quoted in Loyd Haberly, *Pursuit of the Horizon: A Life of George Catlin, Painter and Recorder of the American Indian* (New York: Macmillan, 1948), p.80.

38. *Catalogue Descriptive and Instructive of Catlin's Indian Cartoons* (New York: Baker and Godwin, 1871), p.90; Dale L. Morgan, quoted in *Letters,* pp.55–57; GC, St. Louis, —— 4th, 1833, *NYCA,* June 20, 1833; GC to Thomas L. Smith, September 4, 1833, NA, RG 108: Records of the Headquarters of the Army, Letters Received; *Illustrated London News* 30, no.853 (April 11, 1857): 330, 332; *Catalogue Descriptive and Instructive* (1871), no.412, no.48–49 annotated copy in the Missouri Historical Society, St. Louis; Harold McCracken, *George Catlin and the Old Frontier* (New York: Dial Press, 1959), p.133.

39. "Mr. Catlin's Gallery," *Cincinnati Daily Gazette,* November 15, 1833, quoted in Haberly, *Pursuit of the Horizon,* p.84.

40. [James Hall], "Mr. Catlin's Exhibition of Indian Portraits," *Western Monthly Magazine* 1 (November 1833): 535–38.

41. GC to J. H. Hook, December 20, 1832, NA.

42. See Alvin M. Josephy, Jr., *The Artist Was a Young Man: The Life Story of Peter Rindisbacher* (Fort Worth, Texas: Amon Carter Museum, 1970). The quotation is from a letter in the St. Louis *Beacon,* December 12, 1829, in ibid., p.73.

43. Ibid., pp.78–80; "Black Hawk," *Missouri Republican* (St. Louis), May 21, 1833, from the Georgetown, D.C., *Gazette.* See "Rindisbacher, the Painter," *Neue Zürcher*

Zeitung, April 13, 14, 1870, translated and edited in Michel Benisovich and Anna M. Heilmaier, "Peter Rindisbacher, Swiss Artist," *Minnesota History* 32(Autumn 1951): 155–62; and Grace Lee Nute, "Rindisbacher's Minnesota Water Colors," *Minnesota History* 20(March 1939): 54–57.

44. Washington Irving, *The Adventures of Captain Bonneville,* ed. Robert A. Rees and Alan Sandy (Boston: Twayne, 1977), p.5; GC to J. H. Hook, December 20, 1832, NA. Irving visited Hook in early 1836; his book included Bonneville's original dedication to Hook. See John Francis McDermott, "Washington Irving and the Journal of Captain Bonneville," *Mississippi Valley Historical Review* 43(December 1956): 464–66.

45. GC to Thomas L. Smith, September 4, 1833; Smith to Lewis Cass, October 15, 1833, NA, RG 108: Letters Received, Records of the Headquarters of the Army. For the army's role in Indian affairs and the establishment of the dragoons, see Francis Paul Prucha, *The Sword of the Republic: The United States Army on the Frontier, 1783–1846* (New York: Macmillan, 1969), chaps.10, 12.

46. GC, Mouth of Yellow Stone, July 15, 1832, *NYCA,* October 20, 1832; "From the 'Far West,'" *Missouri Republican* (St. Louis), July 16, 1833. See Charles E. Rosenberg, *The Cholera Years: The United States in 1832, 1849, and 1866* (Chicago: University of Chicago Press, 1962), chap.1; Prucha, *Sword of the Republic,* pp.225–26, 230–31; and Frank B. Woodford, *Lewis Cass: The Last Jeffersonian* (New Brunswick, N.J.: Rutgers University Press, 1950), pp.176–77.

47. GC, Fort Gibson (Arkansas Territory), June 12, 1834, *NYCA,* July 23, 1834; GC to Dudley S. Gregory, June 19, 1834, AAA: 2136; GC, Fort Gibson (Arkansas Territory), June 12, 1834.

48. GC, Mouth of False Washita, Red River, July 14, 1834, *NYCA,* August 22, 1834; GC to Dudley S. Gregory, 80 mi. above the mouth of False Washita on Red River [ca. July 12, 1834], AAA: 2136; GC, Dragoon Camp, on the head of the Canadian, August 5, 1834, *NYCA,* October 1, 1834.

49. T. B. Wheelock, "Journal of Colonel Dodge's Expedition from Fort Gibson to the Pawnee Pict Village" (August 26, 1834), *House Exec. Doc. No. 2,* 23d Cong., 2d sess., p.77.

50. GC, Fort Gibson, August 18, 1834, *NYCA,* October 1, 1834; Wheelock, "Journal," pp.87–88; GC, Fort Gibson, September 8, 1834, *NYCA,* October 20, 1834. This and Catlin's letter of June 12 were reprinted entire in [James Hildreth], *Dragoon Campaigns to the Rocky Mountains . . .* (New York: Wiley and Long, 1836), pp.121–27, 183–89, further broadcasting his views.

51. *L&N,* 2:87–95.

52. Polly Catlin to Francis Catlin, February 5, 1835, *Letters,* pp.78–79; *L&N,* 2:33–35. James Catlin was appointed cashier of the Pensacola Bank by Dudley Gregory in 1833. See *Letters,* p.67.

53. Henry S. Spalding to David Greene, March 2, 1836, in Clifford Merrill Drury, *Henry Harman Spalding* (Caldwell, Idaho: Caxton Printers, 1936), p.119; and *L&N,* 2:109–10; GC, St. Peters', Upper Mississippi, August 14, *NYCA,* December 26, 1835; and *L&N,* 2:130.

54. GC, St. Peters', Upper Mississippi, August 14; Lawrence Taliaferro Journal, 11:104, 108 (entries for June 24 and 29, 1835), Taliaferro Papers: 3. This paragraph is based on Taliaferro's journal for the period of Catlin's visit, and Mrs. R. L., "Mrs. Catlin, the Indian Traveller" (ca. May 1840), Catlin Papers, Bancroft, folder 161.5, which also mentions that Clara Catlin kept a journal of her trip. Details of the entertainment staged for the Catlins are in GC, St. Peters', Upper Mississippi, August 14.

55. *L&N*, 2:141–55.

56. G. W. Featherstonhaugh, *A Canoe Voyage up the Minnay Sotor . . .*, 2 vols. (London: Richard Bentley, 1847), 2:43–51; GC, "Indian Scenes," *Evening Star* (New York), July 1, 1836; Putnam Catlin to George and Clara Catlin, December 26, 1835, *Letters,* pp.82–84. Though hypercritical, Featherstonhaugh admired Catlin. His companion at the time was another Englishman, Charles A. Murray, who would be of assistance to Catlin in London but did not mention the artist in his own account of his western wanderings, *Travels in North America during the Years 1834, 1835, & 1836,* 2 vols. (London: Richard Bentley, 1839).

57. Receipt for rent of former Baptist Church, Buffalo, August 1, 1836, for $100; invoice, T. & M. Butler, Buffalo, January 3, 1838, for $10 owing since July 10, 1836, for printing of one thousand show bills; invoice, Salisbury, Manchester & Co., Buffalo, July 6, 1836, for $5.38 for advertisements in the *Commercial Advertiser,* July 5 to August 8, 1836 (AAA: 2136); "Catlyn Again.—The Pipe Stone Quarry of the Indians," *Evening Star* (New York), July 23, 1836; Polly Catlin to Francis Catlin, September 11, 1836, *Letters,* p.95.

58. *L&N*, 2:163, 166; 1:234; GC to Charles T. Jackson, "Account of a Journey to the Côteau des Prairies, with a description of the Red Pipe Stone Quarry and Granite Bowlders Found There," *American Journal of Science and Arts* 38, no.1 (1839): 138–39 (conveniently reprinted in John C. Ewers, ed., *Indian Art in Pipestone: George Catlin's Portfolio in the British Museum* [Washington: British Museum Publications and Smithsonian Institution Press, 1979], appendix); *L&N*, 2:164.

59. Margaret Fuller Ossoli, *Summer on the Lakes* ed. Arthur B. Fuller (New York: Haskell House, 1970), pp.22–23, recounting an 1843 tour. Also see Louis Agassiz and J. Elliot Cabot, *Lake Superior: Its Physical Character, Vegetation and Animals . . .* (Boston: Gould, Kendall and Lincoln, 1850), pp.18–22.

60. GC to Henry and Francis Catlin, August 1, 1836, *Letters,* pp.92–93; [Hercules S.] Dousman to Henry H. Sibley, August 9, 1836, Sibley Papers: 1; Lawrence Taliaferro Journals, 14:152–53, 155, 163 (entries for August 17, 21, September 5, 1836), Taliaferro Papers: 3.

61. *L&N*, 2:173–75. Also GC, Red Pipe Stone, on the Coteau du Prairie, September 1836, *Missouri Republican* (St. Louis), November 22, 1836, from the *NYCA;* and GC, Prairie Du Chien, October 1, 1836, ibid., November 18, 1836, from the Buffalo *Journal.* The original of the second letter, addressed to F. Stanley, is in the NYHS.

62. GC, "The Dighton Rock," *New-York Mirror* 16(December 29, 1838): 213; *L&N*, 2:202, 205–6.

63. GC, Red Pipe Stone, on the Coteau du Prairie, September 1836 (*L&N*, 2:164–65, 206); GC to Francis Catlin, December 29, 1836, *Letters,* p.102.

64. *L&N*, 2:155. See Henry Adams, *The United States in 1800* (Ithaca: Cornell University Press, Great Seal Books, 1955 [1889]), pp.1–2; and Glyndon G. Van Deusen, *The Jacksonian Era, 1828–1848* (New York: Harper and Row, 1959), p.6.

65. [William Rudolph Smith], *Observations on the Wisconsin Territory: Chiefly on That Part Called the "Wisconsin Land District"* (Philadelphia: E. L. Carey and A. Hart, 1838), p.15. See Alice E. Smith, *The History of Wisconsin,* vol.1, *From Exploration to Statehood* (Madison: State Historical Society of Wisconsin, 1973), chap.8; Robert C. Nesbit, *Wisconsin: A History* (Madison: University of Wisconsin Press, 1973), pp.122–25; Roy M. Robbins, *Our Landed Heritage: The Public Domain, 1776–1936* (Princeton: Princeton University Press, 1942), chap.4; and Malcolm J. Rohrbough, *The Land*

Office Business: The Settlement and Administration of American Public Lands, 1789–1837 (New York: Oxford University Press, 1968), chap. 11.

66. Lawrence Taliaferro Journal, 14:167 (entry for September 7, 1836), Taliaferro Papers: 3; Charles J. Kappler, comp. and ed., *Indian Affairs: Laws and Treaties*, 2 vols. (Washington: GPO, 1904), 2:473–78; GC, Rock Island (Upper Mississippi), September 25, 1836, *Missouri Republican* (St. Louis), December 8, 1836, from the *NYCA*. See William T. Hagan, *The Sac and Fox Indians* (Norman: University of Oklahoma Press, 1958), pp. 209–13; and *L&N*, 2:209–16.

67. Kappler, *Laws and Treaties*, 2:349–51; GC, Rock Island (Upper Mississippi), September 25, 1836 (*L&N*, 2:217). See Donald Jackson, ed., *Black Hawk: An Autobiography* (Urbana: University of Illinois Press, 1964); and Cecil Eby, *"That Disgraceful Affair," the Black Hawk War* (New York: W. W. Norton, 1973).

68. "Arrival of the Indians from Washington," *Morning Herald* (New York), October 26, 1837. See also John Francis McDermott, "Another Coriolanus: Portraits of Keokuk, Chief of the Sac and Fox," *Antiques* 54 (August 1948): 98–100. Catlin retold the story of his New York meeting with Keokuk in *L&N*, 2:212–13, characteristically misdating it 1838, and Philip Hone recorded his impressions of both Keokuk and Black Hawk, whom he met on October 26, in Bayard Tuckerman, ed., *The Diary of Philip Hone, 1828–1851*, 2 vols. (New York: Dodd, Mead, 1889), 1:275–76. The treaty, signed October 21, 1837, is in Kappler, *Laws and Treaties*, 2:495–96.

69. GC, Rock Island (Upper Mississippi), September 25, 1836 (*L&N*, 2:217); Polly Catlin to Francis Catlin, November 25, 1836, *Letters*, p. 98; Putnam Catlin to Francis Catlin, November 25, 1836, *Letters*,

p. 97. Catlin was "imprisoned" in Utica in January when the closing of navigation stopped him short of Albany and New York. GC to Dr. Beck, January 14, 1837, NYPL.

CHAPTER 2

1. HRS to Evert Duyckinck, May 5, 1853 [1854?], HRS Papers: 14.
2. *Memoirs*, p. 87.
3. Ibid., p. 109 (July 31, 1822).
4. See Vernon Kinietz, "Schoolcraft's Manuscript Magazines," *Papers of the Bibliographical Society of America* 35, no. 2 (1941): 151–54; *Memoirs*, pp. 184–86, 189, 255, 276–77; Freeman, "Schoolcraft," pp. 85, 95–98, 105–12. "My only object is to 'dig' and to 'collect materials,'" Schoolcraft wrote Cass on October 22, 1822. "The building, the plan and the ornaments of the edifice must all be your own" (p. 85). A few years later he was still attending to "some literary commissions of my friend Cass" (HRS to Jane J. Schoolcraft, January 28, 1825, bound in with copy of *Information*, vol. 1, Public Archives of British Columbia, Victoria, B.C.). His *Narrative Journal*, appropriately, Schoolcraft dedicated to his first patron, John C. Calhoun, "as a proof of my anxiety to be serviceable in the station occupied."
5. HRS to Jared Sparks, October 13, 1829, in Herbert B. Adams, *The Life and Writings of Jared Sparks, Comprising Selections from His Journals and Correspondence*, 2 vols. (Freeport, N.Y.: Books for Libraries Press, 1970 [1893]), 1:279–82; also, *Memoirs*, p. 327 (entry for August 29, 1829). For Catlin and Sparks, GC to Sir Thomas Phillipps, Thursday [October 29, 1840], Gilcrease. The relationship involved an exchange of favors—see GC to Jared Sparks, [November 3, 1840], May 24, 1841, Harvard University Library, Cambridge, copies in Catlin Papers, Bancroft, folder 177.
6. [Lewis Cass], "Structure of the In-

dian Languages," NAR 26(April 1828): 366 (Schoolcraft admired this line and worked several variations on it); *Memoirs,* pp.89 (and 165); 202–3 (December 5, 1824); 331 (January 26, 1830); 396 (July 22, 1831). The 1823 pamphlet combined questionnaires that Cass circulated as early as 1821. See Elizabeth Gaspar Brown, "Lewis Cass and the American Indian," *Michigan History* 37(September 1953): 287–90, an uncritical discussion; and for a sampling of the materials collected, William N. Fenton, ed., "Answers to Governor Cass's Questions by Jacob Jameson, a Seneca (ca. 1821–1825)," *Ethnohistory* 16(Spring 1969): 113–39, and idem, "A Further Note on Jacob Jameson's Answers to the Lewis Cass Questionnaire," *Ethnohistory,* 17(Winter–Spring 1970): 91–92. Cass maintained an interest in the Indian—see, for example, his "Aboriginal Structures," NAR 51(October 1840): 396–433—but after 1830 it was casual.

7. *Memoirs,* p.488 (July 26, 1834); John G. Palfrey to HRS, September 26, 1836, HRS Papers: 25; *Memoirs,* pp.542–43; HRS to Jane J. Schoolcraft, December 19, 1835, HRS Papers: 23; *Memoirs,* p.276.

8. Original certificates, signed by James Schoolcraft, AAA: 2136; HRS to GC, February 28, 1853, HRS Papers: 14; *L&N,* 2:161. Also see Clara B. Catlin to HRS, June 22 [1842], HRS Papers: 9, which establishes that Catlin had met Jane J. Schoolcraft; likely this was in 1836, though he may have met her even earlier, since he painted a portrait of her mother, Mrs. John Johnston, about 1828. See Marie Hewett, "Pictorial Reporter: George Catlin in Western New York," *Niagara Frontier* 17(Winter 1970): 102–3. By the same token, this portrait could also mean an earlier meeting between Catlin and Schoolcraft.

9. HRS to GC, November 12, 1836,

HRS Papers: 26. Schoolcraft's certificate was also reprinted in *L&N,* 1:12. While the language is close to that in the letter, the odd title—Indian agent for Wisconsin Territory—suggests that the certificate may have dated from Catlin's July visit, before Schoolcraft began styling himself superintendent of Indian affairs in Wisconsin. He received orders from the War Department (dated July 2) on July 18 conferring on him "the duties of superintendent of Indian Affairs in Michigan, in addition to those of agent at this [Michilimackinac] post" (HRS to Lewis Cass, July 18, 1836, HRS Papers: 25; also, *Memoirs,* p.541).

10. HRS to Jane J. Schoolcraft, May 16, 1836, HRS Papers: 24; *Memoirs,* pp.534–36 (March 28, 1836); *Information,* 4:188–89; HRS to Jane J. Schoolcraft, March 28, 1836, HRS Papers: 24. The Treaties are in Charles J. Kappler, comp. and ed., *Indian Affairs: Laws and Treaties,* 2 vols. (Washington: GPO, 1904), 2:450–56, 461–62. Schoolcraft also concluded a third treaty, with the Saginaw band of Chippewas on May 21, 1836, but it failed to win Senate ratification. All his activities, drafts, and so on, are fully covered in HRS Papers: 24.

11. GC, Rock Island (Upper Mississippi), September 25, 1836, *Missouri Republican* (St. Louis), December 8, 1836, from NYCA (*L&N,* 2:161, 207); *Memoirs,* pp.543–44 (September 28, 1836); Freeman, "Schoolcraft," pp.183–87. Schoolcraft used the funds he acquired through his wife to speculate in western lands and quarreled with his brother James over his dealings. See HRS Papers: 24, 25, 26.

12. *Memoirs,* pp.652, 654 (June 21, 1839); *New York Morning News* 1, no.99[1844], HRS Papers: 63.

13. *Memoirs,* pp.520, 522 (August, September 15, 1835); William Cullen Bryant to HRS, February 14, 1852, HRS Papers: 13. See Frank Smith, "Schoolcraft, Bryant, and Poetic

Fame," *American Literature* 5(May 1933): 170–72.

14. GC, Mandan Village, August 20, 1832, *NYCA*, February 20, 1833 (*L&N*, 2:3–4); Margaret Fuller to Beethoven, November 25, 1843, in Perry Miller, ed., *The Transcendentalists: An Anthology* (Cambridge: Harvard University Press, 1950), p.337. Loren Wilson Hall, "Portrait of a Mind: A Psychological-Intellectual Biography of George Catlin" (Ph.D. diss., Emory University, 1987), p.63, dismisses such passages in Catlin's work as "tritely poetic" and self-conscious, learned responses rather than natural ones. Either way, they were central to his intellectual experience, or understanding, of nature.

15. HRS to Jared Sparks, October 13, 1829, in Adams, *Life and Writings of Jared Sparks*, 1:280–81; [HRS], "Our Indian Policy," *United States Magazine, and Democratic Review* 14(February, 1844): 171, 169.

16. Crèvecoeur, quoted in Roderick Nash, *Wilderness and the American Mind* (New Haven: Yale University Press, 1967), pp.28–29, the most compelling work on the theme; Melville, quoted in Leo Marx, *The Machine in the Garden: Technology and the Pastoral Ideal in America* (New York: Oxford University Press, 1964), pp.282 ff., which fully explores the implications of Melville's question; GC, St. Louis, ——— 4, 1833, *NYCA*, June 20, 1833 (*L&N*, 1:59).

17. *Information*, 6:27–28; HRS, "Our Indian Policy," pp.169, 171. This point is developed in a speculative fashion in John Finley Freeman, "Religion and Personality in the Anthropology of Henry Schoolcraft," *Journal of the History of the Behavioral Sciences* 1(October 1965): 302–7.

18. GC, Mandan Village, August 20, 1832, *NYCA*, February 20, 1833; and Mouth of Yellow Stone, July 15, 1832, ibid., October 20, 1832; *L&N*, 1:9; 2:238; HRS, "Our Indian Policy," p.169.

19. *L&N*, 1:16; 2:1, 36–37, 84, 87, 141, 149; GC, Fort Gibson (Arkansas Territory), June 12, 1834, *NYCA*, July 23, 1834 (*L&N*, 1:38); *L&N*, 2:26, 249; *Memoirs*, p.629 (December 31, 1838); *L&N*, 2:225.

20. GC to Pierre Chouteau, Jr., January 29, 1833, P. Chouteau Maffitt Collection, Missouri Historical Society, St. Louis. All but the first paragraph of this letter is printed in Annie Heloise Abel, ed., *Chardon's Journal at Fort Clark, 1834–1839* (Freeport, N.Y.: Books for Libraries Press, 1970 [1932]), pp.222–23, n.74.

21. GC, St. Louis, ——— 4th, 1833, *NYCA*, June 20, 1833.

22. GC to [William Renshaw or John B. Sarpy], March 20, 1834, Chouteau Collection, Missouri Historical Society, St. Louis; *L&N*, 2:29–30; GC, Fort Gibson, September 8, 1834, *NYCA*, October 20, 1834 (*L&N*, 2:26–27). For a brief discussion of the army's responsibilities in enforcing the ban, see Francis Paul Prucha, *The Sword of the Republic: The United States Army on the Frontier, 1783–1846* (New York: Macmillan, 1969), chap.10.

23. John J. Audubon to My Dearest Friends, June 13, 1843, in John Francis McDermott, ed., *Audubon in the West* (Norman: University of Oklahoma Press, 1965), p.116; Marie R. Audubon, ed., *Audubon and His Journals*, 2 vols. (New York: Charles Scribner's Sons, 1897), 2:97 (entry for June 11, 1843).

24. "Catlin's Indian Gallery," *Morning Herald* (New York), November 28, 1837. See also [James Hall], "Mr. Catlin's Exhibition of Indian Portraits," *Western Monthly Magazine* 1(November 1833): 537; and the letter from Catlin responding to an article first published in a Philadelphia paper praising Audubon at his expense, "Mr. Catlin's Gallery," *Cincinnati Daily Gazette*, November 15, 1833, in Loyd Haberly, *Pursuit of the Horizon: A Life of George Catlin, Painter and Recorder of the American Indian* (New

York: Macmillan, 1948), pp.83–84. For Audubon's resentment see Donald Culross Peattie, ed., *Audubon's America: The Narratives and Experiences of John James Audubon* (Boston: Houghton Mifflin, 1940), p.275. His spitefulness is evident in comparing his comments on Catlin with those of a companion, Edward Harris, who was critical but balanced: John Francis McDermott, ed., *Up the Missouri with Audubon: The Journal of Edward Harris* (Norman: University of Oklahoma Press, 1951), pp.26, 30, 90, 91–93, 139, 158, 173.

25. Audubon, *Audubon and His Journals,* 2:109 (entry for July 22, 1843), p.180. For the American Fur Company's effort to "build a better public image" in the 1840s, see John E. Sunder, *The Fur Trade on the Upper Missouri, 1840–1865* (Norman: University of Oklahoma Press, 1965), pp.24–25; for Audubon's special treatment, pp.64–68; and for some indication of the extent of the American Fur Company's involvement in the liquor traffic in Indian country, Abel, *Chardon's Journal,* pp.223–25, nn.76–77.

26. Margaret Fuller Ossoli, *Summer on the Lakes,* ed. Arthur B. Fuller (New York: Haskell House, 1970), p.23 (entry dated June 20, 1843). Fuller's poem "Governor Everett Receiving the Indian Chiefs, November, 1837"—inspired by the Sacs and Foxes' visit to the East—was steeped in vanishing Indian sentiment (ibid., p.91):

His stately form shall soon be seen no
 more
Through all his father's land, the
 Atlantic shore;
Beneath the sun, to us so kind, they
 melt,
More heavily each day our rule is felt.
The tale is old.—we do as mortals must:
Might makes right here, but God and
 Time are just.

It is possible that a visit to Catlin's gallery in Boston first kindled Fuller's interest in the Indian. See

Madeleine B. Stern, *The Life of Margaret Fuller* (New York: Haskell House, 1968 [1942]), pp.196, 266. Ralph Waldo Emerson and Walt Whitman also admired Catlin's work.

27. Ossoli, *Summer on the Lakes,* pp.21, 24, 89. Schoolcraft did not allow the slight to pass unchallenged. Miss Fuller had criticized some of his "Indian publications," he wrote, but "knew nothing on that head" (HRS to Evert Duyckinck, May 5, 1853 [1854?], HRS Papers: 14). *Summer on the Lakes* indicates that Fuller met and conversed with Schoolcraft's wife in 1843 and probably met him as well. Her views were shared by some contemporaries: W. J. S., "Traits of Indian Character," *New-York Mirror* 18(July 4, 1840): 12–14.

28. Account for July 20 to August 15, 1832, P. Chouteau Maffitt Collection, Missouri Historical Society, St. Louis; receipt, including payment for earlier charges at Ft. Union, for a total of $54.51, AAA: 2136; *L&N,* 2:50, 224; also, 1:9–10.

29. William Dunlap, "Mr. Catlin's Lectures," *New-York Mirror* 15(October 14, 1837): 126. The account that follows is based on Catlin's first published version of the Wi-jun-jon story, datelined Red Pipe Stone, Côteau des Prairies, September 3, 1836, but published in *NYCA,* September 30, 1837. According to John C. Ewers, the name should be rendered Ah-jon-jon, The Light. See "When The Light Shone in Washington," in *Indian Life on the Upper Missouri* (Norman: University of Oklahoma Press, 1968), pp.75–90.

30. Ossoli, *Summer on the Lakes,* pp.100, 89.

31. Clara Catlin to Putnam Catlin, October 29, 1840; GC to Francis Catlin, May 18, 1844, *Letters,* pp.196, 289.

32. *House Journal,* 25th Cong., 2d sess., p.974 (May 28, 1838); *Catalogue of Catlin's Indian Gallery of Portraits, Landscapes, Manners and Customs, Costumes, &c. &c.* (New York: Piercy

and Reed, 1837), p.36. The same catalog was reprinted in 1838, slightly enlarged. I have used a copy of the 1837 catalog in AAA: 2137 and a copy of the 1838 catalog in the Boston Public Library except where otherwise indicated. Catlin's father deemed Webster and Clay "the two best characters in the Union" (Putnam Catlin to GC, May 20, 1840, *Letters,* pp.167–68). Webster viewed the collection on December 6, 1837, as recorded in the diary of Philip Hone (Truettner, *Natural Man,* p.36), and Catlin used the occasion (the mayor and aldermen of New York City were also in attendance) to attract other guests to see his paintings—GC to George P. Morris, [1837], Dawes Memorial Library, Marietta College, Marietta, Ohio.

33. *House Journal,* 25th Cong., 3d sess., pp.518–19 (February 11, 1839); GC to Joel R. Poinsett, [February] 15, [1839], Poinsett Papers, Historical Society of Pennsylvania, AAA: P 29.

34. GC to Peter B. Porter, February 22, 1829, Buffalo and Erie County Historical Society, Buffalo, N.Y.; GC, "The North Americans in the middle of the Nineteenth Century . . ." [Brussels, 1868], preface, p.3, original manuscript in the Huntington Library, San Marino, Calif.

35. "Catlin's Letters," *New York Review* 19(January 1842): 229–30; *Philadelphia Saturday Courier,* in *A Descriptive Catalogue of Catlin's Indian Collection, Containing Portraits, Landscapes, Costumes, &c.* (London: Author, 1848), p.76; Putnam Catlin to Francis Catlin, May 4, 1838, *Letters,* pp.129–30.

36. "Catlin's Indian Gallery," *Morning Herald* (New York), November 28, 1837; also "Catlin's Lectures," *New-York Mirror* 15(October 7, 1837): 119; "Catlin's Indian Gallery," *Niles'* 55(November 10, 1838): 164; and the extracts from the New York *Evening Star* and the *United States Gazette,* in *Descriptive Catalogue of Catlin's Indian Collection* (1848), pp.73–74. To revive interest in his

exhibition, Catlin on December 11 included a printed notice in his catalog announcing his intention to close in a "few days" and, in a "few months," take his collection to Europe. See *Catalogue of Catlin's Indian Gallery of Portraits* (1837), copy in the Montana Historical Society, Helena.

37. Henry Clay to Earl Selkirk, July 3, 1838, AAA: 2136; S. E. Spring Rice to George Adlard, August 10, 1838, in *Niles'* 55(November 10, 1838): 164; GC to [George Adlard], November 12, 1838, British Museum, London, Add. no.27, 952, folder 176 (Adlard wrote the Lords of the Treasury on Catlin's behalf on May 7 and received the reply of August 10 in November); "Foreign Correspondence" (New York, June 7, 1839), *Athenaeum,* no.609 (June 22, 1839): 485; GC to Alexandre Vattemare, November 24, 1839, Indiana Historical Society, Indianapolis.

38. GC to Joel R. Poinsett, November 24, 1839, Poinsett Papers, Historical Society of Pennsylvania, AAA: P 29.

39. GC to his parents, June 29, 1840, *Letters,* p.173.

40. Prosper Wetmore (1848), quoted in Lucille Wrubel Grindhammer, *Art and the Public: The Democratization of the Fine Arts in the United States, 1830–1860* (Stuttgart: J. B. Metzlersche, 1975), p.19. For the Art-Union, see ibid., chap.2, and Lillian B. Miller, *Patrons and Patriotism: The Encouragement of the Fine Arts in the United States, 1790–1860* (Chicago: University of Chicago Press, 1966), chap.14.

41. "Editor's Easy Chair," *Harper's New Monthly Magazine* 10(December 1854): 120. This view was a traditional one. "Appeal in Favor of the Fine Arts," *Evening Star* (New York), December 1, 1835, began: "Amidst the rapid strides to wealth and power as a nation, and the general prosperity of trade, commerce and the mechanic arts throughout the country, the liberal arts are still allowed to

languish without any participation in public favor."

42. *House Journal,* 26th Cong., 1st sess., p.563 (March 9, 1840).

43. GC to his parents, June 29, 1840, *Letters,* p.173; *Catalogue of Catlin's Indian Gallery of Portraits* (1837), p.36 (Catlin promised his work "in a few weeks," perhaps responding to newspaper pleas that he issue his "Letters" in book form—for example, " 'Catlin's Travels,' " *Evening Star* [New York], December 2, 1836); GC to Sir Thomas Phillipps, [August] 18, 1840, Gilcrease; GC to Putnam Catlin, August 31, 1840, George Catlin Papers, Missouri Historical Society, St. Louis; Art III, *Quarterly Review* 65 (March 1840): 419–22; *Notes Europe,* 1:50–51. Catlin claimed that Murray subsequently regretted his decision. Once *Letters and Notes* was out, he actually read it and realized what a success it was bound to be (*Notes Europe,* 1:51–52). Also see Clara Catlin to Putnam and Polly Catlin, February 28, 1841, *Letters,* p.209.

44. *Notes Europe,* 1:50; GC to Sir Thomas Phillipps, [September], September 3, September 18, November 4, [December] 29, 1840, Gilcrease; Theodore B. Catlin to Francis Catlin, February 7, 1841, *Letters,* p.206; and *Notes Europe,* 1:51. The subscription sheet began: "Under the Distinguished Patronage of Her Majesty the Queen, Prince Albert, The Queen Dowager, The Duchess of Kent, and Many of the Nobility, Who Are Subscribers to the Work" (copy, AAA: 2137).

45. Clara Catlin to Putnam and Polly Catlin, February 28, 1841; GC to Putnam Catlin, June 19, July 18, 1841, *Letters,* pp.209–10; 212–13, 217.

46. GC to ——, September 26, 1841, Manuscripts Department, Lilly Library, Indiana University, Bloomington; GC to [editor, Literary Gazette], October 9, 1841, Catlin Papers, Missouri Historical Society, St. Louis; and GC to [Mr. Dilke, edi-

tor, Athenaeum], n.d., Boston Public Library, Boston. It was the *Athenaeum* that John Murray mentioned as the kind of journal in which a good review would ensure Catlin's success.

47. GC to Sir Thomas Phillipps, November 4, 1841, Gilcrease; GC to Putnam Catlin, November 3, 1841, February 3, March 3, 1842, *Letters,* pp.222, 234, 236; GC to ——, January 21, 1841 [1842], Gratz Collection, AAA: P22; also GC to ——, Wednesday evening [ca. 1841–42], Dreer Collection, AAA: P20. In fact, the original subscription sheet listed the two volumes at two guineas (AAA: 2137); but a later advertising brocure emphasizing the book's "*Illustrious* and *Honorable* Patronage" and its favorable reception priced it at £2.10. Copy in NA, RG 233: House Joint Committee on the Library, 29th Congress, accompanying papers.

48. GC to ——, September 12, 1841, Beinecke Rare Book and Manuscript Library, Yale University, New Haven; GC to Putnam Catlin, March 3, 1842, *Letters,* p.236.

49. GC to Putnam Catlin, November 3, 1841, *Letters,* p.222; GC to Sir Thomas Phillipps, September 3, 1840, Gilcrease. For typical plugs, see "Catlin's Indian History," *Cincinnati Daily Gazette,* May 6, 1841; "National Institution," *Newark Daily Advertiser,* September 28, 1841 (letter of R. R. Gurley, reprinted from *NI*); and after publication extracts from *Letters and Notes* appeared in the *Cincinnati Daily Gazette,* December 31, 1841; January 5, 7, 8, 26, and February 7, 1842.

50. "George Catlin" (April 12, 1842), *House Rep. No. 636,* 27th Cong., 2d sess.; GC to Putnam Catlin, March 3, 1842, *Letters,* p.236. John Quincy Adams (Whig, Massachusetts) introduced Catlin's petition in the House on January 21; a second petition, this one referring to the work as now finished, was introduced by Adams on February 8. Both were referred to

the Library Committee, then to the Committee on Ways and Means. It was this committee that reported adversely on April 12 (*House Journal*, 27th Cong., 2d sess., pp.253, 327, 328, 367, 693).

51. *Athenaeum,* no.727(October 2, 1841): 755 (the first of four notices); "Catlin on the North American Indians," *Edinburgh Review* 74(January 1842): 429; "Catlin's Letters," *Westminster Review* 37(January 1842): 122–23; "Catlin's Work on the North American Indians," *Chambers's Edinburgh Journal* 11(February 5, 1842): 19; "The North American Indians," *Dublin University Magazine* 19(March 1842): 372, 385. For Catlin's selection of notices, see *Notes Europe,* 1:52–59.

52. "Catlin's North American Indians," *United States Magazine, and Democratic Review* 11(July 1842): 44; "Vindication of the United States, &c.," *Southern Literary Messenger* 11(April 1845): 202–4, 211. For favorable responses to Catlin's British reception, see *American Eclectic* 3(March 1842): 391; and "The Western Indians," *New-York Mirror* 20(April 23, 1842): 135 (paraphrasing *Athenaeum,* no.747[February 10, 1842]: 163).

53. Message from the British to the American ministers, September 4, 1814, *American State Papers, Class I: Foreign Relations,* 6 vols. (Washington: Gales and Seaton, 1832–59), 3:715; Cass, quoted in Francis Paul Prucha, *Lewis Cass and American Indian Policy* (Detroit: Wayne State University Press, 1967), p.6. Prucha neatly summarizes Cass's actions to counteract British influence. A campaign pamphlet written by Schoolcraft, *Administration of Gen. Cass in the Northwest* (published under the authority of the Committee [for Cass as President], [1845]), p.5, noted: "It was the effort to break up these visits of fealty to a foreign power, where they were supplied with arms

and ammunition, and to teach them their true interests and duties, both to themselves and the United States, that constituted *one of the peculiar and arduous branches of administrative duty that marked the superintendency of Gen. Cass.*" Copy in HRS Papers: 66; and for his authorship, HRS to John Calhoun, September 23, 1848, roll 12. Also see W. Sheridan Warrick, "The American Indian Policy in the Upper Old Northwest Following the War of 1812," *Ethnohistory* 3(Spring 1965): 109–25.

54. [George Procter], "The North American Indians," *Quarterly Review* 31(April 1824): 94, 101, 77. There is some confusion as to the date of this issue—when bound together with the January 1824 issue, it was assigned a December date on the title page.

55. [Lewis Cass], "Indians of North America," NAR 22(January 1826): 53–119; "North American Indians: Cursory Remarks upon an Article in the 'United States Literary Gazette,' for August, 1826, Entitled 'Examination of an Article in the "North American Review,"' &c.," *United States Review and Literary Gazette* 2(April 1827): 46 (much about this reply suggests that Cass wrote it, or had it written); [Lewis Cass], "Services of Indians in Civilized Warfare," NAR 24(April 1827): 365–442. Cass explicitly stated his intention of using Hunter to get at the British in his correspondence with the *North American Review*'s editor, Jared Sparks. See Adams, *Life and Writings of Jared Sparks,* 1:274–78; and Richard Drinnon, *White Savage: The Case of John Dunn Hunter* (New York: Schocken Books, 1972), chap.4. The Cass-British clash over the morality of American Indian policy continued: see [Lewis Cass], "Removal of the Indians," NAR 30(January 1830): 62–121; and C. Colton, *Tour of the American Lakes, and Among the Indians of the North-West Territory, in 1830,* 2 vols.

(London: Frederick Westley and A. H. Davis, 1833), vol.2, chaps.3–4.

56. Lawrence Schoolcraft to HRS, April 16, 1813, HRS Papers: 17; HRS, "JANE, Wife of Henry Rowe Schoolcraft Esqr." [May 22, 1842], roll 9; "Sketches of the Life of Henry R. Schoolcraft," *Memoirs,* pp.xl–xli; 238(entry for October 28, 1825); *Notes Europe,* 1:82–83; *Memoirs,* pp.83–84; *Information,* 5:54. Schoolcraft met Hunter in 1821 and was unimpressed. He had a "soft, compliant, half quizzical look"—sure signs of the poseur—and his book had been exposed by Cass "in a manner which gives very little encouragement to literary adventurers and cheats." A campaign biography also praised the "masterly manner" in which Cass exposed Hunter and his "design to create odium against the United States" (William T. Young, *Sketch of the Life and Public Services of General Lewis Cass . . .* [Detroit: Markham and Elwood, 1852], p.411). Since Schoolcraft mentioned George Psalmanazar, it is worth noting that Cass in his review of Hunter first cited Psalmanazar as an example of the charlatans who had fooled the credulous in the past. Schoolcraft remained his mentor's student. Hunter's credibility is outside the scope of this book, but his claims have made one modern convert: Richard Drinnon in his 1972 book *White Savage: The Case of John Dunn Hunter.*

57. [HRS], "The Chippewa Indians," *NAR* 27(July 1828): 101. The "unchanging Indian" was a favorite Schoolcraft theme.

58. Art III, *Quarterly Review* 65(March 1840): 421–22.

59. John G. Palfrey to HRS, December 14, 27, 1841, February 1, April 4, 1842, HRS Papers: 32; [HRS], "The Red Man of America," *NAR* 54(April 1842): 283–95.

60. James L. Carter and Ernest H. Rankin, eds., *North to Lake Superior:* *The Journal of Charles W. Penny, 1840* (Marquette, Mich.: John M. Longyear Research Library, 1970), p.4 (May 24, 1840); HRS to Jane J. Schoolcraft, December 12, 1835, HRS Papers: 23; HRS to the President of the United States, February 10, February 22, 1836, HM–16366–67, Huntington. These letters followed on a personal interview with Jackson on December 26, 1835.

61. HRS to Jane J. Schoolcraft, December 12, 1835, HRS Papers: 23; January 31, 1836, roll 24; HRS to Andrew Jackson, December 4, 1835, with supporting letters, December 4, 7, others, roll 23; Jane J. Schoolcraft to HRS, May 13, 1836, HRS to Jane J. Schoolcraft, May 16, April 24, 1836, roll 24; HRS to Carey Harris, October 31, December 3, 1836, roll 26; *Memoirs,* p.596 (June 16, 1838).

62. An instructive episode early in Schoolcraft's publishing career involving a colleague on the 1820 Cass expedition, David Bates Douglass, is treated in Freeman, "Schoolcraft," pp.64–77, and in Sydney W. Jackman and John F. Freeman, eds., *American Voyageur: The Journal of David Bates Douglass* (Marquette: Northern Michigan University Press, 1969), pp.xix–xxi; an episode in the next decade, equally instructive, involving Dr. Edwin James and publication in 1830 of *Narrative of the Captivity and Adventures of John Tanner,* is well covered in Maxine Benson, "Schoolcraft, James, and the 'White Indian,'" *Michigan History* 54(Winter 1970): 311–28.

63. HRS to Thomas H. Benton, May 27, 1841; and Jane J. Schoolcraft to HRS, April 24, May 3, 1841, HRS Papers: 32. For the scandal, see the exchange between Schoolcraft and T. Hartley Crawford, January 1841 to October 3, 1842, roll 9; and Freeman, "Schoolcraft," pp.215–21, 226–28. Stuart had aspired to be commissioner of Indian affairs; failing that, he had settled for School-

craft's post. See S. H. Porter to HRS, April 4, 1841; and J. T. Cochrane to HRS, April 23, 1841, HRS Papers: 32.

64. John Greig to HRS, June 10, 1841; and HRS to J. C. Calhoun, March 2, 1842, Calhoun to HRS, May 6, 1842, HRS Papers: 32; HRS to Albert Gallatin, January 22, 1844, roll 33. The magazine's precursors were two others Schoolcraft proposed to publish in the 1820s, *Indian Annals* (1825) and *Algic Magazine* (1826). Like their later incarnation, they never made it past the prospectus stage. See Freeman, "Schoolcraft," p.106.

65. HRS to John Tyler, July 23, 1841, HRS Papers: 32. HRS also wrote to Daniel Webster the same day, looking for his signature, and approached both the commissioner of Indian affairs and the secretary of war, ostensibly about the magazine but probably also to present the case against his removal as agent. See H. Crawford to HRS, July 14, 1841, HRS Papers: 32; and HRS to John Bell, July 16, 1841, roll 9. The original endorsements that appeared on the reverse of the printed prospectus are in the Huntington, RH 238.

66. Printed copies and a draft of the prospectus are in the HRS Papers: 9, 32.

67. *Memoirs*, p.185; HRS to Lewis Cass, January 30, 1833, HRS Papers: 21; HRS to Cass, October 20, 1835, roll 23; HRS to T. Hartley Crawford, December 24, 1838, roll 8; "England. Liverpool, 1842," draft (apparently chap.2 of an intended book on his trip abroad), roll 64.

68. HRS to Jane J. Schoolcraft, May 8, 1842, HRS Papers: 32.

69. Draft Prospectus, HRS Papers: 64; HRS to Washington Irving, March 28, 1842, roll 32; and see *Memoirs*, p.703, which ended not with Schoolcraft's dismissal from office, but with his departure for England a year later. The implication was that his journey abroad marked a new beginning and would provide

the basis for another book. That Schoolcraft did not write it suggests how disappointing he found the trip's results.

70. HRS to Duff Green, June 8, 1842, HRS Papers: 32. Cass had set the terms for HRS's case when he praised his Indian researches in an 1826 review: "His opportunities for observation have been great. . . . His official station, and his local residence, are highly advantageous" (Cass, "Indians of North America," p.60).

71. HRS to Harper and Brothers, February 27, 1844; and draft table of contents, memorandum (January 31, 1844), HRS Papers: 34; HRS to Francis Lieber, February 10, 1851, roll 12. Harper's was so discouraging that Schoolcraft chose to withdraw his manuscript and shelve the "Cyclopedia."

72. Clara Catlin to Matthew Gregory, July 14 [1842], Catlin Papers, Missouri Historical Society, St. Louis; "Memorial of George Catlin" (Bruxelles, Belgium, December, 1868), copy in AAA: 2137. See Donaldson, *Catlin Gallery*, pp.374–75; Haberly, *Pursuit of the Horizon*, p.210; Harold McCracken, *George Catlin and the Old Frontier* (New York: Dial Press, 1959), pp.201–2; *Letters*, pp.312, 344 (Roehm describes Schoolcraft as a "petty politician"); John C. Ewers, Introduction to GC, *O-kee-pa: A Religious Ceremony and Other Customs of the Mandans* (New Haven: Yale University Press, 1974), p.19; Mary Sayre Haverstock, *Indian Gallery: The Story of George Catlin* (New York: Four Winds Press, 1973), pp.186–87; and Truettner, *Natural Man*, pp.52–53.

73. Draft Prospectus, HRS Papers: 64; HRS, "Memorandum of Letters" [1842], roll 32, indicating that Schoolcraft wrote Cass on June 1, 1842; Cass to GC, December 8, 1841. Catlin first published Cass's letter in French in *Catalogue raisonné de galerie indienne de Mr. Catlin, renfermant des portraits, des paysages, des*

costumes, etc., et des scènes de moeurs et coutumes des Indiens de l'Amérique du Nord (Paris: Wittersheim, 1845), p.5; and in English in *Descriptive Catalogue of Catlin's Indian Collection* (1848), p.7.

74. See John T. Flanagan, *James Hall: Literary Pioneer of the Ohio Valley* (New York: Russell and Russell, 1971 [1941]); and Randolph C. Randall, *James Hall: Spokesman of the New West* (Columbus: Ohio State University Press, 1964), which includes a comprehensive bibliography of Hall's writings.

75. [James Hall], "Mr. Catlin's Exhibition of Indian Portraits," *Western Monthly Magazine* 1 (November 1833): 535–38.

76. Ossoli, *Summer on the Lakes*, p.25 (Lewis had executed Indian portraits for Cass as early as 1824 and accompanied him on the treaty tours the year before and after McKenney's summer excursion, making it a certainty that McKenney was acting on Cass's advice in 1826); Herman J. Viola, *Thomas L. McKenney, Architect of America's Early Indian Policy: 1816–1830* (Chicago: Swallow Press, 1974), pp.108–9, 136–53, 226–33; and see Richard B. Latner, "The Kitchen Cabinet and Andrew Jackson's Advisory System," *Journal of American History* 65 (September 1978): 367–88.

77. T. L. McKenney to Jared Sparks, September 22, 1829, in Viola, *Thomas L. McKenney,* p.252; "History of the Indian Tribes of North America," *Missouri Republican* (St. Louis), October 25, 1833; Randall, *James Hall,* p.256. Frederick W. Hodge's introduction to Thomas L. McKenney and James Hall, *The Indian Tribes of North America, with Biographical Sketches and Anecdotes of the Principal Chiefs,* ed. Frederick W. Hodge, 3 vols. (Edinburgh: John Grant, 1933), was long the standard discussion of the *History;* it has been supplanted by Viola, *Thomas L. McKenney,* chap.14; and his *The Indian Legacy of Charles Bird King*

(Washington: Smithsonian Institution Press and Doubleday, 1976), chap.4. Hall quickly became disillusioned with McKenney, finding him "as lazy a man as ever lived, and as unreliable a mortal as ever made big promises. This hoard of materials dwindled down to almost nothing."

78. James Hall to GC, February 12, 1836, AAA: 2136. This letter has been published in full several times; its first appearance was in Donaldson, *Catlin Gallery,* pp.766–67.

79. GC to J. H. Hook, December 10, 1832, NA, RG 92: Quartermaster Consolidated file, Records of the Office of the Quartermaster General, entry 225.

80. GC, "Indian Scenes," *Evening Star* (New York), July 1, 1836 (reprinted in *American Turf Register and Sporting Magazine* 7 [August 1836]: 554–55, giving it wide circulation); Viola, *Thomas L. McKenney,* p.268, and idem, *Indians of North America: Paintings by Henry Inman* (Cody, Wyo.: Buffalo Bill Historical Center, 1983); "Mr. Catlin's Indian Gallery," *Evening Star* (New York), April 22, 1836, and "Gallery of Indian Portraits," ibid., June 14, 1836. Previously the *Star* had been warmly supportive of Catlin's endeavors: April 21, May 19, 1835; February 2, 12, 1836.

81. "More Indian Portraits," *Evening Star* (New York), June 16, 1835; "Advertisement to the Third Number of the Aboriginal Port-Folio" (Philadelphia, July 20, 1835); "Advertisement to the First Number of the Aboriginal Port-Folio" (Philadelphia, July 20, 1835). The date of this advertisement, corresponding to that on the advertisement for the third number, and following that on the second, suggests a second printing. Viola, *Indian Legacy of Charles Bird King,* p.55, notes that some 45 of Lewis's estimated 250 Indian portraits were sent to Washington for copying, 11 by Athanasius Ford, the rest presumably by King. Hodge, "Introduction," pp.xxxviii–

xli provides a list of the portraits in Lewis's *Aboriginal Port-Folio* and also in McKenney and Hall's *History.*

82. Thomas L. McKenney, *Sketches of a Tour to the Lakes, of the Character and Customs of the Chippeway Indians, and of Incidents Connected with the Treaty of Fond du Lac* (Baltimore: Fielding Lucas, 1827), pp.184, 360–61; "Advertisement to the First Number."

83. *Memoirs,* p.531 (March 4, 1836). Schoolcraft noted that Lewis sent him seven numbers of the *Port-Folio* consisting of plates and "biographical notices of the common events in the lives of the chiefs." This statement suggests some confusion on Schoolcraft's part, possibly with McKenney and Hall's *History.* Schoolcraft did edit and rearrange material in his *Memoirs* (p.vii)—deleting, for example, any mention of Catlin's visit in 1836—and he may have taken pleasure in underlining Lewis's primacy in this entry.

84. GC to Carey A. Harris, [October 1837], NA, RG 75: Registers of Letters received, 1824–80, Office of Indian Affairs, vol.10, entry 398. See Viola, *Indian Legacy of Charles Bird King,* pp.107–8; and John E. Sunder, *Joshua Pilcher, Fur Trader and Indian Agent* (Norman: University of Oklahoma Press, 1968), p.128.

85. J. R. P[oinsett] to the Officer Commanding at Fort Moultrie, Charleston Harbor, South Carolina, January 10, 1838, NA, RG 107: Office of the Secretary of War, Letters Sent, Military Letter Book, no.18, p.217; GC to Carey A. Harris, January 31, 1838, NA, RG 75: Letters Received 1824–80, Office of Indian Affairs, Florida Emigr., C 535.

86. T. Hartley Crawford to GC, November 15, 1838, NA, RG 75: Letters Sent, Office of Indian Affairs, vol.22, p.361; Viola, *Indian Legacy of Charles Bird King,* pp.55–56. King's commission for nineteen portraits the previous fall brought him $730—sixteen at $30 each, one at $40, one at $60, and one at $150, the most King ever received from the government for an Indian portrait; his assistant, George Cooke, received $30 for each of the nine portraits he painted in the same period (ibid., pp.108–9). It is unlikely that Catlin would have commanded any more.

87. McKenney and Hall, *Indian Tribes of North America,* 2:102; *Recommendatory Notices of the Indian History and Biography, Now Publishing by Edward C. Biddle, Philadelphia: With a List of the Subscribers, to March 1, 1837* (Philadelphia: E. C. Biddle, 1837), pp.1, 6.

88. *Recommendatory Notices,* p.1; [Jared Sparks and Cornelius C. Felton], "McKenney and Hall's *History of the North American Indians,*" NAR 47(July 1838): 148; Viola, *Thomas L. McKenney,* pp.260–63, 271–72. Sparks, who as editor of the *North American Review* encouraged Cass and Schoolcraft to contribute and knew Catlin in England, was one of the first supporters of McKenney's project and offered a ringing endorsement on September 27, 1829, that became part of its publicity. For Catlin's Osceola print, see pp.116–17.

89. Edward C. Biddle to Carey A. Harris, July 7, 1838, cited in Viola, *Thomas L. McKenney,* pp.272, 274–76.

90. T. L. McKenney to William D. Lewis, June 11, 1839, cited in ibid., p.278; also pp.252, 269.

91. *Catlin's North American Indian Portfolio: Hunting Scenes and Amusements of the Rocky Mountains and Prairies of America* (London: Author, 1844), p.5.

92. HRS to Absalom Peters, September 20, 1842; HRS to W. C. Bryant, September 20, 1842; HRS to Charles Dickens, September 20, 1842, HRS Papers: 32; pocket journal, entry for October 3, 1842, roll 48; Charles Dickens, "The Noble Savage," *Household Words* 7(June 11, 1853): 337–39; reprinted in part in *Literary World* 12(July 2, 1853): 530–31.

93. HRS, pocket journal, entry for September 30, 1842, HRS Papers: 48.

94. Clara Catlin to HRS, June 22,

[1842], HRS Papers: 9; GC to HRS, October 9, 1842, roll 10.

95. GC to Mssrs. Longmans, Book publishers, October 27, 1842, Boston Public Library, Boston.

CHAPTER 3

1. GC to Sir Thomas Phillipps, January 23, 1853, Gilcrease. Most of this letter is published in A. N. L. Munby, *The Formation of the Phillipps Library from 1841 to 1872* (Cambridge: Cambridge University Press, 1956), pp.58–60.

2. GC to Putnam and Polly Catlin, June 29, 1840; GC to Putnam Catlin, February 3, 1842, *Letters,* pp.175, 234; rental agreement, London, December 30, 1839, AAA: 2136. For the invitation to exhibit the model, from Catlin's friend Charles A. Murray, master of the queen's household, December 31, [1841], see AAA: 2136.

3. GC to Putnam Catlin, August 31, 1840, Catlin Papers, Missouri Historical Society, St. Louis; Theodore Burr Catlin to Francis Catlin, February 7, 1841, *Letters,* p.207. In a letter intended for newspaper publication, GC to J. Murray, April 14, 1840, Historical Society of Pennsylvania, Misc. Coll., AAA: P 23, Catlin claimed a brisk business at his gallery (the private covering letter more candidly said he was "just beginning to do tolerably well"). Things had not changed six months later when Clara Catlin wrote to Putnam and Polly Catlin, February 28, 1841, *Letters,* p.208: "London is no place to make money by exhibition. Rent and provisions are just double what they are at home, and the English grudge a shilling more than an American does fifty cents. There are so many shows and exhibitions here, too." But Catlin did meet his expenses that first year—so well, his wife noted in October, that the owners of the Egyptian Hall had given him a rent reduction of £50 in recognition of his punctual payment each month

(Clara Catlin to the Putnam Catlins, October 29, 1840, ibid., p.196).

4. *Notes Europe,* 1:40–43, 48–49; 2:67–68.

5. Adv., New York *Morning Herald,* October 24, November 27, and December 25, 1837; Richard D. Altick, *The Shows of London* (Cambridge: Harvard University Press, 1978), p.3; Putnam Catlin to Francis Catlin, January 21, 1838, *Letters,* p.126; Theodore Burr Catlin to Francis Catlin, March 7, 1838, and Putnam Catlin to Francis Catlin, March 18, 1838, Catlin Papers, Bancroft, folders 89–90; Theodore Burr Catlin to Francis Catlin, February 7, 1841, *Letters,* pp.206–7 (he included a self-portrait in costume with the original, Catlin Papers, Bancroft, folder 120); and George Catlin to ——, [July 1840 to February 1841], Misc. MSS, AAA: D 8; Straws, "Mr. Catlin's Indian Gallery," *Weekly Reveille* (St. Louis), October 14, 1844.

6. "The Ojibbeway Indians," *Illustrated London News* 3, no.86(December 23, 1843): 401; "The Iowa Indians," ibid., 5, no.117 (July 27, 1844): 64; and no.119(August 10, 1844): 91.

7. Adv., ibid., 5, no.121(August 24, 1844): 126.

8. Mason Wade, ed., *The Journals of Francis Parkman,* 2 vols. (London: Eyre and Spottiswoode, n.d.), 1:222–23 (entry for May 1844).

9. P. T. Barnum, *Struggles and Triumphs; or, Forty Years' Recollections* (Buffalo: Warren, Johnson, 1873), p.175; Wade, *Journals of Francis Parkman,* 1:222; P. T. Barnum to Moses Kimball, February 5, 1843, August 1, 18, 1844, in A. H. Saxon, ed., *Selected Letters of P. T. Barnum* (New York: Columbia University Press, 1983), pp.14, 27–28. The Iowas may have been the same party who passed through Cincinnati in December on their way to Washington ("Iowa Indians," *Niles'* 65[December 9, 1843]: 226). If so, Barnum somehow arranged to have their eastern trek extended all the way to London. In 1839 the secre-

tary of war had opposed a combination in New York that was attempting to send a group of Sacs and Foxes to England "on speculation . . . to exhibit these people in Europe for money" (J. R. Poinsett to Secretary of the Treasury, October 21, 1839, *Niles'* 57[November 2, 1839]: 150).

10. Barnum, *Struggles and Triumphs,* p.364 (Barnum also noted, p.179, that Catlin's "great Gallery of Portraits of American Indians and Indian Curiosities" served as "an adornment" to Tom Thumb's Egyptian Hall triumph); Altick, *Shows of London,* p.278n; GC to Clara Catlin, Newcastle on Tyne [ca. January 1845], Edinburgh [1845], AAA: 2136. Frederick W. Hodge notes that the pamphlet Catlin published promoting the Iowas and the whole program they put on were "characteristic of the professional showman" (Thomas L. McKenney and James Hall, *The Indian Tribes of North America, with Biographical Sketches and Anecdotes of the Principal Chiefs,* ed. Frederick W. Hodge, 3 vols. [Edinburgh: John Grant, 1933], 1:309, n.7).

11. "Paid out for the Exhibition in the Week Ending 7th June [1845]," AAA: 2137. There was a curious inconsistency in Catlin's position on this. Like most friends of the Indians, he had deplored alcohol's ruinous effects. But it was also Catlin who intervened on behalf of the Iowas, pledged to total abstinence while abroad, and allowed them to drink wine and ale but not spirits; and it was Catlin who persuaded Melody that they should be allowed to don their frock coats and beaver hats and visit a London gin mill if they chose. The principle he espoused was that the Indians should be exposed to the white man's civilization, warts and all. See *Notes Europe,* 2:49–50, 95–101.

12. Barnum to Kimball, August 18, 1844, in Saxon, *Selected Letters,* p.28; GC to Francis Catlin, May 18, 1844, in *Letters,* p.288.

13. GC to Alexandre Vattemare, October 10, December 3, 1843, Vattemare Collection, NYPL.

14. GC to Mr. Ledyard, January 12, 1844, Redwood Library and Athenaeum, Newport, R.I.; GC to Alexandre Vattemare, October 21, 1844, Vattemare Collection, NYPL. Vattemare (1796–1860) and Catlin first came into contact in 1839, when Vattemare requested a contribution to his visionary "plan of international literary and scientific exchanges" which he was then promoting in the United States. (See "Memorial of Alexandre Vattemare" [February 5, 1840], *House Doc. No. 50,* 26th Cong., 1st sess.). Subsequently, during his stay in France, Vattemare took Catlin under his wing, translating his letters, introducing him in society, and lending him money. Vattemare left for an extended stay in America in May 1847, which resulted in another appeal to Congress ("Memorial of Alexandre Vattemare . . ." [February 9, 1848], *Sen. Misc. Doc. No. 46,* 30th Cong., 1st sess.) and deprived Catlin of his closest friend in France. In the same period, Catlin obtained a letter of introduction from Edward Everett, then residing in London, to the American minister in France. The introduction was brief because, Everett wrote, Catlin's "reputation as an artist and an author supersedes the necessity of a farther recommendation" (Everett to W. R. King, December 2, 1844, letterbook copy, Edward Everett Collection, Massachusetts Historical Society, Boston).

15. GC to [George Putnam], March 4, 1845, Department of Special Collections, University of California, Los Angeles. Sir Thomas Phillipps, at Catlin's request, paid Putnam for his copy of the *Portfolio,* which suggests that Catlin's offer was accepted. GC to Sir Thomas Phillipps, April 7, 1845, Gilcrease; and Phillipps to George Putnam, June 11, 1845, Autograph file, Houghton Library, Harvard University, Cambridge.

16. Mrs. R. L., "*Mrs. Catlin,* the Indian Traveller" (ca. May 1840), Catlin Papers, Bancroft, folder 161.5 (intended for publication in the New York *Sunday Morning News,* this tribute was in the nature of a public farewell to Clara Catlin on her departure for England); Clara Catlin to Matthew Gregory, July 14, [1842], Catlin Papers, Missouri Historical Society, St. Louis (portion printed in *Letters,* p.255); GC to Clara Catlin, Edinburgh, Tuesday [ca. January 1844], Edinburgh, Friday [ca. January 1845], Friday [ca. January 1845], January 5, 1844 [1845], and Newcastle on Tyne [ca. January 1845], AAA: 2136.

17. GC to Putnam Catlin, April 3, 1842, *Letters,* pp.243–44 (Putnam Catlin would never receive this letter; he died on March 12); Clara Catlin to Matthew Gregory, January 30, 1842 (also July 14, 1842, March 23, 1843), Catlin Papers, Missouri Historical Society, St. Louis; GC to Sir Thomas Phillipps, February 17, 1846, Gilcrease. The family letters are filled with a sense of separation and loss—for example, Eliza Dart to Clara Catlin, August 24, 1840, Mary Hartshorn to Francis Catlin, January 22, 1842, Mary Hartshorn and Putnam Dart to Clara Catlin, October 27, 1844, Catlin Papers, Bancroft, folders 113, 124, 140. Clara Catlin's obituary in *Galignam's Messenger,* July 30, 1845 (copy in the notebook of Horace P. Hartshorn, Catlin Family Papers, AAA: 2707), mentioned the pathos of her passing without revisiting "the land of her birth."

18. AAA: 2136 (see *Notes Europe,* 2:210, 219–20, for Catlin's grumblings about French bureaucracy); "American Indians in Europe—*Burial of O ki-oui-mi, Wife of the Little Wolf, at Paris,*" *Niles'* 68(August 2, 1845): 339; *Notes Europe,* 2:273, 278–79.

19. See Donald B. Smith, "Maungwudaus Goes Abroad," *Beaver,* Outfit 307, 2(Autumn 1976): 4–9.

20. GC to Alexandre Vattemare, January 12, 1846, Vattemare Collection, NYPL; GC to ——, [New York], January 30, 1846, "Indians Exhibited in Europe," *Niles'* 70(March 7, 1846): 2.

21. *Notes Europe,* 2:296, 302, 308–9, 311–12.

22. James Elliot Cabot, *A Memoir of Ralph Waldo Emerson,* 2 vols. (Boston: Houghton, Mifflin, 1899), 2:697–702: "Letter to Martin Van Buren, President of the United States" (dated April 23, 1838, the letter was first published in *NI,* May 14, 1838); S. E. Sewall to Louisa M. Sewall, August 26, 1838, Robie Sewall Collection, Massachusetts Historical Society, Boston; Loyd Haberly, *Pursuit of the Horizon: A Life of George Catlin, Painter and Recorder of the American Indian* (New York: Macmillan, 1948), p.111, citing the Boston *Evening Transcript,* September 11, 1838; Peter Jones to his wife, March 7, 1846, Peter Jones Collection, Victoria University Library, Toronto; and see Donald B. Smith, *Sacred Feathers: The Reverend Peter Jones (Kahkewaquonaby) and the Mississauga Indians* (Lincoln: University of Nebraska Press, 1987). And see William H. Truettner, "For European Audiences: *Catlin's North American Indian Portfolio,*" in Ron Tyler, ed., *Prints of the American West: Papers Presented at the Ninth Annual North American Print Conference* (Fort Worth, Tex.: Amon Carter Museum, 1983), pp.25–45, which focuses on the subjects Catlin chose for inclusion in his *North American Indian Portfolio* and the changes introduced in copies from his originals painted while abroad, to show how he adapted his work to European tastes.

23. R. R. Gurley to James A. Pearce, June 11, 1846 (quoting "a recent note" from Catlin), NA, RG 233: House Joint Committee on the Library, 29th Congress, accompanying papers; *Notes Europe,* 2:313.

24. Ibid. The printed version, "Memorial of George Catlin," *Sen. Doc. No. 374,*

29th Cong., 1st sess., was dated "Louvre, Paris, or Place Madeleine 21, April 2, 1846," but the draft actually provided Congress, in R. R. Gurley's hand, was dated "Louvre, Paris, or, place Madileine 21st April 1846." NA, RG 233: House Joint Committee on the Library, 29 Congress, accompanying papers. I assume that the April 2 date was a printer's error.

25. GC to the Secretary at War [J. R. Poinsett], Wednesday evening 27th inst. [February], 1839, AAA: P 20. This letter, in the Dreer Collection, Historical Society of Pennsylvania, is cataloged as to Samuel L. Southard, Whig senator from New Jersey. But since the envelope is clearly addressed to the secretary at war, it seems that Southard simply acted as courier, an assumption supported by an earlier Catlin letter to Poinsett, dated the 15th inst., in the Poinsett Papers, Historical Society of Pennsylvania, AAA: P 29.

26. "Memorial of George Catlin" (1846).

27. Original in NA, RG 233: House Joint Committee on the Library, 29th Congress, accompanying papers; it was printed as an appendix to "Memorial of R. R. Gurley" (July 18, 1848), *Sen. Misc. Doc. No. 152*, 30th Cong., 1st sess., pp.5–6.

28. Thomas Sully to GC, July 16, 1839, AAA: 2136; Edward Biddle and Mantle Fielding, *The Life and Works of Thomas Sully (1783–1872)* (Philadelphia: Wickersham Press, 1921), p.362, no.2341; J. T. Headley, address, December 19, 1845, *Transactions of the American Art-Union, for the Year 1845* (New York: Evening Post, [1846]), p.13; Henry Kirke Brown to GC, undated draft letter with Lydia Brown to Mrs. Willard, March 10, 1843, Henry Kirke Brown Papers, AAA: 2770; Jno. Vanderlyn et al., "Memorial of American Artists in Paris" (May 14, 1846), appendix to "Memorial of R. R. Gurley" (1848), pp.4–5. The copy of this memorial in NA, RG 233:

House Joint Committee on the Library, 29th Congress, accompanying papers, is not the original, but a transcript in Gurley's hand. For Brown and Clevenger, see Wayne Craven, *Sculpture in America* (New York: Thomas Y. Crowell, 1968), pp.144–58, 180–87; and for an anecdote about Clevenger's sculpture, "Our Artists," *Western Literary Journal and Monthly Review* 1 (November 1844): 61. Brown's finished figure of the Indian youth was hardly overburdened with ethnological detail, but after his return to America Indians became his minor specialty.

29. "Memorial of A. B. Durand, and Other Artists of New York" (July 9, 1846), *Sen. Doc. No. 424*, 29th Cong., 1st sess. (original, dated July 1, in NA, RG 233: House Joint Committee on the Library, 29th Congress, accompanying papers, and bears the notation: "presented by J. R. Ingersoll / July 7, 1846 referred to the Joint Committee on the Library"); GC to A. B. Durand [July 1840], A. B. Durand Papers, NYPL; John G. Chapman to Charles B. King, November 9, 1835, Charles Roberts Autograph Collection, Haverford College, Pennsylvania, AAA: 88; and Andrew F. Cosentino, *The Paintings of Charles Bird King (1785–1862)* (Washington: Smithsonian Institution Press for the National Collection of Fine Arts, 1977), pp.47, 66–69. Chapman took liberties, putting one Indian woman in a pair of men's leggings— a fault Schoolcraft pointed out in a note in *Information*, 3:66. It was Chapman who sent Greenough the King portraits and the bust that he in turn lent Brown—though Greenough had previously studied Indian physiognomy while living in Washington in 1829, where he was intimate with King. See Horatio Greenough to James Kirke Paulding, December 14, 1839, in Nathalia Wright, ed., *Letters of Horatio Greenough, American Sculptor* (Madison: University of Wisconsin Press,

1972), pp.272–73; and Sylvia E. Crane, *White Silence: Greenough, Powers, and Crawford, American Sculptors in Nineteenth-Century Italy* (Coral Gables, Fla.: University of Miami Press, 1972), p.31.

30. Samuel F. B. Morse to R. R. Gurley, June 27, 1846, and George P. A. Healy to R. R. Gurley, July 2, 1846, NA, RG 46: Senate Joint Committee on the Library, 30th Congress, accompanying papers (published as appendixes to "Memorial of R. R. Gurley" [1848], pp.8–9); Neil Harris, *The Artist in American Society: The Formative Years, 1790–1860* (New York: George Braziller, 1966), p.274, and see chaps.4, 10.

31. *Cong. Globe,* 29th Cong., 1st sess., p.1072; "Catlin's Indian Gallery" (July 24, 1846), *House Rep. No. 806,* 29th Cong., 1st sess. Catlin's advocate, R. R. Gurley, had mentioned the possibility of payment in western lands—a proposition the committee chose to ignore. R. R. Gurley to Robert C. Schenck, June 4, 1846, NA, RG 233: House Joint Committee on the Library, 29th Congress, accompanying papers.

32. GC to Sir Thomas Phillipps, February 17, 1846, Gilcrease; *Notes Europe,* 2:313.

33. *Cong. Globe,* 29th Cong., 2d sess., p.529.

34. "The National Museum," *Newark Daily Advertiser,* December 22, 1841 (from the New York *Evening Post*). See William Stanton, *The Great United States Exploring Expedition of 1838–1842* (Berkeley: University of California Press, 1975), chap.18; and Curtis M. Hinsley, Jr., *Savages and Scientists: The Smithsonian Institution and the Development of American Anthropology, 1846–1910* (Washington: Smithsonian Institution Press, 1981), pp.15–20.

35. *Sixth Annual Report, SI* (Washington: A. Boyd Hamilton, 1852), p.8; and see Wilcomb E. Washburn, "Joseph Henry's Conception of the Purpose of the Smithsonian Institution," in *A Cabinet of Curiosities: Five Episodes in the Evolution of American Museums* (Charlottesville: University Press of Virginia, 1967), pp.106–66; and Hinsley, *Savages and Scientists,* chap.3, which modifies Washburn's argument that Henry was philosophically opposed to museums by emphasizing his practical concerns instead.

36. *Cong. Globe,* 29th Cong., 2d sess., p.529.

37. GC, Fort Moultrie, Charleston, January 17, in "Indian Portraits," *Niles'* 53(February 10, 1838): 384 (reprinted from "the New York papers"); also *L&N,* 2:218–20; George H. Colton, *Tecumseh; or, The West Thirty Years Since* (1838), quoted in Aaron Kramer, *The Prophetic Tradition in American Poetry, 1835–1900* (Rutherford, N.J.: Fairleigh Dickinson University Press, 1968), p.237. Kramer discusses several Osceola poems. The best known of these today is Walt Whitman's "Osceola," though it was not written until 1890. Edgeley W. Todd, "Indian Pictures and Two Whitman Poems," *Huntington Library Quarterly* 19(November 1955): 5–11, contends that Catlin's Osceola portrait was Whitman's inspiration. Typical contemporary examples include Mary E. Hewitt, "Osceola Signing the Treaty" (1845), and Lucy Hooper, "Osceola" ("Woe for the bitter stain / That from our country's banner may not part!"), in Thomas Buchanan Read, *The Female Poets of America,* 7th ed. (Philadelphia: E. H. Butler, 1857), pp.160–61, 169–71; and G. W. Cutter, "The Death of Osceola," in *Buena Vista: And Other Poems* (Cincinnati: Morgan and Overend, 1848), pp.33–37. For a fanciful modern version, see R. T. Smith, "Painting Osceola: An Epistle from George Catlin to His Wife," *Cimarron Review,* no.68(July 1984): 23–26.

38. GC, January 17, in "Indian Portraits," p.384; Putnam Catlin to Francis Catlin, January 21, 1838, *Letters,* pp.125, 127; J. Gideon, Jr.,

bill to George Catlin, May 25, 1838, AAA: 2136; *Catalogue of Catlin's Indian Gallery of Portraits, Landscapes, Manners and Customs, Costumes, &c. &c.* (New York: Piercy and Reed, 1837), foldout slip, p.21 (the copy consulted [AAA: 2137] was acquired on May 2 or 3, 1838, on a visit to the exhibition in Washington); invoice from Thomas Chany[?], Washington, D.C., April 7, 1838, AAA: 2136; and Putnam Catlin to Francis Catlin, March 18, 1838, *Letters,* p.127. Catlin's print set the standard in Osceola portraiture, and his standing pose was often borrowed. See John M. Goggin, "Osceola: Portraits, Features, and Dress," *Florida Historical Quarterly* 33(January–April 1955): 161–92.

39. Alexis de Tocqueville, *Journey to America,* trans. George Lawrence, ed. J. P. Mayer, rev. ed. (Garden City, N.Y.: Anchor Books, 1971), p.206. Tocqueville mulled over these thoughts: see, for example, "A Fortnight in the Wilds" (August 1, 1831), ibid., p.354. A highly polished version of this same idea appears in his classic *Democracy in America.* Loren Wilson Hall argues that Catlin's psyche (an innate need for wilderness) warred with his ego (the implanted message that he must enjoy worldly success), accounting for his contradictory impulses: "Portrait of a Mind: A Psychological-Intellectual Biography of George Catlin" (Ph.D. diss., Emory University, 1987), pp.38–39 ff.

40. GC to Henry Ward Beecher, October 18, 1863, NYPL. This strange, rambling letter made Catlin a ubiquitous figure present at several important events in Cherokee and Seminole history. Catlin's memory obviously betrayed him, but he did take an interest in the Cherokee and Seminole causes in this period and knew John Ross, the Cherokee chief. He could have spoken to Jackson, but no contemporary evidence corroborates this dramatic meeting. See Ross to John Howard Payne, January 27,

1838, in Gary E. Moulton, ed., *The Papers of Chief John Ross,* 2 vols. (Norman: University of Oklahoma Press, 1985), 1:588–89.

41. *Cong. Globe,* 29th Cong., 2d sess. p.529. See Arthur W. Thompson, *Jacksonian Democracy on the Florida Frontier,* University of Florida Monographs, Social Sciences, no.9 (Gainesville: University of Florida Press, 1961), p.11 and passim.

42. GC to ——, January 16, 1847, Massachusetts Historical Society, Boston; John Howard Payne to GC, January 1, 1847, Cornell University Library, Department of Rare Books, Ithaca, New York. Payne (1791–1852), New York–born, was in England when he wrote his nostalgic masterpiece "Home, Sweet Home" (1823). Both Whigs, both befriended by Daniel Webster and acquainted with Washington Irving, Payne and Catlin probably met in Washington in 1838. Both men lacked the knack for making money from their art, borrowed more than they could repay, fled English creditors to live in Paris, and saw themselves as exiles. Most interesting, both were concerned with the Indians, Payne having become involved in the Cherokee cause in the years 1835–42. See Gabriel Harrison, *John Howard Payne, Dramatist, Poet, Actor, and Author of Home, Sweet Home!: His Life and Writings* (Philadelphia: J. B. Lippincott, 1885), chap.5; Rosa Pendleton Chiles, *John Howard Payne: American Poet, Actor, Playwright, Consul and the Author of "Home Sweet Home"* (Washington: Columbia Historical Society, 1930), pp.35–43, 61–70, 75–77; and Grant Foreman, ed., "John Howard Payne and the Cherokee Indians," *American Historical Review* 37(July 1932): 723–30.

43. *Notes Europe,* 2:323; GC to John Howard Payne, [April 1847], NYPL; GC to Alexandre Vattemare, June 15, 1847, Vattemare Collection, NYPL. In a letter to Vattemare dated April 29, 1847, Catlin complained of

"a severe influenza," suggesting it was he who introduced it at home. Letters of January 25, 1846, to Monsieur Cailleux, with a note to Vattemare, and undated (ca. May 1847) to Vattemare establish that Catlin's little boy was sickly and had three times previously been prostrated by "brain fever." Both are in the Vattemare Collection. Catlin employed the flower image in his letter to Vattemare, June 15, 1847; and in *Notes Europe,* 2:324. The date of the boy's death is usually given incorrectly as late summer 1846.

44. *Catalogue raisonné de galerie Indienne de Mr. Catlin, renfermant des Portraits, des paysages, des costumes, etc., et des scènes de moeurs et coutumes des Indiens de l'Amérique du Nord* (Paris: Wittersheim, 1845), p.46; and *Notes Europe,* 2:216.

45. *Diary of My Travels in America: Louis-Philippe, King of France, 1830–1848,* trans. Stephen Becker (New York: Delacorte Press, 1977), pp.67–68, 91–94; and Suzanne d'Huart, "Afterword," ibid., p.170. See *Notes Europe,* 2:212, 283–85, 291–93, 318.

46. *Notes Europe,* 2:282, 318–19.

47. Ibid., 2:211; "Indians and Egyptians—A Scene," *Niles'* 68(June 14, 1845): 229; *The Mirror of Art: Critical Studies by Charles Baudelaire,* trans. and ed. Jonathan Mayne (Garden City, N.Y.: Doubleday Anchor Books, 1956), pp.49, 72–73 ("The Salon of 1846"), and pp.268, 289 ("The Salon of 1859"); George Sand to Alexandre Vattemare [May 31, 1845], in George Sand, *Correspondance,* ed. George Lubin, 17 vols. to date (Paris: Garnier Frères, 1964–83), 6:874 (Sand invited Delacroix to accompany her on May 20, 1845); George Sand, "Relation d'un voyage chez les sauvages de Paris," in *Le Diable à Paris* (Paris: J. Hetzel, 1846), 2:186–212. Sand, who described herself as "*très liée*" with the Iowas (to Gabriel Planet [late May 1845], *Correspondance,* 6:882), still recalled Little Wolf with affection a year and a half later (to

Pierre-Jules Hetzel [December 30, 1846], ibid., 7:574). Sand wrote *Le Diable*'s publisher, Pierre-Jules Hetzel, on June 3, 1845, agreeing to meet him "sous le wig-wam" (ibid., 6:892); her article appeared that month as two letters to a friend, and was reprinted in *Eclaireur* for June 14, 21, 28, 1845. Sand also wrote to Edouard-Thomas Charton regarding Catlin in the early fall, 1845 (Beinecke Rare Book and Manuscript Library, Yale University, New Haven); his journal, *Illustration* 5, nos.117, 119, 121(May 24, June 7, 21, 1845), carried extracts based on Catlin's *Letters and Notes:* "Les Peaux-Rouges," translated by L. Xavier Eyma. Sand recognized the tendency to dismiss Catlin's artistry and told Alexandre Vattemare, "j'écrirais avec plaisir quelque feuilleton qui pourrait être utile à Mr. Catlin, dont l'oeuvre me parait, du moins au point de vue de l'art, beaucoup plus importante que le public ne l'apprécie" ([May 31, 1845], *Correspondance,* 6:875). For the romantics' fascination with American noble savages, see Reneé Rémond, *Les Etats-Unis devant l'opinion française, 1815–1852,* 2 vols., Cahiers de la Fondation Nationale des Sciences Politiques, 117 (Paris: Librairie Armand Colin, 1962), 2:482–88. Delacroix mentioned Catlin's Ojibwa Indians in letters to M. de Planet on August 30 and George Sand in September 1845 (André Joubin, ed., *Correspondance générale d'Eugène Delacroix,* 5 vols. [Paris: Librairie Plon, 1935–38], 2:234, 237). Some of his sketches are reproduced in Robert N. Beetem's useful "George Catlin in France: His Relationship to Delacroix and Baudelaire," *Art Quarterly* 24 (Summer 1961): 129–45, where the Indians are identified as Ojibwas; elsewhere they have been called Iowas. Delacroix saw, and may have sketched, both groups.

48. *Notes Europe,* 2:246, 225; Gustave d'Eichthul to GC, June 27, 1846,

AAA: 2136. For the society, see
Elizabeth A. Williams, "Anthropo-
logical Institutions in Nineteenth-
Century France," *Isis* 76(September
1985): 333–35, 338.

49. GC to Sir Thomas Phillipps, [Febru-
ary] 1846, Gilcrease; *Notes Europe,*
2:293–94.

50. GC to John R. Brodhead, September
20, 1847, Benjamin F. Butler Papers,
New York State Library, Albany.

51. GC to Sir Thomas Phillipps, Febru-
ary 9, 1842, April 10, 1842,
Gilcrease; [John R. Brodhead],
"Draft" [October 4, 1847], Bartlett
Papers; Brodhead to Bartlett, Octo-
ber 4, 1847, Butler Papers (formal
communication), Bartlett Papers
(private communication); Brodhead
to Bartlett, January 28, 1848, Bart-
lett Papers.

52. See Jean-Pierre Babelon, "The Duc
de Montpensier, Painter of the New
World," in *Diary of My Travels in
America,* pp. 127–41; the paintings
selected by the king are listed in GC
to [M. Cailleux], January 25, 1846,
Vattemare Collection, NYPL. See
Notes Europe, 2:291, for the king's
pleasure with Catlin's depiction of
the Indian ball game.

53. GC to the President, NYHS, March 2,
1870, NYHS; published in *Letters,*
pp. 449–54; Truettner, *Natural
Man,* p. 53, citing Harold Mc-
Cracken, *George Catlin and the Old
Frontier* (New York: Dial Press,
1959); GC to Sir Thomas Phillipps,
February 17, 1846, Gilcrease, pub-
lished in Munby, *Formation of the
Phillipps Library,* pp. 54–56.

54. See Michael Marrinan, *Painting Poli-
tics for Louis-Philippe: Art and Ideology
in Orléanist France, 1830–1848*
(New Haven: Yale University Press,
1988), for the official taste in history
painting. Louis-Philippe's Spanish
collection—some 450 paintings—
was exhibited at the Louvre from
1838 to 1848 and influenced French
painting in the second half of the
century. Returned to Louis-Philippe
in exile in England and dispersed af-

ter his death, its richness is attested
by Jeannine Baticle and Cristina Ma-
rinas, *La galerie espagnole de Louis-
Philippe au Louvre, 1838–1848,*
Notes et Documents des Musées de
France 4 (Paris: Editions de la Ré-
union des Musées Nationaux, 1981).

55. GC to Pierre Margry, May 18
[1846], Bibliothèque Nationale,
Paris, MSS. Fr., N.A.: Margry,
9292, ff. 7–12; GC to ——, Janu-
ary 16, 1847, Massachusetts Histor-
ical Society, Boston.

56. GC to Sir Thomas Phillipps, Febru-
ary 17, 1846, October 4 [1847],
March 9, 1854, Gilcrease; Francis
Catlin diary note, [November–
December 1868], *Letters,* p. 370; GC
to President, NYHS, March 2, 1870,
NYHS; *Niles'* 72(July 10, 1847):
301; and GC to John Howard Payne,
July 18, 1847, Long Island Histor-
ical Society, Brooklyn.

57. *North and South American Indians:
Catalogue Descriptive and Instructive
of Catlin's Indian Cartoons . . .* (New
York: Baker and Godwin, 1871),
p. 91; Francis Catlin, diary note,
[November–December 1868], *Let-
ters,* p. 370. This catalog inventories
the La Salle oils Catlin exhibited in
1870, actually twenty-seven in num-
ber. For a selection in color, see
American Heritage 8(April 1957): 4–
19. GC wrote to Sir Thomas Phil-
lipps, January 23, 1853, Gilcrease: "I
came to Paris in the hope of getting
the Govt to take the 25 paintings I
made for Louis Phillipe just before
the Revolution, illustrating the dis-
coveries of Lasalle on the Mississippi,
but have failed in my object." Catlin's
letters to Sir Thomas were almost al-
ways pleas for understanding and fi-
nancial assistance and, with that end
in mind, were often self-serving tales
of woe. But in his letter to the presi-
dent, NYHS, March 2, 1870, he indi-
cated it was five years before he
reclaimed his La Salle paintings in
Paris. Subsequently he attempted to
sell them. In 1864 he sent them to
the American minister in Belgium in

hopes of securing a £30 loan that was denied (GC to Henry S. Sanford, January 28, 1864, Sanford Papers).

58. Francis Catlin, diary note, [November–December 1868], *Letters*, p.370. Once again unable to find a publisher, Catlin published his *Notes* himself. The exact timing is unclear, but it seems likely he had much of the book in draft form before his return to England. He wrote Sir Thomas Phillipps on February 16, 1848, that the work would be ready in a few weeks and enclosed a copy of the preface; on March 29 he reported his failure to find a publisher, and on May 20 he indicated that copies were ready for subscribers (Gilcrease). It was reviewed in the *Athenaeum* a week later. This time the British critics were not as charmed by Catlin's American directness, complaining of infelicities in style and arrangement and of outright bad taste—"a recklessness and a roughness in some of his anecdotes" (*Athenaeum*, no.1074[May 27, 1848]: 531), "indelicate inuendoes and *double entendres*" (*Westminster Review* 49[July 1848]: 560). The larger judgment lurking behind specific complaints was most wounding of all. "There is more of the Showman than of the Artist or of the Man of Letters in these volumes," the *Athenaeum* warned its readers, designating Catlin's work "our Showman's History of the American Indians in England and France" (no.1074[May 27, 1848]: 529; no.1075[June 3, 1848]: 553). Anecdotal though it is, *Notes* is a readable and revealing book in the classic satirical vein of the visitor from a foreign culture commenting on the peculiarities of civilized society, a point made in "Savage Views of Civilisation," *Chambers's Edinburgh Journal*, n.s. 9(June 24, 1848): 406–10, and *Art-Union* 10(July 1, 1848): 232. It is also a defensive book, chronicling the years in which Catlin's original purpose became con-

fused and his early hopes dimmed. It tells a great deal about a life that after 1848 would be enveloped in comparative obscurity. For a good evaluation, see Christopher Mulvey, "Among the Sag-a-noshes: Ojibwa and Iowa Indians with George Catlin in Europe, 1843–1848," in Christian F. Feest, ed., *Indians and Europe: An Interdisciplinary Collection of Essays* (Aachen: Edition Herodot, Rader, 1987), pp.253–75.

59. GC to Sir Thomas Phillipps, February 16, March 29, 1848, Phillipps to GC, draft, May 25, 1848, Gilcrease.

60. "Sale of the Pictures of the Late King Louis Philippe," *Times* (London), May 2, May 5, 1851; see T. J. Clark, *The Absolute Bourgeois: Artists and Politics in France, 1848–1851* (London: Thames and Hudson, 1973), chap.2, for the tyranny of historical painting and the failure of state art under the Republic.

61. Edward Waldo Emerson and Waldo Emerson Forbes, eds., *Journals of Ralph Waldo Emerson, 1820–1872*, 10 vols. (Cambridge: Riverside Press, 1909–14), 7:106.

62. See Early Lee Fox, *The American Colonization Society, 1817–1840* (Baltimore: Johns Hopkins Press, 1919), pp.73–74, and P. J. Staudenraus, *The African Colonization Movement, 1816–1865* (New York: Columbia University Press, 1961), pp.76–79, chap.4, passim. The colonizationist-abolitionist dispute is discussed in both books. Fox's treatment (chap.3) is predictably hostile to the abolitionists; Staudenraus's (pp.197–206) is considerably more balanced. William Lloyd Garrison launched the attack, accusing the colonizationists of aiding and abetting the southern slaveholders, in *Thoughts on African Colonization, or An Impartial Exhibition of the Doctrines, Principles and Purposes of the American Colonization Society* (New York: Arno Press and the New York Times, 1969 [1832]). Slavery, the abolitionists insisted, was "a heinous sin, and, like every

other sin, ought to be immediately abandoned" (William Jay, *Inquiry into the Character and Tendency of the American Colonization, and American Anti-slavery Societies* [New York: Negro Universities Press, 1969 (1838)], preface). As gradualists, the colonizationists were implicated in the sin of slavery, and G. B. Stebbins, *Facts and Opinions Touching the Real Origin, Character, and Influence of the American Colonization Society* (New York: Negro Universities Press, 1969 [1853]), quoted freely from Gurley in making the case against the society. See also Bruce Rosen, "Abolition and Colonization, the Years of Conflict: 1829–1834," *Phylon* 33(Summer 1972): 177–92.

63. See Brian W. Dippie, *The Vanishing American: White Attitudes and U.S. Indian Policy* (Middletown, Conn.: Wesleyan University Press, 1982), part 2. The abolitionists rejected this reasoning. They saw slavery and the Indian question as essentially moral issues and were particularly sensitive to America's image abroad. "In Great Britain, France, and Germany," one wrote in 1838, "we are regarded as the most cruel and rapacious peoples, since the times of Cortez and Pizarro" (David Lee Child, quoted in Linda K. Kerber, "The Abolitionist Perception of the Indian," *Journal of American History* 62[September 1975]: 277). It was this sentiment that helped account for Catlin's popularity abroad, since his defense of the Indian constituted an attack on American morality—and it was to counteract the impression that the abolitionists had a monopoly on morality that Gurley made his English tour. But Catlin would have been hard-pressed to refute Garrison's argument that free blacks were as "unanimously opposed to a removal to Africa, as the Cherokees from the council-fires and graves of their fathers" (*Thoughts on African Colonization*, 2:5).

64. "National Institution," *Newark Daily Advertiser*, September 28, 1841.

Gurley's letter, dated September 22, was reprinted from the *NI*. Putnam Catlin wrote his son on October 4 that the letter was much in his favor and augured well for his chances before the next session of Congress (*Letters*, p.220). For the Gurley-Gregory relationship, see Records of the American Colonization Society, ser.2, vols.41–43, 45 (reels 231–33, 235), Ralph R. Gurley Letterbooks, LC.

65. R. R. Gurley to Robert C. Schenck, June 4, 1846, and to James A. Pearce, June 11, 1846, NA, RG 233: House Joint Committee on the Library, 29th Congress, accompanying papers; "Memorial of R. R. Gurley" (1848). Gurley suggested that Schenck (Whig, Ohio) approach Charles H. Carroll (Clay Whig, New York), "a Friend of Catlin," William W. Campbell (American party, New York), Robert Dale Owen (Democrat, Indiana), Joseph R. Ingersoll (Whig, Pennsylvania), John Quincy Adams (Whig, Massachusetts), George P. Marsh (Whig, Vermont), and Edward D. Baker (Whig, Illinois), giving an accurate idea of which party Catlin counted on for support. Gurley's original memorial and copies of some of the supporting documents are in NA, RG 46: Senate Joint Committee on the Library, 30th Congress, accompanying papers.

66. "Catlin's North American Indians" (August 8, 1848), *House Rep. No. 820*, 30th Cong., 1st sess. (to accompany Joint Resolution H.R. No. 39).

67. Frank Davis, *Victorian Patrons of the Arts: Twelve Famous Collections and Their Owners* (London: Country Life Limited, 1963), p.85 (A. N. L. Munby titled his biography of Phillipps *Portrait of an Obsession* [London: Constable, 1967]); Sir Thomas Phillipps to GC, October 8, 1847 (Phillipps's comment on his daughter was meant to console Catlin in his grief over the death of his son); GC to Phillipps, July 10, 1851, August 25, 1848, Gilcrease.

68. GC to Sir Thomas Phillipps, December 5, 1848, Gilcrease; "Catlin, the Artist," *NI*, January 17, 1849; GC to Hon. Sir, January 4, 1849. Copies of this letter are in the Papers of John M. Clayton, vol.2, LC; Sterling Memorial Library, Manuscripts and Archives, Yale University, New Haven [to Roger S. Baldwin]; Newberry Library, Department of Special Collections, Chicago [to Daniel S. Dickinson]; and Houghton Library, Harvard University, Cambridge [to John G. Palfrey].

69. *Cong. Globe,* 30th Cong., 2d sess., p.604.

70. *NI*, March 5, 1849. Party lines were more important than sectional ones in this debate. Henry S. Foote, a Mississippi Unionist, while "as earnest and consistent an advocate of strict construction as any gentleman belonging to that school," saw no danger in the purchase of Catlin's gallery since its subject was peculiarly a federal government concern, the Indian, and thus established no precedent for the arts in general; and John M. Berrien, a Georgia Whig, thought it a "privilege" for the Senate to have the opportunity to acquire Catlin's collection.

71. Based on a letter from Davis to Joseph Emory Davis, January 1838, the editors of the Davis Papers surmise that he visited Catlin's gallery about the same time as Webster, December 1837. See Haskell M. Monroe, Jr., and James T. McIntosh, eds., *The Papers of Jefferson Davis: 1808–1840* (Baton Rouge: Louisiana State University Press, 1971), 1:434–35, for the letter, and Lynda Lasswell Crist et al., eds., *The Papers of Jefferson Davis: 1849–1852* (Baton Rouge: Louisiana State University Press, 1983), 4:17, n.6, for the editors' assumption.

72. *NI*, March 5, 1849; *Cong. Globe,* 30th Cong., 2d sess., p.603. Catlin frequently reprinted Webster's speech in a slightly modified version combining his separate comments and smoothing the prose. See, for example, his *Museum of Mankind* (London: W. J. Golbourn, 1851), pp.15–16; and *Last Rambles amongst the Indians of the Rocky Mountains and the Andes* (London: Sampson Low, Son, and Marston, 1866), pp.47–49. The Dead Sea expedition, November 1847 to December 1848, under Lieutenant William F. Lynch, was defended as a naval exercise. Lynch's two-volume *Narrative* was privately published in 1849. See *NI*, January 1, June 22, 1849.

73. *NI*, March 5, 1849; and *Cong. Globe,* 30th Cong., 2d sess., pp.604, 613, 694. Davis's speech can be found conveniently in Crist et al., *Papers of Jefferson Davis,* 4:14–17.

74. GC to Sir Thomas Phillipps, May 8, 1849, December 30, 1848; and Phillipps to GC, January 7, 1849, Gilcrease.

75. All quotations are from a three-page reprint from the *Manchester Guardian,* January 7, 1849: *Mr. Catlin's Lecture on the Valley of the Mississippi, and Its Advantages to Emigration, with an Account of the Gold Regions of California, in the Free-Trade Hall, in Manchester.* Copy in the William Robertson Coe Collection, Beinecke Library, Yale University, New Haven. Reports were circulating in America of the alleged treasure trove; a party of Texans investigated the upper waters of the Red River and the Wichita Mountains in July 1849 and returned empty-handed. They were of the opinion that the abundance of mica in the region had started the gold rumors. "The Texas Gold Hunters Returned," *NI*, July 25, 1849.

76. HRS to Thomas Hart Benton, December 9, 1848 (two drafts), HRS Papers: 12, published in *NI*, January 6, 1849; [Charles Eliot Norton], "Adventures on the Prairies," *NAR* 69(July 1849): 177. Norton blamed the publisher, not Parkman, for this bit of deception, but Parkman was not unmindful of the appeal of California in his title—see Parkman to EGS, March 15, 1849, in

Wilbur R. Jacobs, ed., *Letters of Francis Parkman,* 2 vols. (Norman: University of Oklahoma Press, 1960), 1:61.

77. "American Land Agency Swindlers," *Times* (London), June 10, 1851. In his tract *Catlin's Notes for the Emigrant to America* (London: Author [Leicester: G. Smallfield], 1848), Catlin urged "the Associative plan" on prospective immigrants and indicated he was available for discussion or correspondence as agent of a company then forming in London to buy Texas lands. The tract was intended to supplement lectures on the West's agricultural potential that Catlin was giving by November 1848. Indeed, he was already so involved in promotion that he had the temerity to praise Texas's climate as temperate in summer owing to "a constant exhilarating breeze from the Gulf of Mexico that checks the oppressive rays of a typical summer's sun." Copy in the Beinecke Library, Yale University, New Haven. Catlin probably did not visit Texas proper (still a Mexican possession) during his travels in 1834, but he got close enough to be repelled by its furnace heat on the six-day march from the Comanche village to a camp on the north bank of the Canadian River and deliver a stinging condemnation of a land of drought and polluted water (*L&N,* 2:77).

78. See W. S. Shepperson, *British Emigration to North America: Projects and Opinions in the Early Victorian Period* (Minneapolis: University of Minnesota Press, 1957), chap. 3. More than a year later Catlin was still delivering the same lecture linking emigration, Texas, and California's goldfields. A handbill (AAA: 2137) places him—"colossal maps," paintings, and all—at the London Mechanics' Institution on April 9, 1850. This and related evidence suggests that he was by then involved in the Texas promotion scheme in some official capacity, perhaps with one of the two companies before their merger.

Catlin apparently was serious about returning home in 1850; see GC to ——, February 28, 1850, Gratz Collection, AAA: P22, in which he was "anticipating a return to my own Country in a few weeks."

79. *State Gazette* (Austin), November 2, 1850, quoted in Dorothy Waties Renick, "The City of Kent," *Southwestern Historical Quarterly* 29 (July 1925): 57; Mrs. Charles F. Mackenzie to Katherine Pidcocke, quoted in ibid., p. 57. See, for one English reaction to Texas in 1849, William S. Shepperson, *Emigration and Disenchantment: Portraits of Englishmen Repatriated from the United States* (Norman: University of Oklahoma Press, 1965), pp. 75–77. By then the English press was warning would-be immigrants off Texas: "The United States as an Emigration Field," *Chambers's Edinburgh Journal,* n.s. 11 (June 16, 1849): 376, reviewing Sidney Smith's *The Settler's New Home; or, The Emigrant's Location* (1849).

80. GC to Sir Thomas Phillipps, December 14, 1850; Phillipps to GC, December 20, 1850; GC to Phillipps, July 10, 1851, Gilcrease. As late as November 3, 1853, Phillipps was still reminding Catlin of his bad judgment in wasting his money on Texas "gamblings."

81. GC to Sir Thomas Phillipps, April 15, 1851, and Phillipps to GC, July 12, 1851, Gilcrease.

82. *Notes Europe,* 1:61–63, 246–47 (app. B). The Royal Institution had a utilitarian bent that represented a realignment in English science, a principal argument in Morris Berman's *Social Change and Scientific Organization: The Royal Institution, 1799–1844* (Ithaca, N.Y.: Cornell University Press, 1978). Catlin's Museum of Mankind would not have been out of place with such institution projects as gas lighting, medical lectures, and water analyses (p. xxiv).

83. [George Catlin], *Museum of Mankind;* copy in the Boston Public Library. Catlin did not immediately

abandon his scheme; on January 9, 1852, he introduced it in an Indian Gallery lecture (*International Magazine* 5[March 1852]: 426; copy in AAA: NY 59-29), and it was mentioned in the press: *Art-Journal*, n.s. 4(March 1, 1852): 98.

84. GC to Honourable Sir [Members of Congress], April 4, 1852, copies in Morristown National Historical Park, Morristown, N.J. (to Daniel Webster), and the George Winter Collection, Tippecanoe County Historical Association, Lafayette, Indiana (to Daniel Mace); "The Productions of Aborigines in the Exhibition," *Illustrated London News* 18, no.488(May 24, 1851): 457–60; W. C. Rives, "The Great Exhibition—The American Department," *New York Times,* October 31, 1851; "Mr. Catlin's Indian Family and Its Manufactures: A Museum of Man in the Exhibition," *Illustrated London News,* suppl.19, no.512 (August 23, 1851): 254–55; and, for background, C. H. Gibbs-Smith, *The Great Exhibition of 1851,* rev. ed. (London: Her Majesty's Stationery Office, 1964), pp.32–33, 76, 129. For an illustration showing Catlin's models, see Truettner, *Natural Man,* p.57; and for a contemporary reaction, Samuel Warren, *The Lily and the Bee: An Apologue of the Crystal Palace* (Edinburgh: William Blackwood, 1851), pp.43–44.

85. "The Great Exhibition," *Illustrated London News,* 19, no.511(August 23, 1851): 235; and GC to Sir Thomas Phillipps, November 27, 1851, Gilcrease.

86. Sir Thomas Phillipps to GC, December 1, 1851, Gilcrease. See the series of clippings in a scrapbook maintained by a rival artist: "The Indian Gallery," *Cincinnati Evening Journal,* February 2, 1846; "Gallery of Indian Portraits," *Cincinnati Herald,* February 9, 1846; "The Gallery of Paintings at the Apollo," *Louisville Daily Journal,* March 7, 1846; "Stanley's Indian Gallery," *Albany State Register,* November 9, 1850; "Indian Por-

traits," *New York Sunday Times,* December 8, 1850; and "Stanley and Dickerman's Indian Portrait Gallery," *New York Express,* December 27, 1850 (Stanley Scrapbook, AAA: OAM). In his public pronouncements Catlin had always asserted his patriotic wish to see the gallery returned to America—for example, GC to J. Murray, April 14, 1840, Historical Society of Pennsylvania, Misc. Coll., AAA: P 23.

87. "The Indian Collection," *Times* (London), January 25, 1851; GC to Daniel Webster, April 4, 1852, NYHS: "My liabilities here are such at present that I much fear I shall not be able to reach Washington this Session, as I had designed." This is published in its entirety in *Letters,* pp.441–43.

88. GC to Honourable Sir, April 4, 1852. The four-page brochure was printed in London by T. Brettell and bore no title or date; the pamphlet was titled *Catlin's Indian Gallery: Opinions of the Most Celebrated Artists and Distinguished Statesmen . . . ,* bore neither date nor printing information and contained, besides Webster's speech and an extract from the 1846 committee report, the memorial of American Artists in Paris, and of American Citizens Resident in London, and the letter from George P. A. Healy (all 1846); Lewis Cass's 1841 letter; and the usual certificates (attesting to the authenticity of his portraits) that appeared in all his catalogs. Copies of both documents are with the form letter in the Winter Papers, and in NA, RG 46: SEN 32A-H25.

89. GC to Daniel Webster, April 4, 1852.

90. GC to Daniel Webster, May 8, 1852, Morristown National Historical Park, Morristown, N.J. See Peter J. Parish, "Daniel Webster, New England, and the West," *Journal of American History* 54(December 1967): 530–31; Irving H. Bartlett, *Daniel Webster* (New York: W. W. Norton, 1978), pp.145–46, 192–93, 286–88; and the section on

"Personal Finances" in C. H. Van Tyne, ed., *The Letters of Daniel Webster* (New York: Greenwood Press, 1968 [1902]). Webster's finances made him an easy target for unsympathetic Democrats and tarnished his reputation as an eminent statesman. Webster, Henry H. Sibley observed in 1842, "is regarded as a great scamp who will do anything, even sell his country if needs be, for money" (Sibley to Solomon Sibley, March 19, 1842, Sibley Papers: 3).

91. GC to Daniel Webster, April 15, 1852, Morristown National Park, Morristown, N.J.

92. GC to Webster, May 8, 1852.

93. Copy by R. R. Gurley of GC to Gurley, April 15, 1852, NA, RG 46: SEN 32A-H25; *Cong. Globe,* 32d Cong., 1st sess., p.1845 (July 20, 1852); "Mr. Catlin and His Collection of Indian Memorials," *NI,* May 26, 1852 (reprinting Gurley's letter to the *Gazette*); "Chronicle of Passing Events," *North American Miscellany and Dollar Magazine* 4 (July 1852): 271.

94. *Cong. Globe,* 32d Cong., 1st sess., p.1533; William H. Seward to GC, October 4, 1839, AAA: 2136. The draft of this letter is in the Seward Papers, University of Rochester Library, Rochester, New York.

95. Solon Borland, July 20, 1852, *Cong. Globe,* 32d Cong., 1st sess., p.1846.

96. Ibid., pp.1547–49, 1566.

97. "Report" [to accompany joint resolution S. No. 43] (June 23, 1852), *Sen. Com. Rep. No. 271,* 32d Cong., 1st sess. *NI,* July 19, 1852, published the report in full.

98. Petition, New York, June 16, 1852, NA, RG 46: SEN 32A-H25; "Report" (June 23, 1852).

99. "Report" (June 23, 1852), p.3; also GC to Webster, April 15, 1852; R. R. Gurley to Senator Seward, n.d., NA, RG 46: SEN 32A-H25 (Gurley trusted that the government "will not think of giving less than $50,000," but in citing the $25,000 figure he may inadvertently have planted it in Seward's head); GC to James A. Pearce, Chairman, Senate Committee on the Library, June 24, 1852, in *Cong. Globe,* 32d Cong., 1st sess., p.1845; ibid., p.1601 (June 23, 1852).

100. Holman Hamilton, *Prologue to Conflict: The Crisis and Compromise of 1850* (Lexington: University of Kentucky Press, 1964), pp.76–85; *Cong. Globe,* 32d Cong., 1st sess., p.1548; Robert F. Dalzell, Jr., *Daniel Webster and the Trial of American Nationalism, 1843–1852* (Boston: Houghton Mifflin, 1973), pp.251–74.

101. Daniel Webster to Fletcher Webster, July 4, 1852, in Van Tyne, *Letters of Daniel Webster,* p.532; GC to Webster, April 4, 1852. See Dalzell, *Daniel Webster and the Trial of American Nationalism,* pp.276–83; and Roy Franklin Nichols, *The Disruption of American Democracy* (New York: Macmillan, 1948). In contrast, party cohesiveness is a particular theme in studies arguing the primacy of party over section in antebellum politics: see, for example, Joel H. Sibley, *The Shrine of Party: Congressional Voting Behavior, 1841–1852* (Pittsburgh: University of Pittsburgh Press, 1967); and Thomas B. Alexander, *Sectional Stress and Party Strength: A Study of Roll-Call Voting Patterns in the United States House of Representatives, 1836–1860* (Nashville, Tenn.: Vanderbilt University Press, 1967), which, while arguing that Whigs and Democrats alike "maintained a high level of cohesion and intersectional unity" on most issues, concludes (p.110): "Forces greater than party discipline or loyalty, nonetheless, were evidently at work continuously, relentlessly forcing party to yield to section on a definable array of issues."

102. *Cong. Globe,* 32d Cong., 1st sess., pp.1845–46; see Glyndon G. Van Deusen, *William Henry Seward* (New York: Oxford University Press, 1967), p.565.

103. *NI,* March 5, 1849; Charles Lanman

to William Sidney Mount, December 21, 1849, in Alfred Frankenstein, *William Sidney Mount* (New York: Harry N. Abrams, 1975), pp.122–23; *Cong. Globe,* 32d Cong., 1st sess., p.1548.

104. GC to William H. Seward, August 1, 1852, Seward Papers, University of Rochester Library, Rochester.

105. *Cong. Globe,* 32d Cong., 1st sess., p.1846. Eastman's attempt to block Catlin could have been aided by an old friend, Charles Lanman, since 1850 Daniel Webster's private secretary and in a position to know of Catlin's desperate appeals.

106. GC to Seward, August 1, 1852; *Cong. Globe,* 32d Cong., 1st sess., p.1846.

CHAPTER 4

1. See Freeman, "Schoolcraft," pp.233–42.

2. William H. Herndon, quoted in Richard Hofstadter, *The American Political Tradition and the Men Who Made It* (New York: Vintage Books, ca. 1948), pp.93, 99.

3. Freeman, "Schoolcraft," p.73; *Memoirs,* p.255 (entry for December 18, 1826).

4. C. A. Harris, "Report of the Commissioner of Indian Affairs" (December 1, 1837), *Sen. Doc. No. 1,* 25th Cong., 2d sess., p.572; [HRS], "History and Languages of the North American Tribes," *NAR* 45 (July 1837): 58; HRS to Carey A. Harris, September 30, 1837, HRS Papers: 27 (printed in Harris, "Report," pp.573–74); Harris, "Report," p.526.

5. George Winter to A. C. Pepper, April 10, 1838, George Winter Papers, Tippecanoe County Historical Association, Lafayette, Indiana, courtesy of Mrs. Cable G. Ball. For Winter's career, and examples of his work, see *The Journals and Indian Paintings of George Winter, 1837–1839* (Indianapolis: Indiana Historical Society, 1948). A Winter paint-

ing on the vanishing Indian theme, *The Indian's Farewell,* appeared as the frontispiece to *West American Monthly* 3 (July 1854).

6. George Winter to William Blackmore, August 9, 1871, George Winter Papers; HRS to T. Hartley Crawford, December 25, 1838, HRS Papers: 8; *Memoirs,* p.631 (entry for January 4, 1839). Crawford had replied noncommitally on January 4, 1839: the department would reserve judgment until Schoolcraft's book was ready for the press. On June 8, 1843, Schoolcraft wrote Secretary of War James M. Porter that the lexicon was about finished and he was looking for the promised funding (roll 10).

7. See [HRS], "Our Indian Policy," *United States Magazine, and Democratic Review* 14 (February 1844): 169–84. The article, a showcase for Schoolcraft and his ideas at a time when he was seeking federal preferment, was a conventional defense of the removal policy that in the end admitted the idea of isolating the Indians in a western country of their own had become obsolete: "Our greatest apprehensions . . . arise from the peculiar geographical position of the Indian territory with relation to our own. . . . Our population is on the broad move West. Nothing, it is evident, will now repress them this side of the Pacific. . . . the path which has been trod by a few, will be trod by many. Now, the removed tribes are precisely in the centre of this path. . . . will those who compose . . . [this new tide of emigration] spare to trample on the red man? . . . Will they cease to desire the lands which their children want? . . . Twenty years will answer these questions."

8. Caleb Cushing, et al. (draft in HRS's hand) to James M. Porter, May 26, 1843, HRS Papers: 10; HRS to Thomas Hart Benton, January 22, 1844, roll 33; Lucius Lyon to HRS, January 23, January 31, April 16, 1844, roll 34.

9. HRS to John C. Calhoun, April 6, 1844, HRS Papers: 10.

10. See HRS Papers: 34; and Freeman, "Schoolcraft," pp.248–50; HRS to James Harper, August 10, 1844, roll 10; draft bill, with HRS to Thomas Hart Benton, January 22, 1844, roll 33 (designating the "Pres. U.S." or "Gov. of the S." to undertake the proposed survey); HRS to Albert Gallatin, January 22, 1844, HRS Papers: 33, deleted paragraph in draft letter.

11. HRS to Moses G. Leonard, April 20, Leonard to HRS, April 22, Lucius Lyon to HRS, April 22, 1844; William P. Patrick to HRS, December 4, 1844, HRS Papers: 34; HRS to James K. Polk, April 16, to William L. Marcy, June 24, to Charles S. Andrews, April 30, 1845, roll 10.

12. Augustus Schell to HRS, January 6, 1845; [New York State Legislature], "Fifteenth Section of an Act Relative to the Census or Enumeration of the Inhabitants of the State, Passed May 7, 1846"; and N. S. Benton to HRS, June 25, 1845, HRS Papers: 35. Both this and the document previously cited were printed in the appendix to HRS, *Notes on the Iroquois; or, Contributions to the Statistics, Aboriginal History, Antiquities and General Ethnology of Western New-York* (New York: Bartlett and Welford, 1846), pp.203–5. Schoolcraft accepted the post in a letter to Benton, June 27, 1845 (HRS Papers: 10); for the extension, State of New-York to HRS, January 26, 1846 (roll 35).

13. HRS to John C. Wright, February 7, 1846, and draft bill, February 11, 1846, HRS Papers: 35; HRS to John R. Bartlett, January 21, 29, 1846, Bartlett Papers.

14. HRS, *Notes on the Iroquois,* preface, dated February 7, 1846; HRS to William Medill, February 24, 1846, HRS Papers: 35.

15. *Sen. Exec. Doc. No. 68,* 29th Cong., 1st sess.; *Cong. Globe,* 29th Cong., 1st sess., pp.208, 231–32, 251, 290–91; *Sen. Journal,* 29th Cong., 1st sess., p.401. Benton was chairman of the Senate Committee on Military Affairs, accounting for his particular involvement in this matter.

16. John C. Spencer to HRS, March 7, 1846, HRS Papers: 35; "Administration of Indian Affairs," *United States Magazine, and Democratic Review* 18(May 1846): 335–36.

17. William M. Campbell to HRS, April 27, 1846, HRS Papers: 35, passim; HRS to John R. Bartlett, June 10, June 23, 1846, Bartlett Papers.

18. HRS to John R. Bartlett, July 15, 1846, Bartlett Papers; HRS note on back of draft letter, June 27, 1846, HRS Papers: 35.

19. HRS to John C. Calhoun, June 30, 1846, HRS Papers: 35. The resolutions were on the back of his draft letter.

20. The draft, in HRS's hand, signed by Cass, Dickinson, and Dix to William L. Marcy, July 21, 1846, HRS Papers: 11 (the letter also formed a part of the file "General Inquiry Respecting the Indian Tribes, Their Progress in Civilization, etc.," roll 35); *Cong. Globe,* 29th Cong., 1st sess., pp.231–32; J. L. O'Sullivan, endorsing a recommendation for HRS, July 3, 1845, roll 10.

21. Undated draft resolution (a second copy is dated August 5, 1846); HRS to William Medill, July 28, 1846, HRS Papers: 35, answering a query that implies a prior knowledge of the resolution on Medill's part.

22. HRS, Memorandum for the President, [August 1846], with penciled note regarding the interview on August 17; HRS to William L. Marcy, August 18, 1846, HRS Papers: 35. The self-justifying tone no doubt related to another HRS memorial before the Senate in 1846 (S.R. No. 34) claiming compensation for "certain disbursements" and "extra services" as Indian agent in Michigan (*Senate Journal,* 29th Cong., 1st sess., pp.200–201, 437 [March 18, July 23]).

23. *Cong. Globe,* 29th Cong., 1st sess., p.1204.

24. Undated proposal, [January 1846],

HRS Papers: 35; and *The Plan for the Investigation of American Ethnology,* printed in New York by E. O. Jenkins in October 1846, reprinted as "Plan for American Ethnological Investigation," *Annual Report, SI, 1885* (Washington: GPO, 1886), pp.907–14. See HRS to Jane Howard, October 10, 1846, HRS Papers: 11; to William J. Hough, October 12, 1846, and to Joseph Totten, October 16, 1846, roll 35.

25. HRS to Robert J. Walker, August 24, 1846, HRS Papers: 35; "Plan for American Ethnological Investigation," p.910.

26. "Memorial of George Catlin, Praying Congress to Purchase His Collection of Indian Portraits and Curiosities" (June 5, 1846), *Sen. Doc. No. 374,* 29th Cong., 1st sess., p.2; "Plan for American Ethnological Investigation," p.913; Robert Dale Owen to HRS, November 4, 1846, HRS Papers: 35.

27. John R. Brodhead to HRS, August 20, 1846, HRS Papers: 35; Albert Gallatin to John R. Bartlett, Thurs. morn, [1846–47], Bartlett Papers; Curtis M. Hinsley, Jr., *Savages and Scientists: The Smithsonian Institution and the Development of American Anthropology, 1846–1910* (Washington: Smithsonian Institution Press, 1981), chap.2; HRS to William J. Hough, December 3, 1846, HRS Papers: 11; and to Joseph Henry, December 5, 1846, roll 35; EGS to John R. Bartlett, December 31, 1846; Thomas H. Webb to Bartlett, October 25, 1846; J. R. Brodhead to Bartlett, January 4, 1847, Bartlett Papers. Webb aspired to be the Smithsonian's librarian and was much worried about rivals—the "many greedey seekers," as he put it to Bartlett on May 22, 1846. Lewis Cass continued to hope that Brodhead would yet be made secretary. Cass to HRS, October 31, 1846, HRS Papers: 35.

28. Joseph Henry to EGS, August 16, 1847, Squier Papers, LC: 1; Henry to HRS, March 6, 1847, HRS Papers:

36; George Minot, ed., *The Statutes at Large . . . December 2, 1845, to March 3, 1851* (Boston: Charles C. Little and James Brown, 1851), 9:204.

29. HRS to John R. Bartlett, July 15, 1846, Bartlett Papers.

30. HRS, *An Address, Delivered before the Was-ah Ho-de-no-son-ne, or New Confederacy of the Iroquois* (Rochester: Jerome and Brother, for the Confederacy, 1846), p.7; HRS, *Incentives to the Study of the Ancient Period of American History: An Address, Delivered before the New York Historical Society . . .* (New York: Press of the Historical Society, 1847), pp.17, 38.

31. Richard Brodhead, *Cong. Globe,* 32d Cong., 1st sess., p.2255 (August 19, 1852).

32. HRS to John R. Bartlett, July 15, 1846; William W. Turner to Bartlett, July 7, 1847, Bartlett Papers.

33. Draft table of contents, memorandum to self, January 31, February 1, 1844; and Albert Gallatin to HRS, February 21, 1844, HRS Papers: 34.

34. John R. Bartlett to HRS, August 5, 1846, HRS Papers: 35; Albert Gallatin to W. Medill, July 21, 1846, in *Information,* 3:397–402. Schoolcraft printed Gallatin's letter in order to expose his rivalry, apparently, and then refute him. He knew of the Gallatin letter because John Bartlett, in commiserating with him over the defeat of his project ("I . . . think it unfair that the Department should avail itself of your plans and suggestions, without employing you"), had applauded Gallatin's offer to Medill (Bartlett to HRS, July 27, 1846, HRS Papers: 35).

35. HRS to John R. Bartlett, August 14, 1848, April 30, 1856, Bartlett Papers; and *Information,* 3:199, 403–7. Sensitive to his own standing, Schoolcraft was no doubt further annoyed by the lavish tributes paid Gallatin following his death in 1849. Luther Bradish of the New-York Historical Society, for example, pronounced him without superior "as a general philologist, and especially in

the extent and accuracy of his knowledge of the native languages and dialects of America. . . . In Archaeology, and especially as an ethnologist, he was equally distinguished" ("The New-York Historical Society and the Late Albert Gallatin," *NI*, October 6, 1849). Bartlett delivered the eulogy before the American Ethnological Society. Gallatin's contributions included: "A Synopsis of the Indian Tribes within the United States East of the Rocky Mountains, and in the British and Russian Possessions in North America," *Archaeologia Americana: Transactions and Collections of the American Antiquarian Society,* vol. 2 (1836); "Notes on the Semi-civilized Nations of Mexico, Yucatan, and Central America," *Transactions of the American Ethnological Society,* vol. 1 (1845); and an introduction to "Hale's Indians of North-West America, and Vocabularies of North America," ibid., vol. 2 (1848). For an assessment of his work, see Robert E. Bieder, *Science Encounters the Indian, 1820–1880: The Early Years of American Ethnology* (Norman: University of Oklahoma Press, 1986), chap. 2.

36. Memorial, New York, November 30, 1846, in "Statistics, Etc., of the Indian Tribes" (February 9, 1847), *House Rep. No. 53,* 29th Cong., 2d sess., pp. 1–3; W. Medill to Jacob Thompson, February 1, 1847, ibid., p. 4 (the same materials were reprinted in *Information,* 3:617–20). The bill passed easily through both Indian Affairs committees, and debate did not touch on the proposed inquiry. See, for example, the House debate of February 26, *Cong. Globe,* 29th Cong., 2d sess., p. 518.

37. HRS to William Medill, March 17, 1847, HRS Papers: 11; W. L. Marcy to HRS, March 18, and HRS to W. L. Marcy, March 19, 1847, roll 36.

38. HRS to W. Medill, March 25, 1847, HRS Papers: 36. Medill reported that fall that Schoolcraft had already made considerable progress on his first two objectives: "Report of the Commissioner of Indian Affairs"

(November 30, 1847), *Sen. Exec. Doc. No. 1,* 30th Cong., 1st sess., p. 748.

39. Circulars, May and July 10, 1847, HRS Papers: 36; Freeman, "Schoolcraft," pp. 282–85, 288–91, for questionnaire; HRS, "Executive Address," November 15, 1847, HRS Papers: 37; and HRS to James S. Raines, May 3, 1848, roll 38.

40. Freeman, "Schoolcraft," pp. 260–61.

41. HRS to James K. Polk, [unsigned draft, December 19, 1848], HRS Papers: 39; to Lewis Cass, January 23, 1849, and Edwin Croswell, January 23, 1849, roll 12. Cass, already committed to another applicant, declined (Cass to HRS, February 6, 1849, roll 39). HRS to W. P. Mangum, February 26, 1849; Henry Whiting to Zachary Taylor, February 20, 1849, HRS Papers: 39; HRS to William H. Seward, April 30, 1849; Seward to Thomas Ewing, June 2, 1849, roll 12. HRS to William Medill, May 11, 1849; also to William L. Marcy, February 1, 1849, and to Medill, May 20, 1849, roll 39. That March Schoolcraft issued a pamphlet indicative of his ongoing interest in linguistic studies: *A Bibliographical Catalogue of Books, Translations of the Scriptures, and Other Publications in the Indian Tongues of the United States, with Brief Critical Notices* (Washington: C. Alexander, 1849). It was noticed in *NI,* March 22, 1849.

42. See David I. Bushnell, Jr., *Drawings by George Gibbs in the Far Northwest, 1849–1851,* Smithsonian Miscellaneous Collections, vol. 97, no. 8 (Washington: Smithsonian Institution, 1938); and Hinsley, *Savages and Scientists,* pp. 51–56. Gibbs kept up an extensive correspondence with Schoolcraft after his departure West—January 27, February 20, April 15, June 4, 1852, HRS Papers: 13; March 10, April 4, 1857, roll 15. His contributions can be found in *Information,* 3:99–177, 420–23, and 5:662–65.

43. James G. Swan to HRS, July 25,

1857, HRS Papers: 15; George Gibbs to HRS, March 29, 1847, roll 36.

44. Joseph Henry to John R. Bartlett, May 18, 1849, Bartlett Papers; Henry to Thomas Ewing, June 19, 1849; Peter Force et al. to Secretary of the Interior, with covering letter to HRS, June 18, 1849; HRS to Thomas Ewing, June 21, 1849, HRS Papers: 12.

45. See William Stanton, *The Great United States Exploring Expedition of 1838–1842* (Berkeley: University of California Press, 1975), pp.297–300, 305–15, 360–63.

46. Parker Cleveland et al., February 17, 1824, accompanying Robert Eastman to John C. Calhoun, of the same date, and John Chandler (Democratic Senator, Maine) to Calhoun, March 19, 1824, NA, RG 94: Records of the Adjutant General's Office, USMA Application file no.151 (1824). The biographical data on Seth Eastman is drawn from John Francis McDermott, *Seth Eastman: Pictorial Historian of the Indian* (Norman: University of Oklahoma Press, 1961); and papers in NA, RG 15: Records of the Veterans Administration, pension application file WC 171–295.

47. Samuel Henry Starr to Eliza Starr, June 26, 1849, Starr Papers, Barker Texas History Center, University of Texas, Austin (for the trust reposed in Eastman by a quick-tempered second lieutenant in the Second Dragoons); Mary H. Eastman to Benjamin Pringle, March 14, 1856, NA, RG 233: Records of the United States House of Representatives, LC Collection, box 250.

48. McDermott, *Eastman,* chap.4; and Marilyn Anne Kindred, "The Army Officer Corps and the Arts: Artistic Patronage and Practice in America, 1820–85" (Ph.D. diss., University of Kansas, 1980), chap.3, which puts Eastman within the tradition of officer-artists trained at West Point.

49. *Transactions of the American Art-Union, for the Year 1848* (New York:

George F. Nesbitt, 1849), p.22; John Francis McDermott, *Seth Eastman's Mississippi: A Lost Portfolio Recovered* (Urbana: University of Illinois Press, 1973); SE to Charles Lanman, November 1, 1847, Lanman Papers, LC.

50. Mary H. Eastman to Pringle, March 14, 1856, NA.

51. Mary H. Eastman to Henry Lewis, January 4, [1849], Henry Lewis and Family Papers, Stehli Collection, Minnesota Historical Society, St. Paul; Mary H. Eastman to Pringle, March 14, 1856, NA.

52. George W. Manypenny to Robert McClelland, December 27, 1856, Report Books of the BIA, vol.9, pp.519–21, NA, M–348, roll 9; and copy with Seth Eastman petition, December 5, 1859, NA, RG 46: SEN 39A–H1–H2, drawer 33: Petitions and Memorials (A–L) (a letter of application from Eastman was received August 28, 1848); Solitaire [John S. Robb], On Board the "Mini-Ha-Ha," Below Lake Pepin, July 15, *Weekly Reveille,* July 31, 1848; reprinted in John Francis McDermott, ed., "A Journalist at Old Fort Snelling," *Minnesota History* 31 (December 1950): 220–21.

53. C. H. Peaslee to William L. Marcy, September 28, 1848, NA, RG 94: Records of the Adjutant General's Office (AGO), 1780s–1917, Letters Received by the AGO, 16–E–1849; Mary H. Eastman to Henry H. Sibley, January 31, [1849], Sibley Papers: 5; AGO, November 8, 1848; W. L. M[arcy], November 14, 1848, NA, RG 94: Letters Received by the AGO, 16–E–1849.

54. Mary H. Eastman to Henry H. Sibley, December 20, 1848, Sibley Papers: 5.

55. *L&N,* 2:136–37.

56. Taliaferro's comment, on back of the official letter from William Clark, March 26, 1827, Taliaferro Papers: 1; Taliaferro Journal, 8:260 (entry for May 8, 1829, reporting a conversation with visiting Chippewas), roll 3; Taliaferro to HRS, September 12,

1831, roll 1; Philip P. Mason, ed., *Schoolcraft's Expedition to Lake Itasca: The Discovery of the Source of the Mississippi* (East Lansing: Michigan State University Press, 1958), pp.55, 102, n.63, 113–14, 121, 334; Taliaferro Journal, 14:110–11 (entry for July 15, 1836), roll 3 (also p.1, an undated entry attacking Schoolcraft's book, p.117, entry for July 16; and Taliaferro to A. I. Hill, August 12, 1868, roll1); Taliaferro Journal, 14:158, 162, 180 (entries for August 26, September 2, October 8, 1836), roll 3. Taliaferro's letter was published in the *Galenian* for September 20, 1836.

57. GC, Yellow Stone, June 17, 1832, *NYCA*, July 24, 1832; *L&N*, 1:209, 21, 225, 51; 86, 99, 256–57, 260–61, 264; 2:6–7, 145, 216, 250, 255.

58. Henry H. Sibley to Ramsay Crooks, December 21, 1836, Sibley Papers: 1 (Crooks was president of the "new" American Fur Company); Lawrence Taliaferro to Carry A. Harris, July 24, 1837, Taliaferro Papers: 2. This letter was consistent with Taliaferro's views as revealed in his journals, correspondence, and official documents. See Willoughby M. Babcock, Jr., "Major Lawrence Taliaferro, Indian Agent," *Mississippi Valley Historical Review* 11 (December 1924): 358–75; and Roy W. Meyer, *History of the Santee Sioux: United States Indian Policy on Trial* (Lincoln: University of Nebraska Press, 1967), pp.35–36, 41–42, 54.

59. Martha Coleman Bray, ed., *The Journals of Joseph N. Nicollet: A Scientist on the Mississippi Headwaters with Notes on Indian Life, 1836–37,* trans. André Fertey (St. Paul: Minnesota Historical Society, 1970), p.25; Joseph M. Street to Lawrence Taliaferro, December 14, 1827, Taliaferro Papers: 1; *L&N*, 2:145. Catlin's painting of a ball game played by the Indian women at Prairie du Chien shows the men sprawled on the ground in various stages of drunkenness, bottles in

hand, kegs before them, a bleak commentary on what Catlin saw.

60. Hercules S. Dousman to Henry H. Sibley, August 9, 1836, Sibley Papers: 1.

61. Henry H. Sibley, "Reminiscences: Historical and Personal," draft address, February 1, 1856, Sibley Papers: 10. His words were paraphrased in Edward Duffield Neill's official *The History of Minnesota: From the Earliest French Explorations to the Present Time* (Philadelphia: J. B. Lippincott, 1858), p.416.

62. *L&N*, 1:5; GC, "Account of a Journey to the Côteau des Prairies, with a Description of the Red Pipe Stone Quarry and Granite Bowlders Found There," *American Journal of Science and Arts* 38, no.1 (1839): 139.

63. *L&N*, 2:166, 172. In conversation with Taliaferro the day after returning to Fort Snelling, Catlin remarked that "previous to their visit no white men except one or two Traders have been permitted to go" to the quarry. Lawrence Taliaferro Journal, 14:164 (entry for September 6, 1836), Taliaferro Papers: 3.

64. See Freeman, "Schoolcraft," pp.400–403; *L&N*, 2:206; GC to Benjamin Silliman, November 24, 1839, Historical Society of Pennsylvania; Benjamin Silliman, October 14, 1839, AAA: 2136.

65. GC to Benjamin Silliman, October 20, 1841, Ayer MSS 148, Newberry Library, Chicago.

66. "Trip to the Falls of St. Anthony," unidentified clipping [from the Cincinnati *Daily Gazette*], HRS Papers: 66; GC to Silliman, October 20, 1841, Newberry. This seems to be the story Catlin referred to in his letter to Silliman, though an examination of the files of the *Gazette* for March 16, 1841, to June 15, 1842, failed to turn it up, or Catlin's promised rebuttal in the same paper. I also examined the file of the Cincinnati *Enquirer,* April 10 to September 30, 1841, and January 3, 1842, to

March 3, 1843, without finding Catlin's rebuttal. The break in the file makes this search inconclusive. It is noteworthy that the *Gazette* declared itself partial to Catlin's work and published several extracts from his *Letters and Notes* between December 31, 1841, and February 7, 1842.

67. Lawrence Taliaferro Journal, 14:163–64 (entries for September 5–6, 1836), Taliaferro Papers: 3; GC to Silliman, October 20, 1841, Newberry. Catlin never fully elaborated his case against the traders in print, though he threatened to: see *Life amongst the Indians* (London: Gall and Inglis, [1861]), p.145; *Last Rambles amongst the Indians of the Rocky Mountains and the Andes* (London: Sampson Low, Son, and Marston, 1867), p.354; and *O-Kee-Pa: A Religious Ceremony; and Other Customs of the Mandans* (Philadelphia: J. B. Lippincott, 1867), pp.50–51. He did specify some of his charges in private: GC to Henry S. Sanford, [1868], Sanford Papers.

68. Benjamin Silliman to GC, May 9, 1842, AAA: 2136.

69. H. L. Dousman to Henry H. Sibley, June 20, 1842, Sibley Papers: 3, indicates that Sibley ordered a copy of Catlin's work as soon as it became available ("The Compass & Catlins 'Expedition' I shall hand to the Capt."); H. H. Sibley to the Legislative Council of Minnesota Territory, September 11, 1849, in Neill, *History of Minnesota*, pp.513–14.

70. SE to Henry H. Sibley, December 9, 1848, Sibley Papers: 5; SE to Thomas H. Harvey, August 6, 1848, *House Exec. Doc. No. 1*, 30th Cong., 2d sess., p.444. In his annual report, October 4, 1848, Harvey endorsed Eastman's proposal in principle (p.441).

71. "Fort Snelling Investigation" (April 27, 1858), *House Rep. No. 351*, 35th Cong., 1st sess., pp.89–103, 124–31, and appendix. Eastman was ap-

pointed co-commissioner on May 25, 1857; the contract was signed June 6; and he testified on January 18 and 21, 1858. His conduct in the affair was roundly criticized in the New York *Daily Tribune*, April 28, 1858.

72. Mary H. Eastman to Henry H. Sibley, January [February] 5, [1849], January 31, [1849], Sibley Papers: 5 (Sibley had written to her about his need for an ally on January 24); H. H. Sibley and C. H. Peaslee, February 5, 1849, NA, RG 94: Letters Received by the AGO, 16–E–1849.

73. *NI*, March 5, 1849; Mary H. Eastman to Henry H. Sibley, April 30, [1849], Sibley Papers: 5. Reviews of *Dahcotah* did Captain Eastman's cause no harm either: "His paintings of Indian Life are well known and much admired, and it would be well if his pencil were called into requisition for an illustrated work on a larger scale than the present" ("Indian Legends," *Literary World* 4[May 19, 1849]: 433).

74. Mary H. Eastman to Henry H. Sibley, June 26, April 30, [1849], Sibley Papers: 5; HRS to William Medill, May 20, 1849, HRS Papers: 12 and 39. Eastman's furlough ran from September 4, 1849, to March 1, 1850. See E. D. Townsend's report, October 15, 1875, NA, RG 15: Records of the Veterans Administration, pension application file WC 171–295.

75. Freeman, "Schoolcraft," pp.253, 256; HRS to Mary E. Howard, September 13, 1846, HRS Papers: 11; HRS, Pocket journal, entry for October 6, 1842, roll 48. The earliest reference to this problem I have encountered is HRS to Jane J. Schoolcraft, December 12, 1835, roll 23.

76. Mrs. Henry R. Schoolcraft, *The Black Gauntlet: A Tale of Plantation Life in South Carolina* (Philadelphia: J. B. Lippincott, 1860), pp.467–69, 475. Schoolcraft is called Mr. Walsingham in the novel.

77. Orlando Brown to HRS, August 23, 1849, HRS Papers: 39.

78. Charles Lanman to William Sidney Mount, December 21, 1849, in Alfred Frankenstein, *William Sidney Mount* (New York: Harry N. Abrams, 1975), pp. 122–23. Lanman had been hoping for a minor post in the Bureau of Indian Affairs and was ecstatic about his War Department appointment. See the letters of recommendation of Alexander H. Stephens, January 18, 1849, and others, and Stephens to Lanman, April 25, 1849, Lanman Papers, LC.

79. Charles Lanman, *A Summer in the Wilderness; Embracing a Canoe Voyage up the Mississippi and around Lake Superior* (New York: D. Appleton, 1847), p. 59; "The Soldier Artist," *NI*, December 21, 1849.

80. McDermott, *Eastman*, p. 51. See *A Seth Eastman Sketchbook, 1848–1849* (Austin: University of Texas Press for the Marion Koogler McNay Art Institute, San Antonio, 1961).

81. J. J. Abert to Henry H. Sibley, December 23, 1849, Sibley Papers: 6; Sibley to Alexander Ramsey, December 23, 1849, Sunday evening, [December 23, 1849], and Ramsey to Sibley, December 28, 1849, Alexander Ramsey Papers, Minnesota Historical Society, St. Paul, roll 4. See the thorough discussion in William Watts Folwell, *A History of Minnesota*, rev. ed., 4 vols. (St. Paul: Minnesota Historical Society, 1956), 1:267, 459–62. The intended motto was *Quae sursum volo videre,* "I fain would see what lies beyond"; it was replaced with French on the state seal in 1858, *L'Etoile du Nord,* and while the symbolic motif was retained, its elements were modified and corrected. Ibid., 2:357–61. Mary Eastman wrote a poem explaining the seal's meaning: "Seal of Minnesota," in Neill, *History of Minnesota,* p. 517.

82. "Indian Tribes of the United States," *NI*, November 12, 1849; HRS to John R. Bartlett, December 24, 1849, Bartlett Papers; Bartlett to HRS, December 29, 1849, HRS Papers: 39. Lanman's authorship is suggested by the subject matter (he wrote on art and literature), his acquaintance with Schoolcraft, and his interest in the Indian. He helped bring Brantz Mayer and Schoolcraft together in 1851, for example, with consequences that will be discussed in the next chapter. See Mayer to Lanman, April 6, 1851, Lanman Papers, LC.

83. William L. Marcy to HRS, September 22, 1847, HRS Papers: 36; HRS to John R. Bartlett, October 13, 1847, Bartlett Papers; "Library of the Smithsonian Institution," *NI*, January 10, 1849; and "Smithsonian Institution," ibid., August 8, 1849.

84. See George P. Marsh to John R. Bartlett, November 25, 1849; recommendation by Edward Everett, April 30, 1849; Joseph Henry to Bartlett, May 18, 1849; Thomas Ewbanks to Bartlett, June 29, 1849, Bartlett Papers. Though reluctant, Joseph Henry eventually saw the secretary of state on Bartlett's behalf. Bartlett related his failed quest in letters to EGS, August 12, October 23, December 10, 1849, Squier Papers, LC: 1.

85. John R. Bartlett to EGS, December 10, 1849, Squier Papers, LC: 1; Bartlett to HRS, January 12, 1850, HRS Papers: 39. For Bartlett's early interest in the boundary commission appointment, see C. C. Jewett to Bartlett, December 21, 1849; Bartlett wrote to Thomas Ewing accepting the post of commissioner on June 18, 1850, Bartlett Papers.

86. HRS to John R. Bartlett, January 9, 1850, Bartlett Papers; HRS to Henry H. Sibley, February 1, 1850, Sibley Papers: 6.

87. A. S. Loughery to HRS, February 7, 1850, HRS Papers: 39; HRS to Loughery, February 7, 1850, roll 12.

88. Orlando Brown to W. K. Sebastian, February 8, 1850, HRS Papers: 39; Mary Eastman to Henry H. Sibley, January 31, [1849], Sibley Papers: 5, and R. Jones, Adj. Gen., Special Or-

ders No. 13, February 27, 1850, HRS Papers: 12.

89. Columbus Alexander to HRS, February 12, 1850, HRS Papers: 12; HRS to Orlando Brown, February 13, 1850; Brown to W. K. Sebastian, February 14, 1850, HRS Papers: 39; *Cong. Globe,* 31st Cong., 1st sess., p.743.

90. HRS to John R. Bartlett, January 9, 1850, Bartlett Papers; Henry R. Sibley to HRS [ca. July 1850], HRS Papers: 39; HRS to Luke Lea, July 22, 1850, roll 12. This letter was printed in its entirety in *Information,* 1:vi–viii.

91. Henry H. Sibley to HRS, [ca. July 1850], HRS to Lewis Cass, August 1, 1850, Luke Lea to D. C. Goddard, August 7, 1850, HRS Papers: 39; Goddard to the President, August 9, 1850, roll 12 (Lea's letter was printed in *Information,* 1:vi); *Senate Journal,* 31st Cong., 1st sess., pp.551, 556.

92. Lewis Cass to HRS, September 9, 1850; and HRS to James A. Pearce, September 13, 1850, HRS Papers: 12.

93. HRS to [Luke Lea], September 14, 1850, HRS Papers: 12; and *Cong. Globe, Appendix,* 31st Cong., 1st sess., p.1705 (September 25, 1850).

94. *Cong. Globe,* 31st Cong., 1st sess., p.2026. The Senate Library Committee was discharged from further consideration of the April 16 resolution on September 30, since the Indian appropriations bill accomplished all that Schoolcraft had wanted. *Senate Journal,* 31st Cong., 1st sess., p.708.

95. "Memorandum of an Agreement" signed by Lippincott and Grambo and HRS, October 21, 1850, HRS Papers: 12; and Stanton, *Great United States Exploring Expedition of 1838–1842,* pp.309, 314, 351.

96. HRS to A. S. Loughery, October 1, 1850, HRS Papers: 12; "An Extensive Publishing House," *NI,* February 10, 1853.

97. Herman J. Viola, *The Indian Legacy of Charles Bird King* (Washington: Smithsonian Institution Press and Doubleday, 1976), pp.76, 80, 85; "State of the Useful Arts," *NI,* November 17, 1849; HRS to Luke Lea, October 15, 1850, HRS Papers: 12; Stanton, *Great United States Exploring Expedition of 1838–1842,* pp.350–51; Charles Lanman to HRS, October 18, 1850, HRS Papers: 39. Forty-nine of the first volume's seventy-five lithographs were chromolithographs, utilizing color processes that, a recent student believes, were not really successful. Subsequent volumes utilized fewer lithographs and more engravings. See Peter C. Marzio, *The Democratic Art: Chromolithography 1840–1900, Pictures for a Nineteenth-Century America* (Boston: David R. Godine in association with the Amon Carter Museum of Western Art, Fort Worth, 1979), pp.27–31, 284–85.

98. HRS to Peter Force, October 26, 1850, Huntington, RH 241; SE to HRS, October 31, 1850, October [November] 4, 1850, HRS Papers: 39; SE to HRS, November 7, 1850, roll 42; SE to HRS, November 13, 1850, roll 39; SE, signed receipt, November 14, 1850, Huntington, RH 365; SE to HRS, December 5, 1850, HRS Papers: 39.

99. *Information,* 1:xiv; Constance McLaughlin Green, *Washington: Village and Capital, 1800–1878* (Princeton: Princeton University Press, 1962), pp.211–12; Mary H. Eastman to Henry Lewis, January 4, [1849], Minnesota Historical Society; Benjamin Perley Poore, *Reminiscences of Sixty Years in the National Metropolis* (New York: AMS Press, 1971 [1886]), p.493.

100. Schoolcraft was not happy with the title but noted that he was constrained by the act establishing the inquiry and the belief that, "to secure the future patronage of Congress, a strict adherence, to the terms of the organic law, would be expedient" (HRS to Francis Lieber, March 22, 1851, Lieber Collection, box 61, LI 3133, Huntington). When the sec-

ond part appeared in 1852, HRS dropped "Historical and Statistical" from the title.

101. See McDermott, *Eastman,* chap.9, for a discussion of Eastman's illustrations; Marzio, *Democratic Art,* p.30; J. B. Lippincott to HRS, January 9, 1851, HRS Papers: 12. Marzio includes the Bowen chromolithograph mentioned below in this judgment, lumping it with the lithograph *Ruins of an Antique Watch Tower,* whose defects actually accentuate the virtues of *Indians Offering Food to the Dead.*

102. In the original proposal drafted in 1846, Schoolcraft subdivided the "objects" of his inquiry into four categories: "Physical Type"; "Material Existence"; "Intellectual Existence"; and "Climate, & topography & geography" (Undated memoir, [ca. July 1846], Bartlett Papers).

103. HRS to J. B. Lippincott, December 4, 1850, HRS Papers: 12; *Memoirs,* p.165 (April 2, 1823). At the same time, using the government contract as an inducement, Schoolcraft got Lippincott to agree to publish his *Personal Memoirs*—a self-indulgent compilation from his journals and correspondence, augmented with clippings—and to pay him 50¢ per copy sold. The contract, dated December 6, 1850, is in roll 12. See Freeman, "Schoolcraft," pp.292–93, 308.

104. Joseph Henry to EGS, April 28, 1851, Squier Papers, LC: 2; Millard Fillmore to Luke Lea, February 28, 1851, HRS Papers: 40; HRS to Francis Lieber, April 8, 1851, Lieber Collection, box 61, LI 3134, Huntington.

105. "The Aboriginal Tribes of the United States," *Pennsylvania Inquirer,* September 12, 1851, clipping in HRS Papers: 12; and "Ethnological Researches Respecting the Red Men of America," *NI,* April 25, 1851. Schoolcraft's efforts to get Lieber's article reprinted can be traced in Lieber to HRS, April 16, 1851, HRS Papers: 40, and March 6, April 26, 1851, roll 12; and HRS to Lieber,

April 8, 24, 1851, Lieber Collection, box 61, LI 3134–35, Huntington. Schoolcraft's correspondence from William Gilmore Simms, editor of the *Southern Quarterly,* on the subject is conveniently printed in Mary C. Simms Oliphant, Alfred Taylor Odell, and T. C. Duncan Eaves, eds., *The Letters of William Gilmore Simms,* 5 vols. (Columbia: University of South Carolina Press, 1952–56), 3:101–2, 117–18, 129–30, 166, 176, 186. The short notices the *Southern Quarterly Review* did carry were not uncritical—see "Ethnological Researches respecting the Red-Man of America," 24, n.s. 8(July 1853): 256–57.

106. HRS to Francis Lieber, March 22, April 24, 1851, Lieber Collection, box 61, LI 3133, 3135, Huntington; Charles Wilkes to HRS, March 1, 1851, HRS Papers: 12.

CHAPTER 5

1. HRS to Francis Lieber, March 22, 1851, Lieber Collection, box 61, LI 3133, Huntington; Alex. H. H. Stuart to Charles E. Mix, July 28, 1851, HRS Papers: 40. Schoolcraft had asked for $2,000, retroactive to January 1. See [L. Lea] to Stuart, May 26, 1851, and HRS to Stuart, July 30, 1851, roll 13.

2. See, for example, SE to Gideon H. Pond, February 29, 1852, Division of Archives and Manuscripts, Minnesota Historical Society, St. Paul; Spencer F. Baird to SE, May 18, 1852 to June 3, 1854, Assistant Secretary, 1850–77: Outgoing Correspondence, SIA.

3. SE to HRS, November 24, 1851, HRS Papers: 13; [Mary H. Eastman] to HRS, January 11, 1853; HRS to [Mary Eastman], January 13, 1853 (the correspondence is about the Eastman's new baby boy and the apparently serious intention to name him after Schoolcraft); Mary H. Eastman to Mary H. Schoolcraft, December 6 [1851], [November 30 to December 3, 1851], roll 40.

4. See, for example, Washington Irving to HRS, May 5, 1851, May 27, 1852, in Ralph M. Aderman, Herbert L. Kleinfield, and Jennifer S. Banks, eds., *Washington Irving: Letters,* vol.4, *1846–1859* (Boston: Twayne, 1982) pp.249, 306.

5. George Copway to HRS, June 12, August 5, 1851, HRS Papers 40. For a positive appraisal, see J. F. A. Sanford to Henry H. Sibley, July 28, 1849, Sibley Papers: 6. For a negative appraisal, see Francis Parkman to EGS, November 18, [1849], and to Charles E. Norton, November 10, 1850, in Wilbur R. Jacobs, ed., *Letters of Francis Parkman,* 2 vols. (Norman: University of Oklahoma Press, 1960), 1:65–66, 78. Parkman was revising an earlier favorable estimate—Parkman to Norton, March 3, 1849, ibid., p.59. Squier had already lent his name to Copway's project (a western Indian state); see Kah-ge-ga-gah-bowh, or George Copway, "To the American Public," *NI*, May 23, 1849.

6. *The Life, History, and Travels of Kah-ge-ga-gah-bowh, (George Copway) a Young Indian Chief of the Ojibwa Nation, a Convert to the Christian Faith, and a Missionary to His People for Twelve Years . . . ,* 2d ed. (Philadelphia: James Harmstead, 1847), pp.vii–viii. Also see *Recollections of a Forest Life: or, The Life and Travels of Kah-ge-ga-gah-bowh, or, George Copway . . . ,* 2d ed. (London: C. Gilpin, 1851); and Dale T. Knobel, "Know-Nothings and Indians: Strange Bedfellows?" *Western Historical Quarterly* 15(April 1984): 175–98, for the argument that Copway was connected to the nativist political movement of the pre–Civil War years. Certainly he contributed to the Order of United Americans' monthly *Republic* 2(November 1851): 221–22. For a sympathetic overview, see Donald B. Smith, "The Life of George Copway or Kah-ge-ga-gah-bowh (1818–1869)—and a Review of His Writings," *Journal of Canadian Studies* 23(Fall 1988): 5–38.

7. Maungwudaus to HRS, May 2, September 26, 1855, HRS Papers: 41; Mary H. Schoolcraft to Mrs. Miller, November 17, 1851, roll 13.

8. See Freeman, "Schoolcraft," pp.309–18, for a full-blown Freudian interpretation that argues that the Indian history became an extension of Schoolcraft's ego and a means of assuaging wounded vanity; certainly he had problems distancing himself from it.

9. D. D. Owen to Henry H. Sibley [1851–52], Sibley Papers: 8; *Cong. Globe,* 32d Cong., 1st sess., pp.1142–43 (April 21, 1852).

10. Ibid., pp.875, 1136 (March 25, April 20, 1852).

11. Ibid., pp.1845–46 (July 20, 1852), 748 (March 15, 1852).

12. See W. Allston to Leonard Jarvis, June 24, 1836, in Jared B. Flagg, *The Life and Letters of Washington Allston* (New York: Benjamin Blom, 1969 [1892]), pp.288–89. As Jarvis summed up the matter eight years later (ibid., p.291), Allston "preferred being a free man to being the slave of a multitude."

13. HRS to ——, May 11, 1854, draft, HRS Papers: 41. It was a Schoolcraft conceit that he had not, "at any period of his life, sought advancement in political life, but executed with energy and interest various civic offices, which were freely offered to him" (*Memoirs,* p.xli).

14. *Cong. Globe,* 32d Cong., 1st sess., pp.1143 (April 21, 1852), 2252, 2254 (August 19, 1852).

15. Ibid., pp.871, 875–77 (March 25, 1852); 1136 (April 20, 1852).

16. George Minot, ed., *Statutes at Large and Treaties of the United States of America,* vol.10 (Boston: Little, Brown, 1855), p.19; HRS to ——, May 11, 1854, draft, HRS Papers: 41 (Schoolcraft may have been referring to Borland's remarks in 1853 as well); W. Gilmore Simms to HRS, [April 14, 1852], in Mary C. Simms Oliphant, Alfred Taylor Odell, and T. C. Duncan Eaves, eds., *The Letters of William Gilmore Simms,* 5 vols. (Co-

lumbia: University of South Carolina Press, 1952–56), 3:176.

17. *Appendix, Cong. Globe,* 32d Cong., 3d sess., p.309.

18. HRS to W. W. Turner, April 12, 1857, HRS Papers: 15; Spencer F. Baird to EGS, February 5, 1853, W. W. Turner to EGS, December 29, 1853, Squier Papers, LC: 3. Bartlett attended his wife round the clock in her final illness, literally making up for lost time, but she died in his arms, and he was "in the deepest affliction," Turner reported.

19. Francis Parkman to EGS, April 2, 1850, October 15, 1849, in Jacobs, *Letters of Francis Parkman,* 1:68, 64. Bartlett read one of Squier's communications to the October meeting of the American Ethnological Society: Evert A. Duyckinck to EGS, Squier Papers, LC: 1. See also David J. Weber, *Richard H. Kern: Expeditionary Artist in the Far Southwest, 1848–1853* (Albuquerque: University of New Mexico Press for the Amon Carter Museum, 1985), p.26.

20. John R. Bartlett to HRS, July 18, 1851, HRS Papers: 13; and "New York Historical Society," *Literary World* 11 (October 16, 1852): 250–51, quoting a letter from Bartlett of May 20, 1852; "American Ethnological Society," undated [1854] clipping, HRS Papers: 66; "New York Historical Society," p.251. This discussion follows William H. Goetzmann, *Army Exploration in the American West, 1803–1863* (New Haven: Yale University Press, 1959), chap. 5; and Robert V. Hine, *Bartlett's West: Drawing the Mexican Boundary* (New Haven: Yale University Press, 1968).

21. Goetzmann, *Army Exploration,* pp.186–95, concludes that Bartlett's line was technically correct under the terms of the treaty.

22. W. W. Turner to EGS, February 8, 1853, Squier Papers, LC: 3; Brantz Mayer to John R. Bartlett, October 30, 1856, Bartlett Papers.

23. HRS to John R. Bartlett, January 9, 1850, Bartlett Papers; Bartlett to

HRS, January 12, 1850, HRS Papers: 39; Bartlett to HRS, July 18, 1851, roll 13.

24. *Appendix, Cong. Globe,* 32d Cong., 3d sess., p.312 (April 5, 1853).

25. Ibid., p.313; John Russell Bartlett, *Personal Narrative of Explorations and Incidents in Texas, New Mexico, California, Sonora, and Chihuahua . . . ,* 2 vols. (New York: D. Appleton, 1854), 1:xii.

26. *Appendix, Cong. Globe,* 32d Cong., 3d sess., pp.313–14.

27. SE to John R. Bartlett, August 25, August 27, 1853, Bartlett Papers; W. W. Turner to EGS, October 8, 1853, Squier Papers, LC: 3; "Mr. Bartlett's American Explorations," *Literary World* 13 (December 3, 1853): 297; Millard Fillmore to John R. Bartlett, June 29, 1854, Bartlett Papers; Turner to EGS, October 8, 1853; Hine, *Bartlett's West,* p.89.

28. Francis Parkman to John R. Bartlett, January 24, 1856, Bartlett Papers.

29. [Francis Bowen], "Schoolcraft on the Indian Tribes," NAR 77 (July 1853): 245–62.

30. HRS to John R. Bartlett, May 10, 1847, Bartlett Papers.

31. HRS to Edward Everett, March 29, 1852; Everett to HRS, April 2, 1852, HRS Papers, LC: 13; Francis Bowen, *Gleanings from a Literary Life, 1838–1880* (New York: Charles Scribner's Sons, 1880), which indicates why Schoolcraft doubted Bowen's authorship; F[rancis] P[arkman] Jr., "Indian Antiquities in North America," *Christian Examiner and Religious Miscellany* 50 (May 1851): 421; HRS to H. T. Tuckerman, August 16, 1853, HRS Papers: 14.

32. Joel S. Squier to EGS, April 15, 1844; EGS to his parents, October 19, 1844; Joel S. Squier to EGS, March 4, 1846, Squier Papers, NYHS: 3.

33. Joseph Henry to EGS, April 28, 1851, Squier Papers, LC: 2; Evert A. Duyckinck to John R. Bartlett, November 19, 1849, Bartlett Papers. When he sent Squier some news-

papers the following March 5, Duyc-
kinck wrote: "You make news—not
read it." Squier Papers, LC: 1. See
Craig L. Dozier, *Nicaragua's Mos-
quito Shore: The Years of British and
American Presence* ([Birmingham]:
University of Alabama Press, 1985),
pp.57–75; and Charles H. Brown,
*Agents of Manifest Destiny: The Lives
and Times of the Filibusters* (Chapel
Hill: University of North Carolina
Press, 1980), pp.226–37. For con-
temporary coverage and a mixed re-
sponse to Squier's pugnacious diplo-
macy, see the items on Nicaragua in
NI, October 12, 13, November 19,
1849. Interestingly, one of Squier's
successors in Nicaragua would be
Solon Borland ("The Senate had
sixty-one men in it better qualified to
fulfill the duties of the post," the
New York *Times* editorialized on
July 26, 1853), and in revenge for a
personal insult that he interpreted as
an insult to the American flag, he had
San Juan del Norte (or Greytown)
leveled on July 13, 1854 (Dozier,
Nicaragua's Mosquito Shore, pp.88–
90). Borland's forte of shooting
down artists and writers had found
wider application in the diplomatic
corps.

34. "From Our London Correspon-
dent," *NI*, February 20, 1852. The
quotation is from an ultimatum de-
livered by a British officer to the Nic-
araguan government in 1848;
quoted in Dozier, *Nicaragua's Mos-
quito Shore,* p.57.

35. Pliny Miles to John R. Bartlett, April
27, 1855, Bartlett Papers; Francis
Parkman to Charles Eliot Norton,
November 10, 1850, in Jacobs, *Let-
ters of Francis Parkman,* 1:79; Norton
to EGS, April 29, 1849, Squier Pa-
pers, LC: 1; Parkman to EGS,
September 20, 1851, in Jacobs, *Let-
ters of Francis Parkman,* 1:91.

36. EGS to his parents, July 20, 1845,
Squier Papers, NYHS: 3. Also see his
letters of February 6, February 24,
and November 26, 1845.

37. HRS to John R. Bartlett, June 10,
June 23, 1846, Bartlett Papers; Bart-

lett to EGS, June 8, 1846, Squier Pa-
pers, LC: 1. See Robert E. Bieder
and Thomas G. Tax, "From Ethnolo-
gists to Anthropologists: A Brief
History of the American Ethnologi-
cal Society," in *American Anthropol-
ogy: The Early Years,* ed. John V.
Murra (St. Paul: West, 1976),
pp.11–22. For centenary tributes to
its importance to American anthro-
pological studies, see Franz Boas,
"The American Ethnological So-
ciety," *Science* 97(January 1, 1943):
7–8; Marian W. Smith, "Centenary
of the American Ethnological So-
ciety: Foreword and Brief History,"
American Anthropologist, n.s.
45(April–June 1943): 181–84; and
"Bibliography of the American Eth-
nological Society, 1842–1942,"
ibid., pp.241–43.

38. EGS to John R. Bartlett, September
21, 1846, Bartlett Papers; Benjamin
Silliman to EGS, December 22,
1846, Squier Papers, LC: 1; EGS to
his parents, June 29, November 2,
1846, Squier Papers, NYHS: 3;
Donald M. Scott, "The Popular Lec-
ture and the Creation of a Public in
Mid-Nineteenth-Century America,"
Journal of American History 66(March
1980): 793.

39. EGS to John R. Bartlett, January 24,
1847, Bartlett Papers; Bartlett to
EGS, February 8, 1847, Squier Pa-
pers, LC: 1.

40. EGS to his parents, June 9, 1847,
Squier Papers, NYHS: 3.

41. Nathaniel Hawthorne, *The Blithedale
Romance* (New York: Dell, 1960
[1852]), chaps.22–23.

42. HRS to John R. Bartlett, June 10,
1846, Bartlett Papers; "Puffery in
England," *Literary World*
13(August 6, 1853): 19–20; *Ninth
Annual Report, SI* (Washington: Bev-
erley Tucker, 1855), p.11. See
Robert Silverberg, *Mound Builders of
Ancient America: The Archaeology of a
Myth* (Greenwich, Conn.: New York
Graphic Society, 1968).

43. EGS to his parents, May 15, 1847,
Squier Papers, NYHS: 3; "American
Archeology," *Chillicothe Gazette* (?),

September 29, 1847, clipping, HRS Papers: 66; EGS to Joseph Henry, December 31, 1847, draft, Squier Papers, LC: 1; EGS to John R. Bartlett, November 12, 1848, Bartlett Papers. See Terry A. Barnhart, "A Question of Authorship: The Ephraim George Squier–Edwin Hamilton Davis Controversy," *Ohio History* 92(1983): 52–71, for a thorough discussion.

44. *Transactions of the American Ethnological Society,* vol.2 (New York: Bartlett and Welford, 1848), p.xi; E. H. Davis to John R. Bartlett, May 25, 1846, Bartlett Papers; Davis to EGS, June 4, 1846, Squier Papers, LC: 1. Davis had delivered a commencement address on archaeology when he graduated from Kenyon College in 1833. It attracted attention—including Daniel Webster's—and may have been the basis for the course of lectures on archaeology he delivered in Boston seven years later.

45. E. H. Davis to EGS, June 27, August 2, September 22, 1847, Squier Papers, LC: 1; EGS to Joel Squier, July 9, 1846, Squier Papers, NYHS: 3; EGS to John R. Bartlett, November 12, 1848, Davis to Bartlett, April 17, 1849, Bartlett Papers; P. T. Woodbury to EGS, May 3, 1850, Squier Papers, LC: 1.

46. George P. Marsh to EGS, March 6, 1847, Squier Papers, LC: 1; EGS to his parents, March 18, 1848, Squier Papers, NYHS: 3, for rueful reflections on his original "golden expectations"; Marsh to Joseph Henry, June 27, 1847; Henry to EGS, July 5, 8, 19, August 16, December 29, 1847; EGS to Henry, December 31, 1847, Squier Papers, LC: 1; *Ninth Annual Report, SI,* pp.9–10; EGS to John R. Bartlett, February 1, 1848, Bartlett Papers; EGS to his parents, March 10, March 18, May 3, 1848, Squier Papers, NYHS: 3; EGS draft letter [to E. H. Davis], September 18, 1848, Squier Papers, LC: 1. This arrangement, announced by Henry in his second annual report

(1848), was abandoned as policy in his third (1849). *Eighth Annual Report, SI* (Washington: A. O. P. Nicholson, 1854), pp.149, 161.

47. EGS to John R. Bartlett, February 1, 1848, Bartlett Papers; Joseph Henry to Messrs. Squier and Davis, February 16, EGS to Henry, February 21, George P. Marsh to EGS, March 3, 1848, Squier Papers, LC: 1; Marsh to Bartlett, March 3, 1848, Bartlett Papers; Henry to EGS, December 25, EGS to the Board of Regents, Smithsonian, December 27, 1848, and Henry to EGS, February 20, 1849, Squier Papers, LC: 1; EGS to his parents, September 17, 1848, Squier Papers, NYHS: 3.

48. *Third Annual Report, SI* (1849), reprinted in *Eighth Annual Report,* pp.160–61, 170; *Ninth Annual Report,* p.11; Joseph Henry to EGS, June 28, 1848, Squier Papers, LC: 1; EGS to John R. Bartlett, November 7, 12, 1848, Bartlett Papers; EGS to his parents, September 17, 1848, Squier Papers, NYHS: 3; Henry to EGS, September 30, December 21, 1848, Squier Papers, LC: 1. The project was a collaboration between the Smithsonian and the New-York Historical Society, which paid Squier another $100. *Eighth Annual Report, SI,* p.164. The paltry sums offered were spoofed by Henry's assistant, Spencer F. Baird, to EGS, February 5, 1853, Squier Papers, LC: 3.

49. *Information,* 5:x; also 4:113; EGS, "Lecture on American Archg. & Ethng." (undated draft), Squier Papers, LC: 13. See Josiah C. Nott's manifesto, *Two Lectures on the Connection between the Biblical and Physical History of Man* (New York: Bartlett and Welford, 1849), prefatory letter to J. D. B. De Bow; and, for an excellent history, William Stanton, *The Leopard's Spots: Scientific Attitudes toward Race in America, 1815–59* (Chicago: University of Chicago Press, 1960).

50. Squier designated *Crania Americana* "that really splendid monument of

scientific research" (*The Serpent Symbol, and the Worship of the Reciprocal Principles of Nature in America* [New York: George P. Putnam, 1851], p.22); in turn, Morton described *Ancient Monuments* as "by far the most important contribution to the Archaeology of the United States that has ever been offered to the public" (Morton to John R. Bartlett, June 8, 1847, Bartlett Papers). See also Robert E. Bieder, *Science Encounters the Indian, 1820–1880: The Early Years of American Ethnology* (Norman: University of Oklahoma Press, 1986), chap.3.

51. Samuel A. Cartwright, *Ethnology of the Negro or Prognathous Race: A Lecture Delivered November 30, 1857, before the New Orleans Academy of Science* (New Orleans: Office of the Delta, 1858), p.4; J. C. Nott, "Nature and Destiny of the Negro," *De Bow's Review* 10(March 1851): 329, 331; "The Indians of the United States—Their Past, Their Present, and Their Future," *De Bow's Review* 16(February 1854): 147. For a vivid example of the same reasoning in Congress, see the speech by John C. Mason of Kentucky, August 2, 1850, *Cong. Globe,* 31st Cong., 1st sess., p.1508.

52. EGS, *Peru: Incidents of Travel and Exploration in the Land of the Incas* (London: Macmillan, 1877), p.569; J. C. Nott to EGS, February 14, 1849, Squier Papers, LC: 1; George Gliddon to EGS, November 11, 1850, roll 2; Joseph Henry to EGS, June 23, 1847, April 11, 1848, roll 1; Gliddon to EGS, April 16, 1851, roll 2. This letter relates Gliddon's encounter with Henry, a priceless description of two kinds of midcentury science meeting face to face. See Curtis M. Hinsley, Jr., *Savages and Scientists: The Smithsonian Institution and the Development of American Anthropology, 1846–1910* (Washington: Smithsonian Institution Press, 1981), pp.25–29, 35–37.

53. Bieder and Tax, "From Ethnologists to Anthropologists," pp.17–18;

Samuel George Morton, "Physical Type of the American Indians," *Information,* 2:315–31; P. A. Browne, "Examination and Description of the Hair of the Head of the North American Indians, and Its Comparison with That of Other Varieties of Men," ibid., 3:375–93; D. Lowry, "Education, Christianity, and the Arts," ibid., 3:477–79; Samuel Forrey, "Considerations on the Distinctive Characteristics of the American Aboriginal Tribes," ibid., 4:354–65; ibid., 3:vi; also pp.373–75; 4:ix.

54. See Bieder, *Science Encounters the Indian,* chaps.4–5.

55. HRS, "Observations Respecting the Grave Creek Mound, in Western Virginia; the Antique Inscription Discovered in Its Excavation; and the Connected Evidences of the Occupancy of the Mississippi Valley during the Mound Period, and Prior to the Discovery of America by Columbus," *Transactions of the American Ethnological Society,* vol.1 (New York: Bartlett and Welford, 1845), pp.371, 385–93. The Society earlier had received a communication from H. G. Comingo on the mound and its inscription.

56. HRS to John R. Bartlett, June 10, 1846, Bartlett Papers; HRS to John R. Bartlett, January 14, 1848, HRS Papers: 11; E. G. Squier, "Observations on the Aboriginal Monuments of the Mississippi Valley; the Character of the Ancient Earthworks, and the Structure Contents, and Purposes of the Mounds; with Notices of the Minor Remains of Ancient Art," *Transactions of the American Ethnological Society* 2(1848): 200–207. The mounds were a popular topic at Society meetings, as the list of papers read but not published in the *Transactions* attests.

57. William B. Hodgson to John R. Bartlett, August 11, 1847; EGS to Bartlett, February 1, 1848, Bartlett Papers.

58. GC, "The Dighton Rock," *New-York Mirror* 16(December 29, 1838): 213 (Schoolcraft himself had read a paper

on the Dighton Rock in which he interpreted the inscriptions as Chippewayan—*Transactions of the American Ethnological Society* 1[1845]: xi); EGS, "The Alleged Monumental Evidence of the Discovery of America by the Northmen, Critically Examined," *NI*, March 27, 1849, reprinting an article in the *British Ethnological Journal* for December 1848; also EGS to John R. Bartlett, November 7, 1846, Bartlett Papers; EGS, "Historical and Mythological Traditions of the Algonquins; with a Translation of the 'Walum-Olum,' or Bark Record of the Linni-Lenape," *American Review* 3 (February 1849): 3–23; EGS to HRS, February 5, 1849, HRS Papers: 12; HRS to EGS, February 16, 1849, Squier Papers, Indiana Historical Society, Indianapolis. For evidence of the validity of the Walam Olum, see Daniel G. Brinton, *The Lenâpé and Their Legends; with the Complete Text and Symbols of the Walam Olum, a New Translation, and an Enquiry into Its Authenticity* (New York: AMS Press, 1969 [1884]).

59. John R. Bartlett to HRS, April 16, 1849, HRS Papers: 39; HRS to Bartlett, April 30, 1849, Bartlett Papers; HRS to EGS, April 30, 1849, Squier Papers, LC: 1; *Information*, 1:47, 107, 124–25.

60. HRS to EGS, February 18, February 26, 1851, Squier Papers, LC: 2; EGS to HRS, February 20, 1851, HRS Papers: 40 (drafts of Schoolcraft's letters indicate a stronger tone that was subsequently modified; Squier's work is vindicated in "Antiquities of the State of New York," *NI*, September 19, 1851); HRS to Spencer F. Baird, March 25, 1851, roll 40; HRS to ——, March 20 [1851], March 31, 1851, rolls 40, 12; Joseph Henry to EGS, April 28, 1851, Squier Papers, LC: 2.

61. W. W. Turner to HRS, September 19, 1851, HRS Papers: 40; George R. Gliddon to EGS, April 16, 1851, Squier Papers, LC: 2.

62. William B. Hodgson to EGS, August 12 [1859], Squier Papers, LC: 6; Jared Sparks to EGS, February 19, 1847; Joseph Henry to Messrs. Squier and Davis, February 16, 1848, roll 1.

63. E. H. Davis to John R. Bartlett, October 28, 1846, Bartlett Papers; Bartlett to EGS, November 13, 1846, Squier Papers, LC: 1; Brantz Mayer to EGS, September 13, 1850, June 1, 1851, roll 2; George R. Gliddon to Bartlett, March 9, 1847, Bartlett Papers; Gliddon to EGS, September 21, November 21, 1847, Squier Papers, LC: 1. Squier gave considerable room to Gliddon's views in the published monograph (*Serpent Symbol*, pp. 167–72), and Gliddon declared the book "*No. 1*, with a vengeance! . . . *first chop* 'la pure science'" (Gliddon to EGS, April 22, 1851, Squier Papers, LC: 2).

64. EGS to Francis Parkman, March 8, 1850, February 1, 1851, Squier Papers, NYHS: 3; Joseph Henry to EGS, October 3, 1850; Charles E. Norton to EGS, April 19, July 11, 1851, Squier Papers, LC: 2; W. Gilmore Simms to HRS, June 10, [1851], in Oliphant, Odell, and Eaves, *Letters of William Gilmore Simms*, 3:129–30; Wills De Hass to HRS, October 18, 1852, HRS Papers: 40; HRS to Evert A. Duyckinck, May 5, 1853 [1854], roll 14.

65. *Information*, 4:116; HRS to J. B. Lippincott, February 1, 1858, HRS Papers: 42.

66. Francis Markoe to EGS, November 14, 1852, Squier Papers, LC: 2; Charles E. Norton to EGS, February 5; EGS to Norton, February 7; Norton to EGS, February 16, 1849, Squier Papers, LC: 1; Francis Parkman to EGS, [1849], to Norton, March 3, 1849, and to EGS, March 15, 1849, in Jacobs, *Letters of Francis Parkman*, 1:58–61; EGS to Parkman, March 20, 1849, Squier Papers, NYHS: 30; [Charles E. Norton], "Ancient Monuments in Amer-

ica," *NAR* 68(January 1849): 466–67, 489–96; E. H. Davis to John R. Bartlett, April 17, 1849, Bartlett Papers.

67. Charles E. Norton to EGS, July 11, 21, 1851, Squier Papers, LC: 2. Schoolcraft's biographer, though aware of the Schoolcraft-Squier feud, accepts Bowen's authorship at face value (Freeman, "Schoolcraft," pp.277–78, 293, 388, n.45).

68. HRS to Cornelius Mather, July 25, 1853; Evert A. Duyckinck to HRS, August 8, 13, 1853, HRS Papers: 41; Duyckinck to EGS, October 25, 1849, Squier Papers, LC: 1; Curtius, "Examination of an Article in the North American Review, for July, on Schoolcraft's Thesaurus of 'Information Respecting the History, Condition, and Prospects of the Indian Tribes of the United States,'" *Literary World* 13(August 20, 1853): 51–54.

69. HRS, "Schoolcraft & His Work & N.A.R. Critic" (August 13, 1853), draft, HRS Papers: 41 (notation on the back names the *Evening Star,* but William W. Moore to HRS, August 24, 1853, roll 41, indicates the essay was subsequently submitted to the *National Intelligencer*); [Bowen], "Schoolcraft on the Indian Tribes," pp.246–47; Curtius, "Examination of an Article," p.51; "Schoolcraft & His Work & N.A.R. Critic."

70. John R. Bartlett to HRS, August 15, 1853, HRS Papers: 41. Schoolcraft had been apprised earlier of Bowen's authorship—see HRS to Henry T. Tuckerman, August 16, 1853, roll 14.

71. *Information,* 4:116; Wills De Hass to HRS, October 11, 1854, HRS Papers: 41.

72. EGS to HRS, July 22, 1854 (held until August 30), HRS Papers: 41. A complete draft, with minor variations, is in the Squier Papers, LC: 3 and 4 (for the last page, which has been separated and misdated January 2, 1858). Squier's position on the newspaper hoax was as he de-

scribed it, judging from a paper he read to the American Ethnological Society in 1852—*Literary World* 11(November 27, 1852): 347.

73. EGS, undated partial draft, [ca. July 22, 1854], Squier Papers, LC: 6.

74. Evert A. Duyckinck to John R. Bartlett, November 19, 1849 (founded in 1847, the *Literary World* aspired to be the "oracle" in ethnological reportage); HRS to Bartlett, October 13, 1847, Bartlett Papers. Schoolcraft hoped (November 19, 1847) that Joseph Henry's decision to take up residence in Washington would improve matters, and he thought of establishing a Smithsonian Club, with weekly meetings and papers. But G. T. Poussin's letter to Bartlett of January 22, 1849, indicated little had changed in Washington: "We have here, at a very few exceptions, neither entertainment or relaxation for the mind; all is politics and frequently of the most bitter taste. I really think that it will be exceedingly difficult for Washington ever to possess a literary society; for all visitors at the seat of government are actuated by self interest in asking and obtaining something from Congress" (Bartlett Papers).

75. HRS to Luke Lea, December 10, 1852, HRS Papers: 14; HRS, July 31, September 30, 1853, roll 41.

76. Mary H. Eastman to Benjamin Pringle, March 14, 1856, NA, RG 233: Records of the U.S. House of Representatives, LC Collection, box 250. Also N. B. Baker to the President of the United States, August 4, 1853, pointing out that Eastman was "laboriously engaged for the Government in the illustration of the History of the Indians, for which he has no *extra* pay,—but I suppose he even receives less than he would when in command of a post" (NA, RG 94: Records of the Adjutant General's Office, 1780s–1917: U.S. Military Academy Cadet Application Papers, 1805–66, file 326/1853).

77. HRS to Charles E. Mix, July 3, 1854,

copy, NA, RG 233: Records of the U.S. House of Representatives, LC Collection, box 250.

78. HRS, undated draft agreement with J. B. Lippincott; HRS to Lippincott, March 13, 18, 1853; HRS draft (in name of secretary of the interior) to George W. Manypenny, April 6, 1853; Robert McClelland to HRS, April 6, 1853, on reverse. Schoolcraft wrote McClelland on April 9 agreeing, "on reflection," with his decision, and on April 18 wrote Manypenny directly to make his demands (HRS Papers: 40).

79. HRS to James A. Pearce, May 10; Pearce to HRS, May 23; HRS to Pearce, June 2; Pearce to HRS, June 16, 1853. On the same day he first wrote Pearce, Schoolcraft wrote to Robert McClelland out of "a proper courtesy to the present administration," *asserting* his right to publish a private edition (HRS Papers: 40). For responses to the dedications, see Lewis Cass to HRS, June 11, 1853, RH 161, Huntington; Washington Irving to HRS, October 27, 1853, HRS Papers: 14.

80. HRS to J. B. Lippincott, April 25; Lippincott to HRS, April 28, 1853, HRS Papers: 40; HRS, "Schoolcraft & His Work & N.A.R. Critic" (August 13, 1853), draft, roll 41.

81. Robert McClelland to HRS, September 1; Charles E. Mix to HRS, October 17, 1853, HRS Papers: 41. Schoolcraft defended his work at length in a letter to the commissioner of Indian affairs, September 30, 1853, partial draft, roll 14.

82. Charles E. Mix to Robert McClelland, June 23, 1854, NA, Report Book of the BIA, 8:59–61 (Micro. M–348, roll 8); HRS to [commissioner of Indian affairs?], May 11, 1854, HRS Papers: 41.

83. Mary H. Eastman, *Aunt Phillis's Cabin; or, Southern Life as It Is* (Philadelphia: Lippincott, Grambo, 1852), p.24; *NI*, August 27, 1852; John Francis McDermott, *Seth Eastman: Pictorial Historian of the Indian* (Norman: University of Oklahoma Press,

1961), p.93. John S. Hart's anthology *The Female Prose Writers of America* (Philadelphia: E. H. Butler, 1855), p.256, claimed sales of 18,000 copies "in a few weeks" for *Aunt Phillis's Cabin* but represented Eastman with one of her Indian tales. See Ann D. Wood, "The 'Scribbling Women' and Fanny Fern: Why Women Wrote," *American Quarterly* 23(Spring 1971): 3–24; and Carl Bode, *The Anatomy of American Popular Culture, 1840–1861* (Carbondale: Southern Illinois University Press, 1959), chap.12.

84. "Indian Legends," *Literary World* 4(May 19, 1849): 433; and "Indian Legend—The Iris for 1852," ibid., 9(September 20, 1851): 227. This was a revealing judgment given the contrived romanticism of these "illuminations." Another reviewer thought the colored plates *The Iris's* outstanding feature and lavished praise not on Eastman but on Duval, a magician at his craft (*NI*, November 19, 1851).

85. "Books of the Season," *Literary World* 13(November 5, 1853): 231–32; Mary H. Eastman to Charles H. Baker, May 6, [1871], Charles H. Baker Papers, Minnesota Historical Society, St. Paul.

86. M. L. Crimmins, ed., "W. G. Freeman's Report on the Eighth Military Department," *Southwestern Historical Quarterly* 52(April 1949): 445–46; Charles E. Mix to Robert McClelland, June 12; HRS to Mix, July 3, 1854, copies, NA, RG 233: Records of the United States House of Representatives, LC Collection, box 250. Schoolcraft was more specific about Eastman's contribution in an undated draft (ca. July 3, 1854), HRS Papers: 41.

87. Robert McClelland to Jefferson Davis, July 13; Davis to McClelland, August 4, 1854, NA, RG 94: Adjutant General's Office, Letters Received, I 17, 1854.

88. *Sixth Annual Report, SI* (Washington: A. Boyd Hamilton, 1852), p.108 (Silverberg, *Mound Builders of*

America, pp.135–51, offers an amusing account of Pidgeon's work); Squier, *Serpent Symbol,* pp.139–44 (Squier corresponded with Pidgeon, whose book appeared the year after *Serpent Symbol*); HRS to Henry H. Sibley, January 17, 1852, HRS Papers: 40.

89. HRS to ——, October 30, 1849, HRS Papers: 12.

90. W. W. Turner to EGS, August 15, 1854, Squier Papers, LC: 3; Hinsley, *Savages and Scientists,* pp.49–50; Joseph Henry to John R. Bartlett, May 18, 1849, Bartlett Papers; "Professor Turner's Letter on Indian Philology" (December 16, 1851), *Sixth Annual Report, SI,* pp.97–101; W. W. Turner to EGS, October 8, 1853, August 15, October 11, 1854, Squier Papers, LC: 3; Turner to Bartlett, November 25, 1854; Henry to Bartlett, December 7, 1859, Bartlett Papers; Henry to EGS, December 8, 1859, Squier Papers, LC: 4; Turner to Bartlett, November 20, 1857, Bartlett Papers.

91. "American Ethnological Society: The Aboriginal Semi-Civilization of the Great California Basin, with a Refutation of the Popular Theory of the Northern Origin of the Aztecs of Mexico," unidentified clipping, [1854], copies in HRS Papers: 66, and Squier Papers, LC: 14; EGS to ——, February 21, 1849, Squier Papers, LC: 1.

92. Buckingham Smith to John R. Bartlett, November 27, 1853, Bartlett Papers; and Smith to HRS, November 27, 1853, HRS Papers: 41; W. W. Turner to EGS (accompanied by a letter from Smith), August 15, 1854, Squier Papers, LC: 3; "Communication Relative to the Publication of Spanish Works on New Mexico," *Tenth Annual Report, SI* (Washington: A. O. P. Nicholson, 1856), pp.307–9; Turner to EGS, November 16, 1854; Smith to EGS (enclosed with Turner to EGS, August 15, 1854), Squier Papers, LC: 3; Francis Parkman to George H. Moore, November 28, 1856, and

to Charles E. A. Gayarré, June 27, 1857, in Jacobs, *Letters of Francis Parkman,* 1:121, 129; *Information,* 3:297.

93. Brantz Mayer to Charles Lanman, April 6, 1851, Lanman Papers, LC; Brantz Mayer to HRS, September 24, 1851, HRS Papers: 40 (Schoolcraft cited Mayer's *Tah-gah-jute, or Logan and Captain Michael Cresap* (Baltimore: John Murphy for the Maryland Historical Society, 1851) in *Information,* 3:56, 4:616, as definitive); Brantz Mayer to HRS, August 10, 1852, HRS Papers: 13; Brantz Mayer to John R. Bartlett, October 30, 1856, Bartlett papers.

94. Brantz Mayer to John R. Bartlett, June 13, 1845, June 15, 1853, Bartlett Papers, Mayer to EGS, May 30, 1849, Squier Papers, LC: 1; Mayer to EGS, March 23, 1851, roll 2.

95. Brantz Mayer to HRS, August 25, September 3, 1852, HRS Papers: 13; and Mayer to HRS, [November 1852], roll 14; *Information,* 3:335–51; Mayer to HRS, October 4, 1854, roll 41; SE to Mayer, May 14, 1854, Beinecke Rare Book and Manuscript Library, Yale University, New Haven.

96. Brantz Mayer to EGS, October 10, 1854, Squier Papers, LC: 3. Richard H. Kern's considerable contribution to the same section of Schoolcraft's history was also ignored. See Weber, *Richard H. Kern,* pp.202–8.

97. HRS to Commissioner of Indian Affairs, September 30, 1853, draft, HRS Papers: 14; Buckingham Smith to EGS, September 13, [1854], Squier Papers, LC: 6. See Charles E. Mix to HRS, September 2, 1854, HRS Papers: 41, for Indian Office pressure.

98. Smith to EGS, September 13, [1854]. Congress passed the bill on July 29; it was signed into law on the thirty-first (*Cong. Globe,* 33d Cong., 1st sess., p.2246).

99. This is based on Buckingham Smith to EGS, [September 21, 1854], Squier Papers, LC: 6. Mayer's con-

sultation with Eastman is confirmed by SE to Mayer, [October] 7, 1854, Beinecke Rare Book and Manuscript Library, Yale University, New Haven; and Mayer to HRS, October 4, 1854, HRS Papers: 41.

100. HRS to John Bachman, September 23, 1854, in Stanton, *Leopard's Spots,* p.192; Mary H. Schoolcraft to ——, October 9, 1854, HRS Papers: 41; HRS to Joseph Henry, August 31, 1854, RH 244, Huntington (also "Schoolcraft's Ethnological Researches," unidentified clipping [1854], HRS Papers: 63); Wills De Hass to HRS, October 2, October 11, 1854, HRS Papers: 41; October 18, 1854, roll 40. See J. C. Nott and Geo. R. Gliddon, *Types of Mankind; or, Ethnological Researches . . .* (Philadelphia: Lippincott, Grambo, 1854), pp.652–53, for Gliddon's dismissal of the relic.

101. HRS to Charles E. Mix, September 5, 1854; HRS to Lewis Cass, January 1, 1855, HRS Papers: 41. The original draft included an extended statement on Squire, indicating that Schoolcraft was still trying to contain the damage done his work by the *North American Review.*

102. George R. Gliddon to EGS, August 31, Josiah C. Nott to EGS, October 24, Brantz Mayer to EGS, October 10, September 10, 1854, Squier Papers, LC: 3. Nott warned Squier off any Gliddon get-rich-quick scheme but himself collaborated on a sequel of sorts to their *Types of Mankind, Indigenous Races of the Earth; or, New Chapters of Ethnological Enquiry . . .* (Philadelphia: J. B. Lippincott, 1857). There is a substantial body of material on this railroad scheme in the Library of Congress (Squier Papers: 8–9) and the Huntington Library. The railroad brought Squier back to Central America in 1853 (one reason Bartlett doubted he had written the *North American Review* attack on Schoolcraft) and occupied much of his time at home and abroad through the 1850s. Gliddon was in Panama as an

agent for the company at the time of his death in 1857. Stephens shared a similar fate promoting the interests of the Panama Railroad, of which he was president. It, at least, was completed in 1855, three years after his death; the Honduras Interoceanic Railway, despite Squier's best efforts, was never built. See *Huntington Library Bulletin,* no.1 (May 1931): 76–77; and Jerry E. Patterson and William R. Stanton, "The Ephraim George Squier Manuscripts in the Library of Congress: A Checklist," *Papers of the Bibliographical Society of America* 53 (4th quarter 1959): 325–26.

103. Wills De Hass to HRS, October 18, 1854, HRS Papers: 40; Brantz Mayer to HRS, October 4, 1854, roll 41; and to EGS, December 5, 1854, Squier Papers, LC: 3.

104. HRS to [commissioner of Indian affairs?], May 11; HRS to J. B. Lippincott, December 28, 1854, HRS Papers: 41 (the dating of this letter is problematical, but it was drafted either December 28 or January 3, and the year had to be 1854 or 1855); Lippincott to HRS, October 30, 1854, HRS Papers: 14.

105. *Cong. Globe,* 33d Cong., 2d sess., pp.130, 733 (December 26, 1854, February 14, 1855); HRS to SE, April 28, 1855, HRS Papers: 41.

106. HRS to Stephen A. Douglas, December 29, 1854, and to Lewis Cass, January 1, 1855, HRS Papers: 41. Also see "Indian Statistics" (December 29, 1854), *Sen. Exec. Doc. No. 13,* 33d Cong., 2d sess., p.10, a letter from Schoolcraft to George W. Manypenny, November 18, 1854, making the case for continuing the history. Senator William K. Sebastian (Democrat, Arkansas) was Schoolcraft's ally in calling for the letter's publication—*Cong. Globe,* 33d Cong., 2d sess., p.19.

107. Contract, Charles E. Mix and Lippincott, Grambo & Co., October 13, 1854, HRS Papers: 14; J. B. Lippincott to HRS, November 30, George W. Manypenny to HRS, April 27,

HRS to Manypenny, April 30, 1855, roll 41; Manypenny to Robert Mc-Clelland, May 4, 1855, NA, Report Book of the BIA, 8:436–37 (microfilm M–348, roll 8); McClelland to Manypenny, May 5, 1855, HRS Papers: 41; *Appendix, Cong. Globe,* 33d Cong., 2d sess., p.414. McClelland was adamant that Schoolcraft complete the fifth volume within the fiscal year ending June 30; Schoolcraft delivered the manuscript into Manypenny's hands that day.

108. SE to Jefferson Davis, December 15; Davis to S. Cooper, December 23; Cooper to SE, December 26, 1854, NA, RG 94: Adjutant General's Office, Letters Received, E 187, 1854; Cooper, Special Orders, No. 85, May 10, 1855; Davis to Robert Mc-Clelland, May 11, 1855, NA, RG 75; Miscellaneous, W526; HRS to SE, April 28, 1855, HRS Papers: 41; Mary H. Eastman to John R. Bartlett, October 1, 1855, Bartlett Papers. Eastman rejoined his regiment in Texas on June 17 and served there until July 20, 1856. The delay in reassigning him was a final concession by the War Department. See George W. Manypenny to McClelland, January 6, 1855, NA, RG 233: Records of the U.S. House of Representatives, LC Collection, box 250.

109. Lewis Cass to HRS, May 7, 1855; HRS quoted in George W. Manypenny to HRS, April 27, 1855, HRS Papers: 41.

110. "Schoolcraft's Statistics of the Indian Tribes—Vol. V," Washington *Daily Union,* December 2, 1855, clipping, HRS Papers: 63; J. B. Lippincott to HRS, December 1, 1857, roll 15. Tidball, who accompanied Lieutenant A. W. Whipple on his survey along the thirty-fifth parallel in 1853–54, contributed illustrations to the third volume of the Pacific Railroad Survey *Reports,* issued in 1856. See Robert Taft, *Artists and Illustrators of the Old West, 1850–1900* (New York: Charles Scribner's Sons, 1953), pp.27–29, 256–57, n.17.

111. *Information,* 5:105, 164, 662–65; 6:232, 602–3; EGS to HRS, January 2, 1858, HRS Papers: 15. HRS to J. B. Lippincott, February 1, 1858, roll 42, indicates that Squier may also have published the full text of his July 22, 1854, letter, though I have not located it in print.

112. [Bowen], "Schoolcraft on the Indian Tribes," pp.255–56. Suggestive, too, is Gliddon's reference to the *North American Review* in his own attack on Schoolcraft in *Indigenous Races of the Earth,* p.419.

113. "Our Washington Correspondence: Wasteful Extravagance in Public Printing," *New York Herald,* January 17, 1858.

114. EGS to HRS, January 2, 1858, HRS Papers: 15; draft, Squier Papers, LC: 4.

CHAPTER 6

1. "Catlin's North American Indians" (August 8, 1848), *House Rep. No. 820,* 30th Cong., 1st sess., p.2. For Miller, see pp.301–2; for Bodmer, chap.7, pp.365–68.

2. "Indian Gallery of Paintings," NI, February 23, 1852.

3. Frederick Stearns and Augustus W. Leggett to Alice C. Stanley, April 20, 1872; "Death of Stanley, the Artist," *Detroit Tribune,* April 10, 1872; also "Death of J. M. Stanley," *Detroit Post,* undated clipping (April 10, 1872); and "The Death of Mr. Stanley—Resolutions of Respect," unidentified clipping, Stanley Papers, AAA: 687.

4. Harry L. Coles, *The War of 1812* (Chicago: University of Chicago Press, 1965), p.149. See Julie Schimmel, "John Mix Stanley and Imagery of the West in Nineteenth-Century American Art" (Ph.D. diss., New York University, 1983), chaps.1–2, the best biographical source. Also see David I. Bushnell, Jr., "John Mix Stanley, Artist-Explorer," in *Annual Report, SI, 1924* (Washington, GPO, 1925), pp.507–12; Nellie B. Pipes, "John Mix Stanley, Indian Painter," *Oregon Historical Quarterly* 33 (Sep-

tember 1932): 250–58; W. Vernon
Kinietz, *John Mix Stanley and His In-
dian Paintings* (Ann Arbor: Univer-
sity of Michigan Press, 1942); and
Robert Taft, *Artists and Illustrators of
the Old West, 1850–1900* (New
York: Charles Scribner's Sons,
1953), chap.1.

5. Lawrence Taliaferro Journals, 15:26
(entry for June 30, 1838), Taliaferro
Papers: 4. For the portrait see Rena
Neumann Coen, "Taliaferro Portrait:
Was It Painted by Catlin?" *Minnesota
History* 47(Winter 1971): 295–300.
Coen argues that Catlin was the artist
responsible, but I think Stanley is
more likely. Catlin was already a ce-
lebrity when he visited Fort Snelling
in 1835 and 1836, and Taliaferro re-
ported his doings fairly fully; he
likely would have remarked on Cat-
lin's painting his portrait. Stanley, in
contrast, was an unheralded itinerant
artist and a professional portraitist
when he visited Snelling in 1838; his
presence was merely noted by Tal-
iaferro despite the fact he commis-
sioned him to paint the locale and
may well have ordered his portrait as
well. See also "Death of J. M.
Stanley," *Detroit Post,* undated clip-
ping (April 10, 1872), Stanley Pa-
pers, AAA: 687; and "Death of
Stanley, the Artist," *Detroit Tribune,*
April 10, 1872.

6. John C. Spencer to the Superinten-
dents of Indian Affairs, the Agents,
Sub agents, and other officers con-
nected with the administration of In-
dian affairs—Military and Civil,
August 17, 1842, Stanley Papers,
AAA: 687; "Indian Paintings by
Stanley," unidentified clipping
(Washington, 1852), Stanley Scrap-
book, p.43, AAA: OAM. The clipping
merely asserts that Stanley hit on the
idea of forming his own Indian gal-
lery while visiting in Washington in
1835. Perhaps the portraits by King
were his inspiration, but the article
goes on to make the case for Stanley's
superiority to Catlin. Also see Schim-
mel, "John Mix Stanley," pp.34–53.

7. Untitled clipping, *Van Buren Intel-*

ligencer (1843); S. [JMS], "Indian
Scenes, & c.," unidentified clipping
datelined Fort Gibson, Cherokee Na-
tion, May 31, 1843, Stanley Scrap-
book, p.5, AAA: OAM.

8. John Ross to John Howard Payne,
January 27, 1838, and to Elizabeth
Milligan, April 10, 1838, in Gary E.
Moulton, ed., *The Papers of Chief John
Ross,* 2 vols. (Norman: University of
Oklahoma Press, 1985), 1:586–89,
626; Ross, "Address to the Indian
Council (Tahlequah, Cherokee Na-
tion, June 24?, 1843), ibid., 2:165;
Sumner Dickerman, "Indian Scenes,
&c.," unidentified clipping datelined
Bayou Menard, Cher. Nation, Au-
gust 4, 1843, Stanley Scrapbook,
p.3, AAA: OAM. Six Ross family por-
traits, all painted in 1844, are re-
produced in Kinietz, *John Mix Stan-
ley,* plates XXII–XXVII; some might
have been worked up from earlier
studies.

9. Dickerman, "Indian Scenes, &c."
(1843); untitled clipping, *Van Buren
Intelligencer* (1843), Stanley Scrap-
book, p.2, AAA: OAM.

10. "The Fine Arts," *Van Buren Intel-
ligencer,* undated clipping, Stanley
Scrapbook, p.1, AAA: OAM.

11. "Indian Portraits," *American Republi-
can,* May 21, 1845 (reprinting item
from the St. Louis *New Era,* May
15), Stanley Scrapbook, p.2, AAA:
OAM; William H. Goetzmann, *Army
Exploration in the American West,
1803–1863* (New Haven: Yale Uni-
versity Press, 1959), pp.111–15.

12. Adv., *Cincinnati Enquirer,* January
14, 1846; untitled clipping, Troy,
N.Y., *Budget* (August, 1845); "In-
dian Portrait Gallery," *Cincinnati
Daily Times,* January 14, 1846,
Stanley Scrapbook, pp.6, 2, 7, AAA:
OAM; *Catalogue of Pictures, in Stanley
and Dickerman's North American In-
dian Portrait Gallery; J. M. Stanley,
Artist* (Cincinnati: Daily Enquirer
Office, 1846), copy in the Rare Book
Collection, LC.

13. "Indian Gallery," *Cincinnati En-
quirer,* January 21; "Indian Por-
traits," *Cist's Cincinnati Advertiser*

(January); "North American Indian Portrait Gallery," *Cincinnati Gazette,* January 21; "Indian Portrait Gallery," *Cincinnati Daily Times,* January 24; "Patronage of Artists and Authors, &c.," *Cincinnati Evening Journal,* February 17, 1846, Stanley Scrapbook, pp.6–8, 14, AAA: OAM.

14. Adv., unidentified paper (Louisville, Ky.), March 3, 1846; and "The Gallery of Paintings at the Apollo," *Louisville Daily Journal,* March 7, 1846, Stanley Scrapbook, pp.14, 16, AAA: OAM.

15. Bernard DeVoto, *The Year of Decision, 1846* (Boston: Little, Brown, 1943); "America in 1846: The Past—The Future," *United States Magazine, and Democratic Review* 18(January 1846): 64, 59; "The War," ibid., 20(February 1847): 99; "The Fine Arts," *Broadway Journal* 1(April 19, 1845): 254. Deas, it should be noted, was living in New York when Catlin's Indian Gallery passed through and shifted his attention to the West, causing him to relocate in St. Louis. In 1848, the year he was declared legally insane, Deas announced his intention of forming an Indian gallery of his own. See John Francis McDermott, "Charles Deas: Painter of the Frontier," *Art Quarterly* 13(Autumn 1950): 294, 297; and Carol Clark, "Charles Deas," *American Frontier Life: Early Western Painting and Prints* (New York: Abbeville Press for the Amon Carter Museum, Fort Worth, and the Buffalo Bill Historical Center, Cody, 1987), pp.51–77.

16. "Indian Portrait Gallery," *Ohio Union* (Cincinnati), January 26; "Indian Portrait Gallery—No. 1," *Cincinnati Enquirer,* January 29; An Admirer of Art and Friend to Modest Merit, Communication, *Cincinnati Enquirer,* February 12, 1846, Stanley Scrapbook, pp.9–10, 13, AAA: OAM. Dickerman almost certainly wrote this piece, which, with minor variations, accompanied press coverage of the gallery in other cities.

17. "Letter from Mr. J. M. Stanley," un-

identified clipping datelined Saukie Camp, Keokuk's Lodge, May 13, 1846, Stanley Scrapbook, p.16, AAA: OAM; Josiah Gregg to George Engelman, April 17, 1846, in Maurice Garland Fulton, ed., *Diary and Letters of Josiah Gregg: Southwestern Enterprises, 1840–1847* (Norman: University of Oklahoma Press, 1941), p.188.

18. "Interesting from California: *Letters from John M. Stanly,*" unidentified clipping printing two letters, JMS to Sumner Dickerman, January 24, 1847, and JMS to ——, January 19, 1847, Stanley Scrapbook, p.18, AAA: OAM. For a supplementary account, see Dwight L. Clarke, ed., *The Original Journals of Henry Smith Turner: With Stephen Watts Kearny to New Mexico and California, 1846–1847* (Norman: University of Oklahoma Press, 1966); and for an objective treatment of the controversial battle at San Pasqual, see Clarke, *Stephen Watts Kearny: Soldier of the West* (Norman: University of Oklahoma Press, 1961), chap.15. There is disagreement over the number of American casualties, estimates of those killed (including a wounded man who later died in San Diego) ranging from eighteen to twenty-two.

19. Untitled clipping (*Oregon Spectator,* July, 1847), Stanley Scrapbook, p.18, AAA: OAM. See J. Russell Harper, *Paul Kane's Frontier, Including "Wanderings of an Artist among the Indians of North America" by Paul Kane* (Toronto: University of Toronto Press for the Amon Carter Museum, Fort Worth, and the National Gallery of Canada, Ottawa, 1971).

20. Peter Skene Ogden to Paul Kane, September 2, 1847, ibid., p.329.

21. Paul Kane, *Wanderings of an Artist among the Indians of North America* (London: Longman, Brown, Green, Longmans, and Roberts, 1859), chaps.16–21.

22. Ogden to Kane, September 2, 1847, p.329. Stanley arrived at Tshimakain October 24 and proceeded on to

Colvile on the twenty-eighth; he returned to Tshimakain with Walker on November 9 and left for Waiilatpu on November 23. His activities in the Colvile-Tshimakain area are mentioned in Clifford M. Drury, *Nine Years with the Spokane Indians: The Diary, 1838–1848, of Elkanah Walker* (Glendale, Calif.: Arthur H. Clark, 1976), pp.418–25; and Drury, ed., *First White Women over the Rockies: Diaries, Letters, and Biographical Sketches of the Six Women of the Oregon Mission Who Made the Overland Journey in 1836 and 1838,* 2 vols. (Glendale, Calif.: Arthur H. Clark, 1963), 2:322–23.

23. This is based on four letters: JMS to Mssrs. Walker and Eells, December 2, 31, 1847, Beinecke Rare Book and Manuscript Library, Yale University, New Haven; JMS to ——, January 8, 1848, in "The Indian War in Oregon," unidentified clipping, and JMS to ——, March 7, 1848, "Letter from Oregon," unidentified clipping, Stanley Scrapbook, pp.16, 22, AAA: OAM. Stanley's letter of December 2, carried back to Tshimakain by Solomon, was received on December 9 and provided the mission with its first news of the murders at Waiilatpu, precipitating a wave of fear. Both of Stanley's letters to Walker and Eells and letters to Walker from John Lee Lewes at Fort Colvile were reprinted in Samuel A. Clarke, "Pioneer Days: New Light Thrown on the Massacre of Dr. Whitman and His Family," *Morning Oregonian* (Portland), August 30, 1885. The situation at Fort Walla-Walla was marked by anxiety. See JMS to [J. B. A. Brouillet?], March 10, 1848, in "Indian Wars in Oregon and Washington Territories" (January 25, 1858), *House Exec. Doc. No. 38,* 35th Cong., 1st sess., p.54.

24. Peter Skene Ogden to Paul Kane, March 12, 1848, Harper, *Paul Kane's Frontier,* p.331; [Elkanah Walker], "Traditions Superstitions Manners & Customs of the Indians in the Northern Part of Oregon," a

letter to JMS, [ca. 1848], Beinecke Rare Book and Manuscript Library, Yale University, New Haven; Ogden to Kane, March 12, 1848, p.331; James Douglas to George Abernethy, January 8, 1848, in *The Works of Hubert Howe Bancroft,* vol.29: *History of Oregon,* part 1 (San Francisco: History Company, 1886), p.686. For a thorough overview of events, see Clifford M. Drury, *Marcus and Narcissa Whitman and the Opening of Old Oregon,* 2 vols. (Glendale, Calif.: Arthur H. Clark, 1973), vol.2.

25. Matilda J. Sager Delaney, *A Survivor's Recollections of the Whitman Massacre* (Spokane: Esther Reed Chapter, Daughters of the American Revolution, 1920), pp.26–27; JMS to ——, January 8, 1848, "The Indian War in Oregon"; JMS to ——, March 7, 1848, "Letter from Oregon"; and JMS to Messrs. Walker and Eells, February 24, 1848, Beinecke Rare Book and Manuscript Library, Yale University, New Haven. Stanley was the house guest of John McLoughlin, former Hudson's Bay Company chief factor, now an American citizen resident in Oregon City. See Drury, *Marcus and Narcissa Whitman,* 2:299.

26. JMS to Walker and Eells, February 24, 1848, Beinecke; Ogden to Kane, March 12, 1848, Harper, *Paul Kane's Frontier,* p.331; and JMS to Walker and Eells, December 31, 1847, Beinecke. Stanley's story did not coincide with that of Solomon, who told Walker and Eells that the two men were within six miles of Waiilatpu, not one or two as Stanley had it, when they were warned away, that the Cayuse who stopped them never drew his pistol, and so on. See Cushing Eells to David Green, December 10, 1847, in William A. Mowry, *Marcus Whitman and the Early Days of Oregon* (New York: Silver, Burdett, 1901), pp.291–93.

27. *Catalogue of Pictures in Stanley and Dickerman's North American Indian Portrait Gallery* (1846), with tipped-in page (ca. 1850), nos.89–90, 101,

106, 123, 131 (copy in the Rare Book Collection, LC); and Peter Skene Ogden to JMS, July 3, 1848, copy with Petition of John M. Stanley (1852), NA, RG 46: Records of the U.S. Senate, SEN 34A–H10; and printed in [JMS], *Memorial: To the Honorable Senate and House of Representatives of the United States of America, in Congress Assembled* (Washington, January 12, 1863), copy in the Rare Book Collection, LC.

28. JMS to S. H. Burton, November 2, 1848, in "J. M. Stanley, the Artist," unidentified clipping (Cincinnati), Stanley Scrapbook, p.19, AAA: OAM; also "Sandwich Island Notices," etc., ibid., pp.20–21; Charles Jordan Hopkins to R. C. Wyllie, and JMS receipt, November 16, 1849, and *Polynesian,* September 16, 1848, Stanley Papers, AAA: 687; and Robert V. Hine and Savoie Lottinville, eds., *Soldier in the West: Letters of Theodore Talbot during His Services in California, Mexico, and Oregon, 1845–53* (Norman: University of Oklahoma Press, 1972), p.113; JMS to ——, November 6, 1848, untitled clipping, Stanley Scrapbook, p.16; Hopkins to Wyllie, November 16, 1849; Wyllie to JMS, February 4, 1850, Stanley Papers; AAA: 687; and "The North American Indian Portrait Gallery," *Troy Daily Whig,* August 14, 1850, and untitled clipping, *Cincinnati Times* (ca. 1850), Stanley Scrapbook, pp.23, 32.

29. "Stanley's Indian Portrait Gallery," *Troy Daily Whig,* September 2; "Indian Gallery," *Troy Daily Post,* September 3; "Stanley's North American Indian Gallery," *Troy Advocate,* September 3; "Stanley's Indian Gallery," *Troy Daily Whig,* September 10; "The Indian Gallery," *Troy Daily Post,* September 16; "Stanley's Indian Gallery," *Troy Daily Whig,* September 16; "Visit of the Orphans to the Indian Portrait Gallery," *Troy Daily Post,* September 18, 1850; "Stanley & Dickerman's Indian Gallery," unidentified clipping (*Troy Whig*?, ca. September 24, 1850);

"Have You Seen," *Family Journal,* undated clipping, Stanley Scrapbook, pp.23–27, AAA: OAM.

30. "Indian Portrait Gallery," *Albany Atlas,* October 7; "The Indian Gallery of Portraits," *Morning Express* (Albany), October 22; "The Indian Gallery," *Evening Journal* (Albany), November 8, 1850, Stanley Scrapbook, pp.28, 30, 32, AAA: OAM.

31. "Rare Exhibition," *New York Courier,* November 29; J. H. C., "Indian Portraits," *New York Sunday Times,* December 8, 1850; "Lectures on Indian Character," *New York Tribune,* undated clipping (ca. January 21, 1851): "Stanley's Indian Gallery," *New York Sunday Eve,* January [26]; Proteus, Correspondence of the *Newark Daily Advertiser,* February 7, 1851, unidentified clipping, Stanley Scrapbook, pp.33–37, AAA: OAM.

32. Thos. L. McKenney to ——, March 20, 1851, in "Stanley's Indian Gallery," *New Haven Palladium,* March 23, 1851, Stanley Scrapbook, p.38, AAA: OAM (Stanley included McKenney's letter with the endorsements accompanying his various memorials to Congress); A Lover of the Arts, "Stanley's Indian Gallery," *Hartford Times,* April 22; Citizen, "Stanley's Indian Gallery," *Hartford Courant,* April 22; George Abernethy to Mssrs. Stanley and Dickerman, December 25, 1850, in "Stanley's Indian Gallery," *Hartford Times,* April 23; "A Card to the Citizens of Hartford," April 19, unidentified clipping; and Alfred Hart to Stanley and Dickerman, May 3, 1851, unidentified clipping, Stanley Scrapbook, pp.39–40.

33. "Dissolution," unidentified clipping, Stanley Scrapbook, p.32, AAA: OAM; Peter Skene Ogden to Paul Kane, March 18, 1851, Harper, *Paul Kane's Frontier,* p.336. This paragraph is based on Harper's introduction, pp.32–34.

34. A Western Man, "Stanly's Gallery," *NI,* March 3, 1852.

35. Petition of John M. Stanley (1852), NA.

36. *Seventh Annual Report, SI* (Washington: Robert Armstrong, 1853), pp.55, 67, 27; Petition of John M. Stanley (1852), NA; and *Portraits of North American Indians, with Sketches of Scenery, Etc., Painted by J. M. Stanley* (Washington: Smithsonian Institution, December 1852).

37. *Cong. Globe,* 32d Cong., 2d sess., p.158; JMS to W. K. Sebastian, January 13, 1853, with Petition of John M. Stanley (1852), NA; L. Lea to W. R. Sebastian, January 22, 1853, NA, RG 75: Report Book of the BIA, vol.7, June 28, 1851 to April 29, 1854, pp.205–6.

38. *Cong. Globe,* 32d Cong., 2d sess., p.1084.

39. JMS to Joseph Henry, March 15, 1853; and JMS, contract with John R. Bartlett, March 15, 1853, John Mix Stanley Collection, folder 5, SIA. Kinietz, *John Mix Stanley,* p.17, n.3, mistakenly assumed that Dickerman owned this quarter interest in the gallery.

40. Isaac I. Stevens to the President of the United States, April 25, 1853, NA, RG 94: Records of the Adjutant General's Office, 1780s–1917, U. S. Military Academy Cadet Application Papers, 1805–66, File 326/1853. Stevens's letter was in support of Seth Eastman's son's application for an appointment to the Military Academy, establishing that Stevens and Eastman were in contact about the time of Stanley's appointment to the survey. The following account draws on Taft, *Artists and Illustrators of the Old West,* chap.1 and the notes (pp.252–78), which exceed the text in value and provide a capsule history of all the artists employed by the surveys; Goetzmann, *Army Exploration in the American West,* chaps.7–8; and Schimmel, "John Mix Stanley," chaps.8–9.

41. Hazard Stevens, *The Life of Isaac Ingalls Stevens,* 2 vols. (Boston: Houghton, Mifflin, 1900), 1:306; Alice C. English, "For Baby" (April 29, 1853); JMS, Last Will and Testament, May 4, 1853; English to JMS, May 9, 13, 18, undated (to "Dear Baby Mine"), 1853, Stanley Papers, AAA: 687. The $2,000 owing was to George Abernethy, governor of Oregon Territory during Stanley's visit in 1847. Abernethy saw the Indian gallery during its New York exhibition and wrote a testimonial on December 25, 1850, that Stanley appended to Petition of John M. Stanley (1852), NA. He probably contracted his debt to Abernethy at that time.

42. JMS to Alice C. English, May 16, 1853, Stanley Papers, AAA: 687.

43. Stevens was a bundle of raw energy. See Taft, *Artists and Illustrators of the Old West,* pp.13–15, and for one part of his activity in organizing the survey, Stevens to Henry H. Sibley, April 12, 17, May 12, 30, June 15, 1853, Sibley Papers: 9. In the letter of April 17 Stevens wrote: "I hope to be able to start from St Pauls by the 15th of May." His pushiness did not sit well with everyone, and as governor of Washington Territory he clashed with Schoolcraft's correspondent George Gibbs. See James G. Swan to HRS, July 25, 1857, HRS Papers: 15.

44. Isaac I. Stevens to ——, September 17, 1853, "Pacific Railroad: Northern Route," *Oregonian* (Portland), January 21, 1854 (from the Washington *Union*); *Reports,* 12:87; JMS to Stevens, January 19, 1854, ibid., 1:448–49 (Stanley made most of the trip north with just an interpreter, three voyageurs, and a party of Blackfeet—ibid., 12:106–7, 114–15); Stevens to Jefferson Davis, December 5, 1853, ibid., 1:53; 12:115–17; JMS to John R. Bartlett, September 20, 1853, Bartlett Papers. Before the trip to the Cypress Hills, on September 4, Stanley made several daguerreotypes of Indians around Fort Benton. *Reports,* 12:103–4.

45. *Reports,* 12:154–55; Alice C. English to JMS, May 7 (1853); Notebook, entries for October 19, November 13, 1853, Stanley Papers, AAA: 687; I. I. Stevens, Orders No.

9, October 29, 1853, *Reports,* 1:67; Stevens to ——, September 17, 1853, "Pacific Railroad: Northern Route"; *Reports,* 12:47, 102–3; George Suckley to John H. Suckley, June 20, 1853, Beinecke Rare Book and Manuscript Library, Yale University, New Haven; Stevens to ——, September 17, 1853, "Pacific Railroad: Northern Route"; George Suckley to John H. Suckley, December 24, 1853, Beinecke, Yale.

46. JMS to Elkanah Walker, November 26, 1853, Beinecke, Yale. The expedition did visit Tshimakain (or Chemakane, as Stevens called it), but Walker no longer lived there. *Reports,* 12:147–48.

47. JMS to Alice C. English, December 10, 1853; JMS, Diary, December 17, 1853 to January 6, 1854, Stanley Papers, AAA: 687.

48. JMS to John R. Bartlett, September 20, 1853, Bartlett Papers; *Eighth Annual Report, SI* (Washington: A. O. P. Nicholson, 1854), p.57; JMS to Bartlett, September 12, 1854, Bartlett Papers; *Ninth Annual Report, SI* (Washington: Beverley Tucker, 1855), pp.26, 77. The newlywed Stanleys honeymooned in Philadelphia and New York, where they visited the Crystal Palace. Judging from the letter Stanley sent their old friend Isaac Strohm on May 7, Alice was right in thinking him preoccupied with art, not romance (Strohm Papers, Cincinnati Historical Society).

49. For a basic introduction, see Robert Wernick, "Getting a Glimpse of History from a Grandstand Seat," *Smithsonian* 16(August 1985): 68–82; 84–85; and for an excellent discussion of the many variations on the panorama, Richard D. Altick, *The Shows of London* (Cambridge: Harvard University Press, 1978), chaps.10–15.

50. See John Francis McDermott, *The Lost Panoramas of the Mississippi* (Chicago: University of Chicago Press, 1958); John L. Marsh, "Drama and Spectacle by the Yard: The Panorama in America," *Journal of Popular Culture* 10(Winter 1976): 581–90; Henry M. Sayre, "Surveying the Vast Profound: The Panoramic Landscape in American Consciousness," *Massachusetts Review* 24(Winter 1983): 723–42; and for a case study in one artist's attempt to make his fortune from panoramas, John L. Marsh, "John Vanderlyn, Charleston and Panoramia," *Journal of American Culture* 3(Fall 1980): 417–29.

51. "Banvard's Missouri," *Times* (London), April 17, 1849. This advertisement was one of three in the same issue, reflecting the intensity of the Banvard-Smith rivalry. Catlin's letter was in response to a planted letter of April 11 soliciting his opinion on the relative merits of the two panoramas. See McDermott, *Lost Panoramas,* chaps.2–3; and Altick, *Shows of London,* pp.204–7.

52. See McDermott, *Lost Panoramas,* chap.5; Bertha L. Heilbron, introduction to Henry Lewis, *The Valley of the Mississippi Illustrated,* ed. Heilbron, trans. A. Hermina Poatgieter (St. Paul: Minnesota Historical Society, 1967), pp.2–8.

53. John J. Schoolcraft to HRS, May 14, 1852, HRS Papers: 13; Henry Lewis to Leon Pomarède, July [June] 14, 1848, in McDermott, *Lost Panoramas,* p.86.

54. "Incidents of Stanley's Western Wilds" and "The Indian and the Picture," undated clippings (Washington, 1854), Stanley Scrapbook, p.44, AAA: OAM. All these anecdotes also appeared in the promotional pamphlet (apparently written by Thomas S. Donoho), *Scenes and Incidents of Stanley's Western Wilds* (Washington: Evening Star Office, [1854]), copy in the Rare Book Room, LC. Also see Gary Clayton Anderson, *Little Crow: Spokesman for the Sioux* (St. Paul: Minnesota Historical Society Press, 1986), p.73.

55. Taft, *Artists and Illustrators of the Old West,* pp.20–21, 276; and Schimmel, "John Mix Stanley," pp.117–20; unidentified clipping (Wash-

ington, 1854); "Gallery of Indian Portraits," unidentified clipping, Stanley Scrapbook, pp.42–43, AAA: OAM.

56. The following is based on *Scenes and Incidents of Stanley's Western Wilds* [1854]; Schimmel, "John Mix Stanley," pp.128–35. It is interesting that Alice C. English used the phrase that would give the panorama its title in her letter to JMS, May 7, [1853], AAA: 687: "I would not care if Gov Stevens would find employment for you [in New York] during the whole six months, rather than send, or accompany you out to the western wilds." This may have inspired the name Stanley adopted, or possibly it suggests that he had such a panorama in mind even before departing on the survey.

57. I. I. Stevens to A. A. Humphreys, September 26, 1854; JMS to G. K. Warren, April 3, 1855, File Microfilm Records, NA, no.126: Correspondence Concerning Isaac Stevens' Survey of a Northern Route for the Pacific Railway, 1853–1861, no.7, 48; JMS, "Memoranda in Relation to Sketches in Natural History, Geology, Botany, and to Views of Scenery and Natural Objects," *Reports,* 1:8; Myrtis Jarrell, trans., and N. N. B. Hewitt, ed., *Journal of Rudolph Friederich Kurz: An Account of His Experiences among Fur Traders and American Indians on the Mississippi and the Upper Missouri Rivers during the Years 1846 to 1852* (Lincoln: University of Nebraska Press, Bison Book, 1970 [1937]), p.131; JMS to Warren, April 3, 1855, NA.

58. *Cong. Globe,* 34th Cong., 1st sess., pp.801–6; Schimmel, "John Mix Stanley," p.258; and Robert H. Ruby and John A. Brown, *Indians of the Pacific Northwest: A History* (Norman: University of Oklahoma Press, 1981), p.130.

59. JMS to Isaac Strohm, November 11, 1855, Stanley Papers, AAA: 687; JMS to John R. Bartlett, November 26, 1855, Bartlett Papers; Memorandum, Treasury Department, Comp-

troller's Office, October 1, 1857, John Mix Stanley Collection, folder 5, SIA.

60. *Cong. Globe,* 34th Cong., 1st sess., p.792; JMS to Committee on Indian Affairs, U.S. Senate, April 14, 1856, with Petition of John M. Stanley (1852), NA.

61. *Cong. Globe,* 34th Cong., 1st sess., p.1581; JMS to John R. Bartlett, July 9, 1856, Bartlett Papers; and material in the John Mix Stanley Collection, folder 5, SIA.

62. JMS to John R. Bartlett, July 14, 1856, Bartlett Papers.

63. Alice C. Stanley to JMS, August 18 [1856], Stanley Papers, AAA: 687; *Cong. Globe,* 34th Cong., 1st sess., p.2017.

64. JMS to HRS, March 24, 1856; HRS to Luke Lea, June 1, 1857, HRS Papers: 15. The specific reference was to the engravers, an old complaint. See HRS to George W. Manypenny, April 30, 1855, roll 41. In pushing for a possible seventh volume, HRS wrote Senator William K. Sebastian in February 1857 seeking his support. He emphasized that since no engravings would be required, "the expense will be comparatively small" (roll 42).

65. Brantz Mayer to HRS, October 1, 1856, HRS Papers: 42; F. B. Mayer, Journal, Memoranda, &c.&c. July 6th, 1847, to November 1, 1854, pp.6, 41, 43–44, 50, 71, 77, Minnesota Historical Society, St. Paul. See Jean Jepson Page, "Francis Blackwell Mayer," *Antiques* 109(February 1976): 316–23.

66. Mayer, Journal, p.102. See Bertha L. Heilbron, ed., *With Pen and Pencil on the Frontier in 1851: The Diary and Sketches of Frank Blackwell Mayer* (St. Paul: Minnesota Historical Society, 1932); and Heilbron, ed., "Frank B. Mayer and the Treaties of 1851," *Minnesota History* 22(June 1941): 133–56. This article is appended to the 1986 Borealis Book reprint of *With Pen and Pencil on the Frontier.* Also see Jean Jepson Page, "Frank Blackwell Mayer, Painter of the Min-

nesota Indian," *Minnesota History* 46(Summer 1978): 66–74.

67. Mayer, Journal, pp.142, 156, 160, 162, 186, 188; W. D. Stewart to GC, Thursday, [May 1839], AAA: 2136; A. J. Miller to Decatur H. Miller, February 10, 1842, and to Brantz Mayer, April 23, 1837, in Robert Combs Warner, *The Fort Laramie of Alfred Jacob Miller: A Catalogue . . .*, Publications 43, 2 (Laramie: University of Wyoming, 1979), pp.191–92, 144. Miller may have been put off by Catlin's recent exhibition of a model of Niagara Falls before the queen. Sir William's biographers naively considered Catlin's work too inferior to arouse Miller's professional jealousy (Mae Reed Porter and Odessa Davenport, *Scotsman in Buckskin: Sir William Drummond Stewart and the Rocky Mountain Fur Trade* [New York: Hastings House, 1963], p.200). Catlin met Stewart about 1834–35, painted a picture purporting to show their meeting on the Platte, mentioned Stewart in *Notes Europe*, 2:172–73, and later spent time with him in Paris: GC to Benjamin P. Poore, May 26, 184[6?], Manuscript Division, NYPL. Perhaps Miller had a right to worry about his rival. Miller probably first saw Catlin's gallery late in 1837, in Baltimore or New Orleans. See Ron Tyler, "Alfred Jacob Miller and Sir William Drummond Stewart," in *Alfred Jacob Miller: Artist on the Overland Trail,* ed. Ron Tyler (Fort Worth: Amon Carter Museum, 1982), pp.19, n.3, 35–36; and Carol Clark, "A Romantic Painter in the American West," in Tyler, *Alfred Jacob Miller,* p.62.

68. Heilbron, "Frank B. Mayer and the Treaties of 1851," p.154 and n.41. Mayer was introduced to Sibley by J. W. McCalub, May 5, 1851, Sibley Papers: 8, and gave Sibley a prominent place in the journal of his trip West.

69. Frank B. Mayer to HRS, November 4, December 4, 1856, January 24, February 9, 1857, HRS Papers: 42;

Mayer Journal, p.22 (entry for December 19, 1847); J. B. Lippincott to HRS, April 6, 1857, 42; Lippincott to HRS, November 6, 1857, and, for Mayer's critical assessment of the end result, Mayer to HRS, November 13, 1857, roll 15. Mayer wrote to Schoolcraft from Paris in 1864 to bring him up to date on his doings (Page, "Frank Blackwell Mayer, Painter of the Minnesota Indian," p.70).

70. Heilbron, *With Pen and Pencil on the Frontier,* intro., pp.14–20; Page, "Francis Blackwell Mayer," pp.318–23; and Jessie Poesch, *The Art of the Old South: Painting, Sculpture, Architecture and the Products of Craftsmen, 1560–1860* (New York: Alfred A. Knopf, 1983), pp.298–300.

71. JMS to HRS, October 8, 1856, HRS Papers: 42. Stanley wrote a curt note on September 7, 1857, requesting the return of his two paintings as soon as the engravers were finished (roll 15); they were returned by the publisher J. B. Lippincott to Schoolcraft for delivery to Stanley on November 16 (roll 42).

72. Jacob Thompson to HRS, May 29; HRS to Luke Lea, June 1; HRS to Thompson, June 10; Thompson to HRS, July 1; and HRS to James W. Denver, July 3, 1857, HRS Papers: 15. Thompson's letter of May 29, in effect a termination notice, provoked a Schoolcraft outburst on the back: "This savage note, denotes ignorance of the state of the appropriation, an utter non appreciation of the subject, & violent ill will."

73. *Information,* 6:xxvi, xvi. In fact the main title for the sixth volume omitted the words "Information Respecting" and settled instead on "History of." In his letter to Luke Lea, June 1, 1857, HRS wrote that the "modern history" of the Indians was designed to show "their 'Present Condition & Prospects,' and thus to supply useful hints for Indian Policy." This was what the limitation of the series short of completion had prohibited (HRS Papers: 15).

74. Unidentified clipping (ca. 1853), Stanley Scrapbook, p.42, AAA: OAM; *Annual Report, SI, 1856* (Washington: Cornelius Wendell, 1857), p.45; *Annual Report, SI, 1857* (Washington: William A. Harris, 1858), p.36.

75. JMS to Board of Regents, January 23, 1858, *Annual Report, SI, 1857,* pp.75–77.

76. JMS to James A. Pearce, January 26, 1858, Ford Autograph Collection, Manuscript Division, NYPL; *Annual Report, SI, 1857,* pp.77, 82–84.

77. W. J. Rhees memorandum, May 14, 1858; JMS, Deed of Trust, May 14, 1858, John Mix Stanley Collection, folder 5; Joseph Henry to S——, June 24, 1858, folder 1; Rhees memorandum, May 14, 1858, SIA.

78. Alice C. Stanley to —— English, August 27, 1858, Stanley Papers, AAA: 687. This and the following paragraph are based on JMS to John R. Bartlett, May 23, 1859, Bartlett Papers.

79. *Annual Report, SI, 1859* (Washington: Thomas H. Ford, 1860), p.113; and Richard Rathburn, *The National Gallery of Art: Department of Fine Arts of the National Museum* (Washington: GPO, 1909), p.57; John Mix Stanley Collection, folder 5, SIA.

80. Andrew J. Cosentino and Henry H. Glassie, *The Capital Image: Painters in Washington, 1800–1915* (Washington: Smithsonian Institution Press, 1983), pp.62, 101, 105–10; [Betham Duffield], Obituary, *Detroit Tribune,* April 12, 1872, Stanley Papers, AAA: 687; Charles E. Fairman, *Art and Artists of the Capitol of the United States of America* (Washington: GPO, 1927), p.204. Corcoran owned oils by Charles Bird King and Frank B. Mayer as well. Only the Eastman is an Indian scene. See *A Catalogue of the Collection of American Paintings in the Corcoran Gallery of Art,* vol.1, *Painters Born before 1850* (Washington: Corcoran Gallery of Art, 1966), pp.49–50, 71–72, 93, 122–23.

81. JMS to Isaac Strohm, September 7, 1859, Strohm Papers, Cincinnati Historical Society; Cosentino and Glassie, *Capital Image,* pp.78–79; Lillian B. Miller, *Patrons and Patriotism: The Encouragement of the Fine Arts in the United States, 1790–1860* (Chicago: University of Chicago Press, 1966), chap.7; Schimmel, "John Mix Stanley," pp.121–26; "American Artists" (March 3, 1859), *House Rep. No. 198,* 35th Cong., 2d sess., pp.7–10 (five New York artists besides Durand signed the Catlin letter in 1846 and the 1858 memorial; Stanley, Alfred Jacob Miller and Frank B. Mayer signed the memorial); JMS to Henry Kirke Brown, May 20, 1859, in Schimmel, "John Mix Stanley," p.125.

82. JMS to John R. Bartlett, November 17, 30, 1860, Bartlett Papers.

83. JMS to Isaac Strohm, June 18, 1861, Strohm Papers, Cincinnati Historical Society.

84. "Frontier Life in America," *Illustrated London News* 32, no.911 (April 3, 1858): 336; JMS to John R. Bartlett, June 28, 1861, Bartlett Papers. Carl Wimar's *Comanches Carrying off a Captive Girl* appeared in the same series (no.909[March 20, 1858]: 292). The *News* published frequently on the American West, including an illustrated feature on the Indians of the Southwest attributed to Major William H. Emory (no.913[April 17, 1858]: 400–402), and two articles on the Northwest with illustrations almost certainly derived from Seth Eastman (no.912[April 10, 1858]: 375–78, no.918[May 22, 1858]: 505–6). In particular, compare *A Sioux Encampment* (p.376) with Eastman's *Sioux Indians* (1850), Joslyn Art Museum, Omaha.

85. JMS to Bartlett, June 28, 1861.

86. JMS to John R. Bartlett, July 6, 1861, Bartlett Papers.

87. JMS to John R. Bartlett, August 7, 1861, Bartlett Papers.

88. [JMS], *Memorial* (1863).

89. *House Journal,* 37th Cong., 3d sess., p.223; *Cong. Globe,* 37th Cong., 3d

sess., pp.440–45; *Annual Report, SI, 1862* (Washington: GPO, 1863), p.43.

90. "Stanley, the Artist," *Washington Sunday Gazette,* April 21, 1872; in Stanley Papers, AAA: 687.

91. JMS to Joseph Henry, February 24, April 28, 1864, John Mix Stanley Collection, folder 3; and note re interest payments, folder 5, SIA; JMS to Henry, January 24, 1865, Secretary, 1863–79: Incoming Correspondence, box 12, folder 17, SIA.

92. Joseph Henry to JMS, March 11, 1865, Secretary, 1865–91: Outgoing Correspondence, box 1, vol.1, pp.108–11, SIA; Richard Wallach and Joseph Henry, "Report of the Special Committee of the Board of Regents of the Smithsonian Institution Relative to the Fire" (February 1865), *Annual Report, SI, 1864* (Washington: GPO, 1865), pp.117–20; and *1865* (Washington: GPO, 1866), pp.14–18. Henry named seven paintings as having survived; he was working from the Stanley catalog, and there may have been some confusion created by similar descriptions. It is also possible that two of the rescued oils were turned over to a third party. King was not around to see his own Indian gallery destroyed, having died in 1862.

93. "Origin of the Fire at Smithsonian Institution" (February 21, 1865), *Sen. Com. Rep. No. 129,* 38th Cong., 2d sess., pp.24–25, testimony of William J. Rhees; "Stanley's Gallery of Indian Portraits," unidentified clipping (Detroit, January, 1865), Stanley Scrapbook, p.49, AAA: OAM; Wallach and Henry, "Report of the Special Committee," p.119.

94. JMS to Isaac Strohm, February 7, 1865, Strohm Papers, Cincinnati Historical Society; G. W. Samson to JMS (1865), Stanley Papers, AAA: 687; *House Journal,* 38th Cong., 2d sess., p.287; B. F. James, J. M. Edmunds, et al., Memorial; and draft resolution, Joint Committee on the Library, NA, RG 233: HR 38A–G11.1; JMS to Strohm, February 7,

1865, Strohm Papers; Henry to JMS, March 11, 1865, SIA.

95. JMS to Strohm, February 7, 1865, Strohm Papers; JMS, Petition, NA, RG 233: 39th Cong. Accompanying Papers File, box 12.

96. Ibid.; *House Journal,* 39th Cong., 1st sess., p.112.

97. *Annual Report, SI, 1865,* p.18; A. A. Barker, committee report, January 20, 1866, NA, RG 233: 39th Cong. Accompanying Papers File, box 12. The Committee on Claims was discharged from further consideration of Stanley's petition on June 5, 1866. *House Journal,* 39th Cong., 1st sess., p.797.

98. JMS to Strohm, February 7, 1865, Strohm Papers; untitled clipping, *Detroit Post,* January 30, 1867, Stanley Scrapbook, p.53, AAA: OAM.

CHAPTER 7

1. Richard Wallach and Joseph Henry, "Report of the Special Committee of the Board of Regents of the Smithsonian Institution Relative to the Fire" (February 1865), *Annual Report, SI, 1864* (Washington: GPO, 1865), pp.119–20; *Annual Report, SI, 1865* (Washington: GPO, 1866), pp.17–18.

2. GC, *Last Rambles amongst the Indians of the Rocky Mountains and the Andes* (London: Sampson Low, Son, and Marston, 1867), p.51; also GC to Sir Thomas Phillipps, January 23, 1853, Gilcrease (published in A. N. L. Munby, *The Formation of the Phillipps Library from 1841 to 1872* [Cambridge: University Press, 1956], pp.58–60); and idem, *Memorial of George Catlin* (Brussels, December, 1868), p.2. In 1858 Harrison was said to have bought two hundred paintings by American artists not counting the Catlins, which he held but never purchased. See Lillian B. Miller, *Patrons and Patriotism: The Encouragement of the Fine Arts in the United States, 1790–1860* (Chicago: University of Chicago Press, 1966), p.158. Catlin was never sure of the

amount Harrison paid out. He made the $8,000 to $10,000 estimate late in life, after his gratitude had soured and he had come to regard Harrison as one more exploiter out to deny him his rightful property by putting an inflated value on the notes paid off in London. See Joseph Henry Diary, 1872, pp.152, 254, Joseph Henry Collection, box 15, SIA; and GC to Librarian, NYHS, October 10, 1870, NYHS (published in *Letters,* pp.405–6).

3. HRS to Luke Lea, July 22, 1850, HRS Papers: 12; and in *Information,* 1:vii.

4. *L&N,* 1:55–57, 67; 2:194–200.

5. William Dunlap, "Mr. Catlin's Lectures," *New-York Mirror* 15(October 14, 1837): 126.

6. [HRS], "The Red Man of America," *NAR,* 54(April 1842): 288; HRS to GC, November 12, 1836, HRS Papers: 26; HRS to Lewis Cass, February 24, 1832, roll 21 (Cass's letter ordering the exploration, December 11, 1831, had just been received when Schoolcraft wrote); Philip P. Mason, ed., *Schoolcraft's Expedition to Lake Itasca: The Discovery of the Source of the Mississippi* (East Lansing: Michigan State University Press, 1958), p.35; "Sketches of the Life of Henry R. Schoolcraft," *Memoirs,* p.xliii. Schoolcraft was doubtless responsible for most of this third-person sketch. It went on to say that he was "believed to be the only man in America who has seen the Mississippi from its source in Itasca Lake to its mouth in the Gulf of Mexico."

7. Undated remarks, Lawrence Taliaferro Journals, 14:[1], Taliaferro Papers: 3; HRS to John R. Bartlett, April 11, 1848, Bartlett Papers; Mary H. Eastman to Henry Lewis, January 4, [1849], Henry Lewis and Family Papers, Stehli Collection, Minnesota Historical Society, Minneapolis; HRS to Henry H. Sibley, August 23, 1850, Sibley Papers: 7. Schoolcraft also published a poem celebrating his discovery, "Stanzas: On Reaching the Source of the Mis-

sissippi River in 1832," *Literary World* 12(July 16, 1853): 559–60. For an exposé of the claims of a later pretender to discovery of the true source (in 1881), see H. D. Harrower, *Captain Glazier and His Lake: An Inquiry* (New York: Ivison, Blakeman, 1886).

8. [HRS], "Red Man of America," pp.290–91; Philander Prescott, "Contributions to the History, Customs, and Opinions of the Dacota Tribe," *Information,* 2:176 (and see P. Prescott to Henry H. Sibley, March 26, 1850, Sibley Papers: 7); Wm. W. Warren to HRS, September 22, 1849, and to Jonathan E. Fletcher, May 1, 1850, HRS Papers: 12; and Warren to HRS, March 19, 1853, roll 40; William W. Warren, *History of the Ojibway Nation* (Minneapolis: Ross and Haines, 1957), p.114. Warren wrote his book over the winter of 1852–53.

9. A chart on which Catlin fastened small specimens collected at the quarry ("A Variety of Specimens of Steatite from the 'RED PIPE STONE QUARRY' on the 'Coteau des prairies,' near the sources of the St. Peters River") bore the legend: "Visited by Geo. Catlin, in 1836, being (as the Indians said) the first ever made to it by white men" (AAA: 2137). In a later manuscript, "A Selection of Indian Pipes in Catlin's North American Indian Collection" (begun 1852, completed 1864–66), he wrote: "The Sioux Indians . . . told me I was the first white man who ever visited it [the quarry], and *certainly* I was the first to give any account of it" (John C. Ewers, ed., *Indian Art in Pipestone: George Catlin's Portfolio in the British Museum* [Washington: British Museum Publications and Smithsonian Institution Press, 1979], pp.16, 26).

10. The following paragraphs are based on GC, Mandan Village, Upper Missouri, August 12, 1832, *NYCA,* January 10, 1833. This letter caused a sensation, was reprinted in other papers, and circulated in handwritten

drafts certified by Catlin. See copy in NYHS. See also GC, *O-kee-pa: A Religious Ceremony and Other Customs of the Mandans,* ed. John C. Ewers (New Haven: Yale University Press, 1967), introduction; and for an anthropologist's account of the O-kee-pa, Alfred W. Bowers, *Mandan Social and Ceremonial Organization* (Chicago: University of Chicago Press, 1950), chap.4. Despite discrepancies, Bowers's account supports Catlin's in the main.

11. The certificate, mentioned in Catlin's letter of August 12, 1832, first appeared in his 1837 catalog and was in all thereafter; it has a blurred paternity. In *L&N,* 1:177, a note indicates that it had been "just received from Mr. Kipp, of the city of New York." Kipp, American Fur Company agent at Fort Clark when Catlin visited in 1832, had been replaced in June 1834 as part of the reshuffling that followed the restructuring of the company. But the date—July 28, 1833—is still problematic, suggesting an ex post facto attempt to draw up an affadavit coinciding with his actual visit, foiled by Catlin's habitual inability to keep the years straight.

12. Dunlap, "Mr. Catlin's Lectures," p.126; and Henry C. Potter, "Mandan Ceremony," MSS, Connecticut Historical Society, Hartford. Potter heard Catlin speak at the Utica, New York, Classical and Commercial Lyceum, March 7, 1837, and carefully summarized his account of the O-kee-pa "for the benefit of Miss Harriet Merrell, Geneva, New York."

13. GC, Mandan Village, Upper Missouri, August 12, 1832; *L&N,* 1:155–84.

14. Ibid., pp.182–83; George Combe, October 16, 1838, quoted in Donaldson, *Catlin Gallery,* p.769. Charles Dickens also commented on this inconsistency: "The Noble Savage," *Household Words* 7(June 11, 1853): 338.

15. GC to the Editor of the [New York] *Herald,* "The Great Park of the Yellow Stone," draft copy (1872), AAA: 2136; and "The Proposed National Park in the Yellowstone Country," *Frank Leslie's Illustrated Newspaper* 33(March 2, 1872): 398; GC, Mouth of Yellow Stone, July 15, 1832, NYCA, October 20, 1832; reprinted as "Scenes on the Upper Missouri," in *The Cabinet of Natural History and American Rural Spots, with Illustrations,* vol.2 (Philadelphia: J. and T. Doughty, 1832), p.186 (the corresponding letters [3 and 4] in *L&N* dropped all reference to the salubrious climate of the region). See Valerie Sherer Mathes, "Four Bears as Seen by His Artists: Catlin and Bodmer," *North Dakota History* 49(Summer 1982): 11–12; Martin Ira Glassner, "Population Figures for Mandan Indians," *Indian Historian* 7(Spring 1974): 41–46; and Ewers, *O-kee-pa,* p.99, n.31.

16. S. E. Sewall to Louisa M. Sewall, August 26, 1838, Robie Sewall Collection, Massachusetts Historical Society, Boston; Putnam Catlin to Francis Catlin, March 18, 1838, *Letters,* p.127; *Catalogue of Catlin's Indian Gallery of Portraits, Landscapes, Manners and Customs, Costumes, &c. &c.* (New York: Piercy and Reed, 1838), pp.34–35 (the second issue of the 1838 catalog [copy in the Huntington] was expanded from thirty-six to forty pages; Truettner, *Natural Man,* p.25, dates *Bird's-eye View of the Mandan Village* 1837–39, and a comparison of the two 1838 catalogs pins the date down to that year); *A Descriptive Catalogue of Catlin's Indian Gallery: Containing Portraits, Landscapes, Costumes, &c.* (London: C. Adlard, 1840), p.17.

17. "Foreign Correspondence," *Athenaeum,* no.609(June 22, 1839): 485; "The Indian Gallery," ibid., no.640(February 1, 1840): 99; *L&N,* 1:207; 2:258.

18. Brian W. Dippie, *The Vanishing American: White Attitudes and U.S. Indian Policy* (Middletown, Conn.: Wesleyan University Press, 1982), chaps.2–3; "The Red Man," *Quar-*

terly Review 65(March 1840): 404–
5, 388; GC to John Murray, April 14,
1840, PS, GC to My Dear Wallace,
Historical Society of Pennsylvania,
Misc. Coll., AAA: P23.

19. "The North American Indians,"
Dublin University Magazine
19(March 1842): 383; "Catlin on
the North American Indians," *Edin-
burgh Review* 74(January 1842):
425; *Athenaeum,* no.747(February
19, 1842): 163. An American critic,
Albert Gallatin himself, specifically
complained about the lack of dates in
L&N and wondered about the actual
duration of Catlin's stay with the
Mandans: "Catlin's North American
Indians," *New York Review* 20(April
1842): 420, 429.

20. See Dippie, *Vanishing American,*
pp.35–36, 39–40; "Vindication of
the United States, &c.," *Southern Lit-
erary Messenger* 11(April 1845): 211:
"Mr. Catlin is not justified in refer-
ring the total extinction of the In-
dians to any, or all the causes to
which he so repeatedly ascribes it.
The causes were and are innate
among themselves"; E. Wagner
Stearn and Allen E. Stearn, *The Effect
of Smallpox on the Destiny of the Amer-
indian* (Boston: Bruce Humphries,
1945), chaps.4–5; "Small Pox
among the Indians" (March 30,
1832), *House Doc. No. 190, 22d
Cong., 1st sess.*; Charles J. Kappler,
comp. and ed., *Indian Affairs: Laws
and Treaties,* 2 vols. (Washington:
GPO, 1904), 2:452; "Small Pox
among the Indians," *St. Louis Bul-
letin,* March 3, 1838 (letter dated Ft.
Union, November 27, 1837), clip-
ping in Private Journal of Indian Af-
fairs, 1837–39, p.15, HRS Papers:
48; *Memoirs,* pp.577, 589; and *Infor-
mation,* 1:257–58. A graphic ac-
count datelined New Orleans, June
6, 1838 (Stearn and Stearn, *Effect of
Smallpox,* pp.89–90), set the Man-
dan population at 1,500, survivors at
30: "The prairie all around is a vast
field of death, covered with unburied
corpses. . . . No language can picture

the scene of desolation. . . . In what-
ever direction we go, we see nothing
but melancholy wrecks of human life.
The tents are still standing on every
hill, but no rising smoke announces
the presence of human beings, and
no sound but the croaking of the
raven and the howling of the wolf in-
terrupt the fearful silence." Such
emotive language confirmed the
most pessimistic statistics, and left an
indelible impression on contempo-
raries.

21. HRS to EGS, February 18, Squier Pa-
pers, LC: 2; EGS to HRS, February
20, HRS Papers: 40; and HRS to
EGS, February 26, 1851, Squier Pa-
pers, LC: 2. The draft of this letter
(HRS Papers: 40) is identical save for
an asterisked note modifying the fig-
ure from three hundred to five hun-
dred, based on a letter Schoolcraft
had received from David D. Mitchell
(HRS, note to self, February 28,
1851, roll 12); subsequently Mitch-
ell revised this total and set it at 348.

22. *Information,* 1:567–68. John Bartlett
had made a particular study of the
Welsh Indian theory. See George
Gibbs to Joseph Henry, February 12,
1866, *Annual Report, SI, 1865,*
pp.126–27. Also see James D.
McLaird, "The Welsh, the Vikings,
and the Lost Tribes of Israel on the
Northern Plains: The Legend of the
White Mandan," *South Dakota His-
tory* 18(Winter 1988): 245–73, and
Ralph Walker, "The Welsh Indians,"
American History Illustrated 15(May
1980): 6–13, 44–48.

23. G. F. Will and H. J. Spinden, *The
Mandans: A Study of Their Culture,
Archaeology and Language,* Papers of
the Peabody Museum of American
Archaeology and Ethnology, vol.3,
no.4 (Cambridge: Harvard Univer-
sity, 1906), p.87; and [HRS], "Red
Man of America," pp.287, 289, 292.
The French scientist Joseph N. Nic-
ollet writing in 1838 adopted a rea-
sonable position: "That which Catlin
recounts on the torture that the Man-
dan undergo in certain ceremonies is

true. Only he did not understand either the purpose or the meaning and attached it to fables." Catlin knew more than Nicollet credited him for, but the clear distinction between observation and theory is fairly drawn. See Edmund C. Bray and Martha Coleman Bray, eds., *Joseph N. Nicollet on the Plains and Prairies: The Expeditions of 1838–39 . . .* (St. Paul: Minnesota Historical Society Press, 1976), p.273.

24. W. H. Smyth, "Address to the Royal Geographical Society of London (May 26, 1851)," *Journal of the Royal Geographical Society of London* 21(1851): xc; GC to Sir Thomas Phillipps (1851), Gilcrease; and GC to William H. Seward, August 1, 1852, University of Rochester Library, Rochester, New York.

25. *NI*, January 19, 1853; R. R. Gurley to HRS, September 21, 1852, HRS Papers: 13.

26. HRS to R. R. Gurley, September 23, 1852, HRS Papers: 13; and Gurley to GC, January 27, 1853, AAA: 2136; published in Donaldson, *Catlin Gallery,* p.376.

27. HRS to GC, February 28, 1853, HRS Papers: 14. Catlin's letter of January 30 oddly is not in the fairly comprehensive Schoolcraft Papers. Thus what he said has to be inferred from Schoolcraft's reply. The following paragraphs are based on it. The Mackintosh manuscript is lost; all subsequent references have been to Mitchell's letter to Schoolcraft. Possibly Mitchell confused names and dates; certainly he was a shaky authority for discrediting Catlin. See Raymond Wood and Thomas D. Thiessen, eds., *Early Fur Trade on the Northern Plains: Canadian Traders among the Mandan and Hidatsa Indians, 1738–1818* (Norman: University of Oklahoma Press, 1985), pp.24–215, 298.

28. Catlin was unrepentant, Schoolcraft unforgiving. In the final volume of the Indian history, *Information,* 6:486n., he wrote: "Mr. Catlin was

mistaken, when he reported the extinction of this tribe."

29. HRS, "A Letter to Geo. Catlin Esqr," undated draft, fragment, AAA: 2136.

30. HRS to William Medill, March 25, 1847, HRS Papers: 36.

31. HRS to R. R. Gurley, March 10, 1853, HRS Papers: 14. A note on the back of HRS to GC, February 28, 1853, says "Sent 9th Mar."

32. Robert A. Trennert, Jr., *Alternative to Extinction: Federal Indian Policy and the Beginnings of the Reservation System, 1846–51* (Philadelphia: Temple University Press, 1975), p.179; "Indian Interview and Presentations," *NI*, January 7, 1852; "Indian Interview," ibid., January 30, 1852; "Indian Interview with the President," ibid., February 4, 1852; "The Omaha Indians," ibid., March 1, 1852; *Information*, 3:254. For Mitchell and his role in the 1851 treaty, see Ray H. Mattison, "David Dawson Mitchell," in *The Mountain Men and the Fur Trade of the Far West,* ed. LeRoy R. Hafen, 10 vols. (Glendale, Calif.: Arthur H. Clark, 1965), 2:241–46; Paul E. Verdon, "David Dawson Mitchell: Virginian on the Wild Missouri," *Montana, the Magazine of Western History* 27(Spring 1977): 2–15; Trennert, *Alternative to Extinction,* passim; and John E. Sunder, *The Fur Trade on the Upper Missouri, 1840–1865* (Norman: University of Oklahoma Press, 1965), pp.30–31, 87, 141–49. Mitchell was again turned out of office with the inauguration of Franklin Pierce's Democratic administration in 1853.

33. HRS, "A Letter to Geo. Catlin Esqr"; HRS to GC, February 28, 1853; William B. Hodgson to John R. Bartlett, August 11, 1847, Bartlett Papers.

34. *Memorial of George Catlin* (1868), p.2. No earlier copy of this letter appears to exist, raising the usual questions. There is nothing to suggest that Catlin would invent such a document, however.

35. Alexander von Humboldt, *Cosmos: A Sketch of a Physical Description of the Universe,* trans. E. C. Otté, 5 vols. (New York: Harper, 1851–59), 2:236. *Cosmos* in its English translation (1851–59) made an enormous impression in the United States. See Helmut de Terra, *Humboldt: The Life and Times of Alexander von Humboldt, 1769–1859* (New York: Alfred A. Knopf, 1955), chap.17; and for the Catlin-Humboldt meetings, GC to Putnam Catlin, February 3, 1842, *Letters,* p.234; and *Notes Europe,* 2:246.

36. HRS to Francis Lieber, April 8, 1851, Lieber Collection, box 61, LI 3134, Huntington; [Francis Bowen], "Schoolcraft on the Indian Tribes," *NAR* 77(July 1853): 262; HRS to ———, July 29, 1853, HRS Papers: 41.

37. Albert Gallatin, "A Synopsis of the Indian Tribes within the United States . . . ," *Archaeologia Americana* 2(1836), prefatory letter; Benjamin Keen, *The Aztec Image in Western Thought* (New Brunswick, N.J.: Rutgers University Press, 1971), pp.329–36, 354–63; and Victor W. Von Hagen, Introduction to William H. Prescott, *History of the Conquest of Peru* (New York: Mentor, 1961), pp.xvii–xviii; Humboldt to Samuel G. Morton, January 17, 1844, in Henry S. Patterson, "Notice of the Life and Scientific Labors of the Late Samuel Geo. Morton, M.D.," in *Types of Mankind; or, Ethnological Researches . . .* by J. C. Nott and Geo. R. Gliddon (Philadelphia: Lippincott, Grambo, 1854), pp.xxxiv–xxxv; J. C. Nott and Geo. R. Gliddon, *Indigenous Races of the Earth; or, New Chapters of Ethnological Inquiry . . .* (Philadelphia: J. B. Lippincott, 1857), p.403; EGS, *The Serpent Symbol, and the Worship of the Reciprocal Principles of Nature in America* (New York: George P. Putnam, 1851), p.viii; "Humboldt at Home," *Illustrated London News* 29, no.825(October 18, 1856): 385; De Terra, *Humboldt,* pp.374–76;

Francis Lieber, "Alexander von Humboldt" (1859), in *Reminiscences, Addresses, and Essays* (Philadelphia: J. B. Lippincott, 1881), pp.395–96; Benjamin Silliman, "Humboldt," *Literary World* 13(October 15, 1853): 181.

38. Silliman, "Humboldt," p.181; Lieber, "Alexander von Humboldt," pp.390–91; Henry Stevens, *The Humboldt Library: A Catalogue of the Library of Alexander von Humboldt* (London: Henry Stevens, 1863), p.696, no.9788; Joseph Sabin, ed., *Catalogue of the Library of E. G. Squier* (New York: Charles C. Shelley, 1876), nos.2000, 2032.

39. HRS to [Baron von Cotta?], September 1; H. Wheaton to HRS, November 22, 1842, HRS Papers: 32; *Humboldt Library,* p.669, no.9394 (Humboldt may have been in Paris when Schoolcraft was in Prussia); HRS to ———, July 29; to Baron von Gerolt, July 30; to Alexander von Humboldt, July 30, 1853, HRS Papers: 41.

40. Curtius [HRS], "Examination of an Article in the North American Review . . . ," *Literary World* 13(August 20, 1853): 51–53. Humboldt, overwhelmed by correspondence in the 1850s, replied only selectively.

41. *Information,* 5:53, 55, 89.

42. Ibid., 5:54, 59–60.

43. [James Hall], "Mr. Catlin's Exhibition of Indian Portraits," *Western Monthly Magazine* 1(November 1833): 538; GC to Daniel Webster, May 8, 1852, Morristown National Historical Park, Morristown, New Jersey.

44. GC, *Last Rambles,* pp.52–53.

45. Catlin provided three chronologies, the last two identical: GC to William Blackmore, April 16, 1871 (printed by Blackmore, London, 1871), Blackmore Collection, HSNM 0245a, Santa Fe, and a corrected variant, George Winter Papers, Tippecanoe County Historical Association, Lafayette, Indiana (in the letter to Winter accompanying it, Blackmore claimed to have struck off only twenty copies

for friends); *Catalogue Descriptive and Instructive of Catlin's Indian Cartoons* (New York: Baker and Godwin, 1871), app. B: "Synopsis of the author's roamings in gathering the paintings enumerated in this Catalogue," pp.90–92; and *Synopsis of the Travels of George Catlin in Gathering His Sketches for His Indian Collection* (n.p., [1872]), accompanying *Petition of George Catlin*, AAA: 2137.

46. GC to [J. Harland], September 7, 1860, Miscellaneous Manuscripts Collection, LC (Harland, editor of the Manchester *Guardian,* was the likely recipient judging from GC to Harland, October 14, [1860], Beinecke Rare Book and Manuscript Library, Yale University, New Haven; *Steam Raft, Suggested as a Means of Security to Human Life upon the Ocean,* was printed in Manchester in 1860, though Catlin dated the text Rio Grande, Brazil, November 12, 1859); *Last Rambles,* pp.115–16, 140–44, 192–97; GC to William Blackmore, April 28, 1871, Museum of New Mexico, Santa Fe, HSNM 0270; GC to Henry Ward Beecher, October 18, 1863, NYPL.

47. GC to Sir Thomas Phillipps, October 26, 1853; Phillipps to GC, November 7, 1853, Gilcrease; the latter reprinted entire in Munby, *Formation of the Phillipps Library,* pp.60–61.

48. GC to Phillipps, November 14, 1853, February 16, undated [March 6], March 9, 1854, Gilcrease.

49. GC to Phillipps, March 24, April 14; Phillipps to GC, April 16; GC to Phillipps, May 3, 1854, Gilcrease.

50. GC to Sir Thomas Phillipps, February 3, 1852, Gilcrease; Joseph G. Rosa, *Colonel Colt London: The History of Colt's London Firearms, 1851–1857* (London: Arms and Armour Press, 1976); Walter E. Taylor, unidentified clipping (New York), September 9, 1940, Artist's File: George Catlin, Montana Historical Society, Helena; "Catlin & Colt," *American Heritage* 19(June 1968): 12–17, for Catlin's illustrations, one, *Artist Shooting Buffalo,* dated 1855; *Illus-*trated *London News,* 30, no.853 (April 11, 1857): 330–32.

51. *Last Rambles,* pp.77–79 (here Catlin *ascended* the Amazon at Obidos, beginning a new series of adventures; at best he descended the river first, then made an ascent and another descent); GC to Sir Thomas Phillipps, November 27, [1854], Gilcrease. Catlin indicated he would contribute to the *Illustrated London News;* in fact it was full of reports and pictures about Balaclava and Inkerman: 25, nos.713–14(November 18, 25, 1854).

52. See Alexander von Humboldt to GC, September 8, 1855, facsimile with translation, Donaldson, *Catlin Gallery,* plates 141–42; September 12, 1855, in GC, *Last Rambles,* pp.331–32; and Humboldt's preface to Baldwin Möllhausen, *Diary of a Journey from the Mississippi to the Coasts of the Pacific with a United States Government Expedition,* 2 vols. (London: Longman, Brown, Green, Longmans, and Roberts, 1858), 1:xv–xvi. Catlin sent Phillipps transcriptions of the Humboldt letters on October 1, 1860.

53. GC to Sir Thomas Phillipps, November 3, 1857, Gilcrease.

54. GC to Sir Thomas Phillipps, November 16, 24, December 23, 31, 1857, January 9, 25, June 11, 1858, Gilcrease. This album, or one like it, was successfully offered to the duke of Portland the next year; it has been published in its entirety, with a facsimile of Catlin's letter to the duke (May 31, 1859) and an introduction by Peter H. Hassrick, as *Drawings of the North American Indians* (Garden City, N.Y.: Doubleday, 1984).

55. GC to Henry S. Sanford, March 26, 1867, Sanford Papers. Besides the duke of Portland album I have examined "Souvenir of the North American Indians as they were . . ." (London, 1852) in the Newberry Library, Chicago, 217 plates; "Souvenir of the North American Indians as they were . . ." (London, 1852) in the Montana Historical Society, Helena, 52 plates; and "The North American

Indians in the Middle of the Nineteenth Century . . ." ([Brussels], [1869]), text only, Huntington Library, San Marino, the basis for Catlin's proposed complete album of his collection. The 1852 date was a convenience only (the preface to the Montana Historical Society's copy noted that the album contained plates "from paintings made during the last three years, on a Tour to the Indian Tribes on the Pacific Coast"); 1852 marked the point at which Catlin's gallery passed out of his hands, leaving him only the tracings. A copy of the "Souvenir" in the Beinecke Library at Yale, 216 plates, is also dated London 1852 but has been corrected to read 1857; since it was not acquired from Catlin until 1868, its actual date is uncertain (GC to Sanford, August 4, 7, 1868, Sanford Papers).

56. GC to Sir Thomas Phillipps, November 3, 24, 1857, February 21, 1858; Phillipps to GC, [March 17, 1858]; GC to Phillipps, March 28, April 9, June 11, 1858, Gilcrease. Phillipps was not the only one who found price negotiable. An undated Catlin letter to Monsr. Street in Paris offers an album at £30 instead of the £35 it should command (Ayer MSS. 147, Newberry Library, Chicago); Henry S. Sanford got his selection, worth £50, for £16 (GC to Sanford, January 28, 1864, Sanford Papers); while the duke of Portland was offered his two-volume album in 1859 at £75, though Catlin valued it at £175—a sharp decrease from the £300 asked the year before of Lord Northwick.

57. See GC, *The Lifted and Subsided Rocks of America, with Their Influences on the Oceanic, Atmospheric, and Land Currents, and the Distribution of Races* (London: Trübner, 1870).

58. GC to Sir Thomas Phillipps, October 1; Phillipps to GC, October 7, 17, 1860, Gilcrease.

59. GC, *Last Rambles,* p.54.

60. The account that follows is based on GC to Blackmore, April 16, 1871, pp.3–4; and *Catalogue Descriptive and Instructive of Catlin's Indian Cartoons* (1871), app. A, pp.87–89. Smyth's account of his travels with Catlin, incorporated in *Life amongst the Indians* (London: Gall and Inglis, [1861]), chaps.15–16, was first summarized in the English papers, for example, "A Traveller in South America.—Colt and Catlin," *Court Journal* (London), February 3, 1855. I am indebted to Joseph G. Rosa for this reference. It is *possible* Smyth was a Catlin alias.

61. GC to Blackmore, April 16, 1871, pp.3–4.

62. GC to the President of the Historical Society of New York, March 2, 1870, NYHS; published entire in *Letters,* pp.449–54. In his letter Catlin claimed to have transferred his original portraits directly onto the cartoon panels, and his brother Francis in 1868 noted that the later outlines were copied from paintings in oil, confirmed in GC to Francis Catlin, January 13, 1869, *Letters,* pp.358–59, 380. Portability alone suggests that Catlin recreated this collection in oils in the mid-1860s from earlier outline drawings. See Truettner, *Natural Man,* pp.56, 135.

63. Elizabeth W. Catlin, commentary on William Henry Miner, "George Catlin: A Short Memoir of the Man, with an Annotated Bibliography of His Writings, Pt. II: Bibliography," *Literary Collector* 3 (December 1901): 81; R. R. Gurley to D. S. Gregory, December 3, 1857, February 10, 1859, Records of the American Colonization Society, series 2, vol.43 (reel 233), Ralph R. Gurley Letterbooks, LC; GC to Louise Catlin, April 22, 1861, AAA: 2136. Any reports from Henry would have come to Catlin's girls through their uncle, Dudley S. Gregory, a friend of Henry's; since the Smithsonian archives were destroyed by the fire in 1865, no evidence of this correspondence remains, but there is reason to doubt that it took place, since Henry in 1866 was unaware that Joseph Harrison had taken possession of

Catlin's Indian Gallery fourteen years earlier, an unlikely circumstance had Catlin kept in touch through the 1850s.

64. Sackville Street Woollen Warehouse, and Tailoring Establishment, Dublin, bill for £4.10.0, May 26, 1843, AAA: 2137; GC to Henry S. Sanford, Bruxelles, n.d., Sanford Papers. Except where indicated, the following paragraphs are based on Francis Catlin diary, October 22 to December 25, 1868, *Letters,* pp.354–69; "George Catlin, the Indian Painter," unidentified clipping (Ostend, ca. 1865), Secretary, 1863–79: Incoming Correspondence, box 3, folder 7, SIA; A. L. Chetlain to Thomas Donaldson, June 22, 1886, and Charles Rau, "George Catlin and His Work," Donaldson, *Catlin Gallery,* pp.715–16, 772–73.

65. Francis Catlin diary, *Letters,* pp.356, 367–68; GC to Francis Catlin, January 4, 1869, ibid., p.377. Francis illustrated the cylinder trap in his original diary, Catlin Papers, folder 174, Bancroft.

66. GC to [J. Harland], September 7, 1860, LC; "Industrial Exhibition of 1851: American Awards," *New York Times,* October 29, 1851; Catlin Papers, AAA: 1191, for drawings, descriptions, and patent applications for both inventions (Catlin did publish a note on his torpedoes in *Trübner's American and Oriental Literary Record* in 1866—Nicolas Trübner to Frank Squier, July 20, 1876, Squier Papers, LC: 6); GC, power of attorney to Francis P. Catlin, January 4, 1869, NYPL; GC to Francis Catlin, June 7, September 9, 18, 1868, January 4, June 11, October 26, 1869, *Letters,* pp.347, 349, 351, 353, 376, 387, 390.

67. GC, *The Breath of Life; or, Mal-Respiration, and Its Effects upon the Enjoyments and Life of Man* (London: Trübner, 1862), pp.32, 74, 61.

68. Loyd Haberly, *Pursuit of the Horizon: A Life of George Catlin, Painter and Recorder of the American Indian* (New York: Macmillan, 1948), p.209; "George Catlin, the Indian Painter" (Ostend, ca. 1865); GC, "A Cure for Influenza," undated MS, 6 pp., Missouri Historical Society, St. Louis.

69. GC, *Breath of Life,* p.64; GC to J. Harland, October 14, [1860], Beinecke.

70. GC to Beecher, October 18, 1863, NYPL; also GC to Henry S. Sanford, July 19, 1864, Sanford Papers.

71. GC, *Last Rambles,* pp.50–51; and GC to Mayne Reid's Magazine *Onward,* July 1869, AAA: 2136.

72. GC to William H. Brewer, January 18, 1869, Sterling Memorial Library, Manuscripts and Archives, Yale University, New Haven; GC to Beecher, October 18, 1863, NYPL.

73. GC, *Last Rambles,* pp.346–47, 358. Catlin was also unimpressed by the Peace (or Quaker) Policy inaugurated by the Grant administration; it compounded criminality with hypocrisy (GC to Henry S. Sanford, [April 1869], Sanford Papers).

74. GC, *Life amongst the Indians,* pp.v, 54, 202, 205; GC, *Last Rambles,* pp.348–50, 358, 361.

75. *National Anti-Slavery Standard,* April 16, 1870, quoted in Robert Winston Mardock, *The Reformers and the American Indian* (Columbia: University of Missouri Press, 1971), pp.71–72.

76. GC to Professor Harper, [March 1870], Ayer MSS, N.A. 149, Newberry Library, Chicago. Apparently this letter was printed as *To General Sheridan,* a two-page leaflet. I have not seen a copy.

77. Ibid.; Richard Catlin to Francis Catlin, April 15, 1870, *Letters,* p.401; GC, *Last Rambles,* pp.v–vi, 357.

78. GC to Prince Maximilian of Neuwied, December 2, 1866. This letter and Maximilian's reply were apparently first published in a two-page leaflet advertising Catlin's forthcoming *O-Kee-Pa, Mandan Religious Ceremony* ([Brussels], [1867]), and frequently thereafter.

79. Maximilian, Prince of Wied, *Travels*

in the Interior of North America, trans. H. Evans Lloyd, 1843 London ed., reprinted in three volumes in *Early Western Travels, 1748–1846,* ed. Reuben Gold Thwaites (Cleveland: Arthur H. Clark, 1906), vols.22–24. See 22:228–36; vol.23, chaps.20, 24–27; vol.24, chaps.28–29; and William J. Orr and Joseph C. Porter, ed., "A Journey through the Nebraska Region in 1833 and 1834: From the Diaries of Prince Maximilian of Wied," *Nebraska History* 64(Fall 1983): 325–453, prelude to what will be a complete, scholarly edition of Maximilian's diaries and letters published under the auspices of the Center for Western Studies, Joslyn Art Museum, Omaha. See also Joseph C. Porter, "Maximilian, Prince of Wied: A Biographical Sketch," in *Views of a Vanishing Frontier,* ed. John C. Ewers et al. (Omaha: Center for Western Studies, Joslyn Art Museum, 1984), pp.9–19.

80. Maximilian, *Travels,* 22:29, 70–71.

81. Frank B. Mayer to A. J. Miller, March 5, 1865, in Marvin C. Ross, ed., "Artists' Letters to Alfred Jacob Miller," unpublished typescript, Walters Art Gallery, Baltimore, 1951, p.10; William J. Orr, "Karl Bodmer: The Artist's Life," *Karl Bodmer's America* (Omaha: Joslyn Art Museum and University of Nebraska Press, 1984), pp.360–63; Mayer to Miller, May 27, 1868, in Ross, "Artists' Letters to Alfred Jacob Miller," p.17; De Cost Smith, "Jean François Millet's Drawings of American Indians," *Century Magazine* 80(May 1910): 78–84; and E. Haverkamp-Begemann and Anne-Marie S. Logan, *European Drawings and Watercolors in the Yale University Art Gallery, 1500–1900,* 2 vols. (New Haven: Yale University Press, 1970), 1:84–87. Notably, it was Millet's contribution, not Bodmer's, that made the collaboration important to art historians; Bodmer had faded into obscurity before his death in 1893.

82. Maximilian, Prince of Wied, "A few remarks about Catlin's book 'Letters and notes on the manners, customs and condition of the North American Indians,'" typescript translation of French draft (ca. 1842), Joslyn Art Museum, Omaha; Maximilian, *Travels,* 23:324, n.291.

83. Maximilian to GC, December 20, 1866, in *Mandan Religious Ceremony, O-Kee-Pa,* and elsewhere.

84. GC to the Editor, *Trübner's American and Oriental Literary Record,* September 22, 1865 (published in the *Record* for September 21, reprinted in James Thorpe, "George Catlin *vs.* the Philobiblon Society," *The New Colophon: A Book-Collectors' Miscellany,* vol.3 [New York: Privately Published, 1950], p.252); Trübner to Frank Squier, April 22, 1876, Squier Papers, LC: 6, and summarized in *Nation* 22(May 18, 1876): 322; *For Sale—Offers Invited/George Catlin's Rare Pamphlet with Two Original Catlin Letters* (Barnes, England: John Jeffery, [1946]), adv. (copy in AAA: 2137); facsimile, Thorpe, "George Catlin *vs.* the Philobiblon Society," p.250.

85. See Colin Taylor, "The O-kee-pa and Four Bears: An Insight into Mandan Ethnology," *Brand Book* (English Westerners' Society) 15(April 1973): 44, 54, n.14, and fig.3; "'Ho, for the Great West!': Indians and Buffalo, Exploration and George Catlin: The West of William Blackmore," in *"Ho, for the Great West!" and Other Original Papers to Mark the Twenty-Fifth Anniversary of the English Westerners' Society,* ed. Barry C. Johnson (London: English Westerners' Society, 1980), pp.38–39; GC, *An Account of an Annual Religious Ceremony Practised by the Mandan Tribe of North American Indians* (London: [Philobiblon Society], 1865), handwritten transcription, p.33, Ayer MS. 150, Newberry Library, Chicago; *O-Kee-Pa: A Religious Ceremony; and Other Customs of the Mandans* (Philadelphia: J. B. Lippincott, 1867), pp.34–35. It is also possible that the offending pamphlet derived from

Catlin's paper for the Ethnological Society of London, known in antiquarian circles since its presentation in 1851.

86. GC to Theodore Burr Catlin, September 9, 1868; GC to Francis Catlin, September 18, 1868, March 17, [1869], October 26, 1869, *Letters,* pp.348–50, 351–52, 383, 389, and app.10, pp.445–48.

87. Ewers, *Indian Art in Pipestone.* There has been confusion about the date of this album. It may have been begun in 1852, but it was completed after 1864. See GC to Harvey ——, December 25, 1864, Catlin Papers, folder 18.5, Bancroft.

88. Adrien de Longpérier to GC, October 25, 1864, *Memorial of George Catlin,* p.5; P. Mérimée to GC, September 2, [1864], AAA: 2136; GC to Harvey ——, December 25, 1864, Bancroft; GC to Henry S. Sanford, [April 1865], Sanford Papers; *Memorial of George Catlin,* p.5.

89. GC to Francis Catlin, January 9, 1869, Catlin Papers, folder 23, Bancroft (in *Letters,* p.378, Gurley's name is rendered "Grenley"). Catlin also tried to involve his nephew Theodore Burr Catlin, but the strapping "Pawnee chief" of the early 1840s was now a grandfather with a good memory of the distance between Catlin's grandiose plans and reality, and he stayed put at home.

90. Undated entries, Francis P. Catlin diary, Catlin Papers, folder 174, Bancroft. The diary is published in *Letters,* pp.354–71, but the transcriptions of the undated entries are not entirely accurate.

91. GC to Henry S. Sanford, November 22, 1868, Sanford Papers; *Memorial of George Catlin,* pp.5–6.

92. GC to Francis Catlin, January 26, 1869, Catlin Papers, Missouri Historical Society, St. Louis, published with minor variations in *Letters,* pp.381–82; *Memorial of George Catlin,* p.4.

93. Undated entries, Francis P. Catlin diary, Catlin Papers, folder 174, Bancroft (*Letters,* pp.360, 369); GC to

Francis Catlin, June 7, 1868, ibid., p.345.

94. GC to Francis Catlin, January 9, 1869, *Letters,* pp.377–79; undated entries, Francis P. Catlin diary, Catlin Papers, folder 174, Bancroft (*Letters,* p.371, combines separate items); GC to Francis Catlin, January 13, 1869, ibid., p.380; GC to Henry S. Sanford, [1868], Sanford Papers. A slight dating back to his Stuyvesant Institute exhibition in 1837 had made Catlin vituperative toward Irving; so had Irving's worldly success.

95. GC to Francis Catlin, January 13, 1869, *Letters,* p.380; *Cong. Globe,* 41st Cong., 1st sess., p.47; GC to Theodore Burr Catlin, September 9, 1868, *Letters,* p.348.

96. GC to Francis Catlin, June 11, 1869, ibid., pp.386–87.

97. Ibid., p.386; GC to Harvey ——, December 25, 1864, Bancroft; GC to Francis Catlin, October 26, 1869, February 5, 1870, *Letters,* pp.390, 396. Succumbing to suspicions, Catlin would later decide that Steele was an unprincipled opportunist: GC to Francis Catlin, March 3, 1870, ibid., p.400.

98. Henry Steele to Ezra Cornell, [October 1869], Department of Special Collections, MS. P499:2, Kenneth Spencer Research Library, University of Kansas, Lawrence; Philip Dorf, *The Builder: A Biography of Ezra Cornell* (New York: Macmillan, 1952), p.326; GC to Francis Catlin, October 26, 1869, *Letters,* p.380; Steele to Cornell, October 18, 1869, MS. P499:3, Spencer Library.

99. Thomas N. Rooker to Ezra Cornell, October 25, 1869, Ezra Cornell Papers, Department of Manuscripts and University Archives, Cornell University Libraries, Ithaca; Dorf, *Builder,* pp.374–75; Henry Steele to Ezra Cornell, October 20, 29, 1869, MS. P499:4–5, Spencer Library.

100. GC to Francis Catlin, December 17, 1869, Catlin Papers, Missouri Historical Society (*Letters,* pp.390–91); Henry Steele to Ezra Cornell, December 22, 1869, MS. P499:6;

GC to the President and Director of the Am‾o Photo-Lithographic Company, January 28, 1870, MS. P499:7, Spencer Library. In his excitement, Catlin extolled Cornell as "a sort of Peabody benefactor" (GC to Henry S. Sanford, December 15, 1869, Sanford Papers).

101. GC to Francis Catlin, February 5, 1870, *Letters,* pp.393–95.

102. Ibid., pp.394–95; Francis Catlin to George Moore, May 5, 10, 1870, NYHS; GC to Francis Catlin, August 29, 1870, *Letters,* p.402 (the $750 figure is a surmise based on the price Catlin named in his letter of May 5); GC to Francis Catlin, February 5, 1870, *Letters,* p.395; GC, "The North American Indians in the Middle of the Nineteenth Century . . ." (ca. 1868–69), p.4, Huntington; GC to Francis Catlin, October 26, December 17, 1869, August 29, 1870, *Letters,* pp.388, 391, 402.

103. GC to Librarian, NYHS, October 10; GC to President, NYHS, March 2, 1870, NYHS (*Letters,* pp.405, 407, 452).

104. Joseph Henry to E. W. Catlin, March 16, 1866, Secretary, 1865–91: Outgoing Correspondence, 3:239–41; E. W. Catlin to D. S. Gregory, January 16, 1866, Secretary, 1863–79: Incoming Correspondence, box 3, folder 7, SIA.

105. Henry to E. W. Catlin, March 16, 1866; E. W. Catlin to Henry, April 10, 1866, Secretary, 1863–79: Incoming Correspondence, box 3, folder 7, SIA.

106. GC, *Lifted and Subsided Rocks,* pp.176, 179. The book was published in March 1870: GC to Francis Catlin, March 3, 1870, *Letters,* p.398.

107. GC to Henry S. Sanford, September 23, 1868, Sanford Papers; *Lifted and Subsided Rocks,* pp.214–28. Catlin wrote often to Sanford extolling Brasseur and advocating his cause; Brasseur, in turn, endorsed Catlin's work unreservedly in a letter to Francis P. Catlin, March 7, 1869,

copies in the NYHS and Spencer Library (MS. P499:1). For Brasseur, see Leo Deuel, *Testaments of Time: The Search for Lost Manuscripts and Records* (New York: Knopf, 1965), chap. 23, esp. pp.536–38.

108. Presentation copy, *Memorial of George Catlin,* AAA: 2137; Joseph Henry to GC, April 1, 1870, Joseph Henry Papers, box 4, SIA (a reply to Catlin's letter of February 4, just received); GC to Henry, March 21, 1870, RH 2837, Huntington.

109. Miller, *Patrons and Patriotism,* pp.155, 172; GC to Francis Catlin, February 26, 1870, *Letters,* pp.397–98, replying to Francis Catlin's of February 7; GC to President, NYHS, March 2, 1870.

110. GC to Francis Catlin, February 26, August 29, 1870, *Letters,* pp.397, 403; GC to Librarian, NYHS, October 10, 1870, NYHS.

111. GC to George Moore, October 15, 29, 1870, NYHS (*Letters,* p.408).

112. GC to Francis Catlin, August 29, 1870, *Letters,* p.403. Catlin was still in Brussels at the end of April 1871, well after some writers have placed him in America: GC to Blackmore, April 28, 1871, HSNM 0270.

CHAPTER 8

1. *Letter of Prof. Henry, of the Smithsonian Institution,* [December 13, 1873] (n.p., [1873]), copy in the Bancroft Library, University of California, Berkeley; and Donaldson, *Catlin Gallery,* p.771.

2. SE to John R. Bartlett, October 8, 1855; Mary H. Eastman to Bartlett, January 7, March 5, April 3, July 20, 1856, Bartlett Papers.

3. An army inspector met Eastman en route to San Antonio for seven days' sick leave (July 16–23) and reported him "quite sick and feeble." At Fort Chadbourne he found discipline good but Eastman's company particularly deficient in marksmanship. He reported that shortly before July 16 Eastman had "invited a party

of wild Comanches into the garrison & in attempting to take them prisoners his men killed 2 men & 5 squaws—the rest escaped." Presumably this was the skirmish Mary Eastman referred to—hardly a glorious encounter (M. L. Crimmins, ed., "Colonel J. K. F. Mansfield's Report of the Inspection of the Department of Texas in 1856," *Southwestern Historical Quarterly* 42[April 1939]: 365, 368).

4. Mary H. Eastman to John R. Bartlett, November 15, 1856, Bartlett Papers; Mary H. Schoolcraft to Miss Cass, February 26, 1857, HRS Papers: 43.

5. For John's trail of bad debts and the final rupture, see Pliny Miles to HRS, April 9, 1852; John J. Schoolcraft to HRS, April 10, August 24, 1852, HRS Papers: 13; also Anna Jamison to HRS, January 8, 1853; John J. Schoolcraft to HRS, December 4, 1854, and to Mary H. Schoolcraft, December 23, 1854, roll 14; for Jane and the Eastmans, Jane Schoolcraft to Mary H. Schoolcraft, September 4, 1851, roll 13; SE to HRS, October 10, 1851; Mary H. Eastman to Mary H. Schoolcraft, [November–December 1851], December 6, [1851], roll 40; SE to HRS, November 20, 1852, roll 14.

6. Mary H. Schoolcraft to Miss Cass, February 26, 1857, HRS Papers: 43; HRS to John R. Bartlett, April 30, 1856, Bartlett Papers; Mary H. Schoolcraft to Mary H. Eastman, 1859, HRS Papers: 16. Mary Schoolcraft always fancied herself an orphan raised by a wicked stepmother and made this a theme in her novel *The Black Gauntlet: A Tale of Plantation Life in South Carolina* (Philadelphia: J. B. Lippincott, 1860), which devoted a chapter to her problems with Jane and Mary Eastman (chap.21) and many pages to deploring the dangers of race mixing and her trials in raising her stepchildren (pp.491–501, 536–42).

7. See John Francis McDermott, *Seth Eastman: Pictorial Historian of the Indian* (Norman: University of Oklahoma Press, 1961), pp.17–19; and Raymond Wilson, *Ohiyesa: Charles Eastman, Santee Sioux* (Urbana: University of Illinois Press, 1983), pp.11–13. Henry H. Sibley, as a young trader at Michilimackinac, received a letter from Lieutenant J. K. Greenough, November 30, 1830, describing the situation at Fort Snelling: "This place is in some respects like the Sault. But the Article *Old Hat* is by no means so plenty. We Bachelors here, sometimes travel in *Africa*, and sometimes into the *Indian* Country but seldom into a civilized cunt-ry. How is it with you? did Josette return with you to Mackinac? or have you found some other fair one to undo." Greenough had left a baby son behind at the Sault, and Sibley would have a daughter, Helen, by a Sioux woman in 1839. Sibley Papers: 1.

8. Lawrence Taliaferro Journal, 11:19–21, 25, 35 (entries for July 1, 3, 10, August 1, 1831); 15:78–79, 81, 83–84, 93, 113 (entries for September 19, 21, 23, October 3, 22, 1838), Taliaferro Papers: 3–4. In May 1839 Taliaferro began pushing for the creation of an orphan asylum near Fort Snelling (ibid., p.125); as Nancy Eastman's trustee, he invested her $300 in April 1841 and lost it in a bankruptcy (Taliaferro to Henry H. Sibley, January 18, 1849, Sibley Papers: 5).

9. Bertha L. Heilbron, ed., "Frank B. Mayer and the Treaties of 1851," *Minnesota History* 22(June 1941): 152 (Mayer's Diary, entry for July 30, 1851). Charles A. Eastman, *Indian Boyhood* (Boston: McClure, Phillips, 1902), pp.4–5, offers an appealing portrait of a mother he never knew, "the handsomest woman of all the Spirit Lake and Leaf Dweller Sioux" who, according to tradition, "had every feature of a Caucasian descent with the exception of her luxuriant black hair and deep black

eyes." Interestingly, he was raised by his paternal grandmother, his maternal grandmother—Seth Eastman's inamorata—being considered too unreliable.

10. This paragraph is based on three draft letters by Mary H. Schoolcraft to Mary H. Eastman, one dated May 16, 1859 (HRS Papers: 43), the other two simply Annodomini 1859 (rolls 16, 42). Mary Schoolcraft's self-description was amusingly elaborated in a newspaper notice she planted in 1860: "Her mind, like her figure, is of a stately and majestic cast, the lofty Roman, rather than the light Ionic. Possessing great independence of character, and a thorough detestation of the fastness and hollowness of mere fashionable life [Mary Eastman titled her 1856 novel of Washington society *Fashionable Life*], she dares to be sincere and honest" ("The Black Gauntlet," unidentified clipping, roll 66).

11. Mary H. Schoolcraft to Mr. Moultrie, April 3, 1854, HRS Papers: 14; also, to Mrs. Miller, November 17, 1851, roll 13, and to J. B. Lippincott, February 5, 1860, roll 16; Mary H. Eastman to Mary H. Schoolcraft, December 6, [1851], roll 40.

12. Mary H. Eastman to Benjamin Pringle, March 14, 1856, NA, RG 233: Records of the United States House of Representatives, LC Collection, box 250; *App., Cong. Globe,* 34th Cong., 1st sess., p.39 (Public, 71, app. August 18, 1856).

13. *Petition to Congress of Henry R. Schoolcraft, Acting Superintendent Indian Affairs, Michigan, &c. &c.* (Washington: Gideon, [1858]), copy in HRS Papers: 15; *Sen. Journal,* 35th Cong., 1st sess., p.319 (April 6, 1858); HRS to the Senate, and House of Representatives, May 8, 1858, and to William K. Sebastian, May 8, 1858, HRS Papers: 15; *Sen. Journal,* 35th Cong., 1st sess., pp.426, 634 (May 10, June 8, 1858).

14. Mary H. Eastman to John R. Bartlett, January 9, 1858, Bartlett Papers;

A Bill for the Relief of Henry R. Schoolcraft (S. 443), 35th Cong., 1st sess. (June 8, 1858), copy with "Mrs." inserted throughout the text, HRS Papers: 42; George Minot and George P. Sanger, eds., *The Statutes at Large . . . ,* vol.11 (Boston: Little, Brown, 1867), pp.557–58; *House Journal,* 35th Cong., 2d sess., pp.222, 235, 239, 243, 256; and *Cong. Globe,* 35th Cong., 2d sess., pp.440, 511–12, 517 (Freeman, "Schoolcraft," pp.264–67, argues that it was Congress's intention to satisfy both Schoolcraft claims by this act; if so, Schoolcraft did not accept this interpretation); HRS to William K. Sebastian, March 9, 1859, HRS Papers: 42; Charles E. Mix to J. B. Lippincott, March 23, 1859, and Lippincott to HRS, May 3, 1859, roll 15; HRS and Mary H. Schoolcraft, contract with Lippincott [May 3, 1859], roll 43.

15. Spencer F. Baird to Mary H. Schoolcraft, July 9, 1859, HRS Papers: 43; Baird to HRS, October 12, 1859, roll 42; Joseph R. Walker to Mary H. Schoolcraft, August 2, 1859, and J. B. Lippincott to Mary H. Schoolcraft, March 22, 1859, roll 43; Lippincott to HRS, November 19, 1859, roll 42; Mary H. Schoolcraft to Lippincott, February 5, 1860, roll 16 (she had done her best to sell copies "for the support of my helpless husband and two destitute orphan children, whom I have adopted," she wrote to William De-Zeng, June 13, 1859, *The Collector* 77[nos.1–3, 1964]: 13, no.E–106); Mary H. Schoolcraft to Mr. Moultrie, April 3, 1854, HRS Papers: 14; HRS to the Senate, and House of Representatives, March 28, 1860, roll 16.

16. *Archives of Aboriginal Knowledge* ([Philadelphia], [ca. 1859]), copy in HRS Papers: 64 (Schoolcraft had completely embraced what his critics meant as a condemnation, the point that his Indian history was " a complete *Thesaurus*—an overflowing treasury of knowledge"); SE to the

Members of the Senate and House of Representatives, December 5, 1859, NA, RG 46; SEN 39A–H1–H2, drawer 33: Petitions and Memorials (A–L).

17. Mary H. Schoolcraft to Mary H. Eastman, 1859; J. B. Lippincott to Mary H. Schoolcraft, September 16; Colonel Cooper to Mary H. Schoolcraft, November 23, 1859, HRS Papers: 16.

18. SE to the Members of the Senate and House of Representatives, December 5, 1859; appended note by Eastman; George W. Manypenny to Robert McClelland, December 27, 1856, copy, in NA, RG 46: SEN 39A–H1–H2, drawer 33: Petitions and Memorials (A–L). The Manypenny letter is also in NA, Report Book of the BIA, 9:519–21 (microfilm M–348, roll 9).

19. *Cong. Globe,* 35th Cong., 2d sess., p.517 (January 21, 1859); Mary H. Eastman to Robert C. Schenck, [February 1867], NA, RG 233: Records of the United States House of Representatives, 40th Congress Accompanying Papers File, box 6; SE to Charles Lanman, December 14, 1859, Charles Henry Hart Autograph Collection, AAA: D5.

20. *A Bill for the Relief of Seth Eastman (S. 308),* 36th Cong., 1st sess. (March 23, 1860); *Sen. Rep. Com. No. 151* (March 23, 1860), 36th Cong., 1st sess.; *Cong. Globe,* 36th Cong., 1st sess., p.1320. The printed bill is in NA, RG 46: SEN 36A–B2; the draft for the printed report, by Daniel Clark (Republican, N.H.), in SEN 36A–D1.

21. *Sen. Journal,* 39th Cong., 1st sess., p.114 (January 29, 1866); SE, note on his illustrations for Schoolcraft's history, with addenda regarding *Chicora,* NA, RG 46: SEN 39A–H1–H2, drawer 33: Petitions and Memorials (A–L); *Sen. Rep. Com. No. 160* (February 7, 1867), 39th Cong., 2d sess.

22. SE to Eugene Carter, April 17, 1866, NA, RG 94: Records of the Adjutant General's Office, consolidated corre-spondence file no.3827 ACP 1875, pertaining to S. Eastman; A. H. Robinson, certificate, September 8, 1862, and Basil Norris, certificate, September 30, 1875, NA, RG 15: Records of the Veterans Administration, pension application file no. WC 171–295, pertaining to S. Eastman; John M. Welty, Summary of Proof, Widow's Pension claim, approved December 9, 1875, ibid.; E. D. Townsend, Military History of Seth Eastman, October 15, 1875, ibid.; and SE to Townsend, September 4, 1866, NA, RG 94: Records of the Adjutant General's Office.

23. Mary H. Eastman to Robert C. Schenck, [February 1867]; U.S. Grant to Schenck, February 9; Edward McPherson to Schenck, February 12, 1867, NA, RG 233: Records of the United States House of Representatives, 40th Congress, Accompanying Papers File, box 6.

24. *Cong. Globe,* 39th Cong., 2d sess., p.1429; 40th Cong., 1st sess., pp.361–62, 351, 360; 40th Cong., 2d sess., pp.1567, 1619 (March 2, 1868).

25. Charles E. Fairman, *Art and Artists of the Capitol of the United States of America* (Washington: GPO, 1927), pp.237–39; S. D. Wyeth, *The Rotunda and Dome of the U.S. Capitol* (Washington: Gibson Brothers, 1869), p.226; Townsend, Military History of Seth Eastman, October 15, 1875; McDermott, *Seth Eastman,* pp.100–102. See Architect of the Capitol, *Art in the United States Capitol* (Washington: GPO, 1976), pp.166–93, for all the Eastman oils in color. The Indian oils are dated 1867–69, the forts, 1870–75.

26. [Mary H. Eastman], Application for a New Certificate, June 11, 1878; Pensioner Dropped form, August 20, 1890, NA, RG 15: Records of the Veterans Administration, pension application file no. WC 171–295, pertaining to S. Eastman; Winton U. Solberg, "Mary Henderson Eastman," in Edward T. James et al., eds., *Notable American Women, 1607–*

1950: A Biographical Dictionary, 3 vols. (Cambridge: Harvard University Press, 1971), 1:545–46; Mary H. Eastman to Spencer F. Baird, April 8, 1884, Secretary, 1882–87: Baird—Incoming Correspondence, box 2, folder 11, SIA.

27. A Southern Lady [Mary H. Schoolcraft], *Letters on the Condition of the African Race in the United States* (Philadelphia: T. K. and P. G. Collins, 1852), p.34; J. B. Lippincott to Mary H. Schoolcraft, April 19, May 4, 15, 19, 24, 29, 31, 1860, and October 20, 1863, HRS Papers: 43.

28. Mary Schoolcraft has been credited with a better novel also published in 1860, *The Household Bouverie; or, The Elixir of Gold: A Romance by a Southern Lady.* It was actually the work of Catherine Ann Ware Warfield, which should afford some amusement to readers of their respective entries in the fourth volume of Lina Mainiero, ed., *American Women Writers,* 4 vols. (New York: Frederick Ungar, 1982).

29. HRS to J. B. Lippincott, October 19; Lippincott to HRS, October 24, 1855, HRS Papers: 41; Freeman, "Schoolcraft," pp.270–76; HRS to Lippincott, February 1, 1858, rolls 42, 15; Memoranda, roll 64; Lippincott to HRS, February 11, 1858, roll 15; HRS to Lippincott, September 24, 1859, roll 16; Mary H. Schoolcraft to Lippincott, [ca. 1870], roll 43.

30. HRS to Editor, *NI,* December 6, 1855; Henry W. Longfellow to HRS, December 14, 1855, HRS Papers: 41; HRS to Horace Greeley, January 21, 1856; Longfellow to HRS, February 14, 1859, roll 42; William P. Dole to J. P. Usher, January 20, 1864, rolls 42, 16; HRS, Memorial, March 28, 1864, roll 16; J. B. Lippincott to HRS, March 31, 1864, roll 42. On July 8, 1864, Schoolcraft wrote W. Clark, son of the explorer, for a contribution on the St. Louis superintendency (roll 16).

31. This discussion follows draft letters, Mary H. Schoolcraft to Sir Roderick I. Murchison, March, July 4, 1865; and to ——, [ca. January 1865], HRS Papers: 43; Rev. Dr. Samson, president, Columbian College, in *Henry R. Schoolcraft Died in Washington, D.C. on the 10th Day of December, 1864, aged 72 Years. His Funeral Services . . .* ([Washington], [1864]), pp.4–5 (copy bound in with *Information,* vol.1, PABC, Victoria, B.C.).

32. See Elisabeth Darby and Nicola Smith, *The Cult of the Prince Consort* (New Haven: Yale University Press, 1983). A few months before Albert's death Mary Schoolcraft had written to Queen Victoria (September 19, 1861) to ascertain if she would care to purchase the English copyright to the *Archives* for £25,000; she would not, Lord Russell informed her on October 28 (HRS Papers: 16).

33. Mary H. Schoolcraft to Lewis Cass, February 14, 1865; to ——, [ca. January 1865]; to William Sprague, February 14, 1865, HRS Papers: 43; "Henry R. Schoolcraft," unidentified clipping, roll 66, which prints her memorial in its entirety; A. B. Johnson to Mary H. Schoolcraft, March 28, 1866, roll 43; Henry W. Longfellow to George Washington Greene, August 5, 1876, in Andrew Hilen, ed., *The Letters of Henry Wadsworth Longfellow,* 6 vols. (Cambridge: Belknap Press of Harvard University Press, 1966–82), 6:163–64.

34. Mary H. Schoolcraft to ——, August 7, 1866; J. B. Lippincott to Schoolcraft, December 8, 1866; Schoolcraft to Lippincott, [ca. 1870], HRS Papers: 43; Schoolcraft to Lippincott, [ca. 1873], roll 42.

35. Mary H. Schoolcraft to J. B. Lippincott, February 5, 1860, [ca. 1873], HRS Papers: 16, 42; Brantz Mayer to EGS, May 11, 1869, Squier Papers, LC: 5.

36. At a meeting in October 1869 the American Ethnological Society was formally dissolved, to be reconstituted as the Anthropological Society of New York (despite Brantz Mayer's advice to call it the American Anthropological Society in order to

"unlocalize" it, a concern that fell victim to a previous claim on that name). See Mayer to EGS, February 28, 1870, and the various circulars, etc., related to the new society, Squier Papers, LC: 14.

37. William W. Turner to John R. Bartlett, June 8; George H. Moore to Bartlett, March 5; Wills De Hass to Bartlett, March 6, 1858, Bartlett Papers; E. H. Davis to HRS, April 5, and HRS to Davis, April 8, 1858, HRS Papers: 15. De Hass to HRS, March 4, 1858, roll 12, was a sustained whoop of joy.

38. Charles E. Norton to EGS, May 9, 1855, Squier Papers, LC: 3; EGS to Francis Parkman, May 30, 1851, copy, Squier Papers, NYHS: 3; Parkman to EGS, November 3, 1851, May 13, 1849, in Wilbur R. Jacobs, ed., *Letters of Francis Parkman,* 2 vols. (Norman: University of Oklahoma Press, 1960), 1:92, 63; "Notes on New Books," *NI,* January 17, 1852; [EGS], "San Juan de Nicaragua," *Harper's New Monthly Magazine* 10(December 1854): 50; Brantz Mayer to EGS, March 23, 1851, Squier Papers, LC: 2; William W. Turner to John R. Bartlett, February 25, 1851, Bartlett Papers. See Michael D. Olien, "E. G. Squier and the Miskito: Anthropological Scholarship and Political Propaganda," *Ethnohistory* 32, 2(1985): 111–23, for the argument that Squier's writing in the 1850s was essentially that of a publicist rather than a scholar.

39. EGS to John R. Bartlett, June 10, 1849, Bartlett Papers, and *Nicaragua: Its People, Scenery, Monuments . . . ,* rev. ed. (New York: Harper, 1860), p.39, for a corresponding passage; EGS, "The Aboriginal Remains of Honduras," *New York Times,* October 5, 1853; also EGS to Joseph Henry, December 2, 1850, *Fifth Annual Report, SI* (Washington, 1851), pp.78–80. See Benjamin Keen, *The Aztec Image in Western Thought* (New Brunswick, N.J.: Rutgers University Press, 1971), chaps.10–11.

40. EGS to John R. Bartlett, October 29, 1863, December 30, 1864, Bartlett Papers; EGS to Francis Parkman, January 12, 28, February 6, 20, 23, 1866, Squier Papers, NYHS: 3; Parkman to EGS, January 18, February 2, in Jacobs, *Letters of Francis Parkman,* 2:5–7. Twelve years before, E. H. Davis had delivered a course of lectures on American archaeology at the institute.

41. EGS to his parents, September 1, 1869, Squier Papers, NYHS: 3; "Frank Squier," in *The National Cyclopaedia of American Biography* (New York: James T. White, 1891–), 3:324.

42. HRS to Charles F. Hoffman, November 5, 1844, RH 240, Huntington (Hoffman's Indian enthusiasm was budding a decade earlier when he visited Peter Rindisbacher in St. Louis and admired his Indian paintings; see John Francis McDermott, "Peter Rindisbacher: Frontier Reporter," *Art Quarterly* 12[Spring 1949]: 142); "Translation of an Indian Love Song," in *The Poems of Charles Fenno Hoffman,* ed. Edward Fenno Hoffman (New York: AMS Press, 1969 [1873]), pp.164–65; HRS to Mary H. Schoolcraft, April 27, 1849, HRS Papers: 12, and *NI,* April 28, 1849; HRS to John R. Bartlett, May 4, 1849, Bartlett Papers; Francis Parkman to EGS, November 18, [1849], in Jacobs, *Letters of Francis Parkman,* 1:66, and David Embury to EGS, November 29, 1849, Squier Papers, LC: 1; Mary H. Schoolcraft to George Hoffman, September 30, 1849, HRS Papers: 12; John R. Bartlett to EGS, October 23, 1849, Squier Papers, LC: 1; HRS to Jane Schoolcraft, November 18, 1849, HRS Papers: 12; Emma C. Embury to HRS, December 4, 1853, roll 41. A report in the New York *Daily Tribune,* January 5, 1858, squelched the persistent rumor that Hoffman was in precarious health and still held out hope for his full recovery in the Pennsylvania Hospital near New York.

43. Brian W. Dippie, *The Vanishing American: White Attitudes and U.S. Indian Policy* (Middletown: Wesleyan University Press, 1982), pp.257–62; EGS to Francis Parkman, March 8, 1850, copy, Squier Papers, NYHS: 3.

44. George R. Gliddon to EGS, November 19, 1855, Squier Papers, LC: 3; John R. Bartlett to EGS, November 14, 1854, Squier Papers, LC: 3, for an attempt at matchmaking; Brantz Mayer to EGS, March 18, 1858; J. C. Nott to EGS, December 4, 1857, Squier Papers, LC: 4.

45. The account that follows relies on Madeleine B. Stern's well-researched and highly entertaining *Purple Passage: The Life of Mrs. Frank Leslie* (Norman: University of Oklahoma Press, 1953).

46. EGS to J. L. L. Warren, July 15, 1860, Warren Papers, C–B418, box 4, Bancroft; Stern, *Purple Passage,* pp.47–48.

47. Squier Papers, NYHS: 3.

48. Stern, *Purple Passage,* p.60; "Tales of To-day: No. 4.—From Puddle to Palace," *Town Topics,* March 27, 1886, copy in Squier Papers, NYHS: 3 (the prose bears evidence of Squier's style); Stern, *Purple Passage,* pp.63–65; EGS to Douglas Campbell, June 5, 1873; "Supreme Court in the Matter of E. George Squier a lunatic: *Commission to Committeo,*" August 11, 1874, Squier Papers, NYHS: 3. Campbell was Miriam's lawyer; Squier's letter is a threat to expose his ex-wife if a certain "*single* contingency" arises: "You will not know what all this means, but your client, to whom I have surrendered every consideration of pride and manhood, will." Other interpretations are possible, but her marrying Leslie seems the likeliest meaning.

49. EGS to Harper Brothers, October 21, 1874; to Frank Squier, October 29, November 18, 1874; to his parents, September 11, 1878, June 17, 1879, March 9, 1881; to Frank Squier, July 6, 1880, October 27, 1884, Squier Papers, NYHS: 3. The few scattered letters indicate how dif-

ficult Squier found writing. See Joel Squier to Frank Squier, July 11, 1876, for confirmation. Nevertheless, Squier had lucid moments and undoubtedly had a hand in certain newspaper attacks on the Leslies. See Stern, *Purple Passage,* pp.93–96.

50. Edgar Allen Poe, "For Annie," in *Selected Writings of Edgar Allan Poe,* ed. Edward H. Davidson (Boston: Houghton Mifflin, 1956), p.42 (first published April 28, 1849).

51. JMS to Isaac Strohm, February 7, 1865, Strohm Papers, Cincinnati Historical Society.

52. JMS to Isaac Strohm, January 16, 1866, Strohm Papers, Cincinnati Historical Society.

53. See Mary M. Kenway, "Portraits of Red Jacket," *Antiques* 54(August 1948): 100–101; Truettner, *Natural Man,* pp.12–13, 83, 216–17; and Herman J. Viola, *The Indian Legacy of Charles Bird King* (Washington: Smithsonian Institution Press and Doubleday, 1976), p.60. Weir's portrait illustrated William L. Stone, *The Life and Times of Sa-go-ye-wat-ha, or Red Jacket* (Albany, N.Y.: J. Munsell, 1866), facing p.103, and J. Niles Hubbard, *An Account of Sa-go-ye-wat-ha or Red Jacket and His People, 1750–1830* (Albany, N.Y.: Joel Munsell's Sons, 1886), frontispiece; King's portrait, of course, illustrated McKenney and Hall's *History.* For Eastman's Red Jackets, see *Information,* vol.3, between pp.198 and 199; and John Francis McDermott, *Seth Eastman,* plate 110. The 1868 oil derived from Eastman's 1852 painting of the same title (plate 8), which was a purely western scene and included no Red Jacket.

54. "The Trial of Red Jacket," unidentified clipping; "Stanley's Great Painting: 'The Trial of Red Jacket,'" *Detroit Free Press,* December 13, 1868; clipping enclosed with JMS to Isaac Strohm, December 14, 1868, Stanley Papers, AAA: 687.

55. SE to the Members of the Senate and House of Representatives, December 5, 1859, NA, RG 46: SEN 39A–H1–

H2, drawer 33: Petitions and Memorials (A–L); Mary H. Eastman to Robert C. Schenck, [February 1867], NA, RG 233: Records of the United States House of Representatives, 40th Congress Accompanying Papers File, box 6.

56. "A National Loss," *Grand Rapids Eagle,* April 12, 1872, in Stanley Papers, AAA: 687; F. W. Hodge, "A Proposed Indian Portfolio by John Mix Stanley," *Indian Notes* 6(October 1929): 359–67; JMS to Isaac Strohm, April 21, May 2, 1868, Strohm Papers, Cincinnati Historical Society.

57. JMS to Alice C. Stanley, May 24, May 28, 1868; *Just Published: Stanley Chromos* ([Detroit: J. M. Stanley], [ca. 1870]); "Our Home Artists," "Indian Telegraph," unidentified clippings, Stanley Papers, AAA: 687; and "Art Matters," *Detroit Post,* April 28, 1868, Stanley Scrapbook, p.55, AAA: OAM; "Mr. Stanley's Chromos," "The Trial of Red Jacket," unidentified clippings (Detroit), Stanley Papers, AAA: 687; "Red Jacket," unidentified clipping (Buffalo, ca. January 16, 1869), "The Trial of Red Jacket," unidentified clipping (Detroit); and A., "Red Jacket: Stanley's Historical Painting Now on Exhibition in This City," undated clipping, *Detroit Express,* Stanley Scrapbook, pp.58, 59, 61, AAA: OAM. After exhibiting in New York State, Stanley proposed taking *Red Jacket* to Europe. W. Vernon Kinietz, *John Mix Stanley and His Indian Paintings* (Ann Arbor: University of Michigan Press, 1942), p.28, contends that the painting earned $8,000 on exhibition; likely Kinietz confused the first newspaper source cited here, which referred to subscription sales of the print.

58. JMS to Isaac Strohm, January 25, April 21, 1868, Strohm Papers, Cincinnati Historical Society.

59. *Cong. Globe,* 41st Cong., 2d sess., pp.1075, 1454 (Chandler was approached by Michigan's state senators in 1865 to see that Congress

made restitution to Stanley—JMS to Isaac Strohm, February 7, 1865, Strohm Papers, Cincinnati Historical Society); JMS to Strohm, January 5, 1870, January 25, 1868, Strohm Papers; *Cong. Globe,* 41st Cong., 2d sess., p.4526; Julie Schimmel, "John Mix Stanley and Imagery of the West in Nineteenth-Century American Art" (Ph.D. diss., New York University, 1983), pp.153–56; Peter C. Marzio, *The Democratic Art: Chromolithography 1840–1900, Pictures for a Nineteenth-Century America* (Boston: David R. Godine in association with the Amon Carter Museum of Western Art, 1979), pp.180–83, plates 104–5. Marzio gives the 1871 date for the *Red Jacket* print.

60. "Death of the Artist Stanley," *Detroit Free Press,* April 11, 1872 (longhand copy); "Stanley, the Artist," *Washington Gazette,* April 21, 1872 (which stressed how distraught Stanley was after the fire), Stanley Papers, AAA: 687; JMS to Isaac Strohm, January 11, 21, 1868, Strohm Papers, Cincinnati Historical Society; JMS to Alice C. Stanley, May 24, 1868, Stanley Papers, AAA: 687; JMS to Strohm, January 5, 1870, Strohm Papers; JMS to Alice C. Stanley, April 24, 1871, Stanley Papers.

61. "Building Improvements," undated clipping, *Detroit Post;* Frederick Stearns and Augustus W. Leggett to Alice C. Stanley, April 20, 1872; "The Death of Mr. Stanley—Resolutions of Respect," unidentified clipping, Stanley Papers, AAA: 687.

62. See J. Russell Harper, *Paul Kane's Frontier, Including "Wanderings of an Artist among the Indians of North America" By Paul Kane* (Toronto: University of Toronto Press for the Amon Carter Museum, Fort Worth, and the National Gallery of Canada, Ottawa, 1971), pp.38–40.

63. *Annual Report, SI, 1865* (Washington: GPO, 1866), pp.17–18.

64. "Death of Stanley, the Artist," *Detroit Tribune,* April 10; "Death of J. M. Stanley," *Detroit Post,* April 11;

"Death of the Artist Stanley," *Detroit Free Press,* April 11, 1872; "Jno. M. Stanley's Widow," unidentified clipping (Detroit, ca. January 1891), Stanley Papers, AAA: 687.

65. Untitled, unidentified clipping; "Fine Arts: Stanley's 'Trial of Red Jacket,'" *Evening Post* (New York), February 5, 1873, reprinting an article in the Detroit *Post,* January 18, 1873, clippings in Stanley Papers, AAA: 687 (there was also a move to purchase his *Mt. Hood* for the Detroit Council chamber; unidentified clipping, ibid.); Alice C. Stanley to Spencer F. Baird, August 12, 1883, John Mix Stanley Collection, folder 4, SIA; Spencer F. Baird to Alice C. Stanley, August 18, September 3, 1883, Secretary, 1865–91: Outgoing Correspondence, box 44, vol. 145, p.395; vol.147, pp.193–94, SIA.

66. Alice C. Stanley to Spencer F. Baird, September 6, 1883, Secretary, 1882–90: Incoming Correspondence, box 11, folder 15, SIA; L. C. Stanley to Mary A. Henry, January 21, 1884, and to Frank W. Hackett, February 25, 1884; Henry to Hackett, June 23, 1884, John Mix Stanley Collection, folder 2, SIA.

67. *Cong. Record,* 50th Cong., 1st sess., p.1810 (Senate, March 7), p.1976 (House, March 12); 51st Cong., 1st sess., p.898 (Senate, January 28), pp.1427–28 (House, February 17). Congressmen were provided with a summary of Stanley's 1866 petition and a brief description of *Red Jacket* (NA, RG 46: SEN 51A–F17).

68. "Jno. M. Stanley's Widow" (ca. January 1891); Joseph Safron to Frances Bayles, August 28, 1947; Edith Stanley Bayles to Robert W. Bingham, September 23, December 31, 1947, January 20, 1948; Bingham to Bayles, September 29, 1947, January 5, 22, February 6, 1948; George M. Stanley to Edith Bayles, January 12, 1948, Stanley Papers, AAA: 687. The family had been making a concerted effort to sell the painting since 1945, asking $5,000 to $6,000.

69. "A National Loss," *Grand Rapids Eagle,* April 12, 1872, clipping in Stanley Papers, AAA: 687.

70. See Loyd Haberly, *Pursuit of the Horizon: A Life of George Catlin, Painter and Recorder of the American Indian* (New York: Macmillan, 1948), p.220.

71. GC to Francis Catlin, [March] 17, [1869], *Letters,* p.383; *Catlin's Indian Cartoons,* printed invitation (New York, 1871), George Winter Papers, Tippecanoe County Historical Association, Lafayette, Indiana, courtesy of Mrs. Cable G. Ball; *Catlin's Indian Cartoons, 600 Paintings . . . Extracts from the Opinions of the New York Press,* single sheet (New York, 1871), copy in Secretary, 1863–79: Incoming Correspondence, vol.109, p.73, SIA; GC to Manton Marble, [November 1871], Papers of Manton Marble, vol.29, no.6509, LC; Dulieu to GC, July 16, 1870, AAA: 2136; GC to Henry S. Sanford, December 15, 1869, Sanford Papers.

72. Charles Rau, "George Catlin and His Work," in Donaldson, *Catlin Gallery,* pp.772–73; GC to Joseph Henry, n.d. [received November 1, 1871], Secretary, 1863–79: Incoming Correspondence, 109:74, SIA; Joseph Henry to GC, November 7, 1871, Secretary, 1865–91: Outgoing Correspondence, 25:677–78, SIA.

73. GC to Joseph Henry, November 26, 1871, Secretary, 1863–79: Incoming Correspondence, 109:75, SIA; GC to Henry A. Boller, December 7, 1871, Boller Papers, State Historical Society of North Dakota, Bismarck; GC to William Blackmore, December 12, 1871, Museum of New Mexico, Santa Fe, HSNM 0406; Joseph Henry to GC, December 18, 1871, Secretary, 1865–91: Outgoing Correspondence, 26:261, SIA.

74. Thomas Phillipps to [Nicolas Trübner], September 2, 1870, Squier Papers, LC: 5. For Blackmore see Colin Taylor, "'Ho, for the Great West!': Indians and Buffalo, Exploration and George Catlin: The West of

William Blackmore," in *"Ho, for the Great West!": The Silver Jubilee Publication of the English Westerners' Society,* ed. Barry C. Johnson (London: English Westerners' Society, 1980), pp.8–49.

75. Printed invitation, dated by hand August 19, 1867, Squier Papers, NYHS: 3; GC to William Blackmore, April 27, 1871, Museum of New Mexico, Santa Fe, HSNM 0269. Squier, who also knew Sir Thomas Phillipps, maintained an interest in Catlin's descriptions of the O-kee-pa: Joseph Sabin, ed., *Catalogue of the Library of E. G. Squier* (New York: Charles C. Shelley, 1876), nos.179–80. Catlin, in turn, knew of, and respected, Squier's archaeological researches in Central America: GC to Henry S. Sanford, [November 1863], Sanford Papers.

76. William Blackmore to George Winter, August 6, November 20, 1871; Winter to Blackmore, August 9, November 24, 1871, March 5, November 21, 1872, George Winter Papers, Tippecanoe County Historical Association, Lafayette, Indiana, courtesy of Mrs. Cable G. Ball; GC to Blackmore, April 27, 28, Museum of New Mexico, Santa Fe, HSNM 0269–70. Blackmore was probably the English nobleman Catlin told the New-York Historical Society was prepared to pay $40,000 for his collection on demand.

77. GC to William Blackmore, December 12, 1871, Museum of New Mexico, Santa Fe, HSNM 0407; and, for Catlin's inquiries into phototypography, GC to Francis Catlin, August 29, 1870, *Letters,* p.403.

78. GC to Blackmore, December 12, 1871, Museum of New Mexico, Santa Fe, HSNM 0406; GC to Spencer F. Baird, December 12, 1871, Secretary, 1863–79: Incoming Correspondence, 109:76, SIA; GC to Col. Norton, December 14, 1871, Massachusetts Historical Society, Boston; "Catlin's Indian Collection," *New York Times,* February 1, 1872; "Proposed Indian Testi-

monial," *Frank Leslie's Illustrated Newspaper* 33, no.857(March 2, 1872): 391.

79. *Frank Leslie's Illustrated Newspaper* 33, no.857(March 2, 1872): 385; George Harvey to New York *Post,* December 23, 1872, in Donaldson, *Catlin Gallery,* p.715.

80. GC to Joseph Henry, February 13, 1872, Secretary, 1863–79: Incoming Correspondence, 109:72, SIA; Henry Diary, 1872, pp.28–29, 36, Joseph Henry Collection, box 15, SIA; *Annual Report, SI, 1871* (Washington: GPO, 1873), pp.40–41; Henry to D. S. Gregory, October 29, 1872, AAA: 2136; Henry Diary, 1872, p.53, Joseph Henry Collection.

81. *Cong. Globe,* 42d Cong., 2d sess., p.3097; *Petition of George Catlin* (n.p., n.d.), with *Synopsis of the Travels of George Catlin in Gathering His Sketches for His Indian Collection* (n.p., n.d.) and *Catlin's Indian Collection: Opinions of the Most Distinguished Statesmen Concerning This Extensive Collection . . .* (Brussels: C. Coomans, [1870]), copies in AAA: 2137.

82. *House Journal,* 42d Cong., 2d sess., pp.943, 977.

83. GC to [George Moore, NYHS], [February 1872?], and March 14, 1872, NYHS. The two letters are usually both dated March 14, but the first was written in New York, presumably during Catlin's February exhibition.

84. GC to [Moore], March 14, 1872; GC to William Blackmore, [May 27, 1872], Museum of New Mexico, Santa Fe, HSNM 0262; Taylor, "'Ho, for the Great West!'" pp.25–26, 42; James C. Olson, *Red Cloud and the Sioux Problem* (Lincoln: University of Nebraska Press, 1965), pp.150–52; GC to Henry A. Boller, February 19, 1872, Boller Papers, State Historical Society of North Dakota, Bismarck.

85. Joseph Henry Diary, 1872, p.134, Joseph Henry Collection, box 15, SIA; *Annual Report, SI, 1872* (Wash-

ington: GPO, 1873), p.41; and Joseph Henry to D. S. Gregory, October 29, 1872, copy in AAA: 2136.

86. Henry to Gregory, October 29, 31, 1872, copies in AAA: 2136.

87. Joseph Henry Diary, 1872, p.152, Joseph Henry Collection, box 15, SIA.

88. Elizabeth W. Catlin to William Blackmore, December 18, 1872, Museum of New Mexico, Santa Fe, HSNM 0544; Taylor, "'Ho, for the Great West!'" pp.35–36; Donaldson, *Catlin Gallery,* p.717.

89. "George Catlin, Artist," *New York Times,* December 24, 1872; Donaldson, *Catlin Gallery,* p.716; "George Catlin, the Artist," *New York Herald;* "George Catlin," *New York Tribune;* "George Catlin," *Jersey City Times,* all December 24, 1872. Catlin's grave was finally marked in 1961: [Peter Decker], "The Hitching Post," *Westerners New York Posse Brand Book* 8, no.2(1961): 27; and *Letters,* p.411.

90. *Cong. Globe,* 42d Cong., 3d sess., pp.991, 1023; and *House Journal,* 42d Cong., 3d sess., pp.288, 319; Elizabeth W. Catlin, Clara G. Catlin, and Louise Catlin Kinney, *Catlin's Indian Collection* (n.p., [1873]), copy in AAA: 2137.

91. *Cong. Record,* 43d Cong., 1st sess., p.217; *Annual Report, SI, 1872,* pp.82–83; *Letter of Prof. Henry, of the Smithsonian Institution* (1873).

92. Elizabeth W. Catlin to Joseph Henry, February 5, 1874, Secretary, 1863–79: Incoming Correspondence, 142:51, SIA; Henry to Elizabeth W. Catlin, February 6, 1874, Secretary, 1865–91: Outgoing Correspondence, 37:594–95, SIA; Elizabeth W. Catlin, Clara G. Catlin, and Louise Catlin Kinney to President and Faculty of the University of California, February 10, 1874, California Miscellany, 1800–1899, Bancroft Library, University of California, Berkeley, published in *Letters,* pp.411–12; printed endorsements with *H.R.* 4729 (February 27,

1875), 43d Cong., 2d sess., copies in AAA: 2137; John A. Dix to Louise Catlin Kinney, March 16, 1874, AAA: 2136; H. Millard, R. B. Roosevelt, et al., to Chairman, Library Committee of Congress, December 30, 1874, AAA: 2137; and Frederic de Peyster, Wm. Cullen Bryant, et al., testimonial, January, 1875, RH 3627, Huntington.

93. *H.R.* 4729; and *Cong. Record,* 43d Cong., 2d sess., p.1861. The amended bill was passed March 3.

94. Joseph Henry Diary, 1872, p.154, Joseph Henry Collection, box 15, SIA; Truettner, *Natural Man,* p.135; Henry to Elizabeth W. Catlin, March 24, 1873, Secretary, 1865–91: Outgoing Correspondence, 33:225; E. W. Catlin, C. G. Catlin, and L. C. Kinney to Henry, March 16, 1876, Secretary, 1863–79: Incoming Correspondence, 151:360, SIA; Thad. Norris, Jr., to Spencer F. Baird, May 29, 1879, and Card Catalogue of Accessions, U.S. National Museum, Registrar, 1834–1958, Accession Records no.7792, SIA.

95. Spencer F. Baird to Sarah Harrison, June 11, 1879; Thad Norris, Jr., to Baird, June 26, 1879, with Accession Records no.7792. The gift was noted in *Annual Report, SI, 1879* (Washington: GPO, 1880), pp.40–41, and *1880* (Washington: GPO, 1881), p.56.

96. Henry to Gregory, October 29, 1872; Henry Diary, 1872, pp.59, 61, Joseph Henry Collection, box 15, SIA; Henry to Gregory, October 31, 1872.

97. *Annual Report, SI, 1872,* pp.369–71.

98. D. D. Mitchell to HRS, April 21, 1852, HRS Papers: 13; August 11, 1852, roll 40; Mitchell to HRS, October 18, 1852, roll 14. There is evidence that Kipp also entertained some reservations about Catlin: Myrtis Jarrell, trans., and J. N. B. Hewitt, ed., *Journal of Rudolph Friederich Kurz* . . . (Lincoln: University of Nebraska Press, Bison Book, 1970 [1937]), p.130. The

biographical accounts of James Kipp (1788–1880) tend to repeat one another with some variation: Donaldson, *Catlin Gallery,* pp.381–82n; Annie Heloise Abel, ed., *Chardon's Journal at Fort Clark, 1834–1839* (Freeport, N.Y.: Books for Libraries Press, 1970 [1932]), pp.225–27, n.80; Ray H. Mattison, "James Kipp," in LeRoy R. Hafen, ed., *The Mountain Men and the Fur Trade of the Far West,* 10 vols. (Glendale, Calif.: Arthur H. Clark, 1965), 2:201–5. Useful for Kipp and the Mandans is Alan R. Woolworth and W. Raymond Wood, "Excavations at Kipp's Post," *North Dakota History* 29(July 1962): 237–52. Kipp is usually said to have left the fur trade in 1865; Boller gave 1860 as the year of his retirement.

99. Henry A. Boller to his father, March 3, 1857, to his mother, June 1, 1858, to Alfred P. Boller, May 29, 1858, to his father, June 19, 23, 1858, to Frederick J. Boller, June 23, 1858, and to Alfred P. Boller, August 18, 1858, in Ray H. Mattison, ed., *Henry A. Boller: Missouri River Fur Trader* (Bismarck: State Historical Society of North Dakota, 1966), pp.7, 25, 30, 39, 42, 44, 58.

100. Henry A. Boller to GC, December 28, 1871; GC to Boller, February 19, 1872, Boller Papers, State Historical Society of North Dakota, Bismarck; Dan Carpenter to Thomas Donaldson, September 1, 1885, in Donaldson, *Catlin Gallery,* p.382n. Carpenter notarized Kipp's affidavit in 1872 attesting the accuracy of Catlin's Mandan scenes. Boller's confusing title (the dates referring to the four of Boller's eight years in the West actually spent among the Indians) was changed in a recent reprint, edited by Milo Milton Quaife, *Among the Indians: Four Years on the Upper Missouri, 1858–1862* (Lincoln: University of Nebraska Press, Bison Book, 1972).

101. *Annual Report, SI, 1872,* pp.436–38. Kipp's own prose was neither so formal nor so polished, judging from

a letter to his son Joe Kipp, August 15, 1878, typescript in the James Kipp Papers, Montana Historical Society Archives, Helena.

102. "Notes Relative to George Catlin," *Annual Report, SI, 1872,* pp.53–54; Donaldson, *Catlin Gallery,* pp.374–83; Louise Catlin Kinney to Donaldson, September 6, [1889], AAA: 2136. Donaldson's volume was inspired by the first public exhibition of Catlin's works in the newly opened National Museum in 1883 (*Annual Report, SI, 1883* [Washington: GPO, 1885], p.53). For the Catlin sisters' participation, see G. Brown Goode to Elizabeth W. Catlin and Goode to Donaldson, both May 2, 1885, Assistant Secretary in Charge of the U.S. National Museum, 1879–1907: Outgoing Correspondence, L–19:139–42, SIA; and Elizabeth W. Catlin to Donaldson, August 5, 1885, AAA: 2136. Though Donaldson's monograph is dated 1886 on the title page, it was not issued until late in 1888. See *Annual Report, SI, to July, 1888* (Washington: GPO, 1890), p.55, and a review, "The George Catlin Indian Gallery," *American,* January 5, 1889, clipping in AAA: 2137.

103. Washington Matthews, "The Catlin Collection of Indian Paintings," *Report of the National Museum, 1890* (Washington: GPO, 1891), pp.593–610. Matthews was far more critical of Catlin in an earlier monograph on the Hidatsas, though he accepted his account of the O-kee-pa as entirely accurate: *Ethnology and Philology of the Hidatsa Indians,* U.S. Geological and Geographical Survey, Misc. Pubs. 7 (Washington: GPO, 1877), pp.6, 10, 14, 21–22, 28–29, 44–46.

104. Spencer F. Baird to Elizabeth W. Catlin, May 28, 1885, Secretary, 1865–91: Outgoing Correspondence, 179:84; Accession Card, June 30, 1885, Catlin to Baird, June 28, 1885, and Louise Catlin Kinney to G. Brown Goode, October 15, 1890, U.S. National Museum, Registrar, 1834–1958, Accession Records

no.16206; S. P. Langley to Kinney, November 8, 1892, Secretary, 1865–91: Outgoing Correspondence, 2.2:373; William Harvey Miner to Librarian, Bureau of Ethnology, October 17, 1904, and to W. H. Holmes, July 3, 1905; Holmes to Miner, July 6, 1905; R. Geare to O. T. Mason, October 12, 1905, with Accession Records no.16206, SIA.

105. Haberly, *Pursuit of the Horizon*, p.232; *National Gallery of Art: American Paintings and Sculpture: An Illustrated Catalogue* (Washington: National Gallery of Art, 1970), pp.22–39.

106. GC to Peter B. Porter, February 22, 1829, Peter B. Porter Collection, Buffalo and Erie County Historical Society, Buffalo, N.Y.: "George Catlin," *Nature* 7(January 23, 1873): 223; *Annual Report, SI, 1872*, p.83.

107. Jarrell and Hewitt, *Journal of Rudolph Friederich Kurz*, p.130.

108. Edwin Swift Balch, "The Art of George Catlin," *Proceedings, American Philosophical Society* 57(1918): 144–54; Alfred H. Barr, Jr., et al., "Catlin as Artist," *New York Herald Tribune Book Review*, January 2, 1949.

109. George M. Stanley to Edith Stanley Bayles, January 12, 1948, Stanley Papers, AAA: 687; *North and South American Indians, Catalogue Descriptive and Instructive of Catlin's Indian Cartoons* (New York: Baker and Godwin, 1871), Remarks; "McKenney and Hall's Sketches of the Indian Tribes," *Eclectic Magazine* 9(September 1846): 13; also "Mr. Stanley's Chromos," unidentified clipping, Stanley Papers, for the opinion that Stanley (and his peers presumably) had founded "a school of art that is from its nature purely American."

BIBLIOGRAPHICAL NOTE

This book rests mainly on primary sources drawn from the following collections (the most important for the purposes of this study are indicated with an asterisk):

American Antiquarian Society, Worcester, Massachusetts

 Catlin letter

Archives of American Art, Smithsonian Institution, Washington, D.C.

 Roll 88: Charles Roberts Autograph Collection: American Artists

 *Roll 687: John Mix Stanley Papers

 Roll 1191: George Catlin Papers

 *Rolls 2136–37: George Catlin Papers

 Roll 2707: Catlin Family Papers

 Roll 2770: Henry Kirke Brown Papers

 Rolls 3023–24: Catlin Family Papers

 Roll D5: Charles Henry Hart Autograph Collection

 Roll D8: Miscellaneous Manuscripts: Abbey, Edwin A., through Church, F. S.

 Roll N81: New York Public Library Prints Division

 Roll NY59–29: Mary Bartlett Cowdrey Nineteenth Century American Artists File

 *Roll OAM: John Mix Stanley (1814–72): Scrapbook

 Roll P20: Dreer Collection, Historical Society of Pennsylvania

 Roll P21: Elting Papers, Historical Society of Pennsylvania

 Roll P22: Gratz Collection, Historical Society of Pennsylvania

 Roll P23: The Historical Society of Pennsylvania, Miscellaneous Collection

 Roll P29: Poinsett Papers, Historical Society of Pennsylvania

Roll P73: Pennsylvania Academy of Fine Arts Collection

Bibliothèque Nationale, Paris, Department of Manuscripts

P. Margry Collection

Boston Public Library, Manuscript Collection

Two Catlin letters

British Museum, London

Catlin letter

Brown University, Providence, Rhode Island, John Carter Brown Library

*John R. Bartlett Papers

Buffalo and Erie County Historical Society, Buffalo

Peter B. Porter Collection

Cincinnati Historical Society, Cincinnati

Isaac Strohm Papers

Connecticut Historical Society, Hartford

Henry C. Potter, "Mandan Ceremony" (1837)

Cornell University Library, Department of Rare Books, Ithaca

Three Catlin letters; J. H. Payne to Catlin

Ezra Cornell Papers

Detroit Public Library, Burton Historical Collection, Detroit

G. B. Catlin, "John Mix Stanley," typescript (1924)

Harvard University, Houghton Library, Cambridge, Massachusetts

Three Catlin Letters; Sir Thomas Phillipps to Mr. Putnam

Henry E. Huntington Library, San Marino, California

Francis Lieber Collection

William J. Rhees Collection

G. Catlin, "The North American Indians in the Middle of the Nineteenth Century . . ." (1869)

H. R. Schoolcraft, "Ethnological Views and Inquiries Respecting the North American Indians" (ca. 1845)

Henry Shelton Sanford Memorial Library and Museum, Sanford, Florida

*Henry Shelton Sanford Papers

Indiana Historical Society, William Henry Smith Memorial Library, Indianapolis

Catlin letter

E. G. Squier Papers

Indiana University, Manuscripts Department, Lilly Library, Bloomington

Catlin letter

Iowa State Education Association, Des Moines, Iowa

Washington Irving to William Jerdan, regarding Catlin

Joslyn Museum, Center for Western Studies, Omaha, Nebraska

Maximilian, Prince of Wied, "A few remarks about Catlin's book 'Letters and notes on the manners, customs and condition of the North American Indians,'" typescript translation, 1842 manuscript

Knox College, Archives and Manuscripts Collection, Galesburg, Illinois

Catlin letter

Library Company of Philadelphia, Philadelphia, Pennsylvania

James Barton Longacre Papers

Library of Congress, Manuscripts Division, Washington, D.C.

The Records of the American Colonization Society, Series 2, vols.41–45: Ralph R. Gurley Letterbooks (microfilm edition)

The Papers of John M. Clayton

The Papers of Charles Lanman

The Papers of Manton Marble

Miscellaneous Manuscripts Collection

*Henry R. Schoolcraft Papers (microfilm edition)

*Ephraim George Squier Papers (microfilm edition)

Long Island Historical Society, Brooklyn, New York

Catlin letter

Marietta College, Dawes Memorial Library, Marietta, Ohio

Catlin letter

Massachusetts Historical Society, Boston

Two Catlin letters

Edward Everett Collection

Robie Sewall Collection

Minnesota Historical Society, Division of Archives and Manuscripts, St. Paul

Eastman letter

Charles H. Baker Papers

Henry Lewis Papers, Stehli Collection

Francis B. Mayer Diary, July 6, 1847 to November 1, 1854

Alexander Ramsey Papers

*Henry Hastings Sibley Papers (microfilm edition)

*Lawrence Taliaferro Papers (microfilm edition

Missouri Historical Society, St. Louis

*George Catlin Papers

Pierre Chouteau Collections

Chouteau-Maffit Collection

G. Catlin, "A Cure for Influenza," undated manuscript.

Montana Historical Society Archives, Helena, Montana

James Kipp Papers

G. Catlin, "Souvenir of the North American Indians" (dated 1852; ca. 1860).

Morristown National Historical Park, Morristown, New Jersey

Daniel Webster Papers

Museum of New Mexico, Santa Fe

*William Blackmore Collection

*National Archives, Washington, D.C.

Record Group 15: Records of the Veterans Administration

Record Group 46: Records of the U.S. Senate

Record Group 75: Records of the Office of Indian Affairs

Record Group 92: Records of the Office of the Quartermaster General

Record Group 94: Records of the Adjutant General's Office

Record Group 107: Records of the Office of the Secretary of War

Record Group 108: Records of the Headquarters of the Army

Record Group 233: Records of the United States House of Representatives

Microfilm 126: Correspondence of the Office of Explorations and Surveys concerning Isaac Stevens's Survey of a Northern Route for the Pacific Railway, 1853–61

Newberry Library, Edward E. Ayer Collection, Chicago

Three Catlin letters

G. Catlin, "An Account of an Annual Religious Ceremony . . . ," handwritten copy (1865)

G. Catlin, "Souvenir of the North American Indians . . ." (dated 1852; ca. 1860)

New-York Historical Society, New York

Catlin Papers

Buckingham Smith Papers

*Ephraim G. Squier Papers (microfilm edition)

G. Catlin, "Customs of the Indians," manuscript copy of his newspaper letter of August 12, 1832

New York Public Library, Manuscripts
Division, New York

Catlin Papers

A. B. Durand Papers

Ford Autograph Collection

Alexandre Vattemare Collection

New York State Library, Manuscripts
and Special Collections, Albany

Benjamin F. Butler Papers

Public Archives of British Columbia,
Victoria

Schoolcraft letter

Redwood Library and Athenaeum,
Newport, Rhode Island

Catlin letter

Rockwell Museum of Western Art,
Corning, New York

Stanley Papers

*Smithsonian Institution Archives,
Washington, D.C.

Assistant Secretary, 1850–77: Out-
going Correspondence

Secretary, 1863–79: Incoming Cor-
respondence

Secretary, 1865–91: Outgoing Cor-
respondence

Secretary, 1882–90: Incoming Cor-
respondence

Joseph Henry Papers: Diary, 1872

John Mix Stanley Collection

United States National Museum

—Assistant Secretary in Charge,
1879–1907: Outgoing Correspon-
dence

—Registrar, 1834–1958 (accretions
to 1976), Accession Records

State Historical Society of North Da-
kota, Bismarck

Henry A. Boller Papers

Thomas Gilcrease Institute of American
History and Art, Tulsa, Oklahoma

*Catlin–Sir Thomas Phillipps Corre-
spondence

Tippecanoe County Historical Associa-
tion, Lafayette, Indiana

George Winter Papers (courtesy of
Mrs. Cable G. Ball)

University of California, Bancroft Li-
brary, Berkeley

California Miscellany, 1800–1899

*George Catlin Papers

J. L. L. Warren Papers

University of California Los Angeles,
Department of Special Collections,
Los Angeles

Catlin letter

University of Kansas, Department of
Special Collections, Kenneth Spencer
Research Library, Lawrence, Kansas

Catlin Papers

University of Rochester Library,
Rochester, New York

William H. Seward Papers

University of Texas, Barker Texas His-
tory Center, Austin, Texas

Samuel Henry Starr Papers

Victoria University Library, Toronto

Peter Jones Collection

Walters Art Gallery, Baltimore, Maryland

Marvin C. Ross, ed., "Artists' Letters
to Alfred Jacob Miller," typescript
(1951)

Yale University, Beinecke Rare Book and
Manuscript Library, New Haven,
Connecticut

Two Catlin letters

Two Eastman letters

G. Sand to E. Charton, regarding
Catlin

George Suckley Papers

Elkanah Walker Papers

Marcus Whitman Collection: Corre-
spondence of members of the
Oregon Mission

Yale University, Sterling Memorial Library, Manuscripts and Archives, New Haven, Connecticut

Catlin letter

William H. Brewer Papers

Many of these collections hold a single letter or manuscript by or about Catlin, Eastman, Stanley, Schoolcraft, or Squier. The Schoolcraft Papers in the Library of Congress are voluminous and reasonably complete, since Schoolcraft usually kept drafts of his own letters. The principal problem with the collection is Schoolcraft's handwriting; bad at the best of times, it deteriorated with his worsening paralysis in the 1850s to the point of virtual illegibility. The Squier Collection in the Library of Congress offers much on his antiquarian activities, while that in the New-York Historical Society is rich in family and personal information and supplemented by typescripts of Squier's letters to Francis Parkman. Parkman's side of the correspondence can be found in Wilbur R. Jacobs, ed., *Letters of Francis Parkman,* 2 vols. (Norman: University of Oklahoma Press, 1960). The John R. Bartlett Papers at Brown University are of great value, since Bartlett's activities with the American Ethnological Society put him in touch with the leading antiquarians of his day, including Schoolcraft and Squier, and he also corresponded with both Stanley and Eastman. There are no Eastman papers as such, but he is represented in the Schoolcraft Papers and in the Henry H. Sibley Papers in the Minnesota Historical Society, partly through his wife, Mary, whose letters provide most of the personal detail. The Stanley Papers, Archives of American Art, roll 687, include only a small sampling of letters from Stanley himself but much about his domestic relations. They should be supplemented with the Isaac Strohm Papers in the Cincinnati Historical Society. The Stanley Scrapbook (Archives of American Art, roll OAM) is

an invaluable trove of information on Stanley's western wanderings and his successive exhibitions; it tapers off with his arrival in Washington, D.C., in 1852 but is supplemented by later clippings in the Stanley Papers.

No comparable source exists for Eastman or Catlin. Eastman did use the blank leaves in a journal he kept in 1849 as a scrapbook of sorts. But while the journal is now in the collection of the Marion Koogler McNay Art Institute in San Antonio, its curator reports that the pages with the clippings are unlocated. Catlin, as an inveterate scribbler and self-publicist, frequently used the newspapers to promote his Indian Gallery, but he kept no scrapbook. While his letters were often reprinted and thus turn up in unexpected places, a systematic search of the local newspapers during each of his exhibition tours would doubtless provide additional information. Indeed, much that would shed light on the activities of Catlin and the others remains buried in newspaper files. I did scour a few in the course of researching this book:

Cincinnati *Daily Gazette,* March 1841 to June 1842

Cincinnati *Enquirer,* April to September 1841; January 1842 to March 1843

Newark *Daily Advertiser,* October 1841 to February 1842

New York *Daily Tribune,* January–April 1858

New York *Evening Star,* April 1835 to June 1837

New York *Morning Herald,* October–December 1837

St. Louis *Missouri Republican,* April 1832 to April 1834; July–December 1836

St. Louis *Weekly Reveille,* September–October 1844

Washington, D.C., *Daily National Intelligencer,* 1849, 1851–53

I have also examined the files of selected periodicals:

Illustrated London News, 1840, 1851, 1854–58

New-York Mirror, 1837–39

Niles' Weekly Register, 1838–46

Literary World, 1849–53

This only scratches the surface; much, especially where Catlin is concerned, awaits discovery. Catlin's letters in the New York *Commercial Advertiser* (1832–37) are conveniently available in a bound volume in the Library of the National Museum of American Art and the National Portrait Gallery, Smithsonian Institution: "Letters by George Catlin Describing the Manners, Customs, and Conditions of the North American Indians." However, it should be noted that this collection of photostatic copies is not complete.

The Catlin Papers (Archives of American Art, rolls 2136–37) constitute the largest single body of Catlin material, though the coverage is spotty. Thomas Donaldson had access to these papers in the process of compiling *The George Catlin Indian Gallery in the U.S. National Museum (Smithsonian Inst.) with Memoir and Statistics, Annual Report, 51, 1885,* part 2 (Washington: GPO, 1886). The Catlin Papers in the Bancroft Library, Berkeley, constitute an essential source on the family; they have been published almost in their entirety in Marjorie Catlin Roehm, *The Letters of George Catlin and His Family: A Chronicle of the American West* (Berkeley: University of California Press, 1966), supplemented with some of the Catlin Papers in the Missouri Historical Society, St. Louis, and the New-York Historical Society. Researchers might still wish to consult the originals, since there are errors in transcription in the Roehm edition, as well as deletions, though mostly minor. Valuable for documenting Catlin's relationship with a single patron is the Catlin–Sir Thomas Phillipps correspondence in the Thomas Gilcrease Institute, Tulsa.

Any study of federal patronage must rely on the holdings of the National Archives and published federal documents, and any study of American art relies on the microfilm series the Archives of American Art under the auspices of the Smithsonian Institution. Certainly mine does. It also draws on a wide array of published primary sources, notably exhibition catalogs and the writings of its principals. Especially pertinent are Catlin's *Letters and Notes on the Manners, Customs, and Conditions of the North American Indians* (London: Author, 1841) and *Notes of Eight Years' Travels and Residence in Europe, with His North American Indian Collection* (London: Author, 1848), and Henry R. Schoolcraft's *Personal Memoirs of a Residence of Thirty Years with the Indian Tribes on the American Frontiers* (Philadelphia: Lippincott, Grambo, 1851) and his official compilation, *Information Respecting the History, Condition and Prospects of the Indian Tribes of the United States* (Philadelphia: Lippincott, Grambo, 1851–57).

The most useful study of Catlin is William H. Truettner's exemplary *The Natural Man Observed: A Study of Catlin's Indian Gallery* (Washington: Smithsonian Institution Press for the Amon Carter Museum of Western Art, Fort Worth, and the National Collection of Fine Arts, Smithsonian Institution, 1979). Truettner's work is limited, as the subtitle indicates, to Catlin's first collection; Nancy Anderson, with the National Gallery of Art in Washington, is preparing a needed followup on his second collection. Loren Wilson Hall's "Portrait of a Mind: A Psychological-Intellectual Biography of George Catlin" (Ph.D. diss., Emory University, 1987) offers a Jungian interpretation of the contradictions in Catlin's character. John

Francis McDermott's *Seth Eastman: Pictorial Historian of the Indian* (Norman: University of Oklahoma Press, 1961) will shortly be supplemented by a thesis by Sarah Boehme at the Buffalo Bill Historical Center, Cody, Wyoming. For Stanley, see Julie Ann Schimmel, "John Mix Stanley and Imagery of the West in Nineteenth-Century Art" (Ph.D. diss., New York University, 1983), and for Schoolcraft, John Finley Freeman "Henry Rowe Schoolcraft" (Ph.D. diss., Harvard University, 1959), which reaches for a Freudian interpretation. It has been supplanted by Richard G. Bremer, *Indian Agent and Wilderness Scholar: The Life of Henry Rowe Schoolcraft* (Mount Pleasant: Clarke Historical Library, Central Michigan University, 1987), which became available after my book went to press. Recent and useful for both Schoolcraft and Squier is Robert E. Bieder, *Science Encounters the Indian, 1820–1880: The Early Years of American Ethnology* (Norman: University of Oklahoma Press, 1986).

Finally, I want to mention two excellent books whose handling of complex topics involving large casts of characters has influenced my own: William Stanton, *The Leopard's Spots: Scientific Attitudes toward Race in America, 1851–59* (Chicago: University of Chicago Press, 1960), and William H. Goetzmann, *Army Exploration in the American West, 1803–1863* (New Haven: Yale University Press, 1959).

INDEX

Titles of works of art and written works are indexed under the artist's or author's name. The page numbers of illustrations are in italics.